Jacques-Louis David | *Empire to Exile*

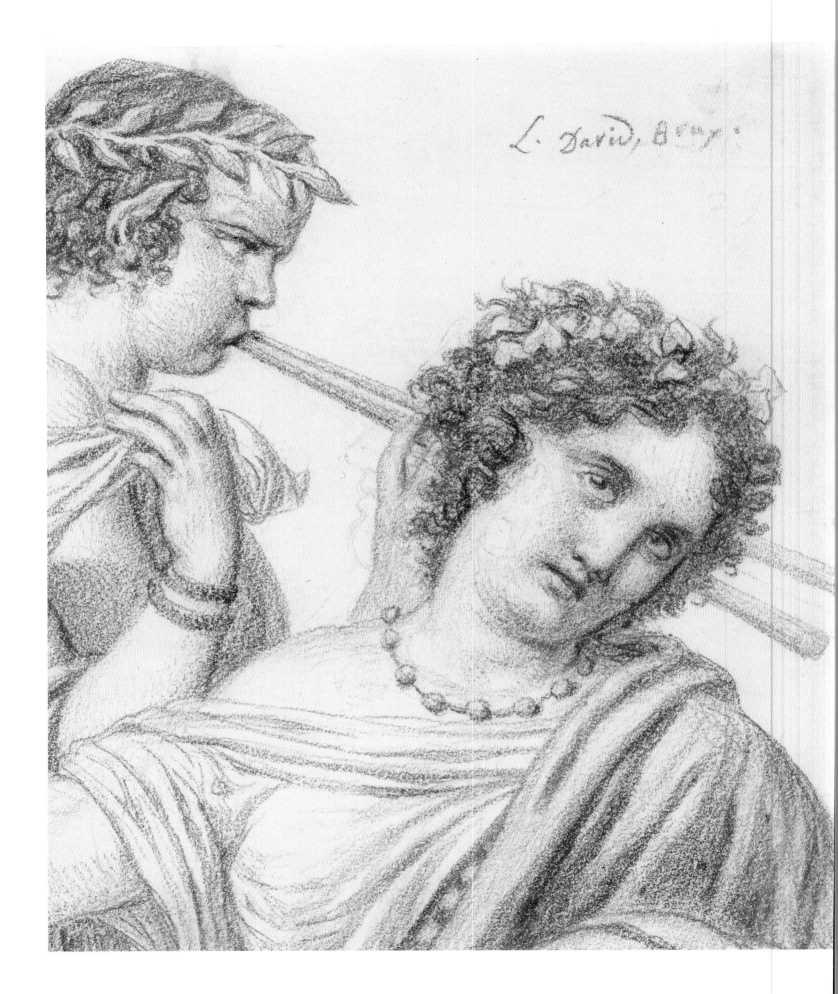

L. David, Bruxe.

Philippe Bordes

Jacques-Louis David

Empire to Exile

YALE UNIVERSITY PRESS

NEW HAVEN AND LONDON

STERLING AND FRANCINE CLARK ART INSTITUTE

WILLIAMSTOWN, MASSACHUSETTS

This book is published on the occasion of the exhibition *Jacques-Louis David: Empire to Exile*

The J. Paul Getty Museum
Los Angeles, California
1 February–24 April 2005

Sterling and Francine Clark Art Institute
Williamstown, Massachusetts
5 June–5 September 2005

NATIONAL
ENDOWMENT
FOR THE ARTS

Jacques-Louis David: Empire to Exile has been organized by the J. Paul Getty Museum and the Sterling and Francine Clark Art Institute. This exhibition is supported by an indemnity from the Federal Council on the Arts and the Humanities. This project is supported in part by the National Endowment for the Arts, which believes that a great nation deserves great art. In Williamstown, additional support was provided by The Brown Foundation, Inc., of Houston.

Produced under the direction of Curtis R. Scott
Edited by Mary Christian
Designed by Leslie Thomas Fitch
Print production by Mary Mayer
Index by Kathleen M. Friello
Color separations by Professional Graphics, Chicago
Printed by CS Graphics, Singapore

COVER ILLUSTRATIONS: (Front) Detail of *Bonaparte Crossing the Alps at Grand-Saint-Bernard* (CAT. 4); (back) *Cupid and Psyche* (CAT. 32)
FRONTISPIECE: Detail of *Composition with Three Figures* (CAT. 41)
PAGES XVIII–XIX: Detail of *The Farewell of Telemachus and Eucharis* (CAT. 35)

Printed and bound in Singapore
10 9 8 7 6 5 4 3 2 1

LIBRARY OF CONGRESS CATALOGING-IN-PUBLICATION DATA
Bordes, Philippe.
Jacques-Louis David : empire to exile / Philippe Bordes.
 p. cm.
Catalog of an exhibition organized by the J. Paul Getty Museum and the Sterling and Francine Clark Art Institute, held in Los Angeles, Feb. 1–April 24, 2005, and Williamstown, Mass., June 5–Sept. 5, 2005.

Includes bibliographical references and index.
ISBN 0-300-10447-2 (cloth: alk. paper)
ISBN 0-931102-60-x (pbk.: alk. paper)
 1. David, Jacques Louis, 1748–1825—Exhibitions. 2. Classicism in art—Exhibitions. I. David, Jacques Louis, 1748–1825. II. Sterling and Francine Clark Art Institute. III. J. Paul Getty Museum. IV. Title.
 ND553.D25A4 2005
 759.4—dc22 2004023962

A catalogue record for this book is available from the British Library.

The paper in this book meets the guidelines for permanence and durability of the Committee on Production Guidelines for Book Longevity of the Council on Library Resources.

CONTENTS

The Art Institute of Chicago

Centre historique des Archives nationales, Paris

The Cleveland Museum of Art

James Fairfax

Fine Arts Museums of San Francisco

Fondation Dosne-Thiers, Institut de France, Paris

The Frick Collection, New York

The Horvitz Collection, Boston

The J. Paul Getty Museum, Los Angeles

Kimbell Art Museum, Fort Worth

James Mackinnon

Dr. Esmond Martin

The Metropolitan Museum of Art, New York

Musée du Louvre, Paris

Musée Fabre, Montpellier

Musée Jacquemart-André, Institut de France, Paris

Musée national des Châteaux de Malmaison et Bois-Préau,
 Reuil-Malmaison

Musée national des Châteaux de Versailles et de Trianon

The National Gallery, London

National Gallery of Art, Washington

Ny Carlsberg Glyptotek, Copenhagen

Palais des Beaux-Arts, Lille

The Peabody Collection, Maryland Commission on Artistic
 Property of the Maryland State Archives, Annapolis

The Snite Museum of Art, University of Notre Dame,
 Indiana

The State Hermitage Museum, St. Petersburg

Sterling and Francine Clark Art Institute, Williamstown,
 Massachusetts

Timken Museum of Art, San Diego

W. M. Brady & Co., New York

Private collections

FOREWORD

J ACQUES-LOUIS DAVID: EMPIRE TO EXILE presents two of the most remarkable personalities of the late eighteenth and early nineteenth centuries—Napoleon Bonaparte, who rose from obscurity to dominate the political and geographical landscape of Europe, and Jacques-Louis David, the most celebrated and controversial painter of his day. The exhibition and catalogue represent, incredibly, the first detailed exploration of David's work under Napoleon's empire, along with his subsequent production in Brussels, where the artist spent his last years in exile.

It is only fitting that the Clark and the Getty should join forces in this enterprise. In recent years both institutions have acquired major examples of David's late work, ranging from the 1804 portrait of Suzanne Le Peletier de Saint-Fargeau to the 1818 history painting *The Farewell of Telemachus and Eucharis*—both at the Getty—as well as two stellar examples from David's later years in exile, the Clark's portrait of the comte de Turenne and the Getty's double portrait of the Bonaparte sisters. Indeed, these paintings, along with many other significant paintings and drawings from museums and private collections around the world, form the cornerstones of the project. Moreover, the Getty and the Clark are institutions dedicated to advanced research in the visual arts, and we anticipate that this exhibition and its accompanying catalogue will spark a reappraisal of the career of one of Europe's canonical masters.

In achieving these goals we could have had no better guest curator than Philippe Bordes, who has long been a pioneering voice in the study of French art of the late eighteenth and early nineteenth centuries. Working closely with Richard Rand at the Clark and Scott Schaefer, Jon Seydl, and Charlotte Eyerman at the Getty, Philippe was responsible for the selection of the works in the show and is the sole author of this magnificent catalogue. The project is the culmination of Philippe's many years of research on the artist and provides a truly revisionist approach to our understanding of David's career. We are deeply grateful for his enthusiasm and professionalism over the past several years.

Organizing and mounting this exhibition required the efforts of numerous staff at both institutions. At the Getty, we wish to thank in particular Sophia Allison, Mari-Tere Alvarez, Cherie Chen, Catherine Comeau, Mikka Gee Conway, Peggy Fogelman, Lorraine Forrest, Christine Giviskos, Deborah Gribbon, Sally Hibbard, Quincy Houghton, Amber Keller, Paige-Marie Ketner, Laurel Kishi, Clare Kunny, Amy Linker, Anne Martens, Elisabeth Mention, Bruce Metro, Silvina Niepomniszcze, Merritt Price, Leon Rodriguez, Betsy Severance, Annelisa Stephan, and Nancy Yocco. At the Clark, our thanks go to Brian Allen,

Harry Blake, Michael Cassin, Sharon Clark, Paul Dion, David Edge, Lindsay Garratt, Lisa Green, Mari Yoko Hara, Sherrill Ingalls, Mattie Kelley, David Keiser-Clark, John Ladd, Mark Ledbury, Sarah Lees, Mary Leitch, Julie Mackaman, Mark Reach, Katie Pasco, Kathryn Price, Curtis Scott, Danielle Steinmann, Colleen Terry, and Ronna Tulgan-Ostheimer.

We are grateful for the support of the National Endowment for the Arts and the Federal Council on the Arts and Humanities in making this exhibition possible. Finally, we wish to acknowledge the many private and institutional lenders who generously agreed to part with their works so that we might realize this ambitious project. In many cases, these works are on public display for the first time, and it is our privilege to share them all with a wider audience.

<table>
<tr><td>Michael Conforti</td><td>William M. Griswold</td></tr>
<tr><td>*Director, Sterling and Francine*</td><td>*Acting Director and Chief Curator*</td></tr>
<tr><td>*Clark Art Institute*</td><td>*The J. Paul Getty Museum*</td></tr>
</table>

DURING JACQUES-LOUIS DAVID's lifetime, only two of his paintings reached America, with the collection of Joseph Bonaparte, Napoleon's brother, who fled France after the fall of the Empire in 1815 and settled in the Philadelphia area (SEE CATS. 4 AND 54). Much earlier, however, from the time Thomas Jefferson viewed David's paintings in Paris, in the 1780s, the artist's reputation among the cultural elites of the new republic was well established. In 1808, some unknown American entrepreneurs ordered a replica of *The Coronation of Napoleon and Josephine*, which they intended to take on a tour of the United States for a profit. In the twentieth century, as the ambitions of American collectors and museums reached new heights, the desire was great to acquire representative paintings by David, the most renowned European painter of his day. Success was far from certain, however; for although his career covered a long half century, he painted only about a hundred pictures, and all his large-scale canvases, with the exception of *Mars Disarmed by Venus and the Graces* (FIG. 64), which was in Brussels, were in French public collections; the last to be negotiated, in the late 1940s, was the replica of the *Coronation*, which went to Versailles. Major works nonetheless crossed the Atlantic. In 1931, the Metropolitan Museum of Art in New York acquired *The Death of Socrates*. In 1936 Martin Birnbaum, an agent in Paris, allowed Grenville L. Winthrop to acquire the portrait of Emmanuel-Joseph Sieyès (FIG. 100), later bequeathed to the Fogg Art Museum, and also Henry P. McIlhenny to secure *Pope Pius VII and Cardinal Caprara* (FIG. 49). The latter wrote back to him: "I really feel triumphant that the David has been captured and I am terribly keen to have it in Philadelphia" (the panel, now in the Philadelphia Museum of Art, is too fragile to travel to the exhibition). In 1947, David David-Weill offered *The Fortune Teller* (FIG. 67) to the California Palace of the Legion of Honor in San Francisco, while in 1954, the Samuel H. Kress Foundation bought the 1812 portrait of Napoleon in his study, for the National Gallery of Art in Washington (SEE CAT. 12). Given the odds, this harvest is impressive.

This determined effort reflected a reappraisal of David's oeuvre, after a period of disaffection. During the second half of the nineteenth century, when the Goncourt brothers blamed him for the assault on the aristocratic *douceur de vivre* of the Ancien Régime, the works of Boucher, Fragonard, and Greuze were the norms by which his art was judged cold and lifeless. In 1880, a monumental monograph by the artist's grandson was apologetic, but also persuasive regarding the seriousness and scope of his practice. It was only after a major exhibition in Paris in 1913 that first the portraits, then the Napoleonic compositions, and

finally the scenes from Greek and Roman history, came to be considered more positively—a revision culminating with the retrospective organized in 1948 for the bicentenary of his birth. The Paris version of the exhibition included a few paintings from the period of his exile in Brussels after 1816 (SEE CATS. 31 AND 32), which were not retained for the English venues, however; and late drawings were excluded altogether. At the time, David's production in Brussels was judged to be idiosyncratic, neither classical nor romantic, ranking neither with his earlier artistic projects nor with those of the younger generation.

A better understanding of his late work has taken place only in the last twenty years, thanks to the foresight of courageous museum officials and the conviction of an art historian. The United States led the way. The Cleveland Museum of Art was unquestionably the pioneer institution when, in 1962, it acquired *Cupid and Psyche* (CAT. 32), and in 1973 an important late drawing (CAT. 43), followed here closely by the Achenbach Foundation in San Francisco (SEE CAT. 39). The acquisition of *Maurice-Étienne Gérard* (CAT. 50) by the Metropolitan Museum in 1965 confirmed the quality of the portraits painted by David in Brussels. Younger museums were particularly enterprising in the 1980s. The Kimbell Museum in Fort Worth bought *The Anger of Achilles* (CAT. 36) in 1980, and the J. Paul Getty Museum *The Farewell of Telemachus and Eucharis* (CAT. 35) in 1987, only one year after acquiring a major late portrait (CAT. 54). By this time, Dorothy Johnson, from her base at the University of Iowa, had begun to publish studies of the late history paintings, revealing David's artistic ambitions and principles; her work, along with that of art historians in Belgium, modified the biographical economy of David studies and forced scholars to dwell more on the last phase of his career. Among museums, the most recent developments are the acquisition in 1993 of a portrait of a mother and child by the National Gallery in London (SEE CAT. 47), and of two other, previously unknown portraits: one acquired by the Musée du Louvre in 1997 (SEE CAT. 56), and a second, purchased two years later by the Sterling and Francine Clark Art Institute in Williamstown (SEE CAT. 48).

The idea of devoting an exhibition to David's late work surfaced almost ten years ago among American museums that owned representative paintings. In the course of exchanges on the subject, the participating institutions and the chronological scope never ceased to evolve, but the J. Paul Getty Museum always remained engaged. Many a potential co-organizer hesitated on account of the limited number of works available and the difficulty in securing loans, but the Sterling and Francine Clark Art Institute proved a dedicated partner. It is telling that no comprehensive retrospective of the artist's oeuvre has previously been organized in the United States; the lone exhibition to focus on David was a private initiative in New York in 1947, a double bill with the sculptor Houdon, comprising fifteen oil paintings, only three of which were unquestionably by David.

Once the two museums had agreed to mount the exhibition of paintings and drawings, the chronological limits of the project needed to be established. The argument in favor of covering only the Brussels period was clean-cut and formally coherent. However, it was easy to demonstrate that the works David produced during the Directory, Consulate, Empire, and Restoration—in other words, after his year-long prison term for political responsibility in the Terror—possessed a much deeper visual and historical coherence, inspired by the desire to renew his practice and express the modernity of post-revolutionary France. Since it was not possible to offer *The Intervention of the Sabine Women* (FIG. 1), it was decided to launch the visual sequence with images of Bonaparte, on whose military and political adventure David mapped his artistic horizon after 1800. David's exile, a consequence of his steadfast fidelity to the Emperor, was no less determined by this relation than his tasks as court painter. The replica of the *Coronation* is after all a major accomplishment of the Brussels period.

Is the second half of David's career a theme for an exhibition? The artist's oeuvre has generally been ordered with an emphasis placed on the 1780s, the heroic decade of *The Oath of the Horatii* and of *Brutus*, to the detriment of works from later periods. Those fortunate enough to have seen the thorough retrospective presented at the Louvre in 1989 will recall the staggering succession of pictures leading up to *The Death of Marat* (FIG. 52) and the *Sabines*, and the difficulty in viewing with a fresh eye the paintings that followed. The present exhibition—after an introductory section that answers the expected first question: Who was David in 1800?—revises the general balance of the biographical and artistic narrative. It considers David's post-revolutionary career out of the shadow of his accomplishments during the Ancien Régime and underlines his commitment to modernity along with antiquity, to Flanders along with Italy, and to sensibility along with morality.

This exhibition further aims to highlight rediscoveries that have redefined the contours of the artist's oeuvre in the sixteen years since the Paris exhibition. Given the reduced number of his paintings, it is indeed astonishing that, for various reasons, fourteen out of the twenty-seven paintings in this show were not in the earlier exhibition, which aimed to be exhaustive. Fourteen of the twenty-nine drawings in this selection, chosen among the more finished sheets, were also not presented. Along with this focus on unfamiliar works, the public will be introduced through the catalogue to new information and to the debates provoked by the 1989 retrospective and the conference organized at the Louvre by Régis Michel on that occasion, aptly branded by him, *David against David*.

None of the papers presented at the 1989 conference dealt with the Empire. This is one reason why the Napoleonic period is given so much attention in this catalogue. To a great extent, this was made possible by the publication in 1999 of the voluminous administrative correspondence of Vivant Denon, Napoleon's director of the museum and coordinator of imperial commissions, which estab-

lishes a solid foundation for the study of the official art during the Empire. Preparation of the exhibition was also significantly facilitated by the remarkable catalogue raisonné of David's drawings by Louis-Antoine Prat and Pierre Rosenberg; the authors kindly allowed me to consult proofs before its publication in 2002, and through their assistant Benjamin Perronet, were most generous in their help with illustrations. Antoine Schnapper's essays and entries in the catalogue of the 1989 retrospective, as the notes to my own texts prove, were invaluable. Sadly, his death late last summer deprives me of the dialogue I was eager to pursue with a supportive colleague whose knowledge of David's art and life was unsurpassed.

Although I have always kept an eye out for unpublished letters by David, often with the aid of Thierry Bodin, two persons were particularly generous in this area: Mark Ledbury, with whom I am preparing a critical edition of the artist's writings, and Éric Bertin. David's correspondence and early printed sources were especially utilized to counter the unfortunate influence of Étienne-Jean Delécluze's 1855 biography on David studies. The conservative positions of this mid-nineteenth century critic, close to Ingres around the time he published his book, are particularly damaging for the study of the second half of the artist's career. With regard to sources that might have been consulted, the context of David's activity in Brussels certainly merits further exploration: neither his passive correspondence among his papers in the École nationale supérieure des Beaux-Arts in Paris, nor the notes taken by Joseph Odevaere during conversations with his former master (now in the Bibliothèque royale in Brussels), nor incidental information in the copious publications of Jacques-Nicolas Paillot de Montabert, have been fully exploited.

The success of an exhibition generally depends on the pleasure and novelty of the experience procured by works whose temporary reunion, the fruit of much hard work by a great many people, is always something of a miracle accomplished by the organizing institutions. The measure of success of historical studies, such as those in this catalogue, is also the offer of something new, along with interpretations and narrative constructs that revise those previously advanced. If persuasive, the texts that follow will let the reader feel he or she gains a closer understanding of David's art and the workings of his creative imagination. Readers will honor this historical proposition, needless to say, no less by their capacity to contend than by their disposition to approve.

It is difficult to imagine more congenial conditions for the preparation of this project than those offered by the Sterling and Francine Clark Art Institute and the J. Paul Getty Museum. I am most grateful to their respective directors, Michael Conforti and William Griswold, and to their colleagues, for their trust, support, and collaboration. In Los Angeles, Scott Schaefer, Jon Seydl, Charlotte Eyerman, Jean Lynn, and Edouard Kopp were unfailingly present, as were, in Williamstown, Richard Rand, Brian Allen, Sarah Lees, Noël Wicke, Lindsay

Garratt, Kathryn Price, Mark Reach, and Colleen Terry. The publication of the catalogue was steered masterfully at the Clark by Curtis Scott, with the editorial backup of Mary Christian and the assistance of Mari Yoko Hara. Leslie Fitch provided the book's elegant design, and Kathleen M. Friello prepared the index. At Yale University Press, I wish to thank Patricia Fidler, Phillip King, Michelle Komie, John Long, and Mary Mayer, who guided it through production.

As always, my work was greatly facilitated by access to the resources of the Service de Documentation et d'Étude of the Département des Peintures du Musée du Louvre, under the direction of Jacques Foucart; the documents collected for the preparation of the 1989 David retrospective were particularly useful. Research was also carried out under ideal conditions as a Clark Fellow and in the Getty Research Institute, where Thomas Crow and his staff made me feel at home. During the later stages, Myriam Pinon and Mehdi Korchane were especially efficient assistants for checking references and straightening out a number of confusing points. At the Université Lyon 2, I received the friendly support of my colleagues from the Département d'histoire de l'art et archéologie, directed by Laure Pantalacci, and from the associated research unit of the CNRS to which I belong, the Laboratoire de Recherche historique en Rhône-Alpes (LARHRA), directed by Jean-Luc Pinol.

Certain arguments put forth in the catalogue were tested in the course of lively discussions with Guillaume Cassegrain, John Goodman, Stéphane Guégan, Mehdi Korchane, and Christian Michel. Thanks for the cordial attention given to my unrelenting flow of queries are due to Joseph Baillio of Wildenstein & Co., New York, and to Étienne Bréton of Blondeau & Associés, Paris, along with Alain Chevalier and Annick Le Gall of the Musée de la Révolution française in Vizille.

The preparation of the exhibition and the catalogue required the collaborative good will of a great number of people, who graciously offered their time and competence. Among the many who helped along the way, with information, access to works, loans, and illustrations, it is a pleasure to acknowledge Sébastien Allard, Pierre Arizzoli-Clémentel, Pierre Babelon, Alexander Babin, Elaine Rice Bachmann, Colin B. Bailey, Jeannine Baticle, Bruno de Bayser and his three sons, Alexander Bell, Sylvain Bellenger, Stephanie Belt, Laura Bennett, Sylvie Bigoy, Leon Black, Yves Bottineau, Alain Boumier, Marie-Françoise Bouttemy, W. Mark Brady, Arnaud Brejon de Lavergnée, Barbara Brejon de Lavergnée, Theobald Brun, Helen Burke, Antoine Cahen, Alain Cano, Dawson Carr, Suzelyne Chandon, Marie-Claude Chaudonneret, Anne de Chefdebien, Bruno Chenique, Bernard Chevallier, Gérard Chevé, Alvin L. Clark, Jr., Jay Clarke, Éric Coatalem, Denis Coekelberghs, Philip Conisbee, Valérie Corvino, Hélène Couot, Jean-Pierre Cuzin, Patty Decoster, Irène Delage, Fabrice Demonchy, Michel Descours, Roger Diederen, Gérard Ermisse, Everett Fahy, J. O. Fairfax, Jérôme Farigoule, Diane Farynyk, Richard L. Feigen, Neal Fiertag, Janet Finn, Hal Fischer, Jay Fisher, Sandrine Folpini, Flemming Friborg, Jean-

René Gaborit, Darrell Green, Anne-Lise Grobéty, Melanie Harwood, Jean-Marie Haussadis, Christophe Henry, Michel Hilaire, Larry Horton, Jeffrey E. Horvitz, Roselyne Hurel, Olga Ilmenkova, David Jaffé, Frédéric Jiméno, Godehard Janzig, Nicholas Joly, Ellen Josefowitz, Annie Jourdan, Claudine Jouve-Lebrun, Diana Kunkel, Frédéric Lacaille, Anne Lafont, Laurent Langer, Sylvain Laveissière, Dominique Le Coënt, Cyril Lécosse, Simon Lee, Thierry Lentz, Christophe Léribault, Fiona Lings, Stephen Lockwood, Catherine Loisel, Charles R. Loving, Henri Loyrette, James Mackinnon, Gaëtane Maës, Esmond Bradley Martin, Jr., Vladimir Matveev, Suzanne Folds McCullagh, Olivier Meslay, Pierre-Auguste-Joseph Messmer, Régis Michel, Christine Minas, Jean-Marc Moret, Frédéric Moricet, John Morton Morris, Michèle Moyne, Vincent de Muizon, Suzanne Nagy, Lynn Federle Orr, Élisabeth Pauly, John Peterson, Mikhail Piotrovsky, Simona Pizzi, Vincent Pomarède, Todd Porterfield, Alain Pougetoux, Earl A. Powell III, Alexandre Pradère, Joëlle Raineau, Katharine Lee Reid, Christopher Riopelle, Joseph J. Rishel, Anne Robbins, Zoya Rondova, Robert Rosenblum, Emmanuel Rousseau, Marie-Catherine Sahut, Nicolas Sainte Fare Garnot, Guy Stair Sainty, Kevin Salatino, Xavier Salmon, Alan Salz, Guilhem Scherf, Mireille Schneider, Nicolas Schwed, Annie Scottez-De Wambrechies, Philippe Sénéchal, Elena Sharnova, Charles Saumarez Smith, Cheryl Snay, Sidsel Maria Søndergaard, Bent Sørensen, Perrin Stein, Marion C. Stewart, Alain Tapié, Gary Tinterow, Annamaria Petrioli Tofani, Carl van Tuyll, Charles Venable, Françoise Viatte, Mary Vidal, Jean Vittet, Malcolm Warner, John Zarobell, Olivier Zeder, and Pascal Zuber.

Lastly, my gratitude goes to Denis Bernet-Rollande, who for more than thirty years now, shares my life adventure with exemplary equanimity, and to Yvette and Pierre Bordes, my parents in Montpellier, for their affectionate presence.

1748

30 AUGUST. Birth of Jacques-Louis David in Paris.

1769

15 AUGUST. Birth of Napoleon Bonaparte in Ajaccio, Corsica.

1774

Death of Louis XV, king of France, and accession of Louis XVI.

The Royal Academy of Painting and Sculpture awards David the Prix de Rome in painting.

1775–80

Study at the French Academy in Rome.

1781

Conditional admission to the Royal Academy and first showing at the Salon, including *Belisarius* (Musée des Beaux-Arts, Lille) and the equestrian portrait of Stanislas Potocki (National Museum, Warsaw).

1782

Marries Marguerite-Charlotte Pécoul.

1783

Birth of son Jules. Member of the Royal Academy. *Grief of Andromache* (Musée du Louvre, Paris) exhibited at the Salon.

1784

Birth of son Eugène (SEE FIGS. 46 AND 108). Settles in Rome for a year.

1785

The Oath of the Horatii (Musée du Louvre) exhibited to great acclaim at the Salon.

1786

Birth of twin daughters, Émilie and Pauline (SEE CAT. 22 AND FIG. 45).

1787

The Death of Socrates (Metropolitan Museum of Art, New York) exhibited at the Salon.

1789

14 JULY. Popular insurrection in Paris and fall of the Bastille. A National Assembly is formed and France becomes a constitutional monarchy under Louis XVI.

SEPTEMBER. *The Lictors Returning to Brutus the Bodies of His Sons* (Musée du Louvre) exhibited at the Salon.

1791

The Oath of the Tennis Court (Musée national du Château de Versailles), a drawing depicting a historic event of the Revolution, exhibited at the Salon.

1792

War with Prussia and Austria.

10 AUGUST. Popular insurrection and overthrow of the monarchy.

SEPTEMBER. France becomes a republic.

SEPTEMBER. David elected deputy from Paris to the National Convention, instituted to govern.

1793

JANUARY. David is among the deputies of the Convention who sentence Louis XVI to death for treason. Paints two "martyrs of Liberty": *Le Peletier de Saint-Fargeau* (lost) and *The Death of Marat* (FIG. 52), which he offers to the Convention.

1793–94

Repressive measures ("The Terror") and an authoritarian regime (Committee of Public Safety) under the leadership of Robespierre.

David, an ally of Robespierre, organizes revolutionary festivals in Paris.

1794

27 JULY ("9 THERMIDOR"). Robespierre and his partisans are outlawed by the National Convention. End of the Terror.

AUGUST. David imprisoned through August 1795 for his role in the repression.

1795

SEPTEMBER. A new constitution for the republic: the Directory replaces the National Convention.

1796

MARCH. Bonaparte marries Josephine de Beauharnais, a widow with two children. He is named General-in-Chief of the Armée d'Italie, and leads his troops to a victorious Italian campaign against Austria.

1798–99

Bonaparte's Egyptian campaign.

1799

David completes *The Intervention of the Sabine Women* (FIG. 1), in process since 1795.

9 NOVEMBER ("18 BRUMAIRE"). Bonaparte and his allies overthrow the Directory and form the Consulate. Bonaparte named First Consul.

1801–3

David paints five versions of *Bonaparte Crossing the Alps* (SEE CAT. 4).

1802

A new constitution allows Bonaparte to become Consul for Life.

1802–3

Year of peace with Britain ("Peace of Amiens").

1804

MAY. A new constitution institutes the Empire and makes Napoleon "Emperor of the French."

4–7 DECEMBER. Coronation ceremonies of Napoleon in Paris.

18 DECEMBER. David appointed First Painter to the Emperor. His commission to paint the coronation ceremonies is confirmed.

1805

War against Austria and Russia ends with French victory at Austerlitz (in the present-day Czech Republic).

1808

The Coronation of Napoleon and Josephine (FIG. 26) is hung in the Louvre, in a special exhibition, and later at the Salon.

1809

15 DECEMBER. Napoleon and Josephine are divorced.

1810

11 MARCH. Napoleon marries Marie-Louise of Austria.

The Distribution of the Eagles (FIG. 31) exhibited at the Salon.

1811

Marie-Louise gives birth to a son and heir, the king of Rome.

1812

David paints *The Emperor Napoleon in His Study at the Tuileries* (CAT. 12).

Napoleon's army invades Russia and is forced to retreat.

1813

Coalition of Britain, Russia, Prussia, Austria, and Sweden aligns against Napoleon.

1814

APRIL. Napoleon abdicates and is exiled to the island of Elba, off the coast of Italy. Restoration of the Bourbon monarchy with accession of Louis XVIII, brother of Louis XVI.

OCTOBER. David exhibits *Leonidas at Thermopylae* (FIG. 82) in his studio.

1815

MARCH. Return of Napoleon ("The Hundred Days").

18 JUNE. Defeat of Napoleon at the Battle of Waterloo (in present-day Belgium).

22 JUNE. Napoleon abdicates for the second time and is exiled to the island of St. Helena, in the South Atlantic.

8 JULY. Return of Louis XVIII ("The Second Restoration").

JULY–AUGUST. David travels in Switzerland and eastern France, perhaps with the intention of emigrating.

1816

JANUARY. David banished by the Bourbon government for having voted the death of Louis XVI and rallied Napoleon after his return. Settles in Brussels.

1817

Cupid and Psyche (CAT. 32).

1818

The Farewell of Telemachus and Eucharis (CAT. 35).

1819

The Anger of Achilles (CAT. 36).

1821

5 MAY. Death of Napoleon at St. Helena.

1821–22

David finishes a replica of *The Coronation of Napoleon and Josephine* (Musée national du Château de Versailles).

1824

Death of Louis XVIII and accession of his brother, Charles X.

Mars Disarmed by Venus and the Graces (FIG. 64).

1825

29 DECEMBER. Death of David in Brussels.

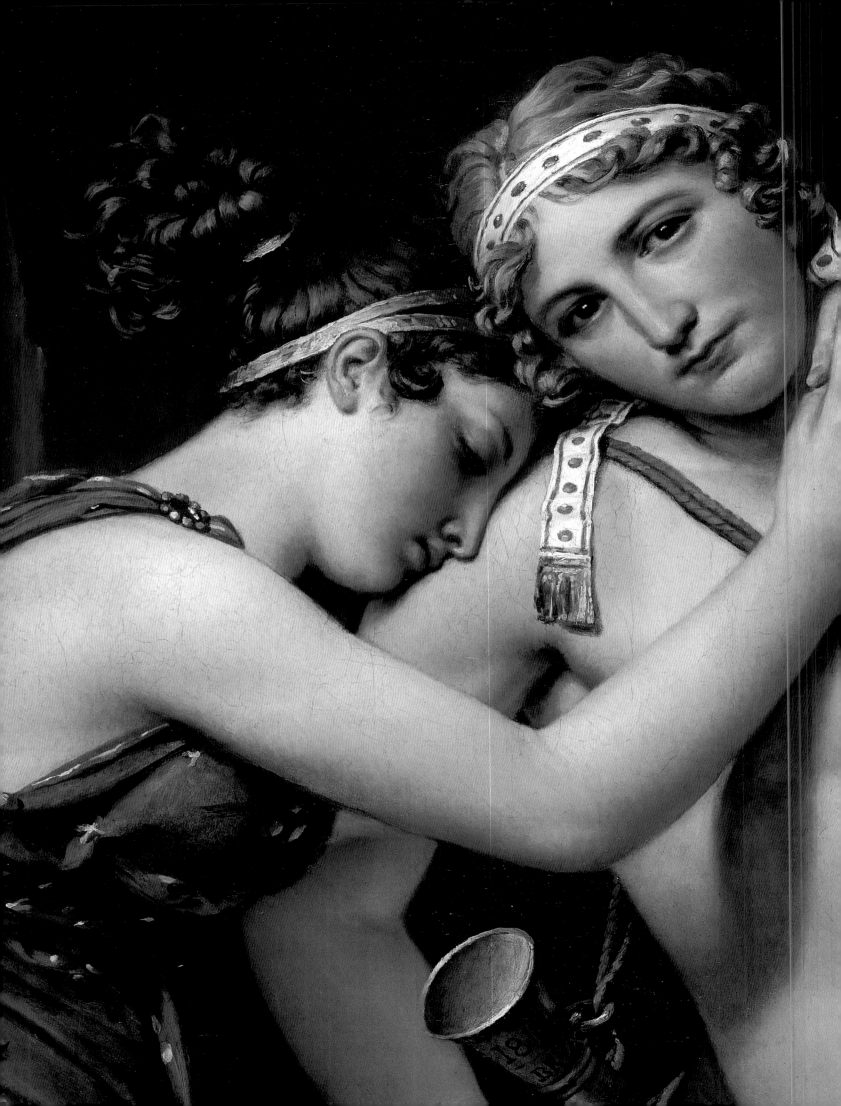

Jacques-Louis David | Empire to Exile

Art after Politics

O N 4 AUGUST 1795 the famous painter Jacques-Louis David, former president of the National Convention, the "house of representatives" to which he had been elected deputy by the Parisians in the fall of 1792, was allowed to go home after a confinement of several months in prison. The Committee of General Security, the same committee in charge of ordering political arrests to which he had belonged during the Reign of Terror, had taken pity on the allegedly sick artist, who was about to turn forty-seven years old, and permitted him to be placed under house arrest in a relative's home outside of Paris. Almost exactly one year earlier, just a few days after the overthrow of Robespierre's government and the end of the Terror on the 9th of Thermidor Year II (the republican calendar date corresponding to 27 July 1794), he had been incarcerated a first time. The accusations directed against him were aimed at the deputy to the National Convention, who had been a close political ally of the Jacobin dictator, and at the member of the Committee of General Security, an administration accountable for months of bloody repression. By 1795, however, there was a widespread desire among the political elites to forget recent events as quickly as possible, since the conduct of many representatives of the National Convention who joined forces to eliminate Robespierre had been far from irreproachable during the Terror.[1] The initial charges against the artist-deputy were dropped surprisingly quickly, and he was freed toward the end of December 1794. But late in May 1795, in the wake of popular uprisings in Paris that brought a crackdown against former Jacobins who were held responsible for the social disorder, he had been led to prison for the second time.

Understandably, David was shaken by what must have seemed a close brush with the blade of the guillotine, and no less by the harsh realization that his Jacobin ideals had provoked much bloodshed. He could not ignore the suffering he had inflicted on those fellow citizens who failed to fit perfectly the republican mold. Nor could he ignore that for several years his creative imagination had essentially served a political message; in the process, he had sacrificed many of the artistic aspirations he had held as a history painter prior to 1789. After five years of Revolution he could show only a few portraits, an abandoned project to

celebrate a contemporary event (*The Oath of the Tennis Court*), and the effigies of two martyred fellow deputies of the National Convention (Michel Le Peletier de Saint-Fargeau and Jean-Paul Marat [SEE FIG. 52]); as a draftsman he had been relatively more prolific, giving form to festivals and pageants, costumes, and emblems. Now that his part on the political stage of the National Convention was over, his primary concern was to reintegrate an art network that had recognized his preeminence during the 1780s. How he viewed the social system of art producers, buyers, and critics radically transformed by the Revolution is not easy to fathom. Artists could no longer count on an academic ordering of talent, nor on assured government support. The patronizing clientele of wealthy aristocrats that had complemented state initiatives during the reign of Louis XVI was supplanted by an elite of *nouveaux riches* under the spell of fashion. Faithful to the patriotic ideology of the Revolution, many artists and critics after Thermidor still preached devotion to the fatherland and called for government encouragement of the arts in return. But others, generally younger, looked more to the commercial ideals of open competition and free market as the way to establish their reputation.[2]

David's *Self-Portrait* today in the Louvre (SEE CAT. 1), painted, according to an early source, during his first incarceration in the autumn of 1794, is usually interpreted as a move to reaffirm his status as practicing painter. The dirty shades of earthy pigment, a range of browns more typical of Dutch art than Italian art, aptly characterize the dreary atmosphere of the prison. Less expected is the deliberate show of the instruments of the painter's craft, which artists with liberal aspirations since the Renaissance had made a point to suppress or romanticize, as in the falsely informal dressing-gown portraits that many history painters had favored since the late seventeenth century. In fabricating this assertive self-image of the artist as practitioner if not artisan, David sought to reinvest a reality from which he had been excluded by his imprisonment: no longer the realm of the National Convention nor the political gatherings, but the free urban spaces of social interaction that after Thermidor were emblematic of the release from the Terror, as the street scenes of Louis-Léopold Boilly from this period so eloquently make clear. In the *Self-Portrait,* the association of an unaffected accoutrement and a determined pose suggests that David strides a fine line between a position of humility and one of pride. He shows himself ready to compete once again in the artistic arena, assuming the guise of the shielded and armed warriors his imagination was inventing: just as he was painting this *Self-Portrait,* he was sketching the combatants for the large painting of *The Intervention of the Sabine Women* (FIG. 1), which was to be his principal occupation in the years to come.

Within a few weeks of his definitive release in early August 1795 he could see signs of his reinstatement in the nexus of social and artistic relations that constituted the Parisian art world of the day. As suggested, much had been shaken up during the heyday of revolutionary mobilization, from the taking of the Bastille

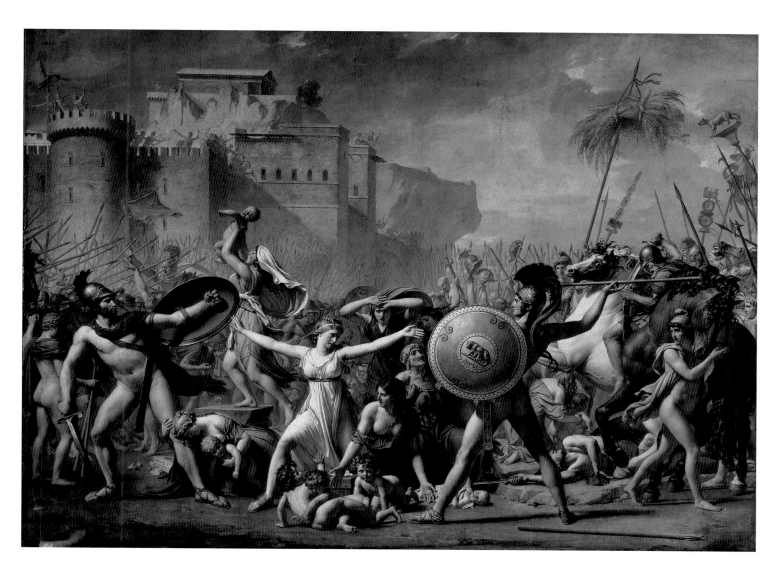

in the summer of 1789 to the downfall of Robespierre in the summer of 1794. The art system of the Ancien Régime had been based on a dominant and privileged royal academy of painting and sculpture that exercised control over teaching, exhibitions—the so-called Salon organized every two years—and official commissions, for the exclusive benefit of its members. The academy had been dissolved in 1793; teaching was largely disorganized after that, the Salon was open to all artists, good or bad, and direct royal commissions were replaced by contests, likewise open to all. Former academicians like David were now forced to compete for attention, work, and honors with a wide range of newcomers, many much younger and most still unknown.

The Revolution had been a political theater animated by young men. David, born in 1748, was senior to the political leaders from whom he took his cue—Robespierre (born in 1758) and Saint-Just (born in 1767)—and also older than Napoleon Bonaparte (born in 1768), who was then a republican military officer. He was of the generation of the sage of the Revolution, Sieyès (born the same year as the artist), and the orator Mirabeau (born the following year, in 1749), who both had played such decisive roles in the events of the summer of 1789.

FIGURE 1 Jacques-Louis David, *The Intervention of the Sabine Women*, 1799. Oil on canvas, 12 ft. 7¾ in. x 17 ft. 1 in. (385 x 522 cm). Musée du Louvre, Paris

David's passionate espousal of republican ideals was far from common among the artists of his generation, which the Revolution decimated—not physically of course, but morally. The most promising history painters with whom he had been competing at the Salons during the 1780s—François-André Vincent, Pierre Peyron, Jean-Baptiste Regnault—emerged artistically numbed from the experience.[3] In contrast to their exhaustion, David's capacity for regeneration is all the more impressive. He was, in a sense, responsible for their existential difficulties. However, there is no indication that he persecuted them when he was involved in the judicial machinery of the Terror. He crushed his rivals simply by establishing new standards by which to judge good art, exempt of the frills and suavities of the "French manner." The example of his major paintings of the 1780s— *Belisarius Receiving Alms* (Musée des Beaux-Arts, Lille), *Andromache Mourning Hector, The Oath of the Horatii, Brutus* (all three in the Musée du Louvre)—had invalidated the art practice of many of his most ambitious contemporaries. When he emerged from prison in the autumn of 1795, however, he was confronted with a rejuvenated art scene that directly or indirectly invoked the lessons of his art. Many of the painters who caught the public's attention in the aftermath of the Revolution were his students, most prominently Anne-Louis Girodet, François Gérard, Antoine-Jean Gros, and Jean-Baptiste Isabey; others, like Pierre-Narcisse Guérin, founded their art on a close study of his paintings.

During the first year after his prison experience—Year IV on the republican calendar—David consolidated his moral and financial situation by devoting himself to portrait painting, an expediency he would also adopt during his first year of exile in Brussels after the fall of Napoleon. Once released, he settled in the country home of his brother-in-law, Pierre Sériziat, husband to his wife's younger sister, where he had already sought asylum after his first incarceration. He immediately set to work finishing a portrait of his sister-in-law, Émilie Sériziat, with her child (SEE FIG. 62), which he may have commenced during his earlier stay. He painted the portrait of her husband just after, a month or two after his release. Sent to the Salon in 1795, David's two portraits were destined to prove that he was still to be accounted for on the art scene. That same year François Gérard and Jean-Baptiste Isabey, two young artists particularly close to David around this time, threw down the gauntlet at their former master: the first painted a full-figure portrait of the second about to take a stroll with his daughter (Musée du Louvre, dated 1795 but exhibited only in 1796). Paradoxically, Gérard chose for his fashion icon the earthy colors of David's *Self-Portrait* rather than the more refined and varied range adopted for *Portrait of Pierre Sériziat* (SEE FIG. 42). The greater success of their picture is implicit in the effusive praise it elicited in 1796, compared to the sparse critical comments merited by the *grand maître* for his two portraits the year before. Whereas David abided by an Ancien Régime discretion on the nature of his relationship to the Sériziat, the two young painters openly exploited their mutual support to attract sympathy and attention.[4] After the Revolution, much more openly than

at the time of the academic regime with its networks of protection, catching the public's eye became the fundamental requisite for gaining and maintaining an artistic reputation.

In late October 1795 the National Convention declared its dissolution to allow for the establishment of a new form of government, with a *Directoire exécutif* of five men presiding over two consultative assemblies that had elected them. During its last session, the convention decreed a general amnesty, which completely freed David from the prospect of returning to prison. During the following years, although he avoided participation in public politics, he remained sympathetic to the more radical republicans, a sentiment recurrently kindled by royalist threats to reinstate the monarchy. The most telling indication of his persistent attachment to the democratic ideals of the Robespierrist era dates to the spring of 1796: the painter is listed among the subscribers to the journal of the Directory's most extreme critic, Gracchus Babeuf, a political agitator whose failed conspiracy led him to attempt a spectacular suicide *à l'antique* upon being sentenced to death in May 1797.[5] Such sympathies reinforced David's commitment to an art with public responsibilities, as in the 1780s, and predisposed him to admire the republican general Bonaparte, whose victories on the Italian front swelled patriotic pride.

The context of reaction during the Directory encouraged negative criticism with respect to his manner, now expressed with more confidence than at the beginning of the Revolution when royalists had championed the aging Greuze in an attempt to overshadow David.[6] Amateurs of Italian and Flemish colorism openly expressed an aversion to the cold academism of his additive mode of composition and his studied manner of drawing.[7] Nonetheless David could easily muster support close to home with the likes of the Sériziat couple, or among the cultural elite, for example with the Parisian theater administrators who, to persuade him to collaborate on their projects in February 1796, declared that his name "would determine a period in the history of art."[8] Outside of the local art milieu he was encouraged by the sympathetic patronage of some independent individuals, two Batavian diplomats and later a visiting Irishman and a Scottish lord, all keen to commission portraits from the famous painter, and even a Russian aristocrat wanting to obtain a history painting. His reputation provided him with an exceptionally wide range of possible contacts, on a European scale. As an artist who had been in contact with the cosmopolitan society of the last decade of the Ancien Régime, David probably found that the Parisian art scene in the aftermath of the Revolution offered uncomfortably narrow prospects and, too often, postures of pretension and whining.

The official sign of David's reinstatement into the social, political, and cultural order of the Directory was his nomination on 3 Brumaire Year IV (25 October 1795) to the newly created Institut national des Sciences et des Arts. Conceived as an academic institution open to merit and strictly limited in its membership, the Institute did not recover the absolute prerogatives of the for-

mer royal academy over commissions and exhibitions. In true Enlightenment spirit it was meant to mediate between the artistic professions and the government, defending the interests of the former and the political measures of the latter. The Directory divided the Institute into three "classes" with a total of twenty-four sections; the third class, Literature and Fine Arts, had eight sections, which included Painting, Sculpture, and Architecture. Of the six members for each section, only two were first nominated: designated for the painting section were David and the flower painter Gerard Van Spaendonck. The forty-eight founders then co-opted four more members for each section: the additional painters were Joseph-Marie Vien, the passive patriarchal figure of the French School; Vincent and Regnault, who had been David's rivals since the 1780s and moderates during the Terror; and Nicolas-Antoine Taunay, a surprise nomination in view of his relatively undistinguished record. The inclusion of that painter of genre and landscape, and of Van Spaendonck, is best explained by the desire not to limit official recognition to history painting.[9] Their presence signified the greater openness of the republican institution compared with that of the Ancien Régime academy, which had never given genre painters a status equal to that of history painters. It also had a conservative aim by excluding the younger history painters and preserving for the older generation an implicit preeminence. The composition of the three art sections reinforced the sense of a generation gap in the Parisian art world. Boilly's painting of a *Reunion of Artists in Isabey's Studio,* exhibited at the Salon of 1798 (Musée du Louvre), would articulate the claims of a younger group. This cleavage, implying rivalry and exchange, furnishes the background to David's decision in the last months of 1795 to devote himself to a major enterprise, a historical subject on a vast scale: *The Intervention of the Sabine Women* (FIG. 1).[10]

In choosing this theme, David characteristically aimed to improve on a tumultuous composition of the subject exhibited by his early rival Vincent at the Salon of 1781 and to offer a sequel to a famous scene by Poussin, for whom on several occasions he avowed a great admiration.[11] Never had he been more explicit in indicating how to interpret the subject: "Romulus holds the javelin in the air, ready to throw it against Tatius. The cavalry general puts his sword back into its sheath. Soldiers raise high their helmets in sign of peace. Feelings of conjugal, paternal, and fraternal love spread among the ranks of both armies. Soon the Romans and the Sabines embrace each other and form only one people."[12] The contemporary reading of David's picture, formulated by critic Pierre Chaussard, saw a message of national reconciliation after the conflicts of the Revolution.[13] Although a scene of confrontation, it holds greater promise of a happy conclusion than the tragic family strife that had been the focus of his art in the *Horatii* and *Brutus.* Since the middle of the twentieth century much stress has been placed by scholars on the archaizing character of the work, reflecting the influence of the most aesthetically radical of the master's pupils at the time, who called themselves the *primitifs.* David's expressed adhesion to the Winckelmannian preference for the Greeks over the Romans marks a very real inflection

in his art, which his *Leonidas* project was to consummate. Over the past twenty years, under the spell of an ever more confident feminist critique, interpretation has privileged the reading of gender relations inscribed in the two historical compositions—the distinctive roles played by the men and the women in the *Sabines* and the homosocial bonding implicit among the men in *Leonidas.* However, such interpretative preoccupations—by definition narrowly angled as history and thus almost mechanically persuasive—rarely fail to dull the political edge of David's art in the process, so they inspire a precautionary endorsement at best.[14]

The decision to present nude the two main soldiers in the *Sabines* transcribed David's new interest in the pure forms of Greek art;[15] he felt the move bold enough to warrant a lengthy explanation when he exhibited the painting in 1799. In spite of this Winckelmannian turn, also evidenced by the virtuoso handling of draped female figures, the choice of subject partakes of a lifelong fascination with the legendary saga of the origins of the Roman republic. The early drawings for the *Sabines,* with Roman warriors in full armor, suggest that once again the history of the Eternal City had fired his imagination. Prior to the Revolution David had meditated on the stories of the Horatii and Brutus for over a decade; late in life, when in exile, he would direct his attention to the union of Mars and Rhea Silvia, who bore Romulus and Remus (SEE CAT. 37). When painting the *Sabines* he had placed the twin infants nurtured by the she-wolf prominently on the shield of Romulus. The French revolutionaries had found in the visual and political trappings of the Roman republic a useful guide to free themselves from the prevalent aristocratic codes and values of the Ancien Régime. But during the Terror many Frenchmen became confident enough to proclaim their ideological and cultural independence from antique models: they considered contemporary events to have surpassed in moral grandeur the examples of antiquity.[16] Exalted by this glorious perspective, the French revolutionaries adopted a republican calendar which proclaimed the beginning of a new historical era. David's paintings in 1793 of the assassinated deputies to the Convention—Le Peletier and Marat, the first two *martyrs de la liberté*—were free of overt classical references, and a Baudelairean posterity would readily affix the label of modernity to such a self-conscious break with the past.

Such celebration of contemporary history during the Revolution would later facilitate the capacity of artists to meet the demands of Napoleonic iconography, but the events of Thermidor, in this domain as in so many others, planted seeds of reaction. Critics and artists, unsettled by the unfamiliar liberal context, championed once again the traditional prestige of themes from ancient history, justified by arguments of morality and dignity. However, there was no turning back to the absolute authority of academic doctrine. After the Terror and through the Empire, painters were constantly moving between past and present. A temporal hybridity characterized history painting: antique history served to represent contemporary situations, while contemporary history was imbued with the ethos of the ancients. David's production through 1815 is a good exam-

ple of this oscillation. His decision to paint *The Intervention of the Sabine Women* was in a sense conservative, since he aimed to reactivate the public success he had enjoyed in the 1780s. At the same time, as he was finishing this picture, he also got very excited at the idea of completing the *Oath of the Tennis Court* (Musée national du Château de Versailles), the huge painting he had begun early in the Revolution. Addressing the minister of the interior whom he hoped might finance the project, he pleaded with an ultimatum: "Please note that it will be the last work of this importance that my hand will ever produce."[17] (As it turned out, he never went back to his canvas and, happily, Napoleon invalidated his prediction.)

David first composed the *Sabines* in prison and worked on the painting for three years in a space in the Louvre allotted by the minister of the interior at his request, proof that his artistic reputation in official circles was intact. He remained a public figure in the eyes of the republican government; none of his colleagues were deemed to merit the same support. He allowed himself only two distractions from his new project: regular visits to another atelier to supervise a group of pupils and irregular attendance at the meetings of the Literature and Fine Arts class of the Institute. There was a strategy behind these distractions that David allowed himself. He remained in contact with the younger generation through the artists working under his direction, and at the Institute with the older generation to which he belonged. In this way, he circumvented his real rivals, the nexus of men around Gérard and Isabey, artists who were on their own striving for official recognition. This latter group strongly felt that the Institute did not represent them.[18]

Thanks to the young men with wide-ranging tastes who paid him a monthly fee to draw after the model in his studio, David kept up with the latest developments in the art world.[19] Among his pupils emerged the *primitifs*, who championed a radically archaic and iconic mode of classicism and recherché iconography, such as the legends of Ossian, as well as an antithetical group, no less original, which fashioned a decorative and moody vision of the Middle Ages out of the Dutch tradition. It has often been remarked that the *primitifs* helped David evolve artistically and transform the *Sabines* project, which was initially a variation on the *Horatii*, into something quite different. As in the 1780s, he called on the more advanced pupils to help him execute his large canvas: Pierre-Maximilien Delafontaine, Jean-Pierre Franque, and Jérôme Langlois.[20] His investment in the formation of younger artists for the Rome Prize was also a way to pursue his old rivalry with Regnault, Vincent, and Joseph Suvée, who also had opened teaching studios; in 1797, when the Rome Prize contest was held for the first time since 1793, three first prizes were awarded, but only one of the recipients was from David's studio. The regular turnover of pupils through the Consulate and Empire also offered David moral support to confront the recurrent show of hostility toward the former agent of Robespierre. An English visitor to his apartments in the Louvre in 1802 related a general opinion con-

cerning his pupils: "David is not without his adherents. He has many pupils, the sons of respectable, and some of them, noble families, residing in different parts of Europe. They are said to be much attached to him, and have formed themselves into a military corps, for the purpose of doing honor to him, and were lately on the point of resenting an insult that had been offered to his person, in a manner that, if perpetrated, would have required the interest of their master to have saved them from the scaffold."[21] The information is perhaps exaggerated, but clearly indicative of the overt spirit of partisanship that reigned in the studio.

After participating in the momentous meetings of the National Convention for two years, David must have found those of the National Institute, with their confined agenda and academic ambiance, to be relatively dull. Nonetheless, he proved to be an assiduous member, although he did not often intervene.[22] From his colleagues at the Institute he could pick up official news and information concerning government policy, and no doubt he sought to influence the various recommendations that the Institute was requested to make. The members of the arts sections represented the whole spectrum of political opinion. Occasionally an effort was made to revive the republican enthusiasm that had stirred Jacobin deputies at the National Convention. For example, in March 1797 David, the architect Jacques Gondouin, and the sculptor Augustin Pajou proposed that the Directory organize an open contest for the reunion of the Louvre and the Tuileries: "[The Republic] will hasten to prove to other nations what a free people can accomplish; by the grandeur and magnificence of its public buildings, it will prove to them how far superior it is to all the republics that have gone before."[23] In other instances, probably under the influence of such moderates as Jean-Antoine Houdon and Vincent, the sections overtly condemned the recent revolutionary past. In April 1797, on the occasion of another report on the same subject calling for government encouragement of the arts, they drafted a collective text claiming that "dried out by seven years of sterility, the arts of design need occupations that will promptly extirpate them from the state of languor in which they have fallen."[24] Along with twelve other members of the Institute, David signed this report offering a particularly bleak picture of the Revolution's heritage. Manifestly, he was torn between defending the initiatives taken since 1789 by the revolutionary assemblies and their committees, often on his own initiative, and the fact that there was not much to show for them on a grand scale. His decision to execute a painting surpassing in size the *Horatii* and *Brutus* was at least one way for him to disprove the Revolution's negative influence on the arts.

There are further indications of David's desire to reorder his life in the period following his release from prison. His remarriage in November 1796 is a first sign (he had divorced his wife in March 1794, just as the Terror was getting under way). It was as if he wanted to set the clock back in time and do away with the politically blurred interim. His eagerness to repossess *Le Peletier* (origi-

nal painting lost) and *Marat* (SEE FIG. 52) is another. During the spring and summer of 1797, at a time when public opinion turned in favor of the royalists, he came under renewed attack. Feeling vulnerable, he took pains to expunge a possibly embarrassing situation: generous government funding had been allotted for the reproduction of *Le Peletier* and *Marat* and it was clear that under the new regime the engravings would never be finished. He obtained an official discharge from the minister of the interior for the lost funds and made sure that the two paintings, which he had given to the National Convention in 1793 but recovered in 1795, were declared his property.[25] It is difficult to ascertain his motive, whether defense or rejection of his recent political activities. He may have wanted to protect his pictures from possible destruction—in other words, to preserve the much-decried past for history. On the other hand, he may have wanted to put them away and occult his terrorist past from public exposure and recall.

Early in 1796, in a letter written to the minister of the interior to secure a studio, David had first estimated he could finish the *Sabines* in time for the Salon of 1798. Although from the middle of 1798 there were regular reports that the painting was finished, it would be put on show only in December of the following year. Around February 1799 the minister agreed to cover the cost of the frame, "out of consideration for the unselfishness of this artist," who had refused a money prize in 1791 and had painted *Le Peletier* and *Marat* in 1793 (he ignored the fact that David had recovered these pictures initially given to the state).[26] Having acquired savoir-faire courting administrative favor while deputy to the Convention, David also obtained a room in the Louvre to exhibit his new painting. It is obvious that by the end of 1799 he had completely recouped his artistic and social confidence.

He found the exhibition space in a shabby state and took pains to have it decorated; this involved expenditures in painting, in sculpture, and for the "interior adornment" "that the room required to fulfill its intended purpose."[27] He could not have failed to notice that Isabey had publicized his call on the young architects Charles Percier and Pierre Fontaine to transform his studio into one of the most modern interiors in Paris. For Isabey and his friends it was important to promote their image as men of fashion and culture in order to attract the clientele of *nouveaux enrichis* dominating the social scene. The Directory regime had been founded on a constitution with an exclusive criterion for citizenship: the capacity to read and to write, which privileged the urban elites. The official sanction granted to the private cultivation of the arts—antithetical to the Jacobin position during the government of Robespierre, inspired by Rousseau—relegitimized the luxury practices of the Ancien Régime, such as refurbishing *hôtels* and collecting art. Although David's *Horatii* and *Brutus* communicated a mood of almost harsh moral austerity, which his intransigence during the Terror and the *sans-culotte* aesthetic of the crate desk in *Marat*

seemed to echo, he was by no means insensitive or depreciative toward upscale decorative arts.[28] His collaboration with the furniture-maker Georges Jacob in the late 1780s is well known; his *Loves of Paris and Helen* (1786, Musée du Louvre) was an exercise in imagining a Greek interior decoration, painted for the king's brother, Artois, a patron notoriously obsessed with fashion, and repeated for a Russian noblewoman. During the Revolution, David responded with enthusiasm to the demand for novel costume designs that captured the spirit of French republicanism. As is detailed in the essay "In the Service of Napoleon" in this volume, on several occasions during the Empire he attended to the furnishings of the emperor, as part of his court responsibilities as first painter.

During the Directory, however, interest in fashion and luxury goods took on a special resonance. The frivolous and highly conspicuous consumption after the Terror has been interpreted as a necessary means for the *citoyens* to recover a sense of identity after the social upheavals of the Revolution and the threats of the Terror.[29] The unabashed commercial values that inspired these attitudes were difficult to reconcile with the lofty republican rhetoric exhorting the sacrifice of individual interest to the nation, which remained the public discourse of government. The social strategy of a rapprochement with the milieu of bankers and army suppliers, adopted by Isabey's circle, implied a degree of political alignment with this new elite. David had been fascinated by court aristocracy at the beginning of his career, before finding more congenial the well-to-do liberal circles of the capital that greeted the Revolution with enthusiasm. During the Terror, he fell in with his fellow Jacobins and celebrated a life ornamented only by strict republican essentials. As proven by the portraits of the Sériziat couple, he was not insensitive to the merrier mood of the Directory: after the rigors of the Terror, he recognized the need to indulge in the pleasures and embellishments of the quotidian and even the frivolities of fashion. His *Sabines* project may have been high-minded, but it lent itself to appropriation somewhat in the manner of a new play offered on the Parisian stage (which it in fact inspired). It seemed natural to render David responsible for the diaphanous gowns *à l'antique* that women were wearing about town. The scope of the picture's social impact may even have included the painter's private life: rumor had it that Madame de Bellegarde, who had modeled for one of the Sabines, was his mistress.[30] Unquestionably fascinated by all this, as soon as he finished his painting, David set to work on the portraits of Henriette Verninac and Juliette Récamier, which were outright manifestos of modern fashion. Had he not fallen out with the young wife of the banker Récamier and left her portrait unfinished, he would have presented the two portraits together as intended, probably at the Salon.[31]

David exhibited the *Sabines* in December 1799, about two months after General Bonaparte's coup d'état against the Directory. In this context, the message of reconciliation conveyed by the antique subject took on a new and different

meaning. The bruised mood of post-Thermidorian reconstruction that had inspired the original idea was replaced by a sense of expectation and excitement as the French rallied around the military hero in the hope of political and economic stability. Confronted with this republican disaster, David chose to remain aloof or resigned, willing to give the soldier hero he admired his chance (see the essay "In the Service of Napoleon" in this volume). He was embarrassed and uneasy in January 1801 at having to testify at the trial of one of his students accused of wanting to assassinate the military dictator; he swallowed his republican ideals and apparently did nothing as Topino-Lebrun was led to the guillotine.[32] Unpleasant events such as this may even have confirmed his resignation to the political helplessness inflicted by Bonaparte.

David's *Sabines* did not run foul of the distinction now imposed between real and imaginary politics, which probably seemed familiar to anyone who had lived during the Ancien Régime. If his Roman pantomime alluded to the woes of republican France, it was with the precaution of metaphor and philosophical distance. After Brumaire the slick painting offered a poetic reverie of great beauty, a perfectly poised escapist drama, and momentary relief from the very real pressure to resolve the problems of the day: the urgent need to elaborate a satisfying religious policy, to decide on measures concerning the émigrés, and to find the means to finance a foreign war. Prior to the Revolution David had rejected academic preoccupation with the technical requisites of good painting to make room for the full expression of his imaginary genius. Of his *Brutus,* one critic in 1789 remarked, "this seems more the production of a great poet than of a painter."[33] Although Brutus was a traditional figure of moral rigor, David willingly played out the notion that he was at the same time an unnatural father, fit to inspire Greuze. A decade later, with the *Sabines,* he attempted to reactivate this open vision of historical narrative, but the notion of history had changed. In the meantime, the intense investment in contemporary events during the Revolution had exerted a dual and contradictory impact on the manner of imagining ancient history: as if thrown back in time, the Greeks and the Romans suffered a heightened estrangement, while at the same time, through a process of cultural cannibalization, they were cast in explicitly contemporary terms. Represented in this way, they were more than ever before the focus for identification and projection. The triumph of Pierre-Narcisse Guérin's *Return of Marcus Sextus* (Musée du Louvre) at the Salon in the autumn of 1799 was the result of a forceful composition, but also of the intriguing perception of an explicit allusion to the plight of the returning émigrés in the antique narrative he concocted. In light of his practice during the 1780s, David could hardly have approved such a direct predication of history painting on the contingencies of a political moment, which manifestly bridled its poetic potential. And yet he did not hold back his compliments to Guérin. Perhaps hearing of Bonaparte's interest in battle scenes, he already understood that the representations of Napoleonic

epic would free anxious history painters from the need of alluding to contemporary situations. His own choice in 1798–99 to paint *Leonidas* (SEE FIG. 82) as a pendant to the *Sabines* must be considered in the context of these profound mutations affecting the genre still identified with the most elevated pictorial ambitions. Bonaparte's initial disquiet upon hearing of this project to celebrate a military defeat was to be expected, as was the success of his pressure to have David set it aside. What will require an explanation, however, will be the reprise of the project and Napoleon's tardy benediction as the empire was crumbling down.

The stir caused by the nudity of the male figures in the *Sabines* when the painting was shown to the public has been well analyzed.[34] Worth noting is David's capacity and apparent willingness to step in line with dominant opinion, in this instance bourgeois and Napoleonic prudery. At some point before he reexhibited the painting in 1808, he reworked the figure of Tatius, the principal warrior on the left of the composition: he scraped the sheath initially visible along the back of the left thigh and painted it between the legs.[35] The exhibition in 1799 occasioned another polemic that dragged on in the press for over three months. It was provoked by David's decision to charge an admission fee to view his new picture. Concerning the financial venture, he took care to send a cautionary note to the newspapers two days before the opening: "This here is not a vile speculation, but an honorable endeavor for art and artists."[36] As he explained in the booklet that he published and distributed to each paying visitor, he was simply imitating the "moeurs" and "institutions" of the ancients.[37] On the question of artistic perfection, he argued rhetorically, the Greeks were surely the best guides available. He further invoked the example of England, where, it seemed to him, a greater freedom traditionally enjoyed by artists was an enviable model for France.[38] In this text David explicitly invokes his ideal of the "noble independence that suits genius" that he endeavored to achieve throughout life. Even during the years of Napoleonic patronage and court service, when he might have been thought furthest removed from this ideal, his determination to be independent remained strong. Most surprising with respect to postromantic and modernist attitudes is that reliance on state support was apparently not at odds with this ambition. Government funding for the frame and gracious use of a convenient venue for the *Sabines* exhibition project greatly reduced the commercial risks of the venture and increased the chances of commercial success: David's profits were to be high indeed.

Is this way of thinking to be explained, as some historians would have it, by an obsession with personal gain? In the contemporary press, as the exhibition continued to attract a large number of visitors, even the painter's closest allies, such as Chaussard, were disquieted by what seemed an unrelenting avidity. It is a fact that David's finances needed consolidating after sacrificing his time and energy to the Republic for two years. It is also true that during the Empire, the

financial negotiations surrounding the coronation pictures and other Napoleonic commissions would often be conflictive and even harsh; it is easy to conclude that after the Revolution, he painted for money. As will be argued, his insistence in obtaining his due from the imperial administration may have had another explanation. With regard to the *Sabines* exhibition, to understand how he could find it natural to solicit government help and at the same time lay claim to an artistic independence usually attributed to the romantic generation, one must turn to his social and cultural identity as a citizen of the new republic. Thanks to the ideology and legislation of the Revolution, Frenchmen were no longer in a position of subservience to political authority; they were exposed to a discourse and a promise of fusion between the citizen and the nation, incarnated by the soldier-citizen but extended progressively to all forms of civic action. During the Terror the citizen was asked to sacrifice himself totally to the state; during the Directory, domains of personal experience were revalorized, but the line between public service and private interest was not yet clearly drawn. Because he had personally covered costs during the execution of the *Sabines*—canvas, colors, models, assistants, especially, "the four years he had employed"—and because he felt it served a national cause—"une tentative honorable pour l'art et les artistes"—David found it quite natural both to reap financial rewards and to receive government support. Precisely because of this official sanction, he could claim that his enterprise was not "une spéculation vile."

On 31 December 1799 the *Journal de Paris* published an unsigned article on the exhibition of the *Sabines*. It is tempting to ascribe this encomiastic text, which refers precisely to the brochure David handed out to visitors, to someone in the painter's circle of friends. One point made, echoing an idea expressed by the painter early in the Revolution with reference to the *Horatii* and *Brutus*, was that artists constituted a kind of cultural avant-garde: "Artists were alone in initiating this useful regeneration, it is up to the government to finish the job." The anonymous author defended the position that the arts, which many politicians considered futile, "have a strong influence on all the branches of industry, on public morality, and for this reason on the nation's glory and prosperity." Although it is not clear whether this is a comment on the situation since 1789 or only after Thermidor, the terms of the argument, with reference to the economy and national pride, correspond to what was being aired during the Directory. The sublimity of David's *Sabines* and the novelty of his exhibition initiative were affirmed to be the most eloquent signs of the profound artistic regeneration taking place: "The system of the arts has changed, or rather there is no more system in the arts. Restored to their true objective, through the naïve imitation of nature, revitalized by the study of antique models, reestablished in their moral and political mission, by perpetuating acts of heroism and virtue, they have taken on a new vigor even in the midst of the storms of the Revolution, and everything seems to presage that their development, each day more certain, will

gain in force, and receive from the new order of things a firm and permanent luster."[39] Written about six weeks after Bonaparte overthrew the directory regime by military force, the article partakes of the resigned optimism that greeted the "nouvel ordre des choses." The Revolution had swept clean the slate of artistic activity and the time of construction was at hand. For the timorous, attached to traditional values and hierarchies, this open horizon generated a great deal of anxiety; in effect, a number of prominent or promising artists retreated into their shells. For the more confident—David among many others—notwithstanding the mourning of a decade of republican dreams, it was an exciting prospect with unlimited possibilities.

I Self-Portrait

1794

Oil on canvas
31⁷⁄₈ x 25⁵⁄₈ in. (81 x 64 cm)

Musée du Louvre, Paris. Département
des Peintures. Don Eugène Isabey, 1852
(inv. 3705)

PROVENANCE
Given by the artist to Jean-Baptiste
Isabey (1767–1855); before 1852, his son,
Eugène Isabey (1803–1886); 1852, given
by him to the museum.

EXHIBITIONS
Los Angeles 1934, no. 9; San Francisco
1934, no. 87; Baltimore 1934–35, no. 10;
Paris 1939, p. 143, no. 1026; Paris 1948,
p. 72, no. 44; London 1948, no. 15; Paris-
Versailles 1989–90, pp. 304–5, no. 135.

BIBLIOGRAPHY
Seigneur 1863–64, p. 363; David 1880, pp.
222, 640–41; Rosenthal [1904], p. 164;
Valentiner 1929, pp. 168–71; Cantinelli
1930, pp. 87, 108 no. 87; Humbert 1936,
p. 119; Holma 1940, pp. 66, 127 no. 92;
Maret 1943, p. 55; Humbert 1947, p. 130;
Cooper 1948a, p. 278; Hautecoeur 1954,
p. 145; Siegfried 1957–59, p. 30; Wilhelm
1964, p. 168; Verbraeken 1973, pp. 17,
27–28; Wildenstein 1973, p. 114, no. 1131;
Brookner 1980, p. 15; Schnapper 1980,
p. 167; A.-M. Lecoq in Dijon 1982–83,
p. 203; Leighton 1987, p. 13; Bordes 1988,
p. 94; Michel and Sahut 1988, p. 93;
Lajer-Burchath 1989, pp. 310–12; Roberts
1989, pp. 99–101; Clark 1994; Lajer-
Burchath 1999, pp. 6, 8–15, 33–48, 84;
Lee 1999, pp. 186, 188–89.

THE ONLY SOURCE of information concerning this painting is a recollection by David's pupil Pierre-Maximilien Delafontaine, who accompanied him to prison on 2 August 1794: "It was in the Hôtel des Fermes [the prison] that he made a portrait of himself from the mirror I brought to him. This portrait was given by him a few years later to Isabey, the miniature painter and his pupil. He is represented dressed in a greatcoat, the costume of the period."[1] The *houppelande* David wears was the outfit of a number of deputies of the Third Estate he had drawn for the *Oath of the Tennis Court*. The neutral background is usual in his portraits, however in this self-confrontation the relative lack of transparency creates a singular impression of confinement.[2]

Neither the reason he gave this portrait to Jean-Baptiste Isabey nor the date and circumstances of his gift are known. He remained on friendly terms with his former pupil, even through occasional rivalry for responsibilities at Napoleon's court. Worth noting is that David did not want to keep this work associated with his close call with the guillotine and his year in prison and that never again would he execute a self-portrait. During the Empire he asked his pupil Rouget to provide a pendant (SEE FIG. 47) to his portrait of his wife (SEE CAT. 23). His reserve may in part be explained by the exostosis or tumor that deformed his lower left cheek, here discreetly enveloped in shadow, but more generally, except in this instance, he was not inclined to introspection. In his social relations he was more confident, presenting himself with his brush and pen—his letters are remarkably articulate—rather than through the seductions of speech and personal appearance.

Shown holding the brush in his left hand, David makes clear that this is a self-portrait. The image of the artist at forty-two, after two years in the demanding role of a politician, emblematizes his determination to become once again a full-time painter. This second phase in his career is the theme of the exhibition.

NOTES

1. "C'est à l'Hôtel des Fermes qu'il fit un portrait de lui dans la glace que je lui apportais. Ce portrait fut donné par lui, quelques années après à Isabey, peintre en miniature et son élève. Il est représenté vêtu d'une houppelande, costume de l'époque." Cited from Delafontaine's manuscript notes by Wildenstein 1973, p. 114, no. 1131. He remained for five weeks at the Hôtel des Fermes before being transferred to the Luxembourg.
2. For an exceptionally penetrating analysis of this self-portrait, see Lajer-Burcharth 1999, pp. 33–47.

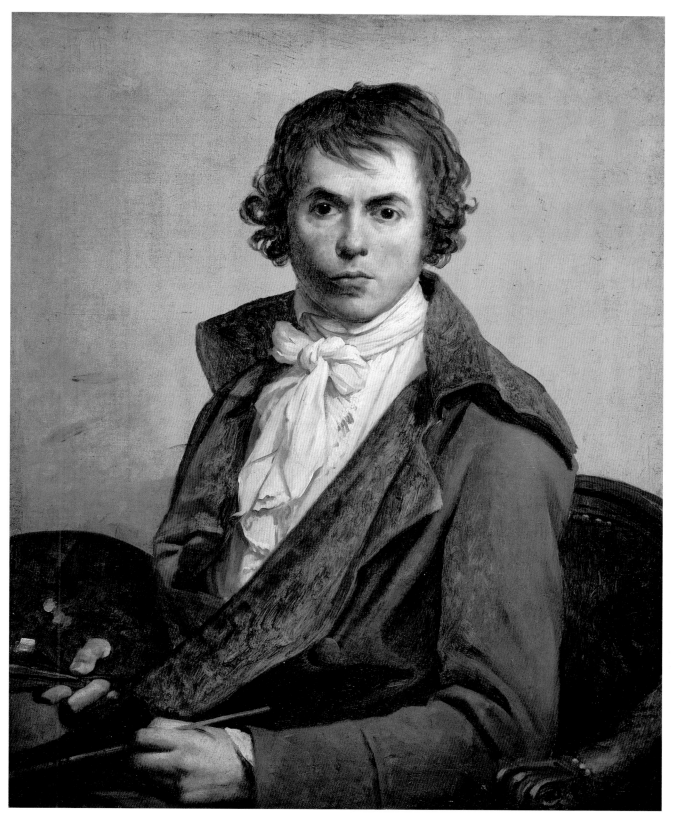

In the Service of Napoleon

THAT JACQUES-LOUIS DAVID, the painter of Marat and the partisan of Robespierre, cast his lot with Napoleon Bonaparte to the point of becoming First Painter to the Emperor and preferring exile to abjuration upon the return of the Bourbon monarchy, has been diversely interpreted. His fawning for the favors of the almighty hero has often been viewed as an opportunistic renunciation of his republican ideals, unbefitting of a man of character. Those historians of the French Revolution who tend to applaud the democratic and regulatory measures of the Jacobin government and decry the bourgeois order that triumphed during the Empire have been especially critical of David's allegiance to Napoleon: one suspects that they would rather he had drunk the hemlock with Robespierre, as he said he would, instead of calling in sick on the fateful day of his friend's downfall. If the idea of dying with Robespierre was unattractive to him, at least he could have been more circumspect once the victorious republican general—the new Alexander, as he was called at the time of the Egyptian campaign—revealed himself to be a ruthless autocrat—a new Caesar. In David's entourage, several of the master's pupils experienced a progressive disillusionment. Some even joined the more radical fringes of the opposition: dreaming of ancient Rome, they imagined ways to assassinate the first consul. Bonaparte's policy of harsh repression against both royalists and neo-Jacobins made clear, however, that this was a dangerous option. Anxious to put his political career at the National Convention and his involvement in the Terror behind him, David might reasonably have chosen to adopt a low profile during these years.

The coup d'état of Brumaire in November 1799 overthrew the Directory, a collegial form of government set up in 1795 to avoid the extremist positions taken during the Terror. It established the Consulate, an authoritarian regime that did not tolerate outspoken opponents: Madame de Staël, whose intellectual confidence got on Bonaparte's nerves, was ordered out of Paris. Marie-Joseph Chénier was also chastised when he took an independent course: he first supported Bonaparte's coup d'état and profited from his favors, but later fell into disgrace for veiled criticism of the emperor's ambition in his *Épitre à Voltaire.* David was clearly more cautious, never adopting an overtly oppositional stance

toward the regime. However, even after he had become Napoleon's first painter he continued to create art that resisted political servicing. When he wrote in 1805 of his *Leonidas* that "it's in Rome that these kind of pictures should be painted,"[1] during a period when he was deeply committed to the pictorial celebration of imperial pomp, he implied the impossibility in Paris of escaping from the triviality of modern life and government constraints on art practice. Had he attempted to situate his work at a distance from the regime, one can assume that the pressure to enroll his talent for official service would have been great indeed. As it turns out, he not only willingly played the game, he even seems to have anticipated what was expected of him, and once the imperial arts project was in full swing, he made every effort to be designated team captain. This compliance is where the difficulty in determining his motivation lies. Before 1789 he had been an adamant critic of the hierarchical servitudes of the Ancien Régime academic system, and during the Revolution he had championed a rule of equality in art practice, favoring open exhibitions and open competitions for official commissions. Why, then, did he accept the position of court painter to a military upstart who had ruthlessly usurped the republican ideal? How could an artist so jealous of his individual freedom act out the sycophant required of him in this privileged and fettered role? The problem is one of interpretation, but also of method. Is it possible to answer these questions without being apologetic and suggesting that attenuating circumstances excuse his decision to serve? Given post-romantic expectations of correct artistic conduct so prevalent today, is it possible, in evoking David during the Consulate and Empire, to refuse a moralizing tone and somehow avoid presenting him as a cynic? The refusal to judge in the narrative that follows does not entail an ignorance of the parallel strategy of recovery and cover-up at the crux of the collaboration between David and Napoleon: the painter was forever attempting to put the crimes of the Terror behind him, while the military officer never ceased to erase the memory of the coup d'état that created an access to the imperial throne. For several years, each managed to do this rather successfully.

At the outset of the Revolution David admired Mirabeau and Barnave, political radicals in 1789, political moderates in 1791; subsequently he fell in with Marat and Robespierre. He progressed in his allegiances as political rhetoric and government became more and more radical. In the same way, his early fascination for the republican general Bonaparte gave way to an admiration for the first consul in the role of soldier-legislator, and then for the *empereur des Français* who pledged to defend the revolutionary foundations of the French Republic. In the course of each of these mutations, Napoleon Bonaparte astutely enlisted references to the ideals of the preceding revolutionary regimes, dissipating any impression of rupture and renouncement. Quite early during his rise to power, the Corsican-born general, who was well aware of David's political past, made a determined effort to have the most celebrated living painter support his cause.

As major public figures in their respective fields, both men were able to represent and imagine the other from a distance, well before any prospect of collaboration was clearly formulated.

David did not conceive his successive images of the republican general—Bonaparte—and of the emperor of the French—Napoleon—in artistic isolation. He was witness to a outpour of painted, engraved, and sculpted imagery that he could not possibly ignore. He perforce measured himself with many other ambitious portraitists, often his former pupils. All who sought to portray the idol of the day were confronted with a set of unprecedented difficulties. Since the reign of Louis XIV, codes of representation were established in France for the representation of royalty: choice of costume, accessories, setting, pose, and expression came to define the Bourbon monarch. Although this absolutist imagery was under pressure during the reigns of the Sun King's successors, who aspired at times to offer more paternal and accessible images of themselves to their subjects, it remained a reassuring benchmark for artists through the constitutional monarchy of the early Revolution. By contrast, the images of Napoleon Bonaparte seemed radically unstable and elusive, systematically hybrid and composite, like the syncretic nature of his political legitimacy;[2] this was the essence of his modernity and authority. In the context of the cultural *tabula rasa* bequeathed by the Revolution, David was not alone in feeling galvanized by the challenge to fix the image of the hero and the ruler. His conceptual strategies and creative choices need to be evaluated with respect to the individual character of his art, but also to the orientations of contemporary painters and sculptors.

Bonaparte's extraordinarily successful Italian campaign of 1796, thoroughly covered in the press at his instigation, brought him wide popularity and attention back in France. His victories compensated for stalemates on other fronts and filled the coffers of the Directory. It is remarkable that, although busy waging a rapid succession of battles and reorganizing regional governments in Northern Italy, the general found time to give attention to artistic matters. His interest in the arts has often been noted. His determination to pursue in Italy the revolutionary government's policy of considering works of art as spoils of victory was inspired by sincere appreciation: to the Directory, he candidly expressed his satisfaction in securing a work of art "missing from our Museum."[3] It would be an error to reduce his taste for the fine arts to an acute awareness of their value as propaganda; his models were Alexander, Julius II, and Louis XIV, whose artistic patronage conferred on their reign the aura of a Golden Age. Bonaparte possessed an artistic sensibility, essentially formed on Italian and classical models, which gave authority to his intuitive judgment. How many visitors today to Malmaison, Josephine's suburban house near Paris, react as he did in 1800 upon discovering Percier and Fontaine's disproportionately high bases to the stucco columns in the vestibule? Concerning some interior

decoration at Malmaison, Fontaine noted in his journal: "The first consul who is not easy to please, it's said, appeared satisfied with it."[4] Certain political figures, such as Boissy d'Anglas, were capable of theorizing on the fine arts, but few except perhaps the major collectors—Bonaparte's brother Lucien, his uncle Cardinal Fesch, and the urbane Talleyrand—probably possessed his confidence and practicality when it came to judging a painting. As matters of state became ever more complex during the Empire however, he came to manifest indifference and even impatience, as on certain visits to the Salon. Toward the end of his reign, more often on the defensive, the arts became a matter of secondary importance with respect to diplomatic and military affairs; significantly, they are given very short shrift in the historical memoirs he dictated after his fall from power.

On 15 May 1796, five days after his victory at Lodi in the course of the Italian campaign, Bonaparte occupied Milan, where he set up his headquarters for several months. Almost immediately, he attracted artists. The first to court Bonaparte in Milan was Andrea Appiani, a local painter who executed his portrait, full length but half life-size (FIG. 2).[5] He represented the hero solemnly dictating his most recent success to the "Genius of French Victory," represented inscribing "Lodi" on a shield bearing the names of earlier battles. Rather uncannily, Bonaparte appears twice in the painting, for his tiny figure is also visible in background leading the momentous cavalry charge on the bridge spanning the river Adda. Stimulated by the victory he celebrated, Appiani approached his subject with the ambitions, resources, and culture of the history painter. How the hero reacted to his narrative archaism and allegorical theatrics is not known, but it seems that he preferred Gros's almost contemporary portrait, since he ordered that it be engraved (FIG. 3). The French painter, who neglected neither meaningful symbols nor explicit inscriptions in his more straightforward portrait, established a visual point of reference for all subsequent images of the victorious general. From 1798 the official engraving by Giuseppe Longhi was available, but no less effective were the verbal descriptions of the bravura composition, which lent itself to an enthusiastic ekphrasis. Notwithstanding this model, the pressure to exalt the figure of Bonaparte by allegorizing his exploits remained strong throughout the Consulate. Printmakers especially found this visual language useful to articulate a transitional relation between the rhetoric of the French Republic since 1792 and the personality cult encouraged by the irresistible general. Too numerous to have all been officially commissioned, these engraved allegories were particularly effective during the years 1799 to 1802 in rallying the

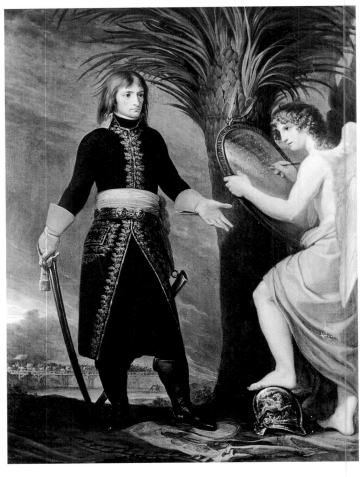

FIGURE 2 Andrea Appiani (Italian, 1754–1817), *General Bonaparte after the Battle of Lodi*, 1796. Oil on canvas, 38½ x 28⅞ in. (98 x 73.5 cm). Collection of the Earl of Rosebery, Scotland

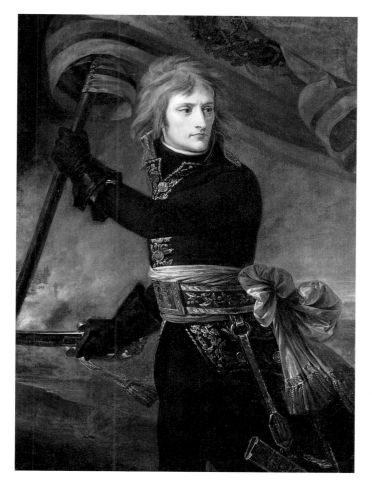

support of a population confronted with a drastic political evolution: in less than three years, Bonaparte did away with the republican form of government, got himself appointed first consul, and managed to have his rule extended for life.

It was in Milan that he first constituted what may be called a court. The example came from the Directory, which had reinstated the pomp and ostentation that were traditional trappings of government, after a period of Spartan regimen imposed by Robespierre and the Jacobins. The new attention given to the embellishment of public interiors, to furniture and costume design, and to protocol in official circles during these years was not lost on Bonaparte. With Josephine, who had no qualms about indulging in an aristocratic lifestyle, he set up lavish quarters in Milan: he could not fail to notice the impression made on visitors by the palatial interiors he invested. Probably more acutely than ever before, in a city fashioned by the glorious history of the Visconti and the Sforza, he came to realize how princely magnificence, court ritual, and luxury could consolidate and legitimize the authority secured by his military prowess. Contemporaries noted a transformation after the victories of the Italian campaign. "Already a strict etiquette reigned around him. His aides-de-camp and his officers were no longer admitted to his table. . . . The man was no longer the general of a triumphant republic. He was a conqueror on his own, imposing his laws to the vanquished."[6] Appiani probably imagined himself in the role of court painter when he composed a group portrait representing Bonaparte seated in the center, discussing affairs of state with his aides, standing in his presence, while several women in passive attendance create a more domestic ambiance (FIG. 4).[7] The precariousness of Bonaparte's situation in Milan may explain why nothing came of this project. Although he unilaterally reorganized the former Austrian possessions into the Cisalpine Republic around this time, officially he was nothing more than an agent of the Directory. Appiani's drawing suggests how difficult it was for artists to come to terms with the strictly personal nature of Bonaparte's initiatives. Traditional formulas might be marshaled, but these were rarely completely satisfactory and at worst, they exposed the sham. Monarchical imagery failed to capture a fundamental quality of Bonaparte's rise to power: the triumph of individual will. Without the advantage of birth and lineage, he was an extreme example of revolutionary meritocracy to which contemporaries could respond positively. Appiani does not represent the victorious general as a prince, although something of the theater of hierarchy, characteristic of court imagery, lingers in the pivotal role attributed to Bonaparte. The composition

FIGURE 3 Antoine-Jean Gros (French, 1771–1835), *General Bonaparte at the Bridge of Arcole*, 1796. Oil on canvas, 51¼ x 37 in. (130 x 94 cm). Musée national du Château de Versailles

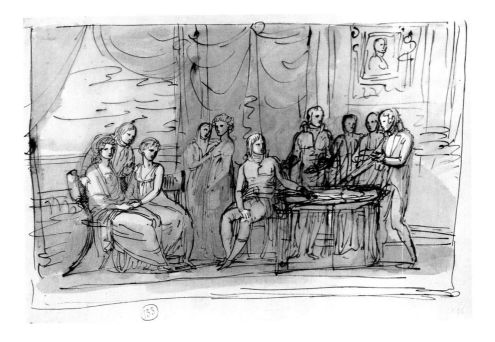

possesses the studied informality of the family portraits commissioned by monarchs across Europe during the eighteenth century, which present domestic happiness as a corollary to wise rule. In spite of certain precautions, like the friezelike arrangement of the figures, suggestive of equality, Appiani exposes the political reality of Bonaparte's precocious autocracy in Milan: with respect to the Directory in Paris, this representation, too informal to persuade and too explicit to reassure, was courting disaster.

The famous image of *Bonaparte at the Bridge of Arcole* (SEE FIG. 3), fearlessly spurring on his men to follow him across the bridge and engage in combat, was also produced in Milan. David's pupil Antoine-Jean Gros, on an extended study trip in Italy and taking his time getting home, painted it at the end of 1796. In a letter to his mother written from Milan on 6 December, he related how he had maneuvered with the help of Josephine, Bonaparte's spouse since March, to be able to portray the master of Italy "whose glory and the details given me of his physiognomy only excited more this wish." To convince Josephine of his talent, he had shown her a portrait of a man "with a severe physiognomy, and built the way I was told Bonaparte was somewhat."[8] The earliest printed portraits of "Buonaparte," as he was often designated with a show of Gallic condescension, conveyed the intriguing image of an emaciated and somewhat tenebrous figure. The personality he projected, an unusual mix of intensity and vulnerability, was notably different from that of the other officers, usually shown taking emphatic rhetorical poses. Gros first executed a half-length version of his portrait; this served as the model for the three-quarter-length portrait painted soon after, but which was revealed to the Parisian public at the Salon only later, in 1801, after a second military operation in Italy had made it timely to reassert the charismatic legitimacy of his authority.

FIGURE 4 Andrea Appiani, *Napoleon at His Court—A Group Portrait*, 1796–98. Brown ink, gray wash, and pencil on paper, 14⅝ x 20⅝ in. (37.1 x 52.4 cm). Accademia di Belle Arti di Brera, Milan

Gros's letter to his mother of 6 December 1796 is of further interest because he relates that Bonaparte had received a request from David for a layout of the Battle of Lodi (10 May 1796), which he wanted to paint, possibly the earliest indication of his attraction to the military hero (SEE CAT. 2). That David had taken an option on this event may explain why Gros chose to ascribe his portrait to another moment of the campaign, the drawn-out confrontation at Arcole dating from November 1796. Bonaparte no doubt encouraged this choice, since he was meeting competition for the leading role in that battle from one of his generals, Charles Augereau, who also commissioned paintings and prints to make his point. Gros's composition was especially effective as an image of military heroism. It is an art historical commonplace to note that the painterly brushwork and Rubensian colorism evident in both versions of the portrait are radically alien to David's manner: the seeds of a generational reaction are here sown. However, the rupture is less absolute than one might think, for Gros has adopted his master's mode of formal synthesis, spatial abstraction, and conceptual richness. His image of Bonaparte possesses the qualities of concision and coherence and the resonance of allegory. Unlike the paradoxically descriptive mode of Appiani's allegorized portrait, anchored to a specific historical moment, the action represented by Gros succeeds in transcending it, with only a few scattered elements in the background functioning like visual synecdoches. When painting *Bonaparte Crossing the Alps* in 1800 (SEE CAT. 4), David was confronted with the contradictory demands so imaginatively resolved by his former pupil: the two painters shared with the critics and theorists of their time the belief that reference to the particulars of history was required to validate a contemporary image, yet that to attain universal expression it was necessary to minimize this constraint.

The reservations David had expressed openly in August 1796, when he had signed a petition opposing the spoliation of Italy's art treasures by the French army for the benefit of the Paris museum—a critique he would again voice during the summer of 1798 on the occasion of the festival organized by the Directory upon their arrival—apparently did not cloud his admiration for Bonaparte when he returned triumphantly to Paris in December 1797. Those who had been critical of the confiscations were incited to discretion, since the instigator of the petition, Antoine-Chrysostome Quatremère de Quincy, had suffered exile during the coup d'état against the royalist faction in September 1797 (Fructidor), and the joy upon Bonaparte's return seemed unanimous.[9] As in so many previous circumstances, David moved with the flow of history. He may even have felt more than admiration for Bonaparte, who is reported to have invited the painter to join him in Italy during the summer of 1797, at a time when republicans had been under the threat of an upsurge of royalist violence.[10]

Although Bonaparte expected a battle picture, David planned a portrait. It may have been his intention to provide background details and link it to a par-

ticular event, but the preparatory drawing makes clear that he started by creating a generic image of the hero confronting his destiny. For Bonaparte was much more than a victorious general on his return from Italy: he had created a new state in Northern Italy and redrawn the map of Europe. Many contemporaries were convinced that his youth, statesmanship, and generosity in victory premised a legendary course. Just over a week after the signing of the treaty of Campo-Formio, even before he had regained Paris, the Directory named him commander-in-chief of the Army of England with a new mission of invasion. However, it did not take him long to prove this enterprise impossible, and by May of the following year he set off in an opposite direction and initiated the Egyptian campaign. At one point, Bonaparte went to David's studio and posed for three hours, according to David's biographer, Étienne-Jean Delécluze, at the time his pupil, for the unfinished portrait today in the Louvre (SEE FIG. 21). This could only have taken place during the few months when he was in Paris, from December 1797 to May 1798. Before the Italian campaign, his reputation was still unaffirmed. When he came back from the Egyptian campaign in October 1799, he had something new on his mind: the overthrow of the Directory, a scheme he would need less than two months to implement.

Worth noting is David's decision, from the outset as the drawings demonstrate, to present the hero directing his attention askance. In the painting, his eyes are directed upward, suggesting some new objective and the attainment of even greater glory. More of a pose than an expression, this self-absorption establishes a distance with respect to the spectators, in marked contrast with David's other portraits, in which the sitter appears to acknowledge their presence. This distancing historicizes the portrait by suggesting the engagement of the hero with his destiny, and at the same time, it effectively deflects the viewer's attention from the problematic question of Bonaparte's official status. His public identity is so uncertain at this point in his career that he quite literally cannot face the viewer. A straightforward portrait would either have been degrading, ranking him with the other interchangeable officers, or too explicit, had the visual tradition of princely authority been registered. In spite of the wide acclaim showered on him, Bonaparte aroused mistrust in government and military circles in the capital. The only mission he had received from the Directory in 1796 had been to create diversions that would disperse the Austrian forces in Italy. Instead of this cautious policy, he had personally implemented a bold politics of conquest.

So there may also have been a political motive for leaving the portrait unfinished. Conscious of the jealousy and suspicion that his military and political success could provoke, Bonaparte chose a posture of discretion upon his victorious return to Paris. He may have realized, after his visit to David's studio, that publicity concerning his future portrait would be ill-timed. This may also explain why in 1798 he did not send Gros's portrait, which he owned, to the Salon. He even encouraged speculation that he would follow Washington's

example and retire from public life. To give credibility to this counter-image of himself, he arranged to be elected to the National Institute on 25 December 1797—to a seat in the mechanical arts section! The letter he addressed the following day to the president, published in the press, attests eloquently to this strategy of modesty. Alluding to his colleagues, he wrote that he was honored by their vote: "I well understand that before being their equal, for a long time I shall be their pupil. If there were a more expressive way to let them know my esteem for them, I would adopt it. The true conquests, the only ones that leave no regret, are those over ignorance. The most honorable occupation, and the most useful for nations, is to help extend the limits of human ideas. The true power of the French Republic must henceforth consist in not allowing that there be a single new idea which does not belong to it."[11] Such talk was intended to seduce the group of intellectuals known as the *Idéologues,* who dominated the Institute. These men were always ready to engage in philosophical discussion and debate; they considered themselves the heirs of Enlightenment philosophers and the guardians of the constitutional legacy of the Revolution. Although the politicians, financiers, and military who occupied center stage during the Directory had pushed them aside, their moral authority was still respected. Bonaparte gained their support for his coup d'état in November 1799 and accorded them various favors once in power as consul. However, by 1802 and with the affirmation of his personal rule, he was seeking to reduce these republican admonishers to silence.[12] David, like the other members of the Institute, took pride in Bonaparte's affiliation, and like everyone else, he was probably taken in by his unassuming figure: "Nothing let on the man who had overthrown, sustained, or created several states and whose protection four kings and a host of sovereign princes have implored; neither his height, nor his features, nor his manner, nor his attire drew one's attention; and yet, the fame attached to his name being so resplendent, he struck all the onlookers."[13]

Bonaparte is reported to have proposed to David, in the spring of 1798, to accompany him on the foreign expedition he was preparing, without fully detailing his goals, nor specifying that the destination was to be Egypt.[14] If the offer was indeed made, it is hardly surprising that the painter chose not to sacrifice his material comfort and peace of mind, delay the completion of the *Sabines,* and perhaps even risk his life in an unpredictable and unknown military adventure; an extended absence from Paris threatened all his efforts since the Terror to reestablish his artistic reputation. The revolutionary years had proven to David that no public figure, not even a Bonaparte in 1798, could be sure that the winds of fortune would not turn against him. In spite of disparate initiatives in the course of the eighteenth century to integrate Egyptian art and culture to the primal history of European civilization, travel to that far-off land would necessitate a profound reorientation in David's artistic priorities, away from the heritage of Greece and Rome. It was left to others to take up the challenge of accompanying Bonaparte to Egypt, notably a draftsman and engraver

with little to lose and much to gain, Dominique-Vivant Denon, whose work would be essentially documentary and archaeological. In fact, no major painter joined the expedition. Although its political and diplomatic impact was mitigated, its cultural and artistic importance would be immense. Over the next decade, the battles and dramatic events of the Egyptian expedition would spark the imagination of a wide array of ambitious painters. Significantly, David would not be among them. Historians have recently insisted on the role played by this Oriental iconography in fueling the civilizing discourse of Napoleonic propaganda and, somewhat paradoxically, introducing a more empathetic attitude toward exoticism than the decorative appropriations practiced in the eighteenth century.[15] That younger painters, especially Gros, Girodet, and Guérin, were eager to engage with this Oriental iconography, which often furnished them with an occasion to surpass themselves, lays bare the yearning for rupture and renewal that this commitment implied. One suspects that David was never able to surmount a fundamental hostility to this modern *engouement.* Following his exile in 1816, he wrote dogmatically to Gros, who had taken over his studio and looked after his affairs in Paris: "You have not yet produced what might be called a true history painting."[16] In saying this, he explicitly deprived *Bonaparte among the Plague-Stricken at Jaffa* (Musée du Louvre) of any high artistic pretensions. Clearly revealing the topology of David's modernity, the virulence of this admonition is not explained simply by Gros's predilection for subjects taken from contemporary history. Napoleon's first painter never felt repugnance at commemorating imperial ceremonies, even beyond what was required of him if one considers the copy of the *Coronation* that kept him busy until 1822. One suspects that David's criticism addresses Gros as the painter of the Egyptian expedition, of *The Battle of Nazareth* (Musée des Beaux-Arts, Nantes), *The Battle of Aboukir, The Battle of the Pyramids* (both, Musée national du Château de Versailles), and *Jaffa,* who had masterly explored territory that the painter of the older generation considered off limits.

The words that Delécluze puts in David's mouth, when the painter learned of Bonaparte's coup d'état of 18 Brumaire Year VIII (9 November 1799) against the Directory and its two representative assemblies, are famous: "Well, David said, I had always thought for sure that we were not virtuous enough to be republicans." He then reportedly mulled over a verse in Latin, which roughly translated goes like this: "The cause of the victors pleased the gods, but that of the vanquished pleased Cato."[17] Whether his reaction to the defeat of his republican ideals adopted in fact such a Robespierrist accent and whether he saw himself as Cato is highly doubtful. Public opinion, influenced by an ever more efficient propaganda machine, had hailed the hero's return from Egypt: "Bonaparte has proven that victory can go hand in hand with moderation and patriotism with humanity. We do believe that he arrives along with glory, peace and happiness."[18] To most observers the full measure of Bonaparte's autocratic intentions

was not immediately obvious. Many expected the republican general, who had often opposed royalists, to consolidate the constitutional victories of the Revolution and reconcile a social body plagued by civil strife. David's *Sabines*, in which the women succeed in persuading two warring factions to lay down their arms and live in peace, exhibited just weeks after Brumaire, gave timely resonance to this hope. Although the painting was conceived in the immediate aftermath of the Terror, it was easily interpreted as a program for the present: in this sense it exemplified and justified the parallel that could be drawn between Thermidor and Brumaire. According to those who participated in Bonaparte's coup, the constant social and economic disruption and the political agitation tolerated by the Directory threatened the future of the republic. Measures openly favorable to property owners, largely indebted to the Revolution for their prosperity, and inflexibly repressive toward extremists, whether royalists or neo-Jacobins, were soon proclaimed.

It was reassuring to the *citoyens* that the new regime had declared itself a Consulate, suggesting a filiation with the patriotic culture of the Roman republic. Although there were three consuls and still two assemblies, power was no longer shared by a collegial executive and balanced by elected representatives. The Constitution of the Year VIII, ratified after Brumaire, marked the advent of a political system in which all final decisions on policy were taken personally by the first consul, in other words by Bonaparte. In January 1800 he let it be known that he had asked David to have the Capitoline bust of the stern roman consul Brutus, one of the prime trophies of his Italian victories, placed in his study at the Tuileries.[19] Through such symbolic gestures and expressions of antagonism toward the Bourbons, he easily dispelled the fear that the new regime sought to reinstate a traditional monarchy. His prime concern at this point was to discredit the idea that the Consulate was a military dictatorship, a tyrannical prospect that remained anathema to post-revolutionary sensibility. To this effect, he made a great effort to promote himself as a statesman and pacificator, engaging by early summer of 1800 the diplomatic negotiations with England that would lead to the Peace of Amiens (25 March 1802) and commissioning a series of portraits of himself in civilian costume. As has often been noted, in the new regime's politics and in its official image, there was a recurring tension between the need to define and impose a resistant and permanent status for the first consul and the impulse to exploit the flashy and dynamic military career on which his authority ultimately rested. While the image of the chief of government tended to invoke traditional iconography to assure its credibility, that of the army commander encouraged artistic invention. The challenge was to express the ruler's modernity and exception and to avoid parody and triviality. The many artists who executed official portraits of Bonaparte during the Consulate seem each to negotiate personally the resolution of these tensions. Judging from the remarkably diversified works created during the period, the optimism in-

spired by the new regime and the relatively uncoercive and undogmatic dispensation of official commissions were powerful stimuli for artists.[20]

Almost immediately after the coup d'état, Bonaparte turned his attention to the trappings and embellishments traditionally associated with his new status of power. Aware that he would need to constitute a group of trustworthy and competent retainers to help in formulating his projects and to carry them out, his first thought was to call upon David and a young architect the latter recommended, Pierre Fontaine. On 30 November 1799, the two advisers visited Malmaison, "that Madame Bonaparte wants to have decorated." From the evidence of Fontaine's journal, it is clear that during the first months of the Consulate, David was adopted by Bonaparte as an intermediary to relay his orders of execution.[21] Encouraged by the first consul's esteem and the public success of the *Sabines,* in late December 1799 the painter submitted a proposal for an administrative organization for the arts, which betrayed his ardent desire to play once again a first role in implementing the nation's arts policy. His project defines a position of *conservateur,* for which he surely thought himself the best candidate.[22] Close attention to the wording—"inspection and surveillance" and not organization—suggests that David's desire was to orient rather than control the arts. Nonetheless, explicit is the will to impose an aesthetic if not a style, since the *conservateur* would oversee the instruction of aspiring artists and the programs for public monuments. Because he insisted on this latter point, David may have had insider information concerning the priority the first consul aimed to give to the urban renovation of Paris.

Although this proposal received no reply, there are indications that David was *de facto* assuming the responsibilities he had detailed. When, for example, Bonaparte asked him to propose designs for two commemorative monuments in the provinces, David delegated the work and returned drawings stamped with his approval. Rumors that he would be given an official position bristled in the art world: in late January twenty-five artists signed a collective letter to compliment him on his presumed nomination. The object of their brief was essentially to obtain some favors: they hoped that the financial wizard of the *Sabines* exhibition, "a man who through his inspiration and his principles, and by the beauty of his works, has so surely helped [public prosperity] develop and shine," would succeed in convincing the government to allot funds for artists. Their initiative was premature but their tip was soon proven correct: David was officially named *peintre du gouvernement* on 18 Pluviôse Year VIII (7 February 1800).[23]

Even before the nomination, problems arose concerning the nature of his attributions, since Napoleon's brother Lucien, minister of the interior since late December 1799, tried to limit them as much as possible. A strong-minded personality who had played a decisive role during the coup d'état of Brumaire, Lucien manifestly enjoyed dealing with artists, collecting art, and taking the lead. According to several sources, there may have been a kind of showdown with David over the attributions, resulting in the latter's decision to refuse the

nomination (in November it would be Lucien's turn to resign from the ministry in a similar showdown with his brother and rival Napoleon). To set matters straight, David published a brief letter in various journals explaining the reasons for not accepting a position "that looked like it would profit only me, and in no way art and artists, my sole concerns."[24] Although rarely insensitive to honors and rewards, David seized the occasion to project a public posture of self-abnegation, perhaps glad to counter the accusations of greed and commercialism that the *Sabines* exhibition had provoked in the press. Upon hearing of his nomination, artists had been prompt to address their demands and projects to him: along with the prospect of petty rivalries within the administration, his ardor may also have been dampened from realizing how difficult the role of arbiter he had imagined for himself might be. Could he forget how he had been forced after Thermidor to defend himself at length against bitter accusations of favoring associates and persecuting artists he disliked? Furthermore, times had changed since Year II, when his advantageous position at the Convention and on government committees had greatly facilitated the adoption of his personal proposals. Artists in 1800 were openly more independent. For example, none wanted to be part of the Société libre des Arts du Dessin, which the new minister of the interior, Chaptal, tried to establish soon after his nomination in November.[25] He knew that the press lay in ambush, notably a new art journal, the *Journal des arts, de littérature et de commerce,* which had begun publication in July 1799. It seemed as if each time an official decision concerning the arts was taken, self-appointed critics and artists-turned-journalists managed to stir up a polemic, perhaps a side effect of the censorship on political debate that had been imposed within weeks of the coup d'état. David could easily enough bear the discussion and criticism elicited by the *Sabines;* it was another matter when his impartiality in judging contests and awarding commissions was attacked.[26] He soon realized that even a *peintre du gouvernement* would probably not always have his way. He would be exposed to public attacks, as had happened right after Brumaire, when it was reported that Bonaparte rejected his design for an official consular outfit on account of its unmilitary opulence.[27]

Early in July 1800, Bonaparte returned to Paris after a second and relatively difficult military campaign in Italy. He had launched the campaign to reconquer territory that had been taken back by Austrian and Russian troops, and according to some historians he was also spurred by jealousy over the victories against the Austrians in Germany of General Moreau, whose popular reputation as a staunch republican foregrounded him as the first consul's main rival. In the course of this new raid into Northern Italy, Bonaparte had astonished contemporaries by successfully crossing the Alps with his army in record time via the Saint Bernard Pass (14–25 May), and by propagandizing a dramatic and decisive victory at Marengo, between Turin and Milan (14 June). Reflecting the need to sustain his reputation and silence a host of rivals, just two weeks after his return the first consul took a significant artistic initiative. He asked Lucien, still minis-

ter of the interior, "to choose the best painters to have the following battles painted: Rivoli [14 Jan. 1797; first Italian campaign], Marengo [14 June 1800; second Italian campaign], Moskirch [5 May 1800; German campaign], Pyramids [21 July 1798], Aboukir [25 July 1799], Mont-Thabor [16 Apr. 1799; all three, Egyptian campaign]."[28] To furnish specific information that the artists might need, he referred Lucien to General Berthier, present at Marengo, and to Denon, well qualified to document the last three victories. This pictorial commission, whose spontaneous formulation is characteristic of the early Consulate, is the first clear directive submitting the arts to the propaganda needs of the regime. Because the results of the Egyptian adventure and the second Italian campaign did not appear as clear-cut as Bonaparte's Italian victories of 1797–98, the paintings were to establish standard versions of the engagements, in the manner of the army bulletins written to represent the military situation in the most favorable terms. The first consul's terse but spirited order for the visualization of his recent military triumphs further confirms his preference for the descriptive and narrative mode of battle painting, as opposed to the abstract and synthetic language of allegory.

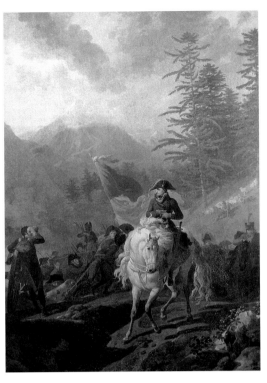

Bonaparte's choice of battles listed for commemoration in July 1800 also shows his readiness to share the artistic limelight with his generals: Murat was honored by the victory at Aboukir, and Moreau by that of Moskirch (Mösskirch). In March 1801 Bonaparte would confirm a promise he had made after the Battle of Nazareth (8 July 1799) to organize a contest for a painting in commemoration of Junot's victory.[29] His reticence to encourage the encomiastic iconography proposed ever more insistently by courtiers and artists vying for favors and employment was also manifest in the brutal rejection of a series of paintings destined for the salon at Malmaison, his official residence at the beginning of the Consulate. In August 1800 Josephine had commissioned paintings to complement two compositions by Girodet and Gérard on the Nordic theme of Ossian: "Madame Bonaparte desires that these pictures represent episodes from the general's life," wrote the architect Fontaine in his journal. In the spring of 1801, when Bonaparte discovered this suite illustrating scenes of the Alps crossing, he ordered the immediate removal of the pictures. One painting, a collaborative effort by Nicolas-Antoine Taunay and Jean-Joseph-Xavier Bidault, could effectively have backfired: "the first consul sleeping from the fatigue of the Alpine crossing before the victory at Marengo with marching soldiers who fear to trouble his sleep." When shown at the Salon of 1801, several critics found the antiheroic iconography unpalatable. Another composition, probably executed by Alexandre-Hyacinthe Dunouy, represented "the first consul on the summit of the Alps pointing out the rich plains of Lombardy to his army." A third painted by Taunay, recently rediscovered, comprised an equestrian portrait of

FIGURE 5 Nicolas-Antoine Taunay (French, 1755–1830), *General Bonaparte's Passage over the Alps*, c. 1801. Oil on canvas, 72 x 47¼ in. (183 x 120 cm). Palazzo Reale, Milan

the first consul, which David surely saw: "General Bonaparte encourages with a glance a cannoneer hauling one of the wheels of his piece and wiping his brow" (FIG. 5).[30] Bonaparte's negative reaction, like that of the critics, was probably provoked by the anecdotal iconography of these works with respect to their destination. Traditionally, state portraits or representations of major historical events might be hung in public rooms; scenes might evoke past or current rulers. However, the status of Malmaison as an official residence was somewhat ambiguous: the architect Fontaine deplored the modest character of the country house. Not authorized to tear down the existing building, he would have liked to triple its scale. Diplomatic visitors were received at Malmaison and Bonaparte was troubled by the trivial incidents the rejected paintings celebrated. Ever since the middle of the eighteenth century, in a characteristic expression of Enlightenment morality, pictorial representations of the private virtues of long-dead rulers, most often Francis I and Henry IV, had developed into a defined genre, either establishing a favorable parallel with the reigning monarch or, more critically, suggesting he imitate their example. During the reign of Louis XVI, paintings celebrating the humanity and benevolence of the monarch appeared at the Salon, but the destination and interpretation of such works remained problematic; conservative opinion considered it undignified to give publicity to this underside of majesty. Bonaparte, whose sensitivity to such matters was understandable given the impetuous and impious manner with which he had seized power, apparently agreed. By contrast, Josephine's personal tastes were oriented toward anecdotal history, sentimental novels, and troubadour painting. Whereas she was probably delighted by the series of paintings, which imposed her mark on the main salon of Malmaison, the first consul, then in the empirical process of fashioning his public image, had no trouble imagining the snickering of his guests.

Unavoidably, from Fontaine or the cabinetmaker Jacob-Desmalter, who were both involved in the renovation of Malmaison, David got wind of the commissions Josephine had awarded during the summer of 1800. He had reason to be envious of the patronage accorded to two former pupils, Girodet and Gérard, and may have registered that a suite of paintings was planned in celebration of Bonaparte's Alpine crossing. It was just at this time, in August, that he was contacted by a representative of Charles IV, king of Spain, with a request for a full-length portrait of the first consul, to be placed in the Royal Palace in Madrid (SEE CAT. 4). With orders to give the painter satisfaction at all cost, the Spanish ambassador accepted David's fee of 24,000 francs. Undoubtedly both the royal patron and the high-priced commission flattered David, who since the 1780s was careful to establish his international reputation and respond favorably to foreign interest in his work; encouraged by the success of the *Sabines*, he esteemed that amateurs all over Europe had eyes on his work.[31] According to Tønnes Christian Bruun Neergaard, a Danish amateur whose reports on the Parisian art world were published in 1801, the portrait of Bonaparte was finished

by January of that year and had demanded four months' work. After offering an impassioned description of the painting for the Spanish king, he concluded: "One easily sees in this work the satisfaction experienced by the author when executing it."[32] Although David never benefited from actual sittings with the first consul striking the desired pose, the painter was indeed inspired by this new challenge and produced a supremely authoritative lesson in historical portraiture. Upon learning of the Spanish commission, perhaps upon hearing it lauded by members of his entourage, once it was well-advanced or even finished, Bonaparte decided to order a replica for himself. By February 1801, the press could report on the two portraits, even revising the history of their inception and attributing the initiative to the first consul. At some point, in 1801 or 1802, the latter requested two more versions. A fifth version was painted, which the artist kept for himself. Important differences distinguish each of the versions, replicated with the help of assistants but of consistently high quality. The color of the horse occasionally varies, as well as that of the sweeping cloak, alternately yellow or red; details in the harness can also differ and Bonaparte's features seem to mature from one version to the next. This manner of working attests to David's active engagement not only with the initial composition but with its possibilities for improvement and chromatic variation. In the second and later versions he simplified the horse's harness, which in the first he probably found fussy and subordinated to a descriptive aesthetic. Ever since the small-format repetitions of *Belisarius* and the *Horatii* painted in the 1780s, down to the full-size replica of the *Coronation* finished in 1822, he generally tried to improve on his originals whenever he was asked to produce new versions; in 1803, learning that *Andromache* was to be placed on public show in the museum devoted to the French School at Versailles, he asked for the right to repaint some parts that no longer pleased him.[33] That he joined the first two portraits of Bonaparte to the *Sabines* exhibition in September 1801, an incitation for the public to compare them and appreciate their differences, denotes that this act of refined connoisseurship was important to him. Such a playful manipulation of replicas was uncommon practice at the time; one can think of no other contemporary painter who dared the virtuoso experimentation in color harmony that David developed in this suite.

Not everyone, of course, was convinced that his exhibition of the two portraits was just a matter of art. After all, some pointed out that David had pocketed the subscription fees to an engraving of the *Oath of the Tennis Court* that was never published, and that he was no longer justifying the pay-per-view scheme for the *Sabines* in a public building as a means to be able to offer the painting to the nation. On several occasions during the Consulate, public polemics led David to send letters to the press in order to defend himself. To many critical observers, he was far more interested in making money than he pretended to be, and he now appeared to be churning out copies of the Bonaparte portrait, cheaply produced by poorly paid students, which he peddled as autograph

works for "crazy prices."[34] However, such hounding against charlatanism and prevarication in the use of public resources, a legacy of the revolutionary press, does not seem to have soured the artist's spirits. Although as a rule David chose greater discretion during the Empire when handling his financial affairs and refrained from engaging the press, he often found himself wrestling with the administration to receive his due. This has been interpreted as further proof of his rapacity and also of his progressive estrangement from Napoleon. The succession of business letters he wrote may seem a thoroughly unartistic and undignified exercise to some historians, yet for someone as conversant with revolutionary bureaucracy as David, it was a question of justice and perhaps also of beating the administration at its own game. In any event, such difficulties were no cause for disillusionment with the regime: Napoleon gratified David continuously down to the Hundred Days (the period between his regain of the Empire after Elba and his final defeat at Waterloo), and the painter paid homage to the emperor until the end of his life.[35]

Many problems resulted simply from the gross imprecision presiding over official commissions during the Consulate and the first years of the Empire. Admittedly it was not easy to fix a price on artistic commissions around 1800: on the one hand, incredibly high sums were obtained by a handful of fashionable artists during the Consulate from private and public patrons; on the other, the majority, craving work, readily accepted the relatively low standard fees that the administration strived to impose. David, not surprisingly, was in the select group, which counted two considerably younger artists, Guérin and Isabey. Given his accomplishments and reputation, it was natural for him to believe that no one had more right than he to benefit from the highest pay scale, except, perhaps, Canova, whom he admired and who was being co-opted as the official sculptor of the regime.

It is impossible to dissociate the energy David deploys during the Consulate from Bonaparte's military and political ascension: confronted with this new phase of revolutionary history, the artist might at first have chosen to remain a sympathetic observer on the sidelines, but an impatience to play an active role soon overtook him. This is often explained by his driving personal ambition, a mix of opportunism and cupidity. Without aiming to contradict this point of view, shared by contemporaries with various axes to grind, a more positive interpretation of his career strategy needs to be recovered, since it patently also found expression. David never rose to the degree of cynicism and corruption that was the political norm of the consular and imperial governing elites, exemplified to the point of caricature by Talleyrand and members of Bonaparte's family. There is no reason to believe that the artist ever doubted his mission in life. On the basis of his own declarations at this time, David felt that his driving ambition was fundamentally artistic. In November 1803 he summarized in a nutshell his global achievement: he had "restored good taste within the French School, which today put it at par with the great period of the Italian School."[36]

The development of the painting collections in the national museum, open in the Louvre since in 1793, attuned the artist's awareness of his future position in the history of art. The hanging in the Grande Galerie around 1800 celebrated the preeminence of the Italian school, which occupied four bays, like the Northern schools, while the French school was allotted only one.[37] More and more, as the passage cited suggests, David was concentrated on a rivalry with sixteenth-century Italian painters, in particular Raphael, who was showcased in the Grande Galerie. David was reported to have been most excited, around the time of Napoleon's coronation, by his visits to the pope to paint his portrait: "He was beautiful to see; he reminded me of Julius II, whom Raphael painted in the *Heliodorus* of the Vatican." Thanks to the emperor, his art could reach new heights, in terms not of an aesthetic ideal but of art history: "I admit that I have long been envious of those great painters who preceded me for those occasions which I thought would never come my way. I shall have painted an *emperor* and finally a *pope!*"[38] These words are put into David's mouth by a biographer publishing in 1855, at a time when art historical self-consciousness had been sharpened by historicist imagination. With respect to attitudes prevalent at the beginning of the century, the position attributed to David is too articulate to be true, but it does find support in the cult of Raphael that prospered during the Empire. As will be shown, David's dialogue with art history also makes room for Rubens and eventually for fifteenth-century Flemish painters, who near the end of the Empire make a side entrance into the canon thanks to the historical vision operating in the museum. But around 1800–1805 the supreme accomplishments of Raphael constituted a challenge that Europe's most famous painter met with confidence. At least during the first years of Empire he was convinced by the creative exhilaration he felt, that he had been given an exceptional opportunity to prove his artistic greatness. More than the material gains that were his reward, more than the money and the honors, and surely more than the exercise of influence, this was his motivation.

David's studio activity during the Consulate was unusually multifaceted. As already mentioned, after finishing the *Sabines* in 1798, he began composing a pendant on the theme of Leonidas at Thermopylae. He also produced a number of private portraits in these years, of Henriette de Verninac in 1799 (SEE FIG. 54), of Juliette Récamier in 1800 (Musée du Louvre), which he left unfinished, and of Cooper Penrose in 1802 (SEE CAT. 14).[39] He may have begun to paint *The First Consul Restoring the Cisalpine Republic,* for which he demanded the enormous sum of 60,000 francs, in response to a commission the puppet government restored by Bonaparte in Milan during the second Italian campaign had given him in April 1801.[40] The various versions of the equestrian portrait of the first consul required a great deal of attention from the fall of 1800 to early 1803, at which time he again took up *Leonidas.*[41] During these years his personal relation with Bonaparte apparently remained close and distinguished. He received special treatment after the weekly military review on 14 June 1801: a flattering insert

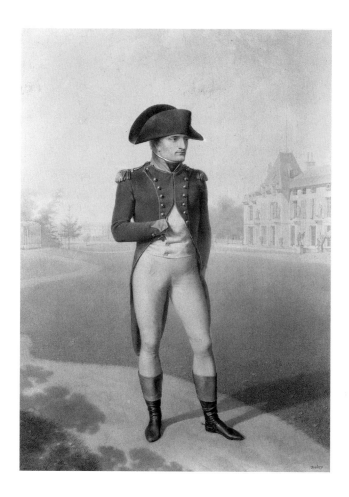

in the press signaled that the first consul and the third consul, Charles-François Lebrun, visited his studio to see the equestrian portrait and then proceeded, in the artist's company, to the *Sabines* exhibition.[42]

During the year 1802 the republican order came to an end as Bonaparte became "Consul for Life." In the wake of the official proclamation in August, he arranged for the adoption of a new constitution giving him the right to define and interpret its articles. He multiplied measures to gain the support of the most prosperous citizens; by encouraging a fusion of the elites and founding social hierarchy on wealth, he hoped to establish the stable regime so desired by his countrymen. The Civil Code of the French People—later referred to as the Code Napoléon—promulgated in March 1804 would be the legal text confirming the social and cultural ascendancy of the bourgeois upper-middle-class that had most benefited from the Revolution. Although Bonaparte's monarchical aspirations could not be mistaken by the end of 1802, because of the advent of the long-desired peace—the Italian treaties, then the Peace of Amiens signed with England in March of that year—most French citizens chose to hear only his peremptory invocation of the French Republic and to perceive the leader whose image David was so busy multiplying.

The peace with England proved fragile and ended in the spring of 1803; the strategy of war resumed for control of seas. At home, treacherous plots seemed to encircle the first consul, while sparks of royalist unrest and violent banditry

FIGURE 6 Jean-Baptiste Isabey (French, 1767–1855), *Bonaparte at Malmaison (as First Consul)*, 1801. Pencil on paper highlighted in gouache, 27¼ x 19 in. (69 x 48 cm). Musée national du Château de Malmaison, Rueil-Malmaison

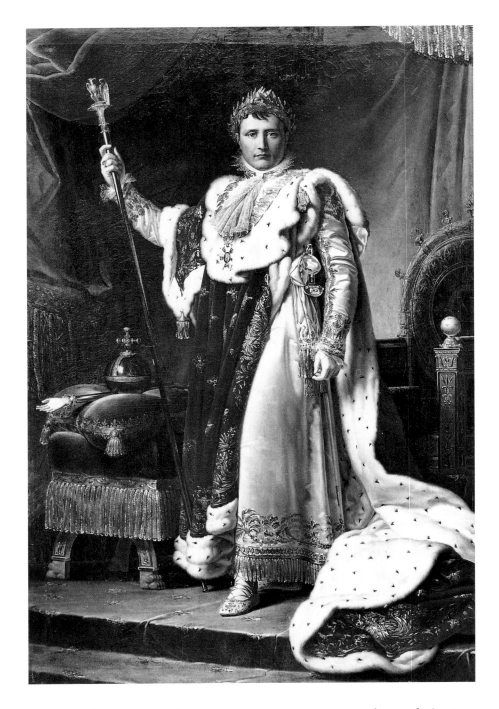

spread in the provinces. Strong repressive measures were taken early in 1804, including the summary execution of a Bourbon prince who had been unlawfully kidnapped across the border, on neutral soil. Even Bonaparte's bourgeois clientele began to criticize the autocracy of the regime during these troubled months. The sober portraits of the first consul by Isabey (FIG. 6) and Gérard (1803, Musée Condé, Chantilly) from this period exemplify the low profile and the republican and military spirit that he adopted for a time. Paradoxically, in this context the politicians with republican sympathies who applauded the blows directed against the royalists were the ones proposing the establishment of a hereditary succession to consolidate the government. In a striking example

FIGURE 7 François Gérard (French, 1770–1837), *Napoleon I in Imperial Robes*, after an original dated 1805. Oil on canvas, 88½ x 57⅞ in. (225 x 147 cm). Musée national du Château de Fontainebleau

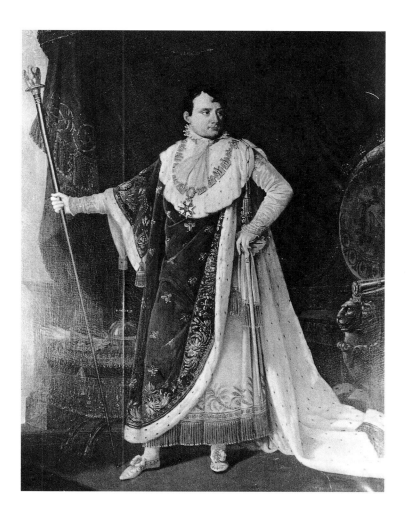

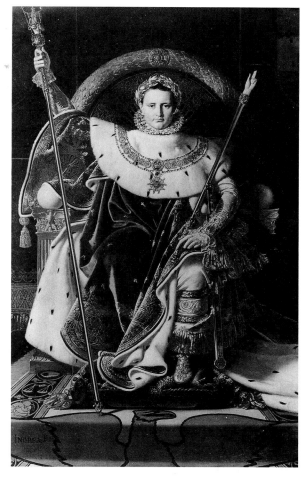

FIGURE 8 Robert Lefèvre (French, 1755–1830), *Napoleon I in Imperial Robes*, 1807 (adapted from an original dated 1806). Oil on canvas, 89 x 65⅜ in. (226 x 166 cm). Musée national de la Légion d'Honneur, Paris

FIGURE 9 Jean-Auguste-Dominique Ingres (French, 1780–1867), *Napoleon I on His Imperial Throne*, 1806. Oil on canvas, 8 ft. 6 in. x 5 ft. 3¾ in. (259 x 162 cm). Musée de l'Armée, Paris

of political double-talk, the various consular institutions decreed in May 1804 that the "government of the Republic" was entrusted to a hereditary emperor. The republic became an empire and Bonaparte became Napoleon. A new constitution was drafted, made to measure for the emperor's unfulfilled parental ambitions, and instituting a series of court positions—grand dignitaries, grand officers—which formed the nucleus of an improvised aristocracy. How David felt about this evolution is not known; in any event, residual republicanism, perhaps an apt characterization of his political sentiments in 1804, and support of the French empire were in no way incompatible.

From 1802, once the first consul set up residence in the Palace of the Tuileries, an unofficial court ritual was progressively adopted; the first guidelines concerning etiquette were published in March. Following the creation of the empire, a decree of 24 Messidor Year XII (13 July 1804) specified rules of protocol and etiquette at court and in his household. To ensure the political credibility of his new role, Napoleon saw the need to refute the expressions of familiarity that previously might have been tolerated in military circles. Imitating absolute monarchs, he decided that henceforth his entourage would remain at a respectful distance. The jarring conceptual differences among the first imperial portraits painted by David (FIG. 10) and Gérard (FIG. 7) in 1805 and by Robert

Lefèvre (FIG. 8) and Ingres (FIG. 9) in 1806 prove that it was no easy matter to find the right pose for the upstart emperor: the portraits might be judged too military or too royal or too olympian.

David acceded to a court position only on 18 December 1804 with his nomination as first painter to the emperor. It was an isolated initiative, personal to Napoleon and personalized for David, taken relatively late, once the court had been largely organized. The position was honorific and did not entail a role ruled by official court etiquette.[43] David blocked out of his mind the status of the king's first painter during the preceding century, a position subordinate to that of the Directeur des Bâtiments; during the reign of Louis XVI, only this latter official consulted regularly with the monarch on artistic matters. As his occasional references to Charles Le Brun's more extensive attributions suggest, he preferred to imagine that a revival of the *siècle de Louis XIV* was at hand. His nomination allowed him to believe that the intimacy he had established with Bonaparte since the late Directory was not compromised by the pomp and formality that came to define the Empire.

The most eloquent indication of the benefits he could reap from direct access to the emperor was the suite of four immense paintings he was asked to execute in conjunction with the coronation ceremonies planned for early December. The commission was apparently the outcome of a conversation between the two men some time in autumn, before David was designated first painter; when the matter would be handed over to the administration in 1806, once the project was well under way, both parties would discover the inconvenience of not having put the contractual agreement on paper.[44]

David's recollection of the initial conversation he had with Napoleon regarding the coronation suite, in the form of notes jotted down sometime after 1810, may be pure fiction, but as fantasy precisely, it reveals how he wanted to represent to himself his relationship with Napoleon. As often in David's autobiographical writings, the narrative is self-serving and develops the conceit, familiar since Vasari, whereby the homage to the patron gratifies the reputation of the artist he employs. The discussion focuses on the appellation for the room in which all four of David's pictures would one day be permanently hung. David, asked by Napoleon to make a suggestion, is said to have proposed: "La Galerie du Sacre." "Non, la Galerie David," retorts the emperor, invoking the example of the Rubens Gallery in the Luxembourg Palace. Flattered, David plays the courtier: "The difference here is significant; Rubens was much greater the painter than Marie was the great queen, while here emperor Napoleon is far greater than the painter!" The last rejoinder of this imagined exchange is perhaps the most revealing: "Let time pass, this is the name it will be given."[45] David invents an ambitious personal rivalry with Napoleon, in which the emperor finally concedes that posterity will endorse the triumph of the artist over his patron. Once again, this text confirms that David's alignment and engagement with the Napoleonic regime could not be reduced to an appetite for honors and rewards; he was acutely receptive of the opportunity offered to

him by the imperial order to create enduring works of art.

David's need to recall this lofty dialogue with the emperor was perhaps a way to bear the much more mundane exchanges with the latter's administration. From the moment that Denon, who had just authored the magnificently illustrated *Voyage dans la Basse et la Haute Egypte,* was named director of the museum and the national manufactures in September 1802, official dealings with artists were increasingly mediated, controlled, and structured. Also in charge of overseeing state commissions and the organization of the Salon, Denon occupied a central position in the art world. His influence was curtailed only by Napoleon, who occasionally made personal decisions, and by different branches of the administration that kept an eye on artistic operations—the ministry of finance, the Trésor public, the ministry of the interior, and especially the Maison de l'Empereur.

However, it was the nomination of Pierre Daru on 24 July 1805 as Intendant général de la Maison de l'Empereur, Denon's immediate superior, that heralded a true reorganization in the official patronage of the arts. The letter sent by the emperor from the Camp de Boulogne on 6 August 1805, remarkably detailed and rarely quoted extensively, constituted the program he wanted implemented during the years ahead. After evoking his designs for the forests of Marly and Saint-Germain and for the *petit parc* at Versailles, revealing his fascination for Louis XIV, and a problem concerning the imperial library, he wrote:

> A good portion of the expenses of the civil list are for furniture, paintings, and palace renovations, which are so many instances for encouraging the arts. From this point of view, the intelligence and attention of the *intendant général* should naturally be directed toward everything that can fuel industry, encourage the arts, and inspire emulation among artists. David receives quite important sums for the arts. My librarian made me subscribe to a great many engravings and books, and I shall not refuse to agree to whatever you esteem necessary to encourage artists; but I do not want this to be an obligation imposed on me. The manufacture of the Savonnerie, those of the Gobelins, of Sèvres, must operate without cost to the household, which means that I should recover in furnishings what they cost me. Every time a palace is renovated, the advantage for the arts and manufactures should be taken into account, which is not the case today. The Museum is run at my expense, it costs me quite considerably; this is another encouragement of the arts. None of these things have been done with a global vision. You must take over all of this, pay the individuals personally, meet with them, know what their roles are. I must tell you that my intention is to direct the arts especially toward subjects that perpetuate the memory of what has been accomplished in fifteen years. It is astonishing, for example, that I have not been able to obtain that the Gobelins set aside religious scenes and finally put their artists to work on all those actions of all kinds which have distinguished the army and the nation, events which have elevated the throne.

When you have the time, recapitulate for me the statues, engravings, pictures, etc., that I have commissioned. I suppose that M. de Ségur [Grand Master of Ceremonies], who had the funds to undertake the *Livre du Sacre*, has it underway. It is a quite important affair. The work of M. Denon, who is traveling across the Italian battlefields to make drawings and maps that will constitute a pendant to his atlas of Egypt, will offer another incentive for the emulation of painters and engravers. M. de Fleurieu [the former *intendant*], because of his age, could not keep an eye on all these things, since he could barely drag himself and get to the most urgent business. Henceforth, M. Denon must be your subordinate, as he naturally should be, without hurting his pride, and he remains curator of the Museum, never allowed to sign for any expenses, with my orders always going through you.[46]

Central to this slightly rambling overview, prompted by the wish to put an end to the improvisation that had prevailed until then, is Napoleon's insistence on an economic and political justification for the voluntary support of the arts, strongly reminiscent of Colbert. The passage from the letter most often cited concerns the encouragement of subjects from contemporary history since 1789, proof of a willingness to appropriate at least part of the Revolution's legacy. The passing reference to David reflects the reality of direct contacts between the two men and suggests that the coronation commissions entrusted to the first painter were considered an autonomous enterprise, with respect to all the other work handed out to artists. The rivalry between David and Denon is finally acknowledged by the structure of the missive, which literally situates them at a great distance from one another.

It would take the untiring Denon several years to resolve problems resulting from the generous sums paid by the government to a few artists during the early Consulate; he also had to clarify and fix the terms of a number of agreements with artists that had never been priced or confirmed in writing. Not surprisingly, he has been held primarily responsible for convincing Napoleon to restrain David's financial pretentions.[47] The emperor was certainly not unwilling to seize the occasion, since it was his custom to pit courtiers against one another, a traditional tactic of autocratic rule. David was asking 100,000 francs for each of his four huge pictures, inclusive of his emoluments as first painter. He would eventually receive 65,000 francs for the *Coronation* (SEE FIG. 26) and 52,000 francs for *The Distribution of the Eagles* (SEE FIG. 31), a stipend of 12,000 francs a year as first painter, and 2,400 francs for the *Arrival of Napoleon at the Hôtel de Ville*, a compositional drawing for one of the four ceremonies he had intended to paint.[48] In spite of the depressing profusion of bureaucratic letters written by David to a succession of administrators and Napoleon between 1806 and 1810 to achieve this compromise, the crux of the matter was not a question of money. Canova obtained 120,000 francs, his asking price, for the execution of his colossal figure of Napoleon. The engraver Raphael Morghen was to receive 60,000

francs for a print of David's *Bonaparte Crossing the Alps* and 50,000 francs for another of Gérard's portrait of Marie-Louise, Napoleon's second empress—less than he had hoped but a sum he bragged about. The run of two hundred copies of the *Livre du Sacre,* an album of forty-one engravings prepared by Isabey, Percier, and Fontaine, cost the imperial finances 200,000 francs, more than three times what was paid to David for his *Coronation.*[49] Admittedly, this was a collective enterprise, allowing not only draftsmen but also printers to reap some state benefits, but nonetheless it was an impressive sum for an illustrated book.

Manifestly, painters and their lifestyles were the problem. Denon's efforts to lower the sums paid by the government for their pictures pinpoint the conflict between two opposing visions of their profession in this period. The Revolution had disrupted the traditional order of social hierarchies and relations; during the Directory, anyone could refashion his or her identity, provided the finances were at hand. New wealth, often in banking and military supply activities, produced recomposed elites. Painters, especially those clustering around Isabey, Gérard, and Guérin, began to mingle with the rich, whose lifestyle they envied and sought to imitate. Percier and Fontaine published in the same album the lavish decoration for Isabey's studio and for Juliette Récamier's *hôtel.* When painting the portrait of a client, giving private lessons, or making the rounds of fashionable establishments and *hôtels,* artistic and social activity were in complete fusion for this highly visible group.[50] Around 1800 extreme models of behavior were being adopted by Parisian artists: some sought recognition by parading indifference to social norms of dress and comportment to signal their creative inspiration; others believed that their fashionable accoutrements, indicative of professional success, would attract prosperous clients. Reacting to this, the critic and painter Charles-Paul Landon suggested in the *Journal des arts* that artists take a middle road and aim simply at acquiring "a respectable affluence."[51] In his 1806 annual report to the emperor, Denon, whose failed artistic ambitions may have inspired some jealousy, reiterated a point of view expressed by him two years earlier: that it was necessary to moderate painters' "exaggerated pretensions and bring them back to the modest simplicity of true artists the world over, who have always found glory in being highly productive and in living honorably but without pomp from the proceeds of their nightly labors and plentiful works."[52] The young Guérin was the target of Denon's criticism, for after the Salon of 1802 his *Phaedra and Hypolitus* (Musée du Louvre) had been acquired for 24,000 francs; that Gros was awarded only 16,000 francs for *Jaffa* in 1804 had been a deliberate move to bring down the official pay scale. Guérin in fact was playing an ambiguous game. On the one hand, he nurtured the reputation of a painter dedicated to his work, whose studio was closed to society visits; on the other, he cultivated his public image as man of fashion and, although only in his mid-twenties, demanded very high prices for his pictures.[53]

David also had the reputation of being expensive, but all recognized that he was the most famous painter alive, the "Raphael" of France, "the immortal

David."[54] Furthermore, although he had several studios at his disposal, his personal lifestyle was characterized neither by ostentation nor by luxury. He seems to have had five servants during the Empire, and three servants when in exile, but the wages for domestics at the time were extremely low.[55] In 1808 the reason he gives to Wicar, his frequent confidant, for asking so much for his coronation pictures is personal: "I have four who are my ruin," meaning his four children. For from the time his daughter Émilie married in March 1805, and her twin sister, Pauline, in May 1806, until his death, his objective was to amass 160,000 francs and allot each one an endowment of 40,000 francs.[56] Such an attitude toward his progeny characterizes more exactly a provident *père de famille* imagined by Balzac than a profligate nouveau-riche *flambeur*.

In contrast to this domestic homeliness, David's public persona was relatively ostentatious. In December 1803 he was gratified by the order of the Legion of Honor and the following July attended a lavish ceremony at the Invalides to receive the medal he may have designed.[57] However, it was truly his nomination as first painter in December 1804 that distinguished him from other contemporary artists. Above all, this corresponded to the exceptionally important commission for the coronation pictures, which anticipated by several months Napoleon's program of August 1805, encouraging artists to treat primarily subjects from contemporary history. Furthermore, the only portraits David would be asked to execute for the government would be of the emperor, whereas other painters received from Denon modestly paid commissions for effigies of court and military officials. As suggested by his difficulties in getting paid for his pictures, his position as first painter did not exempt him from vexations, the most mortifying being Napoleon's extreme dissatisfaction in July 1806 upon seeing a finished portrait in imperial robes destined for Genoa (FIG. 10). Judging from the number of copies of their portraits ordered, during the initial years of the Empire Gérard and Lefèvre were more in tune with the demands of the regime than David. Although the latter's unexpected disavowal may have been the result of Denon's strategy to weaken his position as they were negotiating the terms for a backlog of commissions, this also revealed his independence with respect to traditional pictorial solutions that received official approval.[58] The remaining sketch, which suggests the composition and spirit of the lost Genoa portrait, attests to David's resistance with respect to such options. It also confirms the experimental nature of his creative process. The monarchical image is anchored in the modernity of the Revolution and the Empire: the emperor of the French is fundamentally a self-made man. With more conservative attitudes and dynastic preoccupations emerging in the context of the imperial court, it is perhaps not surprising that such a conception was rejected. The year 1805, as the artist came to realize too late, was a time of transition: on 1 January 1806 the republican calendar, the quotidian expression of revolutionary aspirations for more than twelve years, was officially abolished.

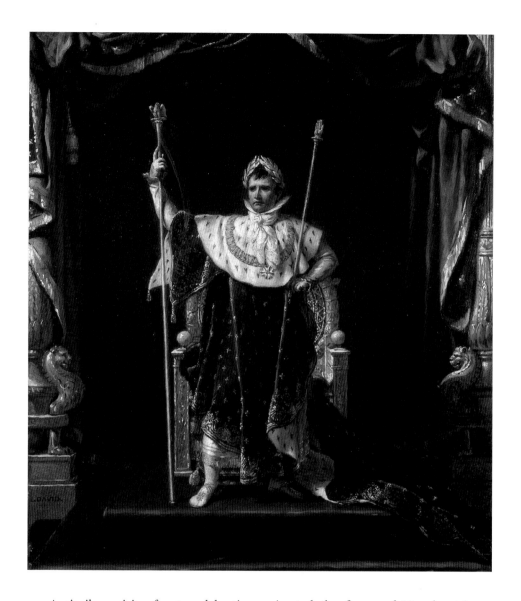

A similar spirit of auto-celebration animated the figure of Napoleon in David's *Coronation,* as first conceived (SEE CAT. 5). This is the famous image, faithful to reality, of the emperor crowning himself in Notre-Dame Cathedral on 2 December 1804: by 1807–8 the aggressively confident gesture had come to seem unnecessarily provocative and even foolhardy. What saved David from early disgrace was his compliance with orders to modify his composition and the enormous success of his picture, transformed into a representation of Napoleon crowning Josephine. On 4 January 1808, Napoleon paid an official visit to his studio, where he spent an hour examining the vast composition and the array of familiar figures, astounded by the veracity of the individual portraits. After this inspection, for all his retinue to see, he drew his hat in salute to the painter, whom he complimented at length. David, relieved and proud, sent a detailed relation of the event to Wicar, adding, as if he were paraphrasing a passage of Saint-Simon's evocation of the court of Louis XIV, that ever since he had

FIGURE 10 Jacques-Louis David, *Napoleon I in Imperial Robes*, 1805. Oil on panel, 22⅝ x 19½ in. (57.5 x 49.5 cm). Musée des Beaux-Arts, Lille

received the mark of the emperor's favor, it seemed as if his contacts in the high administration out of jealousy were all bent on giving him the cold shoulder.[59]

In June 1806 David wrote a detailed description of the coronation scenes he had finally retained, at the request of Napoleon's administration that seems to have been in ignorance of his choice and even of their number. This was addressed to Daru, in charge of fixing the conditions for the execution of the canvases. He listed four subjects, adding: "I do have a fifth one in mind, and even a sixth, but I will talk to you about this only when the others are finished."[60] The first two, the *Coronation (Le Sacre)* and the *Enthronement (L'Intronisation),* had taken place on the same day, 2 December 1804, in Notre-Dame Cathedral. The religious character of the ceremony, which this location and the pope's presence might have implied, was much played down both during the ceremony and in David's projected pictures.[61] In the *Coronation,* exactly as it took place, the pope did not meddle with crowning, nor was he present for the constitutional oath that was the subject of the *Enthronement.* The third scene was *The Distribution of the Eagles,* three days later, set on the Champ-de-Mars and distinctly martial in spirit, while the fourth was the reception at the Hôtel de Ville on 16 December. The first three scenes respected the protocol outlined in various official documents published before and after the ceremonies, while the last was more anecdotal and personal: David imagined an impromptu contact between the emperor and the Paris population in the forecourt of the city hall.

In the June 1806 report to Daru, he claimed that he had begun painting the *Coronation* in late December 1805. Elaborate drawings dated from that year for this and for the *Arrival of the Emperor at the Hôtel de Ville* suggest that along with the exclusive group of courtiers allowed into Notre-Dame, he had also wanted to illustrate the scene with the most open social and civic appeal. He had composed both with the help of Ignace Degotti, a set designer affiliated with the Opera, whom he contacted in April 1805 for the execution of the architectural perspectives of his four pictures.[62] An unpublished letter from David to Degotti, dated 17 Vendémiaire Year XIV (9 October 1805), sheds light on how the painter set to work on his picture. Unable to go to the church of Cluny, where the government allowed him to install his studio for the project, he asks Degotti to tell his assistants Jérôme-Martin Langlois and "Bourgeois," who were apparently in charge of transferring the drawn composition to the canvas, "to simply try to position the composition as a whole to gauge the general effect"; after that, he explains, "I shall reposition the figures that might not work but I can do that only by seeing everything together." David joins a postscript, giving directions to one of their collaborators: "have him pick up at your home the panel on which I plan to paint the sketch and take it tomorrow to my studio at [the church of] Cluny."[63] The panel on which he intended to execute an oil sketch may be the one reused for the *Portrait of Pope Pius VII and Cardinal Caprara* (SEE FIG. 49), which, as X-rays reveal, is painted over a compositional study of

the *Coronation.* Much of the year 1806 was devoted to filling in the costumes and the portraits of the participants, for which David requested of each two hours of their time (SEE CAT. 6). In June he could declare to Daru that the painting was about half done and, overly optimistic, that it would be finished in six months' time (although after describing the projected paintings, he indicated that the execution of each would take eighteen months, and later he would affirm that he devoted three years to the *Coronation*).[64] He explicitly interpreted the figure of Napoleon crowning himself and pressing his sword to his heart, in front of "the stunned spectators," as an aggressive military evidence: "he who has been able to conquer it [the crown] will be just as able to defend it"(SEE CAT. 5).[65] David, an eyewitness to the event he portrayed, invented a powerfully emblematic figure, imbued with the sense of determination and defiance that characterized the deputies in the foreground of the unfinished *Oath of the Tennis Court* (1790–91). A variant drawing of the laurel-crowned emperor, unencumbered by the second crown, with right arm raised and index pointing to heaven, is annotated "dieu et mon épée" and invokes even more strongly the heroic dimension of the event (SEE FIG. 28). The focus on the sword established a link with the military image dominant a few years earlier. David seems to have shared the view expressed by one of the emperor's closest collaborators: "It should not be forgotten that Napoleon himself, however thoroughly emperor he may have been, never for a moment shed his habits of general-in-chief, and that whether an immediate preoccupation or not, it was the professional role he always needed to play."[66]

As everyone can see when visiting the Louvre today, this emphatic self-absorbed image of Napoleon disappeared from the final composition. Apparently this important change intervened quite late, probably once the painting was finished. In other instances, when important participants were unhappy with their image or place in the composition, David would oppose a basic aesthetic principle: "everything is calculated in a picture, and changing one figure can bring about an incalculable number of other changes, and disorganize the whole part of a picture, and often the entire work."[67] This position would suggest that the modification of the figure of the emperor in the painting was an order. However, as shrewdly observed by Antoine Schnapper, in sketches apparently from 1805, when David began to explore how to depict the imperial couple and which moment of the coronation ceremony to paint along with the dramatic self-crowning, he had already considered the next episode, when Napoleon steps down and places the crown on Josephine's head. Furthermore, it is certain that he had shifted to the crowning of Josephine before May 1807, when one of David's correspondents regretted the change.[68] An article in the *Journal de Paris* of 9 December 1807, describing the composition, opens the possibility that this was an intermediate conception adopted in the course of the year: "The main action . . . is the crowning of H. M. the Empress by her august spouse. The Emperor, the crown on his head, holds another with both hands

and goes down the first step of the altar. The Empress, almost prostrated on the lowest step, on her face manifests the involuntary emotion provoked by such an important event." The crucial element here is the observation that Napoleon has been obliged to go down one step to reach Josephine. If this action was in fact painted, it was what the emperor saw during his visit in January 1808. Since he is known to have ordered some changes, this would mean to be shown not stepping down from the altar, but immobile, as we see him today.[69]

According to the description of the painting, manifestly written with David's collaboration, first published in the *Moniteur* on 16 January and then as a brochure distributed to the public, the definitive choice of action is a compromise between the two initial options studied: "Wanting as much as possible to represent in one single action the crowning of the Emperor and that of the Empress, which took place successively during the ceremony, the artist has chosen the moment when the Emperor, after having placed on his head two crowns, one after another, has just taken hold the second, and raising it in the air with both hands, readies to place it on the head of his august spouse."[70] We have seen that this change intervened before May 1807; in September, Louis Bonaparte, hostile to Josephine like the rest of his family, complimented David on his picture, except for the fact that it did not represent the high point of the coronation ceremony. Since Napoleon returned from the Polish campaign only in late July 1807, after almost a year's absence from the capital, he was surely not behind this first change. At the end of his life, according to his entourage, he attributed it to "une petite intrigue de Joséphine avec David."[71]

The final image of Napoleon is an odd compromise. The symbolic meaning of the coronation ceremony is transformed into showy pageantry, as betrayed by the attention given sartorial luxury in the revised description of the picture. All the attendants seem mesmerized by the crown hovering in mid-air, except for Napoleon and the pope, who direct their gaze toward Josephine, her own eyes shut. How Napoleon interpreted the restrained representation of himself proposed by David is reported only through a late source: "vous m'avez fait chevalier français." The remark has been related to the emperor's apparent deference to the empress, an allusion to the spirit of chivalry then being romanticized by Alexandre Lenoir's Musée des Monuments français and by a group of painters (many formed in David's studio and patronized by Josephine) specialized in sentimental scenes from the medieval and Renaissance periods of French history. Although Napoleon's remark surely acquired such a resonance as this nostalgic romanticism developed, early in 1808 it may have referred more specifically to his efforts in creating an imperial nobility, officially decreed on 1 March. The titles of dukes, counts, and barons were reserved to dignitaries and high functionaries, while the more democratic *chevalier* was granted to civil and military members of the order of Legion of Honor; nobility could also be accorded at the emperor's discretion.[72] The *Coronation* was the timely visualization for Napoleon of these aristocratic and dynastic aspirations. Its celebration

of courtly splendor was premonitory of the traditional aura of royalty that the former general was beginning to cultivate. Fontaine, in charge of redecorating the emperor's apartments in the Tuileries, lamented in August 1808 that Napoleon's tastes were becoming ever more costly: "he is asking though for more richness and gilding, something that hardly agrees with our finances."[73] In fact, his preoccupation was less with luxury than with majesty, which explains the final statue-like pose suggested to David. To explain to Canova in April 1811 why his over-life-size nude statue of Napoleon did not meet favor in Paris, Denon reported on the emperor's sentiment: "His Majesty observed with interest the beautiful execution of this work and its imposing aspect, but He finds the forms too athletic and that you have misunderstood the character that particularly distinguishes him, which means the calm in the way he moves."[74]

Early reports focus on Napoleon's appreciation of the visual impact of the picture. During his visit to David's studio in January 1808, he proclaimed his admiration for the painter's magic: "How grand! How all the objects project! It is so beautiful! What truth! This is not a painting; one walks in this picture."[75] With respect to previous representations of similar events, David succeeds in enhancing the sense of illusion and presence conveyed both by the figures and by the architecture. Such a preoccupation, as has been noted, was perhaps stimulated by contemporary discussions in the press and in the Institute concerning the panorama. Contemporaries confronted by the sweeping horizontality of David's *Coronation* may have made the connection; a gallery hung with his four paintings, in spite of their compositional discontinuity, would undoubtedly have called to mind the new "invention" recently imported from Britain. An official report in 1800 noted: "In fact, the Panorama is nothing more than a way of exhibiting a vast picture so that the eye of the spectator embraces successively all of the horizon, and confronted in every direction with the picture, experiences the most complete illusion."[76] Although David was not part of the Institute commission that evaluated how the dissimulated lighting of the panorama might be applied to museum installation and absent on the day of their report, it is not likely that he ignored his colleague's interest in a much-talked about pictorial attraction. Constant Bourgeois, one of his former students cited in the Institute's report, had a key role in the execution of the first two panoramas seen in Paris. In connection with this, it can be recalled that throughout his career David was consistently responsive to stage scenery and on several occasions during the exhibition of the *Sabines,* the *Coronation,* and *Mars and Venus* (SEE FIG. 64) he incited visitors to view his picture reflected in a mirror and experience more intensely the spatial recession.[77]

David aimed to persuade the spectator of the veracity of the reconstitution by the seemingly natural ordering and scale of the figures, sharply individualized in spite of their great number, and by the dramatic play of light that directs attention to the main group. This is somewhat paradoxical since all action seems suspended, as in the *Sabines.* An inexpressive physiognomy characterizes

most of the participants. Only the most remote and anonymous, in the upper tribunes, react excitedly to the scene. David neutralizes the provocativeness of the initial project by reducing the emperor to a medallic profile, a pure object of contemplation, and allowing him to perform only a perfunctory elevation of the crown. The crucial and symbolic complementary relationship between sword and crown is lost. The dressy gathering of family and friends gains solemnity and serenity, but the aggressive political drama commanded by the self-crowning is sacrificed.

Although he may have been influenced, it was David's personal decision to back down from this bold conception, since the imperial administration, informed by his report of June 1806 of his initial conception, never expressed disapproval. Did he realize that the pacification of the iconography, keeping the emperor from overacting his part, would draw greater attention to the rest of the picture, in other words, to its author? The courtier's remark concerning his humble contentment to confront posterity in the hero's shadow, like the later discussion regarding the creation of a Galerie David, proves that the first painter felt a sense of rivalry with his imperial patron. Is it possible that such a sentiment was inscribed, consciously or not, within the picture? One locus might be the figure of the cross bearer, at the very center of the composition. As David wrote to Degotti, he was particularly happy with the sumptuousness of his costume; more effectively than any other figure, this ecclesiastic rivals in splendor the emperor. It is highly curious that this crucial figure should remain anonymous, as if his visual proximity with the imperial couple, suggestive of a privileged intimacy, were too great to be true. David longed for such a relationship with the emperor, as several of his letters make clear. It is tempting to imagine that this figure functions like a proxy: the cross reaches up to the tribune where the painter discreetly took position. His insistence that his collaborator Degotti pose for the head of this mitered prelate, suggestive of a vicarious investment, further demonstrates a willingness to personally appropriate this figure.[78]

The painting is resonant with other expressions of artistic rivalry. David, on several occasions, would insist that the *Coronation* was the largest picture ever painted.[79] The sheer size of the canvas was a primary show of his superiority to Veronese, whose *Marriage at Cana* (Musée du Louvre), confiscated in Venice, was heralded as the largest picture in the Musée Napoléon, and to Rubens, whose *Coronation of Marie de Médici* (Musée du Louvre), easily accessible since the reopening of the senate's Luxembourg Gallery to the public in 1803, invited a direct comparison. David had statufied Rubens's fluid figures, but he had not ignored the warm color harmonies of his celebrated predecessor. Avoiding the play of reflections dear to Rubens, he preferred to saturate the hues locally, as in the cross bearer's historiated chasuble embroidered with gold thread, a rich surface of subtly modulated tones of yellow. In this instance, David puts to profit his study of French late medieval illuminated manuscripts to which his sketchbooks attest. This new interest was probably stimulated by his friendship with

Lenoir, but also by the cultural climate of the early Empire. With the *Coronation* he may have sought to create a visual equivalent to the dynastic antiquarianism of the regime that resurrected a distant imperial past in order to avoid comparisons with the most recent monarchy. The neo-Gothic portal erected in front of the façade of Notre-Dame Cathedral by Percier and Fontaine celebrated the figures of Clovis and Charlemagne, as did various elements of the regalia devised for the emperor. With his customary curiosity, David was probably not averse to widening his artistic horizon in the process. As the profoundly unclassical figure of the cross bearer demonstrates, he was eminently capable of assimilating exogenous forms within his own style, as long as he felt they were not alien to Europe's history and culture.

More generally, the unfurling of color, ornament, and contrast in the *Coronation* was in total contradistinction to the aesthetic principles proclaimed by the *Sabines* a few years earlier. In the first extended critical commentary on the painting, published in the *Journal de l'Empire* on 24 January 1808, Jean-Baptiste-Marie Boutard astutely accounted for this stylistic rupture: "[David] then thought that to keep a grip on a composition filled with so many portraits, he would be obliged to soften the severe style that had ensured the success of his other works, a style that has brought glory to the modern school and for which he gave first the example and the principle."[80] However, in a second article, on 25 February, Boutard was careful to develop a parallel between David and Raphael, to whom he attributes the idea that beauty in painting was incompatible with the representation of movement; he declares that the general effect of the *Coronation* had nothing in common with the brutal colorism and exaggerated contrasts that characterized the art of Rubens and his followers. The comparison with the Flemish master was inevitable because of the subject and David's palette, and Boutard's effort to throw him out of the picture suggests instead the power of his presence. That the adoption of a less "severe" style was not simply due to the demands of the iconography is demonstrated by the work of Regnault: the sharply defined forms and absence of strong contrasts in the *Civil Marriage of Jérôme Bonaparte with Princess Catherine of Wurtemberg* (Musée national du Château de Versailles), painted in 1810, prove that this contemporary ostensibly chose to apply his accustomed cool manner to the representation of colorful court pageantry.

A remark made by Delécluze, although a late source, suggests a fundamental factor inspiring David's stylistic evolution in the *Coronation*. Whereas Gérard, Wicar, Isabey, and Girodet upheld an ideal of exacting draftsmanship when representing scenes of contemporary history, Gros had revealed his genius as an exceptional colorist at the Salons of 1804 *(Pesthouse at Jaffa)* and 1806 *(Battle of Aboukir)*.[81] Just as the primitivist discourse and stylistic experiments of certain of David's students during the Directory had left their mark on the *Sabines,* he was creatively receptive to the persuasive contemporary mythology invented by Gros in his Napoleonic portraits and military subjects: "The emulation stimu-

lated around this time, without the least feeling of jealousy, by his pupil Gros's successes in painting contemporary subjects, is no less remarkable a fact; and during the execution of the *Coronation,* David spoke more than once of the author of the *Pesthouse at Jaffa* as a rival who had rekindled his verve and extended the realm of his ideas."[82] That David's picture is not reducible to an imitation of Gros's manner is an eloquent demonstration of his capacity to assimilate and naturalize the most diverse sources. Nonetheless, he could not ignore that French painting was at a turning point. The idea of the restoration of the *bon goût* in reaction to the deplorable *goût français* of the mid-eighteenth century—for which, in spite of lip service paid to his master Vien, he wanted sole credit—was no longer unassailed doctrine. An increasing number of artists and critics found the price paid in the process to be excessive. Implicit in the recurring designation during the Empire of David's earlier heroic manner as severe—by Boutard in 1808 and Lenoir in 1811—without being derogatory, was a refusal to recognize the pretension of any one style to normative status.[83] Since 1800, favored by the recent institution of the museum, a more eclectic and historicist appreciation of past art prevailed, encouraging notably a re-evaluation of eighteenth-century French painting. This revisionist artistic ambiance incited David to adopt a more pragmatic attitude than he had shown during the Directory. The painter of antique history accepted to respond to the contemporary commemorative demands of the regime and willingly explored more intense chromatic effects. This evolution of his palette is all the more remarkable since his paintings were systematically criticized in the 1780s for their somber palette, and the *Sabines,* for resembling an immense grisaille.

During his visit to the first painter's studio Napoleon lavished praise on the *Coronation* but also expressed criticism of certain details, which was tantamount to ordering changes. The most important, as noted in his journal by Fontaine, who was witness to the inspection, concerned the figure of the pope, seated just behind the emperor. Regretting what might be construed as beleaguered passivity, Napoleon asked that he be shown blessing the imperial couple.[84] Thus it was only on 7 February 1808 that the public finally discovered the painting, which was the object of a special installation in the Louvre. After about six weeks the painter took the huge canvas back to his studio to execute a copy for some unknown "propriétaires américains," also referred to as "une compagnie de négociants américains." He intended to put some students on the job and expected to finish by September. A student copy for the Gobelins tapestry manufacture and another, of reduced size, for Louis Bonaparte, king of Holland, were also planned, although these do not seem to have much progressed.[85] Determined to make a strong impact at the Salon, David sent the original *Coronation* back to the Louvre in mid-October, leaving the other commissions unattended. The repetition he would decide to finish in Brussels was in all likelihood the picture begun for the American entrepreneurs.

The last time he had shown major works at the Salon had been in 1791, when

along with the drawing of the *Oath of the Tennis Court,* he had sent the *Horatii* and *Brutus.* In 1808 he was once again keen to assert his artistic preeminence and justify the official patronage he received, which made other artists envious. On the eve of the public opening, Denon wrote enthusiastically to Napoleon: "David has taken the guise of a young man to dispute the palm with his students. Your Majesty will surely observe with satisfaction that he remains master in the competition, and that he totally merits the honor you have conferred on him in granting him the title of your first painter."[86] Three works were on display at the Salon: the *Coronation,* the more orthodox *Sabines,* and a portrait of Napoleon in imperial costume painted for Jérôme Bonaparte, king of Westphalia (for a copy, SEE FIG. 29). This last painting, ignored or decried by the critics, was probably exhibited in a spirit of competition with other portraitists, in particular Gérard and Lefèvre, whose effigies were most often copied when the administration required a portrait of the emperor. In spite of David's lack of success in this particular domain, his public showing in 1808 was a triumph. As one punning critic wrote, with reference to the laurels thrown at the foot of the *Coronation* by a group of artists when it had been first exhibited—the second exhibition in the more competitive arena of the Salon amounted literally to David's coronation. This was amplified by the strong presence of the "École de David": Lenoir estimated that he could claim forty-five exhibiting artists as his students.[87]

In September 1808, following the decree taken in March permitting members of the Legion of Honor to bear the title of *chevalier,* David, a member of the order since December 1803, gained admission to the imperial nobility. The *lettres patentes* of his nobility, registered on 23 September 1808, described the coat of arms he adopted, without a doubt of his own design (FIG. 11): an escutcheon with the upper two-thirds gold-colored and the lower third red; over the upper part, a black palette with the red-draped arms and three swords of the elder Horatii, and over the lower part, the cross of the Legion of Honor. The colors of his livery were given as blue, yellow, and red (the primary colors) along with black and white.[88] The synecdochic representation of the oath is revealing of the painter's deep obsession with the theme ever since the *Horatii* and the aborted *Oath of the Tennis Court,* but also at a time when the execution of the oath of the army to the emperor was on his mind. The composite nature of the coat of arms creates the fiction of the lower band as an afterthought, since it covers the lower part of the palette, to acknowledge the imperial origin of the nobility. It was as if he wanted to preserve the distinction between two aspects of his life, his reputation as a painter and his position as an imperial functionary.

On 22 October 1808, on the occasion of the emperor's official visit to the Salon, four more painters received the cross of the Legion of Honor: Girodet, Carle Vernet, Pierre-Paul Prud'hon, and Gros. The latter was distinguished by Napoleon, who reserved the medal he was wearing for the painter of the *Battle of Eylau* (Musée du Louvre). After this ceremony orchestrated by Denon, in

FIGURE 11 David's coat of arms, designed by the artist in 1808

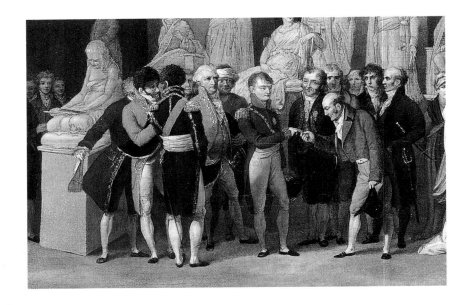

front of the pictures in the Salon Carré, the emperor turned to his first painter: "M. David, I have just rewarded these talented painters, they are your students, it is thus just that I behave in the same way the same toward their master. I declare you officer of the Legion of Honor, for the services you have done in favor of the arts. You are the one who reestablished good taste in France. Continue always to serve your country well."[89] Afterward Napoleon went downstairs where the sculpture was on show and awarded a cross to Cartellier. Around mid-December a small painting by Boilly illustrating this last scene appeared at the Salon (FIG. 12). The central group includes the self-satisfied figure of Denon, mediating between the emperor and the balding sculptor, who bows with deference. Just behind to his right, among the attendants to the scene, it is easy to identify David, with his bad jaw and a full head of hair.

Boilly, always prompt to catch the public's attention with topical subjects, may have had wind of another project to commemorate the homage paid to the

FIGURE 12 Louis-Léopold Boilly (French, 1761–1845), *Napoleon Honoring the Sculptor Cartellier at the Salon of 1808* (detail), 1808. Oil on canvas. Napoleonmuseum, Arenenberg, Switzerland

FIGURE 13 *Napoleon Visiting the 1808 Salon*, c. 1867. Engraving after a lost drawing of 1808 by Antoine-Jean Gros

FIGURE 14 Antoine-Jean Gros,
Napoleon Visiting the 1808 Salon, 1808
(unfinished). Oil on canvas, 11 ft.
5⅜ in. x 21 ft. (350 x 640 cm). Musée
national du Château de Versailles

contemporary French school of painting and sculpture on 22 October. Some
time later, David jotted down his version of the story: "But what capped my tri-
umph: the emperor consented to a wish expressed by the artists, that this
moment so honorable for the arts be preserved for posterity by a picture in
which His Majesty would be represented giving me the cross of officer of the
Legion of Honor, in the presence of my students, the court and the crowd in
assistance. M. Gros was entrusted with this picture."[90] The truth of the matter
was somewhat different. It seems that in early November David invited the
artists honored by Napoleon to his home. It was there that the commemorative
project was elaborated and that Gros was designated to carry it out. In all likeli-
hood this salient celebration of the first painter, whose *Coronation* appears in
the upper right part of the preparatory composition (FIG. 13), was spearheaded
by David himself. He claims to have asked for official approbation, but it was to
be financed not by government funds but by a subscription, about which little is
known.[91] Taking his cue from the *Coronation,* with his master in the role of
Josephine, Gros composed the scene with his usual bravura. When it came to
painting the figure of David life-size though, he manifestly sought to attenuate
the obsequiousness of the courtier he had sketched (FIG. 14). David's bow is less
emphatic and the ample redingote of the member of the Institute dissimulates
the aristocratic *culotte* and *épee* he sports in the drawing. This seems to be the
habit à la française he is reported to have worn when painting the portrait of
Pius VII.[92] Why Gros left his picture unfinished is not known. Problems in

financing the project or the demands of other more pressing commissions may have been the cause. Rivalry among artists has also been invoked, since he accorded premier rank in the composition to David, Girodet, and himself. The two empty frames dominating the scene in the preparatory drawing seem to confirm this: considering the particular distinction Gros had received from the emperor, one of the two frames was surely destined for the *Battle of Eylau*. That this auto-citation, no less than the reproduction of the *Coronation,* may have proved problematic to Gros may account for the cropped format of the painting as it appears today. Believing his visibility to be justified and unwilling to adopt a low profile, as Boilly in his topical scenes, he could not ignore that even in this revised format the painting would expose him to accusations of vainglory, which he may have preferred not to weather.

In the course of his visit to the Salon on 22 October, Napoleon seems to have ordered David to modify his priorities with respect to the coronation suite, for three days later, the painter informed Daru, in charge of court administration: "His Majesty the emperor, who has suspended the painting already begun of the Hôtel de Ville, urges me to set to work immediately on the one he prefers, the Distribution of the imperial flags on the Champ-de-Mars." Hoping it might help him obtain further payment for the first picture, he insisted on his total commitment to the emperor. As his first painter, "I shall not take on any other works . . . my time and my talent are entirely devoted to my sovereign."[93] As has often been noted, the official decision to commemorate the oath of the various military corps on the Champ-de-Mars on 5 December 1804, three days after the ceremonies in Notre-Dame, instead of the Hôtel de Ville reception, was related to the launching of the Grande Armée on a difficult campaign across the Pyrenees. Shortly after David wrote his letter to Daru, Napoleon departed for Spain; he would return to Paris in late January 1809, but would again open a new front to the east, leave for Germany in mid-April and remain absent through October. Like other Frenchmen, the painter lived through this period with feelings of exhilaration and anxiety; although national security was never under threat, through the army bulletins, press reports, and prints the image and drama of the battlefield were brought home. As a patriotic citizen and a former Jacobin who admired the collective action of the *citoyens-soldats,* as an ambitious artist and the court painter to the emperor, David was sensitive to the complexity of the representation of the military oath. It was a ceremony that had occasioned the expression of a shared and popular enthusiasm but was also characterized by formality and pomp. By December 1808, the date on the finished drawing, he had composed his picture. As evidenced by the preparatory sketches, he first focused on the imperial couple framed against the majestic columns of Percier and Fontaine's rich architectural decoration built on the façade of the École Militaire. As in the *Coronation,* he intended to give importance to the tribunes with the public to the right and left. A second pencil sketch closes in on the main scene: the columns loom large, providing a sense of dignity, while the

emperor has moved to center stage and an ascending group of soldiers occupies the right half of the composition. The formality of the ceremony is underlined by the only descriptive notation: the dais, the traditional locus of royalty. The final composition resolved obvious problems, in particular the impression that the empress was separated from the emperor by a highly obtrusive column: the architecture would be diminished in scale and relegated to the left as a backdrop. As Schnapper has pointed out, the decision to create an effect of sharp recession may have been suggested by the print of the ceremony after a collaborative design by Isabey, Fontaine, and Percier published in the official commemorative volume of 1807.[94] Furthermore, Napoleon is moved off center to the left and the group of *maréchaux* is placed between him and the army: the resulting gap between the two main groups is filled with new flags offered by the emperor to the different regiments. Above the flags in the distance, David aligns a tabernacle-like pavilion that gives a religious resonance to the ceremony.

Certain modifications as he evolves from the finished preparatory drawing to the definitive composition reveal a shifting economy of meaning. As noted by Schnapper, the flags from the earlier military campaigns discarded during the ceremony, visible in the foreground to the left in the drawing, are finally preserved and enshrined under the emperor's canopy, since many observers had been furious to see them trampled.[95] Paraphrasing the dynamic motif from Girodet's *Ossian* of the "ombres des héros français, morts pour la Patrie, conduites par la Victoire," a winged allegory that also figured on several commemorative medals minted at the time, David initially included this figure dropping wreaths and laurels over the cluster of officers; according to his testimony, it was eliminated from the composition by order of the emperor, whose program of pictorial commissions was almost exclusively historical in character.[96] The painter expressed regret over this suppression, which removed the visual stimulant for the emphatic gestures of the *maréchaux*. Finally, the mast crowning the pavilion in the center background was transformed to symbolically situate the ceremony under a double aegis: the imperial eagle and the tricolor fanion. Throughout the composition, David has deliberately enmeshed the chromatic harmonies of the Republic with those of the Empire: the warm red, green, and gold of the latter with the cool red, white, and blue of the former. As such, the painting is a celebration of the association of court culture and military ethos aimed for by Napoleon.[97]

As has often been remarked, the painting prolonged the artist's intense engagement with the theme of the oath. The Napoleonic officers inherited the visual legacy of the Horatii brothers and of the deputies of the Third Estate. As David prepared his composition, past and present seemed to overlap: poses, gestures, and even certain groupings of figures, worked out in the pencil sketches, cannot always be attributed definitely to one project or another. Significantly, the dramatic bonding of the nameless officers of the imperial army is what seems to most inspire the artist. From headdress to boots, the costume of

each one is distinguished with utmost care and precision, like military fashion plates come to life. French participation in the American War of Independence and the wave of volunteer enrollments during the revolutionary wars had transformed a fundamental distrust toward the military prevalent in Ancien Régime society into fascination for the uniform. Bonaparte's ascension and the sustained political exploitation of his martial image consummated this evolution. Texts related to military wear from the Empire, like those provided by specialists today, adopt a descriptive mode that is explicitly fetishistic.[98] David's bouquet of uniforms is not only the expression of a wholehearted espousal of this fascination, it reflects a more profound desire to identify with his subject. As Denon reported to Napoleon, describing the spirit that reigned in the art world on the eve of the Salon of 1810, and specifically with the *Eagles* in mind: "It seems that artists share the enthusiasm of the military they have to paint and want to partake of their glory in reciting their exploits."[99]

Contemporaries viewed the *Eagles* as a pendant to the *Coronation*. David's representation of Napoleon in the picture simply turns the earlier portrait around, producing a "counterproof" according to one contemporary critic, although the gesture and military context intensifies the Roman imperial ambiance.[100] As was noted at the time of its first exhibition, the effect of the "physionomie tranquille" of the emperor is heightened by the group of the gesticulating *maréchaux* and by the excited group of rammers approaching from the right; the visual contrast "adds to the moral impact of the picture."[101] Although David had to insert a number of portraits in his composition—and at the last moment remove the one of Josephine, repudiated for her barrenness, along with those of her suite—this was less essential a part of his task than in the *Coronation;* as for the figure of Napoleon, he simply inverted the profile of certain figures, for example Eugène Beauharnais. As suggested by the preparatory drawings, relatively abundant and many highly experimental in character, David approached this composition with a greater latitude to invent than in the earlier scene. The anonymity of half of the main actors of the event released the subject not only from the physiognomic requisites of the *Coronation,* but more generally from the burden of historical transcription. The improbable staging of the *Eagles* serves to transcend the particulars of the official ceremony and produce an aerial allegory of military devotion. David was manifestly eager to show to those who had criticized the absence of movement among the figures in the *Coronation* that he was perfectly capable of mastering this range of expression. For David, as for Girodet in the *Revolt at Cairo* (Musée national du Château de Versailles) exhibited at the same Salon, the catalyst to explore the expressive possibilities of figures in full action, and yet inextricably bound to one another, was Gros's *Battle at Aboukir,* shown in 1806. To make explicit his novel direction, David cited Giambologna's *Mercury* (Museo Nazionale di Bargello, Florence) for the foremost figure in the center of his painting. But he may also have found it reassuring to buttress his experimental move on the authority of a

prestigious Italian sculptor of the Renaissance.[102] Such exploration of the melodramatic limits of pictorial representation was usually viewed with a certain anxiety. For Boutard, writing in the *Journal de l'Empire,* the proximity of the emperor to the assaulting group of officers evoked a memory of revolutionary unrest: "The action . . . is equivocal; it would take very little for us to interpret it as a seditious movement that the monarch and his generals were trying to calm down."[103] This may be the reason why not only David, but also Gros and Girodet, would subsequently back away from such controlled visual acrobatics and it would be left to younger painters to develop their lead. It should be noted that although David invoked a celebrated modern work and not an antique, sculpture remained the index of his picture-making. His admirers, like Denon, lauded the purity of his drawing, while others, notably François Guizot, criticized the lack of compositional unity and liaison, a trait judged common to most contemporary painters with the exception of Gros, and the result of a deplorable insistence on the study of sculpture in the studios.[104]

On account of the pictures by the great masters that adorned the Musée Napoléon, artists were more than ever before incited to meditate on the art of the past. The same rooms in the Louvre presented alternatively canonical masterpieces from the museum's collection and the array of new works sent to the Salon. The subject matter of the *Coronation* and the *Eagles,* their great size, and their presentation to the public in the Salon Carré meant that David could not avoid measuring himself directly with Veronese. As Nicolas Ponce observed when commenting on the first picture in February 1808: "This beautiful work reminds us of the picture by Paul Veronese that we admired on the same wall a few years ago; as with that picture, the spectators get confused with the painted figures, for these seem so natural and true."[105] The reference to the *Marriage at Cana* became negative when the anonymous author of *Arlequin au Muséum* praised it precisely to suggest qualities missing in the *Coronation:* he admired Veronese's painting "in which we see everything, we go around everything, in which the figures are clearly set off from the architecture, and from the sky, and in which the sky is open and appears only like empty space to the eye."[106] The outdoor scene David exhibited in 1810 was a reply to such criticism. His competition with Veronese was avowedly a matter of size: he claimed to be the painter who had produced the largest canvas ever painted.[107] But more profoundly it meant vying with the Venetian's brilliant sense of color and atmospheric transparency. The numerous French landscape painters working in Italy in the wake of Valenciennes had made an impact on contemporaries, for a "ciel sans transparence" had become anathema by 1810. The notion of transparency and the concomitant invocation of Titian, Veronese, Rubens, and Van Dyck amounted to a condemnation of the training in the studios preparing students for the Prix de Rome.[108]

Once the Salon closed its doors to the public, the question of where to hang David's two huge paintings needed to be confronted. It is not clear where the

Coronation was kept after the Salon of 1808; as mentioned, David was asked to produce a copy able to serve as a model for a Gobelins tapestry. The painting probably went back to his studio in the church of Cluny, where it would have been most accessible. Although the project had first been discussed in May 1808, it was reported in December 1809 that because of other priorities he had not begun to have the copy for the Gobelins executed, nor even bothered to retrieve the set of stretchers that were specially fabricated for the cartoons so that several weavers might work concurrently.[109]

From August 1810 and for about two months, the *Coronation* was on exhibit in the Louvre with the other paintings submitted to the Concours Décennal, a multi-faceted competition including eight prizes in the arts, arbitrated by a small group of members of the Institute. David submitted the *Coronation* for the prize of best painting of "un sujet honorable pour le caractère national"—in other words, of Napoleonic history—which the jury favored over Gros's *Jaffa;* he also presented the *Sabines* in the category of history painting, but Girodet's *Deluge* (Musée du Louvre) was preferred. However, in the course of review of the jury's report by no less than three echelons—an enlarged Institute commission, the minister of the Interior, and, finally, the emperor—there was pressure to overturn the initial results in favor of *Jaffa* and the *Sabines.* It seems that David and Gros actively campaigned for this reversal, and finally, as the contest was turning into a public polemic, particularly acrimonious in the literary domain, Napoleon simply abandoned the idea of awarding prizes. A folio of engravings after ten sculptures and twenty paintings "mentionnés dans le rapport de l'Institut" was produced in 1812: David's superior status over the other artists, as "Officier de la Légion d'Honneur / Premier Peintre de Sa Majesté," is duly credited.[110]

As for the *Distribution of the Eagles,* which Denon suggested should be sent to the École militaire, David obtained word in May 1811 that it was to be hung in the Salle des Gardes of the Tuileries. This was somewhat capricious on his part, perhaps a jealous reaction upon discovering that Gérard's *Battle of Austerlitz* (Musée national du Château de Versailles) was installed in the ceiling of a major room of the palace. Much to Fontaine's annoyance, a number of architectural modifications were required to place David's painting; as predicted by the architect, the huge canvas proved a nuisance, constantly in danger of being damaged by a soldierly gesture. Within a month after being installed, it was sent off to David's Cluny studio. In his journal, a furious Fontaine lashed out against his "amour-propre" and "égoïsme."[111]

The completion of the *Eagles* marked a critical moment in the career of Napoleon's first painter. On the upside, his coronation pendants had confirmed his prowess working on a monumental scale. The reputation he sought "aux yeux de l'Europe éclairée" was a reality: in 1809 he had completed a history painting, *Sappho, Phaon, and Cupid* (SEE CAT. 27), for the Russian prince Nicolay Yusupov and had been honored by the royal academies of Amsterdam and Munich; in 1811, with the help of Canova, the Florentine and Roman academies

joined the chorus.[112] In 1810 and again in 1811 Alexandre Lenoir, the founder and administrator of the Musée des Monuments français, published several texts praising David's works and the influence of his teaching, which claimed that the contemporary French school and the École de David were one and the same.[113] Even the thorny question of the price he merited for his paintings and for his pension as first painter had been settled; he had not obtained as much as he had sought, but the terms were an honorable compromise and assured him a regular income.[114]

On the downside, the suite of paintings of the coronation was de facto abandoned: that David received an indemnity for having composed the Hôtel de Ville reception and was allowed to keep his finished drawing amounted to an official quittance. As with the *Oath of the Tennis Court*, the unrelenting progress of historical events, in this case the emperor's remarriage, played again a cruel trick on the painter. In light of the new Austrian alliance many officials found the subject of Josephine's crowning an embarrassment: in 1813, Denon had no qualms proposing that David's picture decorate an imperial palace in The Hague, arguing that putting it on show in the Parisian area "would always create great difficulties."[115] The exhibition of the *Coronation* and the *Eagles* and the Institute's report during the Concours Décennal had been the occasion for critics to openly contest his authority as first painter. His claim to absolute preeminence was seriously challenged by Gros. The suite of Napoleonic paintings— *Jaffa*, *Aboukir*, and *Eylau*—that formed a Galerie Gros was praised even by his friend Lenoir, who declared that David's former student proved "that he possesses all the qualities that make a history painter."[116] Official encouragement for battle painting and Gros's Rubensian manner intensified the negative perception of David's style as academic and undermined the normative status it had enjoyed for twenty years following the *Horatii*. A decade after the triumph of the *Sabines* it seemed as if contemporary painting had diversified beyond recognition. That so many artists showed readiness to cater to the public's taste for novelty, spectacle, and even bizarreness seems to have encouraged David to cultivate an unusually regressive disposition around this time. His decision to complete *Leonidas* well reflects this state of mind.

David found himself in the uncomfortable position of a pensioned but ignored courtier. It seemed to him shameful that as first painter he should be without work. Presuming himself to be the victim of court intrigue, he sought to gain a better access to Napoleon. He first hoped to succeed with the help of Pierre Daru, the intendant of the emperor's household, who had helped him resolve his financial negotiations and to whom, in March 1810, he had offered an appreciated portrait of his wife (SEE CAT. 18). He wrote to Daru one month later: "His Majesty having done me the honor of inviting me into his household as first painter, I beg you, Monsieur le Comte, to support the request to His Majesty, to be presented to him as officer of the household, and with that rank, to benefit from the same prerogatives as the others gratified by this position." The great advantage of this hoped-for change in status, as he stressed by invok-

ing the position of Charles Le Brun at the court of Louis XIV, would be to receive orders directly from the sovereign. Careful to not appear to want to sidestep Daru, his current superior, he added that he would not fail to consult with him before carrying out personal initiatives. The *Almanach impérial* that each year publicized the subtle hierarchy of positions at the imperial court proves, however, that he failed to throw off the yoke of the intendant.[117] Because Denon manifestly directed no painting commissions to him, David seems to have become somewhat desperate not to appear inactive in his official role. In January 1811, with great caution, he attempted to revive the request for three identical portraits of Napoleon in imperial robes, to be sent to Genoa and two other Ligurian cities, for which a first submission in 1805 had not met with approval.[118] But it was quickly made clear to him that neither Napoleon nor the administration wanted to pursue the matter.

In light of all the painters who at one time or another produced coronation portraits, it is indeed astonishing that David was never officially directed to that task by the emperor.[119] Several factors can be summoned to account for this state of affairs. The status of first painter distinguished the artist's superiority with respect all the others, but at the same time, as Napoleon's program for the arts in 1805 suggests, he found himself estranged from the usual channels of commissions. That these were controlled by Denon isolated him further. Two procedures were common: a related suite of portrait or historical commissions might be distributed to a motley group of artists or a staggering number of replicas might be requested from just one. David may have congratulated himself to not receive such perfunctory demands, but he had some reason to feel excluded from the system. From its end, the administration was increasingly reluctant to endure his financial pretensions, which had always been judged excessive. Of course, a sign of the emperor's favor might have unlocked this situation, but from 1809, on account of the successive military campaigns, his period of residence in the capital was limited. He manifestly did not want to impose the first painter on his new wife, Marie-Louise, who was more attracted to her drawing professor Prud'hon; the latter obtained a series of commissions for her, including the official portrait of the Napoleonic heir, the king of Rome, born in 1811, which David might have expected to receive.[120] For the other commissions celebrating his birth and baptism, the administration preferred to call on Isabey and Pierre-Nolasque Bergeret.[121]

The success of Gérard's swagger portrait of the emperor, first painted in 1805 and closely based on the Bourbon portraiture of Hyacinthe Rigaud and Louis-Michel Van Loo (SEE FIG. 7), suggests that the first painter's estrangement also reflected an aesthetic bias. Although not so radically as his pupil Ingres in his effigy of 1806 (SEE FIG. 9), David adopted an archaizing frontal pose in the two projected compositions dating from 1805 (SEE FIG. 10) and 1807 (FIG. 15). He refused to attenuate the emblematic force of the image through gestural animation, as though against Gérard he was positioning himself in a filiation with the severe revolutionary figures of Liberty and the Republic. However, the allegori-

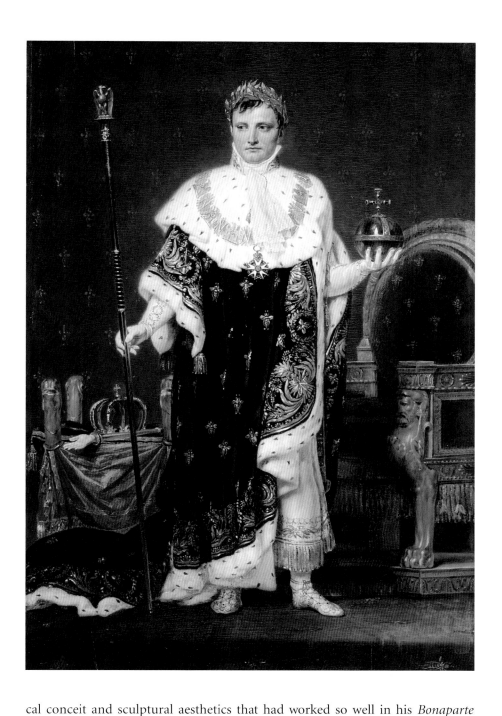

FIGURE 15 Jacques-Louis David, *Emperor Napoleon I*, 1807. Oil on panel, 34¾ x 23⅜ in. (88.3 x 59.4 cm). Fogg Art Museum, Harvard University Art Museums, Cambridge, Massachusetts. Bequest of Grenville L. Winthrop

cal conceit and sculptural aesthetics that had worked so well in his *Bonaparte Crossing the Alps* failed to impress this time. That Napoleon rejected the first portrait for Genoa for what he perceived to be its mediocrity is usually explained by David's recourse to assistants.[122] Since the figure—no less than the one subsequently devised in 1807—projects both power and authority, the failure as political imagery may have been less artistic than aesthetic: David's emperor was too abstract, in other words, too classical and, paradoxically, too imperial. As Napoleon's preference for the dramatic accents employed by Gérard, Lefèvre, and Girodet reveals, the court fantasy of the regime was in fact less imperial—the proclamation of the empire had been a semantic strategy to appropriate the heritage of the Revolution—than conventionally royal. Perhaps realizing how false and misguided all this was, David proceeded independently

in 1812 to imagine a portrait of Napoleon in a totally different spirit (SEE CAT. 12), and help the bourgeois come out of the palace closet.

Failing to get the upper hand on portrait commissions, David attempted on several occasions to impose his prerogatives with respect to the interior decoration of the imperial palaces. In October 1808, after visiting the Salon, Napoleon went around the Tuileries apartments in course of renovation, with a group of courtiers including David and Fontaine. In his journal the latter relates how the first painter reacted to the emperor's harsh criticism of what he saw: "The painter David, who was with us on this visit, did not defend and even vigorously condemned the works being criticized, although I had tried to make him believe that they were done by students of his school. It is not students but masters, he retorted, that His Majesty should employ to decorate his palaces."[123] The obvious implication in this reply was that he should have overseen the decoration. This was the gist of the letter he sent in September 1812 to Champagny, the recently named Intendant général des Domaines de la Couronne in charge of buildings. He informed him that among the attributions of the first painter was the task "to compose and to have executed all the paintings that are destined to decorate the imperial palaces." Specifically with the Louvre in mind, he asked that the architect of the palace send him the dimensions of the *peintures historiques* that were needed for the ceilings and walls so that he might start. Should some of the work need to be assigned, he added with pride that he would have them executed "under my supervision, by artists of my choosing, being more qualified than anyone to know the nature of their talent, since they have all come out of my school." Some compositional drawings dating from this period have been associated with this proposal (SEE CATS. 28 AND 29), to which the imperial administration replied with icy reserve, indicating to David that nothing definite had been decided concerning the Louvre decoration and that in any event, any initiative was the responsibility of Denon. That Champagny assured him he would be most happy to solicit his advice when the matter would be on the agenda amounted to a brush-off.[124]

This state of alienation upon the completion of the *Eagles* has been a topos of David studies since Jules David's monograph in 1880: it sets the context for the painter's renewed interest in *Leonidas*. Less familiar, however, are the diverse official occupations of the first painter during these years. Though not as spectacular as the coronation pictures and the prospect of decorating the Louvre interiors, they reveal a surprising willingness to play out fully the traditional role of court artist. Since the Renaissance, artists admitted to princely courts were entrusted with the task of embellishing the decor and decorum of quotidian surroundings and rituals, by which the magnificence of the master of the household took form and expressed itself. The historical parallel is particularly appropriate, since David, like his Renaissance predecessors, felt with zeal that his superior understanding of antique models gave him the capacity to regenerate taste at court. The time and energy he invested in responding to the discrete

demands made on him suggest that he found such forays in the field of the *arts de l'industrie* exciting. The influence of the rapprochement effected between the fine and the decorative arts during the Directory and Consulate is patent. Of course, with respect to the axiology of the Ancien Régime academic system, which had incited him to formulate his ambition and establish his reputation as a history painter, this participation in apparently minor enterprises will be judged regrettable, perhaps even a waste of time and creative energy; yet, in spite of the retrograde court context of his practice, one can discern even here an experimental imagination and a personal vision that are decidedly modern.

One early commission, at first glance perhaps the most trivial, dates from 1808, about the time he was finishing the *Coronation*. It was addressed to him by the director of the Droits réunis, the excise office for certain taxed items of daily consumption, Antoine Français, whose portrait he was to paint three years later (SEE CAT. 21). As he wrote to David on 13 June 1808, he wanted to replace on playing cards "the bizarre figures of kings, queens, and knaves" with "a drawing whose extreme elegance and purity make forgery difficult and at the same time, through the *correctness of the costumes and the precision of the attributes,* which can capture the allegorical intent that the inventor of this game had apparently devised." He apologized for troubling "le premier peintre de l'Europe" but hoped that he might accept to supervise the work of a pupil. In fact, as the set of fourteen drawings preserved together makes clear, David chose to devote himself personally to the task. The twelve figures he designed, especially the kings (FIG. 16), much like his 1807 portrait of Napoleon, exude an almost ponderous sense of monumentality. Their sober, statue-like character, even once redrawn by Angélique Mongez and engraved for Didot's edition in 1810, can be measured by comparison with the richly adorned and mannered figures of the set produced the following year by Nicolas-Marie Gatteaux, who regularly worked for the Droits réunis.[125] It is quite possible that the portrait David painted of the director in 1811, as that of a number of others he executed during the Empire, was a means to ingratiate himself to an administrator, in this case one constantly in need of designs for vignettes and seals.

Creating lavish settings for the court was a central preoccupation of the imperial regime. As mentioned, like Louis XIV and Colbert before him, Napoleon thoroughly believed that impressive pomp and splendor could be used to political advantage and that encouragement of the luxury trades had a favorable impact on the national economy. One close collaborator observed: "Extremely simple when it came to himself, if he liked to be surrounded in luxury, it was again calculated: for him grandiose representation seemed a means of affirming superiority and facilitating government action."[126] One major project was the decoration of the Grand Cabinet, a central reception room in the Tui-

FIGURE 16 Jacques-Louis David, *King (Charlemagne)* (design for playing cards), 1808. Black crayon on paper, 8¾ x 6⅜ in. (22.3 x 16.3 cm). Bibliothèque nationale de France, Paris

leries palace, measuring about thirty-two by thirty-six feet (10 x 11 m). Early in 1811, not finding the new decorative ensemble of tapestries and furnishings suitably magnificent, Napoleon designated Fontaine to have the room completely redecorated by the end of 1812, with the help of Denon and David. This involved in particular a new series of tapestry designs, over fifty in all, for the armchairs and chairs. In April 1811 Denon and David disapproved of the new motifs proposed by Anicet-Charles-Gabriel Lemonnier, the administrator of the Gobelins. Worried about delays, Daru asked David to provide sketches of his own. In May he submitted a single sketch for the emperor's "fauteuil," a composition with a Victory (or a figure of Fame) for the back (FIG. 17) and another with imperial motifs on the seat (FIG. 18). He continued to work on the project and in August wrote to Lemonnier that he had sent Daru "all the drawings relative to the complete furnishings," except for two that were already on the loom. He expressed concern that the "caractère antique" of his designs be preserved by the painter François Dubois, who was to execute the cartoons. Given the pressure, all those involved were probably relieved to learn that the new furniture was ready to be installed by January 1813.[127] Compared to the designs that the same Dubois had reworked a year or two earlier from Jacques-Louis de La Hamayde de Saint-Ange, under the direction of Charles Percier, David's decorative compositions are more simple and clear, less cluttered and detailed: in other words, like his playing card designs, less evocative of Directory refinement. Contemporaries would have called them more masculine (*mâle*), an epithet common in anti-Rococo and later republican art criticism. Although David adhered to period motifs and materials, the fact that he sought to pare down flourishes in all his decorative proposals would seem to signal a determination to counter Percier and Fontaine, whose penchant for ornamental excess was manifest in the fasci-

FIGURE 17 Dubois after David, *Design for the Back of the Emperor's Armchair*, 1811. Oil on canvas, 23¼ x 23¼ in. (59 x 59 cm). Mobilier national, Paris

FIGURE 18 Dubois after David, *Design for the Seat of the Emperor's Armchair*, 1811. Oil on canvas, 25¼ x 31½ in. (64 x 80 cm). Mobilier national, Paris

FIGURE 19 Armoire from the Grand
Cabinet of Emperor Napoleon at the
Palais des Tuileries, 1811–12. Made by
Jacob-Desmalter after designs by
David, Denon, Percier, and Fontaine.
Ebony, oak, bronze, and porphyry,
48 x 80¾ x 25⅝ in. (122 x 205 x 65 cm).
Portrait Bust of Pope Pius VII, 1803–4,
by Antonio Canova. Musée national
du Château de Versailles

cles of their *Recueil de décorations intérieures,* begun in 1801 and declared complete in 1812.

Fontaine and David had adjusted the profiles and certain decorative details of the gilt furniture ensemble for the Grand Cabinet that bore the tapestries. They also collaborated in designing the massive ebony *bas d'armoires* for the same room, executed by Jacob-Desmalter. It presented an architectural structure of pilasters framing three panels, with bronze reliefs of a nude winged youth on the outer two: on the left, the *Genius of Peace,* and on the right, the *Genius of War.* Jacob-Desmalter's detailed description of the furniture, appended to his invoice of 42,000 francs for three identical pieces (not including the porphyry tops costing 6,000 francs) indicates that Fontaine, Percier, David, and Denon all participated in the design, but does not detail their individual contributions. But it seems reasonable to attribute to David the graceful design of the two ephebes (FIG. 19).[128]

His involvement with the refurbishing of the Grand Cabinet did not end there. He was asked to approve a model after an antique in the Musée Napoléon, elaborated by the bronze founder Pierre-Philippe Thomire, who was in charge of providing four candelabra, over eight feet (2.5 m) in height. Reporting on the design, he observed characteristically: "Most pleased with it at first, I praised the proportions and its elegance; then after giving the matter more thought, I made some remarks to suggest greater refinement . . . as for example, to remove from the top the confusing crown of leaves that bend around."[129]

Given Napoleon's personal investment in this particular room in Tuileries, the redecorating of which was carried through with efficiency and promptitude, unlike so many other renovations, it is possible that in 1812 David composed two

Homeric subjects, *The Departure of Hector* (SEE CAT. 28) and *Venus, Wounded by Diomedes, Appeals to Jupiter* (SEE CAT. 29), with this locale in mind. Both draw-ings are carefully finished and may have been intended as models for tapestry cartoons. The first painter could only have found galling that the Grand Cabinet should be hung with recently woven Gobelins of *Aeneas Pursuing Helen,* after a painting by Vien seen at the Salon in 1793 (Musée d'Art Roger-Quilliot, Cler-mont-Ferrand), and *Zeuxis Choosing His Models from the Most Beautiful Girls in Crotona,* after another by François-André Vincent exhibited in 1789 (Musée du Louvre). He surely esteemed that he could surpass both his master and his long-time rival, who no longer challenged him with his brush but by maneuvering the Institute, as had proven the *Rapport à l'empereur* on the progress of the fine arts since 1789 and the result of the Concours Décennal.

Still another domain in which David played the court artist was costume design. The series he drew during the height of Jacobin rule, engraved by Denon and colored by a team of artists including Isabey, is justifiably well known: the project was part of the Jacobin agenda to regenerate all aspects of life in republi-can France. The costume designs for Napoleon were not inspired by the same political exaltation and dedication. One senses that the artist was motivated per-haps more by concern for his territorial prerogatives than by a strong creative drive. His rivalry with Isabey, officially Dessinateur du Cabinet des Cérémonies, on whom such demands most often fell, appears to have been particularly acute. In December 1799, just a few weeks after the coup d'état of Brumaire, at a time when he was informally serving as Bonaparte's adviser, he is reported to have designed an official costume for him (SEE CAT. 3). Much later, in 1812, he was probably luckier gaining approval about how a military standard-bearer might hold the eagle—which was improperly rising from the crotch in the proposal he revised—and for a type of flag less reminiscent of religious processions (SEE CAT. 13). The archives may reveal more work of this kind, but the unreferenced attributions of costumes to David in popular historical publications—the attire of the *chevaliers* of Milanese Order of the Iron Crown, or Murat's outfit as Great Admiral of France—are most likely fanciful and unfounded.

Whatever their frequency, such servile occupations of the first painter inspired the sarcasm of Henri Beyle (later famous as Stendhal), who in his pri-vate writings throughout the Empire denounced the sham of court pageantry. Employed as his cousin Daru's secretary and decided upon courting his wife during her sittings for her portrait in David's studio, he jotted down in his jour-nal on 14 March 1810: "I have just seen David paint. It's a succession of pettiness, and on the way to trace one's name, and on the difference between a history painter and a miniature painter, about a page's costume that he *sent* to the emperor. Those people exhaust their spirit with petty things, it's not surprising that there is none left for great things. Besides, David thinks not to dissimulate this petty vanity of every instant nor to appear always proving to himself his own importance."[130]

The last years of the Empire saw David's retreat from court life. Not without some hesitation, and leaving aside *Cupid and Psyche,* which interested him (SEE CAT. 32), he devoted the greater part of 1812–14 to *Leonidas* (SEE FIG. 82). He had not forgotten how Bonaparte had disapproved of this project during the Consulate; late in life, he still recalled his words: "How wrong you are to put your energy in painting those defeated."[131] With the recollection of this confrontation in mind, he may have felt that he was defying the imperial regime by returning to *Leonidas,* which he decided to thoroughly rework (SEE CATS. 24–26). With the elaborate life-size portrait of the emperor he had painted for a Scottish lord during the winter of 1811–12 (SEE CAT. 12) and his participation in the decoration of the Grand Cabinet, he seems to have reached a climax in his official role as first painter. But at the same time, his experience at court was ultimately unsatisfying. As proven by the Scottish commission and another from a Russian prince (SEE CAT. 27), he continued to feel that his genius was more recognized abroad than at home. Reflecting on David upon learning of his death, his former pupil Delécluze recalled hearing him say during the Consulate: "In France there is no true love of the arts," a sentiment that haunted him throughout his life and led him to idealize the artistic scene in foreign capitals.[132] His sporadic disillusionment appears to have been both existential and circumstantial.[133] He came to realize that the nature of the court system would always require him to compromise his aesthetic ideals and share the limelight. After proving his capacity to collaborate and without a major commission, he had reason for irritation upon hearing in 1812 that Prud'hon, at Denon's initiative, had been awarded a highly paid commission for a painting of the ceremonious banquet that had been offered by the city of Paris to the imperial couple. Denon continued to decry the first painter's financial solicitations and even pretended that he ignored "whether M. David was working on these paintings [of the coronation]." As late as January 1813, Denon would continue to play deaf and blind whenever David's name would come up.[134]

From the spring of 1812, with the rupture of the Russian alliance, the ambiance at court was also changing. As the Grande Armée marched to Moscow and back from May 1812 to March 1813, echoes of defeat and retreat from faraway battlegrounds, even subversive talk of the emperor's desertion of his army, resounded in the capital. Parisians embraced a sentiment of vulnerability to which they were not accustomed, for it was soon clear that all of Europe was leagued against France.

David chose the position of bystander as the Empire seemed to many to be coming to an end, through the German campaign of May through November 1813, in which his son Eugène was wounded, and the disastrous French campaign of January through April 1814. In August 1813 Fontaine, as architect of the Louvre, met with David, Gérard, Girodet, Gros, and Guérin to discuss the decoration of the palace.[135] Each painter promised to elaborate and submit some proposals, knowing well that only Napoleon's personal implication

might sustain a project of such ambition. Given the climate of political and military uncertainty, any long-term planning probably seemed a chimera. David began devoting more time to his studio and intensified his involvement with his students. He apparently found this environment enjoyable: one of his students, in 1811, reported that although serious when commenting on the exercises, he generally manifested "as much gaiety and vivacity as a young man of twenty-four."[136]

He may also have become aware that the efficacy of his pedagogy in the Institute contest for the Prix de Rome was on the wane. From 1808 to 1811 the winner had always been one of his pupils. Girodet ranted at the time against the *chef d'école* "who cannot bear that students other than his own be crowned in the contests." However, in 1812 and 1813 it was Vincent's studio that clearly got the upper hand. Although David deserted the final deliberation during these two years, probably finding unpalatable the cabal formed against him by the Institute's old guard, he was particularly furious at the result proclaimed in July 1813: four of the ten final contestants were his pupils, and yet not one was awarded either of the two first or the two second prizes.[137] The execution of *Leonidas* was in many respects a studio collaboration: pupils helped him brush in various parts and modeled for the figures. Historians have recently stressed the intense homosocial bonding exemplified both in the execution process and in the subject of the composition. That the information relative to the execution of *Leonidas,* mainly close reporting by students, is more detailed than for any other of David's major productions is testimony to the spirit of collaboration and spectacle that reigned in his studio at the time. The tone of a letter he wrote to a former pupil in November 1814, acknowledging the picture's teamwork when its exhibition was bringing him a flow of compliments, was unprecedented.[138]

The former pupil in question was Bruslart (or Brulart), whom David addressed as "mon cher marquis" and whom he begged in closing to present his respects to his parents. This show of affection toward someone with aristocratic connections, articulated during the yearlong first phase of the Bourbon restoration, raises the question of his sincerity. In May, in a letter to his former patron Prince Yusupov, he had lavished unrestrained praise on the Russian emperor who had conquered Paris with his army: "The Russians in general, like your Magnanimous Alexander, leave with all our regrets. Your great emperor was adored and my happiness would have been complete he had done me the honor of his august presence, as the other sovereigns so deigned, in paying a visit my studio."[139] As David's constant desire to establish a direct personal relation with Napoleon proves, securing homage from the prince was for him near an obsession; the validation of his artistic reputation was explicitly cast in Vasarian terms.[140] He wrote to Yusupov, inevitably with his *Alexander, Apelles, and Campaspe* composition in mind (SEE FIG. 79), that among warring nations, never had there been such "an example of moderation like that demonstrated in our time by Alexander of Russia which will eclipse the ancient in the annals of

the world." Insinuating that if prodded he might even move to Russia, he added: "Alexander has conquered all those in the arts and I do not doubt that many are ready to go and live in his states."[141] These letters are inspired by a will to be reconciled with the new order when one might have expected more reserve and resignation on the part of the privileged Napoleonic functionary. The letters remained private, but they manifestly were intended to cull sympathy among the forces of reaction.

How the former member of the National Convention and Napoleon's first painter confronted the restoration of the Bourbon monarchy in the person of the brother of the monarch whose death he had voted is perhaps not as easy to interpret as one might think. This turn of events might have horrified him and made him anxious and yet, perhaps because of a general weariness during the last years of the Empire and the strategy of moderation initially adopted by the Bourbons, David was careful to show compliance. It seems to have taken him a few months and the experience of some humiliation to fully assess the difficulties that lay ahead for him. As the letters to Bruslart and Yusupov indicate, he was not averse to maintaining contacts such as these with presumed partisans of the new regime. On the other hand, he readily seized a number of occasions to present a more defiant public image. During the distribution of the annual prizes at the Institute in October 1814, he obstinately refused to accede to the demand of the president that he leave, because the presence of a regicide indisposed the duc d'Angoulême, the son of the king's brother. When one of his pupils, Léopold Robert, won the prize for engraving, the colleague in charge of the announcement willfully omitted to name the victor's master. It was especially David's decision that November to not send *Leonidas* to the Salon, overflowing with homages to the royal family, but to show it in his studio, which created a stir. The short text he printed on that occasion was simply a description of the composition, but the conclusion lent itself to imagining a parallel between the Spartans and the outnumbered Grande Armée defeated by the allied forces: "This commitment of Leonidas and his companions made a greater impact than the most brilliant victory: it revealed to the Greeks the secret of their power, and of their weakness to the Persians."[142]

David's original idea for the picture perhaps reached back to 1792–94, when the rhetorical invocation of the sacrifice of the Spartans at Thermopylae was not uncommon among his fellow Montagnards at the National Convention.[143] In his thoughtful *Essai philosophique sur la dignité des arts* of 1798, the critic Chaussard, who was close to the painter and one of his main advocates after Thermidor, evoked the young artists who had answered the call to arms during the revolutionary wars and left their masters' studios: "Artists of the Museum division, you were the first to march forth to the fields of honor! I will always remember the day when, like the three hundred Spartans willing to sacrifice themselves at Thermopylae, you came forward in battle rank in the midst of the assembly I had the honor of presiding, and which received your oath."[144] Many

in the group of recruits had been David's pupils, and along with all the other revolutionary soundings, he may have had them in mind when, shortly after the publication of Chaussard's brochure, he chose this theme for a pendant to the *Sabines*. Although such republican references may have initially been inspired by a spirit of patriotic mobilization, the reality of the decline and fall of the imperial regime brought out the pessimism of the narrative. Something of this change in tone is apparent in the shift from the agitated composition dating from the Consulate (SEE CAT. 24) to that elaborated about a decade later, in which the stiffened figures seem mortified for eternity (SEE CATS. 25 AND 26).

The return of the Bourbon monarchy brought vividly back to the surface the memory of the revolutionary past that had been largely suppressed by the courtly spectacle of the imperial regime. In an effort to compress and superpose the twenty-five years of history from which they had been excluded, the royalists attempted as much as they could to turn the clock back and dismantle the institutions of both the Revolution and the Empire. A flow of caricatures of Napoleon inundated the shops in the capital; as they had always had in Britain, they systematically invoked his revolutionary background and associated him with the Terror. Imitating the iconoclasm of the republicans in 1792, the new masters decreed in April 1814 that "all the emblems, monograms, and coats of arms that characterized the Bonaparte government shall be eliminated and effaced everywhere they may exist."[145] David could easily foresee that once again, as in 1795, the reactionary turn of events would put him in the nightmarish role of accused Terrorist. His court services as first painter to the emperor were nothing compared to the heinous crime of having voted the death of Louis XVI. Although the Bourbon restoration had spurred the revival of a vociferous Jacobin faction, calling publicly for the return of Napoleon, there is no indication that David felt a particular sympathy for this group (as he had during the Directory, when he subscribed to Babeuf's journal *Le Tribun du peuple*). However, as the exhibition of *Leonidas* suggests, he appears to have anticipated the confrontation that lay ahead and adopted a resolutely revolutionary tone in visualizing his recent Napoleonic experience and refusing the Bourbon order. Rather significantly, in June 1814, when taking an English visitor around his studio in the church of Cluny, hung with the *Coronation*, the *Eagles*, the *Sabines*, and the unfinished *Leonidas*, he explained the first picture in detail, "with uncommon civility, entering at length into his own ideas as to the subject, the composition & the manner of handling it, & the light & shade, as well as pointing out the portraits of those who had distinguished themselves during the Revolution."[146]

Visiting the exhibition of David's picture in his studio and praising it became a coded manner of resisting. When news of Napoleon's comeback reached Paris, one pamphleteer cried out for the French to sacrifice their lives in the upcoming struggle against the allies. The heroic destiny of Leonidas and his Spartans would be conferred on the soldiers who later died at the battle

of Waterloo; souvenir objects would be fabricated bearing the inscription paraphrased from the one in Greek at the heart of David's composition: "Passant, va dire à Paris que nous sommes morts ici pour l'honneur français, le 18 juin 1815."[147]

Napoleon managed to escape from the island of Elba, off the coast of Italy, where he had been exiled, and on 20 March 1815, after a triumphant progression, he arrived in Paris. Five days later he took time to reinstate David as his first painter and on 6 April made a publicized visit to his studio to see *Leonidas.* On this occasion, he elevated him to the grade of *commandant* in the order of the Legion of Honor (FIG. 20).[148] Not since 1808 had the artist been graced with such a show of Napoleon's esteem; the context, chronology, and purport of his praise gave the event an aura of heightened drama. On the defensive, Napoleon was in a position to appreciate the sublimation of defeat that the painter had projected on the perfect bodies of the combatants. David exalted his difficulties at a time when others artists, notably Géricault, were already focusing on the tragedy of the moment, on the maimed and broken coming home from the front.

Much like Louis XVIII the year before, Napoleon was confronted with a choice on his return from exile: restoration of the "imperial" Ancien Régime or compromise with the liberal elites and abandonment of autocratic rule. With the help of Benjamin Constant he adopted the latter course and elaborated the *acte additionnel* to the constitution of the Empire. The text prolonged the constitutional bricolage characteristic of imperial doctrine, beginning with the composite construction of a "Napoléon, par la grâce de Dieu et les constitutions, Empereur des Français," but made a number of liberal concessions, which in certain ways recalled the *Charte* Louis XVIII had edicted.[149] In spite of appeals from his entourage that he keep a low profile in these uncertain times, in May David signed the *acte additionnel,* which amounted to an oath of fidelity to Napoleon. News of the decisive defeat of the French at Waterloo on 18 June 1815, followed four days later by that of the emperor's abdication, apparently made him lose his usual self-assurance. He hastened to secure a passport and in July left for Besançon, the hometown of his two sons-in-law, where he spent two

FIGURE 20 Visiting Card, 1815. Engraved by Susse and signed by David. Musée de la Révolution française, Vizille

weeks before traveling around the Alps of Savoy and Switzerland, through August, confronted with administrative harassment at various times. He was back in Paris by September, reunited with his family. But his happiness was short-lived, for the Bourbons, restored for the second time, enacted a law in January exiling to the country of their choice the regicide members of the National Convention who had voted the *acte additionnel*. Refusing an offer to negotiate on the condition that he beg for a royal pardon, he bore with pride the harshness of the measure like the stoic Greeks and Romans who had filled his imagination throughout his life. He may even have relished sharing the fate of the exile on the faraway island of Saint Helena, in the middle of the Atlantic Ocean.

When considering David in Brussels, the city where he chose to settle (see the essay "Portraits in Exile" in this volume), it will not be possible to dissociate his attachment to Napoleon and his aversion for the Bourbon monarchy to determine whether his unyielding refusal to return to France was more motivated by the one or the other. His repetition of the *Coronation* during this period proves that he never forswore the experience of his years of imperial allegiance, and at the same time he would fully realize that the end of the Empire had not brought history to a halt. This attitude is an eloquent testimony to his force of character and sense of independence. That the nineteenth century would not be *le siècle de Napoléon* that so many writers and courtiers had proclaimed constituted a new challenge: painting for a new age.

2 Study for a Portrait of General Bonaparte

c. 1796–97

Pencil, pen, and gray wash on buff paper (with a white discolored area in the center of the sheet, probably a chemical reaction to a glue used for mounting) 11¾ x 8¼ in. (30 x 21 cm)

Musée du Louvre, Paris. Département des Arts graphiques (inv. RF 52524)

Exhibited in Los Angeles only

PROVENANCE
1826, in David's possession at his death (initialed by his two sons, Eugène, lower left [L. 839], and Jules, lower right [L. 1437]); possibly, David sale, Paris, 17–19 Apr. 1826, for an annotated addendum to the copy of the catalogue in the British Library indicates "148. Bonaparte à Lodi," sold for the relatively high price of 170 francs (but described as a "croquis à la plume" in David 1880, p. 659: "à M. Constantin," a Paris dealer); . . . ; by 2001, Paris, Eric Coatalem Gallery; 2001, acquired by the museum (mark [not in Lugt], lower right).

EXHIBITION
Paris, Eric Coatalem Gallery, 2002, p. 37, unnumbered catalogue (already sold to the Louvre).

BIBLIOGRAPHY
Prat and Rosenberg 2002, vol. 1, p. 188, no. 174bis.

FIGURE 21 Jacques-Louis David, *General Bonaparte*, 1797–98. Oil on canvas (unfinished), 31⅞ x 25⅝ in. (81 x 65 cm). Musée du Louvre, Paris

FIGURE 22 Jacques-Louis David, *General Bonaparte*, 1797–98. Pencil on paper, 9¼ x 7½ in. (23.5 x 19 cm). Private collection, Paris

DAVID'S EARLY fascination for Bonaparte is mentioned by his pupil Gros in a letter of 6 December 1796 to his mother, in which he proudly announces having met the French general in Milan. He quotes Bonaparte speaking of a solicitation received from David: "[David] has requested this drawing, he said, pointing in the direction of an artillery officer who was drafting quite precisely and cleverly the taking of the bridge at Lodi. [David] wants to paint this, but I have some other good scenes in mind that I'll have sent to you." Gros, who only aimed for a portrait commission, reports that he responded with modesty: "They all belong to David, my master, because of his great talent, I replied, and reminded him of his various masterpieces."[1] This indirect testimony proves that in the aftermath of the Battle of Lodi (10 May 1796), David was enthused by Bonaparte to the point of wanting to paint a picture in his honor. The victory at Lodi had been boldly courageous, and also decisive, since it opened the gates of Milan, seat of the Austrian government of Lombardy. David's option on this event may explain why Gros chose instead to illustrate Bonaparte's

heroism at Arcole in November 1796. News of his Arcole portrait soon reached Paris and David. On 2 April 1797 a studio comrade wrote to Gros that two days earlier he had informed their master of the prestigious commission: "He learned with great pleasure that you were executing the portrait of Bonaparte. He ardently wants to see it." He added that David had asked him to forward some advice, revealing his state of mind at the time he was painting the *Sabines:* "He invited me to talk to you about him, and especially to engage you to forget somewhat Rubens and to look often at Raphael."[2] During the troubled summer of 1797, when his Jacobin past came under renewed attack, David may have received an invitation to seek refuge with Bonaparte in Milan, and no doubt in December joined in the chorus of adulation when Bonaparte returned from Italy (see the essay "In the Service of Napoleon" in this volume).

This conversation between Bonaparte and Gros indicates that he was first inclined to celebrate the victory at Lodi. For Bonaparte, as the topo-

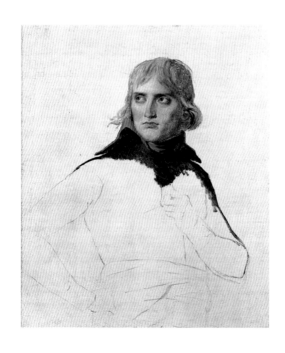

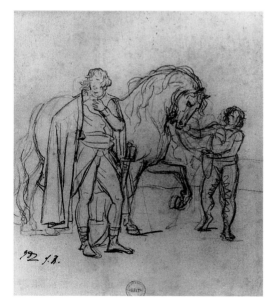

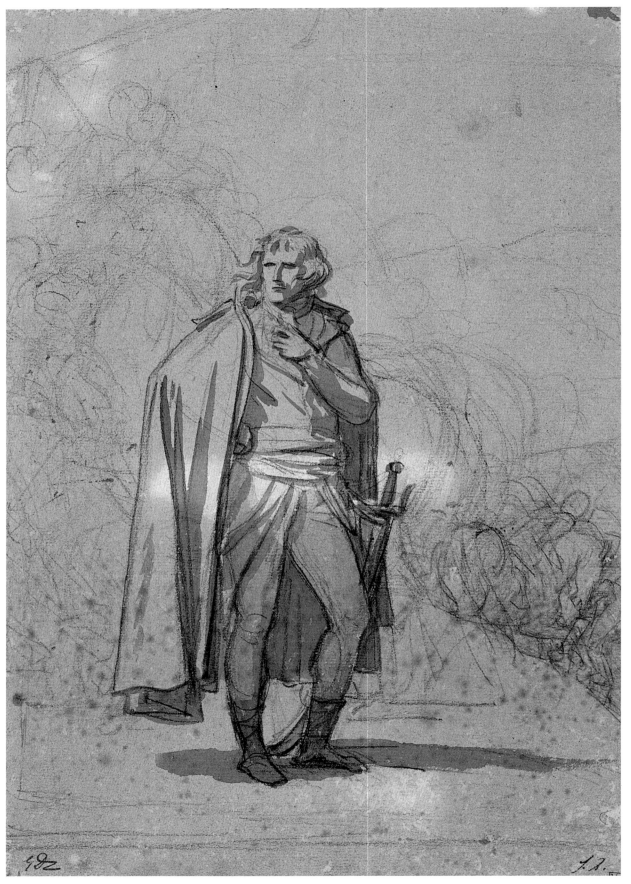

FIGURE 23 Jacques-Louis David, *Profile Sketch of General Bonaparte*, 1797–98. Pencil on paper, 3⅞ x 3⅛ in. (9.7 x 8 cm). Location unknown

graphic drawing he had prepared for the painter suggests, this meant a battle scene.[3] For David however, it could only have meant a historical portrait. Not since his formative years at the French Academy in Rome had he represented the active engagement of two armies in the spirit of Rubens and Charles Le Brun; the aggregate composition and frozen poses adopted for the combatants in the *Sabines* suggest how deeply his artistic conceptions had become estranged from this tradition by the late 1790s.[4] The exhibited drawing is apparently related to this initial phase of the project. Over time it evolved and produced the famous unfinished portrait in the Louvre (FIG. 21), a fragment to which another preparatory drawing is related (FIG. 22).[5] Along with the sequence of execution for the two drawings and the painting, the exact subject of the portrait is in need of clarification.

The Louvre drawing is one of the important rediscoveries that have redefined the contours of David's graphic oeuvre in recent years. The incisive play of the brush and dynamic rhythm of the pencil strokes, bordering on illegibility, possess an expressive intensity that David only rarely allows himself. The introspective image of the young military hero is a novelty with respect to the suite of portraits of Napoleon Bonaparte he produced

throughout his career. His angular features are characteristic of his earliest engraved portraits, visible everywhere, which perforce oriented David's imagination. In the Louvre painting, the face with its wide brow, strong jaw, firm cheeks, and pulpous lips is notably different from the standard introspective figure he still cut in 1797. The contrast between the fleshy Rubensian features and those of a small drawing he quickly sketched about this time, a hollow profile of *le général de la grande nation* bordering on caricature, suggests that he produced the latter after a print or a medallion or with such models in mind (FIG. 23).[6] For the painting, it is hard to imagine that he would have accepted relying on prints or another artist's work, a practice traditionally reserved for second-rate portraitists such as those of the *cabinet du roi* at Versailles prior to the Revolution. According to David's biographer Étienne-Jean Delécluze, who was then his pupil, the unfinished portrait of Bonaparte was painted from life in a three-hour session. He reports that the day after the sitting, David was effusive, "smiling more than usual and in such a way as to let see the tumor of his upper jaw." Often cited are his comments to his inquisitive pupils on Bonaparte's physiognomy: "Oh! my friends what a handsome head *he* has! It's pure, it's grand, it's beautiful like the antique! . . . In short, he said, my friends, he's a man to whom altars would have been erected in antiquity; yes, my friends, yes, my dear friends! *Bonaparte is my hero!*" Delécluze further notes that David culled considerable prestige from being able to approach the hero of the day and paint in his presence.[7] As mentioned in the essay above, the memorable sitting could only have taken place during those few months—from December 1797 to May 1798—when Bonaparte was residing in Paris. The unfinished state of the painted portrait tends to confirm that it was executed directly from life: David worked on it during only one stretch and never went back to it. He seems to have been unwilling to alter the first play of his brush, not unlike Fragonard who proudly annotated his *figures de fantaisie* to stress that they were done in an hour's time. Perhaps he hoped that Bonaparte would return for a sitting; with the *Sabines* in progress, he could afford to wait.

In their recent catalogue of David's drawings, Prat and Rosenberg esteem that the other drawing for the composition, in a private collection, must

have been executed just before the Louvre sheet. Bonaparte's pose is nearly identical in the two, but the technique of each is very different, as is the visual context for the figure. The wash in the Louvre sheet creates a dramatic play of shadows and gives the figure a pictorial sense of relief and form, whereas the crayon in the other drawing produces a more schematic, linear composition with shading totally absent. The latter appears to be a working drawing to make adjustments to a preestablished arrangement, in this instance to the immediate background to the figure. For this reason, although more succinct than the Louvre sheet, this sketch may have been executed only subsequently. The indetermination of the forms behind Bonaparte in the exhibited drawing, an agitated mass of horses and riders going both up and down an incline, also suggests a freedom of invention corresponding to an early stage of composition. The background, with cavalry tugging in opposing directions, could be said to figure the general's unconscious: like Hercules at the crossroads, he is confronted with the promise of a difficult victory or the prospect of a humiliating retreat. This resonance is absent in the other drawing, more orderly, with a precisely positioned horse and an agile young equerry serving to create an articulate contrast to the steadfastness of the main figure. Once again, the process of composition corresponds to a more advanced stage than in the Louvre drawing. That Bonaparte's hair appears windblown in both drawings suggests they were produced prior to the painting, in which David hardened the locks to obtain a firmer contour.[8]

Presumably then, during the famous sitting David asked Bonaparte to adopt the predefined pose, pressing his left forearm against his chest, stern like the drawn figures of toga-clad Romans pasted in the artist's student albums. In the painting the gesture is the same, but the fist rests slightly lower on the chest and is clenched with a greater sense of determination. From the first, the other arm is held akimbo in an attitude of repose and expectation, dignified by an ample cloak; in the painting both arms, somewhat more relaxed, are positioned lower than in the drawings. Although no trace of the cloak appears in the painting, it may have been David's intention to add it at a later stage, for in both drawings Bonaparte's right arm was first lightly drawn in and then mantled over.

The moment of the representation has been the source of some confusion, although this does not profoundly affect its portent. When he composed the portrait, David knew of Gros's image of Bonaparte in action, through verbal descriptions if not yet from Longhi's print. Characteristically, he adhered to a very different conception and invented a meditative figure. This evidences his fundamental predilection for the self-contained figure as defined by antique statuary. David imagined a statuesque cloaked figure, pensively directing his gaze out of the picture, resisting wind and cold. The initial choice of the aftermath of the Battle of Lodi was in harmony with the evolution of Bonaparte's reputation, which went from military commander to political peacemaker during the years 1796–97. In 1826 the painter's family revived the link to Lodi, but, with respect to the three works discussed, the absence of the bridge, the identifying element of the battle as for Arcole, makes this improbable. In the catalogue of the Dominique-Vivant Denon sale the same year, the painting was described as Bonaparte after the Battle of Castiglione (5 August 1796). While Delécluze and Jules David proposed with confidence a reference to the Treaty of Campo-Formio (17 October 1797) and attributed to the artist the intention of placing the treaty in the commander's left hand, it is indeed hard to imagine that this portrait by the most famous painter of the day, and hence meant to function as an official image, should contain no allusion to the historic peace with Austria that concluded the Italian campaign. Bonaparte's political and moral reputation obviously had much to gain from his role as the pacificator of Europe and it is possible, as the project evolved, that reference would have been made to the treaty. But, as noted by Schnapper, there is no sign of a scroll in the painted image nor, for that matter, in the drawings. David's early biographers were probably induced to forward their interpretation, and perhaps mislead, on account of a lithograph executed by Jean-Félix-Marius Belliard around 1830, which extends down and literally completes the composition, by filling in a vast landscape of snow-covered mountains behind Bonaparte and placing in his right hand a scroll of paper with the heading "République Française."[9]

NOTES

1. Delestre 1867, p. 34: "Il [David] a fait demander, dit-il, ce dessin, me montrant ce que faisait un officier d'artillerie qui dessinait très véridiquement et assez spirituellement la prise du pont de Lodi. Il [David] veut le peindre, mais j'ai quelques autres beaux sujets que je vous ferai communiquer. . . . Ils appartiennent tous, repartis-je, à mon maître David, par ses grands talents, et lui rappelant ses divers chefs-d'oeuvre." This is the source for the information usually quoted from David 1880, p. 335.

2. Tripier Le Franc 1880, p. 142: "Il a appris avec grand plaisir, que tu faisais le portrait de Bonaparte. Il désire ardemment le voir. . . . Il m'a invité à te parler de lui, et surtout à t'engager d'oublier un peu Rubens, et de regarder beaucoup Raphaël."

3. By Feb. 1797 Bonaparte had commissioned a painting of the *Battle of Rivoli* from Nicolas-Didier Boguet, based in Florence. In 1801, once Boguet had finished it and its pendant, *The Crossing of the River Pô at Piacenza*, he was asked to complete the series with *The Battle of Castiglione* and *The Arrival of General Bonaparte at Ancona* (Marmottan 1925, pp. 6–11).

4. David's attitude toward Rubens and Le Brun was more complex than this suggests. See the essay "Portraits in Exile" in this volume.

5. Paris-Versailles 1989–90, p. 380, no. 160. Prat and Rosenberg 2002, vol. 1, p. 187, no. 174.

6. The execution of the drawing (Prat and Rosenberg 2002, vol. 1, p. 186, no. 173, location unknown) cannot be earlier than Sept. 1797 when the expression *grande nation* was popularized by Marie-Joseph Chénier's verses on the death of General Hoche (Mathiez 1929, p. 290).

7. Delécluze 1855 [1983], pp. 202–4: "souriant plus de coutume et de manière à laisser voir la tumeur de sa mâchoire supérieure." Often cited are his comments on Bonaparte's physiognomy to his inquisitive pupils: "Oh! mes amis quelle belle tête il a! C'est pur, c'est grand, c'est beau comme l'antique! . . . Enfin, dit-il, mes amis, c'est un homme auquel on aurait élevé des autels dans l'antiquité; oui, mes amis; oui, mes chers amis! *Bonaparte est mon héros!*"

8. The background scene planned for the painting as described by Jules David should be registered with caution since no source is indicated; it corresponds in part to this other drawing: "Une ordonnance lui amène son cheval devant l'état-major qui occupe le coin à droite, au fond du tableau" (1880, p. 642; quoted by A. Sérullaz in Paris-Versailles 1989–90, p. 380).

9. The lithograph edited by Engelmann and mentioned by Schnapper (Paris-Versailles 1989–90, p. 378) is reproduced in Dayot [1896–97], p. 484, with the indication: "dessin [*sic*] de Belliard d'après David." According to Delécluze (1855 [1983], p. 202 n. 1), Maret, duc de Bassano, who bought the painting at the 1826 sale of David's estate (in fact through an intermediary after the sale), commissioned the lithograph. Marie-Anne Dupuy has proposed to relate this reference to a lithograph of just the head, probably by Denon (Paris 1999–2000, p. 449, repr. fig. a).

3 Study for a Costume

c. 1798–1805

Black crayon, pen and ink, gray wash, and red, blue, and bister watercolor on paper, heightened with gold. The figure is cut out and pasted on a sheet with a landscape setting, executed in charcoal and stumping with red and bister watercolor.

13¼ x 9⅝ in. (33.7 x 24.4 cm)

Inscription on verso in pen and brown ink: *Mr Meunier*

Musée national du Château de Versailles (inv. RF 1926; MV5294, Dess[in] 304)

Exhibited in Williamstown only

PROVENANCE

1826, in David's possession at his death (initialed by his two sons, lower right, Jules [L. 1437] and Eugène [L. 839]); David sale, Paris, 17–19 Apr. 1826, part of lot no. 54 ("Neuf dessins à l'aquarelle pour les costumes commandés par la Convention et pour celui des Consuls"); unsold or removed from the sale, David family collection, presumably Eugène David (1784–1830), since his son Louis-Jules David-Chassagnolle (1829–1886), who in 1880 owned it, donated the drawing to the museum in 1886 with a usufructuary restriction in favor of his wife, born Léonie-Marie de Neufforge (1837–1893); 1893, received by the museum (mark, lower center: MV in an oval [not in Lugt]).

EXHIBITIONS

Paris-Versailles 1948, p. 117, no. 109; Paris-Versailles 1989–90, p. 322, no. 145.

BIBLIOGRAPHY

David 1880, p. 659; David 1882, fascicle 11 (engraving); Guiffrey and Marcel 1909, p. 80, no. 3205; Hautecoeur 1954, p. 194; Schnapper 1980, p. 146; Prat and Rosenberg 2002, vol. 1, p. 191, no. 178.

THIS DRAWING was mentioned in the inventory drawn up in Paris on 25 February 1826, after David's death, as "Un dessin à l'aquarelle par M. David, projet de costume pour le Consulat"[1] and presented at the estate sale in April. It has always been considered a "project for the costume of the Consuls of the French Republic," a formulation common to both Jules David and recently, Prat and Rosenberg. The former attributes to the sheet the date of 1799, although nothing indicates on what basis. In 1954 Hautecoeur was the first to propose to relate the drawing to a brief article in a journal dated 18 December 1799, which François-Alphonse Aulard had published in 1903, informing readers that two days earlier the costume maker of the former directory had presented Bonaparte an outfit executed after David's design. The first consul is reported to have rejected it because he found it too fancy, choosing instead to keep his general's uniform. The costume represented in the Versailles drawing is effectively most unmilitary. Although the watercolor has faded, one can imagine the effect of the costume: the pale yellow or white coat with aiguillettes and rich gold embroidery, the blue *culottes* and red boots, both also embroidered, in spite of the spurs, seem fit for no activity other than socializing in a palace salon. The red velvet hat with an aigrette of white feather, like the precious sword and impressive chain, accentuates the courtly tonality of the clothes.

All of the elements of this story, the dating of the drawing to the Consulate, the status of the press report, and the connection with the Versailles sheet, merit a reexamination. The impulse to relate available documents to works of art because they are also available is a common art historical fallacy that is not easy to resist. In this instance, David's heirs should be blamed for having been so peremptory. The republican costume designs for the National Convention, engraved by Denon and then colored by a team of artists, are justly famous in David's graphic oeuvre. Less well known is his participation in projects during the Directory. In June and July 1799, a few months before the régime came to an end, the Bureau des Beaux-Arts et des Fêtes Nationales, an office of the ministry of the interior, consulted with him, the painter Philippe Chéry, and the actor Talma regarding new costumes for functionaries working in the various branches of the ministry.[2] Although there is no indication that David actually proposed any designs on this occasion or earlier, it remains a possibility. The Versailles drawing may date from the late Directory. The tricolor harmony of the costume evokes the republic, like the cockade attached to the hat. But the emblems are irritatingly indeterminate: the radiant design on the belt buckle is difficult to decipher (one would have expected *RF*), as is the pendant medallion, with the profile of a helmeted head, not unlike the Minerva-Republic that decorated the sheath of the ceremonial sword of the Directors.[3] Furthermore, the colors rapidly associated with the official image of the first consul—red, white, and gold—are also present in the drawing.

Whether the press report invoked since Hautecoeur is reliable is another question. The journal was *Le Diplomate*, a royalist publication that often changed titles to avoid being shut down by the censors. Openly hostile to the Directory, the editors were careful after the coup d'état of Brumaire to woo the first consul. The article in December 1799 was ostensibly flattering: "The day before yesterday, the costume-maker of the former Directory showed the first consul a superb outfit, for which David had furnished the design; after examining it, Buonaparte [*sic*] found it too magnificent, and addressing the group of generals and military in attendance, said: 'Comrades, I prefer the general's garb, what do you think?' The military were delighted and warmly applauded the consul's resolution."[4] The Directory is here negatively associated with profligacy, as is David. It is impossible to say whether the incident reported is true or not.

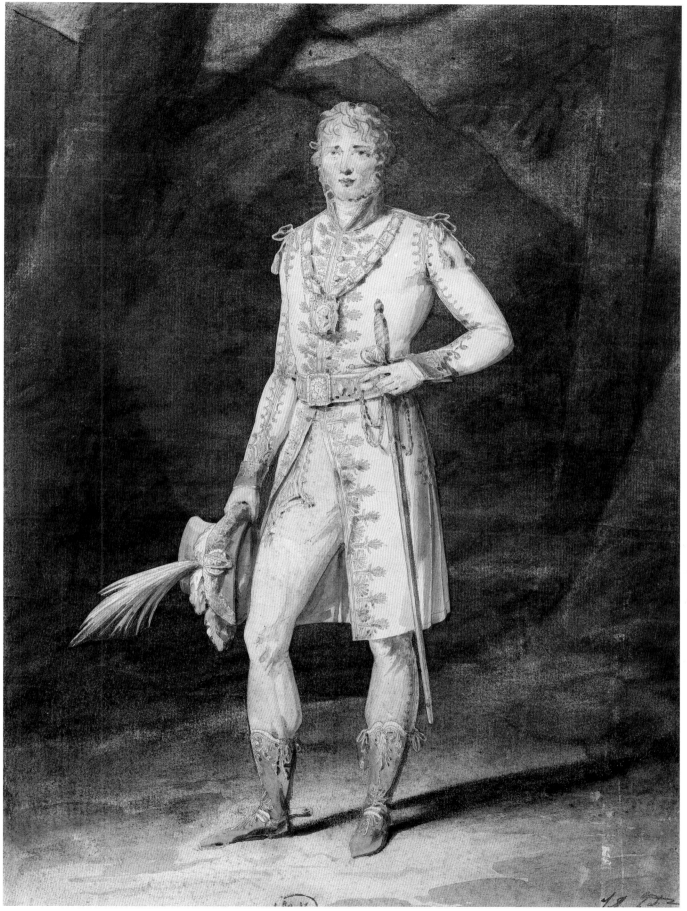

CATALOGUE 3

Bonaparte's relations with David at the very beginning of the Consulate were both intimate and informal and he may have asked him for a costume design (see the essay "In the Service of Napoleon" in this volume). At the same time, the journal defended a reactionary cause and a mildly satirical attack against a former terrorist, often abused by the royalist press, need not have been fueled by a concern for veracity.[5]

Finally, the status of the drawing is affected by its singular mode of fabrication, with the figure cut out and pasted on a landscape background. The costly costume hardly seems appropriate for a stroll in the forest at the foot of a gloomy mountain. The juxtaposition of contrasting techniques—the precise play of the pen and brush for the figure and the broad stumping behind—is highly unusual during the period and unique in David's oeuvre. The shadow cast by the figure attempts to integrate it with the setting, but the result seems perfunctory and dry. The confident sharpness of the pen stroke and the brittle precision of the contours weigh in favor of the attribution, but the application of ink wash and watercolor is unusually detailed and tight. The conventional sweetness of the face, attenuated by Jules David in the reproductive engraving he published in 1882, would suggest rather the more refined manner of David's pupil, Jean-Baptiste Isabey, who on occasion introduced collage in his most elaborate compositions. Not only was he a rival in matters of costume designs for the Napoleonic court, especially around the time of the coronation, he was also fond of moody landscapes of the kind adopted here. That the drawing was in the master's studio and attributed to him by his sons remain strong arguments to support David's authorship, but hopefully the present exhibition will stimulate a more critical examination of this peculiar sheet.

NOTES

1. Wildenstein 1973, p. 236, no. 2041 (no. 12). The inscription on the verso, referring to the husband of one of David's daughters (see cat. 20), may have a relation to the succession.
2. Wildenstein 1973, p. 146, no. 1311; Paris-Versailles 1989–90, p. 596.
3. See Paris 1989, vol. 3, p. 690, ills. 909–10.
4. "Avant-hier, le costumier de l'ancien Directoire présenta au consul Bonaparte un superbe habit, dont David avait dessiné le modèle; Buonaparte [sic] ayant examiné cet habit, le trouva trop magnifique, et dit, en s'adressant aux généraux et militaires qui étaient présents en grand nombre: 'Camarades, je préfère l'habit de général, qu'en pensez-vous?' Les militaires enchantés ont beaucoup applaudi à la résolution du Consul." Le Diplomate 50 (27 Frimaire Year VIII [18 Dec. 1799]). Aulard 1903–6, vol. 1, p. 56. Résumé in Wildenstein 1973, p. 147, nos. 1322–23.
5. David is associated with the guillotine and the figure of the bourreau (executioner) in the anonymous Dictionnaire des jacobins vivans, Hamburg, Year VIII [1799–1800], p. 39 (cited in Bordes 1976 [1978], p. 295).

1800–1801

Oil on canvas
8 ft. 6⅜ in. x 7 ft. 3 in. (260 x 221 cm)
Signed and dated (on the chest harness):
L·DAVID·L'AN IX
Illusionistic inscriptions on the rock,
lower left: *BONAPARTE / ANNIBAL /
KAROLUS MAGNUS MP* [praetor
maximus]

Musée national des Châteaux de Mal-
maison et Bois-Préau, Reuil-Malmaison
(inv. 49.7.1)

PROVENANCE
Commissioned in August 1800 by
Charles IV, king of Spain, through his
ambassador in Paris; sent to Madrid in
July 1802 and installed in the Sala
Antigua del Consejo Estado of the Royal
Palace in Madrid (inventoried in 1808
and 1811); appropriated by Joseph
Bonaparte (1768–1844) during his reign
as king of Spain (1808–13), probably in
1811; transferred by him to Paris, perhaps
to Switzerland (Prangins), and taken
by him to the United States, where he
sought exile in 1815; his daughter,
Zénaïde Bonaparte (1801–1854), wife of
Charles-Lucien Bonaparte, son of Lu-
cien Bonaparte (but not listed in her
death inventory, 1855); probably their
eldest son Joseph-Lucien Bonaparte
(1824–1865), without a descendance;
probably his brother Napoleon-Charles
Bonaparte (1839–1899); his daughter,
Eugénie Bonaparte (1872–1949); 1949,
bequeathed by her to the museum.

EXHIBITIONS
Paris, Palais du Louvre, with the *Sabines,*
for two (?) months from around 25 Sep-
tember 1801; Philadelphia, Academy of
Fine Arts, *Twelfth Annual Exhibition,* May
1823 (according to an article in *Poulson's
Daily Advertiser,* see Bibliography); Rome
1955, no. 29; London 1959, no. 106;
Copenhagen 1960, no. 11; Paris-Versailles
1989–90, pp. 381–86, no. 161 (entry by A.

Schnapper); Madrid 2002–3, pp. 237–40,
no. 6 (entry by J. Jordán de Urries y de la
Colina).

BIBLIOGRAPHY
Chaussard, *Bibliothèque française* 2,
no. 1 (May 1801), pp. 123–24; M. Rigo,
"Beaux-arts. Au rédacteur," *Gazette
nationale ou Le Moniteur universel* 269
(29 Prairial Year IX [18 June 1801]), p.
1120; Bruun Neergaard, [Aug.–Sept.]
1801, pp. 98–100; Chaussard, *Journal des
arts* 156 (30 Fructidor Year IX [17 Sept.
1801]), pp. 420–21; M. Boutard, *Journal
des Débats,* 16 Brumaire Year IX (7 Nov.
1801), pp. 3–4; Meyer 1802, vol. 1, pp.
97–98; *Nouvelles des Arts* 2 (Year XI
[1802–3]), p. 303; [Chaussard] 1806, pp.
163–64; *Journal de Paris,* 1 Jan. 1809, 4;
Poulson's Daily Advertiser (Philadelphia),
22 May 1823, article on the Twelfth
Annual Exhibition of the Academy of
Fine Arts signed "L. Aocoon" [transcrip-
tion in the files of the Philadelphia
Museum of Art]; *Notice* 1824, p. 40;
Th. 1826a, pp. 162–63, 236; Th. 1826b, pp.
111–13, 163; Mahul 1826, pp. 124, 139–40;
Coupin 1827, p. 55; Réveil and Duchesne
1828–31, vol. 9 (1831), p. 7; Hugo 1833, p.
315; Lenoir 1835, p. 9; Miel 1840, pp.
15–16; Blanc [1849–76], p. 15; Miette de
Villars 1850, pp. 178–80; Delécluze 1855
[1983], pp. 233, 236–37; Chesneau 1864,
pp. 37–39; Seigneur 1863–64, p. 363;
David 1867, p. 36; David 1880, pp. 384,
643; Bertin 1893, pp. 86–87, 418, 421;
Saunier [1903], p. 92; Humbert 1936, pp.
136–37; Holma 1940, p. 79; Humbert
1947, p. 144; M. Florisoone in Paris 1948,
pp. 84–85; Florisoone 1948, p. 260;
Wildenstein 1950a; Wildenstein 1950b;
Hautecoeur 1954, pp. 197–99; Connelly
1968, p. 250; Girod de l'Ain 1970, p. 352;
Verbraeken 1973, pp. 26, 155; Wildenstein
1973, pp. 155 (no. 1364), 159–60 (nos.
1373, 1375, 1376), 162 (nos. 1398, 1400,
1401, 1402), 209 (no. 1810), 226 (no.
1938); Schoch 1975, pp. 55–56; Brookner
1980, pp. 146–48; Hubert 1980, p. 77;

Schnapper 1980, pp. 206, 208; Bleyl 1982,
pp. 82–85; Perrin de Boussac 1983, pp.
124–26; Foucart-Walter 1984, pp. 367,
372–73, 380n. 8; Rosenblum and Janson
1984, pp. 30–31; Bottineau 1986, pp.
194–95; Bordes 1988, pp. 82–84; Michel
and Sahut 1988, pp. 102–3; Hubert and
Pougetoux 1989, no. I.15; Roberts 1989,
pp. 143–47; A. Schnapper in Paris-
Versailles 1989–90, pp. 13, 138, 227, 344,
361, 369, 379, 381–87, 449, 520–21, 549,
598, 599, 600–602, 606–7, 615, 617,
634–35, 637; Jordán de Urries y de la
Collina 1991; Johnson 1993a, pp. 178–83;
Prendergast 1997, pp. 99, 108–11, 148,
159, 188, 202, 204; Lee 1999, pp. 231–34;
Pillepich 2001, pp. 414–15; Rosenblum
2001, pp. 400–402; Henry 2002.

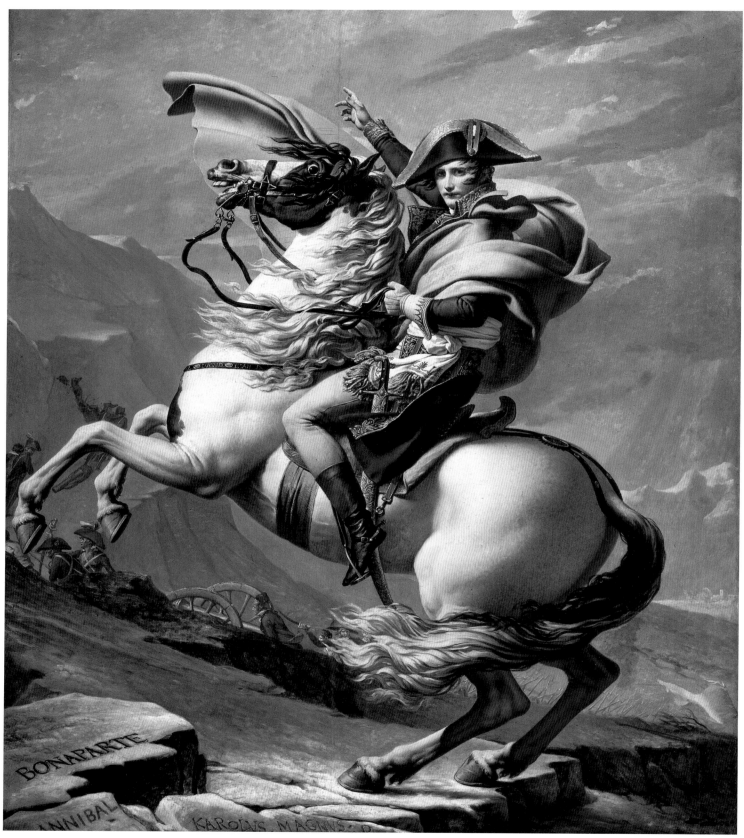

This equestrian portrait commissioned by the king of Spain as an overt homage to the first consul belongs to a series of diplomatic initiatives undertaken to gain the favor of this intimidating neighbor (see the essay "In the Service of Napoleon" in this volume). In August 1800 Charles IV had notably sent sixteen horses, which were officially presented to Bonaparte during a military review in November. Writing from Madrid to the ambassador in Paris on 11 August 1800, Mariano Luis de Urquijo, the secretary of state, expressed his satisfaction at the idea of securing a painting by David for the Spanish crown: "And so not only will we own a work by that famous artist, but we will also satisfy our hero, whose strings are being pulled, although he doesn't realize it, by those greedy hands who unravel so quickly what he achieves at great cost on the battlefield."[1] On 20 August the Spanish ambassador, Ignacio Múzquiz, contacted David, who agreed two days later to paint the desired portrait for 24,000 livres. When in July 1802 it was about to be sent to Spain, the new ambassador, José Nicolás de Azara, who had been a fervent admirer of Mengs in Rome, was far from enthusiastic about his predecessor's initiative and the final result. To his friend Bernardo Iriarte he confided a thoroughly negative impression: "What political finesse my predecessor showed by commissioning this painting to court and please the nation. *First,* it looks like Bonaparte about as much as it looks like you, and likeness is rather important where a portrait is concerned, wouldn't you agree? The horseman is kneeling, not sitting on the saddle. Who knows what he is supposed to be galloping over, but he's about to charge at the mountain, and his horse is far bigger than the Alps. It's anyone's guess quite who those soldiers are standing beneath the belly, no more than flies beneath an elephant. Not a single color is true, with the exception of the tricolor sash round his waist, and his flesh is ashen. Compare it to any of Velázquez's horses and you will find there's nothing else to be said on the matter."[2]

The question of the portrait's degree of resemblance was broached by the critics even before it was exhibited in Paris in the fall of 1801 along with another version painted for Bonaparte. The first consul may have made his position clear several months earlier, during a visit to David's studio on 5 June 1801. According to Michel Rigo, a Genoese painter who had participated in the Egyptian campaign and was appreciated by Bonaparte, writing less than two weeks after the visit, David had resolutely rejected any idea of representing the particulars of his subject's features: "It will be up to the connoisseurs among the public to judge the intention of the painter who, in rejecting all the little details nature offers, has retained only the most characteristic features, to allow for only the hero to appear. Indeed David has sought to render only the superior beauty *(le beau idéal)* of the figure, a manner that not many among the modern fathom. Yet he required some courage and a keen love of his art to sacrifice the praise of his contemporaries to the admiration posterity will accord him. That is how Apelles must have painted Alexander; how Phidias must have represented Pericles."[3] Subsequently the artist's biographers would affirm that Bonaparte himself had explained to the painter how unnecessary it was for him to pose for his portrait, since posterity would attend only to the expression of character. Rigo's personal observation, that the question of likeness was secondary when contemplating the effigies of the great men of antiquity, was put in Bonaparte's mouth in a *Vie de David* published in 1826.[4] The artist did not need such prodding to work with the ambition of a history painter and produce what he would later single out in a list of his works as a "*tableau-portrait.*"[5] Whether a circumstantial constraint or a determined decision, he chose to idealize the hero's features rather than aim at resemblance. Chaussard, in his remarks on the painting, reported how David justified his aesthetic choice: "The cloak of [Bonaparte] is thrown to make one imagine, as the artist was telling me, the wings of a demigod gliding in the air. Furthermore, like the ancients, David has elevated the character of the hero's features to capture an ideal." However, the critic's position evolved between May and September: he finally opined that when a painter executed a historical portrait, he should attend to the specific features of his model: "The art of Lavater and other physiognomists teach how to perceive the true character in the expression a figure takes and sometimes even in a simple attitude. Here, neither the eyes nor the mouth are those of Bonaparte. David realized this, for in the copy [*sic*] he has executed for the king of Spain, he has heightened the resemblance of the

figure; the color of the horse puts it in greater re-
lief."[6] That critics like Chaussard and connoisseurs
like Azara disapproved of his choice to idealize the
hero reflects the intensity of the pressure to fix
Bonaparte's image at a time when the emaciated
long-haired general was metamorphosing into a
first consul with a fuller face and a coiffure à la
Titus. On another level, criticism of the *tableau-
portrait* attests to an uneasiness with regard to the
general trend toward a hybridization of the tradi-
tional academic genres after the revolution (SEE
CAT. 12).

Even though, as Chaussard observed, David
deployed here "un coloris plus chaud que de cou-
tume," in this composition, he developed a sculp-
tural aesthetic more explicitly than perhaps ever
before.[7] The low horizon and the absence of a
middle ground accentuate the visual autonomy
of the horse and rider, a frozen group forcefully
modeled and precisely delineated against a more
thinly painted background. The sharpness of the
image, characteristic of the *Sabines* and the por-
trait of Henriette de Verninac he had just com-
pleted, may have been a way to close the Rubensian
perspectives indicated by Gros's *Bonaparte at
Arcole,* painted in 1796. As noted in the discussion
for David's study for a portrait of Bonaparte (CAT.
2), he had even felt it necessary to caution his
pupil against his passion for the Flemish painter.
His preoccupation with finish, conceived as a
pictorial metaphor for the purity of antique sculp-
ture, was also encouraged by the works of his
former pupils Girodet and Gérard, who were ex-
ploiting this mode with success.[8] The impact of
the antique masterpieces from Italian collections
on show at the Louvre, and of the work of con-
temporary sculptors, notably Chinard and Canova,
with whom he was corresponding around this
time, further reinforced his long-time preoccupa-
tion with sculpture. That small-scale bronzes in-
spired by the equestrian group were subsequently
fabricated and adapted by clockmakers suggests
that contemporaries clearly perceived the sculp-
tural character of the composition.

The choice of the crossing of the Saint Bernard
Pass with the Armée d'Italie in May 1800 reflects
the immense admiration which this exploit and
the ensuing victories had elicited (see the essay
"In the Service of Napoleon" in this volume).
However, the contrast could not be greater be-

tween the main figure and the column of infantry,
half-hidden and diminutive, driven by a sense of
duty as it struggles to drag cannons up the moun-
tain slope. These figures, winding their way across
the canvas, popping up now and then behind the
horse's legs and tail, furnish a historical context to
the portrait. David's allusion to Bonaparte's ex-
ploit as a collaborative effort should probably not
be construed as a surreptitious means to republi-
canize the narrative around the idea of the peo-
ple's army. It seems, rather, a concession to the
descriptive mode of battle painting favored by the
first consul. David could not ignore that Charles
Thévenin had also been commissioned to paint
a scene of the Alpine crossing and had sketched a
vast composition, with Bonaparte in the midst of
a populous army bivouacking at the foot of the
pass (FIG. 24).[9]

A number of drawings shed light on the work-
ings of David's artistic imagination during the
elaboration of the final composition. His interest
in the equestrian group goes back to the elegant
image of Stanislas Potocki taming a horse
(1780–81, Warsaw), begun in Rome, and the pencil
sketch he made after *Tommaso Francesco of Savoy*
by Van Dyck in Turin, on his return to France.
Later, in a sketchbook he employed during his
second Roman sojourn (1784–85) he drew a pre-
cise profile view, presumably after a print, of
Étienne-Maurice Falconet's statue of Peter the
Great in Saint Petersburg, with its impressive rock
base.[10] He may have had these images in mind
when in another sketchbook, which comprised
especially studies for the *Sabines* and *Leonidas,* he
covered six pages with sketches exploring solu-
tions for the Spanish commission, and on other
pages depicted Roman cavaliers after antique and
Renaissance models; an isolated sheet, inscribed in
his hand "Première idée du Bonaparte," was very
likely detached from this sketchbook.[11] He experi-
mented with a wide range of poses for the horse
and rider before the composition was finalized,
with no particular concern to link the equestrian
image to a contingent moment of contemporary
history.

In these studies, after allowing the horse to
demonstrate highly natural and informal move-
ments, perhaps studied from life, he chose to ad-
here to the more conventional pose of the rearing
horse, emblematic of victory, exemplified by the

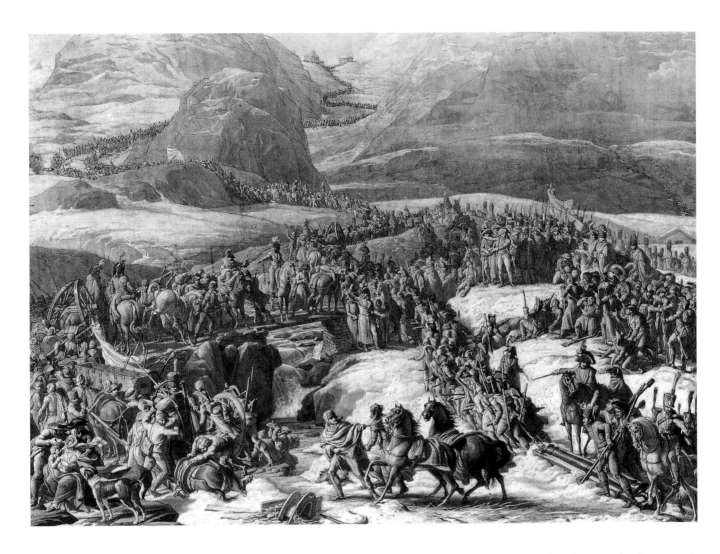

FIGURE 24 Charles Thévenin (French, 1764–1838), *Napoleon Bonaparte and His Army at Grand-Saint-Bernard*, 1802. Pen, ink, wash, and white gouache on blue paper, 18½ x 24⅜ in. (47 x 62 cm). Musée cantonal d'histoire et d'ethnographie, Sion, Switzerland

Van Dyck portrait he had studied in Turin. On account of their canonical status, notwithstanding the opprobrium heaped on them during the Revolution, the portraits of Louis XIV were probably most immediately on his mind, in particular one of the most famous and widely diffused, painted by René-Antoine Houasse (c. 1680) and available as an engraving.[12] This and other royal representations may have suggested to David the low horizon and subordinate narrative as means to aggrandize the hero. However, the modernity of *Bonaparte* with respect to such *grand siècle* models emerges through a number of determined inflections: the raised head of the horse creates an unprecedented élan, corroborating the impression of a gale wind, tearing at the horse's tail and mane and swelling Bonaparte's cloak. Whereas in earlier portraits the horse seems an inert presence, David draws the viewer's attention to the crazed expression of the animal by framing its head against the billowing cloth, a detail that leads back to the calm

confidence of the rider. This conceit of contrasts is usually considered to have been an expressed wish of the first consul, generally on the basis of a dubious narrative published by Delécluze in 1855.[13] In the earliest published reference to the painting however, by David's friend Chaussard in May 1801, this dramatic opposition between hero and nature is explicitly articulated as the central theme and credited to the *secret du génie* of the *artiste-penseur*. Furthermore, Robert Rosenblum has recently proposed another genealogy and pointed to a painting *Alexander Taming Bucephalus* by Nicolas-André Monsiau (FIG. 25), which David would have seen at the Salon of 1787. The formal analogies and historical resonances of this rapprochement are most suggestive, as is the manifest intention to show Bonaparte's steed brought under greater control than Alexander's wild stallion. The compositional dynamics of David's picture, a forward surge arrested by a turn of the body, is basically that developed by Gros in his *Bonaparte at Arcole,*

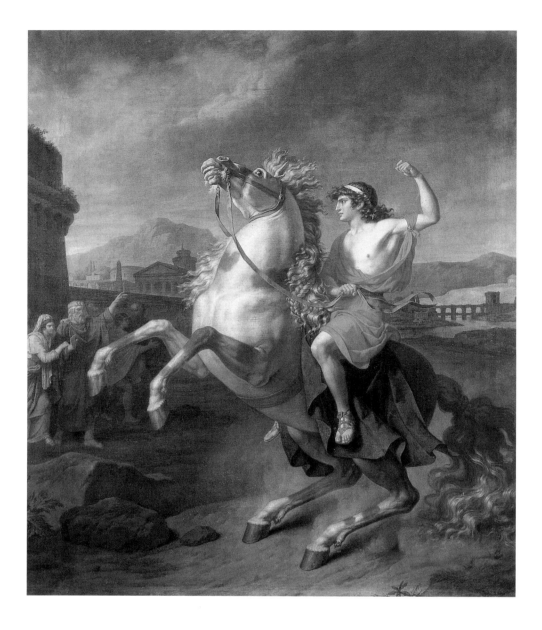

although the rider does not look back to encourage his men, but straight out of the canvas, as if addressing his message to the spectator.

Bonaparte appears to forge his own destiny. Unlike most royal and princely cavaliers in their portraits, he holds no baton or sword, a symbol of delegated authority present in nearly all the drawings. His right-hand glove removed, he appears ostentatiously bare-handed, suggesting less a confrontation with the enemy than one with the elements. Evocative of the ascension that lays ahead, his raised hand holds the promise of success, much like that of the figure of Virtue pleading with Hercules at the crossroads.[14] But with no designated target, the action represented neutralizes all transfer or transcendence and becomes an emblematic expression. Since Chaussard, the allegorical conception of the representation has often been underlined by historians. As in the *Oath of the Tennis Court* of 1790–91, this is manifest in the staged unreality of the historical event. Mock inscriptions graven in the rock explicitly place Bonaparte's Alpine exploit on par with those of Hannibal and Charlemagne before him. As a member of the Institute, David had received in April 1798 a medal by Benjamin Duvivier celebrating the Treaty of Campo-Formio: he may have been responsive to the image of the cloaked republican general on a rearing horse, but unlike the medal engraver, he refused to saturate his

FIGURE 25 Nicolas-André Monsiau (French, 1754–1837), *Alexander Taming Bucephalus*, 1787. Oil on canvas, 9 ft. 10¼ in. x 8 ft. 1⅝ in. (300 x 248 cm). Château de Maisons, Maisons-Laffitte

composition with allegorical figures and symbolic trappings.[15] The result is a delineated image that acquires the immediacy and persuasiveness of visual trope, functioning much like the earlier group of the Horatii.

The extreme confusion concerning the history of the versions since the earliest commentaries—in 1801 commentators in the press refused to admit that the prime version was not for Bonaparte—was masterfully sorted out by Antoine Schnapper in 1989. The following résumé paraphrases his findings, but provides some incidental remarks that tend to assert a greater degree of distinction among the versions. In the earliest list of his works that David drew up, around 1811–12, five versions of the equestrian portrait are itemized.[16] The second version, signed and dated Year IX (hence finished by September 1801 at the latest), like the initial one for the Spanish king, was painted for Bonaparte, who in 1802 had it hung in the Château de Saint-Cloud, just outside of Paris, which he was having renovated at the time by Percier and Fontaine. In 1815 it was taken to Berlin by the Prussian general Blücher (and is now in the collection at Charlottenburg). A third version was in the library of the Invalides by the end of 1802 and was handed over to the museum administration in 1816 (and is now at Versailles, installed in some Louis-Philippe period wall paneling). A fourth portrait, dated Year X (but finished only around February 1803, hence the following year), was sent to Milan in the spring of 1803 to decorate the seat of government (it was transferred in 1834 to Vienna, and hangs today in the Belvedere Gallery). From the time he first listed his works, the fifth version remained in David's possession (and as the third, is now also at Versailles). After his death it was in his April 1826 estate sale, with possibly a sixth version, only roughly blocked in.[17]

The color of the horse's coat differs significantly among the versions: piebald (nos. 1 and 5), brownish-bay (no. 2), white with legs dark gray (nos. 3 and 4), and so does the color of Bonaparte's cloak, which is brick yellow (nos. 1 and 5) and red (nos. 2, 3, and 4). The treatment of the reins replicates this latter grouping: single rein (nos. 2, 3, and 4) and double reins (nos. 1 and 5, although the latter, like the versions with a single rein, is without a nose-piece). There are further variations in the color of the horse's belly-band: yellow (no. 1), reddish-blue (no. 2), blue (nos. 3, 4), and purplish-red (no. 5). Most important for the interpretation of these variations, which at least metaphorically seem to allude to the variety of horses presented by Charles IV to Bonaparte, is the fact that David exhibited the first two versions so that the Parisian public might compare them. He may have begun what is termed the fifth version right after the one for Spain, since it replicates it most closely, but then decided to paint a very different version from the first, no. 2, which he exhibited. At a time when Gros's pictures in the Salon and Venetian and Rubensian works in the museum were directing attention to the colorist tradition, David seemed to be offering his own exercises in chromatic harmony. The two other versions for the first consul (nos. 3 and 4), both with the same striking black-and-white horse, offer the simplified harness adopted in no. 2, possibly because David found the double rein fussy and came to realize that it befitted the parade ground but was of no use on a mountain climb. The fifth version, although in a poor state of conservation and painted over, is the most singular of the five: more insistently than in all the other versions, the angular features of the face suggest a portrait. This was the painting that David sent to an exhibition in London in 1822, and he manifestly reworked it much later than the others. The juxtaposition of the five versions would be enlightening to evaluate fully David's objectives in introducing so many changes and to elucidate his working method, since, as was his practice since the 1780s, he relied on the assistance of pupils to execute the repetitions.[18]

The composition was reproduced during the Empire as a Gobelins tapestry (1806–11) and on Sèvres vases (1811–14). The imperial administration also financed a costly engraving by Raphael Morghen, which he never finished. The composition hung prominently at the Château de Saint-Cloud and in the Invalides and continued to be appreciated in official circles as a reminder of perhaps the most heroic moment of Napoleon's life, but one wonders whether the attention lavished on this consular icon was not also a way for Denon to snub the first painter's later portraits of the emperor.

NOTES

1. "Asi tendremos una cosa de ese célebre Artista y complaceremos a ese Ydolo, que creo lo conducen, sin que se aperciva, manos que por avaricia trastornan en un dia lo que él gana a mucha costa en batallas." Madrid 2002–3, pp. 237–38. My thanks to Helen Burke for help in translating this text and the one quoted in the next note.

2. "Fue una fineza de politica de mi Antecesor ordenar este Quadro para hacer la corte y congraciarse la Nación. *In primis,* se parece a Bonaparte comme a ti; lo que para un retrato ya ves que es punto esencial. El ginete está arrodillado y non sentado en la silla. Galopa no se sabe sobre qué, y va enbestir contra une montaña, y el cavallo es mucho mayor que los Alpes. Los soldados que están debaxo de su barriga no se sabe lo que son, y están en tan exacta proporción commo una mosca a un elefante. En fin, no hai color que no sea falso, si no es tricolor de la faxa o echarpe, y la carne está pintada con ceniza. Conpárolo con los cavallos de Velázquez y no te quedará qué decir, ni qué pensar." Madrid 2002–3, pp. 238.

3. "C'est au public connaisseur qu'il appartiendra de juger l'intention du peintre qui, en rejetant tous les petits détails de nature, s'est emparé des traits les plus caractéristiques, pour ne faire voir que le héros. David en effet n'a voulu rendre que le beau idéal de la figure, manière bien peu sentie des modernes. Mais il lui a fallu quelque courage et un amour bien vif de son art, pour sacrifier, à l'admiration de la postérité, les éloges de ses contemporains. C'est ainsi qu'Apelle a dû peindre Alexandre; ainsi Phidias a dû représenter Périclès." Rigo, "Beaux-Arts: Au rédacteur," *Gazette nationale ou Le Moniteur universel* 269, 29 Prairial Year IX (18 June 1801), p. 1120.

4. Th. 1826b, pp. 110–11.

5. Wildenstein 1973, p. 226, no. 1938.

6. "Le manteau de ce dernier [Bonaparte] est jeté de manière qu'il ressemble, ainsi que me le disait l'artiste, aux ailes qui soutiendraient un demi-Dieu planant dans l'espace. Ajoutez qu'à l'exemple des Anciens, David a élevé le caractère de la physionomie du héros jusqu'à l'idéal." Chaussard, *Journal des Arts,* 17 Sept. 1801, p. 421. Chaussard here cites a passage from his earlier article, published in May 1801, to which he brings two revealing changes. He inserts the parenthetical invocation of a conversation with David to give authority to his position, however he cuts the qualification, "sans rien ôter à la ressemblance," at the beginning of the second sentence, a change of mind in accord with the following quote in the text: "L'art des Lavater, des Physiognomonistes, apprend à lire le caractère tout entier dans l'expression de la figure et quelquefois dans celle de la simple attitude. Ce ne sont là ni les yeux ni la bouche de Bonaparte. David l'a senti, car dans la copie [*sic*] qu'il a faite pour le Roi d'Espagne, il a donné à la figure plus de ressemblance; le cheval s'y détache mieux aussi par la

couleur." These comments appear only in the September text.

7. Chaussard, *Journal des Arts,* 17 Sept. 1801, p. 420. For David's "aesthetic of sculpture," see the illuminating discussion by Johnson 1993a, pp. 8, 40–56, 125–26, 180–81; 180: "We look up at the equestrian group as though we were looking at a sculpted monument from the level of its pedestal (akin to the experience of viewing an equestrian group such as Falconet's *Peter the Great)*." Henry discusses *Bonaparte* with regard to Guillaume Coustou's horses installed in the Champs-Élysées in 1796 (2002, pp. 363–65).

8. For a discussion of the question of finish in their portrait practice, see Bordes in San Diego 2003–4, pp. 24–29.

9. As later indicated by Denon (1999, vol. 2, p. 1294), Thévenin received his commission for the *Passage of the Grand-Saint-Bernard* from Lucien Bonaparte, during his term as minister of the interior (Dec. 1799–Nov. 1800), most probably in reply to Bonaparte's demand on 16 July 1800 for battle pictures (Benoit 1897, p. 166 n. 2; see the essay "In the Service of Napoleon" in this volume). Although the finished painting (Versailles) was only exhibited in 1806, a compositional drawing is dated 1802 (fig. 24). It is probable that Denon, who lavished praise on Thévenin's efforts in 1803, pitted his project against David's portrait (Denon 1999, vol. 2, pp. 1240–41, report to the first consul, 25 Jan. 1803: "Un aspect aussi étrange, un événement aussi extraordinaire, sont des bonnes fortunes pour la peinture qui doivent rendre ce tableau curieux pour notre siècle comme pour les siècles à venir. . . . Il est à désirer que son génie soit emporté par son sujet, qu'aidé de la couleur il puisse donner tout à la fois l'idée de l'âpreté du lieu, de la rigueur du climat, des obstacles à vaincre, des ressources et des efforts employés contre eux, du triomphe de l'énergie, enfin de cette couleur extraordinaire qui caractérise presque toute vos entreprises."). The drawing reproduced was revealed by Martigny 2000, p. 86, no. 114. On this genre, see Siegfried 1993, pp. 235–58.

10. Prat and Rosenberg 2002, vol. 1, p. 657, no. 983 (after Van Dyck); vol. 2, p. 900, no. 1308 (after Falconet).

11. For the drawings in question, see Prat and Rosenberg 2002, vol. 1, p. 198 (no. 186); vol. 2, p. 900, (no. 1308r); 992–94 (nos. 1520r, 1520v, 1521r, 1521v, 1522, 1524v).

12. Cf. the range of equestrian portraits in Nantes 1997–98, pp. 78–81, 88 (n. 24), 103, 141.

13. Delécluze 1855 [1983], p. 233: "Plusieurs fois Bonaparte avait trouvé l'occasion, en s'entretenant avec David, de lui dire que s'il le peignait, il voudrait être représenté calme sur un cheval fougueux. Le peintre combina cette idée avec le passage des Alpes par Bonaparte, et arrêta la composition du portrait équestre de ce célèbre personnage." The succession of preparatory drawings appears to contradict this story. Another source, the recollection by the novelist

Fanny Burney of her visit to David's home in the spring of 1812, might suggest that it was already standard lore at the time: "The celebrated David was appointed to paint him [Bonaparte] on a large & grand scale, for some national exhibition. . . . The Painter consulted with him upon the choice of a subject. Bonaparté [*sic*] paused for a moment, & then said, 'Faits [*sic*] moi calme, posé, tranquil—sur un Cheval fougeux' [*sic*]" (Burney 1975, p. 621). However, these recollections were written much later, and both sources probably cite Th. 1826b, p. 107: "'Je vous peindrai, dit David, l'épée à la main, sur le champ de bataille.'—'Non, lui répondit Bonaparte; ce n'est plus avec l'épée que l'on gagne les batailles. Je veux être peint, calme, sur un cheval fougueux.'"

14. Prendergast 1997, p. 159.

15. On this medal, see Bonnaire 1937–43, vol. 1, p. 118 (David was present on 17 Apr. 1798 when Duvivier offered the medal); and Zeitz 2003, pp. 44–47, no. 7: Napoleon on horseback is crowned by a winged victory carrying the Apollo Belvedere.

16. Wildenstein 1973, p. 209, no. 1810; Schnapper convincingly rectifies the date of the document in Paris-Versailles 1989–90, p. 16.

17. In the catalogue of the 17–19 Apr. 1826 sale, item no. 5 is clearly this fifth version, described as "Bonaparte, premier consul, franchissant le mont-Saint-Bernard" (pp. 3–4); that no. 23 in the sale was a sixth version is not explicit but most likely: "Une étude au trait pour un portrait équestre de Napoléon, la figure est tracée au crayon, le contour du cheval est légèrement indiqué par un frottis à l'huile. Hauteur 8 pieds 6 pouces, largeur 6 pieds, 3 pouces [108 x 80 in.; 275 x 202 cm]" (p. 9). There is no trace of this latter *ébauche* after its appearance in the 1835 David estate sale.

18. The question of the participation of his pupils remains to be clarified; there is some confusion between those pupils who might have collaborated on the versions and those who executed copies at a later date. It has not been noted that Jean-Pierre Granger was involved in the production of a replica or a copy, according to a biographical notice by Alexandre Péron published in 1846 (cited by Naef 1977–80, vol. 1, p. 220).

Napoleon Crowning Himself, with Pope Pius VII

c. 1805

Black crayon on buff paper, with traces
of pen and brown ink
11½ x 9⅞ in. (29.3 x 25.2 cm)
Signed in black crayon, lower left:
L. David. f. [see entry below]

Musée du Louvre, Paris. Département
des arts graphiques (inv. RF4377)

Exhibited in Los Angeles only

PROVENANCE
In the absence of the initials of David's
sons, probably given by David to some-
one in his lifetime, perhaps to Ignace-
Eugène-Marie Degotti (see the entry),
whose ownership was invoked by Émile
Wattier (1800–1868), when he attempted
unsuccessfully to sell it to the imperial
museums in 1854 (Prat and Rosenberg
2002, vol. 1, p. 208, no. 198); anonymous
sale, Paris, Hôtel Drouot, 27–29 January
1863, no. 645; . . . ; collection of "M.
Cottenet" according to David 1880;
Cottenet sale, Paris, Hôtel Drouot, 16–18
May 1881, no. 51; collection of "M. Mil-
let" according to David 1882; . . . ; 1917,
acquired from "M. Sortais" or "M. Sor-
bier" (Paris 1936), perhaps an intermedi-
ary, by the museum (mark, lower right
[L. 1886a]).

EXHIBITIONS
Bucharest 1931, no. 87; Paris 1936, pp.
252–53, no. 538; Paris-Versailles 1948, p.
119, no. 115; London 1948, p. 34, no. 36;
Vienna 1950, no. 140; Paris-Versailles
1989–90, pp. 424–25, no. 173.

BIBLIOGRAPHY
David 1880, p. 660; David 1882, fascicle
16 (engraving); Saunier 1902, p. 315;
Saunier [1903], p. 77; Rosenthal [1904],
p. 77; Marcel 1919, p. 12; Saunier 1925,
pp. 16–17; Guiffrey 1926, p. 69; Saunier
1929, pp. 413, 416, 418; Cantinelli 1930,
pp. 76–77; Sérullaz 1939, no. 5; Holma
1940, pp. 80–81; Brière 1947, p. 1; Brière
1948, p. 112; Cooper 1948b, p. 963; Cas-
sou 1951, p. 44; Hautecoeur 1954, p. 205;
Sérullaz 1974, pp. 417, nn. 3–4; Schoch
1975, 80; Brookner 1980, p. 153; Schnap-
per 1980, p. 221; Newhouse 1982–83,
p. 19; Michel and Sahut 1988, p. 101;
Roberts 1989, pp. 156–57; Sérullaz 1991,
pp. 49, 167–68 (no. 208), 320; Johnson
1993a, pp. 200–201; Prendergast 1997,
pp. 41–42; Lee 1999, pp. 245, 249;
Berthod 2000, p. 12 n. 13; Prat and
Rosenberg 2002, vol. 1, p. 208, no. 198.

THIS DRAWING, one of the artist's cele-
brated, is preparatory for *The Coronation of
Napoleon and Josephine* (FIG. 26) commissioned
from David in 1804, at the time of the ceremony.
It corresponds exactly to the subject of the first
scene he proposed to represent, as he detailed it to
Pierre Daru, the imperial dignitary in charge of
overseeing the arts, in June 1806, when he claimed
the picture was already half done. Napoleon is
shown crowning himself and pressing his sword to
his heart, a gesture meant to express unequivocally
the military rationale of his political power: "he
who has been able to conquer [the crown] will be
just as able to defend it" (see the essay "In the
Service of Napoleon" in this volume). As observed
by Prat, the strict alignment of suspended crown
and sword is an emblematic construct echoing that
of David's portrait of Le Peletier de Saint-Fargeau
painted in 1793. That the sword resembles closely
the ceremonial glaive of the members of the
Directory, whose authority Bonaparte had appro-
priated for himself, activates another symbolic
association.

The contrast between the energetic figure of
the emperor and the passive figure of the pope,
intensified by their mute and blind proximity, has
often been noted. It would be wrong to suppose
that David sought to belittle Pius VII, for whom
he expressed his admiration and whose benevolent
features somewhat obsessed him, as suggested by
the drawn portraits he replicated until the end of
his life. In the *Coronation* the pope assumes the
role of the absorbed sage, the seated philosopher
who more profoundly than all present under-
stands the portent of the historical event—much
as Sieyès in the *Oath of the Tennis Court.* It may
look most uncomfortable, but the curule chair,
whose zoomorphic design has been attributed to
Jacob, was known to be an ancient privilege of
Roman magistrates. It should be noted that in

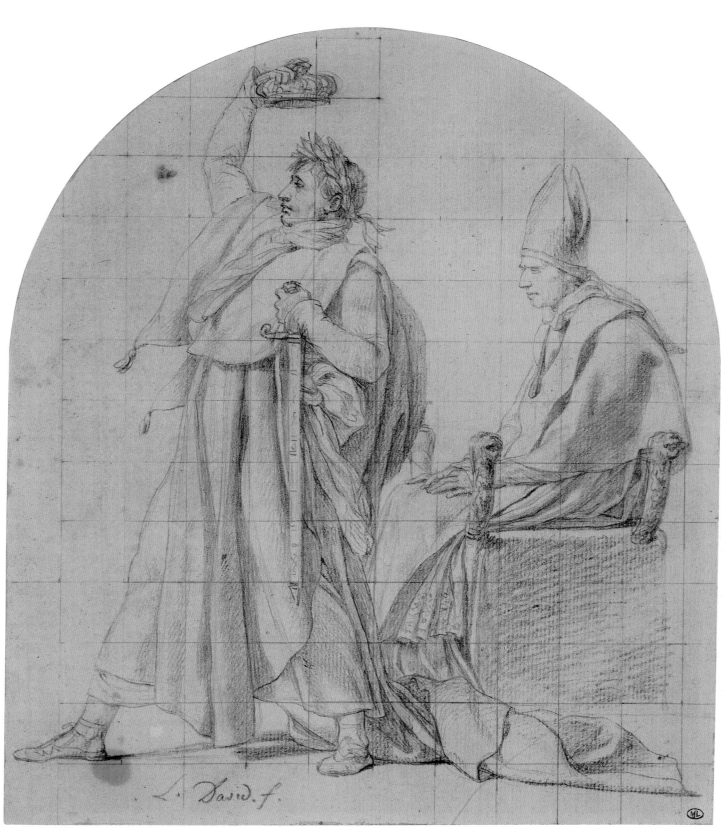

David f.

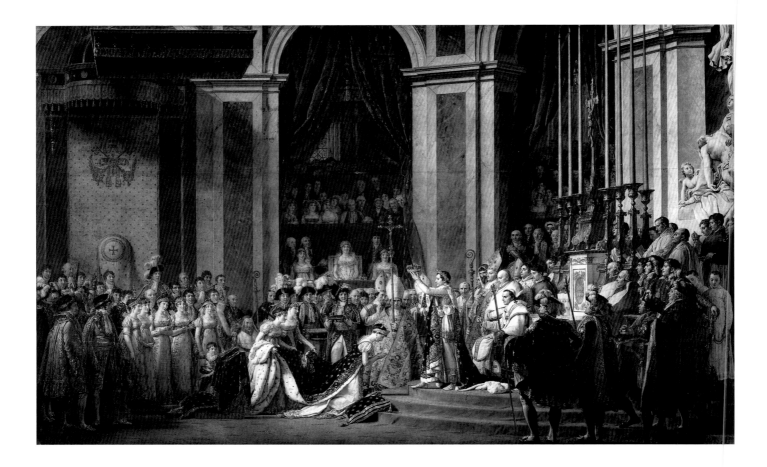

Paris Pius VII weathered the hostility not only of hard-line Jacobins irritated that the government should court the head of the Church, but also of royalists who objected to the sanction that his presence conferred on the farce of the coronation. The absence of a narrative liaison between Pius VII and Napoleon nonetheless demands an explanation, especially since it incited the emperor, after his inspection of the painting in January 1808, to demand that David show the pope blessing the imperial couple. This in fact had been David's initial idea, to have him turn toward the viewer and draw greater attention, as evidenced in the finished preparatory drawing dated 1805 (FIG. 27), which was probably submitted to Napoleon shortly after it was produced. David pared down the scene as the composition evolved. A number of decorative motifs were eliminated, and as the groups were rearranged, the figure of the emperor gained in stature and centrality. To not undermine this focus, David may have felt that a more removed and self-contained representation of Pius VII was in order. The classicizing aesthetic commonly attributed to David in his *Sabines* and *Leonidas,* the predilection for a profile view and

for the visual autonomy of each figure, was also operative in the *Coronation.* When composing the scene for the *Livre du Sacre,* Isabey manifested a similar indecision. In one preparatory drawing representing the self-crowning, the pope raises his right hand high, as if he leads or imitates the gesture of the emperor standing to his side. But in the engraved composition, he joins his hands more discreetly during the one-man show.[1]

The self-crowning image of Napoleon has been called provocative (Sérullaz), arrogant (Johnson), and even brutal (Prat). The fact that in the final composition—and very late it would seem— David changed the pose and substituted a more restrained image of the emperor holding the crown over the empress has served to justify this negative reading. Attentiveness to Josephine was indeed a more chivalrous conception, but as some contemporaries noted with regret, it emptied the ceremony of its true signification: the grand representation no longer tackled head-on the problematic foundation of the new regime, but suffered a kind of semiotic dilution, leaving the spectator only with the lukewarm impression that Napoleon, in spite of all the glitter, was a simple

FIGURE 26 Jacques-Louis David, *The Coronation of Napoleon and Josephine,* 1805–8. Oil on canvas, 20 ft. 8 in. x 32 ft. 1 in. (629 x 979 cm). Musée du Louvre, Paris

family man. Whereas the initial proposition was political, the final image takes refuge in the social register. The severe censorship imposed by the imperial regime on political speculation may have been a decisive factor in this change of mind, although it need not have been conscious on the part of the painter and his entourage. In the immediate aftermath of the ceremony of 2 December 1804, the self-crowning of the emperor was an unambiguously positive image rapidly diffused by the press and authorized prints. The *Journal des débats* of 5 December established the official report: "When the emperor was at the altar for his crowning, he himself seized the imperial crown and placed it on his head: it was a diadem of oak and laurel leaves made of gold. [His majesty] then took the crown prepared for the empress, and after adorning himself with it for just a moment, he placed it on the head of his august spouse."[2] Isabey spontaneously chose to illustrate the self-crowning for the *Livre du Sacre.* The prints suggest that three moments of the coronation ceremony were thus codified: the unction of the emperor administered by the pope, the self-crowning of the emperor, and his crowning of the empress. In one woodcut, representing all three subjects, the self-crowning in the center compartment figures unquestionably as the climax of the ceremony.[3] These images, probably put on the market within weeks or a couple of months after the event, ori-

ented David's reflection both early on and at a later date when the decision was taken to modify the central figure.

The pressure of this iconographic codification was strong, since at no time did David envision following the suggestion made in the *Journal des débats* on 16 December 1804, less than two weeks after the ceremony, to highlight the emperor's oath: "I venture to imagine that among the imposing scenes to choose from, [David's] imagination will have focused on the moment when the emperor pronounced these words, with the aura of a hero and a king: I swear to exercise my authority for the welfare and the glory of the nation."[4] This oath may have accompanied the self-crowning, and it was a familiar theme for the painter, but such a narrative would have dulled the visual impact of the scene, which is effective because it is mute. The prints probably also deterred David from retaining another idea with which he experimented in a sketchbook: Napoleon crowned with laurels, holding the sword to his chest as in this drawing, but with the other hand pointing to the heavens (FIG. 28).[5] This may have been a very early option discarded in favor of the self-crowning. However, this alternative may signify an unease with respect to that radical moment of political solitude: the annotation, *dieu et mon épée,* resonates like a Freudian slip echoing the royalist cry of the Vendéens during the 1793–94 civil war, *dieu*

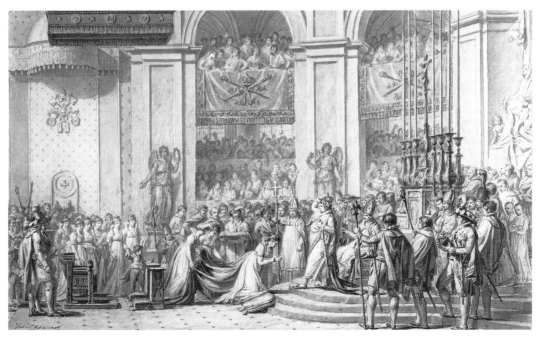

FIGURE 27 Jacques-Louis David, *Preparatory Drawing for "The Coronation of Napoleon and Josephine,"* 1805. Pen, brown ink, and brown wash on paper, 10⅛ x 16 in. (25.8 x 40.5 cm). Fondation Napoléon, Paris

a later date. The reproductive engravings tend to heighten the contrasts and legibility of the originals, but the one after this drawing reveals the degree of wear the sheet had suffered, especially in the head of the pope, over a century.

NOTES

1. The observation is made by Roux, who mentions another preparatory drawing corresponding to the engraving (1969, p. 362).
2. "Lorsque l'Empereur s'est présenté à l'autel pour son couronnement, il a pris lui-même la couronne impériale et l'a posée sur sa tête: c'était un diadème de feuille de chêne et de lauriers en or. S[a] M[ajesté] a pris ensuite la couronne destinée à l'Impératrice, et après s'en être lui-même un instant décoré, il l'a déposé sur la tête de son auguste épouse." *Journal des débats,* 5 Dec. 1804, p. 3. Published amid diverse information, this brief text manifestly was intended to codify the event.
3. Roux 1969, pp. 362–66, no. 7908 (after Isabey), no. 7909 (benediction or unction, in fact Pius VII crowning Napoleon), nos. 7910–12 (self-crowning), nos. 7919–21 (crowning of Josephine), no. 7922 (the three subjects together). Todd Porterfield brought the latter to my attention.
4. "J'oserais imaginer que dans ce choix de scènes imposantes, son [David's] imagination se sera fixée sur le moment où l'Empereur a prononcé avec l'âme d'un héros et l'âme d'un bon roi, ces mots: Je jure d'employer mon pouvoir pour le bonheur et la gloire de la nation." *Journal des débats,* 16 Dec. 1804, p. 4 (anonymous article, "Avis aux peintres de l'école française"). This text, mentioning David's presence during the ceremony and urging Gérard, Girodet, Fleury Richard, Carle Vernet, and Guérin to celebrate the pageantry, was kindly brought to my attention by Mehdi Korchane.
5. Prat and Rosenberg 2002, vol. 2, p. 1053, no. 1643v.
6. Prat and Rosenberg 2002, vol. 2, p. 1057, no. 1651r; Sérullaz in Paris-Versailles 1989–90, 424, no. 173, fig. 115.

et mon roi. So it may date from much later, when the main figure was revised, once the picture was finished, especially since the fulsomeness and confidence of the nude drawn by David betrays a late stage of acquired familiarity rather than an early exploration, while the annotation carries the traditional values of the *chevalier français* that imbue the scene of the crowning of Josephine, his final choice.

Despite the squaring for transfer to the canvas, David actually painted a composite figure of the pope. Instead of the bishop's miter with the lappets hanging from the back, he adopted the more humble white *zucchetto,* or skullcap, which he included in another squared drawing found in one of his sketchbooks, a striking anatomical study of the Pius VII nude on his curule chair, either posed by a model or invented. David transferred this more expressive image of the pope, whose tousled hair seems to flow out from under the small cap.[6]

Although the signature on the drawing conforms to the artist's handwriting, it should be noted that the engraving edited by Jules David in 1882 does not reproduce it. Since all the inscriptions and even the initials of David's sons are scrupulously reproduced for the other drawings in this corpus, it is possible that it was forged at

FIGURE 28 Jacques-Louis David, *Figure of Napoleon for "The Coronation of Napoleon and Josephine,"* 1804–6. Black crayon and graphite, squared in black crayon, on off-white antique laid paper, 9 3/8 x 7 in. (23.7 x 17.9 cm). Fogg Art Museum, Harvard University Art Museums, Cambridge, Massachusetts. Bequest of Grenville L. Winthrop

6 Study for *The Coronation of Napoleon*: The Bust of Madame de La Rochefoucauld and the Hand of Eugène de Beauharnais

c. 1805–7

Oil on canvas
21¼ x 17⅜ in. (54 x 44 cm)

Musée Fabre, Montpellier (inv. 876.3.27)

PROVENANCE
Jacques-Noël-Mary Frémy (1784–?), pupil of David and Regnault; his sale, Paris, 20 Jan. 1859, no. 1; . . . ; the publisher Jules Claye; around 1874, through the critic Théophile Silvestre, sold or given by him to Alfed Bruyas (1821–1877); 1876, donated to the museum by Bruyas.

EXHIBITIONS
Paris 1939, no. 35; Paris-Versailles 1948, pp. 87–88, no. 58; London 1948, p. 39, no. 47.

BIBLIOGRAPHY
Burty 1859, p. 187; *Album de la Galerie Bruyas,* Paris, 1875, pl. 14 (lithograph by Jules Laurens, "Études pour le tableau du Sacre"); Gonse 1900, vol. 1, p. 221; Joubin, 1926, p. 146 no. 455; Cantinelli 1930, p. 111, nos. 113, 115 (catalogued twice); Holma 1940, p. 128, no. 123; Hautecoeur 1954, p. 203; Schnapper 1980, p. 235, fig. 140; Bleyl 1982, pp. 111, 175 n. 281, 222; Schnapper in Paris-Versailles 1989–90, pp. 410, 419 (copy); Prat and Rosenberg 2002, vol. 2, p. 1055 (reference to Schnapper).

THE PAINTING corresponds to the figure in the *Coronation* of Adélaïde-Marie-Françoise Pyvart de Chastullé (1769–1814), who in 1788 married the second son of the duc de La Rochefoucauld-Liancourt, Alexandre comte de La Rochefoucauld. Her family, from Santo Domingo, was allied to the Beauharnais, which may explain how she became *première dame d'honneur de l'Impératrice.* In the *Coronation* she stands in a prominent position, as the foremost of the two ladies-in-waiting holding the train of Josephine's dress. David shows her bending forward with deference, a Goya-like artifice to dissimulate the fact that she was somewhat hunchbacked.[1] To the right of the study, on a slightly larger scale, is a man's hand resting on the hilt of a sword, in the composition the hand of Eugène de Beauharnais (1781–1824), Josephine's son from an earlier marriage, who appears placed just above Talleyrand on the far right. In the *Coronation* this detail inspires an anecdotal insert, with an altar boy distracted from the ceremony and engrossed by the splendid saber of the prince. Snugly fitted in the lower right corner of the Montpellier canvas, Eugène's hand was manifestly executed after the bust of Madame de La Rochefoucauld had been painted in, slightly off center to the left. But were these two studies painted by David or by someone copying the finished picture? The touch is light and assured, in a sense closer to the Venetian colorism of Gros than to the firm manner adopted by David and his assistants when executing the large canvas. However, one would have expected a copyist to be more submissive (academic) or more personal (romantic): the handling is more in the spirit of the eighteenth century than of the nineteenth. That a copyist should have chosen these two secondary details, situated about two meters above the lower edge of the final picture, rather than more prominent historical figures, is difficult to justify. Often the author of a copy betrays a misunderstanding and hence a misinterpretation of the model, such as anatomical structure, articulation of parts, or

iconographic detail: there is no sign of such a discrepancy here. The relative freedom of handling is never an occasion for confusion. It can be added, finally, that the insouciant disparity of these haphazardly assembled studies is a trait of strikingly original works from Rigaud and Largillière down to Ingres, and quite alien to the pedagogical motivations and applied aesthetics of the copy.

In 1989 Antoine Schnapper, in charge of the painting selection for the great retrospective of David's work organized that year in Paris and Versailles, chose to not include this picture, which he dismissed "without the shadow of a doubt" as a "fragmentary copy . . . mistakenly considered a preparatory sketch."[2] As this was the first time David's authorship had been rejected, it is surprising that this position, peremptorily grounded on connoisseurship, has since neither been supported nor contradicted. The inclusion of the painting in the present retrospective reflects the favorable impression it made when examined in its home base and the need to test that reaction by confronting it with pictures known with certainty to have been executed by the artist.

If David is indeed the author, one possible motive he might have had to accord special attention to the head of Madame de La Rochefoucauld and Eugène's hand was the fact that both were subjected to important modifications with respect to the compositional drawing dated 1805 (SEE FIG. 27). The *dame d'honneur* initially sported a rather gaudy feather coiffure, which obscured a good part of her head, while the prince was not yet represented with the arm outstretched behind him, his hand in full view. The anecdote with the altar boy further accrued the importance of his figure.

This work, however problematic, offers an occasion to discuss the artist's method when painting the great number of portraits, around two hundred, that figure in the two coronation scenes. It has often been a source of astonishment

to art historians that David should not have produced portrait studies in relation to the *Coronation* and the *Eagles*.[3] When painting the *Oath of the Tennis Court* (1790–91), he painted about eight individual heads of the major figures. Since he did not finish the picture, it is not known whether he would have pursued this mode. With the *Coronation,* that he portrayed his models directly onto the huge canvas is suggested not only by the absence of painted head studies, but also by knowledge of his usual practice. According to a note jotted down in one of his sketchbooks, he painted the heads and limbs of the male figures in the *Oath of the Horatii* (1784–85) directly from the model placed next to the canvas.[4] When planning the *Oath of the Tennis Court,* he had invited the participants in the event to send him engraved portraits or to drop by his studio.[5] For the *Coronation* and the *Eagles* also, he was willing to work after a portrait if the model was unavailable,[6] but surely he preferred to paint from life. As Schnapper has noted, David recalled that when executing the first scene, "everyone rushed to come and model for their portrait in my picture," a record perhaps embellished over time. Desirous to modify the head of the cross bearer after that of his collaborator Degotti, in charge of the architectural perspective, he pleaded for only two hours of his time, the same sitting he requested of Talleyrand. Finally, when addressing a minor participant who was partially hidden from view by his neighbors, he even cut it down to a half-hour.[7]

When the picture went through the saleroom in Paris in 1859, the critic Philippe Burty was distraught that only twenty-five francs were offered for it, whereas a pastel by Greuze he characterized as *farineux* (mealy) fetched over eight times that price. Although correctly identified at that time, the figures had lost their identity by 1874. Théophile Silvestre, when preparing in Paris the album and the catalogue of the Galerie Bruyas that year, wrote to the Montpellier collector about the picture presently in his collection as an image of Josephine and the hand of Bonaparte from around 1800. The detailed description he transmitted to Bruyas suggests that the latter had not yet seen it, so it was probably a recent acquisition.[8]

NOTES

1. "Madame de La Rochefoucauld, première dame d'honneur de l'Impératrice, était bossue et tellement petite qu'il fallait, lorsqu'elle se mettait en table, ajouter au coussin de sa chaise meublante un autre coussin fort épais en satin violet. Madame de la Rochefoucault [*sic*] savait racheter ses difformités physiques par son esprit vif, brillant, mais un peu caustique, par le meilleur ton et les manières de cour les plus exquises." Constant 1830, vol. 2, pp. 154–55.

2. "Quant à l'esquisse de *Mme de La Rochefoucauld* (Montpellier), généralement acceptée (y compris par moi-même, 1980), ce n'est sans l'ombre d'un doute qu'une copie" (p. 410). "Copie fragmentaire . . . considérée à tort comme une esquisse" (p. 419).

3. Schnapper found unconvincing the attribution of two portrait studies that have in the past been considered preparatory to the *Coronation* (Paris-Versailles 1989–90, p. 410). Indeed, the profile portrait of *Duroc,* in the Musée Bonnat in Bayonne, was already recognized as a study for a Napoleonic subject by Girodet (Ducoureau 1988, p. 88). However, the *ébauche* of *Junot, Duc d'Abrantès,* in a private collection and probably seen by few, should not be condemned without a trial; on the basis of a poor reproduction, it appears to merit attention.

4. Prat and Rosenberg 2002, vol. 2, p. 918, no. 1367r.

5. Bordes 1983, p. 54.

6. Wildenstein 1973, p. 172, no. 1482 (letter from David, 3 July 1806, requesting a portrait of Metternich from which to paint his figure in the *Coronation*). Denon 1999, vol. 1, p. 658, no. 1884 (letter from Denon, 21 Aug. 1810, requesting a portrait of the deceased duc de Montebello from which David might paint his figure in the *Eagles*).

7. Schnapper in Paris-Versailles 1989–90, pp. 405 ("on s'empressa de venir se faire peindre dans mon tableau"), 410. The last reference (see the full text of David's letter: Wildenstein 1973, p. 169, no. 1458 [second item]) concerns a participant described as a friend of David's pupil from Lyons, Fleury Richard, "M. de Charette," whose identity remains mysterious.

8. Paris, Bibliothèque Jacques Doucet (Institut national d'Histoire de l'Art), Silvestre-Bruyas correspondence, MS 215, no. 119, Silvestre to Bruyas, 27 Apr. 1874.

7 Napoleon Bonaparte

c. 1806–8

Oil on panel, with strips of wood added on all four sides
Main panel: 15⅞ x 12⅜ in. (40.5 x 31.6 cm); overall: 17⅛ x 14¼ in. (43.5 x 36.1 cm)

Collection Frédéric Masson, Fondation Dosne-Thiers, Institut de France, Paris (inv. T. 184)

PROVENANCE
. . . ; Collection of Frédéric Masson (1847–1923); bequeathed by him to the Fondation Dosne of the Institut de France, with a usufructuary restriction in favor of his wife, who died in 1932.

EXHIBITIONS
Tokyo 1987–88, no. 54; Genoa 1999, 446–47, no. XVI.7.

BIBLIOGRAPHY
Schnapper 1980, p. 242; Bordes and Pougetoux 1983, pp. 25–26, n. 27.

THIS BOLDLY direct portrait, whose early provenance remains a mystery, was found by Antoine Schnapper among the disparate Napoleonic works of art and *souvenirs historiques* collected by the historian Frédéric Masson. In 1980 he recognized the probable link with the two official portraits David was commissioned to paint, in 1805 for the courthouse in Genoa and in 1808 for the royal palace in Kassel, in the Kingdom of Westphalia, created in 1807. The point of departure for the first enterprise (a painted panel in Lille, dated 1805; SEE FIG. 10) is well established, as is the definitive composition for the second, which can be determined from a copy in Kassel (FIG. 29). How the two portraits interrelate remains, however, the object of a debate, as evoked above in the essay "In the Service of Napoleon," since the im-

age devised for the second commission may have been a revised proposal for the first. Notwithstanding this uncertainty, it is clear that the head study corresponds to the composition for Kassel. The fulsome carnality attributed to Napoleon also suggests a date later than that of the Lille figure, whose features are more angular. The costume is that of the *grand habillement* decreed for the coronation: the ermine mantle with a gold-embroidered collar, which formed part of the opulent ermine-lined coat, the lace cravat, the diadem made of gold leaves, and the gold chain of the Legion of Honor are standard in official portraits of the emperor.

FIGURE 29 Sebastian Weygandt (German, 1760–1836), after Jacques-Louis David, *Napoleon I in Imperial Robes*, 1808. Oil on canvas, 46 x 34⅝ in. (117 x 88 cm). Staatliche Kunstsammlungen, Kassel, Germany

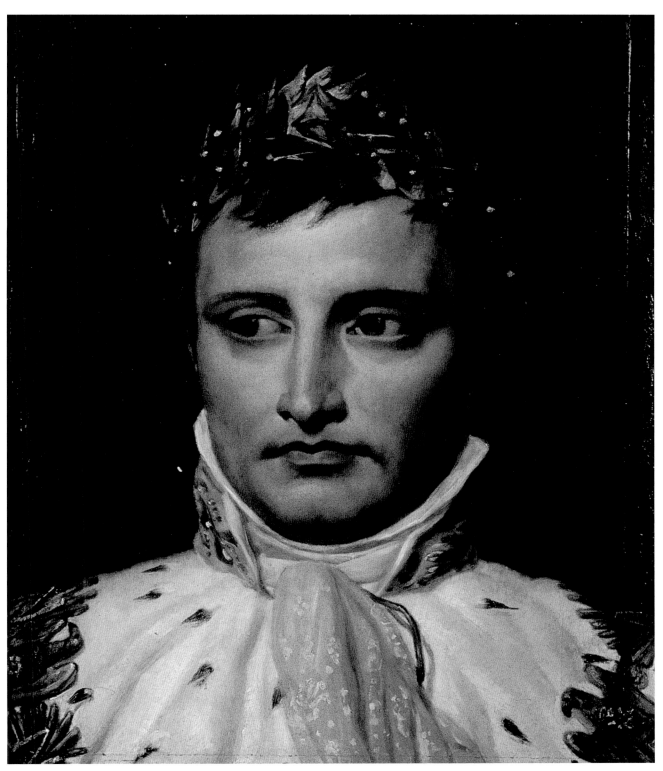

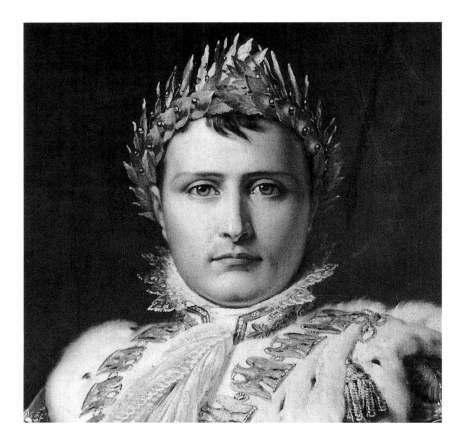

David might have wanted to furnish a critical response to Gérard's highly appreciated image of Napoleon in coronation robes, first painted for the Ministry of Foreign Affairs in 1805 and often replicated (FIG. 30). Probably unable to secure sittings, he borrowed from Gérard the pleasant oval proportions of the face he had canonized. But he sought to infuse force and meaning to the inert expression of Gérard's transcendent figure. Instead of an other-worldly fixity, mobility and vivacity characterize the eyes, given a sharp lateral turn. David seems challenged to affirm physiognomic expression while respecting the straight-laced dignity of the sitter. In Gérard's portrait Napoleon is dressed with more ostentation, sporting a fancier cravat and a disproportionately large crown. David treats these details with greater sobriety, a choice reflecting the taste in decoration he promoted during the Empire. He even re-designed the chain, preferring to the succession of eagles usually represented, alternating medallions with eagles and the identifying letter *N*, an idea he may have borrowed from Isabey.[1]

Set off against a dark background, modeled with a sense of chiaroscuro that is restrained but firm, and painted with a loaded brush, the head possesses an strong presence. Although there is a suggestion of Rubensian ruddiness in the cheeks and lips, which individualizes the figure, the impression of a marmoreal impassivity, evocative of a Roman bust, projects it into the realm of history. That the close-cropped format corresponds to the function of the head as a study for a larger portrait, and as a model for the eventual production of replicas by assistants, does not mean that David could not consider it a self-sufficient work of art. Bridging the span between the *tête d'expression* he had practiced during his early academic training and the concentrated studies and compositions he developed toward the end of his life in Brussels, this terse image of Napoleon is profoundly classical in spirit.

NOTES

1. On the various motifs adopted for the chain of the Legion of Honor, see Paris 1968, *"Grand collier de l'ordre,"* between nos. 278 and 279. The motif in David's picture is found on a shoulder belt after a design by Isabey (Paris 1969, p. 59, no. 178).

FIGURE 30 François Gérard, *Napoleon I in Imperial Robes* (detail of fig. 7)

8. Study for *The Distribution of the Eagles:* Napoleon in Imperial Robes
c. 1808–10
Black crayon on paper
9⅞ x 7¾ in. (25 x 19.7 cm)

Musée national du Château de Versailles
(inv. MV7689; Dess[in] 905)

Exhibited in Williamstown only

PROVENANCE
1826, in David's possession at his death
(initialed by son, Eugène, lower right
[L. 839]); possibly, David sale, Paris,
17–19 Apr. 1826 (originally part of a
sketchbook, detached before 1877, see
the entry); . . . ; the dealer Otto Wert-
heimer (1878–1972); 1949, acquired from
him by the museum.

EXHIBITION
Paris-Versailles 1989–90, pp. 464–65,
no. 193.

BIBLIOGRAPHY
Prat and Rosenberg 2002, vol. 1, p. 274,
no. 286.

9. Study for *The Distribution of the Eagles:* Dragoon Raising an Eagle
c. 1808–10
Black crayon on paper
9 x 6⅞ in. (23 x 17.7 cm)
Annotation in ink, upper right: *24*

Musée national du Château de Versailles
(inv. MV7691; Dess[in] 906)

Exhibited in Williamstown only

PROVENANCE
1826, in David's possession at his death
(initialed by son, Eugène, lower center
[L. 839]); possibly, David sale, Paris,
17–19 Apr. 1826 (originally part of a
sketchbook, detached before 1877, see
the entry); perhaps Eugène David
(1784–1830), since in 1880 in the collec-
tion of his son, Louis-Jules David-
Chassagnolle (1829–1886); . . .; the
dealer Otto Wertheimer (1878–1972);
1949, acquired from him by the
museum.

EXHIBITION
Paris-Versailles 1989–90, p. 471, no. 202.

BIBLIOGRAPHY
David 1880, p. 661; David 1882, fascicle 17
(engraving); Prat and Rosenberg 2002,
vol. 1, p. 279, no. 295.

10. Study for *The Distribution of the Eagles:* Sapper-Grenadier of the Guard
c. 1808–10
Black crayon on paper
9⅞ x 7¾ in. (25 x 19.7 cm)
Annotation in pencil by David, lower
left: *de Songis;* annotation in ink, upper
right: *15*

Musée national du Château de Versailles
(inv. MV7690; Dess[in] 419)

Exhibited in Williamstown only

PROVENANCE
1826, in David's possession at his death
(initialed by son, Eugène, lower right
[L. 839]); possibly, David sale, Paris,
17–19 April 1826 (originally part of a
sketchbook, detached before 1877, see
the entry); . . .; the dealer Otto
Wertheimer (1878–1972); 1949, acquired
from him by the museum.

EXHIBITION
Paris-Versailles 1989–90, pp. 471, no.
201.

BIBLIOGRAPHY
Van der Kemp 1963, p. 310; Schnapper
1980, p. 259; Prat and Rosenberg 2002,
vol. 1, p. 280, no. 296.

ALTHOUGH MODEST in scale, these three draw-
ings possess some of the élan and energy that
characterize the vast composition of the *Distribu-
tion of the Eagles,* a canvas measuring about six by
ten meters, on which David worked from 1808 to
1810 (FIG. 31). This was the military sequence of the
coronation events the first painter proposed to
commemorate. On 5 December 1804, three days
after the main ceremonies in presence of the
pope, Napoleon staged the oath of allegiance of
the troops to his person and the exchange of the
flags from the republican campaigns for the new
imperial "eagles," as the regimental banners were
now to be called. After David completed the scene
of the crowning in Notre-Dame, he was told to
put aside the project of illustrating the civic recep-
tion at the Hôtel de Ville, and to devote himself to
the oath of the Grande Armée to the emperor.
Because of the international situation, the latter
found it opportune to mobilize public opinion to
support the army (see the essay "In the Service of
Napoleon" in this volume). David no doubt con-
sidered the scene as a variation on a theme that
was comfortable, since he had imagined an austere
antique version in the *Oath of the Horatii* and had
composed a tumultuous contemporary one with
Oath of the Tennis Court. He had mastered the
demands of imperial pageantry by painting the
Coronation. The challenge lay probably in the
need to invent, with respect to that first scene, a
different and complementary image of Napoleon
and his court. He was also confronted with the
staging of military actors and their distinct para-
phernalia, implying the adoption of a descriptive
mode that was not natural to the history painter.
Finally, the need to recreate the outdoor setting,
the play of sunlight and an aerial perspective, was
also new to him. To respond to this last obligation
he introduced a dramatic contrast of light and
shade in the painting and a cool Vernet-like sky,
today dulled by a coat of dirty, yellowed varnish.

CATALOGUE 8

21

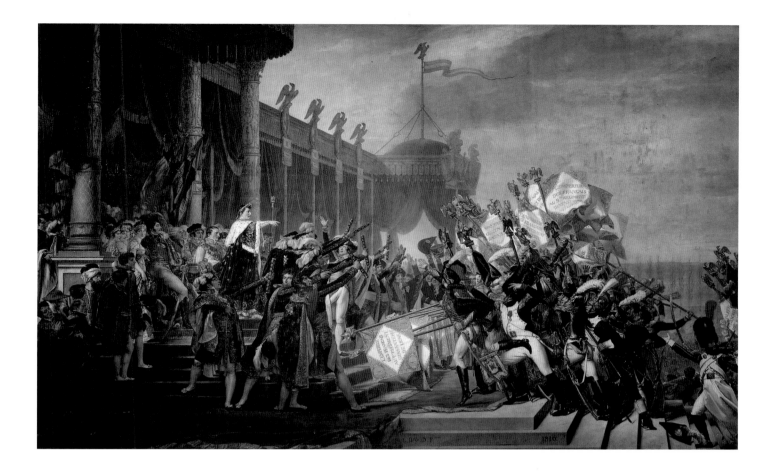

FIGURE 31 Jacques-Louis David, *The Distribution of the Eagles (The Oath of the Army Made to the Emperor after the Distribution of the Eagles at the Champ de Mars)*, 1808–10. Oil on canvas, 20 ft. x 31 ft. 10 in. (610 x 970 cm). Musée national du Château de Versailles

On the steps of Percier and Fontaine's formidable staircase leading up to the monumental portico and colonnade, hung with drapery, David developed the themes of a modern *adlocutio,* the traditional scene of the Roman emperor haranguing his troops.[1] At one point early on he decided to draw out the composition laterally and show the emperor prominently in the center of a protective group of court dignitaries and imperial marshals. The squared drawing for the figure of Napoleon is almost definitive. When the painter transferred it to the canvas he gave more weight to the golden crown of laurels and more amplitude to the great cloak. He redrew the extended right arm, so crucial for the success of the visual narrative, to convey more strongly the sense of authority and force. It was David's practice when painting a figure to place the model—here whoever was standing in for the emperor—so that he could view frontally whatever part of the body on which he was focusing. Hence the impression that the emperor's head is seen from below in the drawing is revised in the painting, replaced by a more majestic profile. In the idealizing process, the naturalistic detail of Napoleon's neck disappears.

The dragoon is easily identified by his distinctive headdress, a copper helmet à la Minerva worn tilted back and wrapped in a turban with a panther motif. David concentrates on the pose of the figure on the stairs, bracing himself to raise the eagle. The representation of arrested movement is David's fundamental objective here, and for the whole group of officers on the right of the composition; taking his cue from the antique, by attributing to each figure a dynamic and yet stable pose, he hopes to suggest movement. In the finished compositional drawing dated December 1808, the group of officers is placed on a stage-like landing, which justifies their coming to a halt; in the final composition their advance is not yet checked. The foremost hussar, who darts in the air like Giambologna's *Mercury,* assumes the metaphorical leadership of all the other figures, who are trapped in an inextricable visual deadlock. David was unable to imagine a middle ground between the weightless hussar and the carefully positioned officers. His artistic practice, notably the need to study each figure individually, and his monumental vision reveal here their limits. The irregular contours, clashing eagles, and imbricated bodies

are perfectly effective in suggesting an intense animation, but it is chaotic and petrified. That the signs of movement attain such point of excess was not disturbing in itself, since Girodet proved that this range of expression could be confronted with confidence at the time; however, it called into question David's classical principles.

The figure studied in the third drawing appears on the extreme right border of the composition. His narrative role is to suggest the advent of a second group of officers, whose eagles are visible over his head: isolated and posed on the stairs, he gestures in the direction of the emperor, but turns his head to address those that follow. David is dialoging here critically with Gros's *Bonaparte at Arcole* (SEE FIG. 3), which represents a comparable action. To the dynamic twist of the arm and flag and the resulting fragmentation of the body adopted by his pupil, David prefers an elegant and almost balletic pose. Though already present in the preparatory drawing, the figure gains in prominence and acquires a distinctive identity only in the final version. The white leather apron he wears designates him here as a *sapeur*, who with his axe had the rude task of breaking down enemy fortifications. The fireball of the *grenadier* on his belt buckle associates him with that regiment. David makes the most of the formidable *bonnet à poil* or *bonnet d'ourson*, which transformed such officers into giants.[2] As David's annotation indicates, he associated this figure with Nicolas-Marie, comte de Songis des Courbons (1761–1810), who retired as general in the artillery in 1809 on account of bad health. Although Songis was not a *sapeur*, giving his features to the figure reflected perhaps a commemorative purpose.

The three drawings, along with a fourth for the *Distribution of the Eagles*,[3] were acquired together from a dealer in 1949. They were all taken out of the sketchbook today in the Art Institute of Chicago (SEE CAT. 11), as observed by Prat and Rosenberg, on the basis of a complementary detail and a counterproof of *Napoleon* on one of the folios and various numbers on all three, inscribed before they were detached. According to his catalogue listings, Jules David possessed the *Dragon* in 1880, and perhaps also *Napoleon;* one wonders if the four sheets formed a group well before 1949.[4] This is of interest to determine the date at which they were removed from the sketchbook. Prat and Rosenberg suspect that the folios were missing by the time of its sale in 1893 with the collection of Hippolyte Destailleur, who had acquired it in 1877.[5] Since Jules David does not list Destailleur's sketchbook in his catalogue, it was presumably unknown to him and it can be assumed his sheets were already detached when the collector bought it.

NOTES

1. See the two drawings in one of his sketchbooks (Prat and Rosenberg 2002, vol. 2, p. 1034, nos. 1606–7), which are free variations of *adlocutio* scenes from Trajan's column (scenes 44 and 77, in particular).
2. On the complicated question of military uniforms, see the thorough but occasionally confusing entry by Raoul Brunon in Tulard 1999, vol. 2, pp. 886–902.
3. Prat and Rosenberg 2002, vol. 1, p. 279, no. 294.
4. In their entry for the study of *Napoleon*, Prat and Rosenberg, as does Sérullaz in Paris-Versailles 1989–90, indicate that Jules David owned it, without founding the affirmation. In 1880 Jules David catalogued "Un livre de croquis de 27 pages" in his collection, comprising sixteen studies for the *Eagles*, including "Un croquis, Napoléon en habits impériaux" (p. 662, with the indication of other subjects). There may be a relation between this sketchbook, one of the three for the *Eagles* in the 1826 David sale (no. 76), and the lost sketchbook, which was in the duc de Trévise's collection between the two wars (see Prat and Rosenberg 2002, vol. 2, pp. 870, 872, 1224, 1227).
5. Prat and Rosenberg 2002, vol. 2, p. 1092.

I I Sketchbook with Sixty-five Folios (Studies for the *Distribution of the Eagles* and other sketches)

c. 1809 (certain sketches are earlier, see the entry)

Sketchbook: 9¼ x 8 in. (25.3 x 20.4 cm); folios: 9⅝ x 7¾ in. (24.3 x 19.2 cm)

The Art Institute of Chicago. The Helen Regenstein Collection (inv. 1961.393)

11A. Study for *The Distribution of the Eagles:* The Empress Josephine (fol. 11r)
Black crayon on paper
Annotated in black crayon by David:
S. M. L'Impératrice d'après nature;
initialed by the artist's son Eugène
David, lower center (L. 839)

11B. Portrait of Angélique Mongez (fol. 39r)
Black crayon on paper
6⅛ x 4 in. (15.6 x 10.4 cm); the smaller drawing pasted on the blank folio has been detached
Signed and dated, lower left: *David / 31 8ᵇʳᵉ 1806;* unidentified collector's mark, *G.C.* in an oval, lower right (L. 1142)

PROVENANCE
In David's possession at his death (most but not all folios are initialed by one or both of his sons, Jules David [L. 1437] and Eugène David [L. 839]; among the sketchbooks listed in David's death inventory in Feb. 1826 [Wildenstein 1973, p. 237, no. 241, item nos. 25, 26, 27?]); David sale, Paris, 17 Apr. 1826, probably no. 77 (cf. no. 68, 76, 78); . . . ; at an unspecified date, collection of Prince Napoleon Bonaparte (1822–1891), son of Jérôme; 1877, acquired by Hippolyte Destailleur (1822–1893); his sale, Paris, Hôtel Drouot, 26–27 May 1893, no. 29, bought by "Morgand"; . . . ; F. Martinet

sale, Paris, Hôtel Drouot, 25 Apr. 1896, no. 92; . . . ; David David-Weill (1871–1952); . . . ; New York, Wildenstein and Company; 1961, acquired by the museum for The Helen Regenstein Collection.

EXHIBITIONS
New York 1963, no. 67 (sketchbook), no. 70 (fol. 39); Paris-Versailles 1989–90, pp. 462–64, no. 192 (sketchbook), and p. 480, no. 209 (fol. 39) (entries by A. Sérullaz).

BIBLIOGRAPHY
Dowd 1948, 195; Calvet-Sérullaz 1969, p. 68 n. 4; Joachim 1974, 120–21, no. 59; Sérullaz 1974, p. 417 n. 3; Joachim 1977, pp. 61–70; Schnapper 1980, pp. 250, 256–57; Sérullaz 1980a, p. 104 n. 11; Sérullaz 1980b, pp. 104, 107 (n. 13), 108 (n. 22); Bleyl 1982, p. 174 n. 276; Prat and Rosenberg 2002, vol. 2, pp. 1092–1110 ("Carnet 10").

T HIS SKETCHBOOK, particularly important for the elaboration of the *Distribution of the Eagles* (SEE FIG. 31), was fully published only in the recent catalogue raisonné of David's drawings by Louis-Antoine Prat and Pierre Rosenberg (the remarkably thorough commentary, as for all the albums and sketchbooks, is by the latter). By convention, it should be designated as a *carnet,* whose folios generally offer suites of sketches directly related to David's paintings, as opposed to an *album,* in which he pasted his early studies after the antique and the Old Masters.[1] In its present state the sketchbook has lost some original folios and gained a few drawings by David and others, which at one time were pasted on blank sheets. For example, in the present exhibition the three figure studies for the *Eagles* were removed from this sketchbook at an unknown date (SEE CATS. 8–10). The degree of tampering to which it has been submitted is suggested by the the presence of no less than four different sets of numbers on certain sheets. These foliations correspond to different states of the sketchbook and have allowed Rosenberg to propose a convincing reconstitution of the original corpus.

The sketchbook was used between December 1808, when David signed the compositional drawing for the *Eagles* (FIG. 32), and November 1810, when the finished painting was exhibited at the Salon. Preceded by schematic studies found in another sketchbook, these are carefully drawn to fix the poses for various figures and groups, both the dignitaries grouped to the left of the composition and anonymous officers climbing the stairs on the right. Most of the studies are squared for transfer onto canvas. A great variety of body movements, usually emphatic, are delineated, with anatomical details appearing through the costume of many of the male figures, some of which are represented completely nude. It is worth noting that David never undertook this academic exercise

S.M. L'impératrice d'après nature

as an end in itself but always in view of a specific application. Proof of his persistent unease in confronting the female nude, he is much more reserved when drawing the female participants, whose court costume is ponderously opaque. He attributes to the princesses a serene dignity and a monumental presence that contrasts with the animation characterizing most of the gesticulating male figures, with the exception of Napoleon (SEE CAT. 8) and the *princes français,* Louis and Joseph Bonaparte (fol. 17r).

Revealing aspects of David's working method are the abundant annotations, especially on folio

9r, which help him articulate the iconographical program. He jotted down a number of details to keep in mind, employing twice the expression "ne pas oublier." Whether or not he observed the ceremony, the compositional drawing and the final painting show that he chose to reinvent the scene from an imaginary vantage point, allowing him to focus on the principal groups and ignore the crowd all around. The annotations indicate that he was concerned with getting right the roll call of monarchs and court dignitaries in attendance, and especially with detailing the fascinating array of military corps, with their distinctive costume and equipment.

Two female portraits are retained for the exhibition presentation. The one of Josephine seated, drawn from life, is rightly famous. It is a particularly moving image, difficult to consider without the thought of her impending divorce from Napoleon, who repudiated her for her sterility in December 1809. David actually painted her into the *Eagles,* but before being allowed to exhibit the picture he was ordered to remove the figure. Whereas he had rejuvenated her in the *Coronation,* here she appears her age: born in 1763, she was around forty-six at the time. In spite of her composure, the eyes, the features, and the body slightly slumped all betray signs of weariness. The portraitist gives the impression of neglecting the purpose and preparatory finality of his drawing, as if absorbed by his model. The swan armchair, of a kind owned by Josephine (an example is at Malmaison), suggests that the sitting took place in her

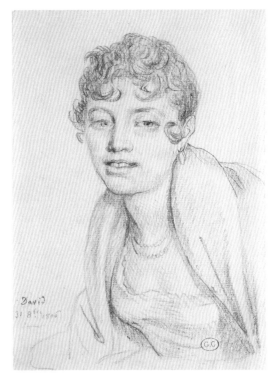

CATALOGUE 11B

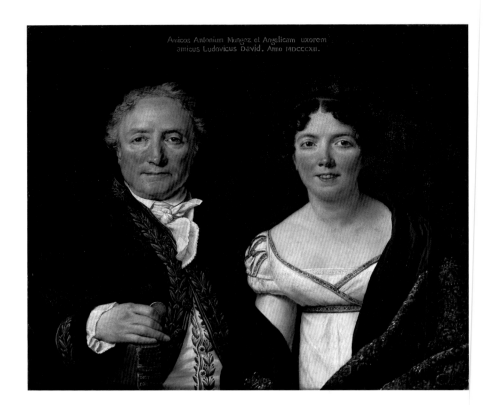

apartments. In the compositional drawing dating from December 1808 she appears in profile looking to the right, backing up the emperor. Here she strikes a pose of self-sufficiency for the first painter, who could not have ignored the fragility of her position and may have sensed the urgency to capture a fleeting image. The harmonious disposition of the figure on the sheet might suggest that he envisioned this drawing in preparation of an individual portrait of the empress that might rival those of Gros and Prud'hon. Satisfied with the result, he refrained from marring his drawing with a grid of lines. On another folio (FIG. 33), he reworked the figure from a model in his studio, after having turned the chair to the right so that it might more easily integrate the planned composition. Thanks to this ghostly proxy, Josephine recovers the elegant and graceful silhouette she had in the *Coronation.*

The bust study of a woman, probably torn out of another sketchbook, is generally thought to represent the painter Angélique Mongez, a pupil, friend and occasional collaborator of David, on the basis of a resemblance to the portrait with her husband he painted in 1812 (FIG. 34).[2] The latter is evidence that Mongez's young wife had a pronounced liking for low necklines. In spite of her somewhat heavy features, the young woman, dressed as if to go out, wearing jewels and a thick

shawl on her shoulders, possesses a direct charm that she flaunts to advantage. As often with the women represented by David, character and humanity are preferred to seduction and beauty. Although casually posed, the drawn portrait is carefully finished, signed, and precisely dated. Whereas the image of Josephine is a masterful exercise in line, close in spirit to the portrait drawings of Ingres, here the priority is form and shading. The application of black crayon is so insistent in certain areas that Rosenberg has wondered whether, in spite of the annotated date, it might not have been produced from memory during the period of David's exile in Brussels. A comparison with certain late drawings in the exhibition (SEE CAT. 55) should reveal that in this instance the touch is relatively lighter and broader, and the date of 1806, persuasive.[3]

NOTES

1. See the illuminating discussion regarding this distinction by Rosenberg in Prat and Rosenberg 2002, vol. 1, pp. 391–406; vol. 2, pp. 869–81.
2. On Angélique Mongez's career as a history painter, see Denton 1998; on her occasional collaboration with David, see the essay "In the Service of Napoleon" in this volume. For another drawing thought to be a portrait, see cat. 16.
3. On the evolution of David's graphic style, see the essay "Late Drawings: Experiments in Expression."

FIGURE 34 Jacques-Louis David, *Portrait of Antoine Mongez and His Wife, Angélique Le Vol,* 1812. Oil on panel, 29⅛ x 34¼ in. (74 x 87 cm). Musée du Louvre, Paris

Oil on canvas
80¼ x 49¼ in. (204 x 125 cm)
Signed and dated, lower left: *LVD.*^*Cl*
DAVID OPUS / 1812

National Gallery of Art, Washington.
Samuel H. Kress Collection (inv.
1961.9.15, formerly 1374)

PROVENANCE
Commissioned by Alexander, marquess
of Douglas and Clydesdale (1767–1852,
from 1819, 10th duke of Hamilton) in
1811 and hung in Hamilton Palace,
Strathclyde (Scotland) in 1813; his son,
William Alexander Douglas, 11th duke
of Hamilton (1811–1863); his son,
William Alexander Douglas, 12th duke
(1845–1895); Hamilton Palace Collection
sale, Christie's, London, 8 July 1882, no.
1108; bought by F. Davis, probably rep-
resenting Archibald Philip Primrose,
5th earl of Rosebery (1847–1929); his
son, Albert Edward Primrose, 6th earl of
Rosebery (1882–1974); 15 June 1951, sold
by him to Wildenstein & Co., London
and New York; by whom sold in 1954 to
the Samuel H. Kress Foundation, New
York (inv. K2046), and hung in the
National Gallery of Art, Washington,
D.C.; 1961, attributed to the museum.

EXHIBITIONS
David's studio, Apr.–May 1812; London
1948, p. 26, no. 23; Paris 1955, no. 17;
Paris 1974–75, no. 36bis (A. Schnapper);
Edinburgh 1985, no. 45; Paris-Versailles
1989–90, pp. 474–77, no. 206 (entry by
A. Schnapper).

BIBLIOGRAPHY
Notice 1824, p. 72; Th. 1826a, pp. 184,
236; Mahul 1826, p. 140; Coupin 1827,
p. 56; Lenoir 1835 (offprint 1838, p. 10);
Miel 1840, p. 16; Blanc 1845, p. 211; "Le
Napoléon de David," *L'Illustration,* 7
Dec. 1846, p. 272; Blanc [1849–76], p. 15;
Waagen 1854, vol. 3, p. 298; Delécluze
1855 [1983], pp. 346–47; Seigneur
1863–64, p. 365; David 1867, p. 37; David
1880, pp. 487–647; Dayot 1895, pp.
259–63; Saunier [1903], p. 108; Cantinelli
1930, p. 112, no. 123; Holma 1940, pp.
79–80, 128, no. 129; Cooper 1948b;
Cooper 1949a, pp. 21–22; Rosenau 1949,
pp. 113–14; Cooper 1949b, p. 175;
Ledoux-Lebard 1952, p. 192 n. 1; Haute-
coeur 1954, p. 200; Suida and Shapley
1956, no. 22; Walker, Emerson, Seymour
1961, pp. 193–94; Markham 1964, pp.
187–91; Gonzales-Palacios 1967, p. 14;
N. Hubert in Paris 1969, p. 51, no. 158;
Mesplé 1969, pp. 100–101; Verbraeken
1973, pp. 11, 28; Wildenstein 1973, pp. 190
(no. 1642), 191 (nos. 1645, 1648, 1651), 226
(no. 1938 [49]); Burney 1975, pp. 620–26;
Haskell 1975, p. 62; Schoch 1975, pp. 61–
62, 214 nn. 270–73; Eisler 1977, pp. 352–
58; Brookner 1980, pp. 168–69; Schnap-
per 1980, pp. 260, 262; Bleyl 1982, pp.
86–87 (ill.); Bordes and Pougetoux 1983,
pp. 26–27; Tait 1983, pp. 400–402;
Bordes 1988, p. 95; Michel and Sahut
1988, p. 112; Roberts 1989, pp. 171–73;
Gonzalez-Palacios 1993, pp. 957–58;
Johnson 1993a, pp. 216–20; Prendergast
1997, pp. 74–75; Lee 1999, pp. 222–23,
272–73; Eitner 2000, pp. 196–208; Prat
and Rosenberg 2002, vol. 1, p. 292.

THIS MOST impressive and justly famous por-
trait resulted from the opportune meeting of
two strong ambitions, that of a princely patron
and that of a talented painter. In September 1811
the marquess of Douglas, a Scottish lord with
royal pretensions, regal tastes, and the wealth to
be taken seriously, wrote to David requesting a
portrait of Napoleon. Perhaps inspired by the
traditional "auld alliance" between Scotland and
France, Douglas—referred to as Hamilton by his
biographers, with reference to his future title—
nurtured an admiration for Napoleon that much
later, in 1843, would be recast in dynastic terms,
with the union of his son to Josephine's grand-
daughter.[1] Self-consciously grand in his patronage,
he addressed his commission to the emperor's first
painter, willing to let him determine his price and
the exact subject, asking simply that he "transfer
onto the canvas the features of the Great Man, and
represent him in one of the historic moments that
have made him immortal."[2] From hearsay since
the 1780s and from firsthand reports during the
Peace of Amiens, David's fame as a painter and as
a political activist, both equally controversial,
had become familiar in British artistic circles.
Hamilton's initiative may have been encouraged
by William Beckford, whose daughter Susannah he
wed in 1810. Beckford was no stranger to the artis-
tic scene in the French capital, where he had
resided from 1801 to 1804 and again visited in 1806.
Hamilton's collecting reflected an eclectic taste
and reliance on intermediaries to whom he gener-
ally accorded a free rein. In this instance, the go-
between was the painter Ferréol Bonnemaison, a
Frenchman with numerous contacts in England as
a dealer, restorer, and adviser. Bearing the Scottish
lord's letter for David, he returned to Paris in the
fall of 1811 probably in connection with his interest
in the Giustiniani collection that was up for sale
and that he was to exhibit the following summer.
While in Paris Bonnemaison kept a watchful eye
over the execution of the portrait; in March 1812

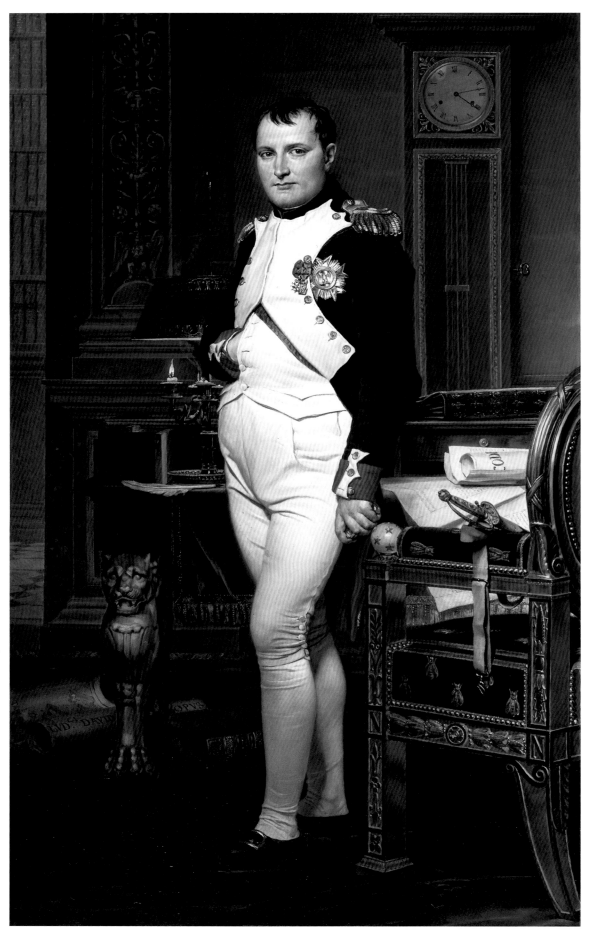

FIGURE 35 Jacques-Louis David, *Preparatory Drawing for "Napoleon in His Study at the Tuileries,"* 1812. Pencil on paper, 8⅞ x 7⅜ in. (22.6 x 18.8 cm). Musée des Beaux-Arts et d'Archéologie, Besançon

one of David's pupils designated him as the agent behind the commission from an "important Englishman."[3]

David greeted the commission with enthusiasm for a number of reasons. He appreciated the confirmation that his artistic reputation, like that of the great masters of the Renaissance, found recognition and support in elite circles all across Europe, especially since at home he waited in vain for a major commission. He continued to be involved in various minor enterprises for the government, but they included nothing comparable to the *Distribution of the Eagles* he had sent to the Salon of 1810. An attempt early in 1811 to reactivate the forgotten commission for three coronation portraits of Napoleon, dating from six years earlier, provoked a humiliating rebuff on the part of the administration (see the essay "In the Service of Napoleon" in this volume). By April of that year, he esteemed it was time to give his career a new orientation: picking up where he had left off a decade earlier, when he had accepted to serve the regime and put aside *Leonidas,* he decided to go back to this project, originally conceived to complement the *Sabines.* Presently unhappy with a composition that seemed unnecessarily agitated, he intended to thoroughly clarify the articulation of the figures and groups.[4] However, he was not yet quite ready to ignore the imperial scene. His exclusion from the run of state commissions that other painters, in particular Prud'hon as the new

empress's preferred artist, continued to receive aroused a sentiment of vexation and the desire to demonstrate anew his artistic superiority. He seized the opportunity and the lucrative prospects of the British commission, relegated once again *Leonidas,* and set to work almost immediately on the portrait.

In the sole preparatory drawing that survives for the painting, remarkable for a variant clock design in the form of a globe alluding to the realm of the emperor's conquests, the principal elements of the final composition are in place (FIG. 35).[5] The choice of the biographical episode, Napoleon at work in his study, does not seem to have been preceded by the exploration of other options. Although the open terms of the commission gave David the liberty to propose a historical scene commemorating a public event, Bonnemaison may have indicated that the picture was to integrate a collection of portraits. In any event, it was to be a posed portrait, as opposed to a figure in action. The painter demanded of his rich patron about the same sum obtained from the king of Spain for *Bonaparte Crossing the Alps,* although the canvas was to be notably smaller. He could consider that he had already produced canonical images of the military commander and of the imperial sovereign, which may explain why he chose to celebrate the legislator. At the same time, as often the case, he was receptive to contemporary trends. Although Napoleon's exploits on the battlegrounds of Europe continued to be the mainstay of the regime's propaganda, a complementary iconography also emerged independently and received official support. A former pupil of David, Louis Ducis, sent to the Salon of 1810 a family portrait of the emperor with his nieces and nephews, holding a baby on his lap and surrounded by no fewer than five children (Musée national du Château de Versailles); this gender-bent modern allegory of Charity was heart-warming, but also involuntarily somewhat sinister, since it radicalized the idea of the social non-existence of women found in the Code Napoléon. More promising and less problematic had been Étienne-Barthélémy Garnier's portrait at the Salon of 1808 of the busy administrator in his *cabinet de travail* in the Tuileries palace, with his secretary at hand to take a dictation. This picture, engraved in Landon's volume on the Salon, has been invoked as a key

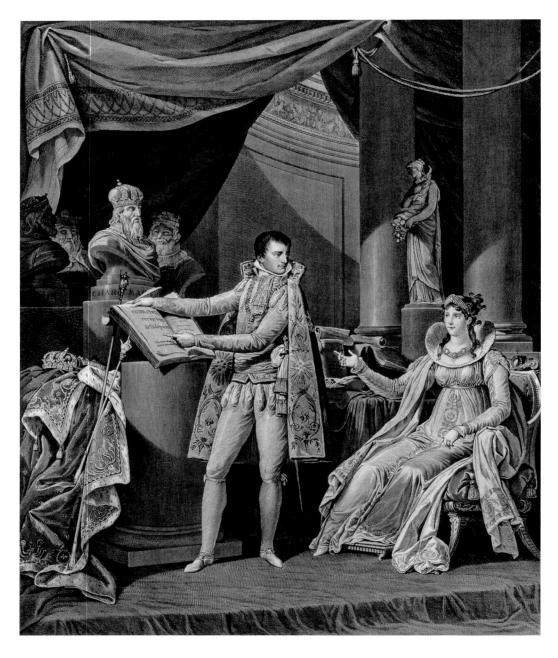

inspiration for the iconography retained by David in 1811.[6] When commissioning the work from Garnier in 1807, Denon had specified that the cabinet should be decorated with busts of the "grands hommes de l'Antiquité," an iconography that tended to allegorize the portrait. For some unknown reason, perhaps on account of upturned hand on the hip, an outmoded aristocratic posture contemporaries presently found foppish, a rumor circulated on the eve of the Salon claiming that the portrait was a "caricature"; when Napoleon got wind of this, he first wanted to prevent Garnier from exhibiting the picture, but finally retracted after seeing it.[7] Not surprisingly, the emperor's image was highly sensitive ground for portraitists,

especially when innovations were introduced. David was surely aware of the problematic reception of Garnier's painting, whose hybrid status made Landon uncomfortable: it was more than a portrait, but not quite a historical composition, since it represented no specific action. One suspects that the critic, like Diderot and others before him, disapproved of the degrading association of portraiture with the inferior mode of genre painting.[8] It is astonishing to find David bragging to Hamilton about an almost obsessive concern for description in the picture, "the scrupulous attention to make sure everything down to the very last details, the costume, the furniture, sword, etc., was truly executed after those of Napoleon."[9] As

FIGURE 36 François-Anne David (French, 1741–1824), *Code Napoléon*, 1807. Metal engraving, 20⅛ x 16¼ in. (51 x 41.4 cm). Bibliothèque nationale de France, Paris

usual, he placed the focus on the figure but betrayed the preference for rather stark surroundings, on which he had built his reputation. Not the least anxious that the inclusion of a richly elaborate setting might undermine his lofty ambitions, he has chosen to challenge those successful portraitists working in a mode influenced by Dutch seventeenth-century painting (see the essay "Portraits of the Consulate and Empire" in this volume). To maintain the visual hierarchy he safeguarded as a history painter, he employed contrasting colors, placing the dark blue and white of the costumed figure against the duller red, green, and yellow of the background.

David reworked a number of the same motifs deployed by Garnier, but managed to give greater focus and legibility to the latter's iconographical novelty. He chose a relatively narrow format adjusted to the figure, which categorized the work unequivocally as a portrait. Like the format, the composition and the chiaroscuro visually subordinated every element in the picture to the figure. The distracting busts serving to create a mythic ancestry for Napoleon have disappeared, but the notion of *grand homme* remained fundamental, as the artist's letter to his patron quoted above makes clear. It led him to inscribe *PLUTARQUE* on the spine of the massive volume lying on the base of the desk. Napoleon's liking for the ancient moralist and biographer was well known and inspired other portraitists: in 1810 Robert Lefèvre had exhibited a portrait of Napoleon "devant une table avec un Plutarque," whose resemblance was much praised.[10] In David's final composition, however, the Code Civil des Français, adopted in March 1804, which for propaganda purposes Napoleon retitled in 1807 the Code Napoléon, is even more prominent than the *Lives* of the eminent Greeks and Romans. To the right of the figure on the desk is a scroll bearing simply the word "COD[E]," an ellipsis that avoids the vexing question of authorship. At the Salon of 1808, perhaps in reaction to the renaming, the portrait of Archi-chancelier Cambacérès "travaillant au Code Napoléon" by his official painter Laurent Dabos reminded the public who in fact had most contributed to the elaboration of the code.[11] The year before, François-Anne David, a Parisian engraver who continually exploited his homonymy with the more famous painter, much to the latter's irritation, had edited a timely print entitled *Code*

Napoléon (FIG. 36), representing the emperor in discussion with Josephine over the articles of the civil code just completed. In spite of the plush interior and costumes, the regalia, and the prominent busts of the Carolingian dynasty, this rates as a domestic conversation between man and wife. Close inspection of the print reveals that the scene focuses on a serious problem facing the couple: Napoleon appears hopeful that the article *De l'adoption* he has concocted will save his marriage. David, of course, was not tempted by such mundane storytelling, the traditional domain of genre painting and since the Consulate of a new form of anecdotal history painting relished by the Salon public (the genre later termed "troubadour painting").

In his first reply to his patron, David was vague as to how he intended to figure the *grand homme*. He aimed for his projected portrait to capture a superior veracity: "it will represent a man, which one always imagines in a way that belies the truth." Several months later, in May 1812, reporting on reactions provoked by the painting when it was exhibited in his studio, he first insisted on the perfect likeness he had captured: "Thus I can guarantee your Lordship (relaying the expression of public opinion) that until now no one has produced a portrait with this degree of resemblance, meaning not only the actual facial features, but also that air of benevolence, composure, and penetration that never forsakes [Napoleon]."[12] Although careful to avoid trivial historical resonances, David aimed to introduce a narrative dimension in accord with his ambitions and status as a history painter. Several details in the composition construct a clear story line. The low-burning candle and the hour shown on the clock—just after four—indicate that it is early morning. Napoleon has worked through the night, his stockings are rumpled; he grips in his left hand the snuffbox with the tobacco that has helped him to stay awake. In the same letter to Hamilton, once the picture was finished, the painter explained the full narrative: "I have represented him in the most common of moments in his daily life, at work; he is in his cabinet, after a night spent writing the Code Napoléon; he notices the light of dawn only because the candles are consumed and about to go out, and the clock has just struck four in the morning; so he gets up from his desk to don his sword and revue the troops."[13] The painting

verifies this program: the sword with its white leather attachment is placed on the armchair ready to be seized, while the morning light enters the room from a library in he background, off to the left. David manifestly found it appropriate that an image revealing the personal character of the emperor should foreground the document regulating the private sphere and founding the social order.

The discrepancies between the written description and the painting are no less instructive than the correlations. David's transcription, allowing his patron to imagine the portrait, suggests that he has represented Napoleon involved in an action: moving around, getting dressed, tidying up, going out the door, when in fact, he takes a pose, perfectly immobile. Even the manual rhetoric so often exploited in portraits to bring them to life is here repressed. David appears to be applying here the same narrative logic and classical aesthetic that he would soon impose on *Leonidas:* the discrete juxtaposition of motifs and figures as the best way to develop an action.[14] With respect to the image of the emperor, such restraint was also motivated by decorum and convention. It was more important to communicate the dignity of his model than his vivacity. The pose was familiar: in his numerous portraits, François Gérard had standardized two fundamental options, one showing the figure with legs crossed as here and the other with legs positioned side by side (a mode David would later adopt for his portrait of General Gérard [SEE CAT. 50]). The balletic pose of Rigaud's Louis XIV, with the feet at ninety degrees, was tamed by Gérard and David, who imagined a more natural disposition. In this instance, furthermore, the silhouette, with a distinctive twist that renders the pudgy body more elegant, may have been a concession to English modes of portraiture, with which David had experimented at the height of his cultural anglophilia, around 1790.[15] To Hamilton he avowed his concern as to how the *artistes célèbres de l'Angleterre* would judge his portrait once it would be hung in his home, which implies that he had this audience in mind while executing it.

This is probably the first time ever that a ruler is valorized for performing the unceremonious part of his job: traditionally, monarchs needed only to appear majestic, the immobile center of attention at court. Although symbolic allusions to the responsibility of state government were frequent in images of monarchy, in fact the king's

role was foremost that of ruler. During the Ancien Régime, work was the curse of the Third Estate and, in France at least, considered a degrading activity for the aristocracy. When under the pressure of Enlightenment values some princes and kings sought to make public demonstration of their humanity, an occupation which was a form of work, this evolution met with resistance. Under Napoleon's rule, the visual chronicle of his biography in its diverse aspects—military, diplomatic, courtly, charitable, domestic—was promoted to an unprecedented degree. It fostered a traditional aura of distant grandeur, but also a contrasting set of images that allowed contemporaries to develop an illusion of proximity to the emperor. The aura of the victorious hero who every now and then dressed up royally maintained the imperial fiction. However, over time, as Napoleon reached middle age and cut a more prosaic figure, in spite of his unceasing military campaigns, he came to be associated with a life in Paris regulated by court ritual and bourgeois comfort. The move of the site of government from the throne to the desk was implicit in the intrusion in official portraits of open books, an attribute alien to the royal imaginary of the Ancien Régime.[16] David's portrait consecrates this image of dedication and administration that Napoleon himself would promote after his defeat and exile: "My true glory is not to have won forty battles; Waterloo will erase the memory of all these victories. What nothing will erase, what will live for all time, is my civil code."[17]

To reveal the emperor's character, David employed the hand-in-waistcoat motif to great effect, since over time it has become, as his bicorn hat, an attribute that suffices to identify him. It is indeed ironic that the pose chosen had been canonized by English patrons and painters during the eighteenth century in a warring context against France. After a peak of fashion at mid-century, it even came to be criticized for being one of many "commonplace attitudes" portraitists should avoid. In the 1740s, Hogarth had perfectly understood the satirical potential of this social posturing. He invoked it to mock both the pretentious air of gravity adopted by the English and the mannered civility of the French.[18] These negative interpretations were counterbalanced by the association, through classical statuary and rhetorical theory, with the flattering notions of modesty, moderation, and self-control. In France, the pose

FIGURE 37 Attributed to François
Gérard, *Emperor Napoleon in His
Study*, c. 1812–15. Ink on tracing
paper, 21⅛ x 30 in. (53.7 x 76.1 cm).
Musée du Louvre, Paris

was most likely associated with British portraiture,
to which prints provided an easy access, and did
not enjoy the same appeal. This marginal status
was transformed by Jean-Baptiste Isabey's large
drawing of *Bonaparte at Malmaison* (SEE FIG. 6),
executed early in 1801, and the year after, exhibited
at the Salon and engraved. Produced at a time
when it was opportune for the first consul to dif-
fuse a down-to-earth image of himself, the por-
trait was extremely popular and would be very
influential.[19] Several contemporaries noted in fact
that Napoleon was accustomed rather to join his
hands behind his back, bent slightly forward, es-
pecially when he walked around. Isabey had first
thought of representing him in this way, so the
choice to show him with a hand tucked away may
have been consciously anglophile. Since the Direc-
tory, French *dessinateurs* were avidly imitating
British stipple-prints and in 1801 the prospect of
political reconciliation with England was already
in the air. By the time David adopted the pose, a
decade later, it had been completely naturalized,
by portraits not only of the emperor but also of
his ambitious brother Jérôme. The main peculiar-
ity in his treatment of the motif is the way he
sharply foreshortens the right arm, a masterful
tour-de-force of contour and shading that few
contemporary portraitists dared to attempt.

David was manifestly proud of his achieve-
ment. He organized a private exhibition in his
studio in May 1812 and exulted when reporting to
Hamilton: "[The portrait of Napoleon] is luring
to my place a great crowd of people impressed by
the resemblance with that immortal man."[20]
Before sending it off he rushed to paint a replica,
with a variant in the costume. Rather than his
Sunday costume of officer of the foot grenadiers
of the imperial guard, a distinctive blue jacket
with white plastron, he wears the more usual
weekday outfit of the *chasseurs à cheval* (light
cavalry), a dark green jacket with red piping.[21] The
conception exerted an immediate influence on
the iconography of the emperor, now more often
imagined as the busy head of government. Girodet,
who received a commission for a suite of official
portraits and probably got wind of David's work
before it went on view, proposed in January 1812
to paint him holding a pen, to suggest that he had
just finished composing the Code Napoléon.
Probably because this was incompatible with the
decorum of imperial grandeur, the painter finally
chose to show Napoleon extending a protective
arm over the regalia and an open folio of the
Code.[22] Gérard borrowed without delay the hand-
in-waistcoat motif, with a shift from the right to
the left, in a painted portrait destined to be exe-
cuted into mosaic by Francesco Belloni. Napoleon
also appears wearing the grenadier costume, but
slimmer, facing almost forward and with feet
apart.[23] Although much more perfunctory in con-
ception, it shares with David's portrait the staging
of the sitter's administrative concerns: as he poses,
he incongruously shuffles some papers on a table
with his right hand. A related composition, but
with the legs crossed as in David's portrait and
an elaborate interior setting that dwarfs somewhat
the figure, has been invoked by several commenta-
tors on the basis of a lost watercolor attributed to
Isabey. However, an exact copy of the composi-
tion, in ink on tracing paper, now in the Louvre,
comes from the family of Gérard, so he may
instead be the author (FIG. 37). The influence of
David's conception was still strong even during
the Restoration. After providing portraits of Louis
XVIII in traditional coronation robes at the begin-
ning of the reign, Gérard went back to the idea of
the ruler at work, seated at his desk, in the same
room of the Tuileries where his master had imag-
ined Napoleon.[24]

1. Haskell is not convinced of Hamilton's admiration for Napoleon or for his first painter, and accounts for the commission of this and other "royal" portraits, as "un moyen de faire valoir sa propre ambition au trône d'Écosse" (1975, p. 62).

2. In his reply of 20 Sept. 1811 to the *marquis de Douglas*, David presumably quoted the letter commissioning the portrait: "J'ai reçu des mains de Mr. Bonnemaison une lettre de votre Seigneurie par laquelle j'apprends que vous avez daigné faire choix de mon pinceau pour transmettre sur la toile les traits du Grand Homme, et le représenter dans un des événements qui l'ont immortalisé" (Tait 1983, p. 401).

3. On Bonnemaison the literature is scattered; see Isabelle Julia in Paris 1974–75, pp. 329–30; Eisler 1977, p. 353; Bailey 1984, p. 37; Denon 1999, vol. 2, p. 888, no. 2548 (see also the index, p. 1415). The letter by Pierre-Théodore Suau, a pupil of David, of 4 Feb. 1812, indicating that the portrait is "destiné à un grand personnage de l'Angleterre," is cited by Mesplé 1969, p. 100 (with further references to Bonnemaison n. 1).

4. Letter by Suau of 23 Apr. 1811, cited by Mesplé 1969, p. 101.

5. Prat and Rosenberg 2002, p. 292, no. 309. The authors relegate among the rejected drawings, the study at one time in the collection of Mrs. Rush H. Kress (reproduced by them p. 1198, no. R111; and by Eitner 2000, p. 198, fig. 1), pending the possibility of examining it. They qualify the execution as "faible" but it appears to be a quick sketch of the composition drawn with energy and precision from memory. That the pilaster on the left appears fluted and not ornamented might be explained by the fact that David at first painted in the fluting (visible when observed at a sharp angle).

6. It is not clear who was the first to invoke Garnier's portrait in this context. Neither Eisler (1977) nor Schnapper (in Paris-Versailles 1989–90) mention it in their thorough discussions of David's portrait, whereas Eitner considers it "an earlier, rather prolix statement of the theme that David was to raise to its final, most concentrated, and impressive form" (2000, p. 203). On Garnier's panting see Landon 1810, vol. 2, pp. 33–34, pls. 23–24; and the illuminating commentary by Alain Pougetoux in Paris 1999–2000, pp. 343–44, 372 (no. 390, a surviving fragment of the composition; the author states that "plusieurs historiens" have made the connection between Garnier and David). He reproduces a hybrid sketch in the Museo Napoleonico in Rome, a variation on Garnier's composition perhaps by him, but with a copy of David's figure of Napoleon painted in surely by another hand (p. 344, fig. 107).

7. A. Pougetoux in Paris 1999–2000, pp. 343–44.

8. Philippe Bordes, "Portraiture in the Mode of Genre: A Social Interpretation," *French Genre Painting in the Eighteenth Century* (*Studies in the History of Art*, vol. 72, National Gallery of Art, Washington D.C., forthcoming).

9. Letter of 8 May 1812: "Il est bon de faire observer à votre Seigneurie que j'ai eu l'attention scrupuleuse que tout jusqu'au moindres détails du tableau, comme habillement, meubles, épée, etc. fut fait d'après les siens propres" (Tait 1983, p. 401). A number of commentators have analyzed the exacting but occasionally composite nature of the costume, accessories, and furnishings: Hubert in Paris 1969, p. 51; Schnapper in Paris-Versailles 1989–90, pp. 476–77; Eisler 1977, pp. 352–53; Gonzalez-Palacios 1993, p. 957; Eitner 2000, pp. 196–97.

10. Eitner (2000, p. 204 n. 6) places a volume of Plutarch in Robert Lefèvre's 1810 portrait presumably on the basis of an unreferenced Salon critique, since the *livret* makes no mention of it. He identifies this submission (improbably) with one signed and dated 1806, presently at Versailles (MV4698; often confused with a grand coronation portrait by the painter exhibited at the Salon of 1806, engraved in [Chaussard] 1806, opposite p. 293 [misprinted as 193]). Napoleon appears wearing the *grenadier* costume (as in David's later portrait), standing next to a table with editions of Caesar and Plutarch. The work exhibited by Robert Lefèvre in 1810, bought by Savary, duc de Rovigo, was praised by Denon as "un des portraits les plus ressemblants qui aient été faits de Sa Majesté" (Denon 1999, vol. 2, p. 1383, no. AN89). In July 1811, Denon evokes a "portrait de Sa Majesté en costume," meaning in coronation robes, required for the Banque de France; on a visit to Lefèvre's studio, he finds the painter finishing one with the emperor "vu de face près d'un bureau dans ses appartements," which he judges appropriate, and vaunts for not being a repetition of the one at the Salon bought by Savary (vol. 1, p. 743, no. 2151). This hybrid conception, like that of Girodet's imperial portrait of 1812 (see n. 22), suggests that toward the end of the Empire the iconography and attributes of government administration transformed the traditional coronation portrait.

11. The exhibition of the portrait seems to have been orchestrated and inspired the publication of a poetic eulogy by François-Louis Darragon (*CD*, XLIII, no. 1130).

12. "Il doit représenter un homme sur lequel l'imagination qu'on s'en forme reste toujours au dessous de la vérité." Letter of 20 Sept. 1811 (Tait 1983, p. 401). "Je puis donc assurer votre Seigneurie (en lui répétant l'expression de l'opinion publique) que personne jusqu'à ce jour n'a encore fait de portrait plus ressemblant, non seulement par les traits matériels du visage, mais aussi par cet air de bonté, de sang froid et de pénétration qui ne l'abandonne jamais." Letter of 8 May 1812 (p. 401).

13. "Je l'ai représenté dans le moment de sa vie qui lui est le plus habituel, le travail; il est dans son cabinet, ayant passé la nuit à composer le Code Napoléon; il ne s'aperçoit du jour naissant que par ses bougies qui sont consumées et qui s'éteignent, et par la pendule

qui vient de sonner quatre heures du matin; alors il se lève de son bureau pour ceindre l'épée et passer la revue des troupes." Letter of 8 May 1812 (Tait 1983, p. 401).

14. David's friend Aubin-Louis Millin had adopted this position in his *Dictionnaire des Beaux-Arts:* "les anciens ont presque toujours représenté dans une attitude tranquille les personnes dont ils ont fait des statues-portraits" (1806a, vol. 3, p. 352, "Portrait"). On the traditional association of portraiture with *being* rather than *doing* in art theory, see Meyer 1995, p. 45.

15. Bordes 1992.

16. Wicar's portrait of Lucien Bonaparte as president of the Council of the Five Hundred proclaiming the Constitution du 18 Brumaire (Rosebery collection, Dalmeny House, near Edinburgh), thought to have been executed around 1806, has been invoked in relation to David's portrait (Maria Teresa Caracciolo in Rome 2004, p. 19, and cf. pp. 82–84).

17. "Ma gloire n'est pas d'avoir gagné quarante batailles et d'avoir fait la loi aux rois qui osèrent défendre au peuple français de changer la forme de son gouvernement. Waterloo effacera le souvenir de tant de victoires; c'est comme le dernier acte qui fait oublier les premiers. Mais ce que rien n'effacera, ce qui vivra éternellement, c'est mon code civil; ce sont les procès-verbaux de mon conseil d'État; ce sont les recueils de ma correspondance avec mes ministres; c'est enfin tout le bien que j'ai fait comme administrateur, comme réorganisateur de la grande famille française." Reported in Montholon 1847, vol. 1, p. 401 (26 Sept. 1816). Reference furnished by Irène Delage.

18. Meyer 1995, p. 49, with reference to the work of Linda Colley: "The transformation of a postural into a portrait convention occurs at the critical juncture when England was emerging as a national power, engaging in the first of a long series of Continental wars that intensified Anglo-French enmity. In response to France's challenge to her political and religious autonomy, England strengthened her self-image and forged her Augustan appearance." See also pp. 59–61, and for satirical visions of the pose, pp. 49–51. The author underlines the irony of David's appropriation, p. 63. For further resonances of the pose in France, see Fleckner 2000.

19. Halliday 2000, pp. 181–84; Fleckner 2000, pp. 32–33. The print after Isabey's drawing was acclaimed in a German journal as late as 1807 (Schoch 1975, p. 214 n. 269).

20. ". . . il attire chez moi une foule innombrable de monde par son extrême ressemblance avec cet homme immortel." Letter of 8 May 1812 (Tait 1983, p. 401).

21. On the complicated history of this replica, "un second original" signed and dated 1812 (donated in 1989 to the French national museums, with a usufructuary restriction), which belonged around 1819 to "M. Huibans" or "Huybens," see Schnapper in Paris-Versailles 1989–90, p. 474; and Eitner 2000,

pp. 205–6 n. 29, who indicates that it was exhibited in London in 1815. The affirmation that four copies of the portrait were executed, going back to the anonymous *Notice* 1824, p. 72, is surely a confusion with the repetitions of *Bonaparte Crossing the Alps.* For the costume, see Hubert in Paris 1969, p. 51.

22. Stein 1907, pp. 358–59 (my thanks to Bruno Chenique for this reference).

23. Hubert 1979, pp. 251–71. The attribution to Gérard of the portrait illustrated from the collection of the Musée napoléonien de l'Ile d'Aix (discussed p. 263) is now accepted.

24. The lost watercolor attributed (improbably) to Isabey is reproduced by Eisler 1977, text fig. 131; and Praz 1994, p. 181, fig. 156. It is mentioned by Schoch (1975, p. 214 n. 272, with a reference to an illustration in a 1965 German edition of Praz). The tracing with the stamp of the "Succession F. Gérard" is in the Département des arts graphiques, Musée du Louvre, inv. RF37252. Adding to the confusion concerning the status of this composition is the unreferenced reproduction of a drawing indicated as by Percier (or of a print after his design) corresponding to the tracing, but with some notable variants: Napoleon wears his bicorn hat and crosses his arms on his chest, and the room is cleaned up of the documents strewn on the sofa and the ground (Fontaine 1987, vol. 1, p. 222). Gérard's *Louis XVIII in His Cabinet at the Tuileries* (1823) is discussed with reference to David by Schoch 1975, pp. 108–9, repr. fig. 111.

13 Project for an Officer Holding an Eagle

C. 1812

Pencil, pen, black ink, and gray wash
on paper
Two sheets of the same width joined
together: 12⅞ x 7⅜ in. (32.7 x 18.8 cm)
overall; height of upper sheet:
3⅞ in. (10.1 cm)

Centre historique des Archives
nationales, Paris (inv. AF IV 1164,
document 267)

Exhibited in Los Angeles only

PROVENANCE
Archived with the papers of the
Secrétairerie d'État Impériale (mark of
the archives, center left [L. 21a]).

EXHIBITIONS
Never exhibited.

BIBLIOGRAPHY
Hollander 1901, pp. 664–66; Gotterie
1992, p. 51; Prat and Rosenberg 2002,
vol. 1, p. 293, no. 309bis.

FIGURE 38 Anonymous, *Standard
Bearer*, c. 1812. Pen, ink, and watercolor
on paper. Right-half detail of a sheet
measuring 12⅜ x 16⅛ in. (31.5 x 41 cm).
Centre historique des Archives
nationales, Paris

IN THE Napoleonic administration the Secrétaire
d'État was the essential intermediary for han-
dling civil affairs between the government and
the ministers. In this instance, the drawings are
in a folder of documents transmitted by the war
minister. From January 1810 to November 1813
the head of the ministry was Jean-Gérard Lacuée,
comte de Cessac, whose collaboration David
solicited in May 1810, at the time he was painting
the *Distribution of the Eagles*.[1] On 25 December
1811 the emperor decreed that the "eagles," which
had replaced the republican flag at the beginning
of his reign, would be redesigned and standard-
ized. Instead of a visible sign around which to
rally the troops, as symbolically played out during
the coronation ceremonies of December 1804
(SEE CATS. 8–10), the eagle henceforth was conceived
more as an emblem to distinguish each regiment.
In January 1812 Lacuée transmitted to Napoleon
a project illustrated by a draftsman working in
his ministry that included four new designs: the
garde-drapeau armed with a lance, the *porte-
drapeau*, and the eagle itself, all three for the in-
fantry, along with the *porte-drapeau* of the cavalry.
That the first painter was consulted on the matter
was probably a personal initiative of Pierre Daru,
who was Secrétaire d'État from April 1811 to
November 1813. As Intendant de la Maison de
l'Empereur, he had supported David in the course
of the drawn-out negotiation for the payment
of the coronation pictures, and in 1810 the
painter surprised him with a portrait of his wife
(SEE CAT. 18).

Presumably David was taken aback by the
wooden figures of the project drawings he was
shown, and also by the form of one of the eagles
and the manner in which it was kept upright. He
redrew one of the figures (FIG. 38), respecting the
initial disposition of the legs and arms but endow-
ing a natural coherence and elasticity to the ana-
tomy. Although relatively schematic in nature, the
confident, undulating contour and the monumen-
tal presence of figure, recalling the statues of sol-
diers crowning the columns of the Arch of the
Carrousel, confer on the sketch a persuasive au-
thority. The miscalculated twist of the right arm
and the ambiguous grip around the staff of the
eagle betray a quickness of execution. In his re-
working David proposed to change the position
of the eagle—to project a more "martial" image,
as he states in his annotation—but also to render
the pose less uncomfortable for the parading
officer and perhaps less subject to satire. His an-
notation to a companion drawing, suggesting that
his design will neutralize the memory of religious
processions, is an echo of a sentiment shared by
the anonymous author of the copious notes on
the original designs. The practice of seeking inspi-
ration in Roman antiquity to fuel the mythology
of empire is well known, but interesting here is
the complementary concern, inherited instead
from republican traditions, with avoiding possible
confusions between military pageantry and reli-
gious ceremony. More than anyone, David was
probably sensitive to the fact that Napoleon's
decree of December 1811 also established a signi-
ficant change in the flag designs, away from the
angular compartments displayed to excess in the
Distribution of the Eagles seen at the Salon of 1810,
back to the vertical tricolor of the Republic, with
blue closest to the staff.

NOTES

1. David wrote to the minister to borrow various
military accessories; Paris-Versailles 1989–90, p. 615.

L. David f.

26†

je crois que cette manière de porter l'étendart est plus martiale, et
remplit mieux par conséquent l'esprit du décret de S.M. l'Empereur

Portraits of the Consulate and Empire

JACQUES-LOUIS DAVID's portraits have never fallen out of favor with collectors and amateurs. During the first half of the twentieth century, in a time of militant modernism when preoccupation with traditional subject matter in art was considered irrelevant at best and damning at worst, they were much preferred to the history paintings that founded his reputation during his lifetime. They were appreciated for their truth to nature, as images of the Ancien Régime or historical records of the Empire. With the vogue for Neoclassicism in the 1960s and 1970s, his *Horatii, Brutus,* and *Sabines* once again became icons of reference for art historians and visitors to the Louvre. The renown of his *Coronation,* indexed on the fame of Napoleon, easily maintained itself through the reigns of Louis-Philippe and Napoleon III. The transfer of this picture from Versailles to the Louvre around 1889 was a consecration, like the exhibition *David et ses Élèves* organized at the Petit Palais in 1913 by Henry Lapauze, who felt that the French School needed once again to be regenerated by the master's "virility."[1] Some shameless advocates on this occasion even adopted an overtly modernist strategy to valorize his portraits, claiming that his style was bolder than that of Manet and inventing the unexpected notion of his "impressionisme."[2]

The fact that David painted portraits throughout his career has incited historians to take this practice somewhat for granted, to view this production as a pragmatic response to demand and circumstance. It is true that the academic doctrine associating portraiture with low commercial values was never a source of anxiety for him, whereas Gros and Ingres admitted a reluctance to devote their time to such work. Although the focus of this section of the exhibition is on his portraits produced during the Consulate and Empire (those from the period of the painter's exile after the Bourbon Restoration are studied in the essay "Portraits in Exile" later in this volume), some general remarks shed light on his state of mind and his artistic imagination when practicing this genre. The sociological model of the portrait specialist at the service of an anonymous customer is obviously inapplicable in his case. David's high fees, legitimated by his reputation, limited his potential clientele, while his other occupations severely restrained the number of his portraits. Furthermore, the traditional social sub-

ordination of the painter to the client was no longer the standard after the Revolution. It had been undermined by Enlightenment celebration of artistic genius and republican ideals of citizenship. More than anyone, David could easily have the upper hand, except perhaps with imperial dignitaries to whom as first painter he had obligations.

It would be as misguided to impose a coherence on his practice, during a career covering over half a century, as on the successive historical periods during which he painted. It would be no less misleading to ignore his personality and presume that he adopted a relative detachment when executing a portrait, a suspension of his ambitions and a creative passivity with respect to tradition and convention. Given his determination and drive, it seems fair to credit him with the capacity and will to conceive of his portraits as artistic statements. His practice, responsive in the fullest sense of the term, was founded on a critical attitude toward past and contemporary formulas, an intuitive reflection on the aims of the genre and an acute sense of social responsibility in capturing for posterity the image of his time. His resolute aversion for the transcendental Virgilian mode of situating portraits in a generic outdoor setting, so often adopted by his contemporaries, can be interpreted as the sign of a profound respect for the contingency of human existence. In other words, he always tried to express a personal or a social truth in his portraits. To articulate this complexity, the essay will invoke the artist's own words in letters and autobiographical texts, the documented relations with his sitters and theirs with him, as well as his professional and figurative strategies with respect to contemporary portraitists.[3]

When a young man, David met expectations by putting his brush at the service of his family and friends. This allowed him to try out current modes of portraiture: for example, showing his aunt who interrupts her reading to acknowledge the presence of the viewer (1769, The Art Institute of Chicago), or his uncle who sits sideways on a chair, a casual pose gleaned from some Dutch or British image (1769, private collection). It also made him realize the exchange value of portraiture, emotional rather than financial in this instance. Deprived of his father and separated from his mother at an early age, he relied on family relations and friends such as Michel Sedaine for affection, support, and encouragement. In 1784, soon after his marriage, he painted straightforward pendants of his wife's parents (Musée du Louvre, Paris), with a visible desire to impress and please. Only on his return from Rome, with an inaugural success at the Salon of 1781, had he fully realized the social and financial benefits to be gained from portraiture. In February 1785, from Rome, where he was executing the *Horatii*, he addressed one of his aristocratic protectors, the Marquis de Bièvre, with the rhetorical abasement expected of a roturier: "I very much regret that [Mme de Vassal, Bièvre's friend] has a bad portrait by me, but we'll see about all that in Paris, and trust that I'll be, myself, my brush, and what little I've learned, totally at your service, for you and your friends."[4] Through the early 1790s,

determined to engage his talent to climb the social ladder, he produced a series of society icons, including some very grand works: an equestrian portrait of *Count Stanislas Potocki* begun in Rome (1781, Muzeum Narodowe, Warsaw), and a double portrait of *Antoine-Laurent Lavoisier and His Wife* in an interior (1788, Metropolitan Museum of Art, New York). David's aggressive attitude toward Élisabeth Vigée Le Brun around 1789, in whom he saw the epitome of the compliant and obsequious artist accepted by court and aristocracy, was probably fueled by some self-loathing for having taken up that role a few years earlier. He had even mixed in her exclusive circle for a time. New friends, notably the dilettante poet André Chénier, and new perspectives opened by discussion with them of Greek liberty (via Winckelmann) and classical Roman republicanism (via Mably), had made him acutely conscious of the value of artistic freedom. In an unpublished essay written around 1787 Chénier had articulated the social consequence of such an idea: "The arts should cease to beg the protection of the great lord [*le grand seigneur*], and he should leave them alone."[5]

This independent attitude and the impact of the democratic aspirations that emerged in the revolutionary context explain the manner chosen to evoke his portrait practice in an autobiographical note dating from the spring of 1793. He was at the time deeply involved in the public affairs of the French Republic. The text casts him in the third person: "He often relaxed by painting portraits and he proved more than once to portraitists that when history painters get down to executing portraits, they instill them with a lifelikeness that the presence of their mannequin always prevents them from capturing."[6] Although the remark concludes with an equivocal formulation open to divergent interpretations—a critique of the aristocratic clientele of portrait specialists? A critique of the mannequin used by portraitists so as not to retain their sitters? An acknowledgment of the contrived practice of history painting, necessitating draped dummies?—it is clear that David here affirms pride in his portraits. By presenting this activity as recreation from the more difficult practice of history, he acknowledged the relatively modest demands of the genre. Nonetheless, he clearly claimed his superiority as history painter over the specialist, a traditional position expressed in all the contemporary compendiums of artistic knowledge.[7] With reference to the *Portrait of Anne-Marie-Louise Thélusson, Comtesse de Sorcy* (SEE FIG. 63), in the same text he wrote: "This portrait is one of his best up to that time: in truth, he has always taken care to choose only beautiful female heads, not wanting to prostitute his brush to a genre which he practiced only for his amusement."[8] Here the invocation of an aesthetic ideal and the posture of artistic detachment work together to morally legitimate his engagement with portraiture. During the 1780s a repulsive physical degeneracy had been attributed to the privileged elites in prints satirizing their moral and financial corruption: *Changez-moi cette tête* was the title of a popular image, representing a shop where decrepit aristocrats bought new attractive heads for themselves. In his autobiography David

sought to protect himself against any assimilation with the specialist portrait painters, suspected by populist republicans of engaging in a similar commerce, at a time when he might be the butt of attacks as a former *peintre du roi*.

During the Directory (1795–99), once freed from jail and amnestied, David continued to confront the dialectic between truth and ideal when portraying women, from the *Portrait of Madame Sériziat* (SEE FIG. 62) to the *Portrait of Juliette Récamier* (1800, Musée du Louvre); however, the social and political environment had evolved considerably in a few years and the moral ambiguities of the genre were perceived as less acute, if not resolved.[9] As a favorable report on a translation of Adam Smith in the French press in 1795 intimated, the tyranny of virtue—the Jacobin Terror of 1793–94—was now happily supplanted by the rule of commerce. Economic prosperity and conspicuous consumption were viewed as the remedy to the nation's troubles. In the course of the Revolution, the social distinctions and stratifications of Ancien Régime society became blurred and the wheel of fortune had turned for many. During the Directory appearances were known to be deceiving, and social self-identity was in need of reconstruction. Louis-Léopold Boilly's *La Marche incroyable* (1797, private collection), a motley reunion of figures, each acting out a different role on the urban stage, is a telling sign of the times.[10] A parallel and related development was the breakdown of the traditional distinction between the exemplary public portrait and the normative private image, which stimulated greater attention for the latter. As well as providing an accessible ground to affirm individuality, the private sphere was vaunted as the refuge of ethics and morality after the rampant fraudulence on the public scene during the Terror. Furthermore, when representing family members or close friends, the obscurity of the sitter could attest to the commercial disinterestedness of the portraitist. In a period when government support of history painting was wanting and the private market for such serious themes nonexistent, critics took the genre of portraiture more seriously than before. This change benefited relatively minor draftsmen and miniaturists like Jean-Baptiste Isabey and Jean-Baptiste Jacques Augustin, while history painters like Anne-Louis Girodet, François Gérard, and David promoted themselves as serious artists through their portraits. In the climate of cultural and economic reconstruction after the Terror, none of them deemed this put their reputation at risk.

David analyzed the post-revolutionary situation in the same terms as these other artists. That he planned to send to the Salon in the fall of 1795 a set of private portraits—at first he wanted to exhibit two others along with those of the Sériziats, his wife's sister and her husband who had taken him in upon his release from prison[11]—reveals his desire to put the Terror behind him and espouse the cultural ambiance of the post-Revolution. The singularity of this initiative can be measured by the fact that he would not exhibit at the Salon again until 1808 and 1810, and during the Empire, only a single portrait. This

was of Napoleon, the year of David's return to the Salon: in 1795 he was eager to prove his capacity as portraitist, in 1808 his concern was to affirm his rank as first painter. Work on the *Intervention of the Sabine Women* (SEE FIG. 1), composed in prison and finished in 1799, in no way deterred him from undertaking portrait commissions. Upon his release, this was a means to restore both his finances and his confidence, and to rekindle a sense of community with supportive patrons. Like other artists, he found it stimulating that the demand for portraits was greater and more diversified than ever before. Taking heed of the experiments and innovations introduced by Gérard, Isabey, Girodet, and others in recent years, he aimed to surpass both these younger rivals and himself. His determination to confront new standards of feminine beauty and antique fashion inspired his portraits of Henriette de Verninac (SEE FIG. 54) and Juliette Récamier. The monumentality of the first and the scale of the second suggest a far greater artistic investment than in his more conventional portraits of the early Directory, while the quality of the sitters, whose elegance is visibly studied, inscribes these works in the cultural circuit of the new elite. However, unlike many of his colleagues, he continued to believe that the representation of moralizing historical subjects was the supreme responsibility of the arts. In 1799, to compensate for the lack of a patron or a commission for the *Sabines,* he obtained government approval to install a personal exhibition in the Louvre and charge an entrance fee as a way to cover his costs.

The Revolution had not resolved the traditional tension between portraitist and sitter, a difficult relation in which the assertion of social hierarchy and artistic preeminence were often in conflict. The republican ideology of equality among citizens had not managed to abolish distinctions based on wealth, unveiled by economic crisis during the Directory. In the relation with the client for a portrait, its redefinition as a superior work of art intensified the occasions for conflict, since it could entail disregard for a patron's expectations of a truthful and flattering image. Girodet's spiteful row with the well-fixed actress Anne-Françoise-Elisabeth Lange during the Salon of 1799, over a portrait she disliked, was for all a warning to proceed with caution when dealing with clients. To alleviate the harsh economic reality of the transaction involved, the painter aspired to an idealized entente with the sitter and found it increasingly intolerable to be considered a hireling by the *nouveaux enrichis.* David's well-known falling out with Juliette Récamier in 1800, whom he accused of "impatience" and which provoked the abandon of her portrait, signified that he wanted to pull out of the free-for-all in which he found himself. He must have felt that since 1795 he had been spurred on by his careerist contemporaries and that the time had come to back off. Notwithstanding his revolutionary experience, he was to be more comfortable with the clear-cut etiquette regulating the imperial court. Because of his position, he would select his clients and not have to suffer the rudeness of certain members of the new nobility, like Caroline Murat, who

exasperated Vigée Le Brun in 1807 by her capricious behavior during sittings for an official portrait.[12]

The new moment of truth redefining relations with his potential clientele was an indirect consequence of Bonaparte's coup d'état against the Directory in November 1799. As detailed in the essay "In the Service of Napoleon," for several years David had admired the republican commander and was now drawn to the first consul, whose equestrian portrait he seized the occasion to paint in 1800–1801 (SEE CAT. 4). Never before, except perhaps the stillborn project of *Louis XVI with the Dauphin* in the spring of 1792, had a portrait commission allowed him to deploy to the full his capacity as history painter. His friend Aubin-Louis Millin claimed categorically in 1806 that *Bonaparte Crossing the Alps* was a *tableau d'histoire* and not a portrait.[13] In only a few portraits thereafter would he invest the image with a comparable degree of content and resonance: of course, *The Emperor Napoleon in His Study at the Tuileries* (SEE CAT. 12), but two others as well. The republican sympathies of both painter and model transpire in the *Portrait of Cooper Penrose* (SEE CAT. 14), a portrait of the Irishman in Paris during the Peace of Amiens totally free of descriptive, symbolic, or allegorical props. The ideology of equality between the sexes is proclaimed in the portrait of Antoine Mongez and Angélique Le Vol (SEE FIG. 34) with a force not marshaled since the pamphlets of Condorcet, again with no concession to demonstrative iconography.

Work on *Leonidas at Thermopylae* (SEE FIG. 82), envisioned around 1799–1800 as a pendant for the *Sabines,* undoubtedly reinforced David's reluctance to accept private portrait commissions after his clash with Juliette Récamier. Few may have been bold or wealthy enough to contact him, since the patronage of the Spanish king seemed to justify fees even higher than those of Isabey, Guérin, and Gérard.[14] In 1802 it probably took pleading and seduction, along with a hefty sum of money, for Penrose to persuade him to paint his portrait. More enigmatic were the artist's motives two years later in accommodating the daughter of his Convention colleague, Le Peletier de Saint-Fargeau, whose death as the first *martyr de la liberté* he had commemorated in 1793 (SEE CAT. 15), or the official in charge of Napoleon's finances (SEE FIG. 41). Other demands for portraits received he may have transmitted to students and assistants.[15] The resurgence of official portraiture during the Consulate made such domestic requests even less attractive. It channeled the ambitions of painters by reinstating the traditional differentiation between public and private commissions. Under the preceding government certain *directeurs* had engaged a revival of such state portraiture, but this seems to have been individual initiative.[16] Although in practice the Directory government surrounded itself with the most lavish furnishings confiscated from the homes of aristocratic émigrés, in principle it continued to abide by the ideology of republican self-effacement. Under the Consulate a policy of magnificence and a personality cult were openly and progressively implemented. Commissions for official portraits were first centralized under the aegis

of the minister of the interior, before being entrusted to Denon during the Empire. Unlike the closed system of the *cabinet du roi* during the Ancien Régime, which had a monopoly on copies, the commissions profited a remarkably wide range of artists. The prestige and rewards associated with such work, through which an artist might meet influential persons and secure complementary demands, made them attractive even for history painters. Gérard's success in this vein, in particular, is reputed to have made his fortune. Increased government intervention revived the Ancien Régime value system, ranking full-length portraits destined for display in public spaces well above private commissions. Ever since the middle of the eighteenth century critics had denounced the vanity of exhibiting images of ordinary citizens at the Salon, a refrain that continued to be heard during the Empire. In 1810 Charles Landon reminded their authors how to merit the public's attention: "Among this multitude of portraits, so many could be mentioned that, far from contributing to the glory of the contemporary school or the splendor of the Salon, instead seem to spoil the show and frustrate the public's curiosity for the character of those represented and the quality of the execution; at least one or the other of these two conditions must qualify portraits for the honor of being admitted to the exhibition."[17] As has been stressed, David never sent any such portraits to Salons during the Empire. Like the critics, he probably only found worthy of attention the gallery of court dignitaries and the rare portraits one could "view as paintings."[18] But on the Parisian scene private demand did not abate and a distinctly inferior commerce developed, often left to women painters, who with the notable exceptions of Marie-Guillelmine Benoist and Césarine Davin-Mirvault, were not gratified by government commissions. This production, found in and out of the Salons, signed by painters of both sexes, was certainly often hackneyed, but it would merit a more thorough look by a discerning eye. A rapid evaluation suggests that the more modest undertakings offered greater opportunity for invention, experimentation, and variety than the official portraits regulated by conventions (CF. FIGS. 39 AND 40).

Portraiture was also lodged in the innumerable scenes of Napoleonic history and pageantry. For a public unable to judge the topographical accuracy of European battlegrounds and Oriental landscapes, exactitude in the individual portrayal of military heroes and public figures, whose features were familiar through prints, was the measure for evaluating the veracity of the representation. Trained history painters who found themselves obliged to treat contemporary events were at times uncomfortable with the documentary requisites of this hybrid genre[19]—though not David, who proceeded with apparent ease in the *Coronation* and the *Eagles.* According to Delécluze, he was accustomed to calling these two compositions "tableaux-portraits," a qualification he also affixed to *Bonaparte Crossing the Alps* in a list of his works.[20] To characterize the two ceremonies he painted, he could have employed the terms *portraits historiés* or *histoire nationale,* both current, but the first may have seemed too reductive and

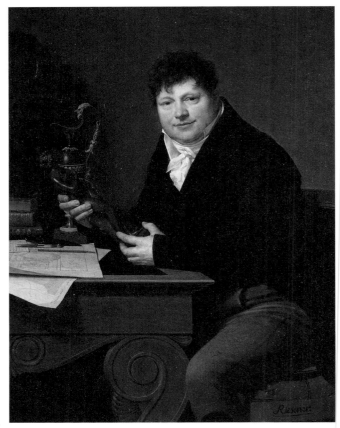

the second too ambitious. The artistic status of the representation (*tableau*) was judged more important than the represented action (*histoire*). The notion of *tableau* introduced a pictorial categorization founded on artistic as opposed to iconographical criteria, while that of *portrait* acknowledged the documentary status inferior to history. The binary term he invented eliminated all reference to the latter, and thus preserved the traditional superiority of antique subjects in which he believed. For posterity, portraits by Titian and Van Dyck had become *tableaux*. That David so decidedly inscribed his own *tableau* in the temporality of the present as a contemporary gallery suggests the acuteness of his historical self-consciousness, sharpened over time by his participation in momentous events since 1789. As first painter of the imperial regime, he took up the challenge of creating a collection of portraits, an equivalent to the engraved images of political figures from the heyday of the revolutionary assemblies. The result is not always judged successful: "unrevealing faces tediously ordered," is the recent description of the *Coronation* by one historian who puts the blame on the artist's courtier mentality.[21] Close inspection of each portrait in the *Coronation* and the *Eagles* is today difficult because of the sunken remoteness of the figures in the first picture and their bilious yellowing in the second. Some reproductions, however, reveal the expressive individuality of each face represented. This is David at his most Balzacian, employing physiognomic detail to distinguish each participant. He could have staged the *Coronation* with more marked reactions to the central event, as in a composed history painting. But he saw the danger of such narrative interaction in a genre context, an artistic strat-

FIGURE 39 Adèle Romany (French, 1769–1846), *Portrait of Jean-Dominique Fabry Garat*, 1808. Oil on canvas, 51⅛ x 38⅜ in. (130 x 97.5 cm). Private collection

FIGURE 40 Henri François Riesener (French, 1767–1828), *Portrait of Antoine-André Ravrio*, 1812. Oil on canvas, 46 x 35⅜ in. (117 x 90 cm). Musée du Louvre, Paris

egy associated at the time with the entertaining boulevard scenes of Boilly. The patent immobility of the figures identifies them as portraits and confers on the event an ambiance of dignity. In the *Eagles* (except for the group behind Napoleon) and in the *Arrival at the Hôtel de Ville* designed in 1805, the scene is far more animated and, as a consequence, portraiture is less preponderant, as if the individual participants were overtaken by their action. A social and temporal differentiation intervenes: the statuesque poses struck by the important figures are eternal, while the anonymous performances seized by the painter appear to merit only a moment's attention.

During the first (and only) decade of the *siècle de Napoléon,* when David was occupied by the relatively lucrative and prestigious homages to the *grand homme,* servicing less exalted individuals was not always a superfluity. In the context of his dependence on the government's administration for payment of his fees and his monthly stipend as first painter, he realized that his brush could be of help in a negotiation. In May 1803, when problems arose over the final installment for the three versions of *Bonaparte Crossing the Alps,* he addressed the treasurer of the consular government, Xavier Estève, to justify his claim. His letter concludes with a reminder of Estève's good will in the past, and a promise: "I shall have a special obligation toward you if you would kindly submit my observations to the first consul."[22] The tone is formulary and not unexpected of a supplicant, yet it seems impossible not to relate this engagement to the oval portrait of the financial administrator that David signed in 1804 (FIG. 41). With the exception of the portrait studies for the *Oath of the Tennis Court,* the bust-length format without hands is as minimal as his portraits get. Some years earlier he had adopted this small scale for a portrait of his servant girl (SEE FIG. 44). Compared to the *Portrait of Suzanne Le Peletier* (SEE CAT. 15), painted the same year on a rectangular canvas of roughly the same size, the oval cropping of the image accentuates the diminutive impression. The oval was a decorative format dear to contemporary miniaturists and associated by most progressive artists with a period of French painting long past, with the *manière française* David more than anyone had thoroughly devalued.[23] That the painter thus curtailed his ambitions suggests that if the portrait was an offering, like that of the wife of another Napoleonic administrator in 1810 (SEE CAT. 18), it was not executed with any great investment. At a later date he began a three-quarter length portrait of Estève, representing the courtier in official dress, implying that the first one was not absolutely satisfactory (cf. the remarks on the two portraits of Turenne, SEE CATS. 48 AND 49).[24]

The portrait of Estève painted in 1804 marks an evolution in David's approach to the model. In this small work, as in the *Portrait of Suzanne Le Peletier,* the severity and monumentality of the *Portrait of Henriette de Verninac* (SEE FIG. 54) and the humanity and naturalism of the *Portrait of Cooper Penrose* (1802) find a dialectical resolution. Unlike the oval portrait of Pierre Sériziat painted in 1790 (FIG. 42), the vivacity of the representation derives not from a fiction of animation—a quick turn of the head or the suggestion of energy in

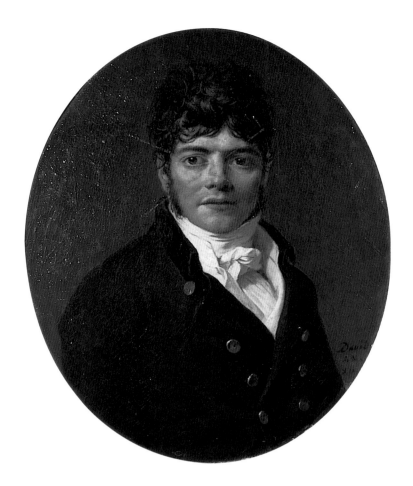

the treatment of accessory details (the tousled wig, the flying lapel, the agitated buttons and cravat)—but from the denotation of Estève's individualized features. Captivated by the intense expression in the eyes, the viewer is attracted to the almost ugly face. By contrast, Sériziat in his portrait appears pretty but paradoxically bland. The change in ethos from one historical period to the next finds no clearer demonstration than here. David copied Estève's figure onto the *Coronation:* his dark, curly-haired head is slotted in the middle ground, below Napoleon's enthroned mother, to the right. His fixed gaze, more radically frontal than that of any other figure on the scene, even Napoleon's mother whose eyes shift wide to focus on her son, sets the standard for the solemn register of expression David adopted.

The *Portrait of Antoine Français* of 1811 (SEE CAT. 21) may also have been undertaken to gain a favorable ally within the imperial administration. However, as David was finishing the *Eagles* and somewhat anxious about his future occupations as first painter (see the essay "In the Service of Napoleon" in this volume), he devoted himself especially to his friends and family, a sentimental rapprochement recalling the need felt upon his release from prison. In 1809 he drew a pair of lively portraits of Alexandre Lenoir and his wife, Adélaïde Binard (SEE CAT. 17). Presently mounted together, the resulting double image evokes the impressive portrait of Antoine Mongez and his wife Angélique Le Vol, side by

FIGURE 41 Jacques-Louis David, *Portrait of Xavier Estève*, 1804. Oil on canvas, 24¾ x 20½ in. (63 x 52 cm) oval. Private collection

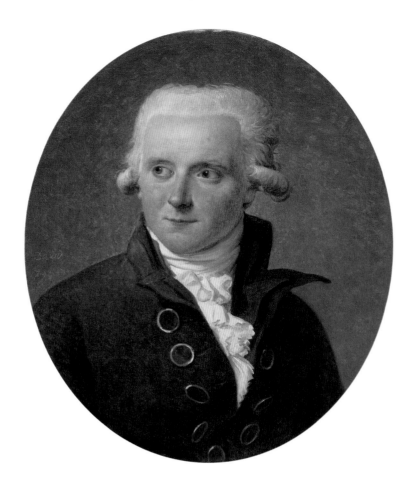

side in a strikingly austere composition (SEE FIG. 34). Here David is careful to not cast the erudite antiquary and numismatist as the paternal protector of his spouse, twenty-eight years younger; and for her, he makes no concessions to conventional coyness or seduction, which her relative youth might have authorized. Set against a saturated dark background like the figure of Estève, but more dramatically lit, the couple confronts the viewer directly. The potentially dour allusion to Etruscan or Roman funerary reliefs is attenuated by the almost jovially rubicund complexions, rarely in David's oeuvre so explicitly Rubensian. Angélique's open mouth revealing a row of bright teeth recalls similar attempts made by Vigée Le Brun and Houdon to enliven their figures in this way, against the grain in contemporary doctrine.[25] The Mongez couple is the "modest, bourgeois, and sympathetic counterpart of the grandiose portrait of the Lavoisier couple," as Antoine Schnapper has observed.[26] In fact, what distinguishes the two couples is not so much their social and cultural estrangement—both are well-off and cultivated—as the dramatic change in David's artistic vision over a quarter of a century.

The fantasy of an unmediated proximity with the Mongez couple, alien to the society images David had produced earlier, reflects the valorization of intimacy in portraiture after the Revolution. With reference to certain portrait drawings by Jean-Auguste-Dominique Ingres, Uwe Fleckner has sought to con-

FIGURE 42 Jacques-Louis David, *Portrait of Pierre Sériziat*, 1790. Oil on canvas, 21⅝ x 18⅛ in. (55 x 46 cm) oval. National Gallery of Canada, Ottawa

ceptualize the notion of *portrait intime,* while Christopher Riopelle has proposed to extend it to some of his paintings.[27] Although the term was proposed quite late by one of his biographers and never actually employed by the artist, it suits well an elusive aspect of social reality. By the end of the eighteenth century it seemed as if writers had managed to reveal all the different workings of mind and soul, and from the early nineteenth century, they were wont to explore what lay beyond the limits of ordinary sensations. In parallel, however, the political rhetoric of the Enlightenment and the Revolution had acted as a centripetal force by dignifying ordinary domestic experience. Since the middle of the eighteenth century artists celebrated situations and expressions exalting natural simplicity and sentimental authenticity. Not surprisingly, the conventional nature of such representations, repeated over and over, came to undermine their message: especially after the social disorder resulting from the Revolution, images of bonding and affection appeared contrived and false, faces expressing joy and happiness seemed forced, reminiscent of the social postures characterizing the Ancien Régime. In so many por-

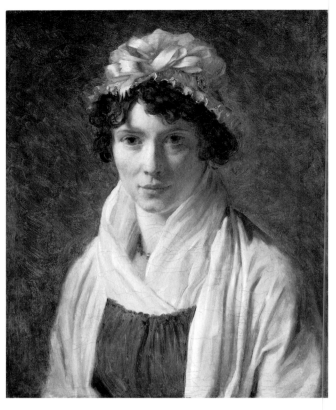

traits of the period, artist and sitter preferred a closed, protective, even blank expression, to one that might appear faked. For more and more citizens, including artists, as soon as they acquired a reputation, the psychological minutiae of bougeois life constituted their quotidian reality. The *portrait intime* should be considered the visual expression of that reality. Formally, it implied a fiction of immediacy, most often communicated by an impromptu sketch, but bereft of the demonstrative virtuosity that Fragonard, for example, put in his *portraits de fantaisie.* The avoidance of formulas was essential, again without appearing to aim for originality. David's former pupil Jean-Baptisite Wicar, while established in Italy, drew a series of portraits of his entourage, from the late 1780s to the early 1800s, which correspond closely to these criteria.[28] That he forged this portrait type on his own and as his own was not an idiosyncratic impulse, but rather a contribution to a period phenomenon. Whereas Wicar made no attempt to preserve the spirit of the *portrait intime* in his paintings, which he submitted to diverse compositional strategies borrowed from others, Gérard captured it remarkably well in several of his paintings from the revolutionary years. The bust-length portrait of his two younger brothers (c. 1792; private collection) makes no allowance for the usual playfulness of youth;[29] that of his cousin, Madame Lecerf (FIG. 43), without the least hint of a pose, is a most persuasive image of modesty and candor, which by comparison reveals the artificial coyness of David's *Portrait of Catherine Tallard* (FIG. 44). Certain of David's drawings create, however, this fiction of nonfiction (CF. CATS. 16 AND 17). In his paintings it was not an articulated conceptual framework he sought to apply,

FIGURE 43 François Gérard, *Portrait of Madame Lecerf,* c. 1794. Oil on canvas, 22 x 18½ in. (56 x 47 cm). Musée du Louvre, Paris

FIGURE 44 Jacques-Louis David, *Portrait of Catherine-Marie-Jeanne Tallard,* c. 1795. Oil on canvas, 25¼ x 21¼ in. (64 x 54 cm). Musée du Louvre, Paris

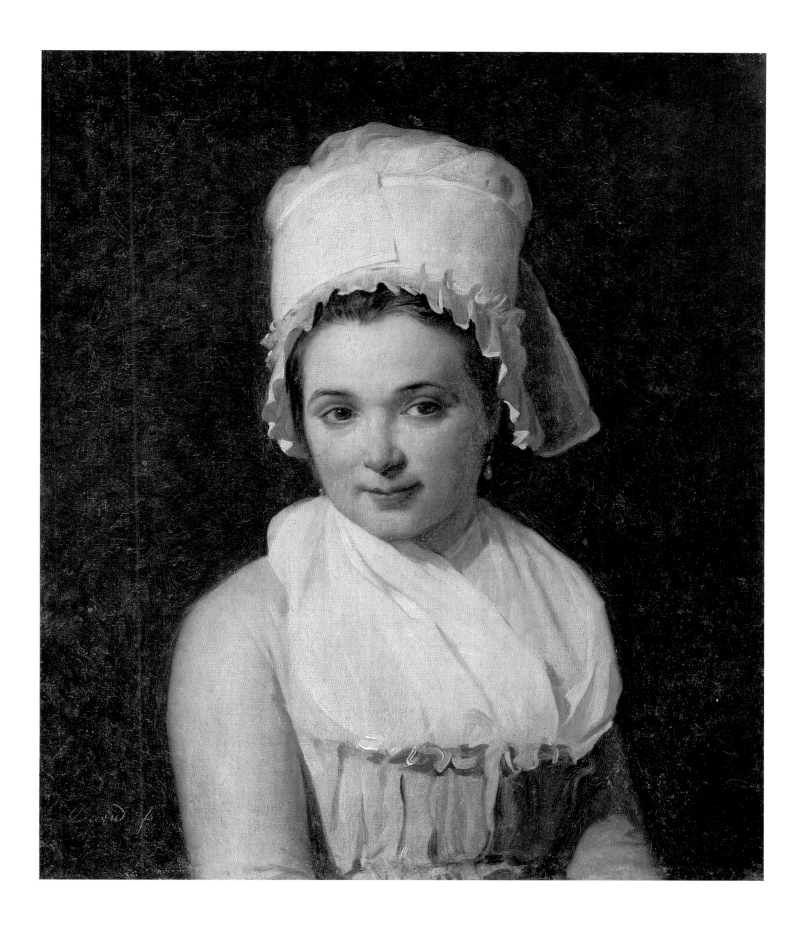

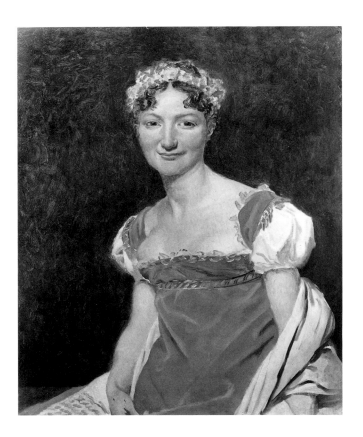

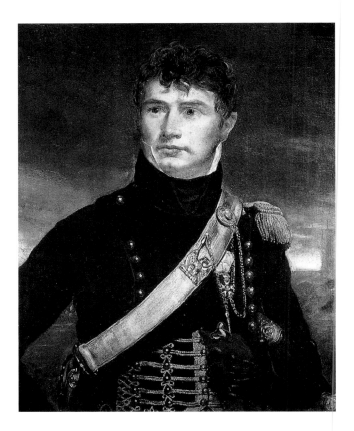

but rather a notional horizon—the glasslike intersubjectivity dreamt of by Rousseau—to which he and other artists aspired in their images of family and friends.

Around 1810 David decided to create a gallery of family portraits, inaugurated by one of Jean-Baptiste Jeanin, his son-in law (SEE CAT. 19), and closing with that of his wife in 1813 (SEE CAT. 23). In the interval he painted his other son-in-law, Claude-Marie Meunier (SEE CAT. 20), and his twin daughters, Pauline Jeanin (FIG. 45) and Émilie Meunier (SEE CAT. 22). For all, he adopted the large half-length format, also chosen for Daru's wife in 1810. Like the latter, the three women in the family appear seated, while the two men stand, an iconographical archaism perhaps suggested by portraits in the museum. For an unknown reason, David did not portray his two sons, Jules and Eugène. The first was living in Germany around this time, and seems to have had strained relations with his father.[30] The second, engaged in the military like his two brothers-in-law, posed in 1812 for Georges Rouget (FIG. 46), who exhibited his portrait at the Salon that year; it has a format identical to those of the family suite, which it presumably was intended to complete, as Alain Pougetoux has suggested.[31] Rouget, then one of David's major aides on *Leonidas,* also painted a portrait of his master, most likely in 1813, showing him seated holding a pencil, with the officer's rosette and cross of the Legion of Honor pinned to his lapel (FIG. 47).[32] In his home, this pseudo-self-portrait formed a pair with his slightly smaller portrait of his wife.

This family series dating from the end of the Empire was a fundamentally regressive occupation. At the time, it was impossible to perceive the family

FIGURE 45 Jacques-Louis David, *Portrait of Pauline-Jeanne David, Baronne Jeanin,* 1810. Oil on canvas, 28¾ x 23⅝ in. (73 x 60 cm). Collection Oskar Reinhart "Am Römerholz," Winterthur, Switzerland

FIGURE 46 Georges Rouget (French, 1783–1869), *Portrait of Eugène David,* 1812. Oil on canvas, 28⅜ x 22⅞ in. (72 x 58 cm). Private collection

other than as the site and safeguard of traditional values codified by Napoleon. Although all the David clan donned their best clothes to sit for the head of the household, as if they were going to an important reception, the series signifies a retreat from society into the family circle. Was it because after Napoleon's marriage to Marie-Louise more and more of the Ancien Régime aristocracy joined in court events, making David feel estranged from the official scene? Was it due to his vexation now that preference went to other artists? Was his attitude a premonition that the imperial regime would soon fall?[33] The regression was social but also artistic. These half-length portraits—though, happily, neither their execution nor their expression—rank among the most conventional he ever produced. This is all the more striking since he also painted some of the most

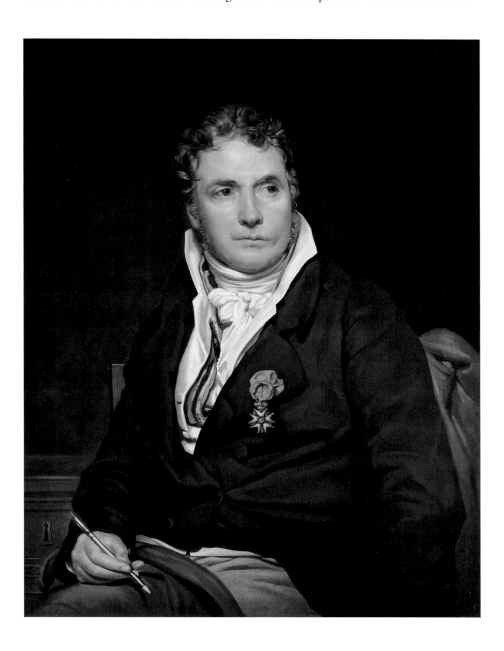

FIGURE 47 After Georges Rouget, *Portrait of Jacques-Louis David*, 1815. Oil on canvas, 35⅛ x 26¾ in. (89.2 x 67.8 cm). National Gallery of Art, Washington, D.C. Chester Dale Collection

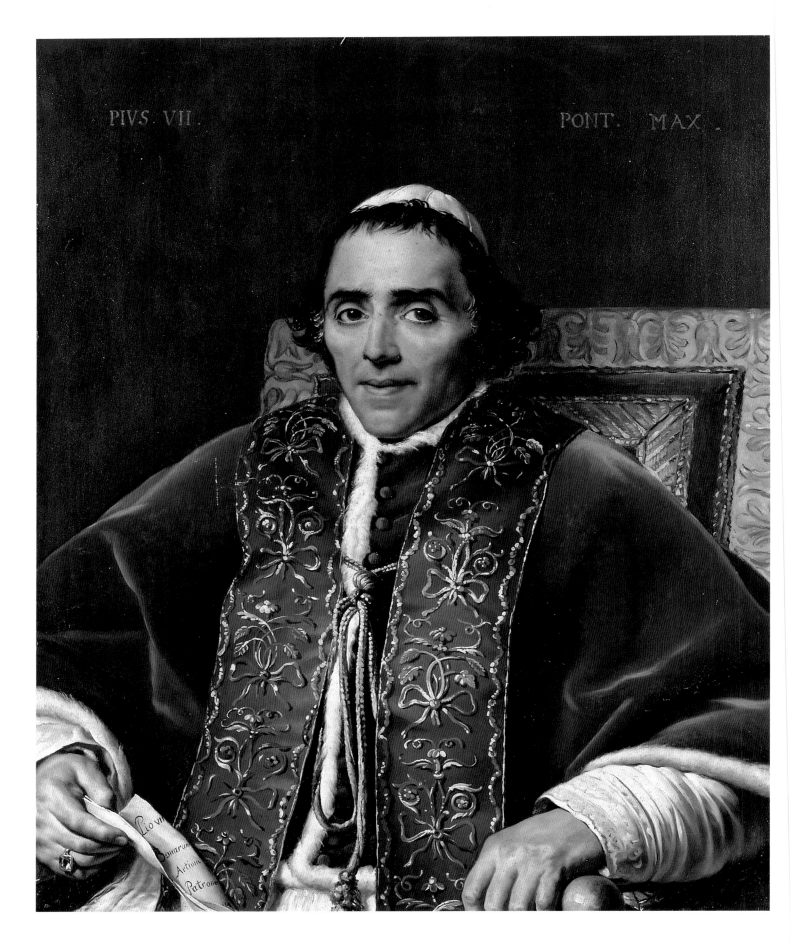

PIVS· VII. PONT· MAX·

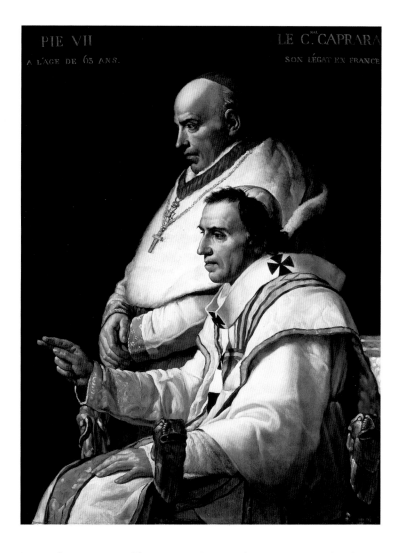

PIE VII
A L'AGE DE 63 ANS.

LE C.^{AL} CAPRARA
SON LÉGAT EN FRANCE

FIGURE 48 Jacques-Louis David, *Portrait of Pope Pius VII*, 1805. Oil on panel, 34 x 28⅛ in. (86.5 x 71.5 cm). Musée du Louvre, Paris

FIGURE 49 Jacques-Louis David, *Portrait of Pope Pius VII and Cardinal Caprara*, c. 1805. Oil on panel, 54⅜ x 37¾ in. (138 x 96 cm). Philadelphia Museum of Art. Gift of Henry P. McIlhenny

innovative and inventive of his career during this same period. The *Portrait of Cooper Penrose* (SEE CAT. 14) and the *Portrait of Antoine Français* (SEE CAT. 21) are both variations on the larger knee-length format that David had standardized around 1790, but each imaginatively reworks the prototype and transgresses the accepted norms of the day. The pressuring of Penrose by so much empty space above his head is no less singular than the strait-jacketing of Français by the unusually narrow format. For the portrait of Pius VII of 1805 (FIG. 48), the painter had likewise severely cropped the figure, much to the annoyance of some critics who thought the pope seemed cramped in his armchair. Inspired by the plethoric collection of pictures in the Musée Napoléon, on every visit he could discover ways to experiment in a variety of directions, without the burden of an articulated program. Although he went back to more conventional formats, traces of his inventive spirit for framing portraits survive in his novel approach to certain historical compositions, notably *The Anger of Achilles* (SEE CAT. 36).

Whereas the family portraits and several others are on canvas, a number were painted on panel: the 1805 sketch of Napoleon (SEE FIG. 10) and the related head study (SEE CAT. 7), along with the *Portrait of Pius VII* (FIG. 48), the *Portrait of Pope Pius VII and Cardinal Caprara* (FIG. 49), the *Portrait of Antoine Français* (SEE CAT. 21), the *Portrait of Antoine Mongez and Angélique Le Vol* (SEE FIG. 34),

and the *Portrait of Alexandre Lenoir* (SEE FIG. 58), dated 1817 but begun in Paris (CF. CAT. 17).[34] David's exploration of the visual potential of this support, manifestly as a means to regenerate his practice, can be assigned to his investment in portraiture after the Terror. The first clear proof of his curiosity dates from 1795, when he adopted panels for the portraits of the two Sériziats. It was commonly thought that the ancients had painted exclusively on wood, and observed that during the Renaissance artists maintained this preference for medium-size works; the disaffection for painting on panel was attributed to the vulnerability of the support to worms and humidity.[35] David was probably giving a delayed response to works by Élisabeth Vigée Le Brun seen at the Salons during the 1780s. During a trip to the Low Countries in 1781 with her husband, who dealt in Dutch and Flemish pictures, she fell under the spell of Rubens and during the following decade produced a stream of stunning portraits on panel. She used the perfectly smooth surface to lay out thin transparent colors and *frottis,* or scumbling with a stiff brush, in fact quite close to David's treatment of shadow and background at the time. Admiring and perhaps even envious of her work, he is reported to have observed in 1791, seeing a portrait by her placed near one of his own at the Salon, that hers looked as if painted by a man and his by a woman.[36] His conscious effort to achieve greater formal clarity and structure in 1795, it would seem then, was a way to reinforce the fantasized virility of his art.[37] The paradox was that in the process he should turn to the example of a woman painter. In truth, his choice was part of a trend among painters during the Directory and Consulate. A number of younger artists, such as Gérard and Martin Drolling, also chose wood supports for some of their portraits, probably under the influence of pictures by Old Masters in the museum. For David it was also a voluntary archaism, an effect of the increasing cultural domination of the museum on art practice at the time: as already mentioned, when painting Pius VII in 1805, he thought of himself replaying Raphael before Julius II. It was also around that time that he began a sketch for the *Coronation* on panel, perhaps because a rivalry with Rubens was implicit in the project. (For some reason, he overpainted his initial tracings with the double portrait of the Pope and Cardinal Caprara.)

In the eyes of partisans of the classical tradition, painting on wood received official sanction, articulated more with regard to form than to color, through the commentary of Nicolás de Azara on the art of Anton Raphael Mengs, published in French in 1786: "[Mengs] preferred to paint on panel when he could, because canvas, however well prepared, never offers as smooth, nor as unified a surface as wood; and every cavity or rough spot, however small it may be, creates a wrong reflection of light. Besides, canvas has further handicap; should it be of a certain size, it yields to the brush, so that the hand is neither firm nor sure."[38] Implicit in this argument is praise for smooth finish, which in fact David, unlike many of his contemporaries, did not champion. Even though he proposed a rough imitation of this mode in the *Portrait of Henriette Verninac*

(SEE FIG. 54), he considered it resulted in paintings that too often were cold and mannered. He generally preferred to build the figure up with tight but visible brushstrokes. Aware that his handling could be found lacking in firmness (SEE CAT. 14), he surely appreciated how the panel support, as noted by Azara, gave a heightened sense of relief to the painted form, the semblance of sculpture having come alive. Toward the end of the Empire, in one instance at least, he further experimented by painting on wood an antique scene, *Alexander, Apelles, and Campaspe* (SEE CAT. 31).

When representing ordinary individuals, David upheld the sober conception of portraiture he had adopted during the 1780s and 1790s: a focus on the figure, scaled to life, with few if any accessories and a neutral background. He was one of many painters who had adopted these principles during the second half of the eighteenth century, in echo to Enlightenment critique of the artificiality and pretense of much society portraiture and the concomitant call to valorize moral qualities and domestic virtues.[39] Portraitists were as a result more concerned with expressing a sitter's physiognomy and personality than laboring over the external trappings of their status in life. To a history painter, this aversion to description was overdetermined by its association with the spirit of genre painting. Around 1800 a number of portraitists, including Boilly, Jacques Sablet, and Adèle Romany, were successful in commercializing small-scale portraits set in precisely detailed interiors, in the manner of seventeenth-century Dutch and Flemish genre scenes. The vogue was such that Gérard and others attempted to carry over this conception to life-size scale.[40] Furthermore, the intense fascination with fashion—*la déesse de la mode*—had not abated since the Directory. That the *Journal des arts* maintained a regular rubric entitled *Mode* was a sure sign of the implication of artists in this domain. During the Directory David had expressed a progressive interest in reforming women's fashion on antique models, while during the Empire he seems rather to have resisted the evolution away from sobriety, to which he would finally surrender in Brussels. It would be instructive to know if he judged the portrait of a woman painted around 1810 by his former pupil Henry-François Mulard (FIG. 50) a fussy variation on his *Portrait of Henriette de Verninac* or a novelty worthy of his attention.[41]

When confronted with commissions for public portraits, David had to admit that setting and accessory elements might be serviced to nourish political, iconographical, and narrative expressions otherwise nearly impossible to convey. He took pains to create a convincing interior for Napoleon in 1811–12, as if to appease the manes of Rousseau, who in *L'Émile* regretted that history ignored the private life of the great man.[42] The neutral barren surroundings he generally imagined for his figures had an undeniable democratic pathos, a revolutionary austerity legitimized by the parallel with the purity and severity of the antique (and for the twentieth century, an ahistorical modernity to its taste). It may also have reflected his conception of dignity in portraiture: whereas several of his

contemporaries painted men with a musical instrument—he himself had a passion for the violin[43]—it is hard to imagine him figuring anyone for posterity in that situation (except a woman, CF. CAT. 56). Certain contemporary critics, however, believed that this desocialized mode sacrificed the complexity of the sitter's personality and the pleasure of pictorial virtuosity.[44] David was generally unwilling to animate his portraits: his figures do not dissimulate the fact that they pose. He probably found the fictions invented by his contemporaries trivial or hackneyed (writing, reading, lost in thought), or else far-fetched and burlesque (ice-skating, drying off after a swim, tying a shoe). During the later part of the Empire, he did paint Alexandre Lenoir at his desk, pen in hand (SEE FIG. 58), a rare instance when he succumbed to conventions he disliked. Was it because he realized the result was disappointing that he kept it for so long? His failure in regenerating this tired formula is surprising, since a number of portraits by Antoine-Jean Gros (FIG. 51), Adèle Romany (SEE FIG. 39), and François-Henri Riesener (SEE FIG. 40) shown at the Salon during the Empire, images of apparently good-natured men of culture—artists and musicians, in fact—suggest that a moderate course could be steered with imagination. Perhaps sensitive to these debates and perhaps placed on the defensive, David surprised everyone

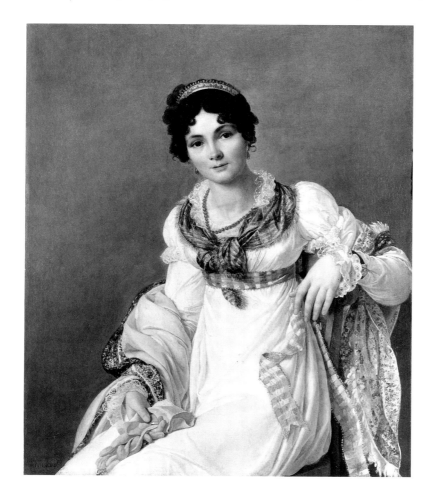

FIGURE 50 Henri-François Mulard (French, 1769–1850), *Portrait of a Woman*, c. 1810. Oil on canvas, 39 x 31¾ in. (99.1 x 80.6 cm). Private collection

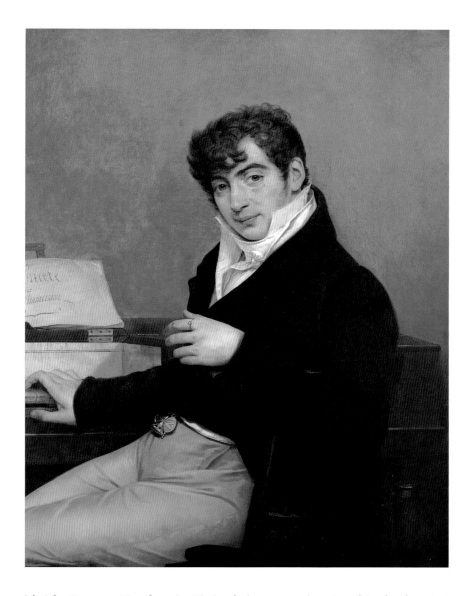

with *The Emperor Napoleon in His Study* (SEE CAT. 12), painted in the descriptive mode so alien to him. This time, he had reason to judge the result persuasive, but it should be noted that he stopped short of total immersion in pictorial fiction. His figure of Napoleon does not appear to perform dynamically across space, but poses in front of a backdrop, next to inert props. The chiaroscuro and the design both accentuate the absolute visual supremacy of the figure. That the globe of the armchair should cover a millimeter of Napoleon's hand is a symbolic aggression barely tolerable. Contemporary portraits, showing figures physically engaged with their surroundings, reveal by contrast how contrived and unnatural David's image is. This is the paradox of his mature portraits: the figures are abstracted—posed and recomposed, perhaps even to excess with respect to contemporary experiments—and yet they project a sense of proximity and truth, which a surplus of description would probably undermine. In sum, the principle of visual austerity, and in *Napoleon in His Study* the control of visual hierarchy, are crucial in permitting him to offer portrait fictions that are not narrative, but fundamentally formal and expressive.

14 Portrait of Cooper Penrose

1802

Oil on canvas
51⅜ x 38⅜ in. (130.5 x 97.5 cm)
Signed and dated lower right: *L^{cus}
David / faciebat / parisiis anno / X^{mo} /
reipublica gallic[ae]*

The Putnam Foundation, Timken
Museum of Art, San Diego

PROVENANCE
Cooper Penrose (4 Dec. 1736–25 Feb.
1815) and thence by descent until 1947
(Cooper 1949a, see Bibliography: "A
really fine signed and dated [1801] [*sic*]
portrait by David, that of *Mr Penrose* . . .
which had been lost sight of, was
recently disposed of by the descendants
of the sitter and has left the country");
1947, acquired by Wildenstein & Co.,
New York; 1953, acquired by the Putnam
Foundation.

EXHIBITIONS
New York, Metropolitan Museum of
Art, extended loan, 1953–55; Cambridge,
Mass., Fogg Art Museum, extended loan,
1955–65; Houston 1986–87, pp. 78, 131,
no. 23; San Diego 2003–4, no. 2.

BIBLIOGRAPHY
Th. 1826b, p. 166 ("M. Pennerin
Villandois"); Blanc 1845, p. 211; Blanc
[1849–76], p. 15 ("M. Pennerin-Villan-
dois"); David 1880, p. 642; Farington
1922–28, vol. 2, pp. 45–46; Cantinelli
1930, p. 110, no. 100; Holma 1940, p. 128,
no. 106; Cooper 1949a, p. 22; Mongan
1969, pp. 100–101, 132–33, no. 38; Wilden-
stein 1973, p. 161, no. 1386, p. 209, no.
1810, p. 226, no. 1938; Farington 1979, p.
1891; Schnapper 1980, pp. 208, 210, 211,
fig. 121; Mongan 1983, pp. 42–43, 118–19,
no. 13; A. Schnapper in Paris-Versailles
1989–90, pp. 19, 21, 375, fig. 93, in reverse,
601; Fischer 1996, pp. 147–51, no. 27
(entry by Richard Rand).

D URING THE Peace of Amiens between France
and Britain (25 March 1802–12 May 1803),
a great number of foreign visitors traveled to
Paris eager to discover a nation transformed by
the French Revolution. Amateurs and artists were
particularly eager to visit the new museum and
evaluate the state of the contemporary French
School. Among the travelers was an Irish Quaker,
Cooper Penrose, who lived in Cork and who had
made his fortune in the lumber trade. He had
built a new house for his family and filled it with
pictures and casts after the antique. A local guide-
book vaunted its treasures in 1810, describing it as
the "Irish Vatican." His trip to Paris in 1802 was
not motivated solely by his desire to acquire some
furnishings for his home. His involvement in the
campaign to abolish the slave trade and his sup-
port of his compatriot James Barry prove him to
have been sympathetic to reformist movements in
Britain, whose circles closely observed the political
events in France. In his publications Barry had
championed David as an exemplar of artistic
excellence accountable to a republican form of
government. Penrose seems to have avoided the
social scene and the British community when in
Paris, but was determined to meet the painter,
whose reputation was inseparable from his
Jacobin past. Judging from the small number of
private portraits painted by David in this period,
as he was entering into the service of Bonaparte,
it is most likely that Penrose's commission resulted
from a persuasive pitch on the part of the aspiring
sitter. The foreigner willingly offered two hundred
gold louis, a sizable sum, for the task, and perhaps
also expressed sincere sympathy for his civic
ideals.[1]

An undated letter from David to the sitter
constitutes a contract for the portrait: "Mr. Pen-
rose can have complete trust in me, I will paint his
portrait for him for two hundred gold louis. I will
represent him in a manner worthy of both of us.
This picture will be a monument that will testify
to Ireland the virtues of a good father [un bon

père de famille] and the talents of the painter who
will have rendered them. It will be handled in
three payments, namely 50 louis at the start, 50
louis when the picture is roughed in [*ébauché*],
and the remaining 100 louis when the work is
finished."[2] At the time of Penrose's commission,
David's financial pretensions were justified by the
thousand louis he had obtained from the king of
Spain for *Bonaparte Crossing the Alps.*

Despite the dry financial considerations, the
tone of the missive is far from simply businesslike.
The procedure of requesting three installments
was a holdover from David's royal commissions.
As David imagines the stages of execution while
writing his note, the status of the project seems
to evolve: only a *portrait* at first, then a *tableau-
monument* in homage to the sitter, it becomes on
completion an *ouvrage* contributing to the fame
of the painter. The fact that he esteems both their
reputations will be at stake in the enterprise rein-
forces the idea of a mutual understanding between
the Frenchman and the Irishman. In 1802 David
could not fail to represent Ireland to himself as
a nation sympathetic to the French Republic and
oppressed by Britain. Why he should want to
underscore Penrose in the role of a *bon père de
famille*, however, is less simple to fathom. At the
time, Cooper Penrose and his wife had two sons
and two daughters, born between 1766 and 1774;
two other sons and a daughter are reported to
have died young. The parallel with David's own
family is striking, since he also had two sons and
two daughters, born between 1783 and 1786 (SEE
CAT. 22). As they were coming of age, he was
increasingly preoccupied with their financial situ-
ation. Whether he effectively projected his own
concerns on his sitter, the spirit of reconciliation
inspiring the *Sabines* shows him to have been
receptive to the family values being promoted in
post-Revolution French society.[3]

146

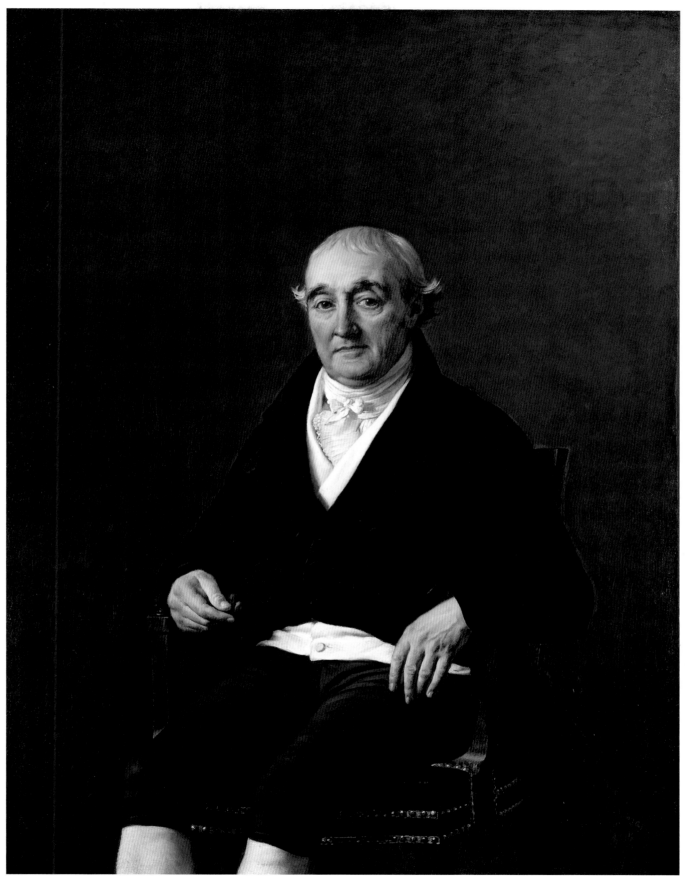

Jean-Baptiste Greuze, who much earlier had built a reputation by dramatizing the gamut of paternal affections, may also have been at the back of David's mind. The aging painter was not a forgotten figure on the Parisian scene: his studio was among those visited by curious foreigners. By conceiving of Penrose in terms of a *bon père de famille*, David was also reviving the domestic ideal championed by the Jacobins during the Terror: his sitter, a sixty-six-year-old father of four and a good citizen, was an apt candidate for public recognition. In the spirit of the republican festivals *de la vieillesse* organized by the government during the early Directory, David's homage was conceived as a *tableau-monument*. A similar aura of virtue enthroned informs the conception of Penrose's portrait.

Such republican resonances may account for the unusually long inscription that David appended to his signature: "Louis David painted this in Paris in the tenth year of the French Republic."[4] That the artist chose to employ a classical conceit he generally reserved for historical compositions may have been a way to register that Penrose shared his admiration for ancient Roman republicanism. It may also have been inspired by their mutual interest in antiquities. Penrose's project to purchase plaster copies of the Louvre's antiques while in Paris would have delighted the painter, in whose studio "busts, statues, casts abounded everywhere."[5]

The artist manages to invest the painted image with a republican aura in still another way. Penrose's sober black costume was perhaps dictated by his Quaker culture. It also defined him as a partisan of a bourgeois simplicity, recalling the official dress of the deputies of the Third Estate during the meeting of the Estates-General in the spring of 1789, which David had planned to honor in the aborted *Oath of the Tennis Court*. Even the unusually vast expanse of empty space above the seated figure (often reduced in reproductions), a traditional religious metaphor of the dominion of the spiritual over the worldly, echoes his radical employment of such a visual effect in 1793 to beatify Marat (FIG. 52). The general starkness of the representation, contrasting with the various portrait modes during the Consulate, is ostensibly the result of an aesthetic choice with strong moral resonances. To contemporary eyes the subdued colors David employed probably evoked the mood of Rembrandt's portraits of the 1630s, as Richard Rand has suggested.[6]

Such sobriety was alien to the conventions of elite portraiture and made some viewers uncomfortable, as is clear from another source documenting the making of Penrose's portrait, the diary of Joseph Farington, who was in Paris at the time. Like the other foreign artists who had made the journey, he was keenly curious about David. On 3 September 1802, he went with Henry Fuseli and John Opie to view the *Sabines*, which he called a "chief work of the French School." Openly unsympathetic with David's method—"I never saw a Composition in which the art of arranging was less concealed"—Farington criticized the picture with easy confidence. A few weeks later, on 20 September, this time with a small group including Fuseli and John Hoppner, he visited "the apartments of David in the Louvre by appointment of Mademoiselle Jaullie, as she is called, a Young Lady from Ireland who is pupil to David." As becomes clear from a later entry in the diary, on 1 October, "Mademoiselle Jaullie," or Julia, was Penrose's niece: "We next called upon Mademoiselle Julia as she is called in Paris, at David's, and saw the Half length portrait of Her uncle which was painted by David. She told us He sat Eighteen times for it, from about Ten o'Clock in the forenoon till four in the afternoon. The price was 200 guineas. It was painted in a very poor manner having a sort of woolley appearance as if done in Crayons. It put me much in mind of the pictures of the late N. Hone."[7]

Since he inscribed "an X" on the canvas, it is certain that David had finished the portrait before 1 Vendémiaire Year XI (23 Sept. 1802), the first day of the new year. Allowing for a few interruptions in the sittings, it was probably executed over a period of three weeks, and perhaps longer on account of the concurrent commissions for the first consul and obligations toward the pupils in the studio who paid for David's guidance. It is a rare insight to be informed of the number of sittings required by the painter; this may explain Juliette Récamier's "impatience" while sitting for her portrait two years earlier. The painter could also be less demanding when necessary, as is apparent from his relations with Bonaparte, who never posed for long, if at all.

FIGURE 52 Jacques-Louis David, *The Death of Marat*, 1793. Oil on canvas, 65 x 50⅜ in. (165 x 128 cm). Musées royaux des Beaux-Arts de Belgique, Brussels

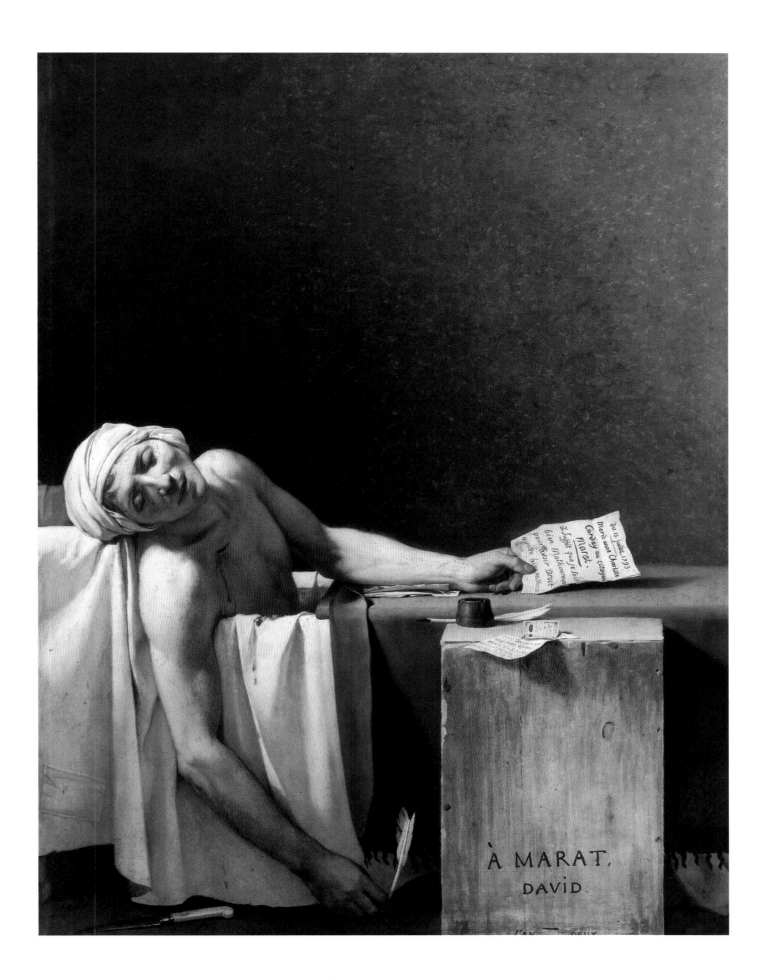

That Farington found the forms "woolley," in other words, not sharply defined, may be due to a combination of factors. David avoided the virtuoso finish dear to his younger French rivals, as well as the expressive pictorial effects deriving from Anthony Van Dyck, which the English school had fully naturalized through the work of Joshua Reynolds and Thomas Gainsborough. Farington's association of David's portrait with the style of Nathaniel Hone, who had died much earlier, in 1785, is revealing. Hone may have come to mind since he was Irish like Penrose. The austere image of the Irish Quaker may have put Farington "much in mind" of the portraits of clergymen, Hone's specialty, many of which were available in mezzotint. He had also achieved notoriety for his painted satire of Reynolds, *The Conjuror* (Tate Britain, London), which had caused a great scandal in London in 1775 and was probably not totally forgotten a quarter of a century later.[8] By pitting David in the role of the modest Hone, who had taunted the most eminent representative of the contemporary English school, the diarist's association is clearly meant to be derogatory.

In his diary Farington further notes Fuseli's ironic reaction to Penrose's portrait and the details furnished by his niece: "Fuseli was very merry in his remarks upon the French pictures. He thought David for the eighteen sittings deserved all the money for *day work,* from *such a subject,* which indeed was a very bad one."[9] Manifestly Penrose struck him as hopelessly uninspiring as a model and the commission as a result could only prompt a hack job (day work). Fuseli's reactions to contemporary French painting were consistently negative and more than often hyperbolic, but his remark does underline a difficulty contemporaries had with David's understated mode of execution. Another Englishman, Bertie Greatheed, shared this attitude. He also proved himself an acerbic critic of contemporary French painting, notably comparing David's *Bonaparte Crossing the Alps* with William Hogarth's bombastic portrait of Baron Squanderfield on the wall in the first scene of *Marriage à la Mode.* On visiting "David's painting room in the Louvre" in early January 1803, he jotted down having seen "a portrait of a man sitting in an elbow chair; the most hard, villainous thing I ever saw," in all likelihood a reference to Penrose's portrait, which was still with David in May of that year.[10]

On the Parisian stage, at concerts and on the walls of the Salon during these years, spectators thirsted for heightened visual drama. The public reserved its applause for what one German visitor called "contrasts," reviving a term that had been central to Rococo aesthetics.[11] Increasingly, it was expected that portraitists stage their subject in some way. This could mean inventing a novel pose: the life-size portrait of the medal engraver Bertrand Andrieu ice-skating by Pierre-Maximilien Delafontaine, a David pupil, exhibited at the Salon of 1798, is a prime example of this phenomenon.[12] The theatrics could also apply to the execution. This meant deploying bravura handling, whether in terms of what Farington called "high finishing"[13] dear to the contemporary French school or broad effects characteristic of the English school. David's manner and conception were equally distanced from these two poles, which each claimed to represent a distinct form of modernity. Whereas Fuseli and other British artists found his portrait of Penrose dull, it is likely that Gérard, Isabey, and their crowd were more inclined to consider its applied restraint old-fashioned.

Exactly one month after the visit during which they looked at Penrose's portrait, Farington and Fuseli once again called on "Madamselle Julia" at David's studio on 3 October 1802, this time with J. M. W. Turner and John James Halls. On their way down the stairs of the Louvre, the group passed the painter, who seemed "shy, keeping himself close to one side of the stair case."[14] However, Farington made no further mention of the portrait of Julia's uncle, which was then lost sight of until the middle of the twentieth century.

NOTES

1. For details and references concerning Penrose's biography, his relations with David, and his portrait, see Bordes in San Diego 2003–4, pp. 14–20. The present entry is a résumé and reprise of this text with no significant additions.

2. The undated manuscript note was joined to the portrait when the Penrose family sold it and is now in the Timken Museum: "Que Monsieur Penrose se fie entièrement à moi, je lui ferai son portrait pour deux cents louis d'or. Je le représenterai d'une manière digne de tous les deux. Ce tableau sera un monument qui attestera à l'Irlande les vertus d'un bon père de famille, et les talens du peintre qui les aura tracées. On s'acquittera en trois payemens. Savoir 50 louis en commençant, 50 louis quand le tableau sera ébauché, et les 100 louis restans quand l'ouvrage sera achevé."

3. For a suggestive discussion of paternal and family values during this period, see Hunt 1992, pp. 17–52 ("The Rise and Fall of the Good Father"), 151–91 ("Rehabilitating the Family").

4. Strictly speaking, the imperfect—*faciebat*—should be translated as "was painting." The imperfect tense of Greek inscriptions found on antique statues, glossed by Pliny the Elder, was interpreted since the late fifteenth century as a mannerism of modesty, which many artists imitated in Latin (my thanks to Christian Michel for this observation); see Juřen 1974, pp. 27–30.

5. Farington 1979, pp. 1861 (quote), 1863 ("there were many casts of figures & busts, and drapery hung up & studiously folded and nailed to secure the forms in which it was so placed") (20 Sept. 1802). See also Carr 1807, pp. 144–45.

6. One conclusion from the recent presentation of nine portraits, all executed around 1800, is that with the exception of Gros, contemporary painters manifested a strong predilection for subdued, earthen colors (San Diego 2003–4).

7. Farington 1979, pp. 1824–25 (3 Sept. 1802), 1861 (20 Sept.), 1891 (10 Oct.).

8. John Newman, "Reynolds and Hone. 'The Conjuror' Unmasked" in London 1986, pp. 344–54; see also p. 343, no. 173.

9. Farington 1979, p. 1891 (1 Oct. 1802).

10. Greatheed 1953, p. 26 (letter dated 16 Jan. 1803); for David's *Bonaparte* and Hogarth, see p. 25. Mark Ledbury has discovered a letter from David's wife to the banker Perrégaux, dated 8 Floréal Year XI (28 May 1803) confirming that Penrose's portrait was still in Paris at that date: "Paris 8 Floréal 11ᵉ / A Monsieur Perregaux senateur rue du mont blanc / Je vous envoye Monsieur la lettre que j'ai écrit a Monsieur Penerosse [*sic*] et dans laquelle je lui marque que vous voulez bien avoir la complaisance de lui écrire pour concerter ensemble le moyens de lui faire passer son portrait qui est chez moi. / Agréez l'assurance de ma parfaite considération / Femme David / Ce jeudi 8 floreal" (Nantes, Bibliothèque municipale, MS français 656[38]). The main passage reads: "Sir, I am sending the letter I wrote to Mr. Penrose in which I indicate that you will kindly be writing to him to make arrangements to send him his portrait which is at my home."

11. Reichardt 1804, vol. 1, p. 192.

12. On this portrait, see Jacques Foucart in Paris 1974–75, p. 383, no. 42; repr. p. 91, pl. 47. Marie-Denise (called Nisa) Villers adopted this strategy at the Salon of 1802 with a painting showing a woman on a walk in the countryside, part of her face veiled, in the process of tying her slipper; although she called it *Étude de femme d'après nature*, it seems to have been perceived as a portrait on account of the format and scale (see Oppenheimer 1996a, p. 165, fig. 1). For the general context, see the essay "Portraits of the Consulate and Empire" in this volume.

13. Farington 1979, p. 1894 (2 Oct. 1802).
14. Farington 1979, p. 1898 (3 Oct. 1802).

15 Portrait of Suzanne Le Peletier de Saint-Fargeau

1804

Oil on canvas
23⅞ x 19½ in. (60.5 x 49.5 cm)
Signed and dated, lower left:
L. David / 1804

The J. Paul Getty Museum, Los Angeles
(inv. 97.PA.36)

PROVENANCE

Suzanne Le Peletier de Saint-Fargeau
(1 Mar. 1782–19 Aug. 1829) and thence
by descent; sale London, Sotheby's,
11 June 1997, lot 47; acquired by Alex
Wengraf for the J. Paul Getty Museum,
Los Angeles.

EXHIBITIONS

Paris 1948, p. 80, no. 51; Paris 1956, p. 14,
no. 23, ill. p. 41; San Diego 2003–4, pp.
57–58, no. 3, ill. p. 47.

BIBLIOGRAPHY

Th. 1826b, p. 163; Coupin 1827, p. 54;
David 1867, p. 35, no. 34; Cantinelli 1930,
p. 110, no. 102; Holma 1940, p. 120, no.
10; Hautecoeur 1954, p. 127 n. 33; Ver-
braeken 1973, pp. 245, 290, ill. (pl. 42);
Wildenstein 1973, pp. 165 (no. 1426), 209
(no. 1810), 226 (no. 1938); Schnapper
1980, p. 208; Tihon 1986, p. 6, ill.; A.
Schnapper in Paris-Versailles 1989–90,
pp. 20–21, 375 (fig. 94); *Jacques-Louis
David. Portrait of Suzanne le Peletier de
Saint-Fargeau*, sale catalogue, Sotheby's,
London, 1997.

FIGURE 53 Jean-Baptiste Isabey,
*Portrait of Suzanne Le Peletier de
Saint-Fargeau*, c. 1804. Watercolor and
gouache on ivory, 2⅞ x 2 in. (7.3 x
5.1 cm) oval. Location unknown

ALTHOUGH DAVID painted this portrait the
year of Napoleon's coronation, it unavoid-
ably provoked recollections of the momentous
first months of the French Republic. Suzanne
Le Peletier de Saint-Fargeau was the daughter of
Michel Le Peletier (often spelled Lepeletier), whom
David had painted over ten years earlier in partic-
ularly dramatic circumstances. Deputy to the
National Convention, Le Peletier voted in favor
of capital punishment for Louis XVI and shortly
after, on 20 January 1793, on the eve of the king's
execution, he was slain by an angry royalist in a
restaurant of the Palais-Royal. Official ceremonies
and numerous prints honored Le Peletier as the
first *martyr de la liberté*. David, also an elected rep-
resentative at the time, took the personal initiative
of painting an homage to his colleague, a symbolic
deathbed scene which he gave to the Convention.
Le Peletier, whose wife had died in 1784, left an
orphaned daughter, Suzanne, who was put in the
care of the state and nicknamed *Mademoiselle
Nation*. In fact, she could rely on family wealth
and property to ensure her future. The prospect
of her union with the son of a Dutch diplomat
became a public affair in 1797–98, on account of
this particular status as the nation's adopted child
and a very rich party. Her two uncles, in particular
Félix Le Peletier, a recent supporter of the radical
agitators around Babeuf, argued unsuccessfully
that the fifteen-year-old girl was being abused for
her money and should be protected by the state.
By the time she posed for David the young woman
had been through the marriage, motherhood,
divorce, and the grievous loss of her two children.
The twenty-two-year-old heiress was reported to
have been on the verge of a love affair with her
cousin Léon Le Peletier de Mortefontaine, whom
she would marry in 1806.[1]

Neither her exact motive for contacting David
nor his for accepting to paint her are known. Was
she curious to see the portrait of her father given
back to the artist with *Marat* in 1795?[2] Did David,
as a former representative of the government that
had decreed her adoption, feel some sort of moral
or paternal debt toward her? An unfounded anec-
dotal explanation has been advanced: that the
portrait was destined as a gift to her new suitor.
Painted around the same time as the oval portrait
of Xavier Estève (SEE FIG. 41), it is similarly a mini-
mal exercise in bust-length portraiture, cropped
close to the body and without the hands, a stan-
dard format at the time.[3] Whether or not it was a
gift to the sitter, David aimed for the portrait to
convey an intimate entente between painter and
sitter. Her image is in remarkable disregard of
social assertion or affectation, almost disquieting
in its passivity. Gérard, in his portraits of Madame
Barbier-Walbonne (Salon of 1798; Musée du
Louvre, Paris) and Madame Regnaud de Saint-
Jean d'Angely (Salon of 1799; Musée du Louvre),
had proposed norms as to how fashionable

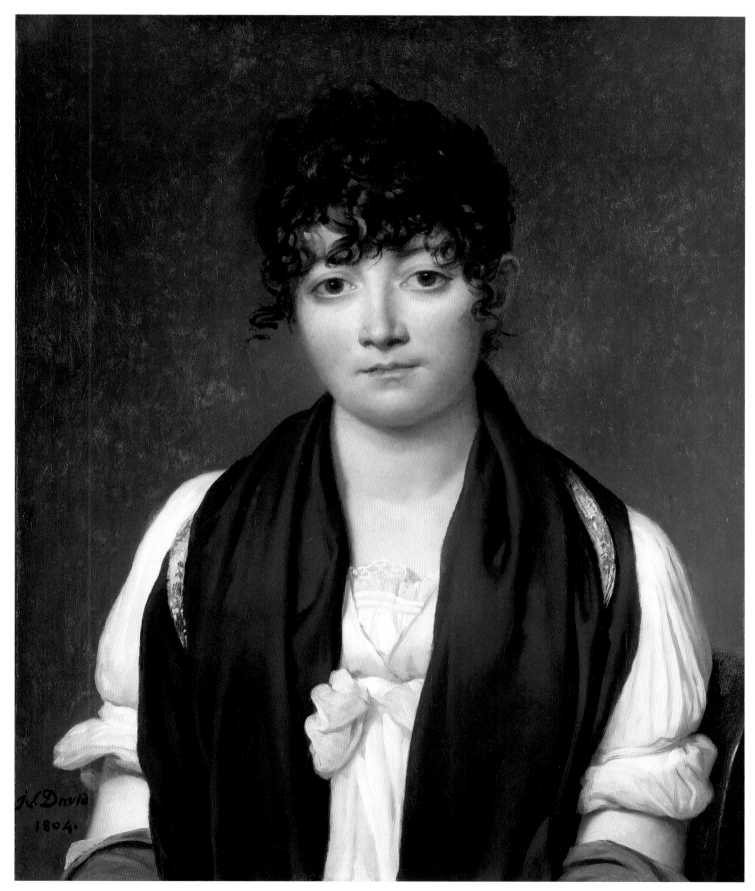

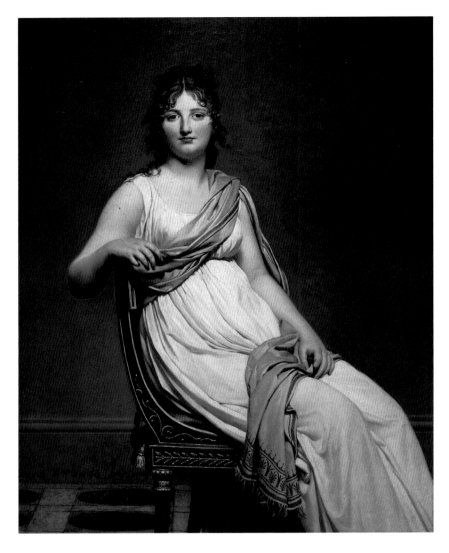

women were to be represented. His full-length portrait of Juliette Récamier in 1805 (Musée Carnavalet, Paris) was the consummate expression in this vein: here the sitter was shown not only acknowledging, but welcoming inspection. Suzanne Le Peletier's closed expression has more in common with Constance Charpentier's *Melancholy* (Salon of 1801; Musée de Picardie, Amiens) than with Gérard's beauties. However, David registered the fact that Suzanne Le Peletier was a fashionable young woman who shared their contemporary elegance, as better seen in a miniature portrait by Isabey, who more clearly detailed her modish hairstyle, cut short in the back and brushed to fall in curls over the forehead, with *oreilles de chien,* or falling locks framing the face (FIG. 53).[4] In his painting, David exploited the contrast between her regular features and her tousled hair.

Although a monumental presence, Suzanne Le Peletier is not transformed into a sculptural icon as was Henriette de Verninac five years earlier (FIG. 54). Despite the strict frontality of the pose, relieved by a series of subtle variations in the costume and the presence of the chair back on the right, her figure seems warm and alive. To this end, the frankness of brushwork and relative roughness of the execution, as well as the choice of an intermediate tone for the background, are particularly effective. As if a response to the sharp details in portraits by Girodet and Gérard, the play of the material surfaces against one another is elaborate but subdued: muslin dress with lace trim, cashmere stole with embroidered ribbon, and kid gloves with silk lining. The modest format and sober conception suggest a rapprochement with the small bourgeois portraits Boilly had begun to produce in great number. The sense of

FIGURE 54 Jacques-Louis David, *Portrait of Henriette de Verninac,* 1799. Oil on canvas, 57⅛ x 44⅛ in. (145 x 112 cm). Musée du Louvre, Paris

unmediated humanity captured in these small works was attractive but radically opposed in spirit to the lavish formal demands of the imperial court to which David would have to cater. He would later reserve the ostensibly humble and somewhat archaizing mode adopted to paint Suzanne Le Peletier for a portrait of some close friends (SEE FIG. 34) and certain commissions he accepted in exile (SEE CAT. 53).

NOTES

1. This entry cites and develops the text in San Diego 2003–4. For biographical information, in addition to the references in the Bibliography, see Goodheart 1998; Baticle 1988, p. 136, which mentions an unreferenced portrait of Suzanne "représentée en Hébé" by "le peintre Guérin."

2. At an unspecified date Suzanne wrote to her uncle, Félix Le Peletier: "Il y a 15 ans j'achetai au fils de David le dessin que son père avait fait d'après nature, je le payais cent louis" (undated letter in a private collection, cited by Vallery-Radot 1959, p. 355 n. 1). This refers probably not to the composed drawing of the deathbed scene, as proposed by Prat and Rosenberg (2002, vol. 2, p. 1212, no. G1), but to the lost profile head study engraved by Denon. Vallery-Radot dates the letter to 1816 "par son contexte": as soon as the Bourbons were restored, she entrusted her uncle with a negotiation to acquire all paintings, drawings and prints related to David's republican homage to her father. Another source, cited by Prat and Rosenberg, dates the letter to around 1825, but this is unlikely, since she asks her uncle to contact David, who has refused to sell her the works. If the 1816 date is right, it means that fifteen years earlier, around 1801, she was in contact with David. However, that she should have acquired the drawing representing her father from one of his sons is a troubling detail: they looked after his affairs in Paris only after his exile in 1816.

3. The recent exhibition in San Diego (2003–4) included bust-length portraits by Gérard and Girodet, and a Dutch-like portrait in an interior by Romany, all painted on canvases about the same size as the *Portrait of Suzanne Le Peletier.*

4. Although the identity of the figure represented in the miniature needs to be confirmed, it appears most plausible; the illustration is from the Madame François Flameng sale catalogue, Paris, Galerie Georges Petit, 26–27 May 1919, lot 182, referenced in *Jacques-Louis David. Portrait of Suzanne le Peletier de Saint-Fargeau,* sale catalogue, Sotheby's, London, 1997, p. 28.

16 Portrait of a Woman (perhaps Angélique Mongez, née Le Vol)

1806

Black crayon on paper
6⅞ x 4¾ in. (17.5 x 12 cm)
Signed and dated, lower center:
L. David. 1806.

Private collection

Exhibited in Los Angeles only

PROVENANCE
. . . ; With the dealer Jérôme Fournier,
Paris; 1993, Galerie Didier Aaron, Paris
and then New York; sold to a private
collector in the United States.

EXHIBITIONS
Never exhibited.

BIBLIOGRAPHY
Prat and Rosenberg 2002, vol. 1, p. 224,
no. 212.

That this small portrait, probably extracted from a sketchbook, was signed and dated by the artist suggests that it may have been offered as a gift. Throughout his career David employed his drawings in this way to strengthen bonds of friendship with a supportive entourage. The young woman's coiffure, with the locks fashionably brushed toward the front, inspired an identification of the model with Suzanne Le Peletier (CF. CAT. 15), which Prat and Rosenberg have recently discounted. They judge that the profile reveals a woman younger than Suzanne (born in 1782) and that she had no particular reason to be in contact with the painter two years after receiving her portrait. The open mouth, with a prominent upper lip, evokes strongly the figure of Angélique Mongez, whom David painted alongside her husband in 1812. The year the crayon sketch was made she exhibited at the Salon an ambitious history painting signed: *f^me Mongez / élève de M^r David*, and at David's instigation, it was subsequently bought by his Russian patron, Prince Yusupov.[1] Obviously this does not confirm the proposed identification, but it suggests that the two were very close at the time. Another element meriting consideration, although no more decisive, is the portrait of Angélique Mongez that David inserted among the spectators of the *Coronation* in 1806–7. The 1808 key to the picture does not detail the names of

those represented with David and his family (see the essay "In the Service of Napoleon" in this volume). However, that the key published in 1822 with reference to the Brussels version of the *Coronation* does list her husband reinforces the probability of his inclusion in the earlier version. It seems reasonable to identify Angélique Mongez as the plume-hatted, slightly pug-nosed woman to the right of David's wife and daughters, and her husband as the man standing next to David (FIG. 55).

The comparison of this portrait drawing with another in the exhibition also dated 1806 and possibly representing Angélique Mongez (SEE CAT. 11) will not resolve the problem, but should be provocative. The focus on the undulating line of the neck in both sheets is a sensuous touch rare in David's images of women. Here the conversational vivacity of the head looks back to the eighteenth century, but the unembellished and rather heavy features reflect the realist trends of the present. Rapidly executed, this profile is one of the best examples of the informal *portrait intime* that develops in the interstices of a graphic production that most often serves to elaborate pictorial compositions (see the essay "Portraits of the Consulate and Empire" in this volume).

NOTES
1. Schnapper in Paris-Versailles 1989–90, p. 478.

FIGURE 55 The David family with Antoine and Angélique Mongez, from *The Coronation of Napoleon and Josephine* (detail of fig. 26)

L. David. 1806.

1809

Black crayon (*Alexandre Lenoir*) and pencil (*Adélaïde Binard*) on paper
Two separate sheets of paper, laid down side by side: 6⅛ x 8½ in. (15.5 x 21.4 cm) overall. On the far left, a strip ¼ in. (0.7 cm) wide has been added and drawn over
Signed and dated, lower left: *L. David. f. 1809.*; and lower right: *L. David. f. 1809.*

Musée du Louvre, Paris. Département des Arts graphiques (inv. RF5218)

Exhibited in Williamstown only

PROVENANCE
Alexandre Lenoir (1761–1839) and his wife Adélaïde Binard (1771–1832); his son, Albert Lenoir (1801–1891); his son, Alfred Lenoir; by 1913, his wife, Madame Alfred Lenoir; their son, André Lenoir, from whom acquired in 1921 by the museum (mark [L. 1886ab], lower right).

EXHIBITIONS
Paris 1884, no. 135; Paris 1913, p. 69, no. 275; Zurich 1937, no. 65; Bern 1948, no. 65; Copenhagen 1960, pp. 41–42, no. 56; Rome 1962, no. 68; Paris-Versailles 1989–90, p. 438, no. 183.

BIBLIOGRAPHY
David 1880, p. 661 (misdated 1806); Saunier 1925, p. 13; Cantinelli 1930, plate 58; Sérullaz 1939, no. 10; Sérullaz 1991, pp. 31, 49, 148, 170–71 (no. 213); Prat and Rosenberg 2002, vol. 1, p. 232, no. 222.

THESE TWO portraits, mounted together at an unknown date, are exceptional in David's graphic production during the Empire. Throughout his life, the painter was never eager to furnish his entourage with such finished drawings. A portrait of a woman, also in the Louvre, appears to date from the 1780s, but some specialists reject the attribution.[1] During his imprisonment after the Terror, he produced a superb series of medallion portraits, treated in a pictorial mode with ink wash and gouache accents, which prove his superior capacity in this domain.[2] Late in life he drew an attractive double portrait of his daughter Pauline Jeanin with her daughter (SEE CAT. 55) and, in the months preceding his death, a relatively ambitious one of his son Eugène and his wife (SEE FIG. 108). The quality of these sheets makes us regret that he did not exercise his pencil more often in this genre, which his pupil Jean-Auguste-Dominique Ingres would establish as a major art form. The reasons for David's reluctance are obscure, although his restrictive attitude toward the uses of drawing (see the essay "Late Drawings: Experiments in Expression" in this volume) sheds some light on the matter.

In this instance it appears certain that his pencil served to celebrate bonds of friendship with the Lenoirs. Alexandre Lenoir, who set out on an artistic career in the studio of the painter Gabriel-François Doyen, one of David's early protectors, is best known as the founder of the Musée des Monuments français in Paris, which collected church property nationalized by the revolutionary government. He is especially well known for his resistance to the republican iconoclasts and his efforts in preserving tombs and sculpture from the Middle Ages, otherwise marked for destruction on account of their religious and royal ideology. His evocative and often fanciful presentation of these historical artifacts in period rooms had a significant impact on artists and amateurs, who came to admit their artistic merit. While his focus was on sculpture, he also began forming a com-

prehensive national portrait collection. David's engagement with classical art probably kept him away from the evocative interiors of Lenoir's museum, but he no doubt approved the republican history of French art it promoted. Whereas the *siècle de la renaissance* was presented as the most glorious moment in the history of French culture, the *siècle de Louis XIV* was evoked as a period of decline due to the academic system.[3]

David is reported to have initially objected to the creation of a collection of monuments from the Middle Ages, but by 1803 at least, he was on friendly terms with Lenoir.[4] Their shared antipathy for Denon, the latter's immediate superior, probably also brought them closer during the Empire. A prolific author of articles, brochures and books, Lenoir defended the superiority of the *Sabines* and the *Coronation* in the context of the *Concours Décennal* in 1810, and gave credit to "*l'école de M. David*" for the regeneration of the French School. That David drew sympathetic portraits of Lenoir and his wife the year before this critical offensive may mean that the two men prepared it together. To speak out in his name the artist had regularly relied on sympathetic critics— André Chénier, Pierre Chaussard—so he was surely happy to enroll a new pen in his favor.[5]

Throughout his life Lenoir seems to have been desperate for honors and recognition. Certain that one day he would figure among the celebrities from French history, including a number of recently deceased personalities, to whose memory his museum was dedicated, he commissioned portraits of himself and his wife, Adélaïde Binard, whom he had wed in 1794. Marie-Geneviève Bouliard exhibited at the Salon of 1796 a pair of paintings of the couple (FIGS. 56 AND 57). Here he appears as somewhat of a dilettante, clutching a folio bearing the title *Monumens Français*, while his wife, who for the first time had exhibited at the

L. David f. 1809.

A. David f. 1809

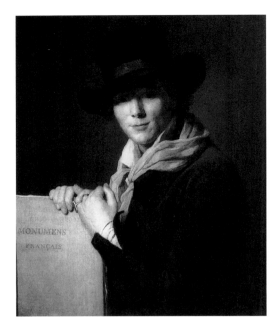

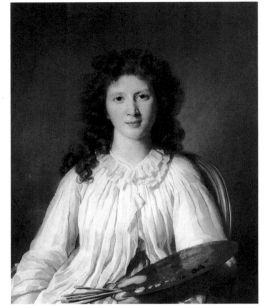

Salon the year before, asserts her ambitions as a painter.[6] Shortly after, Claude Michallon modeled a lively terracotta bust of Lenoir (1796–97; Musée du Louvre, Paris). The autobiographical legend he promoted was fully articulated by 1799, when David's pupil Pierre-Maximilien Delafontaine presented him as the man who cared lovingly for the nation's patrimony (Musée national du Château de Versailles).[7]

David drew the couple about a decade later. In the meantime Lenoir cut his hair much shorter, and rather than brushing it back as before, let it fall negligently over his forehead. Adélaïde became more fashion conscious. Her attire is simple but elegant: the turban is set off by a decorative trim, and the dress by a starched lace collar and bow. The artist creates a series of subtle, complementary contrasts between man and wife: his intelligence and her looks, the simple and the recherché in matters of costume, the hint of a lean forward and an impression of reserve and finally, as several commentators have noted, a robust black crayon for him and a more agile pencil for her. Whether or not David himself mounted the two drawings, this visual dialogue was a part of their fabrication. The signature and date on each are expressions of his satisfaction and of his estimation that they were finished works of art.

At some time between 1809 and 1815, perhaps around 1810 when the two were in close contact,

David began a painting of Lenoir (FIG. 58); the sitter described it in these terms: "David painted my portrait on an oak panel; the head adopts the attitude of a man writing, looking up to see someone who interrupts him."[8] In a list of his works drawn up in 1819, the artist places it among the paintings executed in Paris, after the portrait of Napoleon he exhibited at the Salon in 1808 and before the one he painted for Lord Douglas in 1812.[9] Although the enumerated items do not follow a strict chronological order, since the artist appears to list works as they come to mind, the portrait is clearly associated with the middle years of the Empire. Since it bears the perfectly authentic date of 1817, David must have taken the panel with him to Brussels to finish it.[10] After the artist's death, seizing the opportunity of the sale of his estate in 1835, Lenoir honored his friend one last time by publishing some sympathetic *Souvenirs historiques* detailing his life and work. He evokes the sittings for his portrait: "Having been painted by David, I was able to observe, in the way he handled the brush, that he rejected the showy dexterity ordinary painters too often aim for; he never sacrificed truth; three times he wiped out my eyes, before esteeming he had gotten right the expression he saw."[11] Missing, however, is the sense of immediacy and penetration that enlivens the more modest drawing of Lenoir, not to mention the genteel figure of his spouse.

FIGURE 56 Marie-Geneviève Bouliard (French, 1772–1819), *Portrait of Alexandre Lenoir*, 1796. Oil on canvas, 28¾ x 23⅝ in. (73 x 60 cm). Musée Carnavalet, Paris

FIGURE 57 Marie-Geneviève Bouliard, *Portrait of Adélaïde Binard, Wife of Alexandre Lenoir*, 1796. Oil on canvas, 32¼ x 24⅜ in. (82 x 62 cm). Musée Carnavalet, Paris

OPPOSITE
FIGURE 58 Jacques-Louis David, *Portrait of Alexandre Lenoir*, 1817. Oil on panel, 29⅞ x 24⅜ in. (76 x 62 cm). Musée du Louvre, Paris

NOTES

1. Sérullaz 1991, pp. 152–53, no. 193; Prat and Rosenberg 2002, vol. 1, p. 85, no. 66.

2. Prat and Rosenberg 2002, vol. 1, pp. 164–73, nos. 147–55.

3. McClellan 1994, pp. 190–91.

4. David addressed Lenoir on 30 Dec. 1803 as "mon bon ami," and wrote: "Mes respects à ta chère épouse que j'embrasse"(Wildenstein 1973, p. 164, no. 1415; for the identity of the recipient, cf. no. 1414). The motive of the letter—a gift of minor antiquities to Lenoir—suggests the friendly nature of their relations. Henry Yorke reported in 1802 that David and other artists had manifested their opposition to his preservation project (Yorke 1906, p. 165).

5. Lenoir's texts were published in the press, reprinted in brochure form, and inserted again in his books; see [Lenoir] 1810, and Lenoir 1811, pp. xiii–xliii. Proof that Lenoir wrote promotional texts for David under his supervision is found in an undated letter from the painter to L.-F.-J. Bausset, préfet du palais, concerning Josephine's visit to his studio (consulted thanks to Kenneth W. Rendell, Inc., New York); a date c. 1807 is plausible, since sittings by Bausset and Beaumont for their portraits in the *Coronation* are evoked.

6. As "Madame Lenoir née Binart," she exhibited principally portraits at the Salon, claiming to have studied with Regnault from 1795 to 1817. None are presently located.

7. Delafontaine's full-length portrait is reproduced in Bordes and Michel 1988, p. 201. A portrait of Lenoir with his wife and daughter, represented promenading outdoors, dating from the late 1790s, was presented by Sotheby's at the Château de Groussay, 2–6 June 1999, no. 395 (reproduced vol. 1, p. 227); again at Sotheby's sale, Paris, 23 June 2004, no. 63. The proposed attribution to Delafontaine is unlikely; rather stiff and hesitant, it could be by Lenoir's wife (see note 6).

8. "David a peint mon portrait sur un panneau de chêne; la tête est dans la position d'un homme qui écrit et qui la lève pour voir quelqu'un qui l'interrompt." Lenoir 1835, pp. 8–9. On the portrait and the uncertain history of its execution, see Schnapper in Paris-Versailles 1989–90, pp. 524–25, no. 228. A reference provided by Wildenstein (1973, p. 187, no. 1608) confirms that David paid a visit to Lenoir in Mar. 1811.

9. The list is reproduced by Schnapper in Paris-Versailles 1989–90, p. 21.

10. The explanation for the delay, as intimated by Schnapper, who published an X-ray revealing modifications (Paris-Versailles 1989–90, pp. 524), may be related to Lenoir's admittance to the Legion of Honor late in 1814, a distinction he had solicited for a decade. That he was made *chevalier* in a pontifical order soon after further complicates the question of a possible revision. The painted signature and date of 1817 are by David, but the medals and the area of the waistcoat and shirt, particularly dry, are perhaps by another hand (compare how David treats the ribbons and medals of his sons-in-law [see cats. 19 and 20] and Antoine Français [cat. 21]). Lenoir may have undertaken these changes on his own upon receiving the picture from Brussels.

11. Lenoir 1835, p. 8.

Portrait of Alexandrine Thérèse Nardot, Comtesse Daru

1810

Oil on canvas
32¼ x 25⅝ in. (81.8 x 65.1 cm)
Signed and dated, lower left: *L. David / 1810*

The Frick Collection, New York
(inv. 37.1.140)

PROVENANCE
Pierre-Antoine-Noël-Bruno Daru
(1767–1829) and his wife Alexandrine
Thérèse Nardot (c. 1784–1815); by inher-
itance, "Comte Daru" in 1880, Château
de Bêcheville, near Meulan; by 1925,
David David-Weill (acquired from
"Général Daru"?); after 1932, Wilden-
stein and Co., New York; 1937, acquired
by The Frick Collection.

EXHIBITIONS
London 1932, no. 316 (collection of
D. David-Weill).

BIBLIOGRAPHY
Coupin 1827, p. 56; Blanc 1845, p. 211;
David 1880, pp. 482–83, 646; Cantinelli
1930, p. 112, no. 120; *GBA*, Jan. 1932, p.
80; Holma 1940, pp. 89–90, no. 127;
Hautecoeur 1954, pp. 229, 286; Wilden-
stein 1961; Davidson and Munhall 1968,
pp. 74–77; Wildenstein 1973, p. 183, no.
1571–74; Bleyl 1982, pp. 171–72 n. 233;
Roberts 1989, p. 169; A. Schnapper in
Paris-Versailles 1989–90, p. 372–73, 615;
Johnson 1993a, pp. 224, 226; Ribeiro
1995, p. 124.

THE CIRCUMSTANCES surrounding the execu-
tion of this portrait early in 1810 are known
from David's correspondence and the writings of
Stendhal, a cousin Daru protected and welcomed
in his home. Along with his many attributions in
the military administration, Daru was Intendant
général de la Maison de l'Empereur since July
1805, and in that capacity, between October 1807
and February 1810, devoted much time and energy
to finding a satisfactory compromise regarding the
amount due to the first painter for the *Coronation.*
He manifested his regard for David's position and
his work by paying a visit to his studio, and
proved efficient in concluding the difficult negoti-
ation with Denon and Napoleon.[1] The artist surely
admired Daru's impressive rise to high adminis-
trative responsibility during the Revolution and at
the service of Napoleon (he was made Comte de
l'Empire in 1809), no less than his reputation, rare
at the time, for financial probity. To express grati-
tude for his support, David decided to surprise
him with the portrait of his wife, probably painted
in four to six short weeks. Stendhal, infatuated at
the time with Daru's young wife of twenty-six,
was on hand on 14 March 1810 when he signed it.

The comtesse Daru addressed a letter to the
painter on 22 March 1810: "Receive, Sir, all my
thanks for the beautiful portrait you have done for
me. I admire it more than anyone, and I admit
this, though it is not very modest of me. I am
unable to offer you anything quite as beautiful as
your picture, but at least I've thought of some-
thing that might last just as long. Please accept
this small token of the gratitude I owe you."[2] As
Schnapper notes, she refused the gratuity, in the
sense that she offered in return a gift whose value
apparently surprised the painter (see below). But
she had every reason for satisfaction since private
portraits by the first painter were rare items, as her
husband seemed to acknowledge on 28 March,
upon discovering the painting hung in his home.
In turn, he picked up the pen: "Monsieur, I arrive
from Compiègne, and I discover in my salon a
beautiful portrait whose author and model I can-

not possibly fail to identify. I don't need my wife's
explanations to realize all that I owe to your inge-
nious kindness. I don't recall ever having heard
that Apelles amused himself painting family
portraits for the Intendant of Alexander's armies;
but apparently you have more ambition than he.
Admiration is not enough for you, you also make
demands on our gratitude. I am impatient, Sir, to
express mine directly and tell you that your new
work is doubly precious to me, by its object and
author and by the charming manner you pre-
sented it to me. Accept, Monsieur, with the thanks
that I owe you, the assurance of the high esteem
I have long had for your talent."[3]

David replied promptly to these two letters on
30 March : "When I thought of painting the por-
trait of Madame la comtesse, I only wanted to
seize an occasion to show you my gratefulness. It's
when the work was in the finishing stages that I
realized I had involuntarily been indiscreet, with-
out imagining that a real pleasure for me might
seem an abuse of your wife's obligingness; the
importance of Madame la comtesse's gift allows
me to see this all too well. You deigned, Monsieur
le comte, to make it still more valuable with your
extremely flattering letter. Oh! . . . how far behind
I remain, and how I really would like to have the
talent of that Apelles, to have captured the expres-
sion on the face of that amiable person to whom
the Intendant général of Napoleon's armies is
most attached."[4] Underneath the epistolary polite-
ness and salutations, these letters suggest that
Daru sincerely admired the artist, who in return
surely appreciated his patron. More than any
other figure in the Napoleonic regime, Daru was
the incarnation of the enlightened administrator.
He had co-authored a translation of Cicero in 1787
and edited several volumes of Horace between
1798 and 1805; he had composed a *chant séculaire*
for the festival celebrating the arrival of the artistic
spoils from Italy in 1798. The following year he

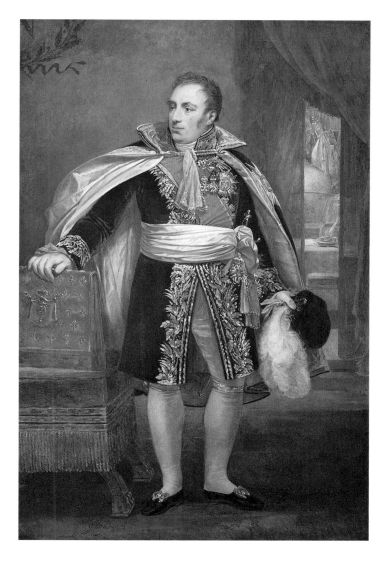

had published *La Cléopédie, ou la Théorie des réputations en littérature,* and in 1806 was elected to the Institute, in the French Language and Literature class. The energetic character of Daru is suggested in the portrait painted by Gros in 1813 (FIG. 59). The stocky, robust figure in court attire—his wife, according to Stendhal, found him wanting in finesse and elegance—seems impatient to go back to his work, clearly the least relaxed official in the series of ministerial effigies.

Stendhal has left a detached and not always kind literary portrait of Alexandrine dating from 1811, one year after she posed for David. He finds her disillusioned with imperial high society, bored and no longer dancing until four in the morning, as when he had first fallen in love with her two years earlier: "She is a woman of twenty-seven, somewhat plump, dark chestnut hair, black eye-

brows, very thick, eyes small and rather fiery, who likes a certain agitation. Everything indicates an active temperament, at least that's the opinion of those who know her. Her features reveal a character that is strong, good-natured and merry."[5] It would be an error to project this moral description by a frustrated suitor onto David's portrait. More important than a sanguine temperament, she appears to have had an exceptionally resistant one, able to meet the familial demands of a rather burly husband, to whom she had already given six children since their marriage in 1802. She would be sacrificed on the altar of Daru's irrepressible energy: like many a noblewoman before her, she died prematurely in childbirth in January 1815, delivering, it seems, for the twelfth time. The observation describing her figure does seem verified by her portrait: the neck, which the painter adorns with a magnificent parure of emeralds, diamonds, and pearls, is thick, and the arms probably as well, which may explain their partial dissimulation. The eyes are indeed sparkling, though hardly small, and the faint smile on her face denotes frank amiability rather than self-satisfaction.

David has represented the comtesse Daru sitting in a square-backed, upholstered, and cushioned mahogany armchair, whose gilt-bronze sphinxes were a common period ornament. The comfortable width of the seat allows her to turn slightly toward the right and place one hand, with a fan between the fingers, on her lap, and keep the other to her side. The opulent green shawl echoes the emeralds and sets off the white satin dress and pink flesh, but like the armchair, also establishes a sense of spatial depth. The formal animation in the lower half of the picture contrasts with the upper half, occupied only by the female hermes against a blank gray background. David represents her as impervious to all distractions, in fact addressing the only spectator that matters, the one for whom the painting is destined. In this regard, his avowal to his patron of his indiscretion toward his wife suggests that during the sittings he fantasized on having sex with the model, a standard narrative in eighteenth-century studio lore that David, fundamentally anti-libertine, seems to have generally resisted. As he took scopic possession of Daru's wife, the modern Apelles perforce imagined himself in the role

of Daru. This was complicated by the homosocial dimension of his relation to the latter, in which the artist was placed in a position of willing submission comparable to that of his wife. With her husband's dominating presence on his mind during the sittings, as he was painting he took into consideration this privileged spectator, through his wife's eyes. In this imaginary *ménage-à-trois,* the intensity of the aesthetic pleasure he hoped his painting would give Daru was inseparable from the latter's physical desire for his wife.[6] David's autobiographical fascination toward the end of the Empire for another sexually involved triad— Alexander, Apelles, and Campaspe (SEE CAT. 31)— which may also have been on Daru's mind, gives some credit to the possible existence of such a circuit of desire.

Like Estève in his portrait from 1804 (SEE FIG. 41), Alexandrine appears to direct a fixed gaze toward the viewer; one commentator has judged her portrayal "dispassionate."[7] Whereas this strict frontality created a fiction of affirmation and proximity for the imperial administrator, in this instance it expresses rather self-protection and distance. Estève was the subject of his portrait, Alexandrine is more exactly the object of hers. The impression of detachment is accentuated by the range of colors, only slightly warmer than that employed for the *Portrait of Henriette de Verninac* (SEE FIG. 54). Nonetheless David was careful to infuse the imperial matron with more life than the late Directory beauty. He painted an expression of contentment, gave the face a healthy ruddiness, and labored over the visual impact of the costume, a tiara of flowers (white orange blossoms, it has been suggested) and a white satin dress, with muslin undersleeves and a neckline trimmed with ruche and lace.[8] Although he was following rather than inventing fashion, as he had during the Directory, the execution is characterized by virtuosity and also a sense of pleasure. It seems possible to invoke the sensuousness of Rubens and Van Dyck as inspiration for the subtle modulations of light and color.

How revealing to compare this society portrait with those by Ingres, a former pupil whose work David always viewed with ambivalence. The master probably shared the position of most critics during the Empire, who recognized his talent but condemned his archaizing manner. At the Salon

in 1806, he had surely seen the portraits Ingres exhibited of the Rivière family, with their disturbingly regressive attention to detail. It was presumably with his pupil in mind that he criticized, according to Lenoir, those artists whose mean manner recalled the "temps gothiques."[9] If from the *Portrait of Henriette de Verninac* David went on to propose a more naturalistic vision of portraiture in the *Portrait of Comtesse Daru,* Ingres evolved in the opposite direction with his *Portrait of Sabine Rivière* (FIG. 60). Working in David's studio at the time he painted his *Portrait of Henriette de Verninac,* the younger painter instead radicalized its idealizing conception and formal rigor. David seems to have noticed Ingres's portrait: the reptile flaccidity of Alexandrine Daru's right hand appears directly quoted from those of Sabine Rivière. Otherwise, the two portraits could not be more different. *Sabine Rivière* is an exercise in

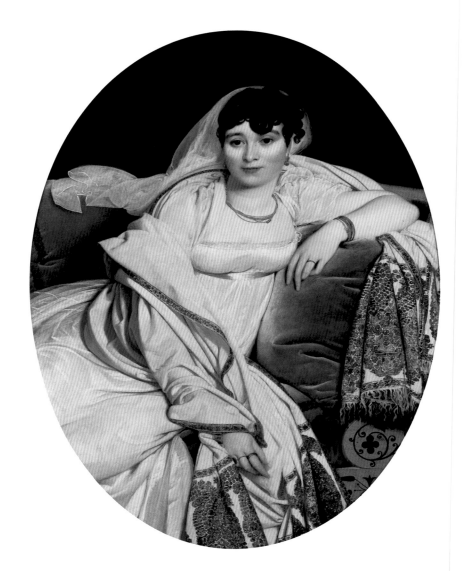

FIGURE 60 Jean-Auguste-Dominique Ingres, *Portrait of Sabine Rivière,* 1806. Oil on canvas, 46 ⅛ x 32 ¼ in. (117 x 82 cm). Musée du Louvre, Paris

circular design and fluidity of form, while *Comtesse Daru* is squarely structured throughout. The serrated edge of her flower tiara responds to the smooth line of Sabine's veil and the play of her pasted-down curls is a fashionable detail that David treats with great moderation in his portrait. The fundamental difference, however, was generational. The young painter accepted the autonomy of the pictorial surface: his portrait was a painting. His master understood this, but his artistic vision dating from an earlier century made him believe that he could—and should—still recreate the presence of a real person. A shrewd observer of David's art in 1880 noted that he possessed a "masterful naïveté that Ingres lacks."[10]

NOTES

1. See Lanzac de Laborie 1913, pp. 28–29, 34–37; Schnapper in Paris-Versailles 1989–90, pp. 372–73; and the essay "In the Service of Napoleon" in this volume.

2. "Recevez tous les remerciements, Monsieur, du beau portrait que vous avez fait pour moi. Je suis la première à l'admirer et je l'avoue, quoiqu'il n'y ait peut-être pas beaucoup de modestie à cela. Je ne puis vous offrir rien d'aussi beau que votre tableau, mais j'ai cherché du moins quelque chose qui peut durer autant. Veuillez agréer ce faible souvenir de la reconnaisance que je vous ai vouée." Wildenstein 1961, pp. 119–21.

3. "Monsieur, j'arrive de Compiègne, et j'aperçois dans mon salon un beau portrait dont il ne m'est pas plus permis de méconnaître l'auteur que le modèle. Je n'ai pas besoin des explications que ma femme pourra me donner pour deviner tout ce que je dois à votre ingénieuse obligeance. Je ne me rappelle pas d'avoir ouï dire qu'Apelle s'amusait à faire des portraits de famille pour l'Intendant des armées d'Alexandre; mais apparemment vous avez plus d'ambition que lui. L'admiration ne vous suffit pas, vous voulez aussi avoir des droits à notre reconnaissance. Il me tarde, Monsieur, d'aller vous parler de la mienne et de vous dire que votre nouvel ouvrage m'est doublement précieux par son objet, son auteur et la grâce que vous avez bien voulu mettre à me l'offrir. Agréez, Monsieur, avec les remerciements que je vous dois, l'assurance de la haute considération que j'ai dès longtemps vouée à vos talents." David 1880, p. 483. On 9 Oct. 1807 Daru had written to David: "Personne n'honore plus que moi votre talent" (Lanzac de Laborie 1913, p. 34).

4. "Quand je me proposais de peindre le portrait de Mme la comtesse, je n'avais d'autre but que de saisir une occasion de vous témoigner la reconnaissance. C'est lorsque l'ouvrage touchait à sa fin, que j'ai reconnu que j'avais involontairement commis une indiscrétion, sans penser que ce qui était pour moi un vrai plaisir pouvait compromettre la délicatesse de Madame votre épouse; l'importance du cadeau que m'a fait Madame la comtesse ne m'en a que trop bien convaincu. Vous daignâtes encore, Monsieur le comte, y ajouter un nouveau prix par votre lettre extrêmement flatteuse. Ah! . . . comme je me trouve en arrière, et que je voudrais vraiment avoir le talent de cet Apelle pour avoir bien exprimé les traits de la personne aimable qui intéresse le plus l'Intendant général des armées de Napoléon." Wildenstein 1961, pp. 121–22; Wildenstein 1973, p. 183, no. 1574.

5. "C'est une femme de 27 ans, assez d'embonpoint, cheveux châtain foncé, sourcils noirs et très fournis, oeil petit et assez ardent, aimant beaucoup le mouvement. Tout annonce un tempérament ardent, du moins c'est l'opinion des personnes qui la connaissent. Ses traits annoncent la force, de la rondeur et de la gaieté dans le caractère." Stendhal 1936, vol. 1, pp. 59–60. This is quoted from a text on the Daru couple written by Stendhal in Apr. 1811, previously published by Stryienski 1905, pp. 27–60.

6. The fundamental study for the pursuit of this line of inquiry, as John Goodman has reminded me, is Eve Kosofsky Sedgwick, *Between Men: English Literature and Male Homosocial Desire,* New York, 1985. Stendhal's aggressive attitude toward David (Wildenstein 1961, p. 119; Paris-Versailles 1989–90, p. 615; a passage from his journal cited in the essay, "In the Service of Napoleon," n. 130) might be interpreted as a manifestation of jealousy over his exclusion and reduction to the role of voyeur.

7. Ribeiro 1995, p. 124.

8. On the costume, see Davidson and Munhall 1968, pp. 74–75; and Ribeiro 1995, p. 124. The latter notes: "Satin was particularly popular as winter formal wear during the second decade of the nineteenth century."

9. "Tous les portraits sortis de ses mains se ressentent de la hauteur de son imagination et portent le caractère grandiose du peintre d'histoire; il dédaignait ces minuties de détail et cette chétive exécution dont quelques artistes abusent et qui rappellent les temps gothiques de nos bons aïeux." Lenoir 1835, pp. 8–9.

10. The comment by Charles Tardieu ("naïveté magistrale qui manque à Ingres") is cited by Verbraeken 1973, p. 17. Although Ingres was in Rome since 1806 and would not have seen David's portrait of comtesse Daru, his portrait of Cécile Bochet, (*Madame Panckoucke,* 1811; Musée du Louvre, Paris), dressed in white satin with a shawl over her arm, pursues the dialogue with his master, unwittingly unless a studio comrade furnished him with a description of the picture.

19 Portrait of Jean-Baptiste Jeanin

1810

Oil on canvas
28¾ x 23¼ in. (73 x 59 cm)
Signed and dated, lower left:
L. David. / 1810

Private collection

PROVENANCE

Jean-Baptiste Jeanin (1769–1830); his
son, Louis-Charles Jeanin (1812–1902);
one of his children, Mathilde Bianchi,
André Jeanin, or Eugène Jeanin;
Comtesse Murat née Caroline-Pauline-
Thérèse Bianchi (1870–1940), who sold
it to Cailleux, Paris, according to
Hautecoeur (1954); . . . ; sale, London,
Sotheby's, 19 June 1990, no. 10; private
collection.

EXHIBITIONS

Never exhibited.

BIBLIOGRAPHY

Coupin 1827, p. 56; Seigneur 1863–64,
p. 367; David 1880, pp. 509, 647; David
1882, fascicle 15 (engraving); Saunier
[1903], p. 107; Rosenthal [1904], p. 165;
Hautecoeur 1954, p. 230 n. 122; Brookner
1980, p. 169; Schnapper 1980, p. 266;
A. Schnapper in Paris-Versailles 1989–90,
pp. 484, 485; Schnapper 1991, p. 63;
P. Lang in Reinhard-Felice 2003, p. 276.

IT IS not known whether David already had
planned a suite of family portraits when in
1810 his son-in-law Jean-Baptiste Jeanin was the
first to pose. Jeanin had begun a military career
in August 1792 in his home region of the Jura, as
lieutenant in a battalion of national volunteers;
later he served in Italy (1796–1798) and in Egypt.
He caught the attention of Bonaparte and in 1802
entered the Garde Consulaire. For his portrait,
he donned the uniform of *général de brigade*, a
promotion he had received in 1808 during the
Spanish campaign. The decoration pinned to his
uniform evokes his elevation to the grade of
commandant in the Legion of Honor in November
1808. Even more recently, on 15 August 1809, he
had been made baron de l'Empire.[1] His military
record indicates that on 17 Floréal Year VII (6 May
1799), at the siege of Saint-Jean-d'Acre during
the Egyptian campaign, "he was hit in the left
jaw by a long-barreled musket" fired from an
English ship.[2]

The unpretentious pose and expression
retained for the portrait suggest a shared sympa-
thy between the painter and the man who had
wed his daughter Pauline on 24 May 1806. His
revolutionary engagement, the courage he demon-
strated on the battlefield, and perhaps even his
facial wound, uncannily reproducing David's own
exostosis, conferred on Jeanin an aura of human-
ity which David seized. Even the thin paint and
limited range of muted colors create an impres-
sion of a self-effacing personality. The pronounced
asymmetry of the eyes, rare in David's portraits,
reveals a strain, which might account for the
difficulties that lay ahead, leading ultimately, in
1824, to an official separation from his wife (SEE
CAT. 55).[3]

NOTES

1. The information in this entry concerning Jeanin's
military service is culled from recapitulative docu-
ments drawn up on 13 and 20 Dec. 1847 by the
War Ministry, in his personal file in Paris, Service
historique de l'armée de terre (Château de
Vincennes), 7Yd805.

2. "Il fut atteint à la région maxillaire gauche d'un coup
de biscayen parti des chaloupes canonnières anglais-
es"(document dated 20 Dec. 1847, cited in the previ-
ous note).

3. These observations rest on the color reproduction in
the 1990 sale catalogue, for I was unable to examine
the painting before the exhibition.

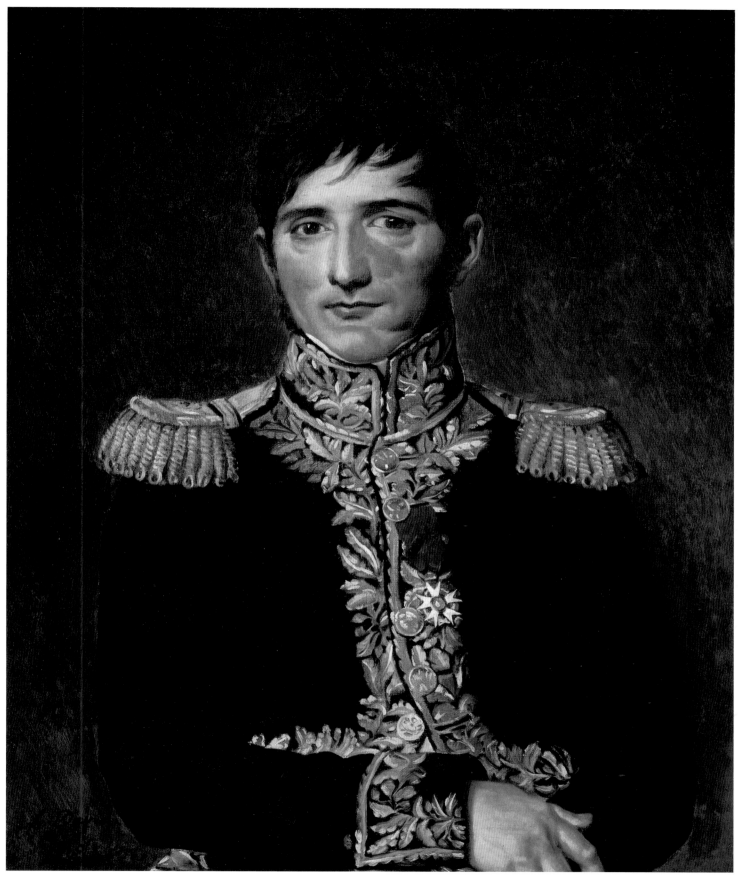

Portrait of Claude-Marie Meunier

C. 1810–13

Oil on canvas
28¾ x 23½ in. (73 x 59.5 cm)

Private collection

PROVENANCE
Claude-Marie Meunier (Saint-Amour,
4 Aug. 1770–Paris, 14 Apr. 1846); his
wife, Émilie David (1786–1863), Calais;
her son, Jules Meunier (1813–1867); his
wife, Pauline Derode, baronne Meunier
(1824–1903); probably given by her to
Mathilde Jeanin, wife of Marius Bianchi
(1822–1904), and daughter of her cousin
Louis-Charles Jeanin (1812–1902), since
"Mme Bianchi" owned it in 1913; her
daughter, Renée Bianchi, Vicomtesse
Fleury (1869–1948); private collection.

EXHIBITIONS
Paris 1913, p. 24, no. 53; Copenhagen
1914, no. 67.

BIBLIOGRAPHY
Coupin 1827, p. 56; Seigneur 1863–64,
p. 367; David 1880, pp. 509, 647; David
1882, fascicle 8 (engraving); Saunier
[1903], p. 107; Rosenthal [1904], p. 166;
Saunier 1913, p. 279; Möller 1914, pp.
158–159; Cantinelli 1930, p. 112, no. 127
(mistakenly attributed to the collection
of "M. Bianchi"); Holma 1940, p. 128,
no. 133; Maret 1943, pp. 86, 118; Haute-
coeur 1954, p. 230 n. 121; Verbraeken
1973, pp. 162 (n. 125), 249; Schnapper
1980, p. 266; Rosenberg and Stewart
1987, pp. 145–46; A. Schnapper in Paris-
Versailles 1989–90, p. 485; Schnapper
1991, p. 63; S. Nash in Canberra 1992–93,
p. 114; Eitner 2000, p. 212 n. 13; Prat and
Rosenberg 2002, vol. 2, p. 1215; P. Lang
in Reinhard-Felice 2003, p. 276.

W HEN CLAUDE-Marie Meunier wed David's
daughter Émilie on 27 March 1805 he had
been Colonel du 9ᵉ Régiment de l'infanterie légère
since December 1803.[1] Like so many officers in
Napoleon's army, Meunier began his military
career during the Revolution, having first enrolled
as a volunteer in his native Jura on 5 August 1792.
He participated in a series of campaigns, with
the Armée du Rhin (1792–95), the Armée d'Italie
(1795–98), and in Egypt; in 1806–7 he was in
Prussia and Poland, and in 1808–11 in Spain. He
was promoted to *général de brigade* in January
1810, and joined the Grande Armée in Russia in
1812 and Germany in 1813. On his epaulets Meu-
nier sports the two stars of the *général de brigade,*
a detail that situates the portrait between 1810 and
November 1813, when he received his third star
with the rank of *général de division.* Referring to
his military engagements, Jules David placed the
sittings in 1812, on Meunier's return from Spain,
and explained the sketchy quality of the execution
by his hurried departure for a new mission. The
affinity of his pose with that conceived by David in
1811–12 for the figure of Napoleon is strong.

Unlike the portrait of his wife (SEE CAT. 22),
painted thinly as an *ébauche* in relatively transpar-
ent colors, the *Portrait of Claude-Marie Meunier*
is executed with a loaded brush and frank strokes.
David seems to be experimenting a manner he
may have thought more masculine and appropri-
ate. The effect is pictorially dynamic and assertive,
less analytical than usual and more intuitive.
The rich play of the gold-thread embroidery
over the deep blue uniform and the treatment of
the epaulets, dabbed with red paint, convey an
impression of spontaneity.[2] Rarely, as in these
decorative motifs and the red ribbon of Meunier's
Legion of Honor, does David's descriptive pen-
chant in matters of uniform and dress succumb
to such an exclusive fascination for visual effect.
The looseness of the handling gives the impression

that he sought to work quickly and seize the whole
figure. At the back of his mind he may have had
the sorry state of his first portrait of Bonaparte
(SEE FIG. 21), likewise an elusive military subject,
which he had begun by focusing his attention only
on the head. The fluid execution is particularly
effective in the depiction of Meunier's face, in
which a Rococo fleshiness seems to surface. The
double curves convulsing the lips, neck, ear, and
curls suggest that David let a repressed pictorial
mode surface in this portrait.

A copy of the picture, formerly attributed to
Rouget, has been in the Musée des Beaux-Arts
at Besançon at least since the middle of the nine-
teenth century.[3] In all likelihood, it was executed
for a gallery of historical figures born in the
region.

NOTES

1. The information in this entry concerning Meunier's
 military service is culled from a recapitulative docu-
 ment drawn up on 13 Apr. 1859 by the War Ministry,
 in his personal file in Paris, Service historique de
 l'armée de terre (Château de Vincennes), 7Yd605. He
 was wounded on several occasions; in particular he
 received a "coup de feu à la tête et un autre à la jambe
 gauche" on 27 July 1809 and a "coup de feu au bras
 droit," on 16 Oct. 1813. On Meunier's career, see also
 David 1880, pp. 508–9. The military file at Vincennes
 includes the draft of the letter, dated 12 Germinal
 Year XIII (2 Apr. 1805), whereby the minister of war
 granted permission, somewhat belatedly, for Meunier
 to wed "Mlle David." Their marriage contract dated
 27 Mar. is referenced in Paris-Versailles 1989–90,
 p. 605.
2. My thanks to Richard Rand for his comments on the
 execution of the picture, which I was unable to study
 before the exhibition.
3. Pougetoux 1995, p. 165.

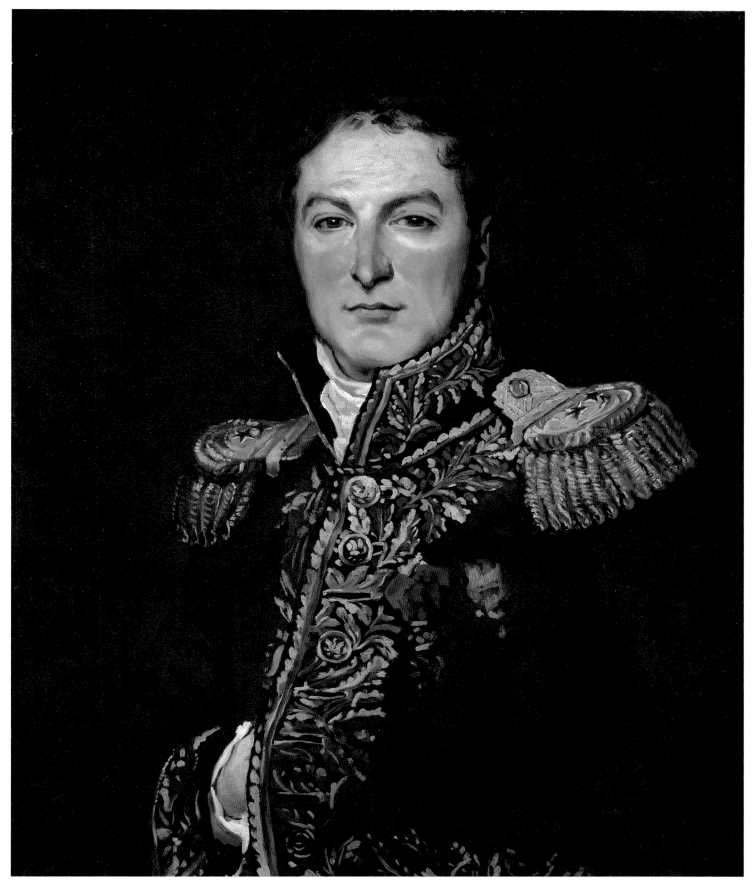

Portrait of Antoine Français, called Antoine Français de Nantes

1811

Oil on panel
A strip of wood has been added on the right and at the bottom: 46 x 28¾ in. (117 x 73 cm) overall
Signed and dated, lower center:
L. David. 1811

Musée Jacquemart-André, Institut de France, Paris (inv. 1398)

Exhibited in Los Angeles only

PROVENANCE
Antoine Français (17 Jan. 1756–7 Mar. 1836) and his descendants (in 1880, "Docteur Français à Lyon"); by 1889, Antoine Dubost; the dealer Durand-Ruel; 1892, acquired by Édouard André; 1912, bequeathed by him along with his collection and house to the Institut de France.

EXHIBITIONS
Paris 1889, no. 609; Paris 1895, no. 785; Paris-Versailles 1948, p. 91, no. 61; New York 1955–56, no. 43; Albi 1959, no 46; Munich 1964–65, no. 75; Montauban 1967, no. 207; Paris 1968, no. 505; London 1972, pp. 46–47, no. 69; Tokyo 1987–88, no. 27; Paris-Versailles 1989–90, pp. 473–74, no. 205; Paris 1995–96, p. 78, no. 29.

BIBLIOGRAPHY
Th. 1826b, p. 242; Mahul 1826, p. 141; Coupin 1827, p. 56; Lenoir 1835, p. 9; Blanc 1845, p. 211; Seigneur 1863–64, p. 367; David 1880, pp. 487, 647; Saunier [1903], p. 107; Dorbec 1907, p. 318; Lafenestre 1914, p. 116; Cantinelli 1930, pp. 81, 112, no. 125; Humbert 1936, p. 147; Holma 1940, pp. 90, 128, no. 131; Humbert 1947, p. 153; Hautecoeur 1954, p. 229; Verbraeken 1973, pp. 28, 32; Wildenstein 1973, pp. 188 (nos. 1619, 1620), 209 (no. 1810); Brookner 1980, pp. 170–71; Schnapper 1980, pp. 266–68; Bleyl 1982, pp. 91–92; E. Agius-d'Yvoire in Paris-Versailles 1989–90, p. 617; Gétreau 1995, p. 184.

BEFORE THE Revolution, when working in the customs office at Nantes, Antoine Français was nicknamed by his colleagues the "Anacreon of fiscal matters."[1] Much later, the fact that he was well read in the classics, as was Daru, probably facilitated his good relations with David. After a term as deputy to the Legislative Assembly in 1791–92—during which he adopted the surname of Français de Nantes with reference to his constituency—and a period of strategic retreat during the Terror, he again was elected representative during the Directory, this time for the Isère department. Support of Bonaparte's coup d'état brought him a succession of administrative posts, including that of member of the Conseil d'État in 1800, and in March 1804 the direction of the Droits réunis, the indirect tax office. During the Empire this administration took an ever more profitable cut on playing cards, public transport, tobacco, salt, gold, silver, and beverage sales; these unpopular taxes were a blessing for the state's finances. In that capacity he contacted David in 1808 to request new designs for playing cards, an initiative that proved his discerning taste and his appreciation for "le premier peintre de l'Europe."[2]

Since he never seems to have ambitioned a ministry, Français was probably more desirous of wealth and honors than of a role in government politics. The fact that he was not part of the emperor's military establishment may explain this somewhat marginal position. He was made Comte de l'Empire in 1808 and promoted to grand officer of the Legion of Honor in June 1811, a distinction he proudly proclaims in his portrait by David. Antoine Schnapper has suggested that the painter may have added the appropriate cross and red ribbon, with its large rosette, once the panel was well advanced or even finished, since he had asked much earlier, on 29 April 1811, to borrow "his complete costume, which means the dress-coat, the coat, the cravat, the jacket, the breeches, and the hat with plumes."[3] The letter, which echoes other requests for costumes at the time of the *Coronation*, confirms his practice of working

from a mannequin or a model. There is no doubt, however, that Français sat for the head, which David managed to characterize as both good-natured and self-important.[4] His ruddy complexion betrays the provincial rusticity of the dignitary and holds its own in the visual rivalry with the spectacular costume of the Conseiller d'État. As he was painting *Napoleon in His Study* in his ordinary military outfit, David was acutely conscious of the artificiality and theatricality of court dress. He allowed the costume in his portrait of Français to deploy itself to the full, but to function visually

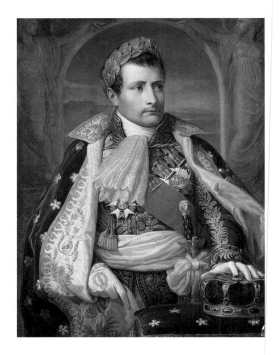

FIGURE 61 Studio of Andrea Appiani, *Napoleon I, King of Italy*, after 1805. Oil on canvas, 38¾ x 29⅜ in. (98.5 x 74.5 cm). Musée napoléonien, Musées de l'île d'Aix, France

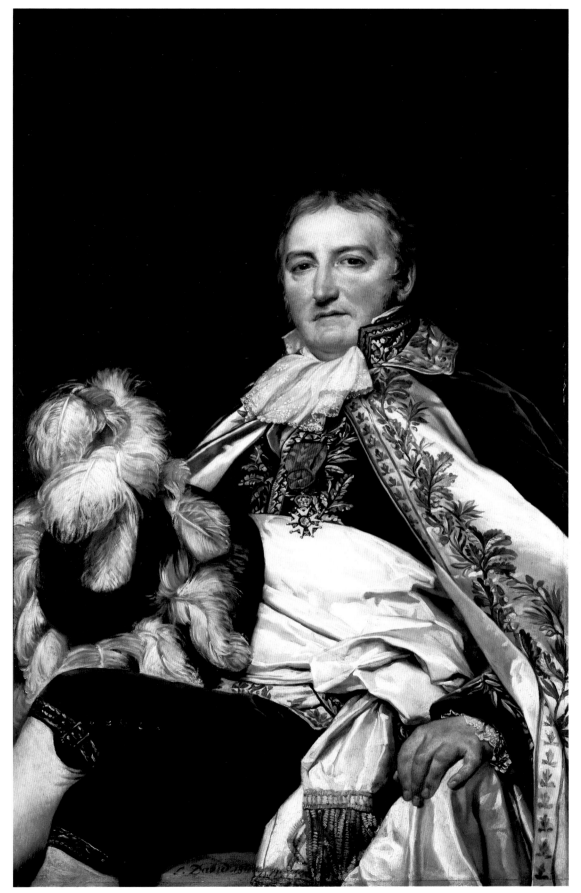

less as clothing than as a motif for pictorial virtuosity. The armchair is engulfed in the process but not the figure. The investment in costume reaches for once an intensity close to that of Ingres, but whereas the pupil aimed at style, the master aimed at expression. The effect is closer to the intense pictorial saturation attained by Andrea Appiani, the other first painter established in Milan, although David's brushwork looks downright rough compared to the suave manner of the Italian (FIG. 61).

The dark blue of Français's costume and the black of his hat create bold contrasts with the variations in white: the cool silver-blue satin, the creamy lace, and the dirty-gray feathers. As discussed in the essay "Portraits of the Consulate and Empire," the narrow proportions of the format are most uncommon, but should be seen more as an experiment than a mannerism. The effect of compression contributes to the visual impact, to which all notion of space and time is sacrificed: more radically than in most his portraits, David's sitter has no room to move, as if turned into a statue. The contrast is extreme with regard to the portraits produced by Gérard and others at the time for the government, in which the comfortably ample space surrounding the figure is the traditional attribute of social superiority.

NOTES

1. Jean Tulard in Tulard 1999, vol. 1, p. 826.
2. See the essay, "In the Service of Napoleon," n. 125.
3. The letter to borrow "son costume complet, c'est-à-dire l'habit, le manteau, la cravate, la veste, la culotte, et le chapeau à plumes" is quoted from a sale catalogue by E. Agius-d'Yvoire in Paris-Versailles 1989–90, p. 617. For A. Schnapper's comments, see ibid., p. 474.
4. Compare the conventional portrait medallion of Français engraved by Ambroise Tardieu after 1819 (Bibliothèque nationale de France, Paris).

22 Portrait of Laure-Émilie-Félicité David, Baronne Meunier

C. 1812

Oil on canvas
28¾ x 23⅝ (73 x 60 cm)

Fine Arts Museums of San Francisco. Roscoe and Margaret Oakes Collection (inv. 75.2.6)

PROVENANCE

Laure-Émilie-Félicité David (26 Oct. 1786–1863), wife of Claude-Marie Meunier (1770–1846); their son, Jules Meunier (1813–1867); his wife Pauline Derode, baronne Meunier (1824–1903); probably given by her to Mathilde Jeanin, wife of Marius Bianchi (1822–1904), and daughter of her cousin Louis-Charles Jeanin (1812–1902), since "Mme Bianchi" owned it in 1913; by 1930, her daughter Thérèse Bianchi, comtesse Murat (1870–1940), widow of comte Joachim Murat (died 1899); her sister Charlotte-Louise-Solange Bianchi, marquise de Ludre-Folois (died 1949), wife of Frédéric-Louis-Marie-René Marquis de Ludre-Frolois; by 1948, Galerie Cailleux, Paris; by 1954, M. Knoedler & Co., New York; 1955, acquired by Roscoe and Margaret Oakes, San Francisco; on loan to the M. H. de Young Museum, San Francisco, from 1956 to 1972, and to the California Palace of the Legion of Honor, from 1972 to 1975; 1975 given to the Fine Arts Museums of San Francisco.

EXHIBITIONS

Paris 1913, p. 24, no. 54; Copenhagen 1914, no. 66; Paris-Versailles 1948, p. 94, no. 65; London 1948, pp. 26–27, no. 23; Paris 1950, no. 25b; Paris 1952, no. 17; Denver 1978–1979, no. 9; Tokyo 1992, pp. 240–41, no. 48; Canberra 1992–93, p. 114, no. 47.

BIBLIOGRAPHY

David 1880, pp. 480, 647; David 1882, fascicle 8 (engraving); Saunier [1903], p. 107; Rosenthal [1904], pp. 130, 166; Saunier 1913, p. 279; Möller 1914, p. 158; Cantinelli 1930, pp. 81, 113, no. 129; Holma 1940, pp. 90, 129, no. 135; Maret 1943, pp. 87, 118; Hautecoeur 1954, p. 230; *Cailleux* 1963, n.p.; Maxon 1967, p. 46; Verbraeken 1973, pl. 57; Brookner 1980, pp. 169–170; Schnapper 1980, p. 266; Bleyl 1982, p. 127; Rosenberg and Stewart 1987, pp. 145–47; Eitner 2000, pp. 210, 212 n. 13; Prat and Rosenberg 2002, vol. 2, p. 1215; P. Lang in Reinhard-Felice 2003, p. 276.

DAVID FIRST drew a double portrait of his twin daughters, Émilie and Pauline, around 1791–92. The medallion with the two girls in profile to the right is lost, but known through an engraving.[1] When painting the *Coronation* in 1806–7 he represented his wife and daughters, but not his sons among the spectators (SEE FIG. 55). He inserted a family scene in the composition, the three women sitting together with him standing behind them. Émilie is probably on the right of her mother, turned to the side with her hand on the railing, while Pauline is on her left, sitting back passively. Whereas the first appears dressed with modesty and absorbed by the ceremony, the second wears a decolleté and jewels and observes the scene wistfully. Sometime between 1810 and 1813 David again painted his two daughters to contribute to a series of family portraits (see the essay "Portraits of the Consulate and Empire"). He was attentive to the fact that the young women, now in their late twenties, were twins. Émilie and Pauline (SEE FIG. 45) are shown both wearing orange-pink and white dresses, with a fashionably wide straight neckline and short puffed sleeves. The broad salmon-colored highlights along the folds suggest the soft texture of velvet, as opposed to the shiny satin preferred by Comtesse Daru (SEE CAT. 18) and the artist's wife (SEE CAT. 23). However the artist introduced a different tonality within each portrait. Like her husband, Claude-Marie Meunier, who stands rather formally in his (SEE CAT. 20), Émilie sits well adjusted, almost locked in her armchair, shoulders broad and strong. Her sister appears literally more unstable, neither clearly sitting nor standing, like the portrait of David's sister, Émilie Sériziat (FIG. 62). She strikes a consciously graceful pose, showing off her long neck and lissome figure. Both women wear flowers in their hair, but Pauline seems to have arranged her bandeau and curls more coquettishly. Jules David in his monograph relates that Émilie was reputed

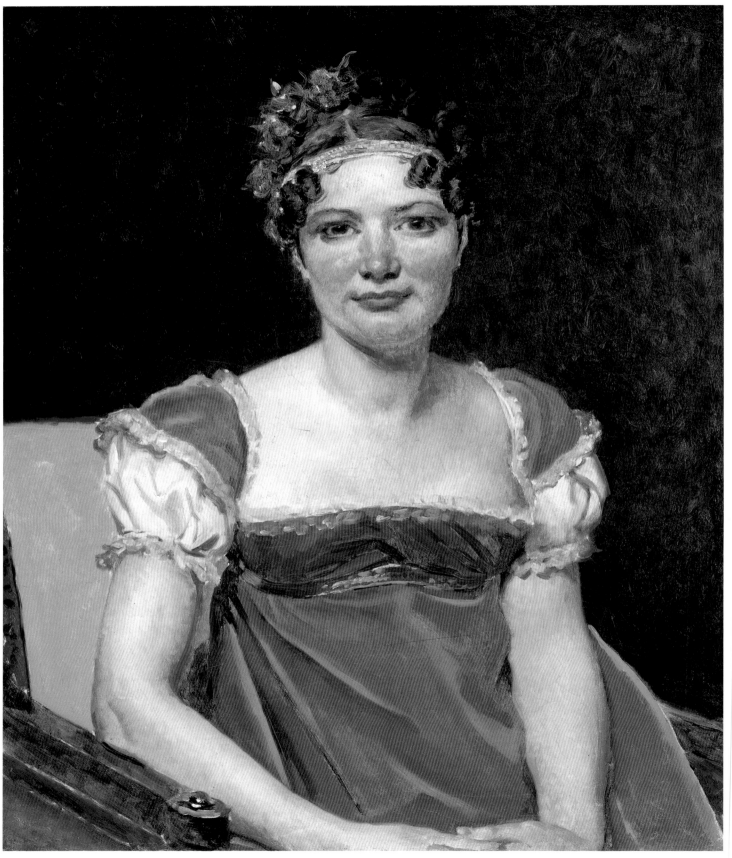

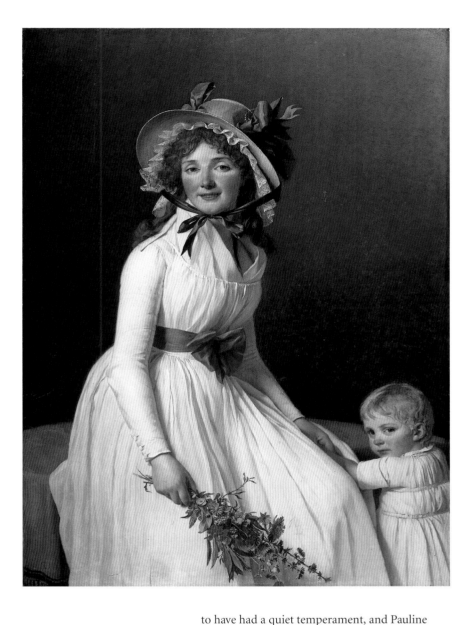

finished.[2] In Émilie's portrait, the line of brown paint just under her right elbow is a bold stroke indeed. Whereas the face and arms are more precisely built up, to capture the inflections of form, the treatment of the dress and hair are sketchy. David gives the impression of wanting to imitate the fluidity and transparency of panel painting. Whereas the technique in his unfinished portraits from around 1790 is clearly that of the *ébauche,* in other words the thin underlayer of paint destined to be covered up, in these instances the execution, with lively brushwork close in certain areas to Fragonard and Greuze, is clearly denotative and not meant to be overpainted. As suggested by both portraits, presenting the hands truncated by the edge of the canvas, this mode was consciously informal. In *Comtesse Daru* and the portrait of his wife, as in those he painted in Brussels, the result is not only more highly finished, but more composed: David wanted the viewer to acknowledge the attention he had accorded to the disposition of the figure. It would seem then that from their inception he never intended to take the two portraits of his daughters further than how he left them.

His motivation can only be surmised. He may have undertaken them for pictorial relaxation, at a time when the standing portrait of Napoleon was demanding his utmost concentration (SEE CAT. 12). They may even have been conceived to counterbalance concessions to the descriptive mode that this important commission required, for he found stifling the preoccupation with accessories and details manifested by so many portraitists. As noted by A. Schnapper, the two portraits are not mentioned in the inventories drawn up after the death of David or of his wife. Even if it cannot be excluded that he took them with him to Brussels, where Pauline visited him in 1821 with her child (SEE CAT. 55), he did end by offering them to his daughters so that in turn they might not forget him.

NOTES

1. Prat and Rosenberg 2002, vol. 2, p. 1215, no. G19.
2. See Schnapper 1991, pp. 63–64; and P. Lang in Reinhard-Felice 2003, p. 276–77.

FIGURE 62 Jacques-Louis David, *Portrait of Émilie Sériziat and Her Son Emile,* 1795. Oil on canvas, 51½ x 37¾ in. (131 x 96 cm). Musée du Louvre, Paris

to have had a quiet temperament, and Pauline a rather exuberant one: the term he employs is *impétueux*—impulsive. This family lore concerning his two aunts was probably well founded, since he was born in 1829 and surely had occasions to discuss the portraits with their models (Pauline died in 1870). Though it is unsound to reduce personalities to a few essential traits and read them into images in this way, it is true that Émilie always took precedence over Pauline: she married first, gave birth to a son in 1806 and to a second in 1813, while Pauline's first child was born only in 1816.

Discussion of the two paintings has often centered on the question of whether they are

Oil on canvas
28¾ x 23⅜ in. (72.9 x 59.4 cm)
Signed and dated, lower left:
L. David. 1813.

National Gallery of Art, Washington.
Samuel H. Kress Collection (inv.
1961.9.14, formerly 1373)

PROVENANCE
Marguerite-Charlotte Pécoul (29 Nov.
1764–9 May 1826); her daughter, Laure-
Émilie-Félicité David (26 Oct. 1786–
1863), wife of Claude-Marie Meunier
(1770–1846); their son, Jules Meunier
(1813–1867); his wife, Pauline Derode,
baronne Meunier (1824–1903); probably
given by her to Mathilde Jeanin, wife of
Marius Bianchi (1822–1904), and daugh-
ter of her cousin Louis-Charles Jeanin
(1812–1902), since "Mme Bianchi"
owned it in 1913; by 1930, her daughter
Thérèse Bianchi, comtesse Murat
(1870–1940), widow of comte Joachim
Murat (died 1899); her sister Renée
Bianchi, vicomtesse Fleury (1869–1948),
wife of vicomte Fleury (1857–1925); by
1950, Galerie Cailleux, Paris; after 1952,
Otto Wertheimer, Paris and Knoedler
and Co., New York; 1954, acquired by
the Samuel H. Kress Foundation, New
York; 1961, attributed to the museum.

EXHIBITIONS
Paris 1846, no. 11; Paris 1913, p. 24, no.
56; Copenhagen 1914, no. 65; Paris-
Versailles 1948, pp. 96–97, no. 68; Lon-
don 1948, p. 28, no. 27; Paris 1949, no. 13;
Paris 1950, no. 25c; Paris 1952, no. 16;
Munich, 1952–53, no. 14; Paris-Versailles
1989–90, pp. 484–85, no. 213.

BIBLIOGRAPHY
Th. 1826a, p. 242; Th. 1826b, p. 166;
Mahul 1826, p. 141; Coupin 1827, p. 56;
Delécluze 1855 [1983], p. 354; Seigneur
1863–64, p. 367; David 1880, pp. 230–31,
487, 648; David 1882, fascicle 2 (engrav-
ing); Saunier [1903], p. 107; Rosenthal
[1904], p. 342; Pauli 1913, p. 546; Rosen-
thal 1913, p. 342; Cantinelli 1930, pp. 81,
113, no. 132; Holma 1940, pp. 90, 129, no.
138; Maret 1943, pp. 85, 118; Cooper
1948a, p. 278; Hautecoeur 1954, p. 230;
Suida and Shapley 1956, p. 68, no. 23;
Cailleux 1963, n.p.; Verbraeken 1973, p.
23; Wildenstein 1973, p. 247, no. 2071
(no. 1); Burney 1975, pp. 623–26; Eisler
1977, pp. 358–59; Brookner 1980, pp.
169–70; Schnapper 1980, p. 265–66;
Schnapper 1982, p. 265–66; Roberts
1989, p. 171; Agius d'Yvoire in Paris-
Versailles 1989–90, pp. 621, 636; Lee
1999, pp. 271–72; Eitner 2000, pp.
208–13.

WHEN DAVID painted this portrait of his
wife, she was nearing fifty and they had
been together for over thirty years. The Revolu-
tion had subjected their union to tensions—they
were married in 1782, separated in 1790, divorced
in 1794 and remarried in 1796—but by 1813 they
were resigned to a harmonious relationship. She
came from a prosperous bourgeois family of
architects and *entrepreneurs des bâtiments du roi*
and had been richly dowried by parents whom
David painted in 1784. She developed a keen inter-
est in contemporary Italian music in Rome at the
time her husband was painting the *Oath of the
Horatii*,[1] but was most likely prevented from pur-
suing any cultural or professional vocation by the
care of four children, born between 1783 and 1786.
While David was incarcerated for his implication
in the Terror, she is reported to have campaigned
actively in favor of his release, and later on, con-
tinued to contact the administration to arrange
her husband's affairs. Denon reported to the first
consul in 1803, for example, on the subject of the
fee for three versions of *Bonaparte Crossing the
Alps* (SEE CAT. 4): "David, naturally more preoccu-
pied with his work than the price of his pictures,
lets his wife do the talking, too passionately with
regard to her personal interest, those of her chil-
dren, and perhaps a kind of glory in obtaining
high prices for her husband's pictures. She will
surely have dictated David's demand [of 20,000
francs for each portrait], which if reduced to
fifteen thousand francs per picture to me would
seem still worthy of the painter's reputation and
the magnificence of the first consul."[2]

This role of his agent that his wife assumed,
which would have a long posterity in the social
organization of art practice, is also suggested by
Fanny Burney in her recollection of a visit to
David's studio about a decade later to see his por-
traits of Napoleon. "Madame David was alone to
receive us, & continued so during our stay. She

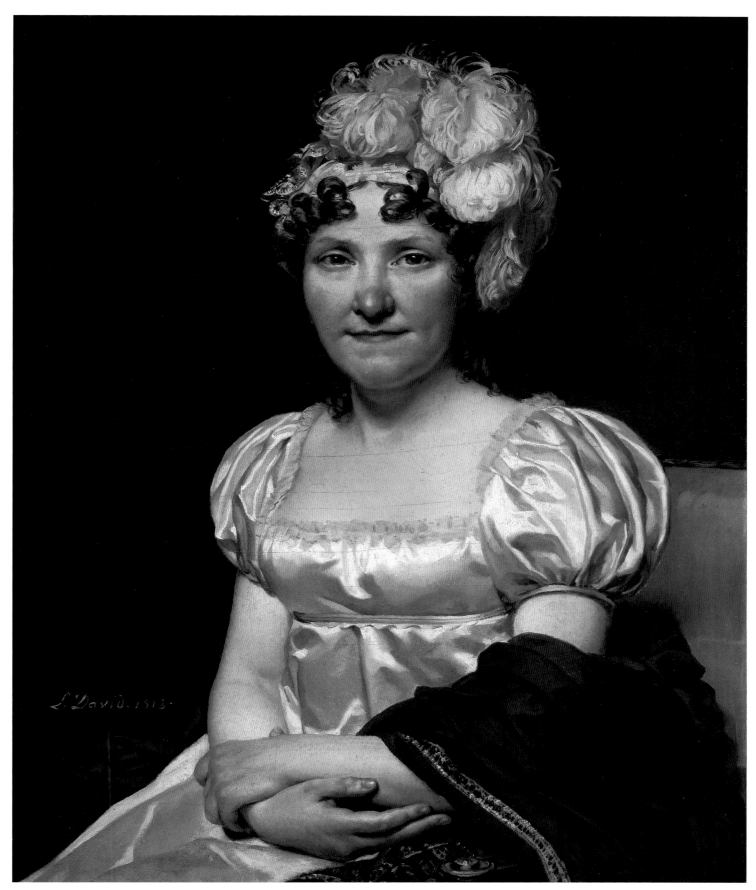

was a woman of no sort of elegance, either of person or attire; & if ever she had possessed any beauty, it had deserted her at an early period, & without leaving any mark, either in her face or form, that there it once had been. Yet she was by no means old; though also by no means young. But if he could not, like another Rubens, impart his conjugal beauty to the world, he had taken care to appropriate something more permanently beneficial to himself in the intellectual endowments of his mate. Mde David appeared to me to be shrewd, penetrating, sagacious & sarcastic. These are qualities very likely to be congenial to the taste of David, who, in return, was to her palpably & sincerely an object of adoration."[3] As she examined the portraits, Burney felt rather uncomfortable, feeling that David's wife expected her to betray some critical opinion regarding Napoleon. "I hazarded not a single comment, nor the smallest observation, save upon the splendid talent which all before me displayed. I could by no means consider myself on safe ground, while I saw the sharp black eyes of Madame David always directed to my face, even while most earnestly conversing with Madame Larrey [who accompanied her]; & though she had seemed to invite from me some sarcasm upon Bonaparte by openly acknowledging to me his own orders, which implied his own motives, for the subjects of the two pictures [*Bonaparte Crossing the Alps* and *The Emperor Napoleon in His Study at the Tuileries*] which she had exhibited; I could not but imagine that my opinions, if gathered, would not rest with herself." She interpreted her admittance to the studio almost as a sort of trap: "Both the artist & his mate were curious to know what would be the sentiments of an Englishwoman upon the subjects of these two celebrated pictures, in which with such characteristic intrepidity & sagacity, the emperor displayed himself as the magnanimous master of the French, & the pacific inviter of fraternity from the English."[4] Her conclusion was that David's wife, like her husband, had mixed feelings toward the imperial regime on the decline: "Madame David, who like her husband, was a rank Republican, could not herself be a thorough votary of Bonaparte; though she wished his prosperity because he was the powerful protector of her mate, & because he had crushed, at least, all legitimate sovereignty. And she was probably

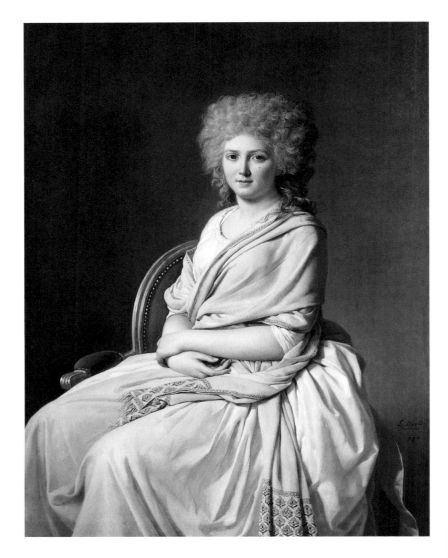

also softened to him the more sincerely, by considering that though he was a monarch, he was a usurper."[5]

These sensitive observations suggest the spirit of trust, collaboration, and also connivance that existed between the artist and his wife. He had included the image of his close-knit family in the *Coronation* in 1806–7 (SEE FIG. 55). With reference to her later portrait, his wife is easily identified among the spectators, represented between her daughters as if to give an echo to Napoleon's own Madonna-like mother and her two *dames d'honneur* just below. In the context of the domestic harmony the painter and his wife enjoyed after 1800 it is perhaps surprising that he waited so long to paint her portrait. One finds mention of another, but it is shrouded in mystery and whether or not it is an autograph work, it is reported to represent an even older woman.[6] In 1813, David had his wife sit in an armchair identi-

FIGURE 63 Jacques-Louis David, *Portrait of Anne-Marie-Louise Thélusson, Comtesse de Sorcy*, 1790. Oil on canvas, 50 3/4 x 38 1/8 in. (129 x 97 cm). Collection of Bayerische Hypo- und Vereinsbank AG in Alte Pinakothek, Munich

cal to the one he employed for the portrait of his daughter Émilie (SEE CAT. 22). The dominant color harmony is also preserved, although reversed. The dull red of the embroidered shawl, with its soft folds, provides a contrast to the shiny white satin of the dress and the playfully extravagant feathers attached to the bandeau. The composition displays more ambition than for the portraits of his daughters, however, since the hands are detailed with great care. As noted by Antoine Schnapper, the result is a variation on the pose of Anne-Marie-Louise Thélusson painted in 1790 (FIG. 63). It is, however, less formal and imposing than that commissioned portrait, and even than the recent *Portrait of Comtesse Daru* (SEE CAT. 18).[7] In the latter, a sense of verticality, in spirit an aristocratic hauteur, is accentuated by the pose of the arms and the disposition of the armchair. In the portrait of his wife David preferred a more matter-of-fact arrangement and reduced the height of his canvas by about four inches (10 cm). The smaller format allows for a closer focus on the sitter and, implicitly, a greater intimacy with her. David was apparently quite proud of this portrait. In September 1815 he asked one of his assistants to show it to an Englishman who was thinking of commissioning a portrait from him, an indication that he considered it a prime example of his capacity in the genre.[8]

In one his rare metaphorical sallies, Schnapper has credited David's wife with having a "a nose like a potato."[9] The remark aims to underline the unflattering realism of David's representation. Whether the painter's uncompromising attitude was encouraged by consideration of his own features, reputed to be ungracious when not downright ugly, is only speculation. Interesting is the resonance of this observation with the notion that this facial detail was most important in a portrait. Roger de Piles, in his *Cours de peinture par principes* of 1708 and republished several times until the end of the century, recommended: "Of all the parts of the face, the one that most contributes to a successful resemblance is the nose, so it is extremely important that it be placed and drawn well."[10]

NOTES

1. Letter from Jean-Germain Drouais to his aunt, 14 Aug. 1785, in Gabillot 1906, pp. 109–10.
2. "David naturellement plus occupé de son travail que du prix de ses tableaux, laisse parler sa femme, trop ardente pour les intérêts de son intérieur, de ses enfants, peut-être d'une gloire qui résulte du prix élevé des tableaux de son mari. Elle aura sans doute dicté la demande de David, qui, réduite à la somme de quinze mille francs par tableau, me paraîtrait encore très digne de la réputation du peintre et de la magnificence du Premier Consul." Denon 1999, vol. 2, p. 1245, no. AN7, letter of 13 May 1803.
3. Burney 1975, p. 624. This passage is partially quoted by Eitner (2000, p. 211).
4. Ibid., p. 625. The first passage is partially quoted by Eitner (2000, p. 211).
5. Ibid., p. 626.
6. In 1913 "Mme Bianchi," then the owner of the portrait today in Washington, sent it to the exhibition *David et ses élèves* along with a second one of David's wife, measuring 24⅜ by 22⅜ in. (62 by 57 cm), hence slightly smaller than the other (Paris 1913, p. 24, no. 55). However, it is odd that Jules David, who thoroughly examined works held by David's descendants, did not catalogue this painting in his monograph (1880). Hautecoeur, in a chapter devoted to the portraits executed in Brussels, writes: "Il portraitura aussi sa femme, devenue une vieille dame, point jolie certes, mais l'oeil avisé (collection Vicomtesse Fleury)" (1954, p. 265; Eitner 2000, p. 212 n. 12, arbitrarily dated to "about 1818"). Although it is most probable that Hautecoeur saw the picture in the Fleury collection, his listing of David's late portraits is so uncritical that his brief comment sheds no light on the status of this one.
7. Both Schnapper (Paris-Versailles 1989–90, p. 484) and Eitner (2000, p. 210) downplay the difference in format.
8. Agius d'Yvoire in Paris-Versailles 1989–90, p. 621.
9. "Comme à son habitude, David ne flatte guère son modèle, à en juger par un nez qui s'achève en pomme de terre." Paris-Versailles 1989–90, p. 484.
10. "Parmi toutes les parties du visage, celle qui contribue davantage à la ressemblance, c'est le nez, et il est d'une extrême conséquence de le bien placer et de le bien dessiner." Piles 1990, p. 127. Christian Michel called my attention to the reprise of this idea in [Chaperon] 1788, pp. 227–28; this author adds that "c'est au centre du visage que se porte habituellement l'oeil du spectator."

Antiquity Revisited

Two STANDARD narratives interlock to chart the evolution of David's relation to the antique as a history painter. According to the first, articulated by the critic Adolphe Thiers in 1824, from *Belisarius* (1781) to the *Sabines* (1799) the influence of Italy progressively diminished while that of the antique increased.[1] The other narrative, established in 1855 by the artist's biographer Étienne-Jean Delécluze, nuances this latter phenomenon by invoking a Roman period, the *Horatii* (1785) and *Brutus* (1789), followed by a Greek period, from the *Sabines* (1799), even though it treats the early history of Rome, to *Leonidas* (1814). In the most succinct terms, this transition is characterized by the shift from fully dressed to fully nude figures. The climactic moment of the Greek period is situated around 1800, when Delécluze has the artist declare that *Leonidas,* his new project, would be more authentically Greek in spirit than all his previous pictures. Among the factors called upon to explain this referential change are the influence of Winckelmann's Hellenism on French art theorists and critics, as well as the radical position taken by a group of David's pupils, the so-called *primitifs,* whose exclusive admiration for archaic cultural forms conditioned their artistic choices and even their lifestyle. For a decade Napoleonic service deterred David from his project and redirected his imagination toward imperial Rome and the pictorial traditions of Ancien Régime monarchies. His practice during these years is held accountable for the heightened realism of his figural style when around 1811, after painting the *Distribution of the Eagles,* he reverted to his initial vocation and completed *Leonidas.* In this same period David's graphic manner appeared to reject the sense of grace and proportion that had been the norm around 1800 and by which Prud'hon, Girodet, and Guérin coninued to abide. The relative brutality of his drawings from the late Empire constituted an idiosyncratic renouncement of the Greek ideal of beauty extolled by Winckelmann, a position that has much displeased the artist's historians. How David approached antique themes and forms, and how his artistic ambitions were redefined and reoriented after 1800, has generally been evaluated with regard to his art of the 1780s and 1790s. It should be more enlightening to put these questions in relation to cultural changes occurring in the first quarter of the nineteenth century.

During the Consulate (1799–1804), when political and economic conditions nurtured greater aspirations than had been possible during the Directory (1795–99), many artists felt an urgency to conciliate respect for the ancients and a reflection on post-revolutionary modernity. Although the status of genre benefited from the situation, the new sense of confidence that stimulated painters was largely the result of changes in style and practice in the domain of history painting effected by David and his pupils over twenty years. On the occasion of the Salon in 1798, Pierre Chaussard proudly celebrated the vigorous state of the contemporary French school: "To the din of theatrical pomp, academic manner, glitter, false tones, false taste, has succeeded calm composition, reasoned arrangement, serene line, correct drawing, a better understanding of color, finally the study and the imitation of the beauties of antiquity."[2] Some who agreed with this statement had become nonetheless estranged by the depiction of superhuman gods and heroes, and deemed that Greek and Roman subjects should now be reinterpreted in more contemporary terms. They avowed a preference for private affections, with which they could directly relate, over visual grandiloquence. Mythological and allegorical themes especially were considered worn out, and a call was made for artists to rejuvenate the approach to this repertory.[3] Girodet observed about this time: "Novels are not banished from literature; fictions are not banished from poetry, why should they be from painting, whose limits, although not infinite like those of poetry, are more extended than one imagines?"[4] David supported this élan to innovate, which for his own agenda implied purging painting of anatomical showmanship, as Delécluze noted, and, another move downplayed by his biographer, exploring the limits of expression. In 1800, in the heyday of the *primitifs,* he praised out loud, much to the dismay of his assembled pupils, the *énergie* of a violently macabre scene painted in warm Flemish hues by Philippe-Auguste Hennequin. Like Vien, who also encouraged Hennequin at the time, David associated his *Remorse of Orestes* (Musée du Louvre) with the merits of the Italian school, in particular the dramatic contrasts of Caravaggio.[5] The *Concours Décennal* in 1810 and the album of engravings that followed would again focus attention on this audacious painting, which was the period benchmark for extreme expression in historical painting, perhaps even more than Girodet's *Deluge,* whose status as history was equivocal.[6]

In 1804, enraptured by Jean-François Lesueur's new opera *Ossian, ou Les Bardes,* David wrote a note to the composer that he released to the press: "When my brush will begin to chill, and my soul to congeal, I shall go warm one and the other to the burning and impassioned sounds of your lyre. I'm told that your spirit has sometimes been inspired by the sight of tableaux from my school, my own burns to the sound of yours."[7] Alluding to paintings of Ossianic subjects by Girodet and Gérard for the first consul at Malmaison, David again proves himself not only open-minded, here with respect to iconographic novelty, but attentive to the fundamental reproach of coldness addressed to his painting. In 1820, he resumed his position on the matter to Jacques-Nicolas

Paillot de Montabert, a former pupil writing a vast treatise on painting: "[W]hat constitutes a masterpiece? It is, I believe, when the conception meets the perseverance of the artist, who without losing hold on the feeling of his first idea, knows how to take it the whole way without it cooling off, and that positively is the merit of those divine artists, different from ours who are quite good at producing a sketch but who fail the picture."[8]

David, who never ceased to encourage his pupils to develop a personal manner and study the life model, disapproved of the most extreme idealist tendencies of his contemporaries. The political climate of the post-Revolution, which directed artists away from a public commitment, and the influence of the museum, which consecrated the autonomy of the work of art, both transformed the nature of the debate around Winckelmann's *beau idéal*. Henceforth, it was less determined by the conditions of liberty required for the emergence of great art than by formal processes and norms. It opposed the partisans of an empirical conception of the *beau idéal* as the chosen reunion of beautiful elements, notably Chaussard and Éméric-David, to those who, as Quatremère de Quincy, appeared to sanction an artist's capacity to forge a superior ideal in his mind. Whether the capacity to combine or to invent forms of beauty was privileged, the creative genius of the artist found itself much valorized by this context, as collective aspirations ceded to individual projects, and patriotic ambitions to moral preoccupations.[9] In the manner of Guizot in 1810, critics observed that there was a pitfall in the shortcut to beauty prescribed by Winckelmann: too often, the beautiful figures claimed to be the product of a painter's imagination were in fact slavish studies of classical statues. An aesthetic relying on the study of plaster casts and the imitation of a canonical set of figures necessarily led to arid repetition. David's constant reliance on the model, in his practice and his teaching, and the jarring realism that he adopts on occasion, were deliberate means to remedy what he esteemed this basic flaw in the application of the *beau idéal*.

During the Consulate, his resistance to theory was reinforced by a critical attitude toward the smooth finish favored by so many contemporary painters.[10] Such a mode of execution was in many ways attractive. By analogizing pictorially the impeccable surface of marble it seemed appropriate to characterize ideal form; by eliminating all trace of manual execution it suggested a miraculous intervention and the idea of the artist as divine. On another level, such sublimation of the imperfections of nature corresponded to the triumphant bourgeois ethos of social order and reserve. As late as 1817, in an exchange of letters with Gros, David still mocked the highly finished paintings of Girodet and Guérin, which for him met the taste of the ignorant *nouveaux riches*.[11] Soon after, as if to exorcize any inclination he might have to imitate their smooth finish, he made sure to work on a canvas with a distinct weave (SEE CAT. 35).

The sentiment that his Parisian contemporaries lacked a feeling for color in their historical compositions further determined his pictorial vision of antiquity. This standard requisite, articulated primarily with reference to the Venetian

school, was especially foregrounded among his artistic concerns by his residence in Flanders. His late preoccupation with color was registered by 1824 as the crowning achievement of his old age.[12] Receptivity to Flemish influences, evoked in the preceding essay with regard to his early trip north and his adoption of panel supports, engaged even more deeply his practice after 1816. From the mid-eighteenth century, somewhat paradoxically, reference to Rubens was marshaled to contribute to the reform of French painting: the preservation of the Luxembourg Gallery was one of the causes upheld by La Font de Saint-Yenne. The concessionary attitude of the sculptor Falconet in 1781 is typical of the period: "We can recognize a simple sublime in other great artists, be they Greek, be they modern; but we cannot escape the artistic domination of the Belgian painter over our soul."[13] During the time he executed the *Sabines,* David had his pupil Delafontaine copy for him a portrait by Rubens, which he reportedly kept on view so that his palette would not darken.[14] With the presentation in Paris of a number of the Flemish painter's masterpieces looted by the armies, appreciation was increasingly enthusiastic. In January 1800 in the *Journal des arts,* Jean-Joseph Taillasson declared him one of the greatest painters of all time: "No other painter has elevated expression to a higher degree. . . . Nature was created in his pictures." The article attacked those *esprits glacés* who failed to understand that "the character of works of genius is not to proceed without faults, but to astonish by their beauties."[15] David no doubt agreed, although when he found himself immersed in Flemish culture, he manifested caution whenever pedagogy was at stake. Evoking in 1818 the situation of Belgian artists who suffered from want of a sufficiently stimulating environment, he wrote to Gros with a keen art historian's eye: "The 'sublime' Rubens has done them much harm. Before him they understood painting like the Italians of the sixteenth century. Every day I admire those works from before the time of that man of genius and I notice that their Old Masters still added color to their beautiful draftsmanship."[16] His receptivity was, however, much more voluntary when it concerned his own inspiration. His adoption of Flemish culture was such that he had the anonymous author of his biography, published in 1824, affirm that in *Brutus* "the background has the fineness and transparency of a Teniers."[17] Conscious that he had secured an eminent position in the history of art by assimilating the lessons of the French and Italian schools, with this ultimate espousal of the third great school of painting, the École du Nord, he aimed at a level of artistic achievement that none of his great predecessors had ever attained.[18]

Evaluating David's later historical compositions with regard to the civic inspiration and political impact of his earlier work fails to take into account the transformation of patriotism by the Revolution. Because the destructive nature of unchecked *amour de la patrie* had been exposed during the Terror, it was no longer defined in absolute terms, but in relation to individual experience and *amour de l'humanité.* It is often noted that David's stark rhetorical mode in the *Horatii* and *Brutus,* like that of the orators in the state assemblies, was

judged increasingly inadequate to express the complexity and diversity of post-revolutionary society. Yet artists perceived this crisis in classicism as a positive reformation, certainly with no obligation to relinquish their political ideals, now a matter of personal opinion. During the Empire, the pervasive social and cultural presence of the military had the effect of accentuating the cleavage between the public and private realms of experience. Napoleonic iconography absorbed the expression of patriotism in the arts; it is telling that David chose a military scene—*Leonidas*—for his last go at an antique *exemplum virtutis* in the manner of his earlier work. Scenes that fueled a passion for liberty continued to be painted, even after the Bourbon Restoration, but antiquity was no longer the preeminent mode of expression, as in Guillaume Guillon-Lethière's *Oath of the Ancestors* of 1822, a modern allegory commemorating the independence of Haiti (National Museum, Port-au Prince, Haiti) or Charles Steuben's *Oath of the Three Swiss* at the Salon of 1824.[19]

Painters who felt a commitment toward antiquity and the historical genre, were left with the possibility of exploring the loves of the gods, or the adventures of imaginary figures from poems and novels. The flow of negative criticism addressed during the second half of the eighteenth century to paintings of mirthful nymphs, excited bathers, and airborne *amours* did not prevent ambitious history painters from investing considerable creative energy in the genre, nor the emergence, as part of the *retour à l'antique,* of a number of compositions in a distinctly classicizing mode, perhaps crowned by David's *Loves of Paris and Helen* of 1788.[20] Recollecting a few years later on this iconographical excursion into what he called, paraphrasing André Félibien, "le genre agréable," he noted that he had ventured far from his "genre naturel, [le] style tragique et historique" out of pride, to silence those who thought him incapable of success in this domain. Works by Jean-Baptiste Regnault and Pierre-Paul Prud'hon, and especially Gérard's *Cupid and Psyche* in 1798 (SEE FIG. 77), confirmed the vitality of this pictorial genre. All through the Revolution such iconography had continued to represent an important sector of the print trade, which literally flooded the market during the Directory and the Consulate.[21] For David the public demand for this imagery, free of the burden of didactic content, found a stimulating relay in the commissions of wealthy patrons Yusupov (CAT. 27), Sommariva (CAT. 32), and Shönborn (CAT. 35). Not surprisingly, their revival of an aristocratic mode of patronage produced an art that was in many ways less progressive than the democratic experiments prompted by the crisis affecting the late Ancien Régime and the ideals of the Revolution. This iconography was depreciated by critics who associated love themes with the boudoir and circumscribed them as particularly suited to women painters, but this sexist position had no effect on David, who collaborated with female pupils throughout his career.[22]

In Brussels, with the exception of *The Anger of Achilles,* this genre became the focus of his activity as history painter. His wife put it bluntly to a friend in 1822, linking this new interest to their peace of mind: "We are blessed with a

tranquility that we have not known for so long, all the revolutionary hassles have been left behind and we recall them only just enough to appreciate the bliss we enjoy. So Monsieur David has devoted himself completely to his dear painting, and since we've been here his genius has settled only on graceful compositions, admired by all the foreigners who saw and picked them up on the spot."[23] In letters to Gros one or two years earlier, David had broached the topic of painting history in troubled times less mundanely than his wife. He urged his designated heir back in Paris to "chausser le cothurne," to dress up in antique costume and paint a "grand tableau d'histoire." In a time when all of Napoleon's commissions were hidden from view by the Bourbon regime, he esteemed that only ancient history and mythology were eternal, "protected from the passions of men." For David it was unimportant whether Gros chose a theme from the history and legends of ancient Greece or those of Rome, more dramatic and tragic, as long as everyone was familiar with it. Among the plentiful suite of subjects he recommended, the first suggested by David would have constituted a sequel and a pendant to his *Leonidas*. After the defeat at Thermopylae, Themistocles, the leader of the popular party in Athens, convinced the youth of the city to wage a naval battle against the Persians; their victory near the Isle of Salamine was the prelude to the flowering of classical Greek culture. The reference to the revolutionary "enrôlements des volontaires" of August 1792 was patent, but also to Napoleon since David writes that the Athenians were inspired by imitation of their leader. That another former pupil, Joseph Odevaere, by then the most respected history painter in Belgium, was probably already engaged illustrating this same scene did not dissuade David from making this suggestion; he also mentioned Sappho and Phaon, which he himself had painted. This attitude was a change from his position during the Revolution, when he lamented that painters had to always treat the same subjects, thrilled that momentous contemporary events furnished new ones.[24] Over the years, the contents of the museum had made an impact on his artistic imagination and made him attentive to his place on the wall with the great artists of the past. Repetition of familiar themes had become the competitive test for artistic invention and genius.

David's pleasant incitation to Gros to "put on the buskin" reveals the critical distance in his attitude toward antiquity. He was surely pleased when his entourage addressed him as Apelles and Zeuxis, but at the same time he must have perceived the fatuity of such flattery. His rational nature had inclined him to paint history rather than allegory and mythology, so when treating the latter, he allowed for and perhaps even demanded a possibility for unbelief, although not to the point of jeopardizing all that he had achieved by sinking into farce or parody. As Lenoir observed, the painter was extremely fond of *opera buffa*, the light, often comic form of Italian opera that brought characters down to earth.[25] David's passion for the theater and opera in Brussels has been documented, however it is difficult to say how the staged tableaux he witnessed may have influenced his pictorial practice.[26] His tone is theatrical when he evokes his

apprehension at painting *Mars Disarmed by Venus and the Graces* (FIG. 64): "I've decided to paint Gods, a new Titan, I've dared to penetrate into their home; may I not share their fate and be struck down by thunderbolts."[27] This vivid remark to his antiquarian friend Antoine Mongez and his wife bespeaks the heightened degree of fantasy in his last confrontations with the antique, the increasing fluidity between what he painted and what he experienced.

Since it was discovered that Delacroix in 1860 jotted down in his journal that "David is a singular composite of realism and ideal," these polarized notions have overdetermined art historical perception of his art.[28] They have authorized much vilification of the later work, as if the seams of fabrication were too visible. Delacroix, when he was musing on his long-dead predecessor, did not really have David on his mind, but two rivals, Courbet and Ingres; in other words, his remark is a compound of two negative terms. Had David's aim been to combine realistic attention to detail and fascination for ideal form, he might have painted like his pupil Christoffer Wilhelm Eckersberg, whose *Departure of Hector* (FIG. 65) possesses a hard brittleness alien to his master's style (CF. CAT. 28). Delacroix's binary vision misleads because it is anachronistic and ignores totally the sense of temporality central to David's artistic practice. More than for any other painter of his day, keeping up with the times was an integral aspect of his art. His friend Pierre Chaussard issued a clear warning to artists in 1806: "[W]hosoever does not make new progress every day, will disappear and fall; this is the result of agitation and revolutions in human affairs."[29] David's exceptional capacity for renewal in Brussels astonished his contemporaries, for it was commonly admitted that artists past their prime became repetitive or unproductive: "Soon old age appears and the most remarkable reputations are no longer of any use except as models offered to the respect of youth."[30]

More adequate to evaluate David's art by associating two terms might be the historical notions of ancient and modern: in other words, of a past which was more than just the *beau idéal,* and of a present which was more than a stake in realism. In *Mars Disarmed by Venus and the Graces* (FIG. 64), his ultimate achievement, almost superhuman given the circumstances, there are distinct echoes of icons of antiquity (Mars as an appeased *Laocoön*), the Renaissance (Raphael's *Banquet of the Gods*), the grand French tradition (Girardon's *Apollo Tended by the Nymphs of Thetis*), and trends in contemporary painting (Ingres's *Jupiter and Thetis*). The result is very personal and not particularly a pastiche, but nonetheless uncanny; as Delacroix noted, employing the wrong terms, it is something of an oxymoron, rather like the notion of *beau idéal moderne* Stendhal put in circulation in 1817 in his *Histoire de la Peinture en Italie.* In his long digression on this idea, Stendhal was not in the least concerned to elaborate a rigorous theory of art, and still today it remains far from clear what the impatient author was getting at.[31] But it is patent from his Salon criticism that, like Guizot in 1810, he loathed the statue-like nudes put on show by painters claiming to represent the School of David. In his thoughtful review of Stendhal's

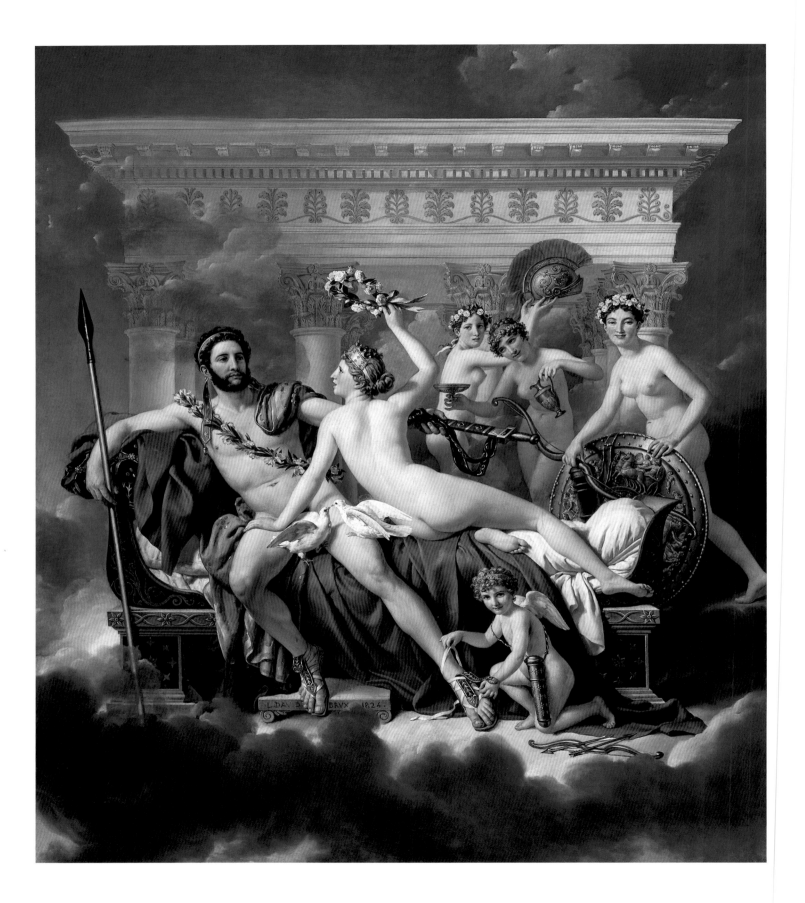

FIGURE 64 Jacques-Louis David,
*Mars Disarmed by Venus and the
Graces*, 1824. Oil on canvas, 10 ft.
1¼ in. x 8 ft. 7⅛ in. (308 x 262 cm).
Musées royaux des Beaux-Arts de
Belgique, Brussels

FIGURE 65 Christoffer Wilhelm
Eckersberg (Danish, 1783–1853), *The
Departure of Hector*, 1813–16. Oil on
canvas, 19⅜ x 13⅝ in. (49.1 x 34.6 cm).
Thorvaldsens Museum, Copenhagen

book, only published in 1826, thus in the different context of drawn battle lines
between *romantiques* and *classiques,* Delécluze took the author's plea to its logi-
cal conclusion: "How strange that M. de Stendhal should not realize that the
'*beau* idéal moderne' he proposes is precisely that type of effeminate graceful-
ness, the *pretty* that characterizes all works of art executed from 1721 to 1780?"[32]
David's future biographer, who admitted that one might prefer the *joli* to the
beau, but not that the two were interchangeable, was horrified by this specter
of reaction. When he received news of his master's death in Brussels, he re-
flected that since 1815 and his exile, the French School had abandoned sound
principles—he was thinking of the encouragement given to troubadour paint-
ing by the Bourbons—and had fallen back on the stylistic malpractice David
had expunged.[33]

The way art and politics were enmeshed in such discussions during the early
Restoration is perfectly illustrated by an anonymous print published by
Lasteyrie, officially registered in October 1817 under the title *Romulus Calicot,*

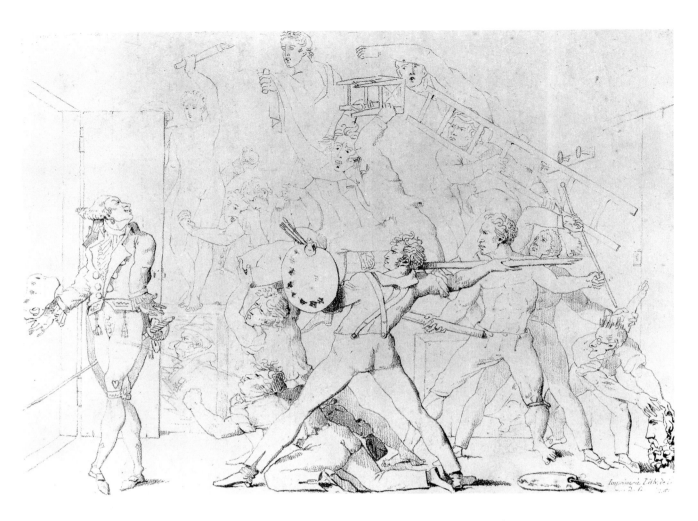

caricature lithographiée (FIG. 66). Freely based on David's *Sabines,* the scene takes place in the master's studio: his profile portrait, dressed up with the Napoleonic Legion of Honor pinned to his jacket, is drawn on a block near the door on the left. A preciously mannered painter with a feminized body, bewigged and wearing the *culotte* of the Ancien Régime aristocrat, defies a group of muscular men in contemporary work dress who strike Davidian poses. He may have provoked them by scarring the master's portrait. In the background, canonical antique statues are disposed as if joining in the assault on the intruder. The term *calicot* in the title, popularized by a play on the Parisian stage that year, designated fabric store employees, but more generally fashionable young men who improbably adopted the virile bearing associated with the military.[34] The image attests to an often neglected fact: prior to the vociferous rejection of the School of David by the Romantics at the Salon in 1824, the year Stendhal put it "on trial," many young painters were persuaded that the spirit of the antique and the heroism of modern life were compatible. This helps explain why in November 1820 Théodore Géricault and Horace Vernet, two artists fascinated by the glory and drama of Empire, were so keen to stop in Brussels to salute the venerable exile. The emergence of a common menace in the Bourbon reaction and what was perceived as a revival of the Ancien Régime in the arts, the imaginary of the boudoir, the church, and the castle all lumped into one, reinforced the desire to

FIGURE 66 Anonymous, *Romulus Calicot, caricature lithographiée,* 1817. Lithograph, 8⅞ x 12½ in. (22.4 x 31.8 cm). Kupferstichkabinett, Staatliche Museen zu Berlin– Preussischer Kulturbesitz

forge a new art from within the school. As in the 1750s, the true grandeur of the antique was most effectively sustained after 1815 not by the academic old guard, but by those with a modern vision.[35]

Ever since Thermidor, David associated this potential for reaction and fear of resurgence of the *manière* with his political adversaries in the Institute and in the École des Beaux-Arts, where he refused to teach during the Empire. Like the younger generation, he understood the need for a modernized vision of antiquity. In the opening essay of this catalogue it was observed that in the period leading to the Revolution, as others, but more forcefully, David referred to the culture of Rome to visualize republican ideals for his fellow citizens, and that after the Terror, the antique past became less a model for the present than a projection of contemporary situations. In the last phase of his career the will to cast the antique in modern terms was stronger than ever, and formally more perceptible. With regard to textual sources, it can also be noted that he may have sought inspiration in La Fontaine rather than Apuleius when painting *Cupid and Psyche,* and certainly found it in Fénelon rather than Homer or Virgil for *Telemachus and Eucharis,* and in Racine rather than Euripides for *The Anger of Achilles.*[36] His late predilection for "compositions gracieuses" allowed him to prove, as had the art of Raphael, that such themes were corrupt only by the false manner in which too often they were treated.

The critic Auguste Jal, openly opposed to the Bourbons, provocatively declared in his review of the Salon of 1824 that if David reappeared on the Parisian scene, he would put himself at the head of the movement "improperly called romantic."[37] Stendhal, although not convinced by such a prospect, explained at length that the artist's rebellious attitude in the 1780s had been no different from that of the younger generation in the 1820s, and each was in its way beneficial to the progress of the French school. David, who saw that antique history painting was losing ground in the studios and in the exhibitions, did not disagree. His cherished pupil François-Jean Navez, like Léopold Robert, chose to paint scenes of Italian folklore that had great poignancy and charm. Stendhal could have signed the lucid analysis of the contemporary situation which the master addressed to another pupil, Jean-Victor Schnetz, who also was backing off from antiquity to focus on religious subjects: "I suspected very early what is happening to you now. You were right to distinguish the kind of study that really suits you. You always kept to it and now you're happy. Like so many others you could have gone for what they call the antique and which is antique only for them, meaning that their works lack character and the stamp of having been done by a truly talented man. The genre practiced by Raphael, Leonardo, etc., is as good as any; by treating our sacred subjects, rather than a genre which is somewhat fanciful, since we don't have the same customs and we have a different religion. I'll go even further, close your ears to the overblown talk of the partisans of the antique, I'm their associate, my taste has always led me in that direction. Your own is not inferior when you can treat it the way you do."[38]

An echo of this acceptance to let nature and history take their course is found in one of David's last paintings, *The Fortune Teller* (FIG. 67).[39] A woman, vaguely reminiscent of the Italian peasants his pupils found so attractive, scrutinizes the palm of a younger woman, draped in antique garb. The Caravaggesque theme was popular at the time; Schnetz made a name for himself at the Salon of 1824 with a picture representing an old bohemian woman predicting to a boy's mother the glorious destiny of her son as Pope Sixtus V, as a papal milestone makes clear (FIG. 68).[40] In David's version the scene is pared of all the picturesque elements dear to Schnetz, but also of its appeal to a public increasingly fond of anecdotal history. The dignity and humanity of the figures dispel all suggestion that the picture might be a moral gloss on the superstitious and idle nature of women. He transformed a simple confrontation into a subdued drama and a meditation on the fortunes and misfortunes of life. With regard to

FIGURE 67 Jacques-Louis David, *The Fortune Teller*, 1824. Oil on canvas, 24½ x 29½ in. (62.2 x 74.9 cm). Fine Arts Museums of San Francisco. Gift of David David-Weill

Schnetz, it is significant that he inverted the roles: the protagonist, the figure who draws attention, is not the fortune teller but the woman, restive and perhaps anxious, reflecting on what she hears or has already been told. This is probably the closest David ever came to creating a mood of religiosity in his painting: not, of course, the outward trappings of religion, but the aura of infinite mystery. That the young matron is posed like a Virgin of the Annunciation may be part of the explanation, but no doubt also the state of mind of the seventy-six year old man holding the brush, who knew that death was approaching and whose future was posterity.

FIGURE 68 Jean-Victor Schnetz
(French, 1787–1870), *The Infancy of
Pope Sixtus V*, 1824. Oil on canvas,
62 x 49¼ in. (157.5 x 125 cm). Musée
des Beaux-Arts, Arras

24. Compositional Study for *Leonidas at Thermopylae*
c. 1798–1800
Pencil on paper, squared in pencil
12⅝ x 16½ in. (32 x 42 cm)
Inscription, lower right: *b*

Musée Fabre, Montpellier (inv. 837.1.193)

PROVENANCE
. . . ; François-Xavier Fabre (1766–1837);
1837, bequeathed to the museum of
Montpellier (mark [L. 919], lower
center).

EXHIBITIONS
Paris-Versailles 1989–90, pp. 500–501,
no. 216.

BIBLIOGRAPHY
Delécluze 1855 [1983], pp. 227, 478 n. 10;
David 1880, p. 662; Cantinelli 1930, pl.
LXXVI; Holma 1940, pp. 88, 124 n. 42;
Bothmer 1964, pp. 328–29 n. 4; Kemp
1969, pp. 179, 182; Nash 1973, pp. 106, 138,
140–42, 144–45, 221 (n. 206), 234 (n. 364),
235 (n. 372); Rubin 1976, p. 567 n. 144;
Nash 1978, pp. 106–7, 109; Brookner
1980, pp. 165–66; Levin 1980, pp. 7, 9;
Schnapper 1980, pp. 197–98; A. Sérullaz
in Lille 1983, pp. 18–20; Gaehtgens 1984,
pp. 219–20, 234–35; Roberts 1989, pp.
174–75; A. Schnapper and A. Sérullaz in
Paris-Versailles 1989–90, pp. 493, 495,
509–10; Sérullaz 1991, pp. 263–64, 267,
288, 292–94; Wisner 1991, p. 289; John-
son 1993a, pp. 163, 166–67, 170; Prat and
Rosenberg 2002, vol. 1, pp. 192–93,
no. 179.

25. Compositional Study for *Leonidas at Thermopylae*
c. 1811–13
Black crayon on paper, squared in
black crayon
15⅞ x 21⅝ in. (40.6 x 55 cm)

The Metropolitan Museum of Art,
New York. Rogers Fund, 1963 (inv. 63.1)

PROVENANCE
1826, in David's possession at his death
(initialed lower right by his two sons,
Eugène [L. 839], and Jules [L. 1437]);
possibly, David sale, Paris, 17–19 Apr.
1826, no. 92 (one of three "compositions
au trait" for *Leonidas*) or no. "159.
grande étude pour le tableau de Leon-
idas"(manuscript annotation to the copy
of the catalogue in the British Library;
Prat and Rosenberg 2002, vol. 2, p.
1229); . . . ; Jean Oberlé (1900–1961),
Paris, according to Wildenstein & Co.;
Henri Baderou (1910–1991), Paris;
Wildenstein & Co., New York; 1963,
acquired by the museum, with the
Rogers Fund.

EXHIBITION
London 1972, pp. 331–32, no. 556; Paris
1973–74, no. 24; Athens 1979, no. 75;
Paris-Versailles 1989–90, pp. 504–5;
Paris 2000, p. 267, no. 51.

BIBLIOGRAPHY
Bean 1964, pp. 327, 329; Bothmer 1964,
pp. 330–32; Nash 1973, pp. 140, 143,
146–53, 155, 156, 232 (n. 352), 233 (n. 359),
235 (n. 374), 236 (n. 385); Rosenberg
1974, p. 428 n. 9; Huchard 1976, p. 83 n.
6; Nash 1978, pp. 103–4, 106, 109–11;
Schnapper 1980, p. 272; A. Sérullaz in
Lille 1983, pp. 19–20; Gaehtgens 1984,
pp. 235–36, 238; Bean and Turčić 1986,
pp. 90–91, no. 93; Roberts 1989, p. 183;
A. Schnapper and A. Sérullaz in Paris-
Versailles 1989–90, pp. 493, 495, 500, 511,
520; Sérullaz 1991, pp. 174, 288, 290, 302,
315–16; Johnson 1993a, pp. 166, 168, 295
n. 90; Michel in Paris 2000, pp. 111,
121–23, 261; Prat and Rosenberg 2002,
vol. 1, p. 299, no. 317.

26. Compositional Study for *Leonidas at Thermopylae*
1813
Black crayon, pen, black ink and wash,
and white gouache on paper, squared in
black crayon with pen line in black ink
on the outer edges
8¼ x 11 in. (20.9 x 28.1 cm)

Signed and dated, with pen and black
ink, lower left: *L. David / 1813.*; inscrip-
tion in white gouache, upper left:
*PASSANS ALLEZ / DIRE A SPARTE / QUE
TROIS*

Musée du Louvre, Paris. Département
des Arts graphiques (inv. 26080)

Exhibited in Los Angeles only

PROVENANCE
1826, in David's possession at his death;
David sale, Paris, 17–19 Apr. 1826, no. 27;
acquired at the sale by Ambroise Con-
stantin for the museum (mark [L. 1886a]
lower left).

EXHIBITIONS
Zurich 1937, no. 66; Paris 1948, pp.
122–23, no. 124; London 1948, p. 36, no.
42; Algiers 1955, no. 22; Paris 1972, p. 26,
no. 59; Cologne 1987–88, pp. 375–76,
no. 117; Lyons 1988, pp. 389–90, no. 122;
Paris-Versailles 1989–90, pp. 506–7, no.
220.

BIBLIOGRAPHY
Cantaloube 1860, p. 302; David 1880,
p. 662; Guiffrey and Marcel 1909, p. 76,
no. 3194; Sérullaz 1939, n.p., no. 12;
Holma 1940, pp. 78, 88; Hautecoeur
1954, p. 232; Bean 1964, p. 329 n. 5; Kemp
1969, p. 179; Nash 1973, pp. 150, 156–57,
236 (n. 390), 237 (n. 392); Wildenstein
1973, pp. 238 (no. 2042 [72]), 244 (no.
2062 [27]); Huchard 1976, p. 83 n. 6;
Nash 1978, pp. 110–11; Schnapper 1980,
p. 197; A. Sérullaz in Lille 1983, pp.
18–20; Gaehtgens 1984, p. 238 n. 38;
A. Schnapper in Ixelles 1985–86, p. 182;
D. Brachlianoff in Lyons 1988, pp. 389–
90; Roberts 1989, pp. 183, 212; A. Schnap-
per and A. Sérullaz Paris-Versailles
1989–90, pp. 495–97, 500; Sérullaz 1991,
pp. 41, 174–75 (no. 221), 288, 298, 300,
302, 315; Johnson 1993a, pp. 166, 168, 295
n. 90; Prat and Rosenberg 2002, vol. 1,
p. 298, no. 316.

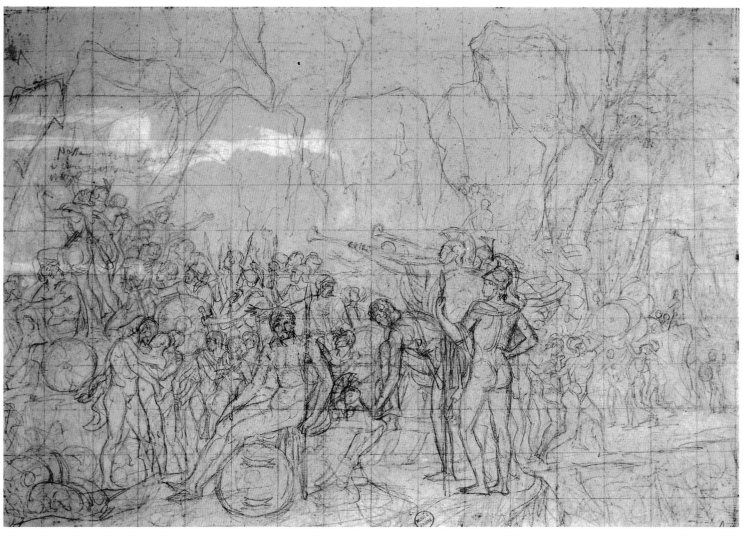

Before David put the finishing touches on the *The Intervention of the Sabine Women* in 1798–99 (see fig. 1), he was already contemplating a possible pendant for the picture.[1] In the same way that *Brutus* (1789) had proven his capacity to innovate and progress within the aesthetic and stylistic framework of the *Horatii* (1785), he intended for his new project to develop and radicalize the formal purity and close imitation of antique models manifest in the *Sabines*. Whereas his predilection as history painter had been for the Homeric legends of the Trojan War and the early history of the Roman Republic, he now turned his attention to a Spartan narrative of patriotic sacrifice and moral austerity. During the Revolutionary wars the Jacobins, and after Thermidor the neo-Jacobins with whom David sympathized, had invoked and lauded Leonidas, the king of Sparta who in 480 B.C. with three hundred soldiers died at Thermopylae ("The Warm Gates") to retard the advance of the Persian army of Xerxes into Greece.[2] In the context of the late Directory, and the 1798 law of "compulsory conscription" founded on the principle that "every Frenchman is a soldier and has an obligation to defend the country," the pictorial celebration of military patriotism and courage was an urgency, a call to which many artists responded through the years of the Consulate.[3]

In the *Sabines*, David chose to paint individual figures of great beauty, and organize his composition around them, especially the two warriors and

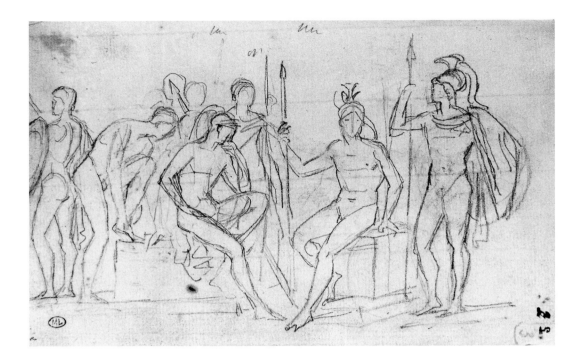

their respective equerries. The Winckelmannian ideal of the expressive isolated figure, the impact of the antique statues in the museum, and perhaps a conservative pedagogical concern in a period when pictorial innovation had become the norm all led him to pursue this direction in his new composition. From the earliest sketches for *Leonidas* the scene was conceived as a foreground collage of male nudes striking a range of studied poses, and a jumble of more lively figures and groups behind. David articulated the composition around the figure of Leonidas, whose centrality is comparable to that of Hersilia in the *Sabines,* but no longer relied on a collective action to unify it. The decision to represent the call to arms allows for a succession of disconnected reactions, in a manner authorized by academic doctrine. To dilate the sense of time and show attitudes ranging from the immobility of expectation to the leap into action, David assembled episodes or *peripéties,* a narrative system for which Poussin's *Gathering of Manna* was justly famous. With respect to this canonical painter he had idolized in the 1780s, however, he introduced two notable differences: an extreme compression of the figures, suggesting confinement in the mountain pass, and a radical self-absorption of the protagonist, who seems removed from his army and the last to react.

Refusing the mode of the gestural interaction and dialogue across the canvas that had established his reputation, David crafted a combination of relatively autonomous figures. He believed he had revived the spirit of antique reliefs and vase decoration and attained a higher degree of formal beauty and expression than ever before.[4] The imitative process is perhaps most radical in a frieze-like proposal for the composition drawn in one of his sketchbooks (FIG. 69).[5]

Some hundred and thirty studies of figures and groups, and five full compositional drawings for *Leonidas,* more than for any other of his paintings, prove how deeply involved he became with this project, which was only finalized in 1814, a full fifteen years after its conception, on account of the succession of Napoleonic commissions he accepted. The earliest study for the composition, a small sketch measuring only twelve by eighteen centimeters (4¾ x 7 in.), is presently lost, but an engraving of it shows David to have initially situated the soldiers in a shallow space, up against a mountain cliff aligned to the picture plane. The figures in the background are raised above those in the front, a visual system based on Roman military scenes on sarcophagi and Trajan's column which he had adopted in the *Oath of the Tennis Court.* The opening in the pass, visible at the

FIGURE **69** Jacques-Louis David, *Study for "Leonidas at Thermopylae,"* 1798–1800. Pencil on paper, 4¹¹⁄₁₆ x 6¾ in. (11.3 x 17.2 cm). Musée du Louvre, Paris

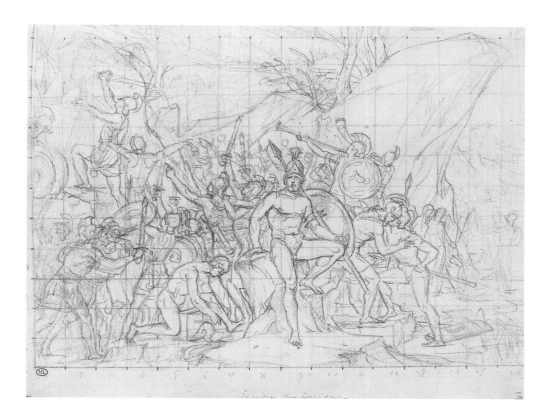

FIGURE 70 Jacques-Louis David, *Compositional Study for "Leonidas at Thermopylae,"* c. 1813. Pencil on paper, 8 x 10 in. (20.3 x 25.5 cm). Musée du Louvre, Paris

extreme right of the composition, is still exterior to the scene, conceived in the manner of a relief.

The drawing from Montpellier in this exhibition (CAT. 24) refines this first idea. The setting remains a wall of rock, but the pass on the right allows for additional soldiers to lead the eye toward the back. Behind Leonidas, whose attitude of repose is accentuated, the figures have been literally brought down, except for the group of soldiers on the left carving the memorial inscription. A number of figures continue to strike beautiful poses, but a greater sense of narrative unity is achieved. This may be the revision to which a pupil of David referred in September 1800: "David is back with a new composition of his picture [*Leonidas*] which, I hear, seems better than the one we know."[6] Grand in scale and squared for transfer, the drawing suggests what the composition might have looked like had the painter not been distracted by the commission for an equestrian portrait of Bonaparte in August 1800 (SEE CAT. 4). Prat and Rosenberg have noted the play of circular shields across the composition, recalling the one held by Romulus in the *Sabines*, but here creating an almost decorative rhythm from repetition.

In November 1802 the press mentioned that David was working on *Leonidas,* and he may have returned to it after finishing *Bonaparte Crossing the Alps* and before beginning the coronation pictures. But only in 1811—after completing the *Distribution of the Eagles* and finding himself with no specific mission as first painter to the emperor—was he again determined to devote himself to the picture. In 1806 Pierre Chaussard had judged David's unfinished painting harshly: "One recognizes his full talent in the execution; but the composition seems faulty."[7] The painter apparently agreed, for to pupils who inquired about his abandoned project he would say that he was unhappy with it. The concluding phase of execution continued to be marked by indecision. As late as the summer of 1813, according to a pupil who wrote home regularly, it appeared as if the master would start the picture afresh on a new canvas. He then changed his mind, but in due time scraped almost every figure he had initially brushed in.[8]

A squared compositional study in one of the sketchbooks (FIG. 70) is usually ascribed to this later phase of execution.[9] The most notable modification concerns the figure of Leonidas, whose pose now suggests greater alertness, although David does not yet provide him with a sword, as in the painting. To restore his confidence with regard to his composition, he put his faith in the scenes of oath-taking treated throughout his

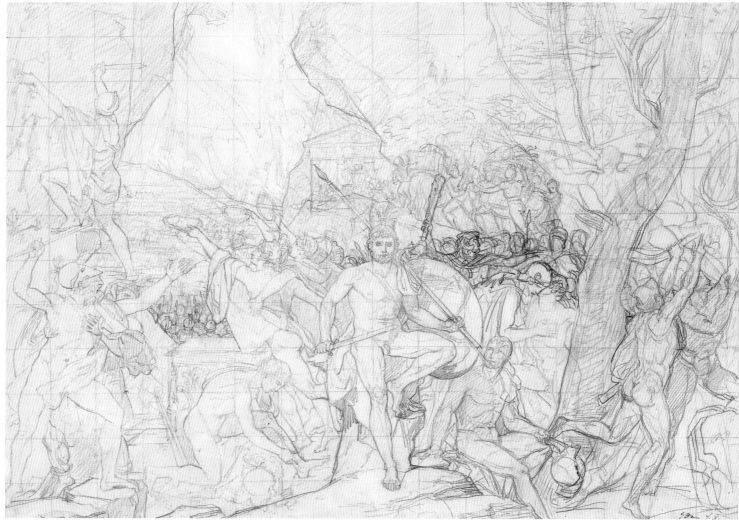

career that were profoundly emblematic of his art, and made this theme far more explicit, previously only latent. The succession of incidents represented behind the foreground figures gained considerably in visual coherence and unity. The view into the distance is still situated on the extreme right, but the rock formations in the background begin to suggest another recession toward the center.

David arrived at the definitive composition as he worked on the large sheet today in New York (CAT. 25). He drew and erased a group of soldiers and a tree hung with shields, still perceptible off center slightly to the left, to open the view between the cliffs in the direction of the Persian army. In the middle distance, on a lower level and seen from above, he added a compact group

of helmeted Greeks, facing the enemy, hence with their backs to the spectator. In the painting, a few heads from this group are visible just behind the altars to Aphrodite and Hercules. On the right of the New York sheet three figures and a prominent tree trunk, partly masking some figures already drawn, were added to better balance both sides of the composition. The secondary incidents in the background come into focus—the officiant in the cult of Hercules exhorts the men to readiness and the non-combatants lead the convoy of supplies out of the pass—although still further clarification will intervene in the final composition. Characteristically, David makes the scene more enlivened and complex when he draws, but chastens himself when he paints. His pictorial style, predicated on sculptural delineation, seems to contradict his

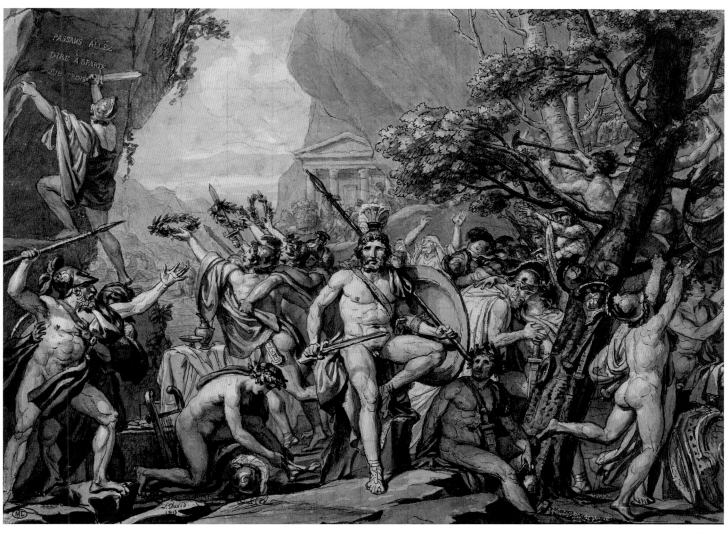

desire to suggest movement and tumult appropriate to his subject. When painting *Leonidas,* he sketched animated figures in the far distance to represent the Persian army, but so schematically and on such a reduced scale that manifestly this part of the picture was only meant for the committed eye.

In 1824 David offered to sell to "M^rs Didot père et fils" what he called "the second composition of my Leonidas at Thermopylae, one can see the changes that came about after some new thoughts."[10] It is not clear whether he meant a work sheet like the one in New York, full of pentimenti and covered by a grid of lines, or the composition signed and dated 1813 in the Louvre (CAT. 26), treated with ink wash and gouache highlights, inventoried after his death as a "dessin esquisse"

and probably as close as he ever got to producing a presentation drawing. An inscription in David's hand on the back of the original mount, indicated that at one time he intended to offer it to Giovanni Battista Sommariva, the patron for whom he painted *Cupid and Psyche* (SEE CAT. 32), although finally it remained in his possession.[11] Executed for pictorial effect with unusual care, even overworked according to some recent commentators, this drawing is in fact only about half the size of the New York sheet. The major changes on the right are now fully assimilated, but some of incidents behind the main figures are notably different. This suggests that David inserted the two darker passages in the New York sheet (the helmeted army in the middle distance, the officiant in the cult of Hercules) after he finished the Louvre

drawing. Among the minor adjustments made on the canvas exhibited in 1814, the expression on Leonidas's face is perhaps the most telling. In all the preparatory drawings, whether for the figure or the composition as a whole, the Spartan hero appears to address the viewer, in the manner of Bailly in the center of the *Oath of the Tennis Court*. In the painting, rather like the abbé Henri Grégoire, a Catholic priest in front of Bailly who looks up to heaven, Leonidas raises his eyes in a mute dialog with the gods of Olympus. Most often interpreted as a dignified bow to *Laocoön* by art historians spellbound by Winckelmann who presume that artists shared this predilection, this expression might also be interpreted as melodrama and a concession to contemporary taste.[12]

The manner of the Louvre sheet has inspired some particularly uncomfortable reactions: the composition is said to look "weighed down and as if congealed," the figures to be "somewhat hard and strangely fattened," and Leonidas, "a type of ape-man," characterized as "brutal looking, awkward, and ugly, and his facial expression is that of one who is blunt and foolish." At a time when David was aiming to recover the purity of Greek art (according to Delécluze), this drawing is said to evidence a "penchant for vulgarity that is disconcerting to say the least."[13] The only explanation to date for the singular graphic mode adopted here has been based on the far-fetched metaphor of the "ape-man," to suggest that the artist was receptive to "recent scientific investigations into the development and evolution of man, issues hotly debated in Paris from 1800 to 1810." With reference to theories of natural selection and the survival of the fittest, which indeed invoked Sparta, David is purported to have wanted to emphasize the "sensual, physical natures" of these "powerful animal-like men."[14] The idea that he aimed to visualize a heightened sense of energy seems sound enough, but the misconception which faults such comments, whether negative critiques or salvage operations, is the notion that the drawing should in some way be realistic or illusionist, in other words, respectful of pictorial norms. When making line drawings, David always valued correction. However in presentation sheets like this one, a category defined by the suggestion of space and form to be attained, he adopted an experimental stylization that can only be judged

on its own terms. Supported by independent critics, a number of contemporaries like Philippe-Auguste Hennequin and Louis Lafitte developed a graphic style founded on the liberty to deform figures for expressive purposes.[15] As argued in the introductory essay to the next section, roughness of execution was for David a choice and a critique of the dominant taste for finish and formal elegance to which the most fashionable contemporary artists catered.

Several historians have attempted to relate the large number of preparatory studies for *Leonidas* to the different stages of execution.[16] This has revealed a particularly intricate play of reprises and modulations between the figures and groups for this composition and those elaborated for the *Oath of the Tennis Court* and for the *Distribution of the Eagles*, and in some instances, it remains uncertain to which of the three a study relates. Interpretation of *Leonidas* has focused on a number of different questions over the last thirty years. Since it was a Greek fantasy meant to supplant the lost masterpieces of ancient painting and a manifest of antiquarian erudition and culture produced in a period when pictorial iconography was increasingly diversified, the literary and visual sources have been studied in detail.[17] The specialized knowledge marshaled in the conception and the inclusion of so many Greek inscriptions suggest that David consulted such competent antiquarians as Antoine Mongez and Aubin-Louis Millin. Another important axis of research has confronted the exclusion of women from the scene, and the insistent homosocial resonances in the picture, both thematic and visual.[18] In a long-term perspective, David's project can be ascribed to the inflection given to European art by Winckelmann's aesthetic system, which valorized the male nude. With respect to the artist's personal thematic predilections, it can be interpreted as the most complex manifestation of the fraternal ideal which haunted him throughout his life. The backdrop of Napoleonic military life probably facilitated the radical nature of his choice: the absence of women from the military scenes commissioned by the government sanctioned the idea of an imaginary all-male world.

In the context of emergent romantic manifestations, the relation of David's art to post-revolutionary academic doctrine has received

consideration, although often biased by an unease with his late work. More explicitly than in any earlier work, he does appear desirous to offer a collection of models for study. It should be noted however, that what may have struck most contemporaries was not the idealization of the figures but their realism. Already in 1810 the critic François Guizot observed that on account of the focus of artistic education on the study of sculpture, historical compositions looked often like paintings of statues.[19] David proved it was possible to restore flesh to the figures. Finally, although the immediate reception of *Leonidas* still merits a more thorough examination, the political uses of Jean-Nicolas Laugier's print, which managed to reconcile liberalism and philhellenism in 1825–26, have been well exposed.[20]

Three years after completing the painting, David produced a fascinating paraphrase of *Leonidas* in the cropped format characteristic of his late drawings (SEE CAT. 33).

NOTES

1. David refers to *Leonidas* as "un pendant à mes *Sabines*" in a letter to Nicolay Yusupov, 31 May 1814 (Wildenstein 1973, p. 195, no. 1689; cited by Johnson 1993a, p. 169).
2. For references, see the essay "In the Service of Napoleon" in this volume, nn. 143–44.
3. Bordes 1986.
4. For the polemical response to the lack of unity of action in the picture in 1814 and 1819, see Mantion 1993, pp. 818–19. David's disjunctive conception in *Leonidas* is often interpreted as the sign of a crisis in classicism; this reading of the shift in classical paradigm from an Italian mode to an imaginary Greek mode is faulted however by the assumption that Italo-French academic doctrine was clearly perceived as the norm.
5. Prat and Rosenberg 2002, vol. 2, p. 1113, no. 1779r. An annotation to a sketch for the departing convoy suggests that he readily associated antique vases and the scene he was illustrating ("les mulets peuvent porter toutes sortes de vases"; vol. 2, p. 1115, no. 1784v). In the picture, the last figure of the convoy conspicuously carries a vase on his head; another is on the altar to Hercules. Lenoir mentions David's study of *vases étrusques,* but prior to 1800 (1835, p. 11).
6. "David est de retour avec une nouvelle composition de son tableau [*Leonidas*] qui, dit-on, vaut mieux que celle que nous connaissons." Letter from Adolphe Lullin to Étienne-Jean Delécluze, dated 1 Vendémiaire Year IX (23 Sept. 1800), cited by Delécluze, 1855 [1983], p. 103; and, with regard to the chronology of

David's preparatory drawings, by Schnapper in Paris-Versailles 1989–90, p. 490.

7. "C'est dans l'exécution que l'on retrouve tout son talent; mais la composition en paraît vicieuse" [Chaussard] 1806, p. 164; referenced by Schnapper in Paris-Versailles 1989–90, p. 493.
8. For a documented chronology of the stages in the elaboration of the picture, and a lucid attempt to distinguish between the early and late work, see Schnapper in Paris-Versailles 1989–90, pp. 490–94.
9. As Schnapper has noted, the fact that Chaussard, in his 1806 commentary on the unfinished canvas (p. 164), focused on a blind warrior "remarquable par l'enthousiasme et presque par l'exagération de ses mouvements," a figure not in the two early compositional drawings but present in this one, has incited some historians to ascribe it to the first phase (Paris-Versailles 1989–90, p. 494).
10. Letter from Brussels dated 23 Mar. 1824 ("la seconde composition de mon Léonidas aux Thermopyles, on y voit les changements que de nouvelles réflexions m'ont suggéré"), cited by Agius-d'Yvoire in Paris-Versailles 1989–90, p. 631; and Prat and Rosenberg 2002, vol. 1, p. 299.
11. "Au bon et véritable amateur des arts, Monsieur Sommariva, David" (David 1880, p. 662); cited by A. Sérullaz in Paris-Versailles 1989–90, p. 506, and Sérullaz 1991, p. 174.
12. Régis Michel, in a vivacious reading of *Leonidas,* sees in this ocular manifestation the sign of a loss of control of the situation and a symptom of the hero's vulnerability: "Aussi lève-t-il, dans le tableau, les yeux vers le ciel (mais non dans le dessin [the one in New York], où il se borne à voir *loin,* privilège du chef et signature du génie): c'est Laocoon à Lacédémone. Et cet échange oculaire avec le surmoi vigile d'un Olympe illusoire est le symptôme obvie de sa vulnérabilité" (Paris 2000, p. 123). A neglected comment by Alexander Lenoir, jotted down in Oct. 1817 on his copy of Stendhal's *Histoire de la peinture en Italie* published that year, merits to be cited; it refers to a note flattering David ("Chose singulière dans l'école française, la tête de Leonidas a une expression sublime!") in a chapter entitled "Des salons et des forums": "Pourquoi donc, Monsieur, vous étonner de la belle tête de Léonidas de M. David? Elle a été admirée de tout Paris. Serait-ce parce que M. David ne passe pas sa vie au *forum* et au Palais-Royal? [*insert:* Il préférait l'*opera buffa;* chacun a son goût.] Je l'ai vu faire cette tête à la fois sublime et admirable. [*insert:* Dans laquelle on lit le sort qui menace les Lacédémoiens.] J'ai vu que le grand peintre des Sabines et des Spartiates l'a entièrement tirée de son cerveau parisien; il l'a peinte devant moi, et cela sans modèle. [*insert:* Il avait les mains levés vers le ciel et sa main agissait sans efforts. Savez-vous pourquoi, Monsieur, cette tête est parfaite?] C'est que M. David a beaucoup étudié l'antique et la nature dans sa jeunesse, qu'il est pénétré du beau idéal de l'un et des

belles formes que lui présentait l'autre; il a fait de tout cela un mariage savant dont il est résulté des chefs-d'oeuvre. Voilà, Monsieur, le secret de M. David. C'est un génie qui ne sera pas remplacé de nos jours" (Lenoir's annotations are in Stendhal 1996, pp. 560–618; citation, p. 600). For more on Leonidas' expression and a reading that places the accent on melodrama, see the introductory essay to the next section.

13. The first two quotes are by Rosenberg and Prat (2002, vol. 1, p. 298 ["alourdi et comme figé," "quelque peu pétrifiés dans un étrange empâtement"]; the next two by Johnson (1993a, pp. 166, 168). The final quote is by Sérullaz (1991, p. 175 ["une tendance à la vulgarité pour le moins déconcertante"]).

14. Johnson 1993a, pp. 168–69. The visual metaphor of the "ape-man" is an anachronism, but the cultural squeeze to which it is subjected is interesting; although nothing indicates that David had any knowledge or perception of the debates evoked, such speculation on the cultural context for David's art is stimulating.

15. On David's admiration for "energy" in painting, see the introductory essay to this section. Johnson likewise posits a "quasi-independent, experimental register" for the 1813 drawing, but buttresses her argument on an oil sketch, also in the Louvre, which she judges to be by David on the basis of an inscription claiming (falsely) that it featured in the artist's 1826 estate sale (1993a, p. 168; sketch repr. p. 167, fig. 91). Only Nash has supported this attribution (1973, p. 237 n. 392); for the list of all those who have considered it a weak copy of the Louvre drawing (also my opinion), see Prat and Rosenberg 2002, vol. 1, p. 298.

16. Sérullaz 1991; Prat and Rosenberg 2002.

17. Bothmer 1964; Kemp 1969.

18. Michel invokes symbolic emasculation and Freudian *Spaltung* or splitting (Paris 2000, pp. 121–23), and Padiyar, on the "*enchaining* of male bodies," discusses the libidinal investment in fraternity and the post-revolutionary fracturing of that ideal (2000). What might be called the politics of style in *Leonidas* is best addressed by Potts (1994, pp. 223–38), and more generally, the fraternal ideal played out in David's studio is a central theme developed by Crow (1995).

19. See the essay "In the Service of Napoleon," n. 104.

20. On the early reception of *Leonidas,* see the suggestive excerpts and remarks by Mantion 1993, pp. 818–22. On the political use of the print, see Athanassoglou-Kallmyer 1989, pp. 55–65.

Oil on canvas
7 ft. 4⅝ in. x 8 ft. 7¼ in.
(225 x 262 cm)
Signed and dated, lower left: *L. David.
1809*

The State Hermitage Museum,
St. Petersburg (inv. 5668)

PROVENANCE

Nicolay Borisovich Yusupov (1750–1831)
and thence by descent, Archangelskoe
estate near Moscow; confiscated by the
Russian revolutionary government in
1918 and deposited in a Moscow
museum; 1925, transferred to the
Hermitage.

EXHIBITIONS

Paris, 1974–75, pp. 371–72, no. 36
(catalogued but not exhibited); Paris-
Versailles 1989–90, pp. 440–41, no. 185.

BIBLIOGRAPHY

Notice 1824, p. 44; Th. 1826a, pp. 152–53,
236; Mahul 1826, pp. 136–37; Coupin
1827, p. 55; Lecointe de Laveau 1828–29,
vol. 1, no. 3, pp. 281–82; Schnitzler 1834,
p. 60; Lecointe de Laveau 1835, vol. 2, p.
278; Lenoir 1835, p. 5; Blanc 1845, p. 210;
Miette de Villars 1850, p. 156; Viardot
1855, p. 315; Seigneur 1863–64, p. 364;
Gautier, Houssaye, and de Saint-Victor
1864, pp. 547–48; David 1867, p. 36;
Dussieux 1876, p. 581; David 1880, pp.
390, 579, 646; Saunier [1903], p. 84;
Rosenthal [1904], p. 170; Prakhov 1907,
pp. 24–25; Ernst 1924, pp. 162, 268–69;
Réau 1929, p. 23, no. 59; Friedlaender
1952, pp. 31–32; Cantinelli 1930, pp. 93,
112, no. 119; Humbert 1936, pp. 145–46,
173; Holma 1940, pp. 96, 128, no. 126;
Sterling 1957, pp. 68–69; Haskell 1972a,
pp. 21–22; Honour 1972, p. 316; Ver-
braeken 1973, p. 189 n. 273; Wildenstein
1973, pp. 182 (no. 1563), 189 (no. 1632),
209 (no. 1810), 227 (no. 1938); Adams
1977–78; Gaehtgens 1978–79, p. 67;
Beresina 1983, pp. 109–11, no. 121; Janson
1983, p. 21; A. Schnapper in Ixelles
1985–86, pp. 28, 34; Bordes 1988, p. 94;
Michel and Sahut 1988, p. 116; A.
Schnapper and E. Agius-d'Yvoire in
Paris-Versailles 1989–90, pp. 440–42,
519, 528, 612, 614, 618, 620; Fried 1993,
pp. 218–19; Johnson 1993a, pp. 244–46;
Laveissière 1993, p. 905; Lebensztejn
1993, pp. 1014, 1017; Schnapper 1993,
p. 920; Johnson 1997, pp. 4–5, 38–39;
Krasnobaïeva and Kiruchina 1999, p. 68;
Savinskaïa 1999, pp. 77–78; Moscow and
Saint Petersburg 2001, vol. 1, pp. 167–69
(no. 69), 299 (no. 400), vol. 2, p. 86; S.
Siegfried in Ottawa 2003–4, p. 350.

DAVID PAINTED *Sappho, Phaon, and Cupid*
for Nicolay Yusupov upon completion of the
Coronation and as he was starting on the *Distribu-
tion of the Eagles*. First mention of a commission
from the Russian prince dates from July 1808,
while the detailed compositional study for the
Eagles today in the Louvre was finished in Decem-
ber. The complementary nature of the two proj-
ects, one a celebration of military zeal, the other
an antique love scene, put the painter in a frame
of mind recalling the mid-1780s, confident years
when he had produced both the *Oath of the Hor-
atii* and *Paris and Helen*. That he had furnished
a replica of the latter picture to a Russian patron
makes the parallel all the more pregnant. Mani-
festly, he continued to categorize his paintings in
function of the binary distinction he made in 1793
between "son genre naturel, [le] style tragique et
historique" and "le genre agréable" (see the essay
"Antiquity Revisited" in this volume).

Yusupov, the sole heir of an immense fortune,
nurtured an all-embracing taste for the arts during
a Grand Tour of Europe he undertook from 1774
to 1777. His first stay in Paris (1776–77), was fol-
lowed by another in 1782, when he accompanied
the grand duke (later czar as Paul I) and his wife
on a visit of European courts. On this last occa-
sion, he bought and commissioned paintings from
Jean-Baptiste Greuze, Joseph Vernet, and Hubert
Robert. From 1784 to 1789, while he occupied a
diplomatic post in Turin, he pursued his acquisi-
tions, especially from painters active in Rome
(Pompeo Batoni, Heinrich Füger, Angelika Kauff-
mann, Anton von Maron). It was through Hubert
Robert in Paris that he attempted in 1787 to com-
mission works from two much talked-about his-
tory painters, François-André Vincent and David,
only to be told that both were too overburdened
with engagements to comply.[1]

After his return to Saint Petersburg in 1789 he
directed the imperial theaters and manufactures of

porcelain, glass, and tapestries. He married in 1793, but was separated from his wife soon after the birth of an only son the following year.[2] He commissioned a replica of *Cupid and Psyche* from Canova and increasingly bought Italian, French, and Dutch Old Master paintings. By the time he retired from public office in 1802, after the assassination of Paul I, whom he had served, he had also developed a taste for two other contemporary French artists, the genre painters Louis-Léopold Boilly and Jean-Louis Demarne. At some point after 1806 he once again traveled west; although his itinerary is not known in detail, it appears certain that he was in Paris during a good part of 1808 and the first half of 1810, in other words during the period following the Treaty of Tilsit (July 1807), when Napoleon sought peaceful relations with Russia. The public success of David's *Coronation,* exhibited in February and March 1808, probably made him more eager than ever to obtain a work from him for the gallery of his St. Petersburg palace, by then already described in guidebooks as a remarkable ensemble.

Writing to David on 9 July 1808, he offered twelve thousand francs for a painting of Sappho and Phaon, presumably with life-size figures, in other words half what the king of Spain had given six years earlier for *Bonaparte Crossing the Alps.* It was nonetheless a good sum, twice what he paid around this time for large pictures by Antoine-Jean Gros, Pierre-Narcisse Guérin, and Angélique Mongez. On 15 July 1808, David wrote to Yusupov on behalf of Mongez, accepting his terms for the sale of *Theseus and Pirithous Rescuing Two Women from Bandits* she had exhibited at the Salon of 1806. On this occasion, he reiterated his opinion, reflecting difficulties met in the course of his career, that taste and support for the arts in France were not as strong as abroad.[3] A few months later, on 22 September, he wrote again to submit his composition: "My Prince. I have just drawn on canvas the subject of the sensitive Sappho and her lover Phaon, whose heart Cupid ("l'amour") has finally succeeded to set aflame: you promised to come by my studio to see it, so that you could leave the country with a fixed idea of the picture you've commissioned from me. If I have delayed granting you this pleasure for so long, this is because I was waiting for the right moment of inspiration, and I think I've found it. It is up to

you, my prince, to make a decision. As a friend, do me the favor to send me the day and hour you will have chosen to come to my studio. So that I might not forget, I'll take instructions to be followed for your affairs in writing."[4] The painter shows himself full of respect for a patron, to whom, in spite of what he wrote, he submitted his composition relatively quickly. He chose to be judged not on the basis of a drawing or a sketch, but by the *ébauche* of his canvas, a procedure that confirms the dichotomy increasingly established between his pictorial and graphic practices (see the essay "Late Drawings: Experiments in Expression"). Rarely taken as openly as here, the dramatic posture of the inspired artist is perhaps the sign of a discomfort with a situation strongly reminiscent of the relation of artists to aristocratic patrons during the Ancien Régime. A few precautions help to make it more tolerable, however: he imagines himself dealing with a man of taste and a friend. Reference to artistic inspiration also allows David to offset the business considerations which conclude his letter.

In his letter, David pretends to have treated the self-awakening of Phaon to love of Sappho. This inverses the relation between Paris who woos a reluctant Helen: here the celebrated Greek poetess of the isle of Lesbos develops a passion for someone who, with the aid of Venus, had been transformed into "le plus beau des hommes."[5] Reaching back to Ovid's *Heroides,* the legendary tale of her spectacular leap into death after Phaon had forsaken her, inspired a number of literary works and glosses. By the end of the eighteenth century, for the Abbé Barthélémy in the *Voyage du Jeune Anacharsis,* and in Étienne-François Lantier's more popular *Voyage d'Antenor,* she was the incarnation of impassioned feeling and extreme sensibility: David qualifies her as *sensible* in his letter to Yusupov. The sublimely radical nature of her suicide was appealing in the age of Werther. At the Salon of 1791 Jean-Joseph Taillasson exhibited a large painting showing her ready to throw herself over the cliff at Leucadia, "still saving her last breath and gaze for Phaon," and ten years later, Gros presented a cabinet picture offering a nocturnal version that a critic qualified as "romantique." David backed off from this direction, preferring the more pleasant tone of his master Joseph-Marie Vien, who in 1787 had exhibited

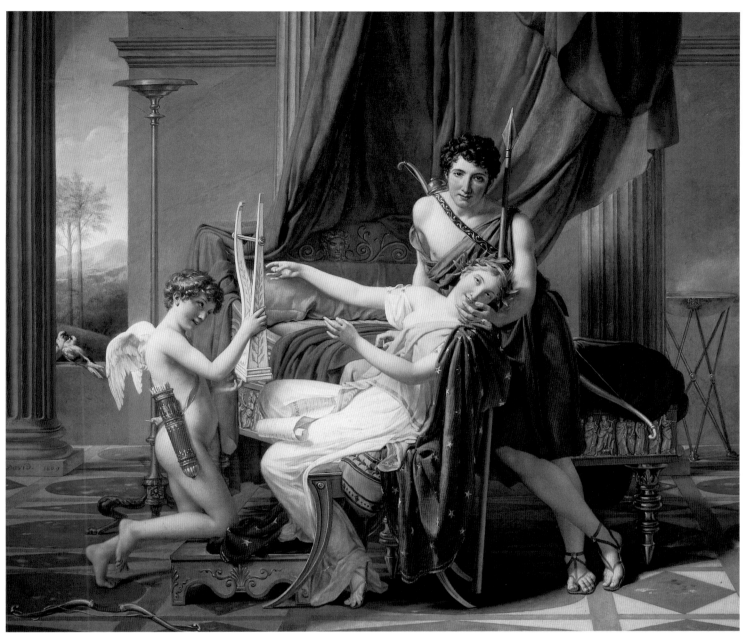

Sappho Singing Her Verses while Playing the Lyre, painted for Madame du Barry.[6] Although at the time it was probably judged old-fashioned by David and the painters of his generation, such a classicizing conception had been sanctioned by Raphael (*Parnassus*) and grand ceiling decorations at Versailles (Michel II Corneille in the Salon des Nobles). By 1808, when he received Yusupov's commission, the painter of the *Horatii* and *Brutus* had become more open-minded toward a tainted iconography that he had long chosen to avoid. That year one of his pupils, Jacques-Louis-Michel Grandin, exhibited *Sappho with Two of Her Companions* at the Salon (lost but engraved), an idyll honoring the capacity of women to cultivate the arts, but with the ominous promontory of Leucadia in the background.

As his letter to Yusupov indicates, David gave much thought to the exact subject he might treat. Whether the theme of Sappho and Phaon resulted from a discussion or was dictated by his patron, it was left up to him to elaborate a visual *concetto,* in other words, to choose a moment in the story that might hold the greatest interest as a narrative and composition. As in his evocation of the family conflicts of the Horatii and Junius Brutus, he invented a subject by projecting the legendary figures into situations that seemed emotionally real. Perhaps because her dramatic end cast such a dark shadow over Sappho's life, unlike Grandin he sought to eliminate all allusion to her misfortunes, retaining the moment of most perfect happiness, when miraculously Phaon finally responds to the love songs she had chanted over and over. As for the figure of Cupid, David's letter does not make clear whether the boyish god was present at this early stage, since "l'amour" might simply be a metaphor.

Exactly six months later, in March 1809, a note by David to Yusupov indicates that he produced a revised composition, on which he wanted an opinion: "I had brought along the finished composition for the painting of Sappho and Phaon to show you; I had taken it with me in my cabriolet. If you have business in the neighborhood of the Sorbonne, you will see it in my studio, where I am transferring it to canvas. I shall wait for your reaction before getting on with the picture."[7] As noted by Schnapper, either the artist had met with criticism or had simply been too busy to devote time to the project.

It was not only on account of the Russian patron that David's task illustrating the loves of Sappho and Phaon was overdetermined by the image of Paris and Helen he had painted about twenty years earlier. Formal affinities among the drawings for the two compositions suggest that the composition for Yusupov evolved quite directly from the earlier one. While in the earlier painting Helen stands on the left, resting on Paris who sits on the right, the two lovers invert roles in some of the preparatory drawings: he stands, while she sits. Another variation shows Paris seated to the left, much like Sappho, and Helen standing on the right. In two of the preparatory sketches for *Sappho and Phaon,* the lovers with arms entwined are a variation on these studies for the first pair.[8] Characteristic of David's working method, such reference to artistic solutions elaborated for a previous composition is not an occasion for repetition, but for revision. The painting he had conceived in the 1780s pretended to be an exacting reconstitution of a Greek interior, a precious fantasy of luxurious decoration, furniture, and sculpture, with a strong erotic charge. Although his *Alexander, Apelles, and Campaspe* (SEE CAT. 31) proves that he continued to be receptive to the visual seduction of this mode during the Empire, he could not fail to realize that it brought his work dangerously close to genre painting. For his Russian patron he chose to invent a more sober but also less confined vision of antiquity, in which ample space and scale ensure proper historical dignity.

A newly discovered letter from Angélique Mongez to Ignace-Marie Degotti, the "décorateur en chef de l'Opéra" who had contracted with David to paint the scenography of his coronation suite, proves that he also helped with "the perspective of the picture of Sappho." While Degotti was terminating this work for David—the letter is undated—Mongez was trying to get him to help out on her current painting, and enticed him with the following postscript: "M^r David is very happy with all that you've done."[9] The reliance on Degotti's skills presumably allowed David to introduce in the final composition a majestic colonnade and drapery, as well as an obliquely foreshortened bed, whose potent recessional effect, however, is prudently dampened by the figures placed in front of it. The aerial perspective of the schematic landscape to the left may also be

one of the decorator's tricks. That Angélique Mongez was close to David during the execution of *Sappho and Phaon* raises the question of her eventual collaboration on the picture. It is indeed striking how close the features and the treatment of the hair of Phaon are to the figure of Theseus in her painting of 1806 bought by Yusupov. Of course, one might surmise that she received David's help on her picture and that stylistic influence flowed rather in the other direction. *Orpheus in Hades,* the very large painting she exhibited in 1808, lost but engraved, offers a further analogy: the figure of Cupid next to Orpheus not only shares the same adolescent canon as the one in David's painting, but holds an identical lyre. No less suggestive of a creative proximity between the two artists is the presence of her drawing for the figure of Persephone, pasted in one of David's sketchbooks in her possession.[10]

The antiquarian spirit of the painted interior—by Degotti and David—is rather ponderous, bereft of the refinements found in the décor for *Paris and Helen.* The sobriety of ornamentation, with the gilt highlights of the furniture boldly brushed in, is an early sign of the aversion for the refined style that Percier and Fontaine had made fashionable, which David manifested in his decorative designs for the emperor (see the essay "In the Service of Napoleon" in this volume). The starkly elegant perfume burner on the far right, in the back, is an implicit critique of the luxurious *athéniennes* and tripods that the bronze-makers André-Antone Ravrio and Jean-Baptiste-Claude Odiot were producing at the time. Sappho's profiled chair (*klismos*) and the stellar motif, employed by David in subsequent paintings, attest to a scrupulous imitation of prints after Greek vases.[11] The frieze at the foot of the bed—which appears to represent Apollo and the Muses, an allusion to the status of the poetess as the Tenth Muse—derives from sarcophagus and votive reliefs.

The finished drawing or painted sketch David wanted to present to Yusupov in March 1809 is not preserved, thus it is impossible to know how the composition evolved in its final stage.[12] This would shed light on the exact subject of the painting, which remains somewhat uncertain. It does not appear to be the awakening of Phaon to the love of Sappho, as David intended before his revision. Schnapper has described the scene as the surprise arrival of Phaon, which makes Sappho

drop her lyre, happily caught by Cupid who begins a love song. The theatrical nature of the situation is no doubt correct, but this visual reading is contradicted by the lover's cross-legged pose, which traditionally denotes repose, and by Cupid's poised fingers, which delicately maintain the lyre in place for Sappho to play. Her own fingers are positioned to play the instrument, even though she has fallen backward into her lover's arms. The scroll on her lap bearing the name of Phaon, a suggestive sexual substitute, might mean that she willingly exchanges the sublimated pleasure of music-making with the childish Cupid for physical abandon to the spear-loving beau. David certainly could not ignore Yusupov's taste for Greuze: in 1790 the Russian aristocrat had bought from him a picture of *La Volupté.*[13] The dispossessed expression on Sappho's face, her wet, glassy eyes, like her exposed breast and erect nipple, are metaphors for the state of her heated body. Seen in this way, the picture becomes a meditation on the respective and often mutually exclusive joys of art and life. The theme is conventional enough, but as always David aims for the representation to innovate. That the two lovers appear to ignore each other and gaze in direction of the spectator, which is so disturbing by academic standards of compositional narrative, requires an explanation. The painter had shown Paris attempting to penetrate Helen's downcast eyes, and later, in his last picture, he would represent Venus warming up a coolly reserved god of war (SEE FIG. 64); in his three other pictures of amorous couples, this *Sappho and Phaon, Cupid and Psyche* (SEE CAT. 32), and *The Farewell of Telemachus and Eucharis* (SEE CAT. 35), none of the figures make eye contact. David shows Venus's doves physically making love here and in *Mars and Venus,* but he is capable only of imagining relations of resistance or incompatibility for the coupled figures. In most instances his love scenes are imperfectly happy, but this one concludes in tragedy and death. It is usual to condemn as false the theatrical pose struck for the viewer, the impression that the figures have stepped out of their narrative. A more positive explanation might be that David resorted to this stratagem to preserve a sense of classical decorum and restraint. It was essential for him to radically dissociate his art from a pictorial tradition and iconography of amorous rapture, whose immorality he anathematized. One also wonders whether

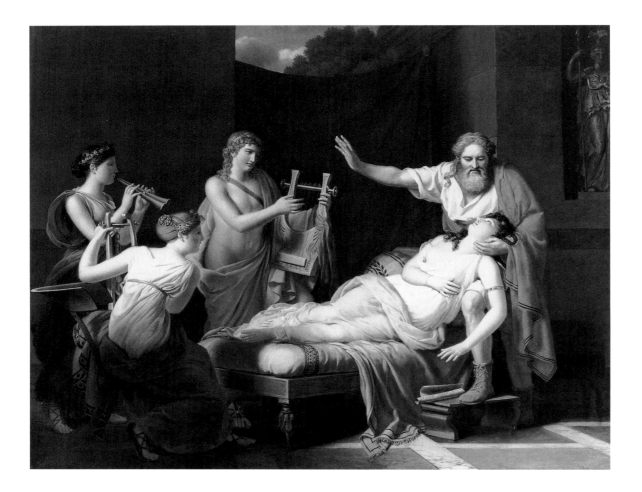

he was catering here to his patron's taste for the theater. Worth noting is the heightened intensity of the local colors in the painting corresponding to the broader palette employed in the *Eagles* around this time. David would tone down his coloristic impulse soon after in *Leonidas,* to allow the picture to stand alongside the *Sabines,* but he would once again give it free rein in Brussels.[14]

Word quickly went around the studios that David had painted a scene from the life of Sappho. Artistic imagination at the time was spellbound by the *genre anecdotique,* so a number of incidents were invented to enrich the meager biography of the Greek poetess. Louis Ducis, one of David's pupils, exhibited in 1812 a *Sappho* in deep melancholy over Phaon's infidelity, but recalled to life by the charm of music (FIG. 71). Two years later Martin Drolling sent a picture of Sappho and Phaon in the seclusion of a shady grotto, away from the heat of midday, a moment of happiness imagined by the author of the *Voyage d'Antenor.*[15]

Respecting the reserve shown by David, he represented Sappho playing her lyre, while Phaon, more stunned than affectionate, refrains from laying a hand on her. Confronted by such a singular interpretation of their love affair, and given the Winckelmannian hold on imagining the antique during the period and Sappho's reputed attraction to other women, one cannot help wondering whether Drolling and, less overtly, David did not weave Phaon's insensitivity to the physical charm of women into their compositions. If this was the case, David's picture takes on a further meaning as a celebration of the magical power of art, since Phaon falls in love with Sappho's songs and not the woman, who was "deprived of the gift of beauty," as Landon reminded his readers in his commentary to Drolling's picture.

David wrote to Yusupov during the First Restoration, on 31 May 1814, to ask for a drawing of his composition of which he claimed he had no trace. Anxious about his fate under the Bourbon

FIGURE 71 Louis Ducis (French, 1775–1847), *Sappho Recalled to Life by the Charm of Music,* 1812. Oil on canvas, 45¾ x 57¾ in. (116.2 x 146.7 cm). The Norton Simon Foundation, Pasadena, California. Gift of Mr. Norton Simon

regime, he was especially wanting to find support should he have to flee the country.[16] A last contact was made in 1820, when he gave a friendly letter for his former patron to his pupil, the portraitist Jean-Henri Riesener, who was in Brussels for a visit and going back to Russia where he had settled a few years earlier.[17]

NOTES

1. Savinskaïa 1999, pp. 72–75.
2. See his wife's portrait by Vigée Le Brun (1797, private collection) in Fort Worth 1982, pp. 110–12, no. 44. For his own portrait around 1794 (anonymous), see Valence 1999, pp. 90–91.
3. David's letter is cited by Agius-d'Yvoire in Paris-Versailles 1989–90, p. 612 ("elle [Mongez] a été si flattée qu'un étranger était plus juste envers elle que sa patrie même"). On the painting, today at Arkhangelskoye, see Denton 1998, pp. 237–38.
4. "Mon Prince. Je viens de tracer sur la toile le sujet de la sensible Sapho et de son amant Phaon que l'amour vient enfin d'enflammer: vous m'avez promis de le venir voir à mon atelier, pour repartir de ce pays avec l'idée formée du tableau dont vous m'avez chargé. Si j'ai tant tardé à vous en faire jouir, c'est que j'attendais le moment heureux de l'inspiration, je crois l'avoir trouvé. C'est à vous, mon prince à qui il convient d'en décider. Faites-moi l'amitié de m'envoyer dire le jour et l'heure que vous aurez fixé[s] pour vous rendre à mon atelier. Je prendrai par écrit, afin de m'en souvenir, l'instruction que je dois suivre pour les affaires qui vous concernent." Letter cited by Agius-d'Yvoire in Paris-Versailles 1989–90, p. 612.
5. Chompré 1778, p. 329.
6. On Taillasson and the iconography of Sappho, see J.-P. Mouilleseaux in Bordeaux 1989, pp. 302–3, no. 110. On Gros's *Sappho*, see J. Lacambre in Paris 1974–75, pp. 462–63, no. 87; and Bordes 2000a. On Vien's lost painting, see Gaehtgens and Lugand 1988, pp. 205–6, no. 265; it can be made out in P. A. Martini's engraving of the Salon of 1787, to the right of the doorway, next to two other pictures by Vien.
7. "Je vous apportais à voir la composition terminée du tableau de Sapho et Phaon; je l'avais apporté dans mon cabriolet. Si vos affaires vous portent dans le quartier de la Sorbonne, vous la verrez à mon atelier, où je la reporte. J'attends l'effet qu'elle vous fera pour m'occuper ensuite du tableau." Letter cited by Agius-d'Yvoire in Paris-Versailles 1989–90, p. 614: here dated 20 Mar. 1809, but 21 Mar. in Moscow and Saint Petersburg 2001, vol. 1, p. 299.
8. Prat and Rosenberg, in their comments on the preparatory drawings for the composition, make the connection with the earlier painting (2002, vol. 1, p. 250).
9. "Monsieur. Vous avez eu la complaisance jeudi dernier de me promettre que vous passeriez à mon atelier lundi avant d'aller chez Monsieur David, pour terminer la perspective du tableau de Sapho. Je crains que vos grandes occupations ne vous aient fait oublier si peu de chose. J'ose le rappeler à votre souvenir et vous prie de dire à mon domestique l'heure et le jour qui vous conviendront. Recevez l'assurance de ma parfaite estime. f^me Mongez. M^r David est très content de tout ce que vous avez fait." Paris, Bibliothèque de l'Institut national d'Histoire de l'Art, autographes, carton 104 (collection Éric Bertin). The latter kindly brought to my attention this document.
10. Prat and Rosenberg 2002, vol. 2, p. 1154, no. 1880. A line engraving of Mongez's painting of *Orpheus* is in Landon 1808, vol. 1, pl. 50–51 (between pp. 56 and 57). P. Rosenberg and B. Perronet (2003, p. 52 n. 32), in a note listing corrections to the catalogue raisonné, reattributed to Mongez no. 120 (vol. 1, p. 132) and 1878 (II, p. 1154), studies for the *Death of Adonis*, exhibited in 1810 (engraved in Landon 1810, pl. 53, between pp. 70 and 71).
11. See the section on "L'athénienne" by J.-L. Martinez and A. Dion-Tenebaum in Paris 2000–2001, pp. 336–53. For drawings in one of David's sketchbooks, after prints of vases from the second Hamilton collection, published by Johann Heinrich Wilhelm Tischbein in Naples from 1791 to 1795, which include the characteristic chair and stellar drapery, see Prat and Rosenberg 2002, vol. 2, pp. 1143–46, nos. 1843–56. The two authors are "certain" they are not by David, while Sérullaz attributes them to Angélique Mongez; the question needs to be considered more generally with respect to David's study of prints after Greek vases.
12. A letter from David to Yusupov, dated 1 Oct. 1811, acknowledges the patron's satisfaction with the painting and commends him for being someone "qui sait entrer dans les contrariétés qu'on essuie en cherchant à bien faire"(Wildenstein 1973, p. 189, no. 1632). This suggests that the painter had unspecified problems arriving at his final composition.
13. Réau 1922, pp. 397–98.
14. Schnapper in Paris-Versailles 1989–90, p. 441.
15. Landon 1814, p. 17, and pl. 7. Drolling's painting was sold in Paris, Hôtel Drouot, 11 June 2001, no. 81.
16. See the letter in Wildenstein 1973, p. 195, no. 1689; and the exegesis by Adams 1977–78, pp. 31–33.
17. Wildenstein 1973, p. 220, no. 1882.

Black crayon, pen, black ink and wash,
and white gouache on beige paper
8¾ x 11½ in. (22.1 x 29.1 cm)
Signed and dated, in pen and brown ink,
lower right: *L. David. f. 1812*

Musée du Louvre, Paris. Département
des Arts graphiques (inv. RF 1919)

Exhibited in Williamstown only

PROVENANCE

1826, in David's possession at his death;
David estate sale, Paris, 17–19 Apr. 1826,
no. 28; bought at the sale by David's
son, Eugène David (1784–1830); his son,
Louis-Jules David[-Chassagnolle] (1829–
1886); bequeathed by him to the Musée
du Louvre, with a usufructuary restric-
tion in favor of his wife, née Léonie-
Marie de Neufforge (1837–1893); 1893,
received by the museum (marked twice
[L. 1886a] lower left).

EXHIBITIONS

Paris 1948, p. 122, no. 123; London 1948,
p. 36, no. 41; Toulouse 1955, no. 68; Mon-
tauban 1967, p. 124–25, no. 208; Paris
2000, p. 267, no. 49.

BIBLIOGRAPHY

Coupin 1827, p. 58; Cantaloube 1860,
p. 302; David 1880, pp. 484, 662; David
1882, fascicle 4 (engraving); Guiffrey and
Marcel 1909, p. 75, no. 3190; Sérullaz 1939,
n.p., no. 11; Hautecoeur 1954, p. 226;
Sérullaz in Paris 1972, p. 26; Nash 1973,
pp. 155, 236 n. 387; Wildenstein 1973, pp.
238 (no. 2042, [73]), 244 (no. 2062 [28]),
250 (no. 2085); Howard 1975, p. 105 n. 54;
Nash 1978, p. 105 n. 14; Schnapper 1980,
p. 260; R. Michel in Rome 1981–82, pp.
126, 129 n. 5; J.-P. Mouilleseaux in Delé-
cluze 1855 [1983], p. 317 n. 10; A. Schnap-
per in Ixelles 1985–86, p. 34; Roberts 1989,
pp. 173, 234 n. 72; A. Schnapper and A.
Sérullaz in Paris-Versailles 1989–90, pp.
374, 483, 509; Sérullaz 1991, pp. 49, 116,
172–73 (no. 216); Gonzalez-Palacios 1993,
p. 934; R. Michel in Paris 2000, pp. 109,
118–19; Prat and Rosenberg 2002, vol. 1,
pp. 251, 288 (no. 305), 289, 649.

IN SEPTEMBER 1812, in a moment when he
felt that his prerogatives as first painter to
Napoleon were being ignored, David wrote to the
intendant of the emperor's household to claim
responsibility for composing and supervising the
execution of all the decorative projects in the
imperial palaces. He was especially focused on the
program of "peintures historiques" for the ceilings
and walls of the Louvre, and proposed to furnish
a suite of drawings and sketches. Nothing came
of this in the short run: David was told that Denon
was in charge of choosing artists to decorate the
palaces. However, in August 1813, a number of
painters, including David, were asked to propose
projects for the Louvre. The disastrous military
situation and depressed political climate probably
dissuaded most from taking this offer very seri-
ously. This drawing and *Venus Wounded by
Diomedes* (SEE CAT. 29), both dated 1812, have usu-
ally been associated to David's proposition that
year to decorate the Louvre, and it is very possible
that he might have submitted these compositions
along with others had the government responded
favorably. He may have even worked with the
Louvre in mind when elaborating the second
composition, since he appears to revise a ceiling
painting installed in the palace by Prud'hon, whose
exceptional favor with Marie-Louise, the new
empress, designated him as a major rival. It is
also possible though, that he intended these for
the Grand Cabinet of the Tuileries, since he was
actively participating in the complete refurbishing
of this room in 1812, hung with tapestries after
Vien and Vincent. (For all these points, and rele-
vant references, see the essay "In the Service of
Napoleon.")

This composition can also be considered a proj-
ect for a painting. The subject had been popular
with painters during the eighteenth century, as it
offered both the classical dignity and epic dimen-
sion of the Homeric source, and the more con-
temporary resonances of a sentimental family
situation, including an afflicted wife and a child
frightened by his father's helmet. David had been
interested in the theme during the mid-1780s.

He planned a frieze-like composition, for which
drawings exist, and integrated a vignette of this
scene to the decoration of Hector's deathbed in
the *Grief of Andromache* (1783).[1] At the time, if he
refrained from pursuing Homeric iconography,
except for the cabinet-size picture of *Paris and
Helen,* it was probably to not appear to rival his
master Vien, who was regularly represented at the
Salon with a scene from the Iliad on a monumen-
tal scale. In 1787, notably, he exhibited the *Depar-
ture of Hector,* preferring the title *Les Adieux
d'Hector et d'Andromaque.* Critical response to his
pictures was increasingly lukewarm and for many
he had become by that time the "maître de M.
David." The latter's relation to his master was
complex but clear: he respectfully avoided his
terrain, but had absolutely no doubt that his own
influence on the French School was the more
decisive. This confident superiority may explain
the absence of conflict in their relation, a relatively
infrequent attitude given David's competitive
nature. During the Consulate and early Empire,
when he vied with Vincent and Regnault in
making a claim for Vien's symbolic heritage, he
was careful to not minimize the impetus their
common master had given to the regeneration of
French painting. However with Vien's death in
1809, David felt freed of the burden of filial respect
and the iconography of the Trojan War once
again seemed an open domain.

As he was accustomed, he sought a new
approach to the theme. Most novel with respect to
the usual iconography is the spatial and narrative
distance that separates the Trojan couple, although
this alignment of the sexes was a central leitmotif
of his art. Reminiscent of the group of women
assembled around the wife of the Roman consul
in the first preparatory drawings for *Brutus,* the
left part of the composition shows a dejected
figure of Andromache surrounded by five women.
On the extreme left of this gynaeceum a somber
cloaked figure lost in thought, the most melan-

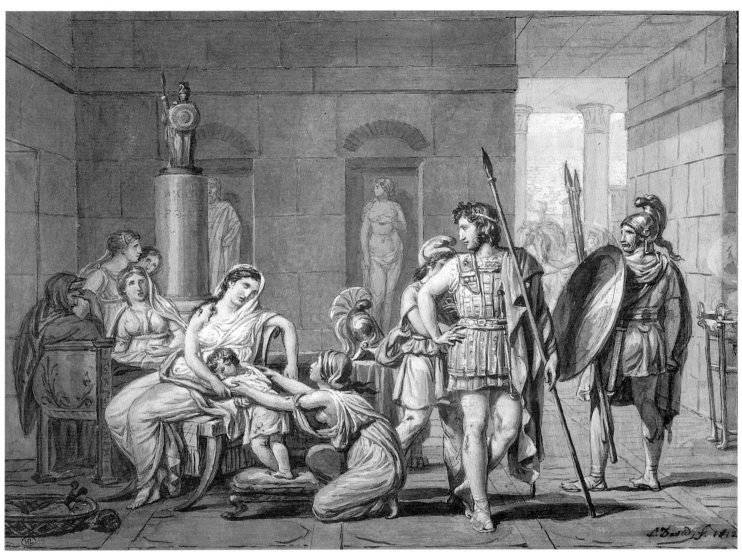

CATALOGUE 28

cholic of the group, seems to ominously presage the oncoming tragedy. A direct citation from the earlier painting, the wool basket *(kalathos)* in the foreground emblematizes the domestic area. David's attention to his early work also inspired the background: the nude female figure in the niche is drawn after a sketch made in Rome.[2] The right side of the scene is the male domain: Hector finishes dressing for his combat with Achilles, helped by a young Phrygian whose face is hidden from view, preceded on his way out the door by a rugged soldier, while in the bright sunlight under the porch, the horses are kept in check by an attendant. The only action depicted involves Astyanax, who seeks refuge in his mother's lap, while a servant with arms extended looks up interrogatively at Andromache: has she brought the child to comfort her or does she want to relieve her of him? In the same way that preparatory drawings reveal how *Sappho, Phaon, and Cupid* was predicated on *Paris and Helen,* this composition appears to derive from the painting for Yusupov: Phaon is metamorphosed into Hector and Sappho into Andromache.[3] However, no surviving sketches chronicle the visual and physical separation imposed on the Trojan couple, which suggests that the dramatic nature of the subject led David to establish a filiation not with the Sapphic love scene, but with *Brutus.*

The representation has nonetheless been interpreted by Régis Michel as an "anti-*Brutus*" and implicitly as an anti-*Horatii:* Hector "goes to war like a bourgeois goes to work." He claims both a de-dramatization of the scene, and a "devirilization" of the hero: "David treats the scene like a vaudeville, a phenomenon whose vogue dates from about this time. Hector is a *dandy,* who strikes a pose, with the fake detachment of a real bourgeois, legs crossed, hand on the waist, a Phrygian servant busy behind his back lacing up his armor. He looks like a *woman* at her toilette, whose chambermaid might be adjusting her corsage, in the rococo spirit of genre scenes that celebrate the feminine ideal: in other words, the boudoir *without* philosophy."[4] Michel condemns Hector as the antithesis of the ideal male nude prescribed by Winckelmann, but also as the negation of the concept of historical representation forged by David in the 1780s. The problem with

this argument is that there is no reason why one point of reference should have priority over another. With remarkable literary verve, the author charts an important evolution in David's practice, which he implicitly explains by the crisis in classicism, detailed in his earlier study, *Le Beau idéal.*[5] This reading of the *Departure of Hector—* fundamentally modernist and anachronistic in the sense that it criticizes the artist for being out of date and out of touch—of course fails to evaluate the composition on its own terms. The depreciative bias in this penetrating text is indeed so strong that it involuntarily provokes admiration for David's capacity to undermine norms and expectations.[6]

NOTES

1. In the collection of Musée du Louvre, Paris; on deposit from the École nationale supérieure des Beaux-Arts. R. Michel posited the reference to the earlier composition in Rome 1981–82, p. 123.
2. This is noted by Sérullaz 1991, p. 117; for the drawing which served as the model, see Prat and Rosenberg 2002, vol. 1, p. 649, no. 969.
3. Note the progression between the two drawings for *Sappho and Phaon* detached from a sketchbook with studies for *Leonidas,* in Prat and Rosenberg 2002, vol. 1, pp. 250 (no. 253v), 251 (no. 254r).
4. Paris 2000, p. 118: "David traite la scène en vaudeville, dont l'essor est du reste à peu près contemporain. Hector est un *dandy,* qui prend la pose, avec la fausse désinvolture d'un vrai bourgeois, les jambes croisées, la main sur la hanche, un laquais phrygien (voir le bonnet) s'affairant dans son dos à sangler son armure. On dirait une *femme* à sa toilette, dont la ca#mériste ajusterait le corsage, dans le goût rococo des scènes de genre où triomphe l'éternel féminin: soit le boudoir *sans* la philosophie." See also p. 119.
5. Michel 1989.
6. Michel's bias (and neo-Winckelmannian fantasy) is that, for example, of a late nineteenth century interpretation of the *Departure of Hector* by David's pupil Chistoffer Wilhelm Eckersberg, a small painting executed in Rome c. 1813–16 (see fig. 65), as resumed by Lene Bøgh Rønbergh: "Emil Hannover thus argued [in 1898] that there is more "flesh than spirit" in Eckersberg's historical figures, who are too heavy, clumsy, and worldly for us to imagine them in an ideal, elevated ancient past" (Washington 2003–4, p. 78). For a positive interpretation of the coarse draftsmanship, the ungainly canon of proportions, and the absence of gestural liaison, all characteristic of his late manner, see the essay "Late Drawings: Experiments in Expression."

Black crayon, pen, black ink and wash, and white gouache on beige paper 9³⁄₈ x 7¹⁄₈ in. (23.9 x 18.2 cm) Signed and dated, in pen and black ink, lower center (on the pedestal): *L. David. 1812*

Musée du Louvre, Paris. Département des Arts graphiques (inv. RF 1918)

Exhibited in Los Angeles only

PROVENANCE
1826, in David's possession at his death; David estate sale, Paris, 17–19 Apr. 1826, no. 29; bought at the sale by David's son, Eugène David (1784–1830); his son, Louis-Jules David[-Chassagnolle] (1829–1886); bequeathed by him to the Musée du Louvre, with a usufructuary restriction in favor of his wife, née Léonie-Marie de Neufforge (1837–1893); 1893, received by the museum (marked [L. 1886a] lower right).

EXHIBITIONS
Paris 1884, no. 147; Paris 1972, pp. 25–26, no. 58; Paris-Versailles 1989–90, p. 482, no. 221.

BIBLIOGRAPHY
Coupin 1827, p. 58; Cantaloube 1860, p. 302; David 1880, pp. 484, 662; David 1882, fascicle 10 (engraving); Guiffrey and Marcel 1909, pp. 72, 74–75, no. 3189; Hautecoeur 1954, p. 226; Hofmann 1958, p. 160 n. 3; Nash 1973, pp. 155, 173, 236 n. 387, 242 n. 441; Wildenstein 1973, pp. 238 (no. 2042 [74]), 244 (no. 2062 [29]), 250 (no. 2085); Howard 1975, p. 105 n. 54; Adams 1977–78, p. 35 n. 25; Nash 1978, p. 105 n. 14; Schnapper 1980, p. 260; J.-P. Mouilleseaux in Delécluze 1855 [1983], p. 317 n. 10; A. Scottez [De Wambrechies] in Lille 1983, p. 113; A. Schnapper in Ixelles 1985–86, p. 34; Roberts 1989, pp. 173, 234 n. 72; A. Schnapper in Paris-Versailles 1989–90, p. 374; Sérullaz 1991, pp. 49, 171–72 (no. 215), 312; Spencer-Longhurst 1992, p. 158; Laveissière 1993, p. 905; Prat and Rosenberg 2002, vol. 1, pp. 234, 289 (no. 306), 290–91, 307, vol. 2, pp. 1135, 1281.

AMONG THE many incidents of the Trojan War that make up Homer's *Iliad,* the direct intervention in the mêlée of Venus, the goddess of love, is one of the most piquant. Seeing that her beloved son Aeneas was about to be struck down by Diomedes with Minerva's support, she descended from Olympus to protect him. Diomedes pursued her with his imprecations and managed to inflict a wound to her wrist. Apollo cared for Aeneas while Iris, who personifies the rainbow, the link between the heavens and earth, rescued Venus with the aid of Mars, who furnished the transportation to Olympus. The story may sound like a vaudeville, but in fact it offered painters a pretext for visual drama (the combat), pathos (a swooning Venus), and animation (the impatient horses and the flurry of clouds). This corresponds to the version of the subject by Vien (Museum of Art, Columbus, Ohio), executed in 1775 in response to the call for Greek subjects around mid-century.[1] David himself had suspended a vignette of this incident in mid-air, in the center of a vast Homeric composition in imitation of Le Brun, drawn in Rome in 1776: Diomedes is shown assaulting Venus, but blinded by the enveloping clouds, while Iris and Apollo rush in from above to save the struck goddess and her inanimate son (FIG. 72). As late as 1795 Antoine-François Callet, who painted in an un-self-consciously retardataire style, exhibited a similarly neo-Baroque interpretation of the theme at the Salon (Musée du Louvre, Paris).

David's return to the subject in 1812 meant a significant shift in iconography. The scene is set on Olympus before the throne of Jupiter. Venus presents herself in the role of victim, exposing her wound. Here David does not follow Homer's narrative, which indicates that Dione healed her daughter just prior to the exchange with Jupiter. Whereas the presence of Cupid is not specified,

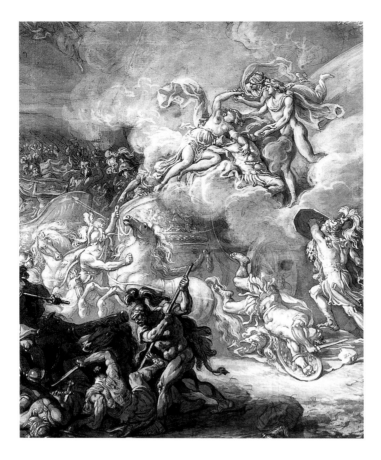

that of Juno and Minerva corresponds to the text, which relates how the latter mocks Venus, suggesting that she wounded herself on the brooch of some woman whose resistance she had tried to break with her caresses. David shows her two rivals more seriously pointing out of the scene in the same direction, presumably toward the battlefield. Jupiter appears to look at Venus, and certainly points his finger at her, while Cupid tries to grab his cheeks, perhaps to prevent him from speaking harshly to his mother. The words that Homer puts in Jupiter's mouth are affectionately reproachful: he found it extravagant that she should be involved in warfare when her domain was love and matrimony, and counseled her to leave the fighting to Mars and Minerva. The composition with the three goddesses becomes a replay of the Judgment of Paris, with the three distinct incarnations of femininity once again in competition. The vulnerability of the goddess of love and the triumph of the two others who represent more orthodox values, expressed through Juno's haughty attitude and expansive pose, reflect exactly the social mood of the Napoleonic court after the emperor's remarriage—both an *embourgeoisement* and an aristocratic revival. There is no

doubt, however, that the draftsman's sympathy goes to the bruised goddess.

This composition should be understood in terms of a competition with two contemporary painters. The first is Prud'hon, who was the preferred artist at court once Marie-Louise became empress (see the essay "In the Service of Napoleon"). When David visited the extraordinary collection of antique sculpture on the ground floor of the Musée Napoléon, he saw in the Salle de Diane one of the most elaborate contemporary interior decoration, which had been executed under the supervision of Percier and Fontaine following a program of commissions launched in 1801. At an unspecified date, perhaps as late as 1809, the vaulted ceiling was redesigned around a canvas by Prud'hon, *Diana Beseeching Jupiter to Not Submit Her to the Laws of Hymen* (FIG. 73).[2] This vault decoration was a nagging reminder to the first painter that he had never accomplished such work, on which the great names of the Italian School and Le Brun's team at Versailles founded their prestige. Although no doubt impressed by the clarity and controlled dynamics of Prud'hon's composition, a powerful confrontation between two figures silhouetted against the sky, David probably judged

FIGURE 72 Jacques-Louis David, *The Battles of Diomedes* (detail), 1776. Pen and black ink on black pencil, gray wash, and white highlighting on paper. Graphische Sammlung Albertina, Vienna

that the picture's spatial illusionism and perspective needed correcting. It is not known whether his own composition of *Venus Wounded by Diomedes* was destined to decorate a ceiling, but surely this prospect would not have incited him to modify it. The scene is composed as a frontal view: one looks down on the base to Jupiter's seat. The vaporous, sun-soaked clouds dear to Prud'hon have been replaced by solid masses on which the figures can rest or stand.

The other painter with whom David entertained a critical dialogue in this project was his former pupil Ingres, at the time studying at the French Academy in Rome, who had just sent to Paris for inspection by the members of the Institute his monumental *Jupiter and Thetis* dated 1811 (FIG. 74). Ingres, who had collaborated with his master long before, at the time he painted the portrait of Juliette Récamier, was embittered toward

him because on several occasions he had failed to show his support.[3] Although David could hardly approve the degree of stylization and finish in his pupil's work, he was no doubt impressed by their visual force. As for Prud'hon's ceiling composition, he aimed to humanize the vision of Ingres, whose severe monumentality is rejected, and whose figures are made to come to life. Cupid takes up the role of Thetis appeasing Jupiter, but this intercession is given a distinctly sentimental note.

This exercise in Olympian mythography is important as a major step toward what would be David's last history painting, finished twelve years later, *Mars and Venus*, in which he would retain the element of superhuman grandeur found in Ingres (SEE FIG. 64). In both the drawing from 1812 and this last painting, clouds also bear the narrative action and architectural elements: here simply the base to Jupiter's throne. Along the lower edge

FIGURE 73 Pierre-Paul Prud'hon (French, 1758–1823), *Diana Beseeching Jupiter to Not Submit Her to the Laws of Hymen*, 1803. Painted on ceiling, 8 ft. x 9 ft. 7¾ in. (244 x 294 cm). Musée du Louvre, Paris

of the sheet is a view into the distance: on the left is the sea with the Greek fleet and in the center is a city, presumably Troy, and a large tree in the midst of hilly territory. Such a diminutive landscape or cityscape was present in certain seventeenth-century religious scenes he had copied while in Italy, as the setting of a saint rising to heaven or an assembly of honorees in a town. The connection with a Christian tradition may explain why in 1824 David would abandon this perspective effect.

NOTES

1. On this picture see Colin Bailey in Paris 1991–92, pp. 400–403, no. 62. The Salon *livrets* give Roman names to the gods of the Homeric epics.
2. On this commission see Laveissière in Paris 1997–98, pp. 154–55. The exact date of installation of the painting, paid for in 1803, remains uncertain. A print of the room with spoils from Germany shows the presentation that opened to the public in Oct. 1807: the

cropped view of the vault does not permit one to determine if the decoration comprised Prud'hon's painting or if that was installed later, along with the sculpted reliefs commissioned in 1799–1800, during the renovation undertaken around 1809 (G. Bresc-Bautier in Paris 1999–2000, p. 156, no. 155). A late date for its installation would make its impact on David's 1812 composition even more likely. Laveissière first noted the affinity between the two compositions (1993, p. 905).
3. See the letter from Ingres to Marcotte, dated 26 May 1814, evoking his absence of contact with David (Wildenstein 1973, p. 194, no. 1688). Ingres was especially angered that David had not supported him for the Prix de Rome in 1800 and when the critics heaped abuse on his submissions to the Salon in 1806.

FIGURE 74 Jean-Auguste-Dominique Ingres, *Jupiter and Thetis*, 1811. Oil on canvas, 10 ft. 8¾ in. x 8 ft. 6⅜ in. (327 x 260 cm). Musée Granet, Aix-en-Provence

30 Cupid and Psyche

1813

Black crayon, pen, black ink and wash,
and white gouache on paper, with pen
line in black ink on the outer edges
6⅝ x 8⅞ in. (16.8 x 22.6 cm)
Signed and dated, in pen and brown ink,
lower right: *L. David. 1813*

The Cleveland Museum of Art. Andrew
R. and Martha Holden Jennings Fund
(inv. 2002.91)

PROVENANCE

Given by David to Louis-Nicolas-
Philippe-Auguste Comte de Forbin
(1777–1841); . . . ; private collection,
Paris; sale Paris, Hôtel Drouot, 7 Nov.
1973 (author and date misidentified);
art market, Paris; 1975, Heim Gallery,
London; 1975, Gallery Arnoldi-Livie,
Munich; 1979, The Artemis Group
(David Carritt), London; successively,
Eugene V. Thaw, New York, Ed Hill, El
Paso, and Elizabeth Eddy, Ohio, accord-
ing to New York 1994; c. 1980, Richard
L. Feigen & Co., New York; Paul Weiss,
New York; 1994, Richard L. Feigen &
Co., New York; 2003, acquired by the
museum.

EXHIBITIONS

London 1975, no. 26; London 1979, no.
25; Zurich 1994, pp. 125–31, no. 28; New
York 1994, pp. 26–28, no. 319.

BIBLIOGRAPHY

David 1880, p. 663; M. Florisoone in
Paris 1948, p. 100; Hautecoeur 1954,
p. 268; A. Sérullaz in London 1972, p. 48;
Nash 1973, p. 238 n. 400; Schnapper
1980, p. 297; J.-P. Mouilleseaux in Delé-
cluze 1855 [1983], p. 495 n. 7; D. Coekel-
berghs and P. Loze in Ixelles 1985–86,
p. 440; A. Schnapper in Ixelles 1985–86,
p. 182; Johnson 1986, p. 467 n. 32;
A. Schnapper and A. Sérullaz in Paris-
Versailles 1989–90, pp. 506, 518; Sérullaz
1991, pp. 175, 311; Bordes 1994, p. 388;
Vidal 1999, pp. 221, 223; Prat and Rosen-
berg 2002, vol. 1, p. 301, no. 319.

SINCE ITS rediscovery in 1973 this sheet is one
of the most depreciated of David's drawings:
"frankly disagreeable," "raw," "unpalatable,"
"unpleasant," "repulsive," "resolutely monstrous,"
are some of the epithets serious art historians have
employed to characterize their reactions and
impressions, perhaps with a secret vocation to
judge beauty contests. Only lately has the critical
tide turned. The drawing has been acquired by a
major institution, and Prat and Rosenberg have
glossed favorably on the Caravaggesque sensuality
of the boy, the Greuzian charm of the girl, and
jovial mood of the situation, as Cupid surrepti-
tiously leaves the bed.[1] Jealous of Psyche's mortal
beauty, Venus ordered Cupid to have her wed a
monster; Zephyr carried Psyche to the home of
Cupid, who unexpectedly falls in love with her.
They unite but he requires that she ignore his
identity. Driven by her curiosity, she sneaks up on
the god in the middle of the night and awakens
him with a drop of oil from her burning lamp.
Abandoned by her lover, she was then submitted
by Venus to a series of trials, one of which left her
in deep sleep. Brought back to life by Cupid, who
took her to Olympus, in the end she was allowed
to marry him and join the gods. The principal
source for this legend is *The Metamorphoses, or
The Golden Ass* by the second-century Latin
author Apuleius. Because of the association be-
tween the figure of Psyche and the human soul,
the story has inspired a succession of allegorical
and symbolic readings and interpretations; its mix
of poetry, philosophy, and erudition rendered the
myth particularly attractive to classically minded
artists.

In antiquity the pair was figured as ideal
adolescent lovers kissing or embracing, a concep-
tion that survived down to Canova's two famous
groups installed in Joachim Murat's country house
near Paris in 1801–2: the first, with the figures
recumbent, illustrates the rapturous moment
when Cupid brings Psyche back to life with a kiss
(FIG. 75) and the second, with the figures standing,
develops a more classically restrained vision of
amatory affection (FIG. 76). Bonaparte was enthusi-
astic over the latter when he saw it in 1802 and
Josephine reserved the replica Canova was execut-
ing. Often, however, when artists represented
Cupid and Psyche, they emphasized instead the
difficulty of their union. Psyche spying on Cupid
asleep was the incident most frequently treated in
the eighteenth century.[2] In the wake of the presen-
tation from 1796, in Lenoir's Musée des Monu-
ments français, of the series of stained glass panels
from Écouen illustrating the legend of Psyche,
two paintings at the Salon in 1798 had created a
new interest for the story, associated with the dec-
orative preoccupations of earlier generations. In
a cabinet-size picture, Jean-Jacques Lagrenée had
represented *Psyche in Cupid's Enchanted Palace*
(private collection).[3] With precious detail he
showed Psyche pampered by nymphs and divini-
ties, but melancholic on account of her solitude.
In spite of visual reference to the grand tradition
of Raphael and Poussin, the scene has a Hogar-
thian tonality by its implicit satire of the pleasures
of consumption to which the Directory elites were
committed. The other painting exhibited that
year was François Gérard's much-acclaimed *Cupid
and Psyche* (FIG. 77), conceived somewhat like a
sculptural group, and representing the winged
god kissing the young girl who cannot see him.
Through this subtle allusion to her incapacity to
set eyes on her lover, Gérard proposed a narrative
of the innocent maid experiencing her first and as
yet undefined sensations of love and desire. Like
Canova's first group, Gérard's composition associ-
ated the play of enveloping arms with the theme,
an influential motif that David would also appro-
priate, to emblematize the amorous entanglement
of the pair. Subsequently, at the Salon of 1808, the
newly arrived version of Canova's standing *Cupid
and Psyche* for Josephine, engraved in Landon's
Annales du Musée,[4] and a painting by Pierre-Paul
Prud'hon gave further impetus to the vogue for

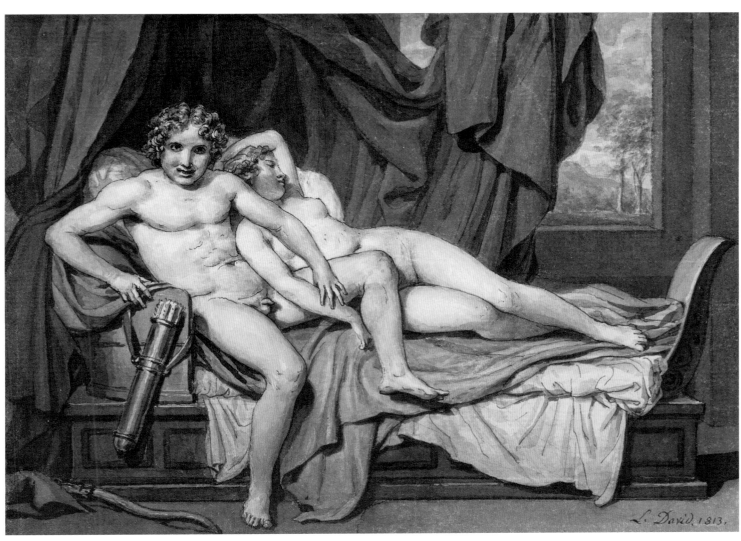

the legend. The latter's *Psyche Transported by the Zephyrs* was probably the most provocative nude on exhibit since Girodet's *Sleep of Endymion* in 1793. Prud'hon, who restored to the Psyche myth an overtly sexual dimension that Gérard had so successfully vacated, was a nostalgic artist and a visionary. By conjoining the values of the past and future, the celebration of pleasure and emotion, he brushed aside the arid goal of so many of his contemporaries, who seemed to want to standardize beauty.

David was naturally attentive to such developments. In April 1813 one of his pupils wrote home that the master was planning to treat *Psyché et l'Amour*.[5] With his customary sense of independence he approached the traditional narrative with fresh eyes. The preparatory drawings confirm that he was focused on the depiction of a reclining nude. He was stimulated by the competition at stake with the great names of the Roman and Venetian schools and, as noted, with several of his contemporaries. He may even have heard of the

Sleeping Woman Ingres had painted for Caroline Murat around 1808. It was especially a personal challenge for him to confront a motif he had long associated with moral depravity and social degradation. There was a direct precedent for the bed scene among the stained glass panels in the Musée des Monuments français; like its engraved source, it offered a side view of the nude sleeping Venus with an infant Cupid over her. In front of the bed hung with drapery, Cupid's bow and quiver lay in abandon. Jean-Baptiste Regnault, inspired by this motif, had transformed the narrative into an intensely erotic boudoir scene (FIG. 78).[6] David's sketches for his own version never illustrate this tender moment of post-coital repose. He shows Cupid getting into bed, or else he is getting away before Psyche awakens. In one instance Cupid is sitting on a chair next to the bed, with one leg caught by his sleeping lover. This would be the pose adopted by David in the painting, but only after having shifted the boy from the chair to the bed. He gave an armchair-like form to the head of

FIGURE 75 Antonio Canova (Italian, 1757–1822), *Cupid Kissing Psyche*, 1787–93. Marble, 61 x 66⅛ x 39¼ in. (155 x 168 x 101 cm). Musée du Louvre, Paris

FIGURE 76 Antonio Canova, *Cupid and Psyche*, 1797. Marble, height 57¼ in. (145 cm). Musée du Louvre, Paris

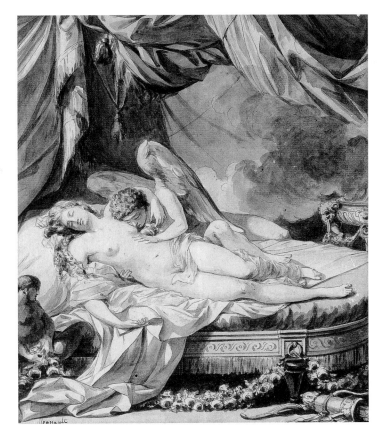

the bed in the Cleveland sheet, so as to main-
tain the suggestion that Cupid makes an effort
to rise.

The spatial articulation in David's drawing
is highly simplified, austere in mood, and sub-
tly archaic in spirit. Only the transparent land-
scape visible through the window provides
relief from the stony hardness of the interior.
The absence of decorative embellishment is so
resolute that one suspects a programmatic
decision to reject the refinement usually intro-
duced to illustrate the story of Psyche. The
mischievous nature of Cupid is well character-
ized as he tries to carry out at least three
actions simultaneously: to slip out from under
Psyche's warm body as quietly as possible, lift
himself off the bed, and grab his quiver. To
judge David's personification with regard to
the Winckelmannian canon of adolescent
beauty, so perfectly expressed by Canova, is
profoundly misleading. Deeming inadequate
such introverted representations of the mythi-

cal figure, he aims rather to reinvigorate an earlier
typology of Cupid, such as those invented by
Carle Vanloo around the middle of the eighteenth
century, and their capacity to hit their mark.[7]

It is generally thought that this was the
drawing of the subject David gave to his former
pupil Auguste de Forbin, who during the Restora-
tion succeeded Vivant Denon as director of the
Paris museum. David appreciated his decisive help
between 1817 and 1820 in the delicate negotiation
concerning the sale of the *Sabines* and *Leonidas*
to the royal administration. He recognized that
the success of the operation was due in large part
to Forbin's tenacity, so he may have offered him
the drawing as a token of thanks.[8] Furthermore,
he probably kept the drawing until then, since he
worked on a painted version of the subject until
1817 (SEE CAT. 32).

NOTES

1. Prat and Rosenberg enumerate the derogatory comments provoked by the drawing (2002, vol. 1, p. 301).

2. See Colin Bailey in Paris 1991–92, p. 440 n. 14. For a list of the notable representations of the myth of Psyche, see Vidal 1999, pp. 216–17; for a list of works on this theme exhibited at the Paris Salon between 1791 and 1819, see Hanna Böck in Zurich 1994, pp. 172–75.

3. See A. Schnapper in Paris 1975, p. 514, no. 114. For a well-illustrated discussion of "the sexual stakes involved in defining the cultural meaning of the [Psyche] myth for Directoire society," see Lajer-Burcharth 1999, pp. 276–85 (quote: p. 280). See also Vidal 1999, and, especially for Gérard, Johnson 1990.

4. Landon presumed the exhibited version to be Murat's (Landon 1808, vol. 1, p. 47 n. 1); however, that Canova's *Hebe,* belonging to Josephine and just arrived from Italy with her replica of *Cupid and Psyche,* was on show suggests that she sent both of her statues to the Salon.

5. Mesplé 1969, p. 102; this reference was noted by Schnapper in Paris-Versailles 1989–90, p. 518.

6. Regnault's signed drawing of *Cupid and Psyche Asleep* was sold in Paris, Christie's, 21 Mar. 2002, no. 297. Judging from the style of the furnishings, it appears to date from 1785–95, although Regnault reworked the composition in a large canvas dated 1828 (The Art Institute of Chicago), manifestly a response to David's painting in Sommariva's collection (see cat. 32).

7. For Carle Vanloo's figures of Cupid, some of which were engraved, see M.-C. Sahut in Nice 1977, pp. 58 (no. 93), 84 (no. 175), 98 (no. 240).

8. Angrand 1972, pp. 110–38; Chaudonneret 1999, p. 39.

31 Alexander, Apelles, and Campaspe

c. 1813–23

Oil on panel

11 x 15⅜ in. (96.3 x 136.2 cm)

Musée des Beaux-Arts, Lille (inv. P444)

PROVENANCE

1826, in David's possession at his death; David sale, Paris, 17–19 Apr. 1826, no. 3 (unsold); David sale, Paris, 11 Mar. 1835, no. 3; acquired at the sale by the artist's son-in-law, Claude-Marie Meunier (1770–1846) and his wife, Laure-Émilie-Félicité David (1786–1863); their son, Jules Meunier (1813–1867); his wife Pauline Derode, Baronne Meunier (1824–1903); 1874, acquired from her by her husband's first cousin, Louis-Jules David[-Chassagnolle] (1829–1886); 1885, bequeathed by him to the museum.

EXHIBITIONS

Paris 1913, p. 23, no. 51; Paris 1948, p. 95, no. 66; Berlin 1964, no. 10; Montauban 1967, p. 125, no. 209; Paris 1974–75, pp. 372–73, no. 37; Calais 1975–76, pp. 53–54, no. 20.

BIBLIOGRAPHY

Th. 1826a, pp. 149, 165; Th. 1826b, pp. 215–16, 238; Coupin 1827, p. 57; Miette de Villars 1850, p. 210; Blanc 1845, p. 213; Delécluze 1855 [1983], pp. 354, 368 n. 1; Seigneur 1863–64, p. 366; David 1880, pp. 569, 648; Saunier [1903], p. 111; Rosenthal [1904], p. 167; Rosenthal 1913, p. 341; Cantinelli 1930, p. 113, no. 130; Holma 1940, pp. 8, 87, 129; Hautecoeur 1954, p. 226–27; Brookner 1958, p. 71; Verbraeken 1973, pp. 22, 29–30, 104; Wildenstein 1973, pp. 243 (no. 2052 [96]), 244 (no. 2062 [3]), 249 (no. 2077 [17]), 250 (no. 2087 [3]); Schnapper 1980, pp. 271, 282–83, 300; Shillony 1982; A.-M. Lecoq in Dijon 1982–83, pp. 50, 56; D. Coekelberghs and P. Loze in Ixelles 1985–86, p. 445 n. 10; A. Schnapper in Ixelles 1985–86, p. 28; Roberts 1989, pp. 211–15; A. Schnapper in Paris-Versailles 1989–90, pp. 13, 392, 517–18, 636, 637; Sérullaz 1991, pp. 327, 333; Spencer-Longhurst 1992; Coekelberghs and Loze 1993, p. 1052; Gonzalez-Palacios 1993, pp. 940–41; Johnson 1993a, pp. 241–42; Sheriff 1996, p. 136; Johnson 1997, pp. 70–71; Lajer-Burcharth 1999, pp. 292–96; Crow 2001, p. 17; Prat and Rosenberg 2002, vol. 1, pp. 246, 302–3, 515, 526, 563, 645, 712, vol. 2, pp. 1049, 1218, 1219, 1222, 1224; Bordes 2004a, pp. 123–25.

IN 1813 David produced an elaborately detailed drawing of the famous tale of Alexander the Great generously conceding his attractive mistress Campaspe to his cherished painter Apelles, who had fallen in love with her (FIG. 79). This recently rediscovered sheet, measuring eleven by fifteen and three-eighths inches (28 x 39 cm), is among the artist's most ambitious graphic works.[1] Executed with the stylistic mannerisms found in four other finished drawings from 1812 (SEE CATS. 28 AND 29) and 1813 (SEE CATS. 26 AND 30), it partakes of a moment when David's imagination was directed more intensely than ever before toward Greek myth, history, and culture (see the essay "Antiquity Revisited" in this volume). That he should have devoted himself to the illustration of the life of the most famous painter of ancient Greece at just that time also reveals his introspective state of mind as he became increasingly estranged from the imperial court.

Although for monarchs this theme of the deferment of the mighty ruler to the talented painter was a lesson in self-control, ever since its formulation by Pliny the Elder this episode had been glossed repeatedly by Renaissance humanists and artists; artists often invoked it to enhance their professional status, especially in court contexts. In the eighteenth century, for decorative suites of tapestries and overdoors on the theme of the different arts, the scene was often chosen to allegorize painting. Its erotic content was also a factor in its appeal to painters and sculptors.[2] Writing in 1820 to Gros after offering him the drawing, David claimed that his wife had initially suggested he treat the subject, which is not unlikely, for she was always quick to flatter her husband's ego.[3] In any event, it is clear that there was a motive of self-projection and self-glorification behind the project.

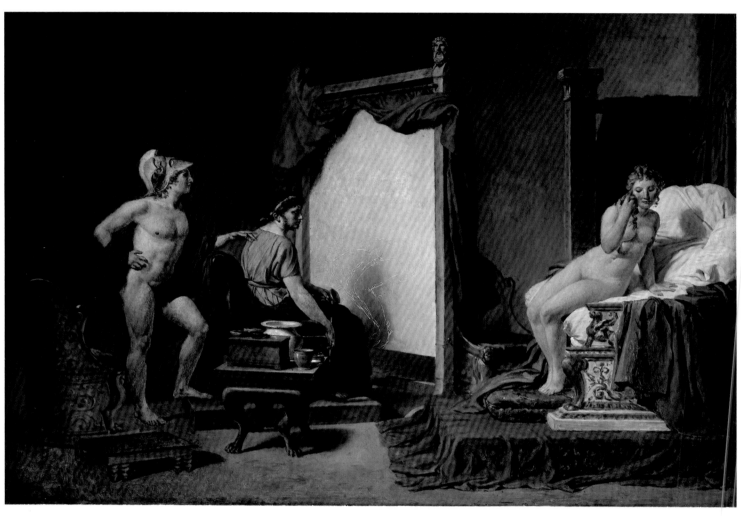

The painter's admirers frequently addressed him as the new Apelles and Napoleon was naturally cast as the new Alexander.[4] Ever since the Egyptian campaign this historical parallel was a commonplace. The meaning of a gift from the Spanish ambassador, José Nicolás de Azara, to the first consul in 1803, of a herm bust of Alexander—then considered the only authentic portrait of the conqueror—was transparent to all in the art world. In 1806 the antiquarian Aubin-Louis Millin, in a commentary of a cameo of Alexander in the collection of the empress Josephine, also offered by Azara, noted that the memory of the *grands hommes* was dear to all with a passion for glory, indicating that "Napoleon the Great likes to contemplate the images of the Macedonian hero"; in fact, he argued at length that the Frenchman was morally superior to his predecessor.[5]

The scene drawn by David in 1813 is certainly the most cluttered interior he ever produced. The stimulation to illustrate the life of Apelles in this genre mode may have come from the public success of similar scenes from the life of famous artists by his pupil Pierre-Nolasque Bergeret. In 1806 he had exhibited *The Honors Accorded to*

Raphael After His Death, a picture acquired by Josephine, and in 1808, *Charles V and Titian.* The *genre anecdotique,* as it was called, was officially encouraged as representative of a novel French synthesis between history and genre, the Italian and Northern schools. David went as far as he could in this direction with *Alexander, Apelles, and Campaspe,* without relinquishing his exclusive preoccupation for antiquity. He freely delved into his Roman albums to find models for the furniture, decorative details, and works of art represented. On the easel is not a panel of Campaspe nude, as indicated by Pliny, but a composition of Orestes and Iphigenia fleeing from Tauris, reproducing a sarcophagus relief he had drawn in Venice in 1780. This confirms that he was at this point less concerned by Pliny's narrative than by the general plot of the story.[6] Alexander's pointing gesture, which conventionally indicates an active intervention and creates a momentum of vision across the composition, directs attention to the figure of Campaspe, whose body manages to convey both a sense of modesty and of exhibitionism. To create this mannered nude, David clearly had images of Raphael's and Sodoma's Roxane in

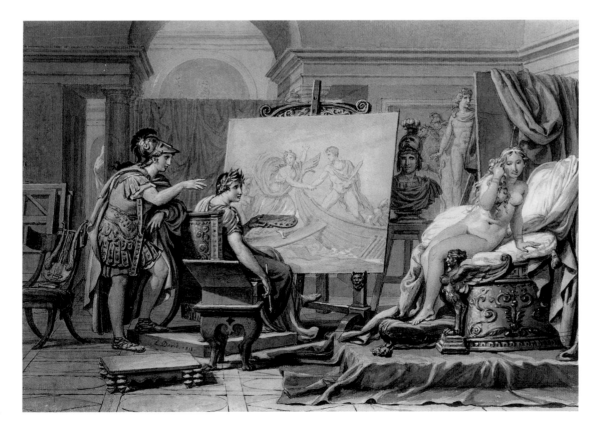

FIGURE 79 Jacques-Louis David, *Alexander, Apelles, and Campaspe,* 1813. Pen, ink, gray wash, gouache highlights, and black pencil on paper, 11⅛ x 15¼ in. (28.1 x 38.8 cm). Private collection

mind, but also Gérard's figures of Psyche and of Juliette Récamier, animated by the desire to rival his pupil, but also haunted by his confrontation with the aggressive Directory beauty. Although in David's drawing Apelles appears attentive, the gift he receives does not provoke the exteriorized reaction that was customary and expected. This singular restraint seems to imply a latent conflict between the artist's glory and his pleasure, especially since David imagines Apelles in the guise of history painter, and not the painter of a nude courtesan. Reinforcing this interpretation is the unusually wide distance separating the two would-be lovers, which will be even greater in the painted version. The descriptive mode adopted in the drawing is in itself a sign of creative anxiety, which relays the suffocating atmosphere of bourgeois

materialism imagined to characterize Apelles' studio. David's alter ego appears to be somewhat obsessed with the furnishings of his professional interior, an unlikely stage for a sexual encounter. The emblematic complex of motifs behind Campaspe—a bust of Alexander and the Apollo Belvedere—concisely resumes the choice he seems so hesitant to make.

The biographer who signed his work "A. Th." claimed in 1826 that David had begun painting the composition in 1813 and that he took it unfinished with him to Brussels. The panel, which on the back bears the printed Paris trade card of Malaine, whose business was appropriately called "A la Palette Flamande," was certainly acquired before his move.[7] The painter probably worked on it in Paris, since a number of details in the picture are

FIGURE 80 Jérôme-Martin Langlois (French, 1779–1838), *Portrait of Jacques-Louis David*, 1825. Oil on canvas, 34⅝ x 29⅜ in. (88 x 74.5 cm). Musée du Louvre, Paris

borrowed from the Roman albums he left behind.[8] There is no mention of *Alexander, Apelles, and Campaspe* in the enumeration of his works David jotted down in 1819.[9] The composition certainly preoccupied him the following year, when he offered the drawing executed seven years earlier to his faithful pupil Gros. Given the radical change in style between the drawing and the painting, this gesture may have signaled a desire to concentrate anew on the composition, without the possibility of referring to an initial state. After his death David's entourage designated the painting an *ébauche,* in other words, an unfinished work.[10] The handling is luscious and firm, vigorously but often thinly brushed in, much like the late manner of Greuze. By contrast however, the still life in the center is sharply delineated and tightly painted in, perhaps by an assistant. The colors are varied but relatively dull, although the discolored varnish may be the cause; a series of chromatic echoes across the composition successfully unify the image.

Absent from the Louvre retrospective exhibition in 1989, the painting has only recently been given serious consideration by art historians.[11] Much information was collected by Spencer-Longhurst in a focused study in 1992. The psychological narrative of the image, notably the bond between the two men who desire the same woman, has inspired some penetrating comments from Sheriff and Lajer-Burcharth.[12] No longer the fully armored warrior as in the drawing, Alexander in the painting wears only a helmet and a drapery over his shoulder that manages to cover his loins. He stands closer to Apelles, and gives the impression of touching his back. As shrewdly observed by Lajer-Burcharth, Alexander looks now like an nude intruder from *Leonidas,* bringing with him the homosocial imaginary of that visual narrative. Apelles has abandoned his palette and is notably more despondent than in the drawn version. Set between two objects of desire, torn between Pliny and Winckelmann, his catatonic state, according to Lajer-Burcharth, appears provoked by a contradictory emotion: he desires Campaspe as the object of Alexander's desire, in other words he also envies her.[13] The image on the panel Apelles has been painting gives weight to this interpretation of a forked desire. The arbitrary composition in the drawing has been duly replaced by a lightly draped figure of the courtesan, but she is not represented alone. Alexander, helmeted and dressed, is sitting with his arm around her, fondling her left breast, a mannered erotic motif found in mid-sixteenth-century prints of the School of Fontainebleau. That David imagined this checked desire of Apelles as fundamentally destructive becomes more explicit in his drawing of a twin sister for Campaspe in 1825, Lucretia being raped by Tarquin's son (SEE CAT. 38).

Finally, as several historians have remarked, when David's pupil Jérôme Langlois painted the portrait of his master in 1825 (FIG. 80), he showed him, no doubt with David's approval and perhaps at his suggestion, drawing a linear variation on the group of Alexander and Apelles. The allusions to David's absolute preeminence in his lifetime and to Napoleon's former first painter were surely intended: this is suggested by the visual proximity between the medal of the Legion of Honor pinned to his coat, given to him by the new Alexander, and the drawn the figure of the antique one. The parallel was politically exploited by Bonapartist artists during the Restoration. In 1819, the Bourbon administration prevented Marie-Nicolas Ponce-Camus, a pupil of David's, from exhibiting a painting of *Alexander Visiting the Studio of Apelles* because it was interpreted as an homage to Napoleon and his exiled master.[14] But on another level, the compositional fragment in Langlois's portrait presents itself as a self-sufficient image: Alexander, fully nude, has moved still closer to Apelles, and places a hand on his shoulder. The painter raises his bowl of color, as if liberated of his lassitude. In this final moment of his long life, when David was posing for posterity, Campaspe is on no one's mind.

NOTES

1. Prat and Rosenberg 2002, vol. 1, pp. 302–3, (no. 319bis). Nicolas Joly brought it to the attention of Prat and Rosenberg, who were the first to publish it (2002, vol. 1, pp. 302–3, no. 319bis).
2. See A.-M. Lecoq in Dijon 1982–83, pp. 53–56, with further bibliography.
3. "Ce dessin de Campaspe et Apelle que vous estimez tant est une idée de ma femme, je l'ai saisie." David to Gros, 22 June 1820 (Wildenstein 1973, p. 219, no. 1877).

4. Daru adressed him as the new Apelles in 1810 and developed the parallel between Alexandre-Apelles and Napoleon-David (see cat. 18), as Sommariva had done already in 1801, when commissioning a picture on behalf of the Cisalpine Republic (David 1880, p. 394). The *Description* of the *Coronation* released in 1808, relating Napoleon's official visit to the studio on 4 Jan. and his compliments to the painter, had exploited this parallel: "C'est par de tels moyens que le génie d'Alexandre enflammait le génie de Lysippe et celui d'Apelles; c'est ainsi que Charles V et Louis XIV honorait le Titien et Le Brun dans les ateliers mêmes de ces grands peintres, et que François I^er témoignait à Léonard de Vinci son estime et sa bienveillance" (Cabanis 1970, pp. 253–54; this text was first pubished in the *Moniteur Universel*, 16 Jan. 1808, no. 16, pp. 63–64). That Jean Broc's *School of Apelles* (Salon of 1800; Musée du Louvre, Paris), in which the artist is shown protesting against his calumniators, might have been conceived with his master David in mind is evoked by G. Levitine, albeit with prudence (1978, p. 116).

5. On the bust (Musée du Louvre, Paris) see D. Gallo in Paris 1999, pp. 196–97, no. 191. Millin's quote (1806a, vol. 2, p. 127): "Napoléon-le-Grand aime à contempler les images du héros macédonien"; his sycophantic defense of the superiority of Napoleon is cited by Gallo 2004, p. 326.

6. Prat and Rosenberg detail the borrowings from the sketches in his Roman albums (2002, vol. 1, p. 302).

7. The trade card is illustrated by Spencer-Longhurst 1992, p. 158, fig. 3.

8. See Gonzales-Palacios 1993, pp. 940–41; Prat and Rosenberg 2002, vol. 1, pp. 526, 563.

9. The list is published by A. Schnapper in Paris-Versailles 1989–90, pp. 20–21.

10. The picture was termed an *ébauche* in the 1826 and 1835 sale catalogues. An anonymous report on the latter sale (perhaps by the expert Thomas Henry) to Alphone de Cailleux, adjunct director of the Louvre, remarked negatively: "on ne voit qu'une ébauche peu propre à donner une idée du mérite de l'auteur" (Paris, Archives du Louvre, P30 [David, acquisitions]).

11. See the thoroughly negative evaluation by Roberts (1989, pp. 211–15): "a work that belongs more to the world of nineteenth-century kitsch than to the severe, heroic world of David's earlier history painting," "a parody of his earlier style" (p. 213). The presumption that "patriotic feeling" (p. 214) is a requisite of artistic greatness faults this position.

12. Sheriff 1996, p. 136; Lajer-Burcharth 1999, p. 292.

13. Lajer-Burcharth 1999, pp. 292–95. She considers that the painting illustrates "a certain phantasmic scenario at the core of David's artistic identity" (pp. 294–95).

14. Gabet 1831, p. 566; Ségu cites the relevant passage in the *Lettres à David sur le Salon de 1819* by Henri de Latouche, who imagines the jury's deliberation: "Alexandre et Apelle! . . . Ne voyez-vous pas que ce sont et le plus grand peintre et le plus grand capitaine de leur temps? Or, nous avons eu dans le nôtre un peintre sans égal, un capitaine sans rivaux, donc c'est à ces personnages qu'on veut nous faire penser au moment où ils sont tous les deux frappés de l'exil. Qui ne voit pas qu'Apelle, c'est David, qu'Alexandre, c'est Napoléon, et que cette scène retrace une fameuse visite à la Sorbonne? Cela est fort clair, fort séditieux; et le Louvre n'est pas fait pour de pareilles compositions" (1931, p. 50). See also Borowitz 1980a, p. 260 (fig. 3: a line engraving after the picture by Ponce-Camus).

32 Cupid and Psyche

1817

Oil on canvas
72½ x 95⅛ in. (184.2 x 241.6 cm)
Signed and dated, on right along
bedstead: *L. DAVID 1817 / BRUXELLES*

The Cleveland Museum of Art. Leonard
C. Hanna, Jr. Fund (inv. 1962.37)

PROVENANCE

Painted for Giovanni Battista Som-
mariva (1760–1826); his son Luigi Som-
mariva (died 1838); his wife, who put
on sale part of the collection her father-
in-law and husband had kept in Paris,
18–23 Feb. 1839, no. 1, acquired by
"Dubois";[1] . . . ; comte James-Alexandre
de Pourtalès-Gorgier (1776–1855), Paris
(his last wishes were that his collection
be dispersed ten years after his death);
Pourtalès-Gorgier sale, Paris, 27 Mar.
1865, no. 242, acquired by "Madame de
Furtado," probably Marguerite Heine-
Furtado (1847–1903), wife of Michel
Ney, duc d'Elchingen (1835–1881), who
still owned it in 1880; [possibly M.
Eisenschitz, according to a label on the
back, or perhaps bequeathed to their
daughter]; by 1913, Joachim Napoleon,
Prince Murat (1856–1932) and his wife,
Cécile Ney d'Elchingen, Princesse Murat
(1867–1960), daughter of Marguerite
Heine-Furtado and Michel Ney; her
sale, Paris, Palais Galliera, 2 Mar. 1961,
no. 140; Rosenberg & Stiebel, New York;
1962, acquired by the museum.

EXHIBITIONS

Brussels, Museum, Aug.–Sept. 1817,
for the benefit of the Hospices Sainte
Gertrude and of the Ursulines;[2] Paris
1913, p. 25, no. 60; Paris 1936, pp. 147–48,
no. 218; Paris 1948, p. 100, no. 72; Paris
1953, no. 45; Cleveland 1964, no. 116;
Minneapolis 1965, no. 21; London 1972,
p. 48, no. 71; Ixelles 1985–86, pp. 182–83,
no. 135 (catalogued but not exhibited).

BIBLIOGRAPHY

Miel 1817–18, pp. 236–39; Didbin 1821,
vol. 2, p. 482; Albrizzi 1822, p. 74; Bast
1823, p. 36 n. 1; *Notice* 1824, pp. 67–68;
Th. 1826a, 209–10, 237; Th. 1826b, pp.
145, 164; Coupin 1827, p. 56; *L'Artiste*
1839, p. 185; Blanc [1849–76], p. 15; Delé-
cluze 1855 [1983], pp. 368–70; Blanc
1857–58, vol. 2, p. 437; Mantz 1865, pp.
113–14; Montaiglon 1879, p. 300; David
1880, pp. 540–44, 546, 581, 649; Saunier
[1903], p. 115; Rosenthal [1904], pp.
139–40; Gallatin 1916, pp. 64, 67; Rey
1925, p. 10; Humbert 1936, pp. 152–54;
Cantinelli 1930, pp. 93, 114, no. 143;
Holma 1940, pp. 94–95, 129 (no. 149);
Maret 1943, pp. 16, 94; Humbert 1947,
pp. 159–60; Cooper 1948a, p. 279; Mau-
rois 1948, n.p., no. 36; Hautecoeur 1954,
pp. 242, 268, 273; Dowd 1955, p. 144;
Lindsay 1960, pp. 144–45; Francis 1963;
Jaffé 1963, pp. 466–67; Rosenblum 1965,
p. 33; Haskell 1972a, pp. 15, 21–22;
Haskell 1972b, pp. 691–92; Verbraeken
1973, pp. 29, 105–6, 184, 186; Wildenstein
1973, pp. 207–8 (nos. 1800–2, 1804–7),
214 (no. 1845); P. Conisbee in London
1975, n.p., no. 26; Borowitz 1980a, pp.
263–65, 273 nn. 50–61; Mazzocca 1981,
pp. 171–72; Janson 1983, pp. 19–20, 22;
Mazzocca 1983, p. 78; Dieu 1985, pp.
91–96; D. Coekelberghs and P. Loze in
Ixelles 1985–86, pp. 440–42, 445 (nn.
12–14, 17), 446 (nn. 18, 23, 31); P. Philip-
pot in Ixelles 1985–86, p. 24; A. Schnap-
per in Ixelles 1985–86, pp. 34, 182–83;
Johnson 1986; Bordes 1988, pp. 100–101;
Michel and Sahut 1988, pp. 124–26; A.
Schnapper and A. Sérullaz in Paris-Ver-
sailles 1989–90, pp. 15, 21, 392, 441, 459,
518–19, 526, 528–29, 619, 622–25; Roberts
1989, pp. 192, 195–96, 200–205, 237 n. 49;
Dieu 1991, pp. 73, 78–82, 85, 95, 97–98;
Sérullaz 1991, pp. 175, 311–13; Coekel-
berghs and Loze 1993, pp. 1052, 1054–58,
1064; Fried 1993, pp. 219, 226 n. 40; Gon-
zalez-Palacios 1993, pp. 935, 940; John-
son 1993a, pp. 171, 236, 246–54, 260, 264;
Johnson 1993b, pp. 1032–39; Kohle 1993,
pp. 1095, 1108, 1111; Lebensztejn 1993, pp.
1014, 1016–1820; Mantion 1993, pp. 807,
815; Schnapper 1993, p. 921; A. Milstein
in New York 1994b, pp. 26–28; Johnson
1997, pp. 1, 3, 8, 29, 37–38, 41, 65–68, 87;
Lee 1999, pp. 298–301, 304–5; Vidal 1999;
Vidal 2000, pp. 702, 704–6, 716, 717 (nn.
5, 12), 718 (nn. 35, 54), 719 (n. 86); Pinelli
2001, pp. 61, 75; Cavicchioli 2002, pp.
205–6; Prat and Rosenberg 2002, vol. 1,
pp. 301, 304, 380, vol. 2, pp. 1134, 1139,
1163–64, 1173, 1177.

David BECAME interested in the story of Cupid and Psyche in 1813. That year he signed and dated a finished drawing representing the god of love leaving Psyche at sunrise while she sleeps (SEE CAT. 30). On 23 April one of David's pupils wrote home that the master intended to treat the subject. Whether this meant executing a painting is unclear. On the basis of this document and a dedicatory annotation—"Au bon et véritable amateur des arts, Monsieur Sommariva"—on a drawing for *Leonidas,* also dated 1813 (SEE CAT. 26), it is generally thought that David had decided by then to paint *Cupid and Psyche* for the enterprising collector.[3] Since his establishment in Paris about 1806, the former head of the Cisalpine Republic, a man with a modest background who had amassed a private fortune in a brief period of time through questionable financial operations, had commissioned or bought for his gallery major paintings from Prud'hon, Guérin, Meynier, and Serangeli. Sommariva had contracted for Girodet's *Pygmalion and Galatea,* delivered only in 1819 but on which the artist reportedly worked for seven years, and had also patronized a number of Italian artists, most notably Canova, so it seems very likely that he should have desired to add a work by David to his collection. During the Consulate, Sommariva had tried to commission a painting from David for the Cisalpine Republic, proof of his admiration. In September 1809 and again in January 1813, the first painter was present at his social gatherings for artists.[4]

The relations between the two men are meagerly documented during the uncertain period of the fall of the Napoleonic régime. From Milan in December 1814, Sommariva wrote to David, who was serving as intermediary for the sale of *Perseus and Andromeda* (Salons of 1812 and 1814; location unknown) by Angélique Mongez.[5] Whether or not it was destined for the collector, David worked on *Cupid and Psyche* during March 1815, manifestly stimulated to have heard early that month how Napoleon had escaped from the Island of Elba and landed at Golfe-Juan. In contact with the American envoy in Paris at the time, probably to discuss his possible emigration in the wake of other Bonapartists, he found that James Gallatin, the diplomat's seventeen-year-old son and secretary, corresponded to his vision of Cupid, and he asked him to pose nude for the figure. In his journal, the young man noted: "I don't think father will approve of my picture Monsieur David is painting: it is Cupid and Psyche. I have not seen the model but would like to. She must be very pretty, only seventeen." He concluded with some regret: "We are not to pose together."[6] No more is heard of the project until 22 May 1817, when from Brussels the artist's wife reported to a pupil in Paris that David "is busy right now with a history painting that will be novel on account of the subject represented. It is Cupid and Psyche, the moment he has chosen is quite new. It is for Monsieur de Sommariva, so it will be going to Paris and you will be able to see it."[7] A letter from David to Gros sent ten days earlier confirms that he was working with great enthusiasm: "Me, I work as though I was only thirty; I love my art the way I did when I was sixteen, and I will die, my friend, brush in hand. There is no power, however evil-minded it be, which can stop me; I forget everything of this earth; but when I put away my palette, I think of my children, of my friends, of good people."[8] These two documents reveal fundamental aspects of the pictorial project: that David sought to give a new slant to a hackneyed theme, and that his investment brought back reminiscences of his youth—in other words, the cultural context of the 1760s and 1770s, against which he built his reputation. His investment allowed him to retreat from the contingencies of his personal situation and attain a high level of artistic expression. At the same time, a spirit of defiance against the Bourbon régime animated him: he perfectly understood that his success as a painter was the most eloquent and efficient manner of denouncing the measure of proscription inflicted on him.

By August 1817 the painting was finished; before sending it to Sommariva, David decided to put it on show in the museum in Brussels for about a month. This was for him a public relations operation, since the entrance receipts were given to religious organizations that cared for the aged. A series of articles in the press contributed to the exhibition's success. In August two supportive articles on *Cupid and Psyche* were published in *Le Vrai Libéral.* Though unsigned, they were probably by Louis Frémiet, a fellow refugee and friend of David's who worked for the journal and the father of the aspiring painter Sophie Frémiet, who would later wed the sculptor François Rude.[9]

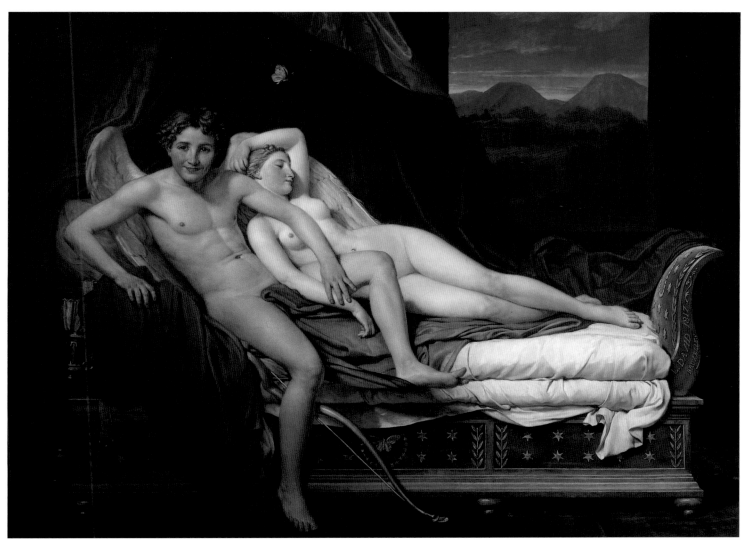

A first article detailed and justified the painter's vision of the subject: "The spectator, seduced by the picturesque truth, believes he sees the reality of nature. . . . Cupid is truly the spouse announced by the oracle: the *crudelis amor* of the ancient poets. An almost libertine smile, a malign joy animate his features. This character which M. David has captured, this expression he has rendered so well accord not only with the action, but with the allegorical decorum of the subject."[10] Given the critical subtlety of the text, there seems little doubt that the former tax collector from Dijon transcribed an explanatory note furnished by David.

The second text is even more articulate and also appears to have been dictated by the artist, although it has been summarily dismissed by all art historians but one, his grandson. It merits attention since it constitutes a response to criticism in a rival journal of Cupid's vulgar features and an expression judged cynical. Frémiet stresses the originality of the subject, and praises its rare clarity and simplicity. For once Psyche's lover is a credible adolescent and not a child, as in Raphael's famous engraved suite, nor does he have a red glow as in the Farnesina. Such literal interpretations of the images invoked by the poets of antiquity was ill-suited to "the pictorial art which, being essentially imitative, cannot materially transcribe an allegorical idea."[11] The argument then comes into focus by condemning the fiction of Cupid's invisibility in Gérard's canonical version of the theme: the "bizzare and complicated ideas" denounced at the beginning of the article. This was manifestly the picture David aimed to surpass. As a consequence, what Frémiet calls allegorical "concetti," accessory figures and the juxtaposition of real and fictitious personifications as in Gérard (and Rubens), have been banished and David has opted for a "purely historical" representation of the mythological scene, or more exactly the *fait mythologique*. Frémiet reminds his readers that the painter had proven in the *Sabines* that he could excel in capturing the "delicate, graceful and naïve nature" of children, that he chose to show the *bel adolescent* slip gracefully out of the bed to make his composition more interesting.[12] Proof of David's supreme mastery is offered by his capacity to give to Cupid's body a sense both of grace and force, reputedly two antithetical qualities.[13]

Only at the very end of the article does Frémiet attempt to justify Cupid's polemical expression, as a "composite of ingenuity, malice and libertine joyousness": "Penetrated by the spirit of the ancients, M. David has no doubt wanted to represent *Cupid* according to the portrait which Moschus has drawn of the *Fugitive Cupid.*"[14] The Greek idyllic poet, one of the authors regularly published by Didot in convenient anthologies during the period, described the cunning boy as having dark skin (a British visitor to Paris in 1818 assumed that David's figure has the features of a "negro"),[15] sparkling eyes, beautiful hair, and an impudent expression. Canova in his two interpretations of *Cupid and Psyche* had imposed a seductive idealized vision of the god of love, which Prud'hon relayed in a number of masterful allegorical paintings. Gérard's Cupid of 1798, although stylized like David's figure of Paris painted a decade earlier to express a sense of bodily tension, sports a curiously naturalistic head of hair, which by comparison gives him a rustic air. David, in turn, developed this interpretation, provoking much recrimination, especially in the French capital, where the picture was judged by the aesthetic principles of the *Sabines* and *Leonidas.*[16] An eloquent if oblique manifestation of this criticism was the painting of the same subject, aligned on Canova's style, by François-Édouard Picot, a pupil of Vincent, shown at the Salon of 1819 (FIG. 81). Although Picot executed his version in Rome in 1817, given the publicity surrounding Sommariva's commissions, he was surely familiar with the details of David's project. Simply his decision to treat the subject invented by the exiled master was an overt act of defiance, which prompted critics in 1819 to compare the two pictures. The normative perfection of Picot's figure of Cupid, its effete "decency"—"this is the nudity of a god whose existence is purely celestial and aerial" wrote one commentator, "this work is made to please women" esteemed another—and perhaps the rising confidence of the political opposition, created an unexpected upturn in favor of the primary version.[17] The commentary most sympathetic to David was that in *L'Indépendant*, a journal of the liberal opposition: "David's Cupid is not idealized like his Psyche: he represents physical love, the emblem of the union of the sexes; he is an adoles-

FIGURE 81 François-Édouard Picot (French, 1786–1868), *Cupid and Psyche*, 1817. Oil on canvas, 7 ft. 7⅞ in. x 9 ft. 6½ in. (233 x 291 cm). Musée du Louvre, Paris

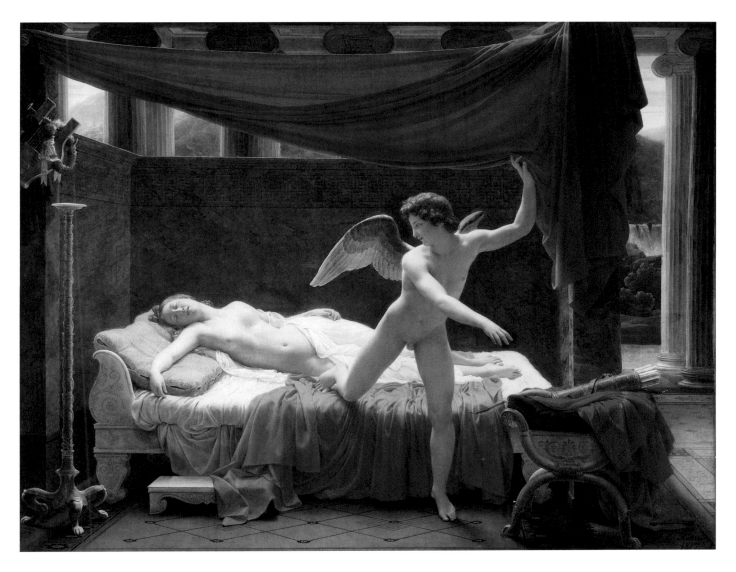

cent full of force and energy, who has conquered
his pleasure; it is Cupid who has conquered
Psyche, and who grins over his triumph. That is
David's idea, an antique idea; slightly more eleva-
tion in Cupid's features would have silenced all
criticism, for the drawing and the color are
admirable. Honor, eternal honor to the painter of
Leonidas!"[18] And in spite of all the criticism, the
painter stood his ground. In 1824 the anonymous
biographer who ventriloquized his point of view
wrote: "M. David has not yet given in to the
critique formulated with regard to his Cupid, he
believes that his intention has not been sounded
thoroughly enough; he relies on the judgment of
posterity to establish the rank which this produc-
tion should have."[19] David detailed his "idea" in a
letter to the engraver Jean-Louis Potrelle in April
1819, who was executing a print after the picture.

After examining a second proof of his work, he
reprimanded him for having misinterpreted the
spirit of his figure. Potrelle had given Cupid a
serious and grave countenance that he found
pedantic; sensitive to this point in particular,
David saw here an attempt to "correct" his work.
In a rare expression of humor, he told the young
man that "unfortunately it was a bit late to give
him a lesson."[20]

Most enlightening is the close commentary on
David's composition that Gros wrote in January
1818 at David's prodding a few months earlier.
That he was so insistent on obtaining his opinion
confirms the self-consciously innovative position
taken in this work, both with respect to his own
production and to Parisian practice. The resulting
critique was somewhat tortuous, since the former
pupil, assuming his master's pedagogical legacy in

Paris, was ill at ease passing judgment on a revered father figure, but it expressed support and searched for understanding. Gros recognized the characteristic dynamic and novelty of the artistic enterprise. He interpreted the mode of execution as a move against the fashionable taste for high finish, which was the ruin of the historical genre, and to which Girodet and Guérin especially catered. David alone seemed capable of indicating the right direction and balance, no less precise and controlled in the treatment of form, but infinitely more expressive and graceful. For Gros, his master's composition revived the spirit of the Greeks and the color of the great Venetians. He admitted that the naturalism of Cupid has been found too pronounced, especially his faun-like head and his roughly painted hands, also too brown. Apparently more comfortable focusing on the perimeter of the composition, he suggested some minor corrections to the proportions of the feet, but fell back immediately after on his immense admiration for his master's "masterpieces."[21]

The straightforward realism of David's love scene, so Flemish in spirit, was obviously not to the taste of repressive nineteenth-century elites, for whom sexuality was a serious menace to the social and moral order and acceptable only as idealized fantasy. From Auguste-Hilarion de Kératry in 1822 to Paul Mantz in 1865, voices condemn the picture for offering a parody of the myth and the idea of love.[22] As suggested, nothing indicates that this was David's intention, although he was ostensibly struggling to come to terms with the contradictory demands raised by the realistic interpretation of an ideal scene. No doubt aware of the pitfalls in such a project, evidenced in the historical compositions by Jacob Jordaens, Jan Steen, and, more generally, Flemish and Dutch classicists, he proceeded with caution and restraint. The picture is above all conceived as a museum piece. Psyche is a traditional exercise in the reclining female nude; her profile evokes Correggio's Magdalene in the famous *Madonna and Child with Saint Jerome (Il Giorno)* confiscated in Parma, one of the glories of the Musée Napoléon, perhaps in a spirit of rivalry with Prud'hon, celebrated since the Consulate as the *Corrège français.* The year David signed his picture Stendhal identified this figure with "la grâce moderne."[23] The influence of Caravaggio, appreciated at the time for the energy of his figures, has been pro-

posed for the figure of Cupid, while the archaism of the lateral composition and spatial illusion bespeaks of a profound attachment to the classical tradition. In spite of these composite sources of inspiration, the frank handling and warm colors confer on the work a visual coherence no less effective than in David's other works from the period.

The provocative decision of the Cleveland Museum of Art to acquire the picture in 1962 announced the end of the systematically negative vision of David's late history paintings, and of this painting in particular. Frances in 1963 and Rosenblum in 1965 were the first to inscribe it in a meaningful art historical context, as new research was making more clear the dialectical complexity of European art around 1800. Schnapper provided a thoroughly documented entry in the catalogue to the 1985–86 exhibition devoted to neoclassicism in Belgium, but it was Johnson who, in a suite of studies between 1986 and 1997, best defended the earnestness of David's investment in this project. She posited the existence of an undercurrent in David's art that was politically critical of the Napoleonic regime and aesthetically opposed to contemporary norms of history painting. Because it is so productive, this hypothesis has often been accepted as the base for further interpretation.[24] With regard to *Cupid and Psyche,* she argued that David portrayed a "repulsive, clumsy, leering adolescent" to characterize his "true, monstrous nature," and that viewers are "only too aware" of his "ugliness and awkwardness." We are shown, she esteemed, "how physically and morally repugnant adolescent sexuality and, by extension, the nature of sexual rapport between men and women can be, absent love, respect, or even tender affection."[25] Admittedly the artist was a family man and no boudoir libertine, but he was a product of the enlightened eighteenth century, in this work even more so than in many others. Imagining him to have been a puritanical pornographer is hardly convincing. I do not doubt, however, that many will prefer to believe David when, through a spokesman, he claimed he found the *bel adolescent* joyfully malicious and his situation amusing.

NOTES

1. Gabet (1831, p. 180) indicates that the picture "exécuté pour M. de Sommariva" belonged to "M. le comte Pourtalès"; this must be wrong, since the picture was featured in the 1839 sale of Sommariva's estate, but it

may echo a tentative negotiation between Pourtalès and Luigi soon after the death of his father.

2. D. Coekelberghs and Pierre Loze in Ixelles 1985–86, p. 445 n. 12. It should be noted that the picture was not exhibited in Ghent in 1817 (cf. Dowd 1955, p. 144, a confusion with *Telemachus and Eucharis* exhibited in Ghent before Brussels the following year; in fact, David denied a request of the Ghent academy on the grounds that "mes jouissances aujourd'hui sont dans les succès de mes élèves," see Engelhart 1996, p. 40 n. 99), nor in 1826 "au profit des Grecs" at the Galerie Lebrun in Paris (cf. M. Florisoone in Paris 1948, p. 100, a confusion with *Psyche Abandoned* [c. 1795; private collection, New York], see Athanassoglou-Kallmeyer 1989, p. 157).

3. A. Schnapper in Ixelles 1985–86, p. 182.

4. Mazzocca 1981, pp. 159, 242–43; Johns 1998, pp. 77, 213 n. 24. On the commission for the Cisalpine Republic, see the essay in this catalogue, "In the Service of Napoleon."

5. "Per il quadro Mongez non ho scritto il proposito a M. David" (Sommariva to his son Luigi, 13 Dec. 1814, cited by Montaiglon 1879, p. 298). The *livret* of the Salon of 1814 indicates that *Mars and Venus* (no. 708) by Angélique Mongez was for Sommariva, but it appears from early inventories of his collection in Tremezzo that he finally acquired *Perseus and Andromeda*, reexhibited that year (no. 707); see Montaiglon 1879, p. 182 n. 2, and Mazzocca 1983, p. 78.

6. Gallatin 1916, pp. 64 (3 Mar. 1815: "Monsieur David, the great artist, has requested father to allow me to pose to him for Cupid. Father has consented, and I sit tomorrow"), 66 (24 Mar: "I had another sitting today for Monsieur David"), 67 (26 Mar.: quoted passage). Schnapper in Paris-Versailles 1989–90, p. 519; Lee 1999, p. 300.

7. "[I]l s'occupe dans ce moment d'un tableau d'histoire qui sera nouveau par le sujet qu'il représente. C'est l'Amour et Psyché, le moment qu'il a choisi est neuf. Il est pour Monsieur Sommariva, ainsi il ira à Paris et vous pourrai [*sic*] le voir." Marguerite-Charlotte David to A.-L.-C. Giroust, 22 May 1817 (Agius-d'Yvoire in Paris-Versailles 1989–90, p. 622). The letter is briefly cited by Hautecoeur (1954, p. 268).

8. "Moi je travaille comme si je n'avais que trente ans; j'aime mon art comme je l'aimais à seize ans, et je mourrai, mon ami, en tenant le pinceau. Il n'y a pas de puissance, telle malveillante qu'elle soit, qui peut m'en priver; j'oublie toute la terre; mais la palette à bas, je pense à mes enfants, à mes amis, aux braves gens." David to Gros, 13 May 1817 (Wildenstein 1973, p. 206, no. 1799bis).

9. Nine references to articles on the picture published in Aug. and Sept. 1817 in the Brussels press are given by Wildenstein 1973, p. 207, no. 1804. Johnson (1993a, p. 302 n. 24) indicates the article listed signed "Y." by Frémiet in *Le Vrai Libéral*, no. 226, 14 Aug. 1817, p. 3, but also another by him in the same journal, not listed in Wildenstein: 23 Aug. (1817 not 1818), no. 233, pp. 3–4. The undated text by Frémiet reproduced by

Jules David (1880, pp. 541–42), appears to be this second article, since it refers to a first announcement. See also the following three notes.

10. On account of its importance, the article merits to be cited in full:

L'AMOUR ET PSYCHÉ, *tableau de M. David.* / Psyché était une princesse d'une si grande beauté que l'Amour même en voulut devenir l'époux. Ses parents ayant consulté Apollon sur le mariage de leur fille reçurent l'ordre de l'exposer sur une haute montagne, au bord d'un précipice. L'oracle ajouta qu'elle ne devait point espérer un époux mortel, mais un époux plus malin qu'une vipère, redoutable à tous les dieux et aux enfers même. / Psyché fut mise sur le haut d'un précipice; mais Zéphyre [*sic*] l'emporta dans un lieu délicieux, au milieu d'un palais superbe, où elle était servie par des nymphes invisibles. La nuit son époux s'approchait d'elle dans l'obscurité, la quittait sans être aperçu et sans qu'elle put le connaître. / On pourrait s'étonner que le mâle génie de M. David ait pu s'attarder à ce sujet, et que le sévère auteur de *Brutus, des Horaces, de Léonidas,* ait trouvé sur sa palette les couleurs riantes dont il vient d'embellir *l'Amour et Psyché,* si l'on ne savait que Raphaël a excellé dans les scènes graves et dans les plus riantes peintures de la mythologie. Le génie inépuisable et varié comme la nature embrasse tout, sait se plier à tout: c'est un terrain fécond qui produit les chênes et fait éclore les roses. / Le mérite de cet admirable ouvrage du chef des arts, est de cacher le talent à force de talent: la *manière* de ce grand artiste consiste en n'en point avoir. En voyant la scène charmante qu'il a représentée, le beau groupe qui le compose, on ne peut pas d'abord s'occuper du style noble, élevé, du dessin pur, du coloris vrai qui qui distinguent ce chef-d'oeuvre; on ne songe pas à l'examen particulier des formes, de l'expression, de la couleur: le sujet est si bien exposé, les personnages si naturels, que l'illusion fait disparaître le mécanisme de l'exécution. Le spectateur, séduit par la vérité pittoresque, croit voir la réalité de la nature. / L'Amour est bien l'époux annoncé par l'oracle: c'est le *crudelis amor* des poëtes anciens. Un sourire presque libertin, une joie maligne animent ses traits. Ce caractère que M. David a saisi, cette expression qu'il a si bien rendue s'accordent non seulement avec l'action, mais sont dans les convenances allégoriques du sujet. La riante imagination des Grâces a embelli, par des fables, les leçons de la morale comme les phénomènes de la nature. Les mythologues ont voulu peindre les maux et les peines que l'Amour, figuré par Cupidon, cause à l'âme désignée par Psyché.

Le Vrai Libéral, 14 Aug. 1817, p. 3 (D. Coekelberghs kindly furnished me with a transcription). Borowitz (1980a, p. 273 n. 53, misdated) and Dieu (1985, p. 95; 1991, p. 81) both provide brief extracts. It would be most enlightening to have a critical edition of all the

early texts on *Cupid and Psyche,* along with the commentaries published later in Paris.

11. "Cette idée . . . ne convient pas à l'art pittoresque, qui, étant essentiellement imitateur, ne peut traduire matériellement une idée allégorique." David 1880, p. 541.

12. "J'aime mieux l'idée naturelle de représenter l'amant de *Psyché* sous la figure d'un bel adolescent. Le tableau des *Sabines* prouve que M. David peut exceller dans les représentations de la nature délicate, gracieuse et naïve des enfants." David 1880, p. 542.

13. See, for example, the peremptory affirmation in Stendhal's *Histoire de la peinture en Italie* (1817): "La grâce exclut la force; car l'oeil humain ne peut voir à la fois les deux côtés d'une sphere" (1996, p. 329).

14. "Que dire du caractère et de l'expression de la tête de *l'Amour,* de ce composé de finesse, de malice et de joie libertine. Pénétré de l'esprit des anciens, M. David a sans doute voulu représenter l'*Amour* d'après le portrait que Moschus en a tracé dans son *Amour fugitif.*" David 1880, p. 542. In spite of this authorized lead, the reference to Moschus has been evoked only by Borowitz (1980a, p. 263).

15. Thomas Didbin, cited by Schnapper in Paris-Versailles 1989–90, p. 519.

16. For a selection of such criticism, see Schnapper in Paris-Versailles 1989–90, p. 519; and Johnson 1993a, pp. 246–50.

17. Lesur 1825, pp. 721 ("David a dévoilé l'énivrement d'une première jouissance, mais la décence murmure peut-être à la vue de son tableau"), 722 ("c'est [of Picot's Cupid] la nudité d'un dieu qui n'a rien que de céleste et aérien"). Even an attempt to claim Picot's superiority backfires: "Il est aisé de voir que M. Picot a *glissé* sur le sujet dans lequel M. David s'est plu à pénétrer" (*Gazette de France,* no. 273, 30 Sept. 1819, "Beaux-Arts. Exposition de 1819. Cinquième article," p. 1169). These and the article cited in the next note are in the file for Picot's painting in the Service de Documentation et d'Étude of the Paintings Department of the Louvre. For an interpretation of the bout that claims victory for Picot, see Johnson 1993a, pp. 255–57.

18. "L'Amour de David n'est pas idéal comme sa Psyché: c'est l'amour physique, c'est l'emblème de l'union des sexes; c'est un adolescent plein de force et d'énergie, qui a conquis la volupté; c'est Cupidon qui a vaincu Psyché, et qui sourit de son triomphe. Voilà l'idée de David; c'est une idée antique; un peu plus de noblesse dans les traits de Cupidon eut écarté toute critique, car le dessin et le coloris sont admirables. Honneur, éternel honneur au peintre de Leonidas!" *L'Indépendant,* no. 122, 8 Sept. 1819, "De l'exposition de 1819. Sixième article" (unsigned), pp. 3–4.

19. "M. David n'a pas encore adhéré à la critique qu'on a faite de l'Amour, il croit qu'on est pas assez entré dans son esprit; il invoque le jugement de l'avenir pour fixer le rang que doit occuper cette production." *Notice* 1824, p. 68.

20. "[Cupid] a l'air d'un sérieux et d'une gravité qui sont bien loin de mon idée en les [*sic*] peignant. . . . enfin il m'a paru que vous ou que quelque autre qui en sait plus que moi, avait voulu me corriger; malheureusement la leçon qu'on me donne est un peu tardive. . . . Les têtes sont ridicules; il y a une pédanterie dans votre estampe qui n'est pas du tout dans l'esprit de mon tableau." David to Potrelle, Apr. 1819 (Wildenstein 1973, p. 214, no. 1845).

21. Gros to David, Jan. 1818 (David 1880, pp. 545–47). The critical reference to Girodet and Guérin, although neither is named, becomes explicit when read in conjunction with David's previous letter to Gros, 13 Sept. 1817 (p. 543).

22. Kératry is cited by Johnson (1993a, p. 303 n. 36); Mantz 1865, p. 114.

23. Stendhal 1996, p. 317. The Capitoline Venus is invoked as the image of "la grâce antique."

24. Johns (1998) and Vidal (1999), the latter more critically, both build certain of their arguments on Johnson's interpretation. Vidal offers a penetrating study of David's "allegorical understanding of the myth" of Psyche (p. 237). She also calls attention to the landscape in the background: "a landscape view that sends us along and around its overlapping trees and planes to a small temple, then to distant mountains and an ethereal expanse of the eastern sky at dawn. . . . The forms and themes of the view invoke a spiritual dimension, a journey, renewal and illumination" (p. 221).

25. Johnson 1997, p. 66; the reading of the iconography that follows is disconcertingly novelistic: "Amor [Cupid] does not love Psyche, he uses her as a pawn in his game of sexual conquest; he has power over her and has literally and figuratively enslaved her." Some, however, will find Psyche to be an image of blissful repose. As for the butterfly, symbol of the soul and Psyche's conventional attribute, hovering above, "a gray insect" that resembles "a moth," it is "certainly meant to be parodic," according to Johnson (1993a, p. 257). Although female figures with moth-wings might personify fornication in seventeenth-century representation of the temptation of Saint Anthony, for example by Simon Vouet (Musée de Grenoble), the visual context of David's naturalistic representation of the insect (see the color detail in Michel and Sahut 1988, p. 124), in no way a menace to Psyche, is not inherently disturbing.

Variation on *Leonidas at Thermopylae*

1817

Black crayon on paper
5 x 7⅝ in. (13 x 19.5 cm)
Signed and dated, upper right:
L. David. Brux. 1817.

James Mackinnon, London

PROVENANCE
. . . ; N. R[evil] sale, Paris, 29 Mar.–2
Apr. 1842, no. 70; . . . ; Charlotte-Louise-
Solange Bianchi, Marquise de Ludre-
Frolois (died 1949), great-granddaughter
of Pauline-Jeanne David, the artist's
daughter, and Jean-Baptiste Jeanin; her
sale, Paris, Galerie Charpentier, 15 Mar.
1956, no. 9; private collection, Paris; sale,
Paris, Hôtel Drouot, 5 June 1996, no. 21;
James Mackinnon, London.

EXHIBITIONS
Never exhibited.

BIBLIOGRAPHY
Cantaloube 1860, p. 303 (item 14?); A.
Sérullaz in Lille 1983, p. 70; A. Schnap-
per in Ixelles 1985–86, p. 34; A. Schnap-
per and A. Sérullaz in Paris-Versailles
1989–90, pp. 498, 548; Prat and Rosen-
berg 2002, vol. 1, p. 311 (no. 322), 317,
vol. 2, p. 1231.

THIS DRAWING quotes *Leonidas at Thermopylae* (FIG. 82), which David had exhibited in Paris in 1814 and left behind in his Cluny studio when he moved to Brussels in January 1816. Executed in 1817, it pairs with a similar variation on the *Sabines* the following year (SEE CAT. 34), qualified by the artist as a *répétition libre*. The drawings may be seen as pendants, complementary meditations on two of his major pictures, which at the time he was discreetly maneuvering to sell to the Bourbon government.[1]

The sheet is more a condensed interpretation than a free repetition of the earlier composition. David presumably felt that it preserved the essence of his grand design. Typical of his drawings from this period, the black crayon serves unsparingly to model bust-length figures and antique accessories, set in front of a blank décor (see the drawings in the next section of this volume). Sensitive to the highly favorable comments on Leonidas's expression, David gives it particular prominence. On the right, according to the painter's published description of the painting, is his brother-in-law, Agis, expecting the call to arms. Behind this figure is the young combatant who "runs to embrace his old father as he bids him his last farewell."[2] Whereas in the painting David dissimulates the younger man's face from view, here he proposes a dramatic Donatellesque confrontation of their two profiles, a communion of body and soul in which the elder more explicitly appears to dominate. The distinctive figure of the high priest Megistias, who warned the Greeks of the danger ahead, has been shifted to the left, with two helmeted soldiers still farther back. More clearly than in the painting, it is possible to discover the inspiration for this figure and the gesture of the raised hand: it is closely based on the so-called *Sardanapalus* (now identified as *Dionysus*) in the Vatican Museum, a source suggested by the fact that in November 1814 David asked his friend the sculptor Joseph Esper-cieux to borrow a plaster bust of the statue.[3]

NOTES
1. Angrand 1972, pp. 110–38.
2. The text of David's *Explication* distributed to visitors in 1814 is reproduced by Schnapper in Paris-Versailles 1989–90, p. 486 (the quoted passage: "court embasser son vieux père qui lui fait ses derniers adieux").
3. Wildenstein 1973, p. 196, no. 1702. My thanks to Jean-Marc Moret for help identifying the statue (Vatican Museum, inv. 2363).

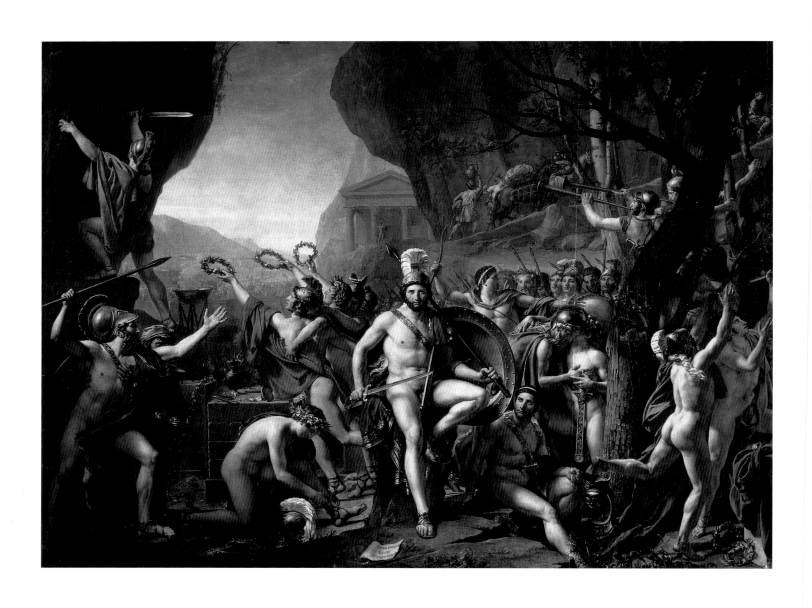

FIGURE 82 Jacques-Louis David, *Leonidas at Thermopylae*, 1814. Oil on canvas, 12 ft. 11½ in. x 17 ft. 5 in. (395 x 531 cm). Musée du Louvre, Paris

CATALOGUE 33

Variation on *The Intervention of the Sabine Women*

1818

Black crayon
5¼ x 7⅞ in. (13.4 x 20 cm)
Inscribed and signed in black crayon,
upper center: *répétition libre des Sabines.
/ L. David Brux. 1818.*

The Peabody Collection, Maryland
Commission on Artistic Property of the
Maryland State Archives. On loan to the
Baltimore Museum of Art (MSA SC
4680-13-0081)

Exhibited in Los Angeles only

PROVENANCE
. . . ; Charles J. M. Eaton (1807–1893),
Baltimore; 1893, bequeathed to the
Peabody Institute, Baltimore (inv. 13.81);
on loan to The Baltimore Museum of
Art (inv. BMA R.11826.352), courtesy of
the Maryland Commission on Artistic
Property of the Maryland State Archives.

EXHIBITIONS
Never exhibited.

BIBLIOGRAPHY
Baltimore 1900, p. 48, no. 340; Prat and
Rosenberg 2002, vol. 1, p. 317, no. 340.

THIS DRAWING was executed a year after the variation on *Leonidas* (SEE CAT. 33), a painting initially conceived as a pendant to the *Sabines.* It is a free interpretation of the huge painting illustrating the history of the foundation of Rome by Romulus on which David had worked in the late 1790s (SEE FIG. 1). After the Romans had abducted the Sabine women to establish families, the Sabines, led by Tatius, marched on Rome. The noble speech of Hersilia, the Sabine taken for wife by Romulus, and the tearful pleas of the other women put an end to the conflict. Compared to the painted figures spread out over the canvas, full-length and life-size, those in the drawing are brought improbably close together in a play of tightly interlocking forms. All suggestion of historical context and setting has been eliminated. It even seems that the story has been modified since the female figure, Hersilia in the painting, has sacrificed her graceful beauty for a crown. Romulus, on the right, retains a relatively noble profile, while Tatius, on the left, has been given a mundane expression of concentration, almost a frown. Although David no doubt felt that the drawing preserved the essence of his grand composition, his interest has swayed from the expression of a formal ideal to a narrative primitivism. He probably referred to this sheet when he composed *The Anger of Achilles* (SEE CAT. 36), for the scene prefigures the spirit and structure of the more articulate Homeric confrontation. In this regard, it attests to his perception of the *Sabines* as the source of many of his later preoccupations.

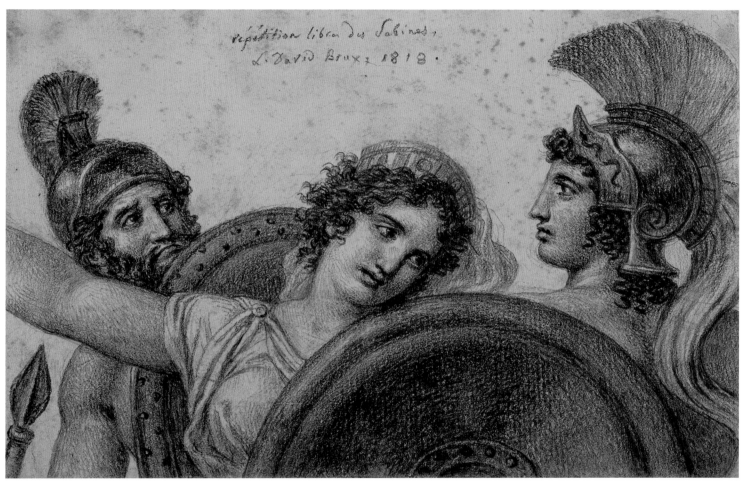

The Farewell of Telemachus and Eucharis

1818

Oil on canvas
34½ x 40½ in. (87.2 x 103 cm)
Signed, left, on the quiver: DAVID; and
dated, center, on the horn: 1818 / BRVX

The J. Paul Getty Museum, Los Angeles
(inv. 87.PA.27)

PROVENANCE

Franz Erwein Graf [Count] von Schön-
born-Wiesentheid (1776–1840), Schloss
Reicharthausen in Rheingau; his eldest
son, Erwein Damian Graf von Schön-
born-Wiesentheid (1805–1865); sold by
his younger brother Clemens, Schön-
born-Weisentheid sale, Montmoril-
lon'sche Kunsthandlung, Munich,
Schönborn Palace, 9 Oct. 1865, no. 46;
C. E. Weber de Turenfels, of Antwerp;
his sale, Paris, Hôtel Drouot, 8 Apr.
1867, no. 57; "Baron de Hirsch" sale,
London, Christie's, 6 Feb. 1897, no. 30,
acquired by Hodgkins; Denys Cochin
sale, Paris, Galerie Georges Petit, 26
Mar. 1919, no. 8; Gallery Berheim jeune,
Paris; 1941 to 1950, Jacques Léon Stern,
Paris (confiscated and restituted during
World War II) and New York; Jacques
Léon Stern estate sale, New York, Parke-
Bernet, 3–4 Nov. 1950, no. 57, probably
acquired by N. de Koenigsberg, La
Passe, Ltd., New York, owner of the
picture in May 1951 (Frick Art Library
Files); private collection, Uruguay, at
least until 1962; by 1986, Pedro Soarin
Bosch;[1] sale, New York, Sotheby's, 24
Feb. 1987, no. 126, acquired by the
museum.

EXHIBITIONS

Ghent, Museum, May–June 1818, for
the benefit of a charitable organization;
Brussels, Museum, June–July 1818, for
the benefit of the Hospices Sainte
Gertrude and of the Ursulines; Paris-
Versailles 1989–90, pp. 526–28, no. 229.

BIBLIOGRAPHY

Cornelissen 1818; Bast 1823, pp. 34–36;
Braun 1820, p. 193; Notice 1824, p. 68; Th.
1826a, p. 210; Th. 1826b, pp. 145–46, 164;
Mahul 1826, p. 139; Coupin 1827, pp. 42,
56; Miel 1840, p. 21; Blanc 1845, p. 212;
Miette de Villars 1850, p. 208; Delécluze
1855 [1983], pp. 368, 370; Seigneur
1863–64, p. 365; David 1867, p. 39; David
1880, pp. 547–51, 570, 573, 650; Saunier
[1903], p. 115; Rosenthal [1904], pp. 139,
162; Hénard 1913, p. 260; Cantinelli 1930,
pp. 93, 114, no. 147; Humbert 1936,
p. 154; Holma 1940, pp. 95, 129, no. 153;
Humbert 1947, p. 160; M. Florisoone in
Paris 1948, p. 103; Hautecoeur 1954, p.
269; Wildenstein 1959, p. 238; Ver-
braeken 1973, pp. 29–30; Wildenstein
1973, pp. 208 (no. 1808), 210 (nos. 1815,
1820–21), 211 (nos. 1822, 1824–32), 212
(no. 1833), 219 (no. 1877), 227 (no. 1938);
Gaehtgens 1978–79, pp. 71, 73; Brookner
1980, pp. 183–84; Schnapper 1980, pp.
297–98; Dieu 1985, pp. 94, 97–106, 151;
D. Coekelberghs and P. Loze in Ixelles
1985–86, pp. 440–41; A. Schnapper in
Ixelles 1985–86, pp. 34, 183, 185, 190;
Johnson 1986, pp. 463–64, 469 nn. 70–71;
Rosenberg and Stewart 1987, p. 149;
Rosenblum 1987; Bordes 1988, p. 100;
Michel and Sahut 1988, p. 125; Bott 1989,
pp. 174–75; Roberts 1989, pp. 205–6; A.
Schnapper, A. Sérullaz, and E. Agius-
d'Yvoire in Paris-Versailles 1989–90, pp.
21, 138, 519–21, 526–30, 623–24, 626, 635;
Rosenblum 1990, pp. 193, 257; Dieu 1991,
pp. 71, 73, 75, 82–86, 88, 92, 98; McPher-
son 1991, p. 28, 33, 35 n. 12, 36 nn. 42–43;
Spencer-Longhurst 1992, p. 161; Bott
1993, pp. xx, 22–23, 192–97; Coekel-
berghs and Loze 1993, pp. 1057–61; John-
son 1993a, pp. 236, 254–55; Johnson
1993b, pp. 1032, 1035; Lebensztejn 1993,
pp. 1017–19; Mantion 1993, p. 815;
Schnapper 1993, p. 922; Engelhart 1996;
Johnson 1997; Engelhart 1998; Lee 1999,
pp. 300–301; Vidal 1999, pp. 230–31;
Vidal 2000; Prat and Rosenberg 2002,
vol. 1, pp. 316, 318–19, vol. 2, pp. 1145,
1173, 1177, 1208, 1222.

IN PARTICULARLY high spirits after the exhibi-
tion of *Cupid and Psyche* in Brussels during the
summer of 1817, also happy with the portraits he
had produced since his arrival, David was ready in
the fall to commence painting a "pendant to my
Psyche." This was the expression he used on
20 October, when he wrote to his friend Mathieu-
Ignace Van Brée (1773–1839)—a former pupil of
François-André Vincent who had been established
in Antwerp since 1798 and was the most renowned
history painter in the city—asking him to super-
vise the fabrication of a canvas measuring about
82 by 110 in. (210 x 280 cm; "de trois aunes de
Brabant sur quatre"), thus somewhat larger than
the picture he had just finished. He did not want
the surface to be as rough as those made in Italy,
nor too smooth: "Since it is for the historical genre,
we rather like the cloth to have a grain; don't go
over it with a pumice-stone, that I can do in Brus-
sels should it have too much grain."[2] It is far from
certain that he was already meditating on the
farewell of Telemachus and Eucharis as the subject
of his new picture; he may have been planning
Mars Disarmed by Venus and the Graces (SEE FIG.
64), for which he drew what he called a "first idea"
in a horizontal format (FIG. 83).[3] This is further
suggested by complementary nature of the action,
with respect to *Cupid and Psyche,* now with the
woman in the active role.

That he referred to his previous work as *Psyche,*
mentally isolating the female figure of his compo-
sition, suggests the more refined and sentimental
direction he wanted his art to take, which his final
choice of subject confirms. This seems to have
been less a way to reposition himself in the public
eye after the polemical reception of the painting
for Sommariva, which does not appear to have
shaken the confidence of the weathered artist,
than a desire to progress.[4] Certainly he wanted to
move away from the realism of the figure of Cupid
and index his new work on that of Psyche, more

willing than ever to explore themes and expressive modes novel to him.

On 12 March 1818 David signed an agreement with Franz Erwein Graf Schönborn-Wiesentheid—a high official in the Bavarian government who descended from the distinguished family that had formed the art collections in Schloss Pommersfelden—who was then in Brussels on a trip to England. He committed himself to finish a *Telemachus and Eucharis* by the first of July for five thousand francs.[5] It seems the painting was nearly completed; it was shown to visitors in his studio and by April the press mentioned it, so he may have requested a delay to allow for the execution of a replica before it went abroad. Around 1811 Schönborn had commissioned from François Gérard a portrait of his wife with their son, but it

was only after her death in 1813 that his collecting became a passion. He acquired Schloss Reicharthausen near Wiesbaden in 1817, probably with a view to installing his collection, in which he sought a comparison between the relative merits of the contemporary French and German schools of painting. By the end of his life Schönborn had collected 126 pictures and 50 works of sculpture by contemporary artists. Once David completed his painting, he was granted permission to exhibit it in Ghent and Brussels, a promotional operation that enhanced the reputation of both artist and patron, for the admission fees benefiting charitable organizations totaled almost the sum paid for the picture.[6]

Through his agent in Brussels, Schönborn received a detailed report on a conversation with

FIGURE 83 Jacques-Louis David, *Study of Mars Disarmed by Venus*, 1817. Black crayon on paper, 5 3/8 x 6 7/8 in. (13.5 x 17.5 cm). Fogg Art Museum, Harvard University Art Museums, Cambridge, Massachusetts. Gift of John S. Newberry

the painter in July over reactions to the exhibitions. David gave one reason for the success of the picture: "For I painted this picture alone, in the past I sometimes made the foolish mistake of having my pupils collaborate, even on works that went under my name, however no one but me has touched the picture of Eucharis; if it has merit, it is mine alone."[7] After the exhibition in Brussels closed and before sending it to its owner, David was allowed to have a copy made by Sophie Frémiet. His double motive was explained by an article in the local press on 18 July, which he certainly initiated. *Telemachus and Eucharis,* it claimed, was "le tableau d'affection," the most cherished picture of the great painter, so for once he wanted to have a copy for himself. For this task he asked the elder daughter of his friend Louis Frémiet, the pupil he esteemed who came closest to his own "manière simple et pure." It was finally pointed out, in the spirit of his recent support of charitable institutions, that this commission relieved the distress of a good family: since the article specified that Frémiet was from Dijon, no reader could fail to note that he was a refugee persecuted by the Bourbons.[8] The twenty-one-year-old pupil worked quickly, and within two weeks the copy was sufficiently advanced for the agent to report on the subtle differences between it and the original, which revealed all the more explicitly the quality of the painting he had acquired.[9]

As is clear from the earliest remarks on the picture, in David's time the subject of Telemachus and Eucharis was familiar through *Télémaque,* the popular story of the adventures and trials of Ulysses's only son, that had been conceived by Fénelon for the education of Louis XIV's grandson and heir. First published in 1699, this modern epic characterized the Homeric heroes in a manner that contemporaries could easily understand. Because it insisted on the virtues of humanity and moderation, it was interpreted as a veiled critique of monarchical absolutism and often invoked by Enlightenment philosophers. The scene chosen by David, as first observed by Cornelissen in 1818, offers an analogy with the choice of Hercules between vice and virtue. Telemachus was shipwrecked on the island of the nymph Calypso, who had retained his father for seven years. The young man avoids her powerful enticements, but

in the course of a hunting party, falls in love with another nymph, the more modest and hence more dangerous Eucharis. David imagines the young lovers in a grotto, perhaps an allusion to the circumstances of Dido and Aeneas's coupling. Telemachus appears torn between his desire to remain with Eucharis and his will to reunite with his father, who had departed for Troy when he was a only a child.

In the middle of the eighteenth century Henry de Favanne had treated the scene as a lachrymose separation, in which a demonstratively regretful Telemachus is led away by Mentor, the guise Minerva had adopted to accompany the young hero, while Eucharis, with the grace of a dancer, looks back seductively.[10] More recently, in 1800, Charles Meynier, a former pupil of Vincent, had exhibited a painting of this subject at the Salon, which he submitted for the Concours Décennal in 1810. David would have been familiar with the engraving of it in the volume produced by Filhol and Bourdon in 1812 (FIG. 84), which included prints after the *Sabines* and the *Coronation.*[11] The separation of the two lovers is more dignified, but perhaps even more superficial than in de Favanne's composition. With arm outstretched, Mentor appears to explain to Telemachus why they should depart, while the young man, with a complementary gesture, calmly repeats the sermon to the nymph. The two lovers exchange a last penetrating gaze, but Meynier avoids suggesting any deep attachment, perhaps inspired by the similarly anecdotal illustrations of Socrates dragging Alcibiades from the house of the courtesans. In 1802 Regnault's pupil Charles Lafond exhibited *The Meeting of Telemachus and Eucharis during the Hunt,* which confirms that during the Consulate such sentimental iconography was attractive especially to painters from studios other than David's.

Whereas Meynier introduced twelve figures, David focused on only two. He implicitly justified this option to Schönborn's agent when he commented on the summary treatment of the grotto setting: "it is not always by means of a plurality of traits and signs that the artist must represent his subject; it is rather by the simplicity of these traits that he should indicate and express his idea, and the character of his subject."[12] David adopted what might be termed a minimalist Winckelmannian

aesthetic: less as more. As well observed by Vidal: "Rather than showing the hero entirely out of control, obliging his elders to intervene, or showing him surrounded and overcome by the luxuries of Calypso's island and the flattering attention of the nymphs, David moves in close to consider the humanity of the hero, to identify the self as the locus of a struggle between virtue and voluptuousness."[13] The gestures and poses are subtly calculated to create a tension. While seeming to abandon herself, Eucharis locks her arms to restrain Telemachus; while his lean gives the impression of offering little resistance to her pull, he places his hand on her knee ready to extract himself from the snares of the nymph and her dog.[14]

The tender feeling uniting David's two figures evokes Canova's *Cupid and Psyche,* seen at the Salon in 1808 (SEE FIG. 76), but is also typical of a genre with paired lovers, sparked by Giorgione and developed notably by Paris Bordone, characterized by a mood of languorous lovemaking. The Musée Napoléon owned a telling example of such

a work attributed to Bordone, variously identified, which had been confiscated with the duc de Penthièvre's collection during the Revolution and which Landon found important enough include in his *Annales du Musée* (FIG. 85).[15] The prestige of a reference to the Venetian painter helped David override the more present association of *Telemachus* with the eighteenth-century vogue for amorous mythologies. It might have suggested the cropped format, the *Kniestück,* which upon seeing the picture in 1820 Georg Christian Braun, author of a recent monograph on Raphael, found ill-suited for historical compositions, a criticism classicists had addressed to Caravaggio's followers, for which he claimed the authority of Goethe.[16] The allusion to Venetian painting also relates to the painter's effort to warm the flesh tones. When the picture was exhibited in Ghent, the general opinion was that he had never shown himself to be a finer colorist; when told of this, he declared himself *enchanté.* Upon seeing it in Brussels, a correspondent of François-Joseph Navez wrote: "This one is

FIGURE 84 Alexis Chataigner (French, 1772–1817) after Charles Meynier (French, 1768–1832), *The Farewell of Telemachus and Eucharis,* 1800. Metal engraving, 10¼ x 13 in. (26 x 33 cm). Published in Filhol and Bourdon 1812

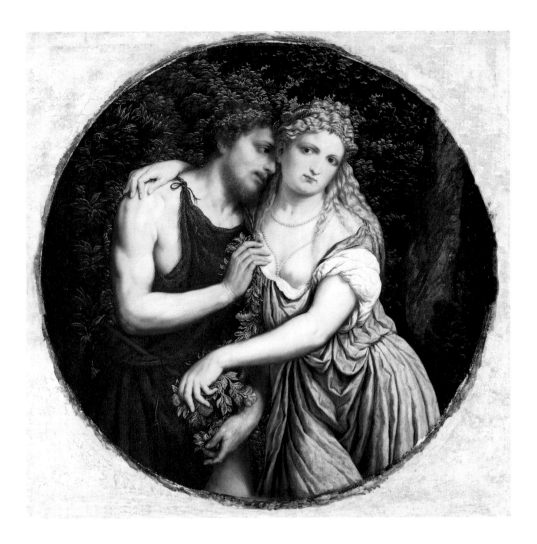

perfect, to the pure drawing that distinguishes the composition, he has added Flemish color, a kind of beauty he ignored until now, and in this regard Van Dyck did no better; sentiment, soul, expression, color, drawing, grace, everything is so exquisite; in fifty years this picture will be truly priceless."[17]

Among the lines of interpretation proposed in recent decades can be noted Rosenblum's attentiveness to the staging of the "intimacy of exposed flesh and feeling" and the sexual suggestiveness of the "disheveled tunic's revealing slits" and the "hunting horn which points upwards toward Eucharis."[18] The overt sensuality of the image is not incompatible with more elevated ambitions for Vidal, who has stressed David's sympathy with Fénelon's pedagogical and moralizing motives. Telemachus sweetly beckons the viewer to appreciate the full measure of his sacrifice.[19]

NOTES

1. Unverified indication reportedly to be found in *The Times* (London), 1 Dec. 1986.

2. "Comme c'est pour le genre historique, nous aimons assez volontiers que la toile ait du grain, sans la poncer à la pierre ponce, sauf à moi, à Bruxelles, à la poncer moi-même si elle avait trop de grain. Je ne voudrais pas cependant que le canevas fût aussi gros que celui d'Italie. . . . C'est pour faire un pendant à ma Psyché." Wildenstein 1973, p. 208, no. 1808.

3. Prat and Rosenberg 2002, vol. 1, p. 443. Johnson notes of this drawing: "Thematically it recalls *Amor [Cupid] and Psyche*" (1993a, p. 264). Although only a scribble, the bushy head of hair sported by Mars here also recalls the realistic spirit of his Cupid. A last element worth noting in this connection is the curtain lightly drawn in the background, later replaced by a temple façade.

4. Johnson, in her various publications, sees David reacting to a presumed negative reception of *Cupid and Psyche,* and his next picture conceived as "an antidote to his brilliant but thematically and stylisti-

cally repellent and rebarbative *Amor [Cupid] and Psyche*" (1997, p. 65; cf. 1993b, p. 1035). For a different view, see the entry to cat. 32.

5. The contract is reproduced and transcribed by Engelhardt (1996, pp. 24–25). Schönborn's son resided for about nine months in Brussels around this time with his tutor, also acting as his father's agent; the latter compiled with David's help a collection of commentary on the picture (the 188-page volume in the Staatsarchiv Würzburg is referenced pp. 36–37 n. 30; Engelhart exploits several unknown documents, including the report on a conversation between Schönborn's agent and David).

6. See the thorough documentation on the two exhibitions by Engelhart that underlines the benefit for Schönborn's image (1996, pp. 26–28). The idea of a confrontation between the French and German schools is evoked by Braun 1820, p. 193; *Tischbein* (Johann Heinrich Tischbein), although not in the collection, is mentioned with regard to David, and Joseph Karl Stieler is paired with his master Gérard (on whose portrait of Shönborn's wife and son, see Nuremberg 1989, pp. 535–36, no. 419). See Bott (1989, p. 178) for the number of works in the collection, which included pictures by Gros (*Bacchus and Ariadne*, 1821; conceived as a pendant to David's picture, see Gaehtgens 1978–79); Meynier (*Cephalus and Procris*, a reduced version of the painting exhibited in 1824), and Picot (*Raphael and the Fornarina*, Salon of 1822).

7. "Car c'est moi seul, qui a peint ce tableau, autrefois jai fait quelquefois la bétise de faire travailler mes élèves, même à des ouvrages sous mon nom, mais il n'y a personne, que moi seul, qui ait touché ce tableau d'Eucharis, s'il y a du mérite, il m'appartient à moi seul." Cited by Bott 1993, p. 194; and Engelhart 1996, p. 29.

8. The article is cited by Bott 1993, p. 195; and Engelhart 1996, p. 30. In the same way that David secured a sale from Yusupov for Angélique Mongez, he praised Sophie Frémiet's talent so that Schönborn's agent might convince his patron acquire a picture (see the agent's report, Engelhart 1996, p. 31).

9. The copy (private collection), larger in size than the original by about an inch, was finished by the fall of 1818. According to an arrangement with Schönborn, it was not to bear the artist's signature. The signature and date (1822), at the base of the quiver are probably false (see the illustration in Maret 1943, p. 95). On this version, sold in 1825 to Firmin Didot, probably after being reworked by David, see M. Florisoone in Paris 1948, pp. 103–4, no. 77; and A. Schnapper in Paris-Versailles 1989–90, p. 526. The observations by Schönborn's agent differentiating the original from the copy, detailed by Engelhart (1996, pp. 31–33), suggest vividly the mode of connoisseurial perception at the time.

10. De Favanne's picture (Salon of 1746; Musée des Beaux-Arts, Lyons) is reproduced in Vidal (2000, p. 709, fig. 5).

11. Meynier's painting is discussed and reproduced after an earlier line-engraving by Johnson (1997, pp. 47–48).

12. "Ce n'est pas la toujours pluralité de traits et de signes, par laquelle l'artiste doit représenter son sujet, c'est plutôt la simplicité de ces traits par lesquels il doit annoncer et exprimer son idée, et le caractère de son sujet." Engelhart 1996, p. 29.

13. Vidal 2000, pp. 713–14.

14. Because a number of viewers presumed the dog to belong to Telemachus, David specified to Schönborn's agent that the "bête fidèle" partook of the sorrow of his mistress (Engelhart 1996, p. 29).

15. The picture, identified at the time as *Angelica and Medora* and today perhaps as *Venus and Anchises*, was reproduced only in 1823 by Landon in the second edition of his *Annale du Musée* (École italienne, vol. 2, plate 19), but this may be seen as confirmation of its reputation during the Empire. On the origins of this genre, see Hochmann 1998 (reference kindly called to my attention by Guillaume Cassegrain).

16. Braun 1820, p. 193. In 1819 David drew a crayon sketch of *Telemachus*, dedicated "à mon cher Antoine" (in my opinion, to Mongez not Thibaudeau; cf. Prat and Rosenberg 2002, vol. 1, p. 319, no. 343). That it appears notably less cropped suggests that he may have regretted not providing more space around the figures.

17. "Ce dernier est parfait, au dessin pur, qui distingue sa composition, il a ajouté une couleur flamande dont jusque là il avait négligé la beauté, et sous ce rapport Van Dyck n'a pas fait mieux; sentiment, âme, expression, couleur, dessin, grâce, tout y est exquis; dans un demi-siècle ce tableau sera vraiment impayable." Huard de Chapel to Navez, 8 June 1818, Brussels, Bibliothèque Royale, II 70 (Navez Papers), V, f. 237 (given a partial résumé by Wildenstein 1959, p. 238). For the reception in Ghent and David's reaction, see Engelhart (1996, p. 29). That Odevaere invoked also a comparison with Correggio in a published review (Schnapper in Paris-Versailles 1989–90, p. 528) was probably inspired by the treatment of the head of Eucharis, close to that of Psyche in the painting for Sommariva (see the entry for cat. 32).

18. Rosenblum 1987, pp. 4–5.

19. Vidal 2000. Schönborn's son may have been an immediate target of the picture's didactic message (pp. 712–13).

Oil on canvas
41³/₈ x 57 in. (105 by 145 cm)
Signed and dated, lower left, on the
sheath: L. DAVID / BRUX. 1819

Kimbell Art Museum, Fort Worth, Texas
(inv. AP 80–7)

PROVENANCE
1819, André Parmentier (1780–1830),
Enghien, near Mons; his bankruptcy
sale (Enghien or Brussels), 21 Oct. 1824,
acquired by Carion Delmotte, *négociant*
at Mons; by 1827 and in 1830, Jean
Naigeon, Paris, probably on deposit for
sale; . . . ; 1880, Madame Noël des Verg-
ers, Paris; . . . ; 1977, Newhouse Gallery,
New York; 1980, acquired by the
museum.

EXHIBITIONS
Brussels, Museum, July 1819, for the
benefit of the Hospices Sainte Gertrude
and of the Ursulines; Ghent, Hôtel de
Ville, July–Aug. 1819, for the benefit of a
charitable organization; Paris 1830, no.
304; Ixelles 1985–86, p. 183, no. 136
(catalogued but not exhibited); Paris-
Versailles 1989–90, pp. 528–30, no. 230.

BIBLIOGRAPHY
Th. 1826a, pp. 237–38; Th. 1826b, p. 164;
Mahul 1826, p. 139; Coupin 1827, pp. 42,
56; Miel 1840, p. 21; Blanc 1845, p. 212;
Delécluze 1855 [1983], p. 365; Seigneur
1863–64, p. 366; David 1867, pp. 39, 42;
David 1880, p. 555–56, 650; Saunier
[1903], p. 115; Cantinelli 1930, pp. 93, 114,
no. 149; Holma 1940, p. 129, no. 155;
Hautecoeur 1954, pp. 243, 269–70; Ver-
braeken 1973, pp. 29–30; Wildenstein
1973, pp. 213 (no. 1841), 214–15 (nos.
1846–51, 1854), 222 (no. 1899), 227 (no.
1938); Brookner 1980, p. 184; Schnapper
1980, p. 300; Pillsbury 1982; Johnson
1984; Dieu 1985, pp. 106–10; D. Coekel-
berghs and P. Loze in Ixelles 1985–86,
pp. 440–41; A. Schnapper in Ixelles
1985–86, pp. 34, 183; Rosenberg 1986, p.
922; Rosenblum 1987, p. 5; Michel and
Sahut 1988, p. 121; A. Schnapper in Paris-
Versailles 1989–90, pp. 138, 435, 519–21,
541, 624–25, 627, 632–33, 635; Dieu 1991,
pp. 71, 75, 82, 87–92, 98; Coekelberghs
and Loze 1993, pp. 1057, 1059–61; John-
son 1993b, pp. 1032, 1035–36; Leben-
sztejn 1993, pp. 1014, 1017–18; Mantion
1993, pp. 813, 815; Schnapper 1993, p. 922;
Lee 1999, pp. 301–5; Vidal 2000, p. 719
n. 58; Prat and Rosenberg 2002, vol. 1,
pp. 217, 349, 370, 378, vol. 2, pp. 1160,
1166, 1168, 1173–74, 1176–77, 1218, 1286.

ON 1 January 1819, David wrote to his son
Jules to announce that he was putting the
finishing touches on his third *tableau d'histoire*
since his arrival in Brussels, after *Cupid and Psyche*
(SEE CAT. 32) and *Telemachus and Eucharis* (SEE CAT.
35). Enjoying good health, although he had turned
seventy the previous summer, and encouraged no
doubt by the critical success of the exhibitions of
the latter picture around that time, he had
promptly set to work in the fall and by November
his new painting had been *ébauché*, or roughed in.
The letter to his son avowed his ambition: "If I
believe what everyone keeps repeating over and
over, never before have I done a picture that was
better and more surely partakes of the simplicity
and energy of ancient Greece."[1] The same letter
reveals however, that his confidence was put to
test by the mood of resignation that befell in the
community of French exiles. Many were regaining
France, and David declared that he could follow
suit, "if I had the weakness to request my recall in
writing." And yet he clearly longed for home, for
he evoked the future as a time "when I shall return
to France," and how his uncle had died at eighty-
seven and how his aunt was thriving at eighty-six,
hoping no doubt for the chance to enjoy a compa-
rable longevity.[2]

Its dramatic subject made this new historical
composition notably different in spirit from the
previous two he had produced. The confrontation
between Agamemnon and Achilles that he chose
to paint appears imbued with the epic character
of Homeric legend, but is in fact a personally
fabricated iconography, resting on an inventive
series of borrowings and references. In the open-
ing book of the *Iliad* Achilles unleashes his wrath
when Agamemnon claims his captive Briseis, to
compensate for having had to return Chryseis to
her father. This scene was painted by Antoine

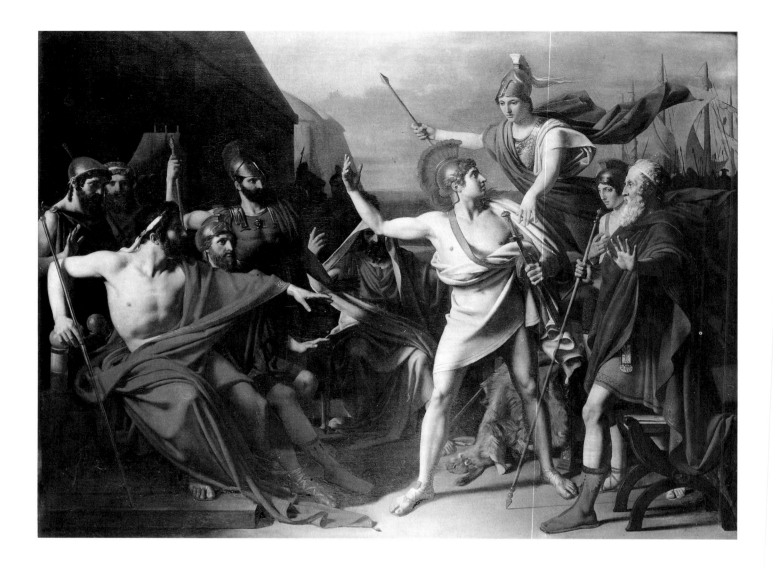

Coypel (Musée des Beaux-Arts, Tours), as a cartoon for a Gobelins tapestry woven in 1718, and in 1810 it was chosen for the Prix de Rome in painting. The distinctive trait in Homer's narrative is the intervention of Minerva, visible only to Achilles, who descends from Olympus to restrain him from striking the "king of kings" with his sword. The absence of Briseis or any other female figure puts the accent on the military duel between the two men. The anger of Achilles is also associated with the sacrifice of Iphigenia, the daughter of Agamemnon and Clytemnestra, as recounted in *Iphigenia at Aulis* by the ancient Greek dramatist Euripides; however in the play there is no direct confrontation of the two men on stage. As several commentators have noted, this occurs in the fourth act of Racine's *Iphigenia,* but Clytemnestra and her daughter do not appear in their midst. In his version of the story, Achilles refrains from assaulting Agamemnon, without the incitation of Minerva, out of respect for the girl's father. David's creative dialogue with these available sources attests to a fundamental concern that history painting not be reduced to illustration. François Gérard, in his composition of the scene for Didot's edition of Racine, a lavish folio publication of 1801 that was edited in 1816 in a smaller format, had adopted a similar freedom, and included the figure of Minerva.[3]

That David chose to interpret a subject retained for a recent Prix de Rome contest, on a canvas which was the standard size prescribed, reflects his lifelong preoccupation with the education of young artists. Collaboration with his students was a constant source of inspiration and an incentive to renewal. By approaching his new work under the conditions of an academic exercise, he nurtured this pedagogical spirit dear to him, but he

FIGURE 86 Michel-Martin Drolling (French, 1786–1851), *The Anger of Achilles,* 1810. Oil on canvas, 44½ x 57½ in. (113 x 146 cm). École nationale supérieure des Beaux-Arts, Paris

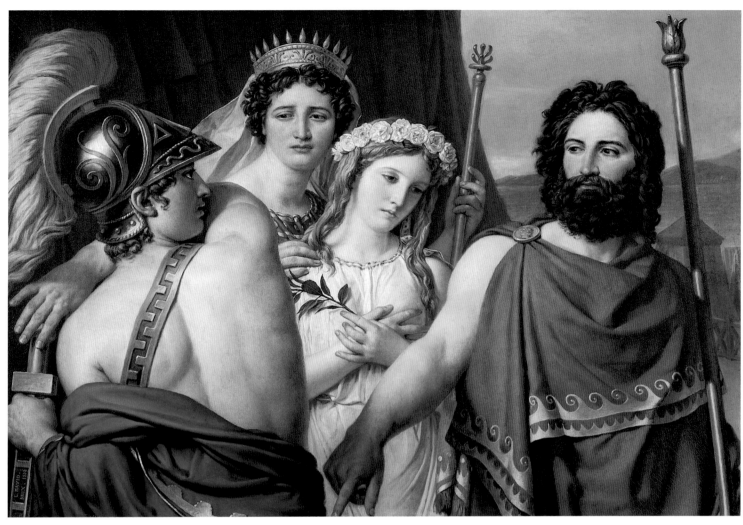

CATALOGUE 36

especially found an occasion to once again prove his artistic superiority. Along with the freely interpretative approach to the subject, which aims for heightened dramatic intensity, the decision to paint figures barely contained by the canvas is the most radical departure from the spirit of the Prix de Rome compositions (FIG. 86).[4] Compositions with life-size figures in a cropped format abounded, from Titian and Rubens to Caravaggio and his followers, but as these examples suggest, they were not commonly associated with the classical tradition. The foregrounding of figures in close proximity produces an effect of confinement, a visual tension that tends to subvert the sequential harmony across the canvas. David's composition is under pressure but carefully ordered: the poses and gestures of the two men are perfectly complementary, the two women are united in their emotion. As his wife explained to

Gros in May 1819, "the expressions are of the greatest beauty, the head of Clytemnestra brings together fear and hope in a supremely beautiful fashion; such rare beauty also in the majestic calm of Agamemnon's, such admirable sensibility in the resignation of Iphigenia."[5]

Although the figures were cropped, David followed the recommended practice of studying the full figure, which let the viewer imagine the invisible parts of a figure extending beyond the frame. In March 1818 he explained to his pupil François-Jean Navez: "It is very difficult to succeed in fitting together figures that are cut, without beforehand making a complete view of the figure's general drift, that you then square, to use only what goes into the picture."[6] A drawing in the Louvre for the figure of Agamemnon (FIG. 87) exemplifies this, along with his usual practice of studying first the posed nude model.[7]

In her letter to Gros, David's wife mentions that he was finishing the painting, five months after the painter had made a similar declaration to his son. Problems and the need for revisions may have arisen along the way. In February he had informed the painter Henri Voordecker, who was apparently collaborating with him, that the head of the black-bearded man they had begun together—presumably the figure of Agamemnon—was a failure; he announced his intention to find a *sapeur* (a husky type, like the one on the extreme right of the *Distribution of the Eagles*) who might model for him. A month later, on 2 March, he wrote again: "You're going to find me really capricious and even bizarre, but, having missed my shot the other day, I feel discouraged right now and as soon as my courage returns, I'll make sure to contact you."[8] The attention David paid to Agamemnon's expression is understandable since it constitutes the focal point of the action represented. He needed to create for this figure a commanding gaze and gesture that appeared capable of neutralizing the threat of the assault. As for Leonidas, he concentrated on the expression of the eyes and the absolute calm of the

hero. Agamemnon clearly dominates the group, framed by two scepters and outlined against the sky, whereas the other heads are set against the dark red tent. A pertinent precedent, as noted by Johnson, was the figure of Marius repelling his assassin with a gaze, painted by Jean-Germain Drouais in 1786, two years before his premature death. David was haunted by the memory of his precocious pupil to the end of his life: the plaster cast of his funerary monument was fixed to the wall of the Paris studio where his pupils gathered. However, unlike Drouais, who had staged a confrontation of two profiles, and raised the arm of Marius in the manner of the Horatii, David chose to confer on Agamemnon a greater sense of interiority and self-control.[9] An analogy with the ideas of Franz Anton Mesmer (1733–1815) has been proposed, with reference to his quack theory of "animal magnetism" that took hold of fashionable Parisian society in the late Ancien Régime. The mesmeric flow, through a touch of the finger, was conceived and perceived as a healing process, in this instance to appease the choleric Achilles whom Agamemnon almost touches.[10]

The profile of the furious warrior has a reddish glow, a chromatic and caloric metaphor that allowed David to avoid the grimacing usually attributed to Achilles in this circumstance. His expression seems to illustrate the fiery temperament and humor described in physiognomic treatises: "vehement gestures, violent, impetuous, broken, the face red and inflamed, like the eyes," according to Antoine Coypel in the early eighteenth century. On the eve of the Revolution, the figure of Achilles on stage was thought to be the perfect incarnation of *La Colère*.[11] More problematic in David's composition is the strained, contorted gesture of the arm reaching for the sword, which received a mixed reception when the picture was shown. This was most likely meant to be a tour de force of drawing and coloring, but the sharp foreshortening and discriminate play of light and shadow required an even greater mastery of anatomical correction than, in this case, he was able to summon. He may have once again wanted to defy Canova, who had sent a plaster cast of his statue of *Creugas* (1801) to Paris in 1804 to prove his capacity in a more expressive mode than his groups of *Cupid and Psyche*. When seen from the back, the pugilist appears to arch his back much

FIGURE 87 Jacques-Louis David, *Standing Figure with Laurel Wreath and Scepter*, 1818. Black crayon on paper, 9½ x 6⅞ in. (24.1 x 17.3 cm). Musée du Louvre, Paris

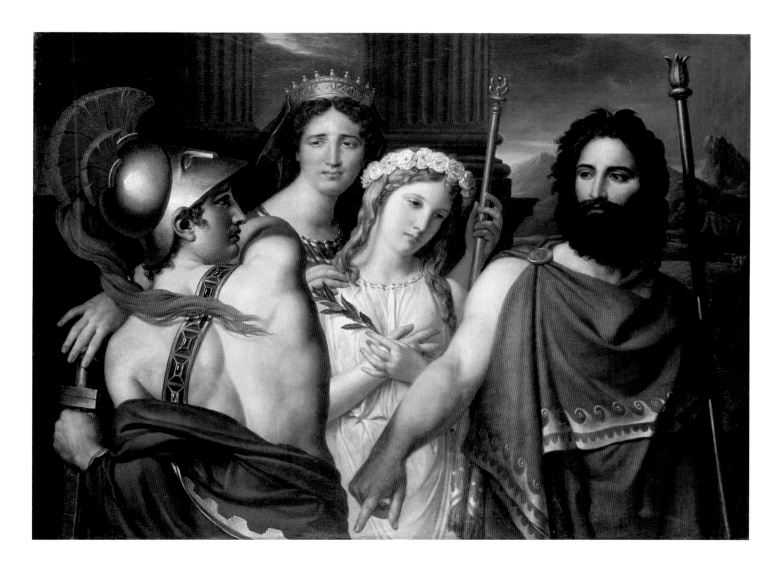

FIGURE 88 Jacques-Louis David and Michel Stapleaux, *The Anger of Achilles* (replica), 1825. Oil on canvas, 43¼ x 59½ in. (110 x 151 cm). Private collection

like Achilles, but with greater elegance, he holds his clenched fist over his head.

Between the two men, David has represented Iphigenia, who was made to believe that she was to wed Achilles. As the relation between the sexes so often implied for him an imaginary violence (SEE CATS. 32, 37, 38), he places the hand of her father as if to protect her virginity. Iphigenia is both at the heart of the drama here and the most passive among the figures, in the spirit of the meek fifteenth-century Madonnas he had come to appreciate.[12] With her downcast eyes, the figure was a departure from what Gérard had retained of Iphigenia raising her eyes to the heavens.[13] Her tearful mother bears the burden of characterizing the sentimentality of the subject. By analogy with developments in opera during the period, notably the vogue for a quatuor of singers who represent a variety of emotions, the musicality of such contrasts has been underlined.[14]

Whether or not the picture was commissioned or simply reserved once it was begun, David affirmed that he painted *The Anger of Achilles* for André Parmentier, who only kept it for a few years on account of financial difficulties that prompted him to emigrate to the United States. This was probably a disappointment for the artist, since in October and November 1819 he had taken a number of precautions to have the painting crated and had traveled to Enghien to assist Parmentier in hanging the work in his home. But did he tell him that he had delayed sending the picture to have a replica made?[15] Perhaps, as he informed Parmentier, because he felt an intense *apathie* that fall he did not pursue this project until 1825, the year of his death. In response to the desire of Firmin Didot, Pierre Didot's younger brother, to add another of his works to the family collection, he executed this replica with the help of Michel Stapleaux (FIG. 88). The painting has recently been

rediscovered and is reproduced here for the first time.[16] David gave special attention to the figure of Achilles, whose action is better articulated in space, and whose helmet adopts a simpler form considered more Greek. The background is also much changed, opened onto an ample sea and landscape. The tent has been replaced by two imposing columns that contribute to this new sense of depth. Although certain contours manifest an unusual dryness, not found in the earlier version and which might be attributed to the collaborator or David's declining means due to bad health, the picture contains much unquestionably autograph execution, and as a classical composition might be judged more satisfying. Perhaps most missing in this corrected version is the pictorial recklessness of the earlier one, which in many ways had been for David a leap into a visual unknown.

NOTES

1. "Si j'en crois ce que l'on ne cesse de me répéter, jamais je n'aurais fait de meilleurs ouvrages et plus décidemment dans le goût simple et énergique de l'antique Grèce." Wildenstein 1973, p. 213, no. 1841. This extract is cited by Schnapper, who details the inception of the project (Paris-Versailles 1989–90, p. 529).

2. "Tous mes collègues rentrent en France. Je serai certainement du nombre si j'avais la faiblesse de redemander mon rappel par écrit." Wildenstein 1973, p. 213, no. 1841.

3. Johnson stresses the importance for David of this composition, which she reproduces (1984, pp. 225–26). Her study was the first to clarify David's iconographical sources, which Schnapper further comments in Paris-Versailles 1989–90, p. 530.

4. David was surely attentive to the contest, since the winner had been his pupil Michel-Martin Drolling, whose composition was engraved in Landon's *Annales du Musée* (1810, p. 51, plate 35).

5. "[L]es expressions sont de la plus grande beauté, la tête de Clytemnestre réunit à un degré éminemment beau la crainte et l'espérance, le calme majestueux de celle d'Agamemnon est aussi d'une rare beauté, la résignation d'Iphigénie est d'une sensibilité admirable." Marguerite-Charlotte David to Gros, 13 May 1819, cited by Schnapper in Paris-Versailles 1989–90, p. 529.

6. "Il est bien difficile de mettre bien ensemble des figures coupées sans faire auparavant un ensemble complet de mouvement général de la figure, qu'on prend au carreau ensuite pour ne se servir que de ce qui entre dans le tableau." Wildenstein 1973, p. 210, no. 1814; cited in Coekelberghs and Loze 1993, pp. 1058–59.

7. Prat and Rosenberg 2002, vol. 1, p. 217, no. 206. For no persuasive reason, the authors relate the study to David's portraits of Napoleon and date it to around 1805. Although there are imperial reminiscences in the image, the gesture of the pointing finger is meaningless as Napoleonic iconography; in my opinion the drawing should be dated to 1818.

8. "Vous allez me trouver bien capricieux et même bizarre, mais, ayant manqué mon coup l'autre jour, je me trouve découragé en ce moment et aussitôt que le courage me reprendra, j'aurai l'honneur de vous prévenir." David to Voordecker, 2 Mar. 1819, cited by Hautecoeur 1954, p. 241 (original document: Bowdoin College [Maine], Livingston Autograph Collection, called to my attention by Mark Ledbury). The previous letter, dated 2 February, is cited pp. 240–41; and by Wildenstein 1973, p. 214, no. 1844. An even earlier letter to Voordecker is dated 18 Dec. 1818 (Paris, Bibliothèque de l'Institut national d'Histoire de l'Art, autographes, carton 104 [collection Éric Bertin]).

9. On Drouais' *tombeau* in the studio, see Wildenstein 1959, p. 237. David recommended to his pupils to avoid placing all the figures of a composition in profile; see his annotations to a drawing by Odevaere in 1813 (M. Woussen in Ixelles 1985–86, p. 174).

10. The Mesmeric reading was proposed by Johnson (1984, p. 226; 1993b, p. 1036) and Lee (1999, p. 304); Lebensztejn insists on "l'oeil et le doigt mesmériques du chef" (1993, p. 1018). The influence of the comparatively static notions of Lavater are no less pertinent.

11. The choleric has "des gestes véhéments, violents, impétueux, interrompus, le visage rouge et enflammé, aussi bien que les yeux" (*Conférences* 1996, p. 495). See the print after Lebarbier in J.-C. Le Vacher de Charnois 1786–89, vol. 1, plate 29.

12. Compare the drawing of the Virgin after an illuminated manuscript, in a sketchbook he used in Brussels (Prat and Rosenberg 2002, vol. 2, p. 1019, no. 1571).

13. See the drawing of *Clytemnestra Imploring the Help of Achilles* for Didot by Gérard, in New York 1999a, n.p., no. 24. On a more positive note, this same composition may have suggested to David the more sober helmet for Achilles in the revised version of the picture (see below).

14. Lebensztejn 1993, p. 1018; he refers to Handel's *Jephtha* and Mozart's *Idomeneo*, which contain dramatic situations comparable to that of the sacrifice of Iphigenia.

15. David to Parmentier, 30 Oct. 1819 (Wildenstein 1973, p. 215, no. 1854). David mentions his intention to have a replica made in a letter to Van Huffel, 7 May 1819 (p. 215, no. 1850).

16. My thanks to Guy Stair Sainty for generously permitting the study and reproduction of this painting, which is signed and dated on the sheath of Achilles' sword: LOUIS DAVID BR VX / 1825 and with respect to the first version, slightly larger.

Pen and black ink, gray and light
brown wash, with scratching out on
paper (recto); black crayon on paper
(verso): FIG. 89
7½ x 5¼ in. (18.9 x 13.2 cm)
Signed and dated, lower right: *L. David
1821 / BRUX.;* inscription in pen and
black ink on the mount, lower center:
Songe de Rhéa Silvia

Private collection, New York, courtesy of
W. M. Brady & Co., New York

PROVENANCE
Angélique Mongez, née Levol
(1755–1855); her descendants; sale, Paris,
Hôtel Drouot, 15 Dec. 1997, no. 37; pri-
vate collection; by 1998, W. M. Brady
& Co., New York; private collection.

EXHIBITION
New York 1999, n.p., no. 30.

BIBLIOGRAPHY
Prat and Rosenberg 2000, vol. 1, p. 372,
no. 429.

THIS DRAWING, whose subject is identified on
the mount, was unknown before its appear-
ance in 1997 in a Paris sale, after which Prat and
Rosenberg related to it a number of sketches that
were previously associated with the preparation of
Mars and Venus (FIG. 64) and *The Rape of Lucretia*
(SEE CAT. 38).[1] It appears from an annotation on
one of these, which relates to the exhibition of *The
Anger of Achilles* in Ghent during the summer of
1819, that David explored the theme of Mars and
Rhea Sylvia after completing this painting. But he
finalized the composition in the present drawing
only two years later, probably after considering its
translation to canvas. This is suggested by the
concern to detail an interior space and the pictori-
alism of the technique, which are alien to the
drawings in black crayon from this period (see
the next section).

The subject, much glossed since Livy, had
inspired Rubens and was often featured in decora-
tive suites devoted to the early history of Rome.

Mars developed a passion for the daughter of
Numitor, the king of Alba Longa, who descended
from Aeneas. She was forced by her uncle, after
he overthrew her father, to become a Vestal Virgin,
sworn to lifelong celibacy so that she might not
have descendants. Mars raped her and she gave
birth to the twins, Romulus and Remus, who later
founded Rome. In choosing this mythological
subject, as with *The Rape of Lucretia* a few years
later, David sought to anchor his new predilection
for the loves of the gods to his earlier fascination
with the legendary origins of the city, a chronolog-
ical sequence illustrated by the *Sabines* and the
Horatii, and for the founding of the Republic,
evoked by *Brutus.*

The result is a provocative synthesis that criti-
cally reinvents the genre of the amorous mythol-
ogy in contemporary terms. Still haunted by

FIGURE 89 Jacques-Louis David,
*Study for the Composition of "Mars
and Rhea Sylvia"* (verso of cat. 37),
1821. Black crayon on paper, 5¼ x
7½ in. (18.9 x 13.2 cm). Private
collection, New York, courtesy of
W. M. Brady & Co., New York

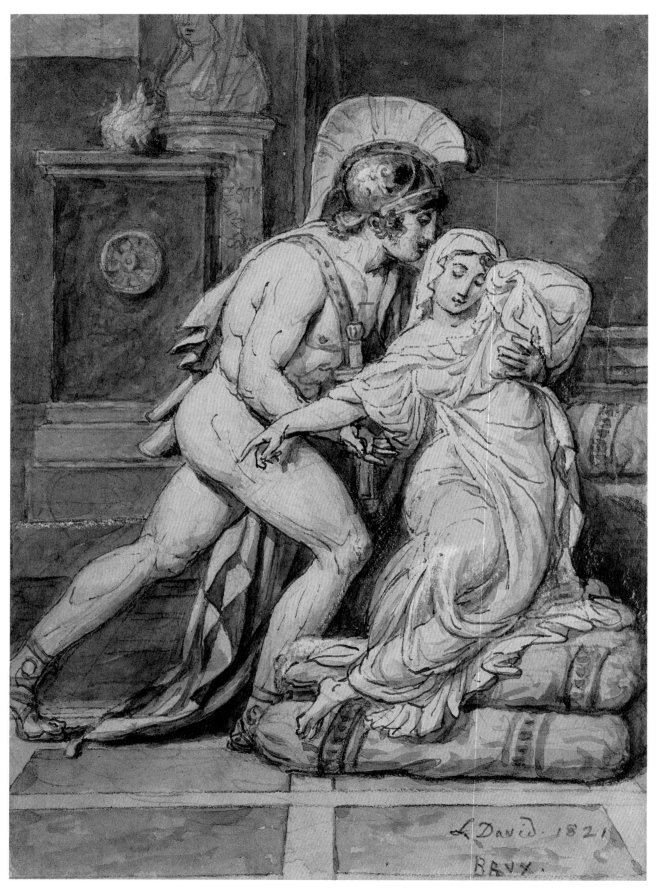

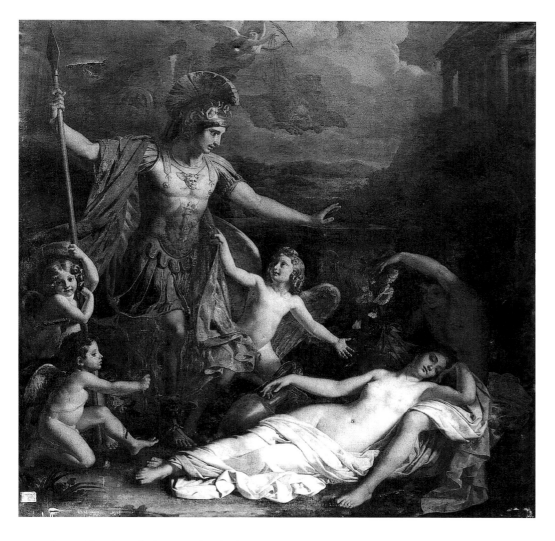

Gérard's *Cupid and Psyche* (SEE FIG. 77), which inspired his boldly personal meditation between 1813 and 1817 (SEE CATS. 30 AND 32), he does not here rework the theme of his rival's picture, but rather the ordering of form, which he turns into a brutal *corps à corps.* Through an engraving in Landon's *Annales du Musée,* David knew of the painting of the subject that his former pupil Alexandre-Charles Guillemot had exhibited at the Salon in 1819 (FIG. 90). Although he complimented him in November 1820, one suspects that like Landon he felt that Rhea resembled more a sleeping nymph than a Vestal, and Mars was in no manner "the frightening god of war" he should be.[2] David instead has an athletic Mars spring on the helpless virgin, whose limp vulnerability as she makes the same commanding gesture as Agamemnon in *The Anger of Achilles* is all the more pathetic. As in the preparatory drawings, she writhes uneasily, anticipating the unfamiliar mix of pleasure and pain which her union with Mars will procure. David's

visual imagination, inspired in this drawing by the muscularity of the nude and the theme of sexual violence, was never closer to the brutal artistic sensibility of Géricault, who with Horace Vernet paid him a visit in Brussels the year before he signed it.

NOTES

1. See notably Prat and Rosenberg 2002, vol. 1, pp. 316 (no. 339), 370–71 (nos. 426–28).
2. "Mars a plutôt la physionomie étonnée et un peu trop naïve d'un jeune pâtre, que celle du terrible dieu de la guerre." Landon 1819, vol. 1, p. 57; the line-engraving by Charles Normand, plate 32. On Guillemot's painting in the Musée Ingres, Montauban, see Ternois 1965, n.p., no. 140. David to Guillemot, 16 Nov. 1820: "A en juger par les gravures plutôt que par les journaux, je vois, mon ami, que vous êtes dans la bonne route. Ne regardez ni à droite ni à gauche, continuez votre chemin, n'imitez personne et vous serez un grand peintre, c'est l'augure de votre dévoué David" (Wildenstein 1973, pp. 220, no. 1885).

FIGURE 90 Alexandre-Charles Guillemot (French, 1786–1831), *Mars and Rhea Sylvia,* 1819. Oil on canvas, 98 x 94⅞ in. (249 x 241 cm). Musée Ingres, Montauban

38 The Rape of Lucretia

1825

Black crayon and white gouache on paper
6⁵/₈ x 7⁷/₈ in. (17 x 20 cm)
Inscribed, signed, and dated, upper right: *donné à Michel Stapleaux / par David Brux. / 1825;* inscribed and signed, lower right: *à ma bru Annette. / David*

Private collection, courtesy of Hazlitt, Gooden & Fox, Ltd., London

PROVENANCE
Anne-Thérèse Chassagnolle (1800–1845), wife of Eugène David, the artist's son; their son, Louis-Jules David[-Chassagnolle] (1829–1886); presumably his descendants; . . . ; 1996, Galerie de Bayser, Paris; private collection, Bologna; sale, New York, Christie's, 23 Jan. 2002, no. 95 (unsold); private collection.

EXHIBITIONS
Never exhibited.

BIBLIOGRAPHY
Th. 1826b, pp. 155–56, 167; Coupin 1827, p. 59; Blanc [1849–76], p. 16; Miette de Villars 1850, p. 225; Cantaloube 1860, p. 302 (no. 15); David 1880, pp. 604, 665; David 1882, fascicle 17 (engraving); Nash 1973, pp. 168–70, 240–41 (nn. 431–37); Brookner 1980, p. 187; A. Sérullaz in Paris-Versailles 1989–90, p. 547; Carroll 1990, pp. 200, 259 n. 3; Sérullaz 1991, pp. 47, 328; Johnson 1997, pp. 70–72.

DAVID MAY have been contemplating a composition on the rape of Lucretia long before 1825, the date of one of the two inscriptions on this drawing. These indicate his hesitation over whether to give the sheet to his collaborator Michel Stapleaux or to his daughter-in-law, who was the eventual recipient. The chain of events that led to the overthrow of the tyranny of Tarquin and the establishment of the Roman Republic was sparked by the rape of Lucretia, the wife of Collatinus, by Tarquin's son. Considering herself dishonored, she chose to commit suicide, while Collatinus and his ally Brutus swore to avenge her. Brutus and Collatinus expelled Tarquin and became the first consuls of the Roman Republic. While David had painted a later episode in the tragic sequence of events, after Brutus' sons joined the Tarquin cause, it had been common since the Renaissance for artists to focus on Lucretia and represent the scene of rape or her virtuous suicide. These pictorial homages most often exploited the voyeuristic and sadistic potential of the drama.

In perhaps the earliest drawing for the composition (FIG. 91), in a sketchbook principally devoted to the *Distribution of the Eagles,* David shows nude the aggressor raising his sword and his cringing victim. The torment inflicted on Lucretia in the final composition, more psychological than physical, is closer to the antique sources: to break Lucretia's resolve, Tarquin's son tells her that if she resists, he will kill her along with the slave he has brought with him and stage her dishonorable death in his arms. David's recurrent fantasizing on hapless love triads finds its ultimate and most pessimistic expression in this composition. As observed by Prat and Rosenberg, historical allusions frame the scene: the seated deity on the left, the relief with the she-wolf on the right. The dedication of this drawing to his son's wife should temper taking this composition too seriously: in spite of its antique trappings, it offers the popular pleasure of melodrama rather than of high tragedy. It is incomprehensible that the roughness of execution should be criticized as labored and the figures as trivial and even repulsive, considering it manifests stylistic and aesthetic qualities that artists freely explored through the middle of the century.

FIGURE 91 Jacques-Louis David, *Studies for "The Distribution of the Eagles" and "The Rape of Lucretia,"* 1808–25. Black crayon on paper, 4³/₈ x 7³/₈ in. (11.1 x 18.6 cm). Musée du Louvre, Paris

CATALOGUE 38

Late Drawings: Experiments in Expression

U NLIKE PIERRE-PAUL PRUD'HON and Jean-Baptiste Isabey, whose drawings were prized by collectors, David's fame in his lifetime rested exclusively on his paintings. Considering himself above all a *peintre d'histoire,* he exhibited a drawing only twice at the Salon, both times early in his career. In 1783 the *Drawing of a Frieze in the Antique Manner* was a declaration of allegiance to the partisans of a break with academic French art, whose influence on him had been strong during his formative years in Rome. In 1791 the exceptionally detailed *Oath of the Tennis Court* was intended to incite visitors to subscribe to an engraving and in this way help finance the projected painting. In fact, if one puts aside some presentation sheets dating from his student years, drawing was fundamentally an instrument for David. Most often, his work in pen or pencil was directly related to his activity as a painter. While a *pensionnaire* at the French Academy in Rome, he produced hundreds of sketches after the antique and works by Old Masters, which throughout his life remained a source of inspiration. While traditionally artists created for themselves a paper museum based on aesthetic criteria, his vision was typological and utilitarian. Although he is generally held responsible for the institutional domination of academic practice during the early nineteenth century, he was surprisingly disinterested in drawing after the life model. It is indeed paradoxical that such artists of the preceding generation as Edme Bouchardon and Carle Vanloo were far more prompt to produce *académies*. Drawn in warm red chalk, their figures adopt those contorted poses denigrated by Diderot as "academic positions" and denounced by David as "the wretched style of the French School."[1] Probably resentful of this production, which inspired a wealth of engravings found in all the studios, he developed a restrained manner in front of the nude model, which attenuated its corporality by insisting on the contours. For this kind of study he limited himself to the small folios of his sketchbooks, and almost always referred to a composition to pose the figure.

During the 1780s, when he elaborated his compositions David progressed from loose, largely undefined sketches to clearly articulated narratives in pen or pencil, often treated with ink wash and white gouache for pictorial effect. Color

was introduced only after the composition was traced in ink on oily yellow paper and glued to a canvas support, a highly personal method meant to counter the formal libertinage associated with the painted sketch.[2] His final drawings for a composition aimed to approximate the effect of the projected picture; the *Oath of the Tennis Court* is perhaps the furthest development in this direction. With the *Sabines* however, there was a hiatus between the composition elaborated on paper and the painted picture. The notable differences between the drawn scenes of Napoleon's coronation ceremonies and the two paintings from the suite David managed to finish, and between the last preparatory drawing for *Leonidas* (SEE CAT. 26) and the finished painting, confirm the establishment of two distinct, if not disconnected, stages of execution and modes of visual expression.

How might this change in attitude toward his drawing practice be explained? In 1789, addressing his pupil Jean-Baptiste Wicar, in Florence to draw the Medici collection for a publication of engravings, David championed the close interdependence of drawing and painting: "Feeling and drawing, these are the true masters to learn to move the brush. Who cares if one makes hatchings to the right, the left, top to bottom, up and down; as long as the light hits the right spots, one will always paint well."[3] More clearly, a remark to another pupil much later reveals that in theory drawing was subordinated to painting and another term for anatomical correction. In 1818, to his pupil Navez, who had gotten wrong the proportions of the child in a picture of the Holy Family—"The thighs are too short or else he doesn't have a belly."—he pleaded: "Drawing, drawing, my friend a thousand times drawing!"[4] The question of style was a different matter however, since it was not a question of principle but of practice. David reacted to other artists past and present and as we have seen, his manner was subject to fluctuations. One of his students in 1810–11, writing to his father, explained: "We assemble our figure in pencil gradually, but firmly; we almost never stump. M. David likes the drawings to be fleshy and soft [gras et moelleux], he doesn't like small details." He further notes: "M. David does not like us to make finished drawings after the antique on big sheets, he wants us to use sketchbooks; in this way, he says, one studies without getting tired." And elsewhere, he makes clear that David "does not want to hear of finished drawings" when working after the model.[5] The master's hostility toward finish and stumping was a reaction to the stylistic one-upmanship that he could observe among artists since his release from prison. His pictorial execution was a critique of the refinement introduced by Anne-Louis Girodet, François Gérard, and Jean-Auguste-Dominique Ingres in their work and the brittle lifelessness of Salon exhibits inspired by his archaizing group of pupils, the *primitifs*. His drawing was, in turn, opposed to the minutiae dear to illustrators and the artificial elegance of practitioners of the *manière noire* of Isabey or the *deux crayons* on blue paper of Prud'hon. These new modes were in his eyes a consequence of the prevalent commercial ethos, in other words they pandered to the

vulgarity of the *nouveaux enrichis* on the social forefront during the Directory. On the subject of Isabey, David's friend, the critic Pierre Chaussard, made clear their shared position concerning this evolution: "drawing will always remain only the cold and inanimate part of picture-making."[6]

This mistrust with regard to drawing that was too polished was perhaps also fueled by nagging memories of the Terrorist regime, whose visual propaganda tended to favor iconic severity. In David's own work, the two versions of the *Triumph of the French People,* both ambitious drawings, shed light on this relation between style and political expression. In the first version the line is supple and lively, evocative of the festive spirit of the early years of the Revolution. Much more controlled, the draftsmanship in the second version is hard and sharp, the wash has the color of steel. The result is frighteningly close to the climate of repression that reigned at the time.[7] Serving as a kind of therapeutic and cathartic exercise, the series of medallion portraits of fellow prisoners executed by David in 1795, among the most highly finished drawings he ever produced, allowed him to reappropriate this graphic mode as his own.[8] They prove that he was able to cater to the virtuoso execution so appreciated by his contemporaries, and that his choice was deliberate to develop a radically different style characterized by a certain roughness. Significantly, this manner was connoted at the time as masculine. An anonymous writer in the art press during the Consulate explicitly invoked "the extreme finish [women] like to give to their works," a comment that was not meant to be derogatory, but matter-of-fact.[9] For David, there was also a moral resonance to this position, in the sense of a parallel between those he had combatted with his brush during the 1780s, whom he called *peintres libertins,* and the younger generation, whose commercial predilections inspired the same reprobation.

The rejection of grace and finish appears extreme in the drawings produced after 1815. The way he exploited the grain of the paper with a soft *crayon noir* produced a rough and velvety visual effect that is at times strikingly close to lithography. The technique, imported from Germany, was experimented with since the beginning of the century, but was mostly considered a *produit de l'industrie* until 1816, when a favorable report on Godefroy Engelmann's *Recueil d'essais lithographiques* was published by the royal Académie des Beaux-Arts (the former arts section of the Institute). After a few short years of presence at the Salons, lithography was duly annexed to the fine arts. For David in exile, the appeal of its distinctive style was favorably overdetermined, since satirists rallied to the liberal opposition employed it, and even as distinguished artists as Guérin, Regnault, Gros, and Girodet gave it a try. His drawing technique was thus imbued with a well-defined air of modernity. That he never chose to produce a lithograph may be explained by his relative isolation in Brussels, away from the enticement of enterprising publishers in Paris, and also by a lifelong mistrust for the milieu of printmakers, most often considered by him parasites who exploited artists while pretending to serve their reputation.[10]

With the recent publication of the catalogue raisonné of David's drawings by Louis-Antoine Prat and Pierre Rosenberg, the full range of his output can be appreciated. If one includes some drawings from 1815 that are extremely close in style and spirit to those that follow, about one hundred and thirty sheets can be assigned to the last ten years of his life. Of these, roughly fifty are studies of single heads (many can qualify as *têtes d'expression*), and forty are portraits, mostly *de souvenir* or in relation to the second version of the *Coronation,* although two of his family were done on the spot (SEE CAT. 55 AND FIG. 108); some twenty prepare the mythological and historical scenes David painted in exile or are independent compositions of a similar nature (see the preceding section). Finally, about thirty, having certain characteristics in common, merit to be considered a set apart, as Arlette Sérullaz first observed in 1989.[11] They represent bust-length or half-length figures—in David's words, "des figures coupées"[12]—usually from two to five, dressed in costumes inspired by antiquity or the Renaissance, and perhaps most important, assembled without a clear narrative intention. They are all about the same size and were probably drawn on pages torn from sketchbooks. In spite of their enigmatic subjects, the gestures and expressions of the figures represented are often demonstratively dramatic in tone and even disquieting. Images of Christ's Passion and the tragic tales of antiquity, or of family conflict codified by Greuze, most often come to mind, although there are also much sweeter scenes of amorous couples, usually tinged with the melancholy of separation. The background is generally blank and no specific setting or space is articulated. Like the other late drawings, these failed to be appreciated until the 1970s and for some scholars were even an embarrassment, signs of decline and possible senility. Their author, however, had no reservations regarding their merit or interest; on the contrary, he considered them to be apposite examples of his talent and he offered a set to the art academy in Ghent in 1825.[13] While in Belgium he gave many of his drawings away as gifts, another indication of his appreciation. Contemporary reception was probably perplexed, however, since after his death those sheets he had kept were not given prominence by the organizers of his estate sale and remained for a long time the property of his family.

As is frequent and perhaps the rule in art history, re-evaluations are predicated on affinities with current trends, which provide conceptual tools for fresh ways of looking and analyzing. That an audience today might find David's mute narratives appealing or simply acceptable is not unrelated to the progressive devaluation of literality in representational imagery during the twentieth century. Traditional belief in the virtue of narration has not resisted the importance given to visual priorities and irrational visions. After abstraction, when representation returned, notably with Dada and Surrealism, it was stripped of its traditional mission to articulate a story as legibly as possible. This evolution and the self-projective protocols of much postmodern art undeniably facilitate the reading, more exactly, a paradoxically open non-reading, of David's mysteri-

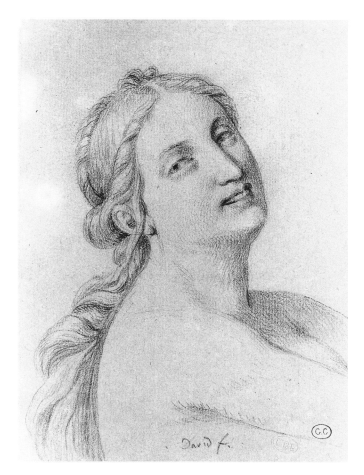

ous scenes. Such a historiographical perspective, which helps to understand the nature of our gaze today, sheds some light on these drawings, but as is well known, it is a light that deforms the object on which it falls. It remains useful, then, to examine the drawings in question with regard to their author's cultural and artistic horizon and at least attempt to imagine how he might have seen them.

The relation of the compositional drawings retained for the exhibition to the many studies of individual heads is patent (FIGS. 92 AND 93). Strictly from this point of view, the proposed focus on multi-figure scenes is arbitrary, for all share the same heavy features. Although some of the heads appear to be studies of stylized classical profiles (SEE CAT. 41) and others show no emotion, many emphatically manifest an expression that tends toward the grimace, an unnatural distortion of the face. During the eighteenth century, art theory and criticism in France were leagued to incite artists to avoid such exaggeration. Whereas Antoine Coypel in 1721, with regard to expression had only reminded painters in passing that "too much is usually found less pleasing than not enough,"[14] the translation of Winckelmann's *Gedanken* in 1786, the first volume of Watelet and Lévesque's *Dictionnaire* in 1788 and Diderot's *Essais sur la peinture* edited from 1795 constituted a front that treated the grimace as the absolute negation of the graceful and noble face. The beautifully idealized figures in David's *Sabines* plead in favor of his alignment with this position. His pupil and biographer

FIGURE 92 Jacques-Louis David, *Figure Study*, c. 1819–23. Black crayon on paper, 8¼ x 6½ in. (21 x 16.6 cm). Musée des Beaux-Arts, Rouen. Gift of Suzanne and Henri Baderou, 1975

FIGURE 93 Jacques-Louis David, *Female Bust*, c. 1819–23. Black crayon on beige paper, 6⅞ x 4⅞ in. (17.5 x 12.3 cm). Musée des Beaux-Arts, Rouen. Gift of Suzanne and Henri Baderou, 1975

Étienne-Jean Delécluze even put these words in his mouth: "Everyone likes clap-traps [*coups de théâtre*], if one does not paint violent passions, if one does not take *expression* to the point of *grimace,* one might be neither understood nor appreciated."[15] Assigned to the period around 1800 when he was first elaborating *Leonidas,* this declaration was probably invented, but the exacerbated theatricality of history painting at the time was widely acknowledged and spurred an ongoing debate provoked especially by the work of Guérin.[16] At the Salon of 1801 Nicolas-André Monsiau's *The Lion of Florence* (FIG. 94) was an exemplary sign of the drift to excess. Like a parody of the afflicted mothers in David's *Sabines,* on show at the time, this one shrieks out when a lion grabs her child. The Salon livret provided the sequel: the lion stops, "looks fixedly" at the woman, and drops his food. Monsiau adopted a strategy of emotional empathy to convince the spectator that his story was true to nature: the scene was recent, suggesting it had been observed, and located in a southern clime, where passions were known to gush forth more spontaneously.

The imitation of stage effects by painters and the concomitant exaggeration of expression was a major leitmotif of François Guizot's review of the Salon of 1810. To refute the new pictorial dogma according supreme importance to "l'énergie de l'expression," he quoted at length the French translation of Lessing's *Laocoon ou des limites respectives de la poésie et de la peinture* published by Charles Vanderbourg in 1802. He quoted the famous argument claiming that the spectator should be allowed to imagine more than what he sees, and that extreme emotions, transitory and hence fundamentally unnatural, will perforce inspire horror and disgust.[17] Guizot singled out *Rodogune* by Jacques-Augustin Pajou, illustrating the scene from Corneille's tragedy when the poison begins to corrupt Cleopatra's features, as a prime example of the period's "obsession with exaggeration" (FIG. 95). To him, all the figures in the painting "look like real madmen."[18] In 1806 Pierre Chaussard had raised a number of similar objections in his commentary of Girodet's *Deluge,* and though careful to spare this impressive work, it led him to reflect on the fact that "all the arts are on their way to exaggeration and thus to corruption." He noted that the "vulgar" increasingly craved strong sensations, and, like several of his contemporaries, acknowledged that the picture in the museum that attracted the biggest crowds was the panel from Gerard David's *Justice of Cambyse,* representing a gruesome flaying. All this was a consequence of the "images terribles" witnessed during the Revolution, an interpretation also proposed by Guizot.[19] It seemed that artists no longer respected any limits and that the foundations of the "temple" might not

FIGURE **94** Nicolas-André Monsiau, *The Lion of Florence,* 1801. Oil on canvas, 76⅜ x 65 in. (194 x 165 cm). Musée du Louvre, Paris

resist, a crisis in classicism often interpreted by historians today as the crucible of romanticism in France.[20]

Notwithstanding this hostile front, a supportive context for artists like Girodet and Pajou carrying out experiments in expression was available. Like many cultural phenomena, its manifestations at first were marginal, and later gained in visibility and authority. Before the Revolution the painter Joseph Ducreux produced a series of paintings and prints that were vigorous and un-selfconscious exercises in grimacing and laughing, exactly what an artist was told not to show. The artist was reputed for his outspoken hostility to the Royal Academy, which refused him admittance on three occasions, not surprisingly, and one imagines that it was with relish that he transgressed its doctrinal limits to expression. After his death in 1802 no one seems to have taken up the challenge of pursuing this vein until Louis-Léopold Boilly, especially during the Restoration. Their aesthetic adventure was buttressed on the notion that goes back to moralizing observers of court life like La Bruyère, that composure was a social disguise, and not the grimace, as was so often claimed. In the early decades of the nineteenth century this idea gained favor, while forced facial

FIGURE 95 Jacques-Augustin Pajou (French, 1766–1828), *Rodogune*, 1810. Oil on canvas, 47¼ x 63¾ in. (120 x 162 cm). Musée Carnavalet, Paris

expressions became a mode of popular entertainment. Two prints after Boilly published in May 1819, *Le Libéral* and *L'Ultra,* a political and generational satire based on portraits of the artist and his father, are particularly suggestive as modern counterparts to certain of David's heads.[21] The volumes of the *Essai sur la physiogonomie* by Johann Kaspar Lavater, in French editions from 1781 to 1801, correlated physical appearance and moral character, and during the years 1808 through 1810 the lectures and publications on phrenology and the "sciences de l'homme" by Franz Joseph Gall, with whom Boilly was in contact, provided a scientific foundation to these artistic experiments.[22]

In institutional circles after the Revolution, though not so audaciously, the desire to visualize the outer limits of expression was also manifest. In 1796, in the context of elaborating a method of art education, a commission of the Institute comprising David and five other members reviewed, among other questions, the need to reform studies of the *tête d'expression.* The commission judged too elementary the canonical designs of Charles Le Brun and recommended that the Leonardo manuscripts, then on their way from Milan to Paris, should be consulted to expand the range of models. This reference to Leonardo implied taking seriously his caricature heads, which were much appreciated during the eighteenth century and known through prints. The commission felt that a more diversified collection of examples would allow artists to develop visual equivalents to more subtle and remote emotional states than those retained by Le Brun. Implicit was the belief that contemporary experience was characterized by a psychological complexity that antiquity and even the age of Louis XIV had ignored.[23] Whereas during the last decades of the Ancien Régime the academic competition for the drawn *tête d'expression* stuck to standard emotions, albeit under pressure to reach a new intensity and, implicitly, to break new ground, the professors of the École des Beaux-Arts after the Revolution invented composite and sometimes bizarre states of the body and mind for the female model presented to the pupils.[24] Perhaps even more than the radical manifestations, this institutional position was an incentive for all including David to enrich the expressive language of the human figure.

During the summer of 1797, twenty-four sheets of "caractères des passions" by Le Brun were shown in the first public exhibition of drawings organized by the museum administration in the Louvre. Among these were some particularly strained faces, such as *Jealousy* and *Acute Body Pain.* The pedagogical purpose of the presentation was made explicit by the availability at the door of a publication relating specifically to the drawings by Le Brun. Some copies of the brochures were sown with blank pages so that artists might draw from the masters, as the text suggested.[25] This interest received confirmation in 1806, when under the auspices of Denon the *Chalcographie du Musée Napoléon* published the series of Le Brun's physiognomic studies comparing men with a variety of animals.[26]

A closely related response was the collection of prints by Jean-Joseph-François Tassaert after pictures in the national museum, launched in 1802. That the initial selection of *têtes d'expression* were from the great masters—Leonardo, Raphael, Luini, Domenichino, Poussin—conferred unquestionable authority on this enterprise which claimed to furnish models for the different *passions de l'âme,* but in fact shunned the more extreme states. Two years later Pierre-Marie Gault de Saint-Germain published an illustrated treatise on the subject.[27] David's own compositions, the *Horatii* and the *Sabines,* were subjected to this sort of flattering citation by engravers toward the end of the Empire, by Louis-Marie Petit and Noël-François Bertrand in particular, although systematically the resulting prints were labeled *tête d'étude,* a more neutral appellation. The production of pedagogical prints of head studies after Old Masters was not new, nor was the practice of making such drawings studies. However, during the Empire and Restoration, because such study prints were published in increasing numbers, their citatory aesthetic acquired a normative status previously not enjoyed. This may explain why the heads that David drew while in exile look so much like studies after paintings, which in only a few instances truly exist.

In front of *Leonidas* exhibited by David in his studio in 1814, commentators fixed above all on the head of the sacrificial hero (FIG. 96). The descriptions and

FIGURE 96 Jacques-Louis David, Head of Leonidas (detail of fig. 82)

readings of his expression are so effusive and wide ranging that they reflect more immediately on their authors than on the artist. However, the painter acknowledged that critics were systematically drawn to the face, in the anonymous biography he inspired in 1824: "What a heavenly expression in the attitude and especially the head of Leonidas!"[28] The general structure of the composition worked to encourage this focus on the visual epicenter of the scene (SEE CATS. 24–26). Although some might be inclined to detect Leonidas' sensual nature in his fleshy lips, by all standards his expression is blank, an empty vessel to be filled by the viewer's imagination.[29] That is, however, except for one detail: the uplifted eyes. These recall with insistence heads by Reni, Dolci, and Sassoferrato at their most solicitous, and even the tragic attitudes of actresses in early eighteenth-century portraits, although certainly not their gesticulation. Since many believed that expression was one domain in which the moderns excelled over the ancients, it seems most appropriate that for the head of the Spartan king, David supplemented, so to speak, a blank-eyed bust of Pericles he had drawn in 1802.[30] The proposed rapprochement with popular religious and theatrical stratagems aims to nuance the exclusively Winckelmannian interpretation of *Leonidas.* The latter is visibly justified by the restraint characterizing the picture, and usually by the claim, invented by Delécluze, that David wanted it to be "more solemn, more meditative, more religious" than his previous compositions.[31] The calm grandeur of the hero's body is undeniable, but contemporaries apparently found it a bore and appreciated the theatrical detail that made so many eighteenth-century critics uncomfortable. That had been the reaction of Pierre-Jean Mariette to the image of Christ in a huge *Ecce Homo* by Charles-Antoine Coypel, who described his figure in 1729 in terms appropriate for Leonidas: "I have him lift his eyes to heaven, as both priest and victim."[32] The face of the Spartan warrior is the source from which much of David's later graphic work flows. The tension between the imitation of Greek models and the fascination for melodramatic modes of expression animating it manifests itself unabated to the end. At times his exploration attains extremes, when he revives almost slavishly the spirit of antique vase decoration (SEE CAT. 41), or invents gratingly dumb faces (FIG. 92).

The sense of emotional release found in David's late compositional drawings is largely repressed in his history paintings from the period (see the preceding section). He employed the graphic medium to keep up with the evolution of modern painting in this direction. In 1820, when he received a visit by Théodore Géricault and Horace Vernet, he could not ignore their position on the Parisian artistic scene. He continued to encourage more orthodox pupils, but also counted on these two independent artists to maintain the reputation of the French School. His sympathy addressed perhaps less the new themes they introduced than their political engagement with the liberal opposition. They had a common foe in nostalgic medievalism, what might be called the troubadour

aesthetic, which had emerged around 1800 and came to be identified with the Bourbon regime. Like the young painters who rallied around him, David probably rebuked Gérard's much-acclaimed *Entry of Henri IV into Paris* (Musée national du Château de Versailles) at the Salon of 1817 as "horribly French, and what everyone in the School now was going after."[33] His attraction to the artistic temper of the liberal opposition was one reason to no longer resist dwelling on the pathos and violence present marginally in his own work. One telling sign was his re-evaluation of compositions he had drawn in the 1780s, but abandoned, presumably because he had judged them too dramatic. In a list of his works dictated to his wife in 1822, he resurrected from oblivion, "Horatius killing his sister Camilla, Caracalla killing his brother Geta in the arms of his mother, and the ghost of his brother [Septimius] appearing to Caracalla a sacrificial offering," images of violence and passion from which he no longer recoiled.[34] The desire to reintegrate such themes into his oeuvre was also a way for David to come to terms with his past, since contemporary critics associated their vogue with the trauma of the revolutionary experience.

With respect to painting, working in crayon on paper was relatively undemanding, both artistically and technically. Whereas the more highly finished drawings of *Mars and Rhea Silvia* (SEE CAT. 37) and *The Rape of Lucretia* (SEE CAT. 38) have a spatial articulation that qualifies them for potential transfer onto canvas, the series of compositions in this section of the exhibition obey to a graphic aesthetic allowing the artist greater freedom. An indication of his profound attachment for this mode was the attempt in 1818–19 to translate into paint the world without perspective and the "figures coupées" characteristic of the drawings in *The Farewell of Telemachus and Eucharis* (SEE CAT. 35) and *The Anger of Achilles* (SEE CAT. 36). He abided by certain rules, which gave the series its coherence, but within that framework there was no limit to the expressive combinations possible.[35]

The narrative indeterminacy of the scenes was a crucial factor that had assuaged a fundamental constraint imposed on picture-making since Alberti. During the sixteenth century some artists managed to explore private fantasies and in-jokes, but the academic system, the Council of Trent, and absolute monarchy all worked to manacle visual representation to the logos. The crisis in the traditional dependence of painting on the text had been brewing all during the eighteenth century, since Roger de Piles had made a persuasive case for the visual autonomy of the work of art. This undermined the notion of a hierarchy of values based on subject matter, and more subversively still, that the natural mission of painting was to depict a story. By 1810 the critic Guizot, who blamed Pajou for representing grimacing and gesticulating actors on a stage, easily pinpointed his fundamental defect: too demonstrative, the painter failed to make the distinction between image and narrative, painting and theater, "an art that shows and an art that tells" ("un art qui montre et un art qui raconte").[36] Other

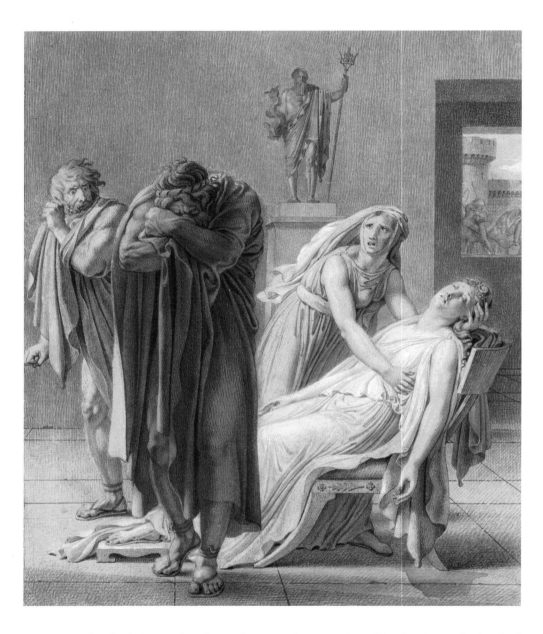

artists had shown the alternative to such overacting. Girodet, in particular, had begun to disassemble his theatrical scenes and create the impression that each figure was immersed in its own emotion, with minimal regard for the others, as in his *Death of Phaedra* (FIG. 97).[37]

The most decisive influence on this general evolution away from traditional narrative was, of course, the normative attitude toward antique statuary and reliefs. It was a commonplace by 1800 that the ancients had imbued their sculpture with an ideal beauty and a power of expression that merited study and imitation. The harmonious rhythm and scansion of mythological sarcophagi had inspired pastiches since the 1770s and 1780s, when Pierre Peyron and David, along with a number of decorative painters, had invented frieze compositions in this mode. In 1803, an inflection was given to this phenomenon by the French edition of John Flaxman's Homeric suites of line engravings, which David is

FIGURE 97 Anne-Louis Girodet (French, 1767–1824), *The Death of Phaedra*, 1798–1800. Brown ink, brown and gray wash, and white gouache on off-white wove paper, 12¹³/₁₆ x 8⅞ in. (32.5 x 22.5 cm). The Horvitz Collection, Boston. On loan to the Fogg Art Museum, Harvard University Art Museums, Cambridge, Massachusetts

reported to have eagerly welcomed in these terms: "This volume will inspire paintings."[38] As the debates provoked by the *primitifs* regarding the classical purity of the *Sabines* prove, for many artists archaism was the new eldorado. Favorably conditioned by Flaxman's outlines, many discovered the visual appeal of engravings after Greek vase decoration. These often presented glaring visual ambiguities that Flaxman had cautiously avoided in his treatment of space and narrative. Whereas before artists might have cited figures or groups from this corpus, familiar since the publication of the William Hamilton collection in the 1760s, henceforth they were receptive to the compositional disarray of the scenes. During the Consulate and Empire, the number of publications reproducing vases attests to a novel vulgarization of antiquarian knowledge and a new appreciation for the naïveté of these models. In particular, the albums edited by David's friend Aubin-Louis Millin helped him forge the aesthetic of his graphic style and his late mythologies. The stylized engravings in these publications fueled the predilection for outré Greek profiles, which for David and his contemporaries functioned now as sign and fetish. Régis Michel has noted: "Here Greece is just an empty form. A pure formalism—or rather: a fetishism."[39]

Another period in the history of art, probably not so expected, exerted its influence on David's art around that time. Shortly after his former master's death, Navez evoked the tenor of his last meetings with him in a letter to Leopold Robert: "Things from the fourteenth and fifteenth century had completely captivated him." He added: "I have a print after Fra Angelico on which he wrote these words: after the Greeks I do not know of anything more sublime than this painting, it is the only style the moderns should follow."[40] David's fascination for Italian trecento and quattrocento painting was part of a widespread re-evaluation, to which Denon as director of the Musée Napoléon had greatly contributed by hanging the "écoles primitives" of Italy and Germany in the Salon Carré during the summer of 1814. Fra Angelico's *Crowning of the Virgin* from Fiesole stole the show and was declared by critics a fit object of study for artists.[41] Although it is not clear exactly how this taste affected his work, except that the profoundly unreligious artist was inclined to draw Madonnas or Madonna-like figures on occasion, it does concur with the archaic compositional formations with which he experimented.

With regard to the *Sabines*, critics had already noted a tendency to subordinate the action to the pose, interaction to juxtaposition.[42] For a variety of reasons, both structural—the definition of art practice in his day—and contingent—the fluctuations of taste—this became the preeminent quality in his late work. The mute dramas David stripped down to bare essentials in his drawings are modest exercises, and yet do not merit to be considered the jetsam of a exceptional and long career. These classicizing vignettes were the fragments of a project too bold and impregnated with contradictions to be fully formulated.

A Scene of Mourning (Composition with Five Figures)

1819

Graphite and black chalk on laid paper
5⅛ x 7⅞ in. (13.1 x 20 cm)
Signed and dated in black crayon, upper
right: *L. David. Brux. 1819* ; autograph
inscription in brown ink, upper center:
*David reconnoissant à Monsieur
Michaud.*

Fine Arts Museums of San Francisco,
Achenbach Foundation for the Graphic
Arts Endowment Fund (inv. 1974.2.11)

PROVENANCE

Given by the artist to "Monsieur
Michaud"; . . . ; according to Prat and
Rosenberg, private collection, Switzer-
land; 1973, Adolphe Stein, Paris; John
and Paul Herring, New York; 1974,
acquired by the Achenbach Foundation
for the Graphic Arts.

EXHIBITIONS

Ixelles 1985–1986, p. 189, no. 147; Paris-
Versailles 1989–90, p. 551, no. 240.

BIBLIOGRAPHY

Sérullaz 1972 [1975]; p. 107 n. 2; Hattis
1977, pp. 245, 249, no. 221; Fried 1993,
p. 226 n. 42; Johnson 1993a, pp. 235–36;
Johnson 1993b, pp. 1030–31; Coekel-
berghs 2000, p. 46; Prat and Rosenberg
2002, vol. 1, p. 320, no. 344 (Cinq per-
sonnages dans des attitudes affligées).

T HE TITLE registered for this drawing tempers
the equivocation at the heart of the image.
In light of the artist's personal situation in Brus-
sels, rather than a scene of lamentation over an
unspecified loss, it could be a reflection on the
torment of exile or imprisonment. The dress,
turbans, and beards evoke more the manner of
illustrating Old Testament and Early Christian
subjects than Greek and Roman history. The
composition, it has been suggested, has affinities
with a painting of Saint Veronica executed under
David's direction in Brussels in 1816 by his pupil
François-Joseph Navez.[1] There seems to be an
inscription on the border of the veil covering
the forehead of the main figure, designating him
as an officiant. There is no articulation of any clear
family relations that might unite the figures, who
all seem locked up in their personal emotion.
Distinct from the others, the man with a cap in
the background appears unaffected by the drama.

The identity of Michaud, to whom David
offered this drawing, has not been discovered,
nor as a consequence, the motive for the gift. But
the fact that the artist considered this harsh image
apposite to thank someone for a service suggests
the nature of the detached pleasure he expected
his compositions might procure. The female
figure recalls one of his Sabines shown pleading
for an end to the fighting, and although the cring-
ing elder in the center lacks the composure of
Belisarius, Brutus, or Homer, he shares their patri-
archal aura. The figure on the right, whose gender
has been diversely interpreted, belongs to a set of
imitations of the expressive heads of Le Brun (CF.
CAT. 45). This figure recalls the one of Marat in
the second version of the *Triumph of the French
People,* lunging toward the spectator, tearing open
his vest and shirt to exhibit his wound. The excess

of drapery in this representation, which lets only
the face come through, might signal a repressed
vision of this revolutionary past.[2] These allusions
to David's earlier work are not meant to suggest
any direct derivations but rather to underline the
sense of familiarity with which he could produce
such compositions.

NOTES

1. Coekelberghs, Jacobs, and Loze 1999, pp. 30–31.
 Navez focused on Old Testament scenes around
 this time, while in Rome; *Hagar and Ishmael* (1820;
 Musées royaux des Beaux-Arts, Brussels) and *Elisha
 and the Raising of the Sunamite's Son* (1821; Parochial
 church, Hulst); reproduced pp. 43, 45. In one of
 David's drawings the presence of a woman with an
 Italian folk veil (Prat and Rosenberg 2002, vol. 1, p.
 321, no. 345, dated 1819) would suggest that he was
 receptive to the innovative work of his pupils in
 Rome; however the earliest paintings with such
 figures reproduced by Coekelberghs, Jacobs, and
 Loze date from 1820–21 (1999, pp. 48, 51).
2. Ewa Lajer-Burcharth (1999) has treated in detail the
 question David's psychic investment in drapery. For
 an example of his fixation on the veiled female figure
 see cat. 44.

CATALOGUE 39

Composition with Three Figures

1819

Black crayon on paper, squared in pencil
6⅝ x 7⅞ in. (17 x 20.2 cm)
Signed and dated in black crayon,
upper left: *L. David. brux. 1819.*

Private collection

PROVENANCE
. . . ; 2000, Galerie Mazarini, Lyons
(La Douleur d'Andromaque); 2001, De
Bayser S.A., Paris (La Douleur d'Andro-
maque); private collection.

EXHIBITIONS
Paris, Salon du Dessin, 2001.

BIBLIOGRAPHY
Prat and Rosenberg 2002, vol. 1, p. 321,
no. 344bis (Deux hommes laurés, vus en
buste, la tête inclinée vers la gauche; à
droite une femme coiffée d'un voile, vue
en buste, de profil à gauche, la tête de
face).

ON THE presumption that the two studies of
male heads crowned with laurels are variants
for the same figure, this composition has been
seen as a late revision of a painting of *The Grief
of Andromache* over Hector's body, exhibited by
David at the Salon of 1783. In at least two other
instances David cited his own compositions in
this way (SEE CAT. 33 AND 34). The drawing radically
condenses the earlier scene, cropping the figures
and eliminating all indication of setting. How-
ever, the Christlike wound visible on the chest of
the foreground corpse has suggested to Prat and
Rosenberg a possible allusion to the martyr images
of Le Peletier and Marat. Whatever its theme, the
drawing is charged with recollections of David's
artistic and political past. The doubling of the
head study, a common feature of preparatory
drawing practice, adds to the iconographic disrup-
tion. As two visions of the same figure, it reveals a
play of artistic and psychological irresolution. As
two different figures, close friends or brothers, it
opens an emotional register of bonding in death
with many resonances in ancient history.

A sense of nervous agitation results from
the proximity of the figures to one another, the
strained pose of the female figure, and the urgency
of her expression. Unusual is the squaring, which
indicates that David envisioned replicating and
perhaps painting the composition, a further argu-
ment suggesting that he may have had a defined
subject in mind.

41 Composition with Three Figures

C. 1816–20

Black crayon on paper
5 3/8 x 7 5/8 in. (13.5 x 19.5 cm)
Signed in black crayon, upper right:
L. David. Brux.

Private collection

PROVENANCE
. . . ; sale Hôtel Drouot, Paris, 31 Jan.
1986, no. 2; private collection.

EXHIBITIONS
New York 1999b.

BIBLIOGRAPHY
Prat and Rosenberg 2002, vol. 1, p. 326,
no. 352 (Deux danseuses et un flûtiste,
vus en buste et vêtus à l'antique).

IN THIS drawing and in another representing three armed Greeks charging (FIG. 98),[1] David most closely imitates engravings after Greek vases. In his *Peintures de vases antiques, vulgairement appelés étrusques,* Aubin-Louis Millin reproduced figures of flutists that could have inspired the central figure.[2] Such stylized hellenism attests to a pronounced divorce between codes of representation for drawing and for painting in the artist's late work. In his paintings, study of the figure from nature acted as a corrective to imitation of the antique, whereas in drawings like this one he attempted to reproduce Greek models more exactly. This unselfconscious pastiche captures a poetic mood explored by a number of contemporary artists when inspired by Longus, Virgil, and Theocritus. But unlike David, they rarely made the same formal concessions to the primitivism of Greek art, a project for a later generation of painters, the so-called *néo-grecs*. In his painting from the period, the artist preferred to maintain a serious tone and created a comparably festive ambiance only in the background of *Mars and Venus* (SEE FIG. 64): his figures of the Graces are a trio that could come straight from one of his drawings.

NOTES

1. Prat and Rosenberg 2002, vol. 1, p. 325, no. 350.
2. Millin 1808–10, vol. 2, pl. XVII. James Millingen abandoned the traditional reference to Etruria in his *Peintures antiques et inédites de vases grecs, tirées de diverses collections,* published in Rome in 1813. David's composition can also be interpreted as a tempered variation on the sculpted relief of frenzied revelers, including a satyr playing two flutes, found on the *Borghese Vase* (Musée du Louvre).

FIGURE 98 Jacques-Louis David, *Drawing of Three Men,* c. 1816–20. Black crayon on paper, 5 1/2 x 8 1/8 in. (14 x 20.5 cm). Private collection

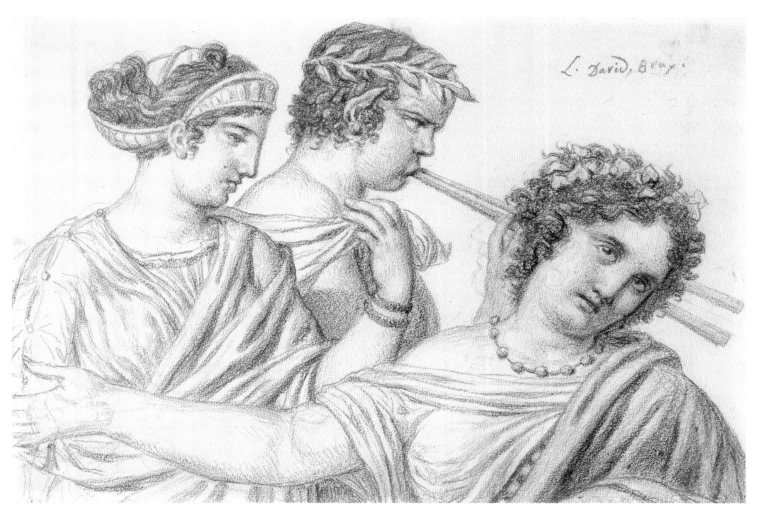

L. David, Bruxl:

42 Composition with Three Figures

c. 1816–20

Black crayon on paper
5¼ x 7½ in. (13.2 x 19 cm)
Signed in black crayon, lower center:
L. David. Brux.

W. M. Brady & Co., New York

PROVENANCE

. . . ; Private collection; sale Christie's,
London, 4 July 2000, no. 185 (Paris with
Juno and Minerva); 2001, W. M. Brady,
New York.

EXHIBITIONS

New York 2001, no. 15.

BIBLIOGRAPHY

Prat and Rosenberg 2002, vol. 1, p. 327,
no. 353bis (Trois figures vues en buste,
l'une coiffée d'un bonnet phrygien,
l'autre d'un chignon, la troisième d'un
casque antique).

THE DRAWING has been identified as a representation of the aftermath of the Judgment of Paris. The Trojan angered Hera and Athena by declaring Aphrodite the most beautiful of the three goddesses and according her the golden apple. The Phrygian cap and the helmet are in effect characteristic attributes respectively of Paris and Athena. However, the helmeted figure is strangely off balance and the manner in which the figures interact in David's representation is, as usual, ambiguous. The unfocused expressions and cacophonous outstretched limbs produce no clear narrative. One commentator has even surmised that the figure on the left, whose long locks and cap evoke the iconography of the Persian-Roman god Mithras, may represent a woman; and the warrior could just as well be a man. In the back, the profile of the woman with her elaborate coiffure recalls similar figures by Regnault and Girodet dating from the Consulate and early Empire, although David's black crayon confers on her disheveled curls an earthiness all his own.[1] David had already elaborated this figure type in *Brutus:* the compact group of the mother and two daughters, when cropped (FIG. 99), offers a spectacle of disorder and suffering that is remarkably close to late compositional drawings such as this one.

NOTES

1. See the drawings reproduced in Cambridge 1998–2000, pp. 332–33 (on the latter page, not Girodet but Regnault; cf. the head study in the Musée Crozatier, Le Puy-en-Velay, inv. 833.1.4).

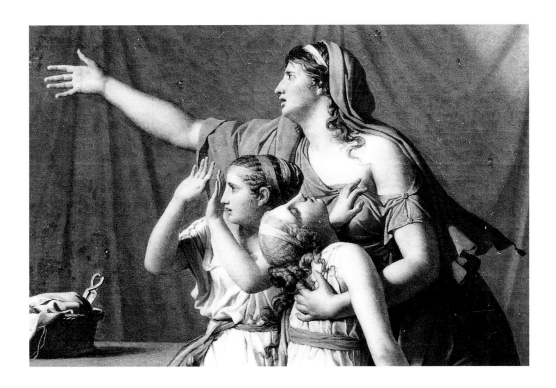

FIGURE 99 Jacques-Louis David, *The Lictors Returning to Brutus the Bodies of His Sons* (detail), 1789. Oil on canvas. Musée du Louvre, Paris

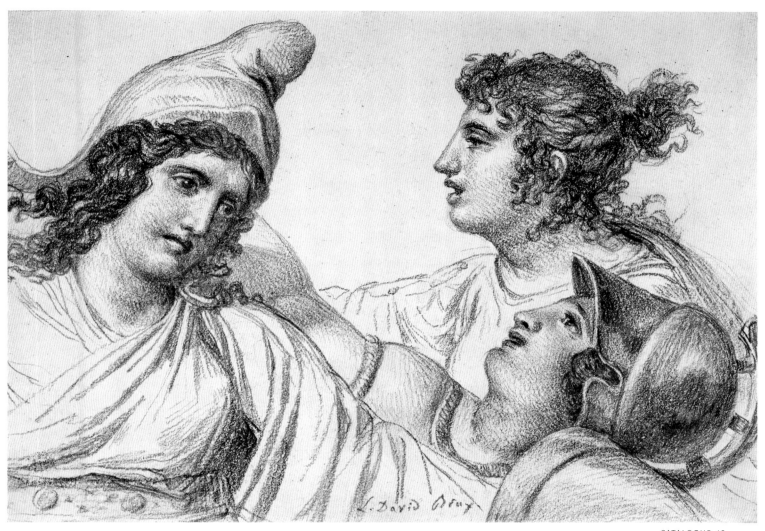

43 The Figure of a Man ("The Prisoner")

C. 1816–22

Black crayon on paper; a drawn line
in black ink frames the image
5¼ x 7¾ in. (13.4 x 19.7 cm)
Signed in black crayon, upper left:
L. David, Brux.

The Cleveland Museum of Art.
Purchase from the J. H. Wade Fund
(inv. 73.36)

PROVENANCE

. . . ; sale Hôtel Drouot, Paris, 9 Feb.
1972, no. 13bis (Étude d'homme. Le
Forçat); Adolphe Stein, Paris and
London; 1973, acquired by the museum,
with a contribution from the J. H.
Wade Fund.

EXHIBITIONS

Ixelles 1985–86, p. 189, no. 148 (Le pri-
sonnier); Paris-Versailles 1989–90,
p. 554, no. 245 (Le prisonnier).

BIBLIOGRAPHY

Nash 1973, p. 241 n. 439; Sérullaz 1972
[1975], p. 107 n. 2; A. Schnapper in
Ixelles 1985–86, pp. 28, 189; Johnson
1993a, pp. 231, 237; Johnson 1997, p. 30;
Lajer-Burcharth 1999, p. 324 n. 94; Prat
and Rosenberg 2002, vol. 1, p. 352, no.
393 (Homme vu en buste, coiffé d'un
turban en partie défait, le torse nu, le
visage appuyé sur la main droite, une
châine derrière lui, dit "Le prisonnier").

THE FILIATION of this melancholy figure
with the plague victim in the foreground of
David's *Intercession of Saint Roch* (1780) has been
noted, as well as with the turbaned figure of
Marat (SEE FIG. 52).[1] Once again his late drawings
are visual commentaries on images from earlier in
his career. Most recently Prat and Rosenberg have
proposed a physiognomic and biographical rap-
prochement with Napoleon, who died in 1821, a
prisoner on the island of Saint Helena. These reso-
nances are most plausible since David sought to
illustrate the notion of incarceration by framing
the figure with a chain, low wall, and lamp, drawn
more lightly. These dispersed elements are intro-
duced more as symbols than as accessories, as if
to prevent the emergence of an anecdotal narra-
tive. The face, modeled with great care in spite of
a manifest sulkiness, exudes a air of resistance,
which the muscular body reinforces.

NOTES

1. Lajer-Burcharth observes furthermore that "the
 turban has often been used in David's work as an
 attribute of the male subject in crisis" (1999, p. 324
 n. 94).

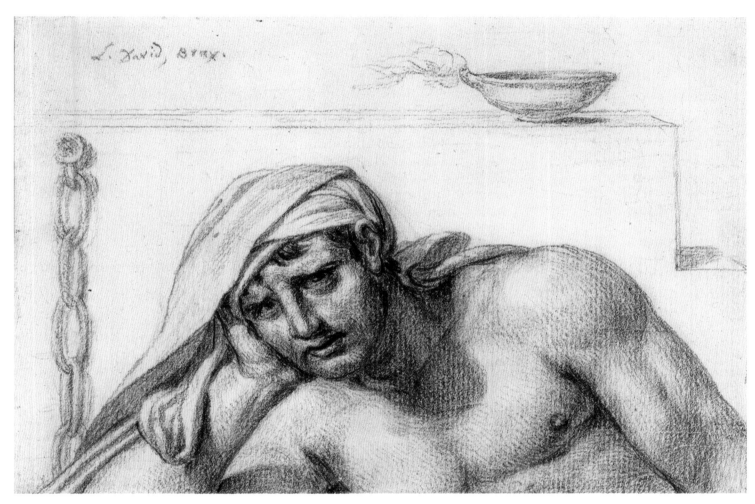

44 Composition with Three Figures

1821

Black crayon on paper
5¼ x 7⅝ in. (13.5 x 19.5 cm)
Signed and dated in black crayon, upper
center: *L. David Brux. 1821.*

The Horvitz Collection, Boston. On
loan to Harvard University Art Muse-
ums, Fogg Art Museum, Cambridge
(inv. D-F-330/1.1996.9)

PROVENANCE
. . . ; sale Rouen, 26 Apr. 1992, no. 2;
James Mackinnon, London; 1995,
acquired by Jeffrey E. Horvitz.

EXHIBITIONS
Never exhibited.

BIBLIOGRAPHY
Alvin L. Clark in Cambridge 1998–2000,
p. 415, no. A.97 (Head and Expression
Studies); Prat and Rosenberg 2002, vol.
1, p. 375, no. 434 (Un homme à demi-nu
soutenant une jeune femme défaillante,
devant un vieillard à gauche au second
plan).

A NUMBER OF factors might explain David's
patent fascination in his late drawings for
female figures with veils over their eyes.[1] The most
obvious motivation was surely to demonstrate the
virtuosity of his crayon. In the portrait of the
Lavoisier in 1788 he had placed a number of glass
instruments, which allowed him to play with pic-
torial effects of transparency and surface. The veil
over the eyes is also resonant with the impending
darkness of death, as in this composition, where
the female figure seems on the verge of expiring.
In another drawing, of a buxom woman in profile,
with full breast and erect nipple, the veil is more
conventionally treated as an element of coy seduc-
tion, a perverted allusion to the traditional
attribute of the modest and pure Vestal. During
the Revolution, the metaphor was much employed
to denounce the evils of religion, corruption,
hypocrisy, and deceit: the veil needed to be torn
and truth revealed. One particularly frequent
verbal image from this period was the statue of
Liberty temporarily veiled to evoke the social con-
trol imposed by the Committee of Public Safety:
the Terror. In this sense, the pathetic image of the
veiled woman could also have been an allegory of
France under the Bourbons, a response to the
anti-Napoleonic prints on the theme of "La
France outragée."[2] As with *The Prisoner* (SEE CAT.
43), the possibility of an oppositional content in
David's late drawings is only beginning to come
into focus.

NOTES

1. The frequency of this motif is noted by Prat and
 Rosenberg (2002, vol. 1, p. 357). Along with this
 drawing, see pp. 327 (no. 353), 353 (no. 394), 357
 (no. 402).
2. The print with this title, showing an allegory of
 France placed in chains by Napoleon, was produced
 in August 1815 by one of David's pupils, Pierre-Marie
 Bassompierre; the composition is borrowed from a
 print by Prud'hon. See Mathis 1998, p. 483, no. 274.

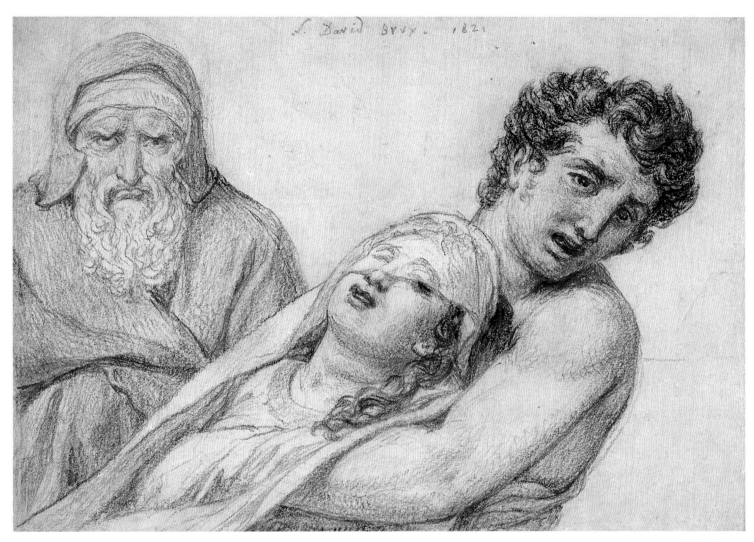

45 Composition with Four Figures

1821

Black crayon on paper
5¼ x 7⅝ in. (13.3 x 19.5 cm)
Signed in black crayon, lower center:
L. David. B. 1821.

James Mackinnon, London

PROVENANCE
. . . ; James Mackinnon, London.

EXHIBITIONS
Never exhibited.

BIBLIOGRAPHY
Prat and Rosenberg 2002, vol. 1, p. 375,
no. 435 (Scène de déploration auprès
d'un enfant mort).

APPARENTLY RELIEVED to find a coherent narrative, Prat and Rosenberg designate the cause of the tragedy they see represented as the "cadaver of the child" on the right. The baby looks healthy enough and might simply be napping. It is true, however, that the woman hovering over the infant adopts a traditional pose of lamentation. The swoon of the adolescent on the left is totally enigmatic, while the central figure seems a variation on Le Brun's successive expressions of pain. The composition recalls the construction of a three-headed allegory (Prudence) or monster (Cerberus). Most significant perhaps is that each of the figures ignores the others, in sharp contrast to compositional doctrine lauded during the eighteenth century. Whatever the exact situation, the theme of emotional separation is present, since the complementary nature of the figures alludes strongly to shared family ties. In the *Horatii, Brutus,* and *Sabines,* David had illustrated different aspects of this theme of a family unity shattered by tragedy and violence. Although relatively mute and far less ambitious, this ultimate variation is perhaps the most somber. That the drawing dates from 1821, when from May news of Turkish atrocities against the Greeks appeared in the press, might help account for this. During their War of Independence the modern Greeks were often cast by the Europeans in the guise of their ancient forebears.[1]

NOTES

1. Athanassoglou-Kallmyer 1989.

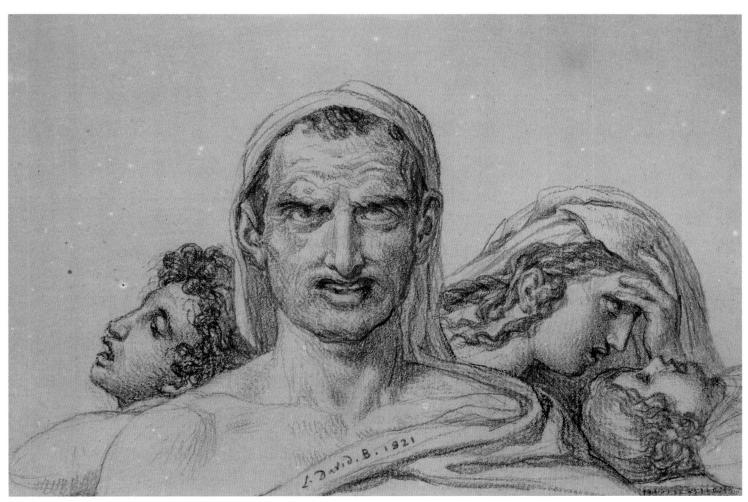

46 Composition with Three Figures

1821

Black crayon on paper
5⅜ x 7¾ in. (13.5 x 19.8 cm)
Signed and dated in black crayon, upper left: *L. David. Brux. 1821.*

Collection of Dr. Esmond Martin

PROVENANCE

. . . ; Private collection, France; Wildenstein and Co., New York; 1963, Dr. Esmond Bradley Martin Jr., Nairobi; 1967–69, on loan to the Walker Art Gallery, Liverpool; since 1970, on loan to the Denver Art Museum (1.1970).

EXHIBITIONS

Denver 1982, no. 11; Ixelles 1985–86, pp. 186–87, no. 141 (Trois études de têtes); Paris-Versailles 1989–90, p. 552, no. 242 (Trois études de têtes).

BIBLIOGRAPHY

Nash 1973, pp. 171, 241 n. 439; A. Schnapper in Ixelles 1985–86, pp. 28, 189; Johnson 1993a, pp. 233–34; Johnson 1997, pp. 31–32; Prat and Rosenberg 2002, vol. 1, p. 375, no. 436 (Une femme couronnée, se retournant vers une vieille femme défaillante que soutient un jeune homme [?]).

THE SUBJECT of this drawing has been interpreted as a scene both of anger and of pity.[1] Although the spiked crown is sometimes negatively connoted, as in caricatures of Robespierre after Thermidor, it appears frequently in allegorical and decorative representations, especially of female heads, with no such associations. Much later such a crown would be judged appropriate for Bartholdi's *Statue of Liberty.* The old woman who is the main object of attention in the composition appears to be asleep and impervious to the scene. It is by no means certain that the figure with a headband—a male, since women are generally represented wearing veils—is supporting her.

Antoine Schnapper proposed an interesting key for the reading of this mysterious mise-en-scène. He finds affinities with *têtes d'expression* drawn after Daniele da Volterra's *Descent from the Cross,* which, as David's annotations indicate, are meant to characterize *Affliction Eager to Relieve* and *Affliction Tinged with Compassion.*[2] Although the head invented in the composition is much less self-contained than these two, it is probably meant to function as a representation of what Le Brun termed a "passion composée," and what a Salon critic in 1785 had praised as "the art of fusing two intricate feelings within the same face."[3]

NOTES

1. "A queen wearing a sharply spiked crown, probably emblematic of her thorny personality, contemptuously yelling at an older woman who bows her head in sorrow and humiliation, while a third figure, unhappy witness to this conflict, looks askance at the sharp-tongued queen" (Johnson 1997, p. 33). Prat and Rosenberg wonder whether the face of the crowned woman "traduit la colère ou la pitié" (2002, vol. 1, p. 375).

2. Prat and Rosenberg 2002, vol. 2, pp. 768–69, nos. 1237–38. The annotations on these drawings ("La douleur empressée à secourir," "La douleur mêlée d'attendrissement") and on two others from the same suite ("Colère noble et élevé," after Reni [no. 1236], "L'abattement ou extrême Douleur," after da Volterra [no. 1239]) suggest that David copied them from prints with these indications, rather than the copy of the *Descent from the Cross* by Odevaere he owned, as does the fact that they are not all after da Volterra. Widely different dates for this suite have been proposed.

3. *Le Frondeur ou dialogues sur le Sallon par l'Auteur du Coup-de-Patte et du Triumvirat* ("l'art d'unir sur les mêmes traits deux sentiments compliquées"), cited by Levitine 1954, p. 40.

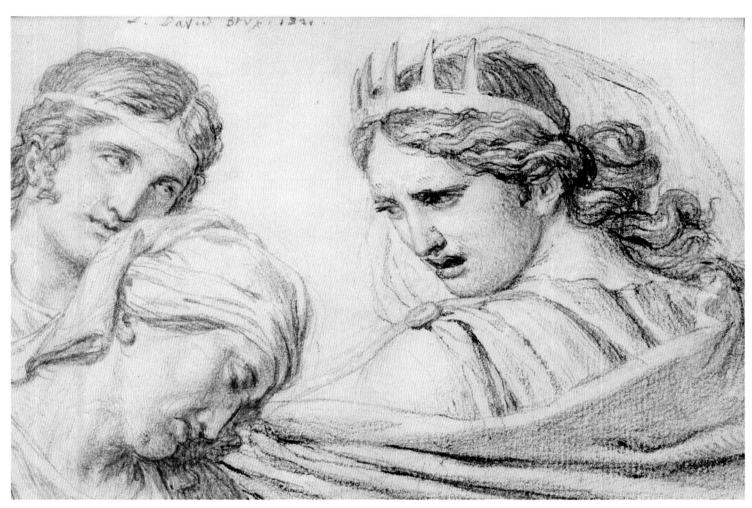

Portraits in Exile

Is THERE AN artistic context for the portraits painted by David from 1816 until his death in 1825 that might shed light on their conception and stylistic evolution? In the 1780s he had painted in various circles of Parisian high society, for attentive patrons and connoisseurs who kept abreast of changing fashions in portraiture. During the Empire he had worked at court with officials who positioned themselves according to the tastes and orders of the emperor, and at home he was surrounded by his family, who only made demands for likenesses. Brussels offered neither a stimulating contemporary art milieu, nor a court, nor even a domestic environment that might inspire him, only dialogue with a self-effacing wife. Of course, he had brought with him recollections of the Salons and the museum, and he could always explore the resources of the Flemish and Dutch traditions of portraiture, although whether he actually did and to what effect remain moot points. To an extent never before experienced, he found himself in a context of creative isolation. Whereas the historical compositions progressed by self-referentiality, each new one conceived in response to those completed, the production of the portraits seems disconnected and even haphazard. The rhythm was irregular: six in 1816 to cover the costs of getting settled (*Charles-Jean-Marie Alquier,* destroyed by fire in 1871 along with cats. 47–51), two in 1817 (*Alexandre Lenoir* [SEE FIG. 58], begun in Paris, and *Emmanuel-Joseph Sieyès* [FIG. 100]), two in 1820 (SEE CATS. 52 AND 53), one in 1821 (SEE CAT. 54), and again in 1824 (SEE CAT. 56). To this short list can be added the suite of portraits, many brought up to date, in the replica of the *Coronation* finished in 1822.

The determinant influences on his portrait practice were not primarily artistic. There was above all the presence of the past, the years of Revolution and Empire mulled over unceasingly by the exiles, who waged solitary battles to quench their contradictory desire to remember, to rewrite, to praise, to regret, and to forget.[1] This affected David's choice of patrons and his attitude toward them, feelings of sympathy inevitably, admiration on occasion, and more rarely deference. Like the painter, Alquier, Sieyès, and Ramel de Nogaret had been front-line actors of the Revolution; Turenne and Gérard incarnated the military grandeur of Napoleon's army, while Joseph Bonaparte's daughters and niece

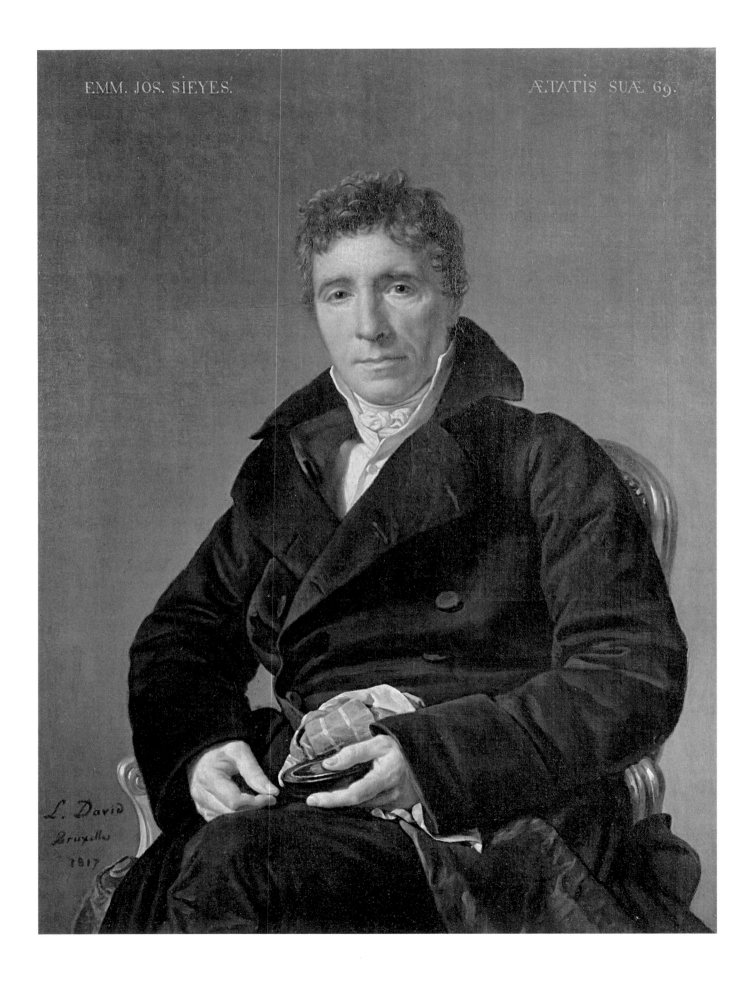

EMM. JOS. SIEYES.

ÆTATIS SUÆ 69.

L. David
Bruxelles
1817

figured the imperial family. There was also the pressure of the present, the impact of an increasingly confident and pervasive bourgeois imaginary of social comportment, family relations, taste, fashion, and property, which conflicted with his egalitarian vision of sitters as individuals, freed by his brush from their niche in society.

During the troubled period of 1814–15, concluded by his departure from France, David worked on very few portraits, perhaps only one. This was the small bust-length of the lawyer Jean-Louis Delahaye, whom he engaged to look after his affairs in Paris, and whose portrait was probably an advance on his commission.[2] When he left toward the end of January 1816, he must have imagined the difficulties that lay ahead and how to best meet them. For about a year he cast himself as a portrait painter, a role that until then he had never assumed so fully.

A few months after his arrival in Brussels, he received and turned down an offer to settle in Berlin as first painter to the King of Prussia. He was flattered, and gave publicity to the invitation, but not without reason, he feared finding himself once again caught up in court intrigues and rivalries. A staunch nationalist, he was further averse to the prospect of serving a nation that had warred for so long against France.[3] In August 1816, he invoked this solicitation to add weight to the proposition submitted to the governor of Brussels to oversee all artistic matters in the Netherlands. He may have accepted to paint for comte Vilain XIIII his wife, and for the Prince de Gavre his son, two native aristocrats with connections at court in The Hague, but he was no more successful than when he had made a similar proposal to the first consul. The perspective of an exclusively private practice prompted the need, manifest from 1818 to 1820, to voice the ideal of the morally and financially independent artist he felt he had achieved: an artist who was learned and proud, unwilling to work on command, needing neither a protector nor the administration, and who relied only on the talent heaven had bestowed to live comfortably.[4]

While one may regret not having a royal effigy of Willem I by David, it is perhaps more unfortunate that the artist never realized an extraordinary project for a painting illustrating Germaine de Staël's novel *Corinne*, in which the heroine would adopt the features of the author. During the summer of 1818 Juliette Récamier contacted David on behalf of a group of admirers wanting to commission "a monument erected to the memory of this famous woman" who had died the year before. She suggested two passages in the novel that might be of particular interest: Corinne's luminous triumph on the Capitol in Rome and her more somber improvisation at Cape Miseno, near Naples. David wrote back that he was honored to be involved in the celebration of de Staël's memory and promised to reread *Corinne* without delay. In September he replied that he had retained the more classical scene of *Corinne's Crowning on the Capitol* and even executed a summary drawing. A triumphal theme demanded depiction on a grand scale; he proposed to paint a canvas about thirteen by sixteen feet

FIGURE 100 Jacques-Louis David, *Portrait of Emmanuel-Joseph Sieyès*, 1817. Oil on canvas, 38½ x 29⅛ in. (97.8 x 74 cm). Fogg Art Museum, Harvard University Art Museums, Cambridge, Massachusetts. Bequest of Grenville L. Winthrop

(4 x 5 m), roughly the size of the *Sabines* and *Leonidas,* with a host of life-size figures. He would need eighteen months to complete it, and asked for forty thousand francs, a sum probably determined by the price of fifty thousand francs he had put on each of those pictures. He requested a "good portrait of this illustrious woman to adapt it for the main figure of the painting" and offered to begin the following spring. Prince Augustus, the Prussian king's cousin and Juliette's suitor, who was covering the expenses, probably found his project too ambitious and his price too high, for the following spring he and his muse made an identical proposition to François Gérard. The latter demanded almost as much time, fifteen months, but less than half the price, eighteen thousand francs, and also preferred the more romantic Neapolitan scene (1819, Musée des Beaux-Arts, Lyons).[5] In spite of the virtuality of the whole affair for David, worth underlining is his unbridled disposition to consider a contemporary novel a legitimate source of inspiration for a major work, and to place an individual portrait in the imaginary scene.

FIGURE 101 Belgian School, *Three Ladies of Ghent (Isabelle Rose van Tieghem, Wife of Anselme Morel de Tangry, and Her Two Daughters),* c. 1820. Oil on canvas, 51⅞ x 41⅜ in. (132 x 105 cm). Musée du Louvre, Paris

It is thus somewhat surprising that the portraits he did execute were so conventional. Portraiture was not an activity that incited his imagination to roam. On the contrary, through expression and gesture, his effigies convey a belief in the virtues of self-control and restraint, as if the slightest hint of affectation on canvas was a reprehensible resurgence of the *manière française*. This staid portrait mode had an immediate and powerful impact on portrait painters working in Belgium (FIG. 101). David taught them to no longer look up to the sitters, but to face them as equals, and to focus on their physical presence. During the twentieth century, many of these portraits by contemporaries, often embellished by a fake signature, sold and exhibited to great acclaim, were considered representative of David's manner in Brussels. By 1990, after the exhibition of Belgian neoclassicism in Ixelles and the David retrospective in Paris, only the small number listed in the *Vie de David* by "A. Th." in 1826 were accepted as autograph. Indeed, since David made sure that every picture he executed received due publicity, it is more than improbable that others should exist (see, however, CAT. 55). The discarded portraits should not, however, be neglected. Close in style to the autograph paintings, they reveal the qualities that characterize David's manner. Some are overly descriptive in the treatment of dress details or facial features; others are too idealized, offering graceful curves and contours closer to the art of Ingres.[6]

Are these portraits in exile, *faciebat in vinculis,* done while in chains, as David proclaimed when he signed the replica of the *Coronation* in 1822? If some of David's sitters were not identified as victims of royal proscription, would it be possible to read their misfortune into their faces? If some of the portraits were not dated, and if costume and furniture history were not so precise, could it be determined that the one who painted them had fallen on hard times? That David needed to so often remind himself and others how happy he found life in Brussels might suggest that all was not well. He was, it seems, disappointed that Charles X did not call him back in 1824, upon succeeding to Louis XVIII. A psychoanalytical critique, of course, will always be tempted to argue that his equanimity and energy were sure signs of repressed mourning and depression. Whether this was true or not, the chains of exile do not appear to have weighed down on his portraits, any more than on his history paintings. The chains, like the affirmed well-being, the sale of the *Sabines* and *Leonidas* to the Bourbons and their placement in the Luxembourg Museum, the successful exhibition of *Mars and Venus* in Paris, the series of engraving operations, some clandestine, were all part of the cause he defended until the end: the common heritage of the Revolution and Empire and a future that would espouse its ideals of liberty, equality, and fraternity.

47 Portrait of the Comtesse Vilain XIIII and Her Daughter

1816

Oil on canvas
37½ x 30 in. (95 x 76 cm)
Signed and dated, right:
L. David / 1816. BRVX.

National Gallery, London (inv. NG6545)

PROVENANCE

Comte Philippe-Louis Vilain XIIII
(1778–1856) and his wife Sophie de
Felz, comtesse Vilain XIIII (1780–1853),
Château de Leuth (Limburg); their
eldest son, comte Charles Vilain XIIII
(1803–1878), Château de Leuth; his de-
scendants in Belgium until 1993; Artemis
and Colnaghi, London; acquired by
the museum, with a contribution from
J. Paul Getty, Jr. (through the American
Friends of the National Gallery).

EXHIBITIONS

Brussels 1889, no. 52; Paris 1948, p. 101,
no. 74; Charleroi 1957, no. 8; Ixelles
1985–86, p. 420, no. 413 (catalogued but
not exhibited).

BIBLIOGRAPHY

Th. 1826a, p. 242; Th. 1826b, p. 166;
Coupin 1827, p. 57; Blanc 1845, p. 212;
Delécluze 1855 [1983], p. 368 n. 1; Seigneur
1863–64, p. 367; David 1880, pp. 583, 650;
Saunier [1903], p. 119; Cantinelli 1930,
p. 148, no. 148; Florisoone 1948, p. 260;
Cooper 1948a, p. 279; Holma 1940, p.
129, no. 154; Hautecoeur 1954, p. 265;
Verbraeken 1973, p. 30; Wildenstein
1973, p. 206 (no. 1798), 227 (no. 1938);
Schnapper 1980, pp. 290–91; D. Coekel-
berghs and P. Loze in Ixelles 1985–86,
p. 439; A. Schnapper in Ixelles 1985–86,
pp. 30, 420, no. 413; A. Schnapper in
Paris-Versailles 1989–90, pp. 514–15;
Coekelberghs and Loze 1993, p. 1053;
[Leighton] 1994; A. Wintermute in New
York 1994a, pp. 19–25; A. Wintermute
in New York 1996, pp. 74–75; Lee 1999,
pp. 292–93; Coekelberghs, Jacobs and
Loze 1999, p. 26; Bordes 2000, p. 276;
Jones and Galitz 2000; Allen 2001.

SOPHIE DE FELZ belonged to a noble family from Ghent established in Brussels. In 1802 she had married vicomte Philippe-Louis Vilain XIIII, mayor of the town of Bazel in the Waasland, to the west of Antwerp, where his family château was located. The quirky appendage to his family name (XIIII) was in use from the sixteenth century, but its origin remains obscure. With the annexation of the Belgian provinces to the French Republic and Empire, the couple was drawn to the Napoleonic court in Paris. Eager to entice the old aristocracy to integrate the imperial elites, especially after the marriage to Marie-Louise, the emperor took on Philippe-Louis as one of his many chamberlains, and named him Comte de l'Empire in June 1811; whereas Sophie was appointed *dame du palais* to the new empress, and that same month participated in the baptism of Napoleon's son, the king of Rome. To remember this exciting visit to Paris the Flemish couple each sat for their *physiognotrace* portrait by Edmé Quenedey near the Palais-Royal (FIG. 102).[1] After the fall of Napoleon and the establishment of the kingdom of the Netherlands, Vilain XIIII became chamberlain to the new king Willem I, and was elected to the States General, where he joined forces with the liberal party. In May 1816, when his wife sojourned in Brussels for the sittings with David,

he was in The Hague for the meeting of the royal assembly.[2]

Most interestingly, five letters from Sophie to her husband, sent between 13 May and 5 July 1816, evoke her appointments with the exiled painter.[3] How she entered into contact with him is not known. It has been proposed that the architect from Lille, François Verly, might have served as an intermediary; at the time he was remodeling the couple's *hôtel* in Brussels and in contact with the local Académie des Beaux-Arts, and he later worked on David's own house.[4] The painter's presence in Brussels was public knowledge, and word surely got around local aristocratic society that he was accepting portrait commissions. No doubt titillated that such a famous artist was available, the couple probably contacted the painter directly, and an unknown fee and calendar were agreed to. In spite of his republican sympathies, David was unfailingly flattered by the patronage of princes and aristocrats, and Vilain XIIII may have wanted to support the former first painter in troubled times. The letters indicate that the sittings took place in the painter's studio, from eleven in the morning to around three in the afternoon. It took a full session for him to paint Sophie's forehead and eyes; another for her nose and cheek. Three months pregnant, she found the sittings tiresome and David boring, but was happy with the resemblance, as were the other women in her entourage. When she found it capricious for him to have her dress up when he was focused on painting her hair, he explained that it was "necessary for

FIGURE 102 Edmé Quenedey (French, 1756–1830), *Portrait of the Comtesse Vilain XIIII*, 1811. Engraving from physiognotrace, diam. 2 in. (5 cm). Bibliothèque nationale de France, Paris

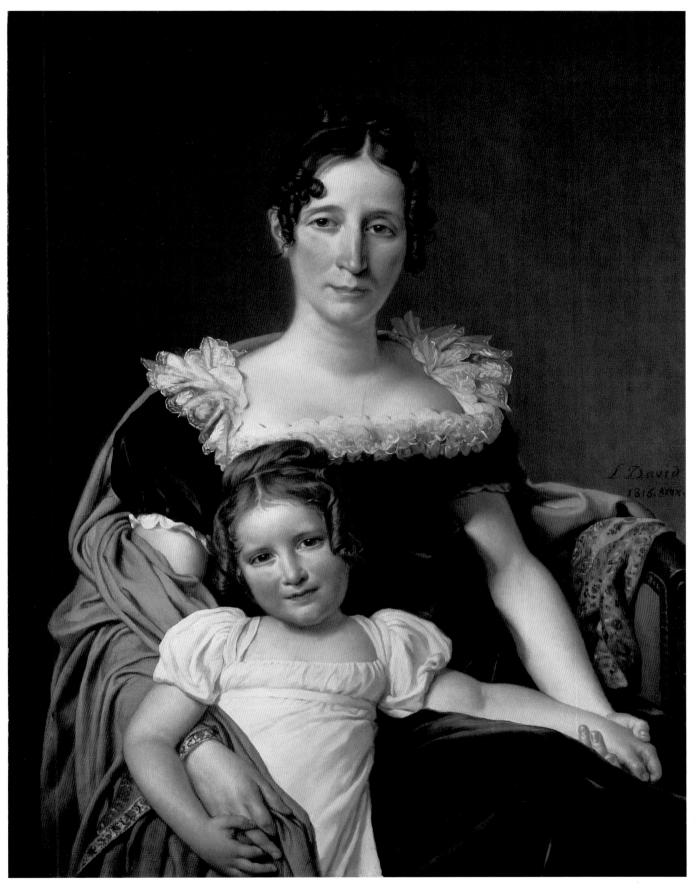

the general effect."[5] Only the last letter preserved mentions her eldest daughter Louise, in fact Marie-Louise (born in November 1811 and probably named after the empress), who posed with her. Most intriguing in this letter is reference to her husband's fearing that David might dare take some "action" concerning the portrait. It may have involved giving publicity to the fact that one of the king's chamberlains was patronizing an exiled regicide, or it may have concerned the payment of the picture, a question discussed in the same phrase, perhaps an increase in price if initially the child was not to be included. Sophie appeased her husband's anxiety by evoking the comte de Turenne (SEE CATS. 48 AND 49), who would not be pleased and whose opinion David was known to respect.

It is possible that the portrait was first composed without the girl, in David's familiar three-quarter-length format. David was working from the head down and could easily have inserted the second figure without much modification. Once set on painting a double portrait, he no doubt reflected on the iconographical tradition of the Virgin and Child.[6] For David's generation, the images of mother and child in this vein that had made the most impact were those exhibited at the Salon in the late 1780s by Élisabeth Vigée Le Brun, above all her self-portrait with her daughter Julie in the Salon of 1787 (1786, Musée du Louvre, Paris). Both David and François-André Vincent, among others, were responsive during the 1790s to this sentimental celebration of the good mother.[7] Unlike Vigée Le Brun and Vincent however, David restrains the effusion of maternal affection: perhaps a reflection of his pedagogical principles, the child is kept at arm's length and not allowed to embrace the adult. The complementary play of the hands in an active-passive mode, with each figure tenderly grasping the other, is the main locus of sentiment. This discrete formality is closer to the spirit of Gérard in his official Napoleonic portraits, for example *Hortense de Beauharnais, Queen of Holland, with Her Son* (1807) or *Elisa, Bonaparte-Bacciochi, Grand Duchess of Tuscany, with Her Daughter* (1811).[8] While other portraitists took pains to enliven their compositions by suggesting the charm of the mother with a slant of the head and the impatience of the child with a brusque gesture, David aimed for dignity and calm. As in

his portrait of comtesse Daru (SEE CAT. 18) but with greater suppleness, the seated figure is securely locked into the shallow space structured by the armchair and the folds of the drapery. With respect to this earlier portrait, he has registered the fashion taste for more lace frills around the neckline, darker colors, and heavier cloths: dark blue velvet has replaced white satin. The more intense contrasts are also characteristic of the evolution of his palette during these later years in Brussels.

NOTES

1. The engraved portrait of Sophie, signed and dated 1811, is in the Bibliothèque nationale de France, Département des Estampes et de la Photographie, Oeuvre de Quenedey, Dc 65b, no. 28, folio 12. On the previous folio is the portrait of her husband.

2. For further references and information see A. Wintermute in New York 1994a; and Jones and Galitz 2000.

3. The pertinent passages are published by Jones and Galitz (2000, p. 303). Excerpts were previously published by A. Wintermute (New York 1994a; New York 1996).

4. Jones and Galitz 2000, p. 302.

5. "Je commence à croire que mon portrait sera fort bien, mais il faut avouer que c'est cruellement ennuïeux, j'ai eu avant hier une séance de onze heures à 3½, pour le front et les yeux, hier de onze à 2¾, pour le nez et les joues, aujourd'hui il fera le menton et [la] bouche." Comtesse Sophie Vilain XIIII to Comte Philippe-Louis Vilain XIIII, 16 May 1816. "[J]e n'en suis encore avec David qu'à faire ma poitrine, hier il m'a fait poser et habiller depuis onze heures jusqu'à 3 uniquement pour faire mes cheveux, j'ai prétendu que de me faire habiller était une fantaisie, mais il a soutenu que cela était nécessaire au ton général, je t'assure que cela est fort ennuïeux." 18 May 1816. For references, see note 2 above.

6. On the basis of visual affinities, Allen has proposed that David "refashioned" the Bruges *Madonna and Child* by Michelangelo (c. 1504–5, Notre-Dame, Bruges), which had been transported to Paris during the Revolution and Empire (2001, p. 18).

7. For Vigée Le Brun, see examples in Fort Worth 1982, pp. 73, 75, 106; see also the portrait of *Madame Pierre Rousseau and Her Daughter* (Salon of 1789, Musée du Louvre, Paris). For David, see *Louise Pastoret and her Son* (c. 1791, The Art Institute of Chicago) and *Émilie Sériziat* (fig. 62). For Vincent, see the presumed portrait of *Marie-Anne Barrère, Wife of François-Bernard Boyer-Fonfrède, and Her Son* (1796, Musée du Louvre, Paris; repr. by Lajer-Burcharth 1999, p. 69, fig. 30).

8. See the reductions of these portraits (Musée national du Château de Versailles) in Cantarel-Besson and Constans 2001, pp. 73 (fig. 45), 80 (fig. 61).

48. Portrait of Comte Henri-Amédé de Turenne

1816

Oil on canvas

27½ x 20⅞ in. (70 x 53 cm)

Signed and dated, lower left:
L. David / 1816

Sterling and Francine Clark Art Institute, Williamstown, Massachusetts (inv. 1999.2)

PROVENANCE

Henri-Amédé-Mercure de Turenne (1776–1852); his descendants; 1999, acquired by the Institute.

EXHIBITIONS

Paris 1878, no. 784.

BIBLIOGRAPHY

Th. 1826b, p. 166; Coupin 1827, p. 56; Seigneur 1863–64, p. 367; David 1880, pp. 583, 649; Cantinelli 1930, p. 114, no. 145; Hautecoeur 1954, p. 264; Wildenstein 1973, pp. 206 (no. 1978), 227 (no. 1938); Roberts 1989, p. 198; A. Schnapper in Paris-Versailles 1989–90, pp. 21, 514; Coekelberghs and Loze 1993, p. 1052; Mantion 1993, p. 809; Bordes 2000.

49. Portrait of Comte Henri-Amédé de Turenne

1816

Oil on panel

44 x 31⅞ in. (112 x 81 cm)

Signed and dated, lower right, on the base of the column: *L. David / 1816 / BRVXELLE[S]*; inscription on the letter, on the left: *Monsieur / le Comte / Turenne / Bruxelles*

Ny Carlsberg Glyptotek, Copenhagen (inv. I.N. 1900)

Exhibited in Williamstown only

PROVENANCE

Henri-Amédé-Mercure de Turenne (1776–1852); his descendants at least until 1878; . . . ; reportedly sold in 1906 by L. Lévy to Galerie Goupil, Paris, from whom acquired by Eugène Kraemer; his sale, Paris, 5 May 1913, no. 13, acquired at the sale by Galerie Trotti et Compagnie; after 1914, Wilhelm Hansen, Ordrup-gaard; 1923, acquired from him by the Ny Carlsberg Foundation, and given to the Glyptotek the same year.

EXHIBITIONS

Copenhagen 1914, no. 63; Copenhagen 1945, no. 65; Ordrupgaard 1957–58, no. 32.

BIBLIOGRAPHY

Notice 1824, p. 67; Th. 1826b, pp. 145, 166; Coupin 1827, p. 56; Miette de Villars 1850, p. 208; Seigneur 1863–64, p. 367; David 1880, pp. 544, 583, 649; David 1882, fascicle 20 (engraving); Saunier [1903], p. 119; Rosenthal [1904], p. 165; Vitry 1926, p. 269; Cantinelli 1930, p. 114, no. 144; Swane 1930, p. 28; Hautecoeur 1954, pp. 259, 264, 304; Verbraeken 1973, p. 28; Wildenstein 1973, pp. 206 (no. 1978), 227 (no. 1938); Brookner 1980, p. 185; Schnapper 1980, pp. 283, 285–86; D. Coekelberghs and P. Loze in Ixelles 1985–86, p. 439; Roberts 1989, p. 198; A. Schnapper in Paris-Versailles 1989–90, pp. 21, 513–14; Coekelberghs and Loze 1993, p. 1052; Bordes 2000.

DAVID PAINTED Henri-Amédé de Turenne twice in 1816. In a list of his works drawn up in Brussels in 1819, six years before his death, under the rubric "Dans mon exil," one finds both "Le portrait de M. de Turenne, buste" and "Le portrait de M. de Turenne, en grand," with the full-length portrait of Maurice-Étienne Gérard (SEE CAT. 50) between the two.[1] The smaller work was thus the first to be executed, whereas the other, which early biographers describe as a "répétition en grand,"[2] was perhaps prompted by the enviously large scale on which Gérard chose to be portrayed. The fur-lined pélisse that Turenne wears in the second portrait is also more appropriate attire for the later months of the year.

Unlike General Gérard, Turenne was not a banished imperial officer, even though since 1805 he had closely linked his career and his fate to the Napoleonic regime.[3] Although he was not a direct descendant of the great military commander of Louis XIV, as his family descended from a Turenne bastard branch recognized by testament in 1399, he most likely used the enormous prestige that his namesake enjoyed during the Revolution and Empire to further his own career. Enrolled as a volunteer in the army of the Pyrénées-Orientales in 1793–94, he ran into trouble during the Terror on account of his aristocratic lineage and chose to abandon military life for the next ten years. His remarkable second career in the army began only in 1805. Engaged in major campaigns with the Grande Armée all across Europe, he rose steadily in the military hierarchy. In 1809 he was gratified with a court appointment, as one of the sixty chamberlains of the emperor, and then in 1811 as Napoleon's Maître de la garde-robe.[4] In 1813, he was accorded the title of *comte de l'Empire*. Promoted to colonel by Napoleon on 8 March 1814, he was presumably present at his abdication on 6 April, since six days later he sent a letter of allegiance to Louis XVIII from Fontainebleau.

Without wasting any time, he petitioned the Bourbon government for a position corresponding to his rank, however the new administration was reluctant to confirm his recent nomination as colonel and give him a regiment. In February 1815, realizing that he was not to obtain satisfaction, he tried to negotiate his retirement with a further promotion to *maréchal de camp,* the Ancien Régime rank corresponding to *général de brigade.*

From March to June 1815, after Napoleon's return which was to end with Waterloo, Turenne once again sided with him and was well rewarded. He was made *pair héréditaire de l'Empire* on 2 June and the following day was upgraded to *maréchal de camp.* But in August 1815, without any hope of further active service, he wrote to the Bourbon war minister requesting permission to travel abroad, invoking his health, private affairs, and the education of his children requiring that he settle for a while in Switzerland. He asked for a year's absence and half-pay and obtained only the leave (22 August 1815 through 30 August 1816, according to a later *état des services*). Although nothing proves an early contact with David, it is curious to note that Turenne planned to go to Switzerland just at the time that David was in self-exile in the area. But he probably departed only in early November 1815, and in December, police authorities sent back to the war minister in Paris, via Lyons, a report on his "bad behavior" and his "extremely improper and dangerous declarations" in Geneva, presumably criticism of the way the Bourbon regime was treating imperial officers. A brief allusion to David's esteem for Turenne in a letter of the comtesse Vilain XIIII to her husband dated 5 July 1816 is the earliest confirmation of his presence in Brussels (SEE CAT. 47). The following month he went to the "eaux de Chaufontaine près de Liège" and obtained a further leave of one year without pay to go to Germany, although no other document suggests that he left Belgium at that time.[5]

Whatever the exact circumstances of their meeting in Brussels may have been, it is easy to imagine David's fascination for the Napoleonic officer whose glorious military record and family names were impressive. Turenne's troubles with the Bourbon military administration could only further endear him to the exiled regicide. It would seem, in any event, that David strongly invested

himself in the first portrait, for although he had previously adopted the close-cropped bust format during the Empire (SEE CATS. 19 AND 20), rarely does he attain a comparable degree of pictorial and psychological intensity. Turenne's ruddy, masculine face with its powdery, blushed complexion is fixedly frontal. Set against the dark hair and background, it comes forward, giving the impression of being over life-size, while the chest with the right shoulder pulled back, seems under pressure in the close-fitted military dress. This is suggested by the red line of the passepoil lining of the dark blue uniform, which contrasts a scalloped effect of tension on one side of the chest and a smooth curve on the other that snakes up to embrace the neck. Standing with a firm grip on the sheath of the saber, affirming a strong physical, almost sculptural presence, Turenne, like General Gérard, is made to embody the force of character of the soldier-hero of the Empire, whose downfall is ignored.

As was common in Napoleon's army, the military uniform worn by Turenne is somewhat fanciful. The dark blue habit and plastron are characteristic of the *artillerie à cheval de la Garde impériale,* but not the collar piece, which should be another color, nor the buttons, which should be decorated with crossed cannons. Another oddity is the lower edge of the plastron, which should not be straight but have an inverted V form, to allow for easier movement of the rider. The white culotte, visible at the lower edge of the canvas, is that worn by officers on social occasions.[6] The epaulets have the thick fringes that identify the *officier supérieur.* The saber *à la mamelouk,* turned the wrong way, may mean that Turenne had been among the European officers of the *escadron des mamelouks de la Garde impériale.* The saber, visibly an afterthought to animate the portrait, would have hung on the long blue cord encircling the chest *en sautoir,* whereas the shorter magenta-colored cord, called a *dragonne,* is a typical cavalry accessory meant to be worn lose around the wrist during combat and retain the weapon should it slip from the rider's hand.[7]

Turenne, who all his life seems to have been avid for honors and favors, wears four crosses. His family history had earned him the distinction of *chevalier* in the order of Malta at his birth. The characteristic medal with a black ribbon is the

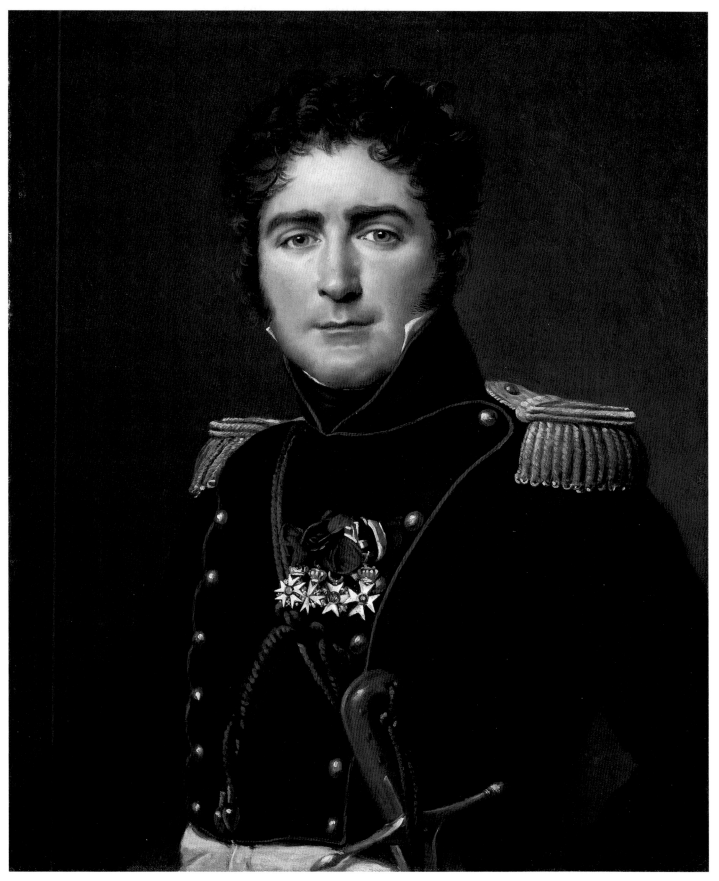

second from the left. Since 1809 he was *chevalier* in the order of the Legion of Honor and officer since 1813 (the first medal, a five-branch cross with a red ribbon). In 1814 he had been named *chevalier* in the military order of Saint-Louis (the third medal, also with a red ribbon, but with a four-branch cross). Less familiar is the medal on the right, an eight-pointed white enamel cross with a ribbon of black moiré edged on each side with a white-blue-white stripe. This is the military order of Maximilian Joseph of Bavaria, awarded for outstanding acts of courage on the field of battle, which Turenne received in 1809, presumably during the Austrian campaign.[8]

That David painted a second portrait of Turenne so soon after this one is indeed curious. He had painted his friend and brother-in-law Pierre Sériziat twice, but in 1790 and 1795, not in close succession. During the Empire, to secure the favor of an influential financial administrator, he had painted two portraits of Xavier Estève (SEE FIG. 41), but about eight years apart, and without bothering to finish the second. As has been suggested with reference to the portrait of General Gérard, if David painted Turenne a second time, the implication is perhaps not so much that the sitter or the painter was not satisfied by the first image, but that something more might be made to figure on the canvas. Since in both paintings Turenne offers the same closed expression, the significant differences are not in the characterization, but in the format and the costume. These transform the spirit and possible destination of the portrait from an image fit for gallery of military commanders to one for an aristocratic salon. Although in the second portrait the sitter's military career is still alluded to in the discrete row of striped ribbons that enumerate his decorations, the image proclaims first of all his civilian status. The first portrait revives an image of the Empire; the second fabricates one for the Restoration. David employs the grandiloquent conventions he had revived for General Gérard, albeit more modestly. The result is an uneasy combination of traditional elements carrying codified social signification with a more modern and democratic sense of abstracted space and a focus on the figure, which he and Vigée Le Brun had imposed around 1788–90 as a new norm for the society portrait. He invents a more confident pose for Turenne for this portrait,

paints with superior virtuosity, and deploys more subtle color harmonies, enhanced by the panel support—contrasts of ash and slate grays with warm tans and dull yellows. This familiar mastery is poorly served, however, by the two props that conventionally frame the figure, the Nattier-blue table cover and the "papier mâché" column, a traditional symbol of fortitude and constancy in aristocratic portraiture.[9] The letter addressed to the sitter, here lying on the table, is also a hackneyed conceit, which David would exploit more imaginatively in the portrait of Joseph Bonaparte's daughters (SEE CAT. 54). The back of the chair emerging from behind the sitter on the left was an afterthought, to buttress the figure. The coat of arms on the inside lining of the hat is an inventive way to insert in the visual narrative a motif often simply painted on the surface of aristocratic portraits, but the present design was certainly not executed by David. Not only is the dryness uncharacteristic, but it reproduces Turenne's armorial bearings from the Ancien Régime, while considering the medals, one would expect those of the Empire. Close inspection reveals that it is an overpaint, although there may be an original design underneath.[10] Perhaps conscious of the untidiness of assemblage in this portrait, when the following year he painted Emmanuel-Joseph Sieyès (SEE FIG. 100) in the same format, David produced a more sober but also a more integrated image.

Unlike the painter, Turenne did not entertain the idea of remaining abroad. In June 1817, still living in Brussels, he was designated by diplomatic correspondence as a leading figure of the "mécontents," the French refugees still intriguing to "overthrow the yoke of the Bourbon House."[11] The date of his return to Paris is not known, although it was certainly before the end of 1817. On 6 October 1817, he was granted a further two months leave to remain in the thermal town of Spa. But Paris had been on his mind for a while, since David had given him a letter for Antoine Mongez dated 7 September, which he was to deliver on his arrival. In the postscript, the painter wrote: "I am amusing myself making heads of easel pictures for M[r] le comte de Turenne, who will give you this letter. He has a passion for painting, I would very much like for him to see the works of your wife."[12] The comment suggests that

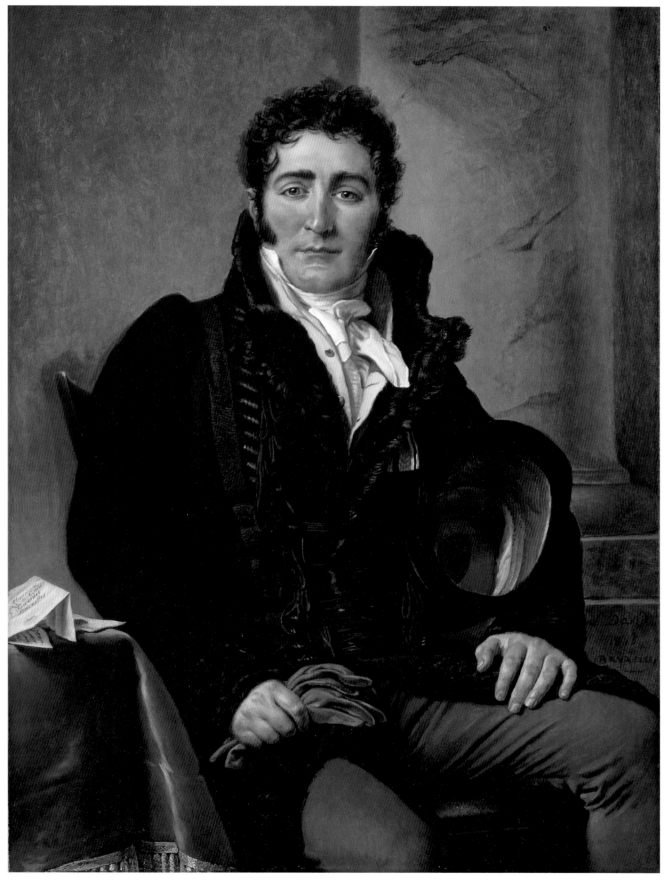

David considered Turenne to be an enthusiastic admirer almost a year after painting his portraits. There may have been some subsequent exchange of correspondence after Turenne's departure, but any trace of letters has yet to be found.

In Paris, Turenne lived quietly with two preoccupations. The first was to keep pressing for his promotion to general, until 1827 when he was finally named *maréchal de camp honoraire pour toute retraite.* The second was to travel: in 1818 to a spa in the Pyrenees and to Montpellier for family affairs; in 1821 and 1822, twice to Scotland, where one of his sons was in school. A military inspection in 1819 mentions his wealth, good health, and appropriate behavior, but the following year he is described as a political "mécontent," suggesting a resurgence of opposition as the royal government became more unpopular. A final report on Turenne, shortly after his death in Paris in 1852, indicates that he had been blind for fifteen years: the military hero had outlived his hour, but as long as he could see them, he surely found solace contemplating the images David had captured of his virile glory fully intact.

NOTES

1. List reproduced by Schnapper in Paris-Versailles 1989–90, pp. 20–21, with critical remarks on the status of the document, p. 16.
2. Th. 1826b, p. 166; Coupin 1827, p. 56.
3. All of the unreferenced documents relative to Turenne's biography and military career mentioned come from his personal file in Paris, Service historique de l'armée de terre (Château de Vincennes), 8Yd2674; the individual documents are not numbered nor in any order.
4. His nomination appears for the first time in the *Almanach impérial* of 1810 (published Dec. 1809), p. 72; the promotion appears in the 1812 edition, p. 71.
5. Document in the military archives (see n. 3), presumably a copy of the official leave sent to Turenne. His project may be in relation to his undefined ties with Bavaria: attested by the military decoration he wears (see below) and by an imperial measure in 1809 of "une dotation de 2000 francs à prendre sur les Biens Domaniaux situés à Bayreuth pour être ladite dotation attachée à votre titre de comte [de l'Empire]."
6. A comparison with the two versions of *Napoleon in His Study* (see cat. 12), each offering a different regulation uniform, helps to understand the singularity of Turenne's outfit. Napoleon is painted with a plastron whose cut is that of the regulation inverted V.

7. My thanks to Jean-Marie Haussadis and Frédéric Lacaille of the Musée de l'Armée, Paris, who detailed the military dress for me.
8. My thanks to Anne de Chefdebien and Élisabeth Pauly of the Musée de la Légion d'Honneur, Paris, for their help in identifying the decorations.
9. The epithet concerning the column is by Brookner (1980, p. 185); Schnapper concurs: "negligence du fond," "colonne négligemment peinte" (1980, p. 286).
10. On this point see Bordes 2000, p. 276 n. 2.
11. During a period of tension between France and the Netherlands in the spring of 1817, resulting from the latter government's policy of moderation toward the French exiles, a Russian envoy sent as mediator met with Turenne and another representative of the refugees; see the report from Brussels, 19 June 1817, Paris, Archives du Ministère des Affaires étrangères, Correspondance Politique, Pays-Bas, vol. 618, folios 146r–151v, reference to Turenne, folio 150v. The quote: "secouer le joug de la maison de Bourbon."
12. "Je m'amuse à faire des têtes de tableau de chevalet pour Mr le comte de Turenne qui vous remettra cette lettre. Il est passionné pour la peinture, je voudrais bien qu'il pût voir les ouvrages de ta femme." David to Antoine Mongez, 7 Nov. 1817 (David 1880, p. 545). It is not clear what the "têtes" for Turenne were. In David's list of works from 1819 (see note 1), there are "têtes d'étude peintes d'hommes et de femmes" and "Beaucoup de têtes peintes, entre autres: . . . Un *Philosophe,* un Bélisaire et l'enfant qui l'accompagne," but these refer to works early in his career.

Oil on canvas
77⅝ x 53⅝ in. (197.2 x 136.2 cm)
Signed and dated, on the pedestal base, lower center: *L. DAVID 1816 / BRUX.*
Inscribed on the envelope: *A Son Excellence / L[e] Gé[néral] Gérard / Com[mandant en] Chef*

The Metropolitan Museum of Art, New York. Purchase, Rogers and Fletcher Funds, and Mary Wetmore Shively Bequest, in memory of her husband, Henry L. Shively, M.D., 1965 (inv. 65.14.5)

PROVENANCE
Maurice-Étienne Gérard (4 April 1773–17 April 1852), Brussels and from 1817, Château de Villers Saint-Paul, Oise; by 1880, the son of his daughter Félicité (1822–1845) and Arnolph Laurent Desmiers d'Olbreuse, vicomte d'Archiac (1811–1848), Jean-Étienne Desmiers d'Olbreuse, comte d'Archiac (1845–1927), Château de Villers Saint-Paul; his adopted son, comte Ferd de Bryas (1895–1958); 1959, sold by his heirs to Wildenstein & Co., New York; 1965, acquired by the museum.

EXHIBITIONS
Minneapolis 1969, unpaginated, no. 22; London 1972, p. 47, no. 70; New York 1982, pp. 65, 93–94, unnumbered.

BIBLIOGRAPHY
Notice 1824, pp. 66–67; Th. 1826b, pp. 145, 166; Coupin 1827, p. 57; Miette de Villars 1850, pp. 207–8; Delécluze 1855 [1983], p. 367; Seigneur 1863–64, p. 367; David 1880, pp. 531, 583, 649; Saunier [1903], p. 119; Cantinelli 1930, p. 113, no. 139; Holma 1940, p. 129, no. 145; Haute-coeur 1954, p. 264; Sutton 1965, pp. 167–68; *GBA,* Feb. 1966, supplement, p. 61; Schlenoff 1972, pp. 5–6; Wildenstein 1973, pp. 204 (no. 1777), 227 (no. 1938); Brookner 1980, p. 178; Schnapper 1980, pp. 282–84; Nanteuil 1985, p. 153; D. Coekelberghs and P. Loze in Ixelles 1985–86, p. 439; Roberts 1989, p. 198; A. Schnapper in Paris-Versailles 1989–90, pp. 21, 514; Coekelberghs and Loze 1993, p. 1052; Mantion 1993, p. 809; Lee 1999, pp. 290–91; Prat and Rosenberg 2002, vol. 2, p. 1161.

FROM MARCH to May 1816, a few months after he settled in Brussels, David was contacted by emissaries of the king of Prussia, who attempted to lure the former first painter of Napoleon to Berlin. Among them was the monarch's brother, who visited David's studio and commented favorably on the portrait of General Gérard, so at the time it must have been well advanced or finished. This suggests that it was painted in the spring or early summer, as does the order adopted in the list of his works jotted down by David about 1819.[1] Among the suite of portraits dating from 1816, it is the only one *en pied,* a grand scale to which he would return eight years later when painting Juliette de Villeneuve (SEE CAT. 56).

Gérard was one of the most distinguished members of the imperial military corps to have sought refuge in Brussels after the defeat at Waterloo. Born in a small town in Lorraine, he had begun his career as a modest volunteer in 1791, and over the following decade had participated in a succession of campaigns in Germany, Italy, and the western region of France. He rose steadily in the hierarchy, attaining in 1800 the rank of *chef de brigade* (colonel); in November 1806, *général de brigade,* after suffering serious wounds at Austerlitz the preceding December; and in September 1812, *général de division.* Napoleon, who appreciated his physical courage and undemanding character, made him baron de l'Empire in 1809, and comte in 1813. After time in Spain in 1811, he played a decisive organizing role during the trying retreat from Russia in 1812, as he did again the following year, during the German campaign, when he was wounded on three occasions. Although he maintained his support of Napoleon until his abdication at Fontainebleau in April 1814, he was wooed by Louis XVIII and accepted the mission to bring the French troops back from Hamburg. When Napoleon returned in March 1815, however, Gérard immediately put himself at his service and

took part in the ill-fated campaign in Belgium, during which he was once again injured. The second Restoration was less kind to former Napoleonic officers: in July an ordinance threatened all those who had sided with Napoleon with expeditious military justice; a handful were shot as examples. Gérard's military record indicates that he was discharged by the Bourbon government in September; prompting by the military authorities apparently motivated his decision to seek haven in Brussels as the repression reached its peak during the winter of 1815–16.[2]

How Gérard came to commission his portrait from David is not known. As for other refugees, political sympathy may have been an incentive. By choosing a full-length format, the successful general of humble background may have wanted to outdo the courtier and aristocrat Turenne, who was patronizing the artist at this time. The dimension and format of Gérard's portrait are those of the series Denon had commissioned of the marshals and dignitaries of the regime for the Tuileries. Napoleon, it seems, had often been on the verge of appointing him *maréchal:* David's portrait gives reality to that prospect, as if Gérard, like the painter reputed uncomfortable with court life, sought in this way to affirm a personal merit equal to those who had been honored. The year in Brussels was clearly a turning point in his life. Whereas so many other exiles dwelled on the past and what had gone amiss, drowning slowly in their memories, Gérard appears to have been determined to give his career an energetic new start, again like David, who communicated this in his work. Around the time he was posing, the forty-three-year-old bachelor took a wife, the daughter of comte de Valence, like himself a distinguished military, and the granddaughter of the popular writer Stéphanie-Félicité ("Madame") de Genlis, a tie that secured him the sympathy of Orléanist circles in Paris.[3] This would be instrumental in helping him acquire even greater prominence in politics than his successes on the battlefield during the Empire had garnered. He obtained permission to return to France in 1817 and immediately bought the Château of Villers Saint-Paul near Creil. As elected deputy, for Paris in 1822 and for Bergerac in 1827, he joined the liberal opposition to the Bourbons. As an outcome of the Revolution

in 1830, Louis-Philippe appointed him minister of war and, finally, raised him to the supreme rank of *maréchal de France.* Shortly after, he waged his last campaign, in favor of the liberation of Belgium from the Netherlands. During the July Monarchy few former Napoleonic officers received more honors than Gérard, who was ill in old age and died in 1852.[4]

In 1816 he probably impressed David even more strongly than Turenne. In the portrait, the stocky build and square features become signs of fortitude, without the slightest suggestion that the body of the soldier was bruised and stitched all over. The sober uniform is like a protective carapace that reveals the vulnerable flesh of the head and hands with utmost parsimony. Gérard's authoritative presence requires no animation or fiction other than the batch of letters he holds, as if to dispel any intimation of moral solitude in exile. This artistic conception contrasts sharply with the series of imperial *maréchaux,* in which they seem to fiddle awkwardly with their swords or batons, or else adopt too studied an attitude. The balance achieved by David, between formal pose and naturalness, is found in the series perhaps only in the 1807 portrait of François-Joseph Lefebvre by his former pupil Césarine Davin-Mirvault (FIG. 103), with a similar floor perspective that seems deliberately archaic.[5] The immediate inspiration for most portraits of this kind and for David in 1816 were, of course, the commanding images produced by François Gérard since the Consulate, notably the portrait of General Jean-Victor Moreau in 1800, which had brought discipline to the earlier tradition of the swagger portrait.[6]

Although David's effigy has been decried for its "cardboard formality" by Brookner, who claims a preference for the Rubensian dash of contemporary military portraits by Gros, the brushwork and color are anything but cold. To create a figure with an aura of public dignity and monumentality David relies on his familiar predilection as a history painter for measure, restraint, and control. However this does not prevent him from demonstrating great suppleness and vibrance with the brush, especially remarkable by comparison with Davin-Mirvault's drier manner. His responsiveness to the colorism of the Flemish school is visible

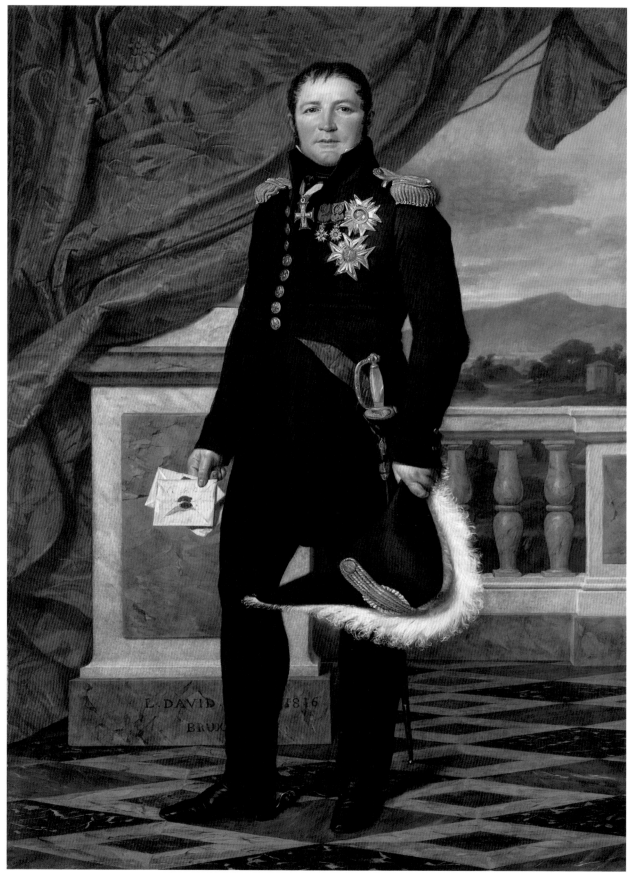

in the luscious red expanse of draped brocade, and, as with *Cupid and Psyche* (SEE CAT. 32), finished the following year, in the moody distant landscape. Thirty years ago Schlenoff suggested that the trompe l'oeil effect of the two-toned marbles, and more generally the finicky attention given to naturalistic details in the picture, betrayed the intervention of Flemish collaborators: it can be fully accepted today that this pictorial sensuality is an essential quality of David's late manner. A recently rediscovered sketchbook includes a small drawing for the portrait (FIG. 104); as noted by Prat and Rosenberg, such preparatory care for a portrait, rare except for those of Napoleon, attests to the importance this one held for the artist. In the painting, David has draped completely the ponderous column, a trite motif visible in the sketch

that finds its way to the second portrait of Turenne (SEE CAT. 49), thus creating a breezy backdrop for the figure, discreetly echoed by the flutter of the white feathers on the bicorn.[7]

As in the portraits of Turenne, central to Gérard's self-fashioning as a military officer, and rivaling for attention with his expressive face, is the bounteous bouquet of military crosses pinned to his dark blue general's uniform—precious rewards and relics recounting long years of service. He wears no less than five distinctions. Around his neck hangs the cross of the Danish Order of the Danebrog, which he received in 1808 on account of his close collaboration with Bernadotte. On the red ribbon next to it is attached the star of the officer of the Legion of Honor, which was customarily worn by *grand-croix* like Gérard, with the

large plaque pinned to the far right; the red moiré sash that slips out from under his *habit* and sets off the hilt of the ceremonial sword, is a distinctive attribute of this same order. Between the two insignias of the Legion of Honor is the white twelve-ray star and light blue ribbon of the Order of the Reunion, to which he was knighted *grand-croix* in 1813. Below is the silver plaque of the Order of the Sword of Sweden, a Maltese cross with a pale blue enamel center, which he had been awarded in July 1814.[8] In these clustered ornaments, David reiterates in miniature the red, golden ocher, and blue color harmonies of the portrait as a whole.

NOTES

1. The solicitations from agents of the king of Prussia are reproduced in *Notice* 1824, pp. 74–79. The last letter, of 16 May 1816, is misdated to March by J. David (1880, p. 530), an error that has led certain historians to place the execution of Gérard's portrait that month. In David's list of works, it follows the portraits of Alquier (destroyed), the comtesse Vilain XIIII (see cat. 47) and the first portrait of comte Henri-Amédé de Turenne (see cat. 48), but it precedes the portraits of Turenne *en grand* (see cat. 49) and François-Antoine Rasse de Gavre (see cat. 51) (Schnapper in Paris-Versailles 1989–90, p. 21).

2. For Gérard's military record, see the undated recapitulative document drawn up by the war ministry after his death, in his personal file in Paris, Service historique de l'armée de terre (Château de Vincennes), 6Yd36. See also the biographical entry in Didot 1855–66, vol. 19, cols. 171–75 ; and the one published in 2002 by Alain Bégyn (http://www.histoire empire.org/persos/maurice_gerard/maurice_gerard.htm). These biographical sources are occasionally contradictory. On the measures against Napoleonic officers in 1815, see Tulard 1994.

3. An annotation to the document in the military archives referenced in the preceding note indicates that he married on 10 April 1816, around the time he posed for David, but later dates in the year are given by other sources. The first of his three children was born in 1817.

4. Portraits of Gérard from this period include a bronze medallion by Pierre-Jean David d'Angers (1830; Angers, Musée David d'Angers, and Paris, Musée Carnavalet) and two paintings by Philippe Larivière commissioned for the historical museum at Versailles (1835, Musée Périgord, Périgueux; 1836, Musée national du Château de Versailles).

5. David would have seen the hackneyed motif of the balustrade and drapery in another pupil's portrait from the series hung at the Tuileries, *Bon-Adrien Jannot de Moncey* by Jacques-Luc Barbier-Walbonne

(1806, Musée national du Château de Versailles; Cantarel-Besson and Constans 2001, p. 251, fig. 287). On Davin-Mirvault and David, see Bordes in San Diego 2003–4, pp. 34, 58–59.

6. On this influential portrait, see Halliday 2000, pp. 177–80.

7. According to Colonel MacCarthy of the Musée de l'Armée, Paris, "Le Général est ici en petite tenue de campagne sans aucune broderie sur son habit. Il a les épaulettes de Général de division. Les plumes blanches de son chapeau sont l'insigne de Général commandant un corps de l'Armée, ce qui était le cas de Gérard pendant la campagne de 1815" (letter to Dean Walker, 7 January 1980, in the museum's file). The inscription on the letter held by Gérard also refers to this rank of *commandant en chef,* which Napoleon had accorded him on 31 March 1815.

8. The identification of the insignias is based on information in the letter by Colonel MacCarthy cited in the preceding note.

51 Portrait of François-Antoine Rasse de Gavre

1816

Oil on canvas
28¾ x 24 in. (73 x 61 cm)
Signed and dated, lower left: *L. David /*
1816 / Brux.

Private collection, courtesy of Richard
L. Feigen & Co.

PROVENANCE
François-Antoine Rasse de Gavre
(c. 1800–1826) or his father Charles-
Alexandre-Antoine de Gavre (1759–
1832), Château de Monceau-sur-Sambre,
near Charleroi; bequeathed with his
property to his sister-in-law, Marie-
Aloïse Egger (died 1864), wife of
Emmanuel-François de Neuborg; after
her death, acquired with all the family
property by Baron Jules Houtart; by
1913, a descendant, Édouard Houtart,
Château de Monceau-sur-Sambre; his
descendant, Baron Maurice Houtart
(1866–1939); his daughter Madame Yves
Pierpont Surmont de Volsberghe; . . . ;
1983, private collection, Belgium; private
collection, United States.

EXHIBITIONS
Paris 1913, p. 25, no. 59; Brussels 1925–26,
no. 14; Paris-Versailles 1989–90, p. 523,
no. 227.

BIBLIOGRAPHY
Notice 1824, p. 67; Th. 1826a, pp. 212, 242;
Th. 1826b, pp. 147, 166; Mahul 1826, p.
141; Coupin 1827, p. 57; Blanc 1845, p.
212; Seigneur 1863–64, p. 367; David
1867, p. 38; David 1880, pp. 583, 651;
Saunier [1903], p. 119; Gronkowski 1913,
p. 83; Pauli 1913, p. 546; Fierens-Gevaert
1926, pp. 166–67; Cantinelli 1930, p. 113,
no. 140; Holma 1940, pp. 79–80, 129, no.
146; Maret 1943, p. 96; Hautecoeur 1954,
p. 265; Verbraken 1973, p. 246; Wilden-
stein 1973, pp. 206 (no. 1798), 227 (no.
1938); Brookner 1980, p. 185; Schnapper
1980, p. 290; A. Schnapper in Ixelles
1985–86, p. 34; A. Schnapper in Paris-
Versailles 1989–90, p. 515; Coekelberghs
and Loze 1993, p. 1053.

ONE OF David's least-known works, this por-
trait represents the scion of a venerable noble
Flemish family. His father had served as chamber-
lain to Josephine during the early years of the
Empire, and to Napoleon from 1810, the year of
his appointment as prefect for the department of
Seine-et-Oise. Since the sitter was reportedly only
sixteen years old at the time, the commission of
his portrait from David in 1816 was presumably an
initiative of his father, then occupying a position
at the court of Willem I.[1] No details of the context
of the commission are available, however it is pos-
sible that the prince de Gavre requested a portrait
of his son for reasons similar to those that might
have motivated the comte Vilain XIIII to secure
one of his wife and daughter about the same time:
David's reputation and perhaps a desire to help
out the exiled first painter of Napoleon. Before
his early death in 1826, the young man portrayed
would become *bourgmestre* of the town of
Monceau-sur-Sambre, where the family château
was located.

The portrait is a straightforward half-length,
without the hands and with hardly any props.
David drapes a reddish-brown cloth over an imag-
inary armchair to anchor and monumentalize
Gavre's blue tight-jacketed silhouette. He confers
on the dressed-up youth an authoritative presence,
but with a very slight inclination of the head, a
vivacious expression in the eyes, and negligently
tousled hair, he also captures the fragility of his
adult composure. The sense of relaxed elegance
appears to justify Stendhal's double-edged remark
in 1824, defending David as the "the greatest
painter of the eighteenth century."[2]

NOTES

1. The sitter's age was noted when the painting was
 exhibited in 1925–26, on the basis of an inscription
 on the back of the painting (A. Schnapper in Paris-
 Versailles 1989–90, p. 523). In 1828 F.-J. Navez painted
 an official portrait of his father as "Grand Maréchal"
 of Willem I (Coekelberghs, Jacobs, and Loze 1999,
 pp. 62–63, fig. 90).
2. ("le plus grand peintre du dix-huitième siècle").
 "Critique amère du Salon de 1824 . . . ," Stendhal
 2002, p. 59.

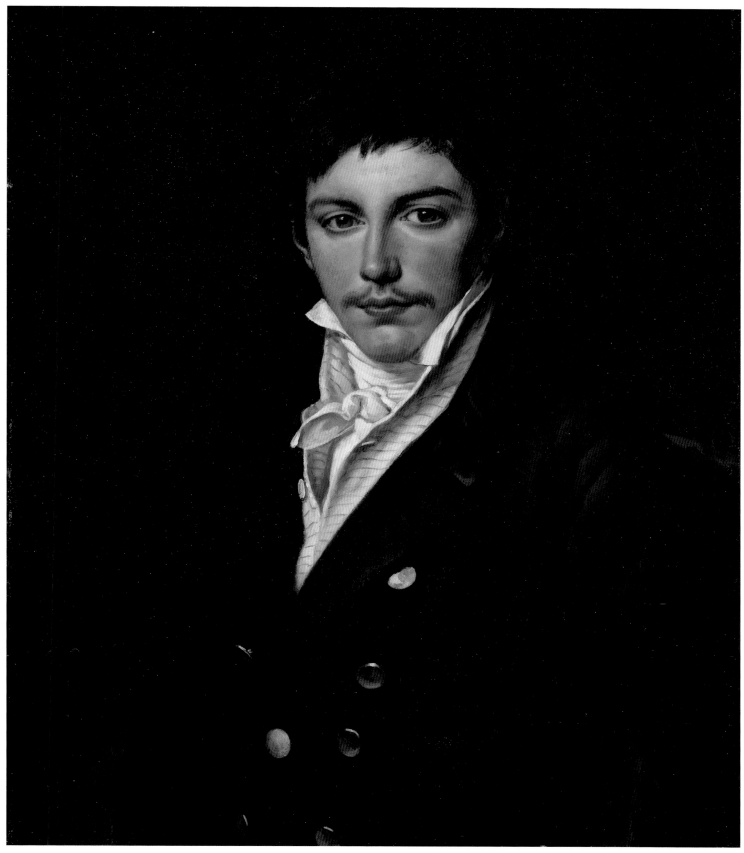

52–53

Portrait of Dominique-Vincent Ramel de Nogaret

Portrait of Ange-Pauline-Charlotte Ramel de Nogaret, née Panckoucke

1820

52. Portrait of Dominique-Vincent Ramel de Nograet

Oil on canvas

23¾ x 18¾ in. (60.5 x 47.5 cm)

Signed and dated, lower left:

L. David / BRUX. 1820

James Fairfax Collection

PROVENANCE

Dominique-Vincent Ramel de Nogaret (6 Nov. 1760–30 Mar. 1829) and his wife Ange-Pauline-Charlotte Ramel, née Panckoucke; their elder daughter Pauline Ramel, wife of Édouard Lorois (1792–1863); their son Édouard Lorois, who owned it in 1880; in 1885 and 1913, "Mme Lorois," presumably his widow; 1913, "MM. P . . .";[1] . . . ; sale, Paris, Hôtel Drouot, 18 Oct. 1995 (special catalogue with texts by Antoine Schnapper and Édouard Bouyé); private collection.

EXHIBITIONS

Paris 1885, no. 41; Paris 1913, p. 26, no. 64; Sceaux 1962, p. 73, no. 180.

BIBLIOGRAPHY

Notice 1824, p. 67; Th. 1826a, pp. 212, 242; Th. 1826b, pp. 147, 166; Mahul 1826, p. 141; Coupin 1827, p. 57; Delécluze 1855 [1983], p. 368 n. 1; David 1880, pp. 583, 650; David 1882, fascicle 13 (engraving); Saunier [1903], p. 119; Saunier 1913, p. 279; Cantinelli 1930, p. 114, no. 150; Holma 1940, p. 129, no. 156; Hautecoeur 1954, p. 264; Poisson 1963, p. 41; Wildenstein 1973, pp. 220 (no. 1883), 227 (no. 1938); Schnapper 1980, p. 288; D. Coekelberghs and P. Loze in Ixelles 1985–86, p. 441; A. Schnapper in Ixelles 1985–86, p. 34; A. Schnapper in Paris-Versailles 1989–90, pp. 21, 515.

53. Portrait of Ange-Pauline-Charlotte Ramel de Nogaret, née Panckoucke

Oil on canvas

23⅜ x 18¾ in. (59 x 47.5 cm)

Signed and dated, on the right: *L. DAVID / BRVX. 1820*

James Fairfax Collection

PROVENANCE

Dominique-Vincent Ramel de Nogaret (6 Nov. 1760–30 Mar. 1829) and Ange-Pauline-Charlotte Panckoucke; their younger daughter Mélanie Ramel, wife of Frédéric Ronstorff; in 1880, "Mme Ronstorff," Brussels; in 1913, "Mme Lorois," presumably the widow of the son of Pauline Lorois, née Ramel; 1913, "MM. P . . .";[2] . . . ; private collection; 1950, acquired by Wildenstein & Co., New York; sale, Deauville, 29 Aug. 1969, p. 29, no. 91; by 1982, private collection, New York; by 1989, Colnaghi, New York; 1989, private collection.

EXHIBITIONS

Paris 1913, p. 26, no. 65; Syracuse 1952, no. 4; Houston 1952, p. 15, no. 44; Havana 1957, no. 28; New York 1989, pp. 131–33, no. 12.

BIBLIOGRAPHY

Notice 1824, p. 67; Th. 1826a, pp. 212, 242; Th. 1826b, pp. 147, 166; Delécluze 1855 [1983], p. 368 n. 1; David 1880, pp. 583, 650; Saunier [1903], p. 119; Cantinelli 1930, p. 114, no. 151; Poisson 1963, p. 41; D. Coekelberghs and P. Loze in Ixelles 1985–86, p. 441; Schnapper 1980, p. 288; A. Schnapper in Ixelles 1985–86, p. 34; A. Wintermute in New York 1989, pp. 131–32; A. Schnapper in Paris-Versailles 1989–90, pp. 21, 478, 514, 515.

As DEPUTY from Carcassonne to the Estates-General in the spring of 1789, Dominique-Vincent Ramel de Nogaret was present at the Oath of the Tennis Court, which David projected to commemorate during the early years of the Revolution. Perhaps he had responded to the painter's call for the representatives to come by his studio to pose for their portrait in the composition. Like David, he was elected to the National Convention in the fall of 1792 and voted for the death of the king; during the Directory he was once again deputy, and minister of finance from 1796 to 1799, when he proved to be a dynamic reformer of the tax system. During the Consulate and Empire, however, he kept a low profile and only accepted a local government position in 1812 in his home department of l'Aude. No doubt in reaction to the prospect of a Bourbon restoration, he took an engagement in favor of Napoleon during the Hundred Days (after his return from Elba) by accepting a position of prefect in Normandy. Like his fellow regicides David and Sieyès, he was exiled in January 1816 and also chose to settle in Belgium, with his wife Ange-Pauline-Charlotte Panckoucke, whom he had married in the Year VIII. She was the grand-niece of Charles-Joseph Panckoucke, the editor of the *Encyclopédie* and founder of the *Moniteur.* For his livelihood in Belgium, as during his political retreat after Brumaire, he successfully fell back on his traditional family activity of manufacturing and trading textiles.[3] But living the life of a prosperous bourgeois merchant did not mean renunciation of his republican ideals. When he died in 1829, a lithograph after David's portrait was published with this quatrain: "Virtuous citizen, incorruptible minister, / He loved nation and liberty, / Just though indulgent, reserved though sensitive, / He lived without stain . . . He died in exile."[4]

The year 1820 was a time of transition for David. After delivering *The Anger of Achilles* (SEE

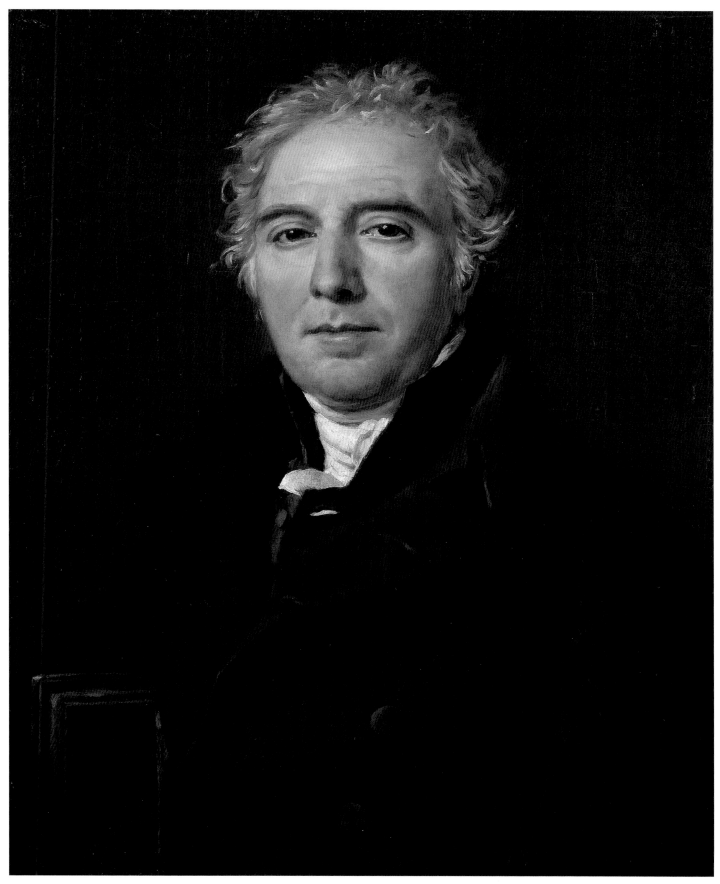

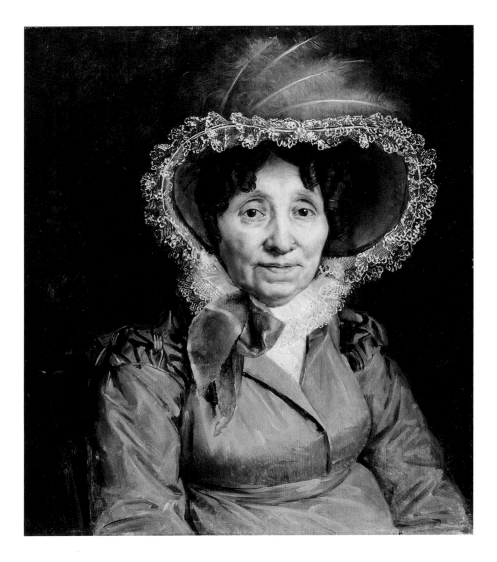

CAT. 36) to its owner in November of the previous year, he was especially busy finalizing the sale of the *Sabines* and *Leonidas* to the French government for a sum of one hundred thousand francs. Other affairs in Paris, such as selling off the accumulated furnishings in the studio in the church of Cluny, which he had been lent initially to paint the *Coronation,* also took up his time. That year the only two pictures he signed were the pendant portraits of Ramel de Nogaret and his spouse. These are relatively small compared to those of the Pécoul, his wife's parents painted in 1784, and to those of the Sériziats, his wife's sister and her husband, in 1795, and also more modest than the double portrait of Antoine Mongez and Angélique Levol, ascribed to 1812. The latter work was conceived as two individual portraits juxtaposed rather than as the image of a mutually responsive couple. Although able to picture the affection shared by a mother and daughter (SEE CAT. 47) or

two sisters (SEE CAT. 54), David was strangely reluctant to metaphorize in any way the mutual attraction of a real couple.[5]

The pictures were surely a commission from Ramel, who was on friendly terms with the painter. It is reported that David attended the receptions his wife organized for the French community of expatriates, and that the former minister helped him put his financial affairs in order.[6] Ramel, who pronounced the painter's funeral oration in Brussels, was most appreciative of his talent, and urged him to write his memoirs, as so many of the refugees were doing, invoking also the example of Benvenuto Cellini.[7] For his portrait, Ramel self-confidently placed himself slightly askew with his right arm wrapped around the back of the chair, an informal attitude going back to Van Dyck and made fashionable by English portraiture; the relative reserve of his wife's pose was also a traditional distinction of gender

FIGURE 105 French or Belgian School, *Portrait of a Woman,* c. 1820. Oil on canvas, 25⅞ x 21⅝ in. (65.6 x 55 cm). The Walters Art Museum, Baltimore

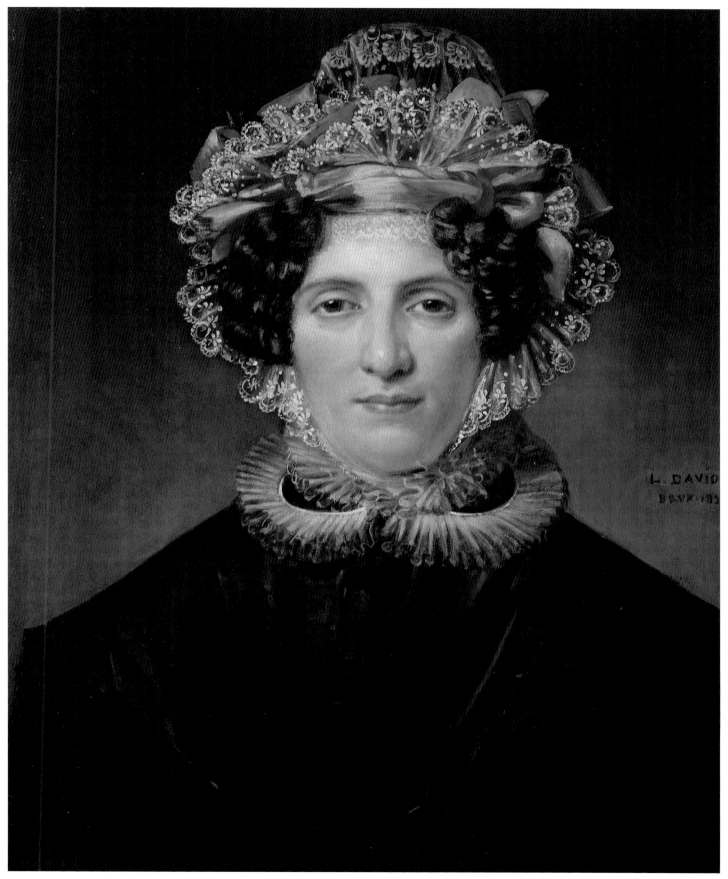

in seventeenth-century marriage portraits. The former minister donned a simple costume, like Emmanuel Sieyès when he sat for David three years earlier (SEE FIG. 100), but he appears much less world-weary than his colleague, older by twelve years. Ramel's wife, much like Geneviève-Jacqueline Pécoul, gathered all the lace gauze and silk ribbon she could find to affirm her social status, but instead of donning the smile that enlivens the earlier portrait, she makes a straight-faced appearance. For her portrait, David indulged in the decorative surcharge of contemporary millinery, which he submitted to a radically archaizing vision. A parallel with Ingres's *Napoleon I on His Imperial Throne* (SEE FIG. 9) comes to mind: both painters were fascinated by Flemish painting of the fifteenth and sixteenth centuries.[8] The hieratic expression and brutal cropping, which prompted a distinguished art historian as late as 1963 to doubt the attribution, contrasts sharply with more naturalistic contemporary modes (SEE FIG. 105).[9] At the same time, the modernity of the effigy, resting essentially on the costume, is overtly militant, for the painter aims to fix a truthful contemporary image devoid of all nostalgia. In both portraits, in spite of self-restrictions on composition and expression, David raises the execution to his accustomed level of measured virtuosity, especially in deceptively monochrome areas broadly treated with a sure brush.

NOTES

1. Manuscript annotation found in certain copies of the catalogue of Paris 1913, p. 26.

2. Manuscript annotation found in certain copies of the catalogue of Paris 1913, p. 26.

3. See the biographical essay by Bouyé in the 18 Oct. 1995 sale catalogue, pp. 37–54 (see Provenance). "Cet homme du Sud n'a paradoxalement pas dû trop souffir d'un pareil exil; ses affaires vont grand train: il possède au Marché au beurre de Bruxelles une galerie couverte, une halle aux viandes et 71 échoppes; en Brabant, non loin de Bruxelles, une fabrique de clous (5 métiers) et une filature mécanique de lin (6 métiers); très lié en affaires avec Liévin Bauwens, Ramel met à profit sa connaissance de la banque d'Amsterdam, acquise en mission vingt ans plus tôt, et dont il avait fait écho dans ses livres publiés sous l'Empire" (p. 53).

4. "Vertueux citoyen, ministre incorruptible, / Amant de la patrie et de la liberté, / Juste mais indulgent, réservé mais sensible, / Il a vécu sans tache . . . il est mort exilé." The lithograph, published shortly after Ramel's death and signed "H. Delpierre 1829," makes no mention of David (Paris, Bibliothèque nationale de France, Département des Estampes et de la Photographie, N2, vol. 1589, D244808).

5. Advice given in a letter to Gros, dated 27 Dec. 1819, reveals David's belief, shared by many, that sexual indulgence conflicted with creative drive: "Méfiez-vous de deux moments difficiles à surmonter dans la vie; l'un, quand on se marie, vous m'entendez sans qu'il me soit nécessaire d'en détailler les causes physiques"(the other moment is when celebrity comes) (Wildenstein 1973, p. 217, no. 1864).

6. Miette de Villars 1850, p. 222.

7. David 1880, p. 617.

8. A. Wintermute has invoked a parallel with the "simple, startling immediacy" of the work of Jan Gossaert, called Mabuse (1478–1533); Ramel, in his funeral speech, insisted that David's art was founded on the "anciens," but also on "les grands hommes du XVᵉ et du XVIᵉ siècle" (David 1880, p. 618). See also Coekelberghs, Loze, and Jacob 1999, p. 9 n. 8.

9. The illustrated portrait of a woman in Baltimore (Johnson 1982, p. 33), painted around 1820, was once attributed to David and identified as Madame Morel de Tangry, on the basis of the Louvre's celebrated *Three Ladies of Ghent* (fig. 101), long thought by many to be autograph. In recent years, only Johnson has defended the attribution (1993a, pp. 224, 228–29). See the essay "Portraits in Exile" in this volume.

Portrait of Zénaïde and Charlotte Bonaparte

1821

Oil on canvas
51 x 39⅜ in. (129.5 x 100 cm)
Signed and dated, lower right: *L. DAVID / BRVX. 1821*; inscription on the letter: *N°. 13 / Philadelphie [. . .] / Mes cheres petites amies [. . .]*

The J. Paul Getty Museum, Los Angeles (inv. 86.PA.740)

PROVENANCE

Commissioned by Joseph Bonaparte (7 Jan. 1768–28 July 1844), the sitters' father; his daughter, Zénaïde Bonaparte (8 July 1801–8 Aug. 1854), wife (from 29 June 1822) of Charles-Lucien Bonaparte, Prince of Canino and Musignano (1803–1857), from whom officially separated in Feb. 1854; their daughter Julie Bonaparte (1830–1900), wife (from 30 Aug. 1847) of Alessandro del Gallo Marchese di Roccagiovine (1826–1892); still in the Roccagiovane family, Rome, in 1967 (according to Gonzalez-Palacios); . . . ; by 1986, Wildenstein & Co., New York; 1986, acquired by the museum.

EXHIBITIONS

Philadelphia, Academy of Fine Arts, Twelfth Annual Exhibition, May 1823 (according to an article in *Poulson's Daily Advertiser,* see Bibliography); Philadelphia 1987, no. 228; Paris-Versailles 1989–90, pp. 530–32, no. 231.

BIBLIOGRAPHY

Poulson's Daily Advertiser (Philadelphia), 22 May 1823, article on the Twelfth Annual Exhibition of the Academy of Fine Arts signed "L. Aocoon" [transcription in the files of the Philadelphia Museum of Art]; Th. 1826a, pp. 212, 242; Th. 1826b, pp. 147, 166; Mahul 1826, p. 142; Coupin 1827, p. 57; Blanc 1845, p. 212; Delécluze 1855 [1983], pp. 368 n. 1, 496 n. 8; Seigneur 1863–64, p. 367; David 1880, pp. 567–68, 650–51; David 1882, fascicle 14 (engraving of the replica in Toulon); Bertin 1893, pp. 286–88, 418, 421; Saunier [1903], p. 119; Rosenthal [1904], p. 168; Boyer 1925, p. 174; Cantinelli 1930, p. 115, no. 154; M. Florisoone in Paris 1948, pp. 101–2; Hautecoeur 1954, p. 251 n. 1; Gonzalez-Palacios 1967, p. 15; Verbraeken 1973, pp. 102 n. 3, 249; Wildenstein 1973, pp. 220 (no. 1879), 222 (no. 1894); Brookner 1980, p. 186; Schnapper 1980, p. 288; Dieu 1985, pp. 125–26, 131, 151; A. Schnapper in Ixelles 1985–86, p. 420; B. Garvan in Philadelphia 1987, pp. 59–60; Rosenberg 1987; Fredericksen 1988, n.p., no. 37; Rosenblum 1990, pp. 192, 257; Johnson 1993a, pp. 224, 229; Johnson 1993b, pp. 1028–29; Mantion 1993, p. 809; Ribeiro 1995, p. 129; J.-P. Cuzin in Paris 1997, p. 180; Lee 1999, pp. 295–97; Jones and Galitz 2000, p. 301; Vidal 2003, pp. 248–50, 260 n. 33.

JOSEPH BONAPARTE, the elder brother of Napoleon, who put him on the thrones of Naples (1806–8) and Spain (1808–13), had fled to the United States in July 1815, one month after Waterloo, leaving behind in Europe his wife Julie Clary and his two daughters, Zénaïde and Charlotte (1802–1839). A passionate collector of Old Master paintings, he was also a keen admirer of David. Upon his eviction from Spain, he extracted *Bonaparte Crossing the Alps* (SEE CAT. 4) from the Spanish royal collection, perhaps to protect it from possible destruction, but kept it for himself. In America, under the name of comte de Survilliers, in the spring of 1816 he bought a mansion, Point Breeze, on the Delaware River near Bordentown, New Jersey. He had the house remodeled and furnishings including about two hundred paintings sent from Europe. After a fire in 1820, which spared the contents of the mansion, he built a new home, where he continued to live the life of a country gentleman. Back in Europe, his wife, a Marseillaise from a modest background, was much alarmed by his spending and doing her best to preserve the family's capital, often haggling with Joseph's brothers and sisters over the spoils of Empire. She was particularly concerned to marry her two daughters within the Bonaparte family, to protect their heritage and their chances of perhaps one day securing an imperial throne. A difficult, drawn-out negotiation with Lucien Bonaparte, who had settled in the Papal States, preceded the union between her elder daughter and Lucien's eldest son. The wedding took place in June 1822 in Brussels, where Julie was residing with her two daughters, along with her sister Honorine Blait de Villeneuve and her own daughter Juliette (SEE CAT. 56). By 1826 the family clan had established its quarters in Florence.[1]

Ever since the birth of his daughters, Joseph had commissioned a succession of portraits, the two girls with their mother or simply together.

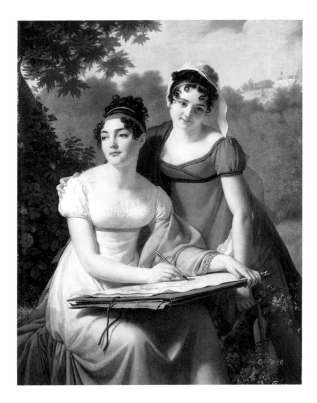

Robert Lefèvre had painted a double portrait in 1805 (Musée national du Château, Fontainebleau); two years later Gérard executed a group portrait of the mother with her two daughters at Morte-fontaine, Joseph's country house outside of Paris (National Gallery of Ireland, Dublin), and the following year in Naples, Wicar received an identical commission (Palazzo Reale, Caserta). Perhaps aware that their daughters' impending marriages would ring the end of this family idyll—after reviewing a number of options, Charlotte would finally wed the son of Louis Bonaparte in Florence in November 1826—he and Julie called upon David to paint them together one final time. The commission, probably discussed in the autumn of 1820, specified that he should execute an original for four thousand francs and two replicas, each for half that sum. David signed a receipt in June 1821 upon delivery of the three versions. Two replicas are known: one in the Museo Napoleonico in Rome, unsigned and undated, although the letter depicted bears the date 1821, and another in the Musée des Beaux-Arts de Toulon, with a fake signature and date (1822).[2] For nearly a century, until the reappearance of the present portrait, the Rome and Toulon paintings were alternately claimed to be the prime version.

David had been able to see a number of portraits of sisters at the Salons in Paris, such as the daughters of Achille Gibert by Henri-François Riesener in 1810, or those of Alexandre Duval by Jacques-Augustin Pajou in 1814 (FIG. 106).[3] Both of these young painters had presented their subjects in an outdoor setting, one young lady sketching, the other pressed close with her arm around the other's shoulders. Although David counseled Charlotte, who took to flower painting and landscape drawing while in Brussels, and could have shown her truthfully in this guise, he chose instead the more formal conceit of an addressed letter held aloft, which in the seventeenth and eighteenth centuries was introduced to evoke the networking of high administrative officials. In this instance, the letter participates in a circuit of family affection, since the scrawl reveals that it was sent from Philadelphia by the sitters' father. Charlotte's elder sister, Zénaïde, holds it at a distance, like a precious document enshrined by the Napoleonic bees behind decorating the red sofa. The bees, an afterthought painted over palmettes, like the two diadems—pink topazes for Charlotte, coral cameos for Zénaïde—both set in gold, develop the theme of imperial nobility.

The personalities of the two sisters are clearly distinguished, the one assertive and the other almost bashful; Charlotte sits literally behind Zénaïde, whose outstretched arm seems to offer protection. Both are fashionably dressed although in different modes: again the elder has bared her arms and shoulder, whose whiteness is dramatically enhanced by the black velvet dress, whereas the younger sister is more modestly sheathed in a blue silk pelisse.[4] David has stressed the resemblance of Zénaïde's slightly heavy, womanly features and those of her uncle in the portrait he painted in 1812 for the marquess of Douglas (SEE CAT. 12); her expression is assertive compared with Charlotte's somewhat sheepish glance, which Léopold Robert would capture in a small full-length portrait painted in Rome around 1830 (FIG. 107).[5] Such contrasts between the two sisters, accentuated by the diverse and intense juxtaposition of colors, do not undermine the fundamental theme of sisterhood as fusion, with which David could empathize from his own experience as the father of twin daughters (SEE CAT. 22). As in the

FIGURE 106 Jacques-Augustin Pajou, *Portrait of Mesdemoiselles Duval*, 1814. Oil on canvas, 51⅛ x 38⅛ in. (130 x 97 cm). Musée du Louvre, Paris

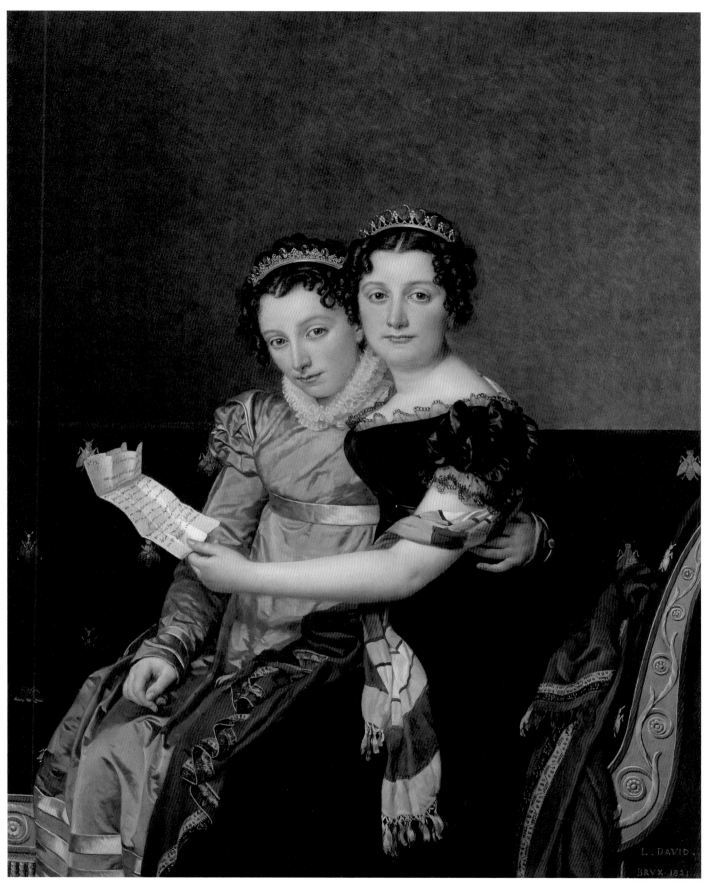

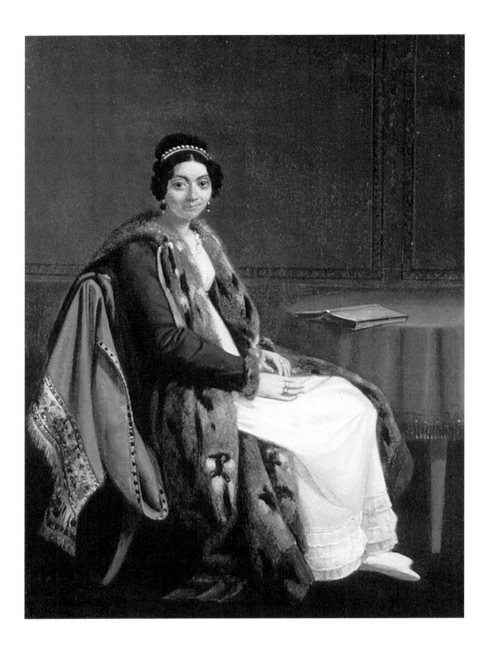

earlier portrait of Cooper Penrose (SEE CAT. 14), the emptiness of the upper part of the picture, more important than was usual, heightens the illusion of a direct confrontation with the seated figures. David apparently judged it unnecessary to include an architectural prop, as he had done five years earlier in a slightly smaller portrait of Turenne (SEE CAT. 49).

Late in 1821 Charlotte sailed to join her father in the United States; Zénaïde followed with her husband only a few months after their wedding in June 1822. One of the two most likely took with her David's double portrait, which was exhibited in the Philadelphia Academy of Fine Arts with pictures from Joseph's collection in the spring of

1823.[6] Charlotte wrote to David in March 1822, mentioning his drawing lessons, which she missed, and how so many people she met would talk to her of the painter. Her letter confirms that the painter was a regular visitor to Julie and her daughters in Brussels. This was in fact widely known since in July 1822, according to a secret police report on the unauthorized exhibition of the *Coronation* in the Hôtel de Ville, he had managed to insert their portraits in the replica: "Madame de Survilliers is represented as the Queen of Spain, and her daughter, who has just married the son of Lucien Bonaparte, is among the ladies in waiting, as if she were replacing the companion of Madame de La Rochefoucauld."[7]

FIGURE 107 Louis-Léopold Robert (Swiss, 1794–1835), *Portrait of Charlotte Bonaparte*, c. 1830. Oil on canvas, 13¾ x 10¼ in. (35 x 26 cm). Museo Napoleonico, Rome

Although Julie was not queen in 1804, David may have invited her to his studio to adjust her portrait in the composition, for her curls are no longer as free as in the original version, but he does not appear to have modified the figure of Madame de Lavalette, who holds Josephine's train, to resemble Zénaïde.

Joseph, who in August 1824 gave a letter for David to his daughter as she returned to Brussels, made the same point: "[Charlotte] will tell you that your fame crossed the Atlantic before we did, but that your works have arrived only since our coming and have justified your fame."[8] Joseph's promotion of the painter may have also entailed support for the public exhibition of David's *Coronation* in Philadelphia, which occurred six months after the painter died, but which had been in discussion with some unknown American entrepreneurs since 1821.[9]

NOTES

1. On Joseph Bonaparte's collection, see Bertin 1983, pp. 415–22; Girod de l'Ain 1970, pp. 349–53. On his stay in America see Connelly 1968, pp. 246–52. For biographical indications concerning members of the family see Tulard 1999, vol. 1, pp. 258–61 (J. Valynseele), 444–45 (E. de Beauverger).

2. Schnapper has sorted out very well the question of the three, and possibly four versions, in Paris-Versailles 1989–90, p. 532; he does not take into account the faked date on the Toulon version, signed most unusually in script with "p¹" for *pinxit* or *pingebat.*

3. The portrait by Riesener, dated 1810, reproduced in the sale catalogue, Paris, Hôtel Drouot, 16 Dec. 1997, no. 6, appears to be no. 683 of the 1810 Salon *livret* (*Portrait en pied d'une dame et de sa soeur*). The portrait by Pajou is signed and dated 1814.

4. "David's portrait of the Bonaparte sisters shows Charlotte on the left in a blue silk pelisse trimmed with satin ribbon; the frilled silk ruff and the ruched upper sleeve are 'Renaissance' features influenced by *le style troubadour.* Zénaïde wears a more formal costume of black velvet, trimmed with embroidered net; her sleeves, with their puffed satin inserts, also reflect the historical theme." Ribeiro 1995, p. 129.

5. Jean-Pierre Cuzin suggests, perhaps because he finds the two sisters unattractive, that "l'intention d'ironie presque méchante du peintre apparaît sous-jacente" (Paris 1997, p. 180).

6. "David has his *Napoleon Crossing the Alps,* and in the Gallery two portraits (in one picture) of the daughters of Count Survilliers. There are ten well executed pieces by the accomplished Countess Charlotte de Survilliers." *Poulson's Daily Advertiser* (Philadelphia), 22 May 1823.

7. "Madame de Survilliers y figure comme Reine d'Espagne, et sa fille qui vient d'épouser le fils de Lucien Bonaparte est parmi les dames d'honneur, comme si elle remplaçait la compagne de Madame de La Rochefoucauld." Report to the Minister of Justice, 4 July 1822 (Dowd 1955, p. 155).

8. "Elle [Charlotte] vous dira que votre gloire avait traversé l'Atlantique avant nous, mais ce n'est que depuis notre arrivée ici que vos ouvrages y sont arrivés et ont pu justifier votre gloire." Joseph Bonaparte to David, New York, 1 Aug. 1824; New York, Pierpont Morgan Library, MA2224. This further confirms that Joseph received the original version. Charlotte's letter to David, 29 [not 20] Mar. 1822, is cited in David 1880, p. 567. She mentions regretting "de n'avoir point vu le nouveau chef-d'oeuvre commencé à Bruxelles" before departing, reference no doubt to *Mars and Venus,* which David began in the autumn of 1821 (as proposed by A. Schnapper in Paris-Versailles 1989–90, p. 541).

9. *Poulson's Daily Advertiser* (Philadelphia), 31 Aug. 1826. On the British and American tour of the *Coronation* by a "maison commerciale de New York," probably in contact with Joseph, see A. Schnapper in Paris-Versailles 1989–90, p. 534 (in Philadelphia, the venue was Washington Hall).

Portrait of Pauline-Jeanne Jeanin, née David, and Her Daughter Émilie

1821

Black crayon on paper
5⅝ x 7⅞ in. (14.4 x 20 cm)
Signed and dated in black crayon, lower center: *Le 12 juin 1821 L. David. Bruxelles.*

The Snite Museum of Art, University of Notre Dame, Indiana. Gift of Mr. John D. Reilly, Class of 1963 (inv. L 86.53.2)

PROVENANCE

Pauline-Jeanne David (26 Oct. 1786–1870); her son, Louis-Charles Jeanin (1812–1902); . . . ; 1986, acquired on the New York art market by John D. Reilly for the museum.

EXHIBITIONS

Paris-Versailles 1989–90, p. 533, no. 232; Notre Dame 1993, no. 45.

BIBLIOGRAPHY

David 1880, p. 663; Sérullaz 1972 [1975], p. 107; Prat and Rosenberg 2002, vol. 1, p. 376, no. 437.

IN THE spring of 1821 David's daughter Pauline spent some time in Brussels to look after her parents and perhaps get away from her husband. She was there around the time he was close to Julie Clary and her daughters, and was among the "other persons of [David's] family" to whom Charlotte sent her greetings from America.[1] Although her portrait with Émilie (1816–1825) is an informal exercise, with only the faces finished, the manner of creating a proximity between the two figures evokes the image of the Bonaparte sisters. The juxtaposition of the two faces invites a visual comparison, a search for signs of resemblance and dissonance, as in the painting. Given the disjunctive structure the composition shares

with so many intensely expressive drawings from these years (see the preceding section), this highly reserved portrayal is all the more singular.

In the list of works appended to his monumental monograph published in 1880, Jules David mentions another family portrait, of Pauline's son, Louis-Charles Jeanin (1812–1902), then in his collection. The painting, measuring about twenty-two by eighteen inches (55 by 45 cm), which it is said David let his assistant Michel Stapleaux sign, is described in detail: "[David's] grandson is represented at the age of ten, facing forward, his arm

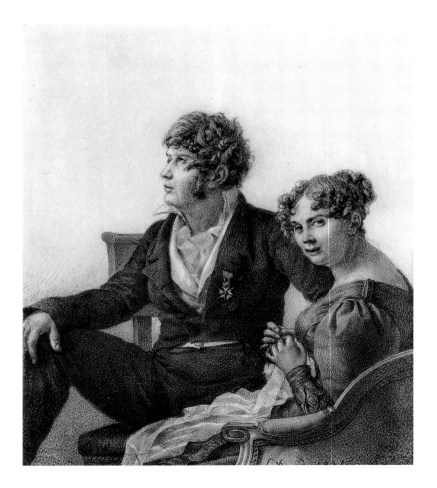

Le 12 juin 182. L. David. Bruxelles.

on the back of a chair, wearing a white cravat, a white vest, and a black jacket." Although Louis-Charles was ten in 1822, Jules David dates this untraced work to 1824.[2]

The most elaborate work in this family gallery is the drawing of Eugène David (1784–1830) and his wife, Anne-Thérèse Chassagnolle (1800–1845), dated 1825 (FIG. 108). Eugène shows off the medal of the Legion of Honor obtained for military service and looks away lost in his thoughts, the image his father had of him when he declared, "his mind is unsteady." Annette, as David affectionately called her, is clearly the solid member of the couple, sharing with the viewer—and her father-in-law—a quick glance that registers understanding. As in the portrait of Zénaïde and Charlotte Bonaparte, David composes by contrasting the two figures, probably drawn independently, since they do not quite fit together spatially, and also the dress and furniture, differentiated with great care. The back of the sheet bears an annotation by Eugène: "last drawing of my poor father."[3]

NOTES

1. David 1880, p. 567.
2. "Son petit-fils est représenté à l'âge de dix ans, de face, le bras appuyé sur le dossier d'une chaise, vêtu d'une cravate blanche, d'un gilet blanc et d'un habit noir." David 1880, p. 651.
3. On this drawing, see Prat and Rosenberg 2002, vol. 1, p. 387, no. 451. "Il [Eugène] n'a pas d'aplomb dans la tête." David to Levol, 17 June 1824 (Wildenstein 1973, p. 230, no. 1967, cited in Prat and Rosenberg 2002). Inscription on the back: "dernier dessin de mon pauvre père / E. David."

Portrait of Baptistine-Julie ("Juliette") Blait de Villeneuve

1824

Oil on canvas
77⅞ x 48⅜ in. (198 x 123 cm)
Signed and dated on the chair, lower
left: *L. DAVID. BRUX / 1824.*

Musée du Louvre, Paris. Don de la
Société des Amis du Louvre en 1997,
à l'occasion de son centenaire et
en mémoire du président F. Puaux,
grâce à la contribution du Fonds du
patrimoine et avec la participation d'un
groupe d'Amis du Louvre et de la
société LVMH (inv. RF1997–5)

Exhibited in Los Angeles only

PROVENANCE
The sitter's mother, Catherine ("Hon-
orine") Clary (d. 1843), wife of Henri-
Joseph-Gabriel Blait de Villeneuve;
although she died before her mother,
perhaps the sitter, Baptistine-Julie
("Juliette") Blait de Villeneuve (21 Apr.
1802–27 May 1840), married in 1833 to
her half-cousin[1] Comte Joachim-
Charles ("Napoleon") Clary
(1803–1856); their son Joseph-Adolphe
Clary (1837–1877), married in 1870; his
daughter Louise-Marie Clary
(1872–1963), "baronne de Beauverger,"
wife of Henri-Auguste ("Arthur") Petit
de Beauverger (1857– 1946); their son
Antoine ("Edmond") Petit de Beau-
verger and his descendants; 1997,
acquired by the museum, gift of the
Société des Amis du Louvre, on the
occasion of its centennial and in mem-
ory of its president François Puaux,
with a special contribution from the
Fonds du Patrimoine and an anonymous
donor in memory of Cécile de Roth-
schild, and with the participation of a
group of members of the Société des
Amis du Louvre and of LVMH / Moët
Hennessy Louis Vuitton.

EXHIBITIONS
Paris 1936, pp. 149–50, no. 223; Paris
1950, no. 25a; Paris 1997, pp. 179–81,
unnumbered.

BIBLIOGRAPHY
Th. 1826b, pp. 147, 166; Coupin 1827,
p. 57; Miette de Villars 1850, p. 210;
Delécluze 1855 [1983], p. 368 n. 1;
Seigneur 1863–64, p. 367; David 1880,
pp. 567, 583, 651; Saunier [1903], p. 119;
Cantinelli 1930, p. 116, no. 158; Holma
1940, p. 129, no. 164; Hautecoeur 1954,
p. 251; Wildenstein 1973, p. 231, no. 1982;
Schnapper 1980, p. 288; A. Schnapper in
Ixelles 1985–86, p. 34; A. Schnapper and
E. Agius-d'Yvoire in Paris-Versailles
1989–90, pp. 515, 631–32; Cuzin 1997;
Vidal 2003, pp. 248, 250.

THE FIRST mention of this portrait, one of the
most spectacular rediscoveries in recent years,
is found in a letter addressed to David from Paris
on 4 June 1824 by Michel Stapleaux, a young
painter who collaborated with him in Brussels:
"You no doubt have finished the *ébauche* of the
portrait of Mlle de Villeneuve."[2] On 26 October
David acknowledged receipt of his fee for the
picture: "Madam / Please accept my thanks; I was
given on your behalf the sum of six thousand
francs in payment for the portrait that I executed
of your daughter Mademoiselle Juliette. / I very
much hope that you will have as much pleasure in
possessing it that I had in painting it; my hand
was guided by my heart and I shall never forget
the signs of esteem and affection by which you
and your family have always honored me. / Please
be assured, Madam, of the profound respect with
which I am honored to be your humble servant. /
David, former first painter of emperor Napoleon
the 1st and *commandant* of the Legion of Honor."[3]

The lady with a harp was a standard motif of
portraiture during the Consulate and the Empire.
David had been able to see such full-length por-
traits at several Salons,[4] although it was only dur-
ing the late Empire that Sébastien Erard, the most
famous harp manufacturer of the time, perfected
his more massive harp *à double mouvement,* with
seven pedals, which intensified the vogue. David,
who had painted Sappho with her lyre in 1809,
surely appreciated how the instrument united
antiquity and modern times, art and industry. He
may even have reflected on the parallel between
such a revival of the ancients in contemporary
music-making and his own artistic endeavors. The
harp Juliette is shown playing is a rather typical
luxury model produced by Erard, who combined
refined classical ornamentation in bronze, *ébénis-
terie,* and marquetry with a sophisticated mecha-
nism hidden by the wooden frame.

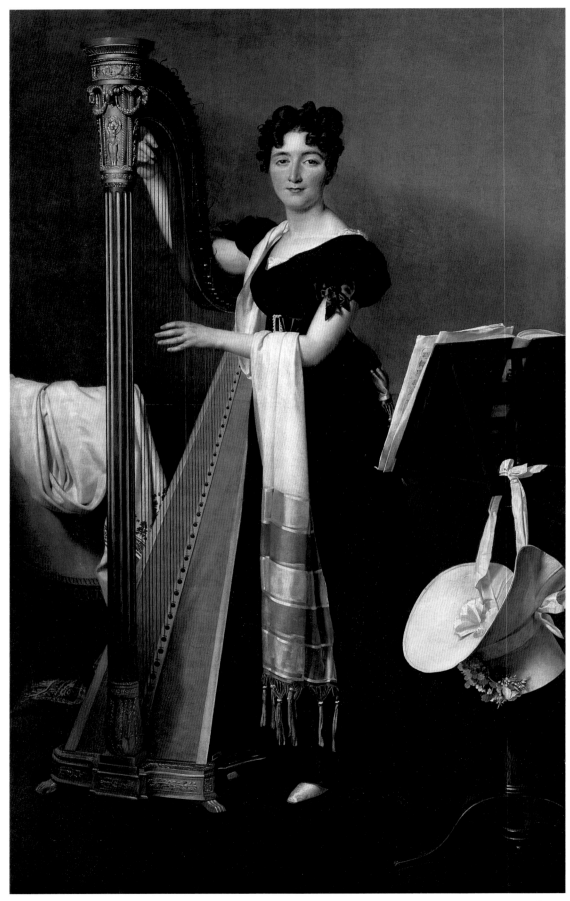

Harp playing was an important pastime in the household of Juliette's aunt. In Paris, Zénaïde had studied with the virtuoso Robert Bochsa, and later in Rome would be represented by Charles de Chatillon seated playing a harp with her husband standing beside her.[5] It is probable that Juliette was represented playing an instrument shared by the young ladies of the house, who were all about the same age. It should be noted that the commission for the portrait dates from a period when both of her aunt's daughters were in America with their father. In their absence, Julie Clary's affection for her niece was probably even greater, and in all likelihood she provided to her sister Honorine the funds for the portrait.

David had not painted a full-length portrait since that of General Gérard in 1816 (SEE CAT. 50), in the same format, but wider by five inches (13 cm). The compositions both manifest a sense of monumentality; the models adopt a slightly stiff, almost unnatural pose, corresponding to David's sense of decorum and dignity, but their visual context could not be more different. The military officer is represented in the grand aristocratic manner of Van Dyck tempered by official imperial portraiture, whereas the young woman is treated in an aggrandized Dutch genre mode.[6] The prominent elements of dress, furniture, and decoration create a domestic environment until then alien to David, if one excepts the detailing of Marat's humble interior required by Jacobin propaganda and of Napoleon's study. David here felt no pressure to provide a realistic description and a pictorial illusion other than that dictated by his artistic imagination, which also led him to employ bold color harmonies and warm tones, in other words, he aspired to be a modern painter. The letter he addressed to Juliette's mother reveals another fundamental motivation: his fidelity to Napoleon. Around the time, 1821–22, he was completing the replica of the *Coronation*. He felt inspired by the presence in Brussels of the former queen of Naples and Spain, the wife of the patriarch and—since the death of the emperor in 1821—the head of the Napoleonic dynasty, with her family. When signing his letter, the recall of his imperial titles, by then a rare occurrence, symbolically situates the portrait in his mind among the series of Napoleonic commissions that had allowed him to express his genius.

NOTES

1. Juliette and Joachim-Charles had the same grandfather, François Clary: Joachim's father was the son of his first wife, Juliette's mother was the daughter of his second.

2. "Vous avez sans doute achevé l'ébauche du portrait de Mlle de Villeneuve." Letter cited by E. Agius-d'Yvoire in Paris-Versailles 1989–90, p. 631. The *ébauche,* not to be confused with a sketch, is the first thin layer of paint on the prepared canvas.

3. "Madame, / Veuillez bien recevoir mes remerciements; l'on m'a remis de votre part la somme de six mille francs pour le payement du portrait que j'ai fait de mademoiselle Juliette votre fille. / Je désire que vous ayez autant de plaisir à le posséder que j'en ai eu à le peindre; ma main était guidée par mon coeur qui n'oubliera jamais les marques d'estime et d'attachement dont vous, et votre famille, m'avez toujours honoré. / Daignez agréer, Madame, l'assurance du profond respect avec lequel j'ai l'honneur d'être votre très humble serviteur. / David, ancien premier peintre de l'Empereur Napoléon 1er et commandant de la Légion d'honneur." David to Catherine "Honorine" Blait de Villeneuve, 26 Oct. [1824] (cited in Paris 1936, p. 150; partially cited in Wildenstein 1973, p. 231, no. 1982).

4. A full-length portrait of a woman with a harp appears in the background of a satirical print by Thomas-Charles Naudet related to the Salon of 1799 (Crow 1995, p. 235, fig. 256). Oppenheimer reproduces a print after the self-portrait of Alexandrine-Adélaïde Auger playing a harp, exhibited at the Salon of 1806 (1996, fig. 1).

5. Bertin 1983, p. 289. The drawing by Chatillon is in the Museo Napoleonico, Rome (illustrated in the museum guide by Laura Capon [1986, p. 60]).

6. More than anyone, François Gérard was responsible for establishing a distinctive formal style in imperial portraiture, however during the Directory and Consulate he experimented in the Dutch genre mode (see my remarks in San Diego 2003–4, pp. 32–34).

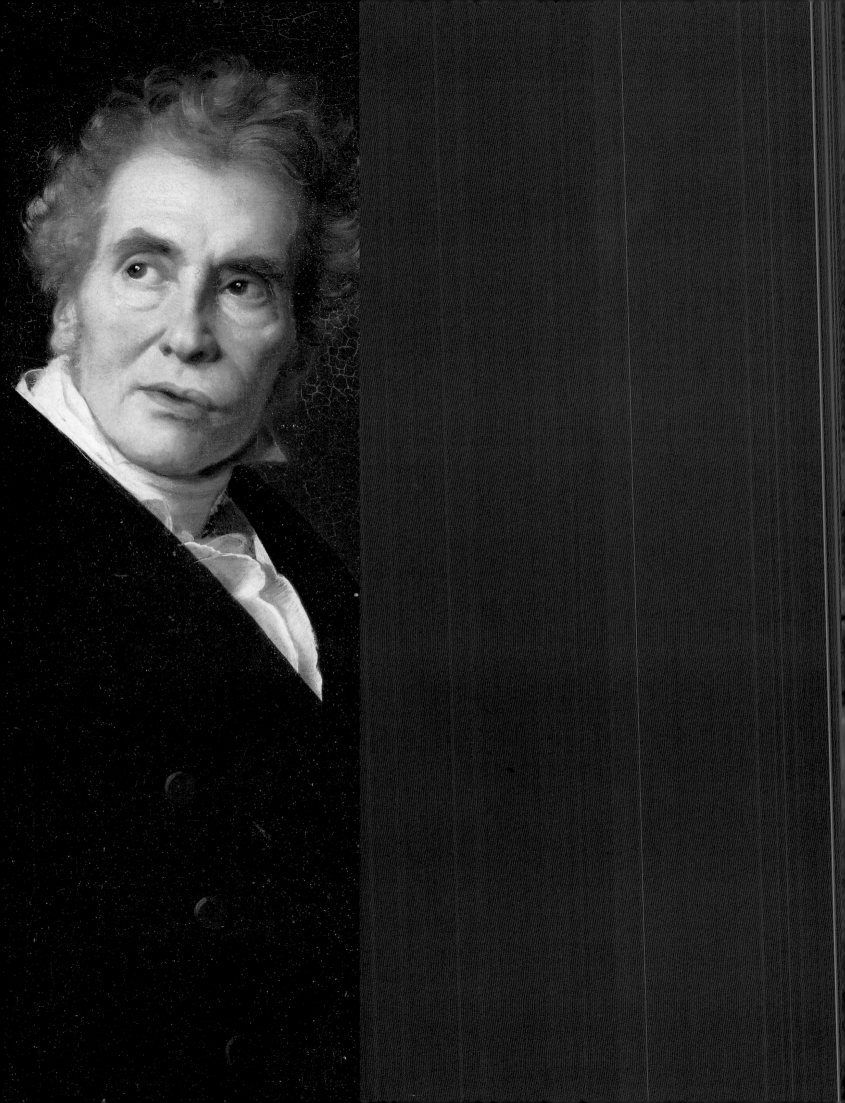

The Image of the Artist

In BELGIUM David felt particularly close to his former pupil Joseph Odevaere (1775–1830), who had won the Rome Prize in 1804 and who was official painter to the king of the Netherlands. He considered him to be the only artist with whom he might converse seriously on matters of art.[1] In 1821–22 it was decided that Odevaere would draw a full-length portrait of David in his studio, which from the start they probably intended to have engraved. Word spread among the local studios of the favor the master had accorded to Odevaere, who was much envied by the other artists. In July 1822 François-Joseph Navez mentioned it to Léopold Robert, adding in his letter that the drawing had been confided to the engraver Jean-Pierre-Marie Jazet, who found it abominably mediocre, but nonetheless had done the work because of David's authority.[2]

The resulting print (FIG. 109)—stiff, hard, and poorly drawn—is in truth not very attractive, no doubt the reason it has received only meager attention. It merits consideration as a visual document, for it aims to visually summarize David's artistic personality and life achievement. As in his prison self-portrait (SEE CAT. 1), he is shown displaying the instruments of his art, with one brush held ready in one hand, a cluster of brushes and his palette in the other. His dress is stylish, notably the riding boots. On the chair is one of his greatcoats—*aux trois collets*—that he wore since the Revolution; on the floor to the right, his hat and cane for going out.

Surrounding the painter are four of his works. On the right, the ephebic figure of Tatius's equerry from the *Sabines* resumes a lifelong fascination. Behind the tilted canvas, which was in Paris at the time, a version of *Bonaparte Crossing the Alps* (SEE CAT. 4) is positioned. No doubt to sidestep the royal censors, the figure is carefully concealed, except for the raised hand; the steed stands in for the hero.[3] On the small chest to the right is a drawing for *Leonidas,* rolled up so as to reveal only the soldier carving the historic inscription in the rock. Finally, on the easel is the *Portrait of Pius VII* painted in 1805 (SEE FIG. 48). The earliest of these four works, the *Sabines* bearing the date of 1799, attests to the artistic threshold that his post-revolutionary productions represented for David. *Belisarius, Andromache,* the *Horatii, Socrates,* and *Brutus* are forgotten, relegated to

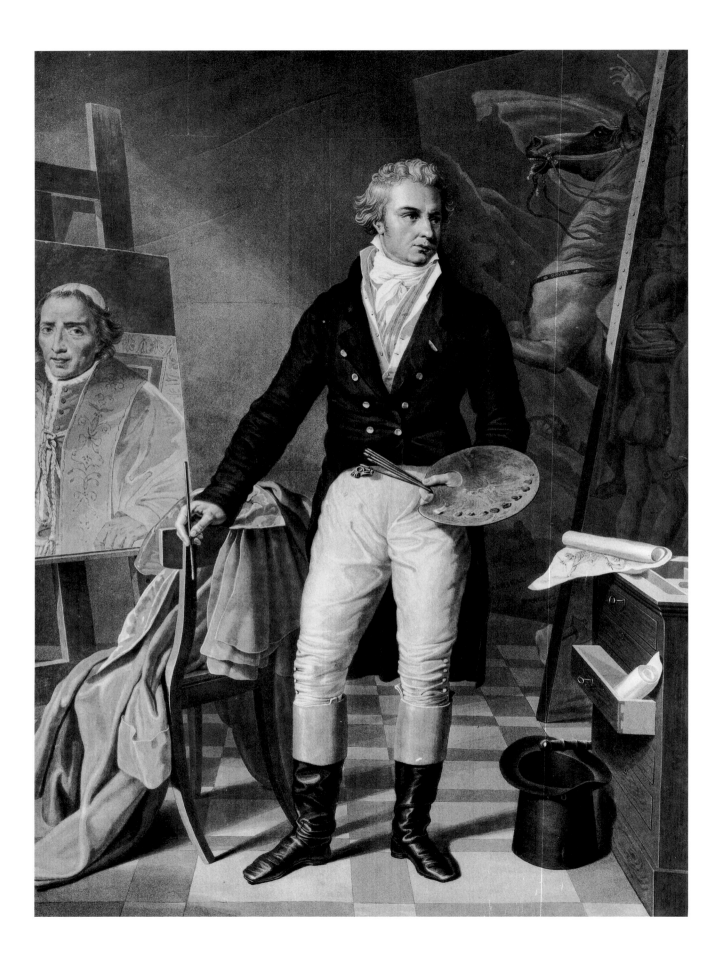

an Ancien Régime past. Although he does not wear his cross of the Legion of Honor, the legendary image that dominates the scene is an unequivocal sign of his fidelity to Napoleon. He may have had at least two motives for highlighting his portrait of the pope. The compact monumentality of the composition was an ostentatious revision of Raphael, to whom he felt a sense of competition as a papal portraitist.[4] Its inclusion also relates to David's insistent return to the figure of Pius VII while in Brussels: he produced at least six drawings, all but one though after the profile in the *Coronation*.[5] Conscious or not, this obsessive focus may have been the surrogate expression of a religious need, not unlike like the *Fortune Teller* (SEE FIG. 17 and the essay "Antiquity Revisited" in this volume).

In 1822 Jazet finished engraving David's *Oath of the Tennis Court*, on a plate some twenty-eight inches (70 cm) high, about the same size as Odevaere's portrait, and would shortly begin to reproduce the *Coronation*, on sale clandestinely in Paris by October 1823.[6] The death of Napoleon in 1821 appears to have put David in a combative mood and prompted him to finish the replica of the *Coronation* to show it around Britain and America. The three prints by Jazet formed an eloquent triptych, with the artist poised between celebrations of the dawn of the Revolution and consecration of Empire. More than any other image of the artist, this was the one he wanted posterity to retain.

FIGURE 109 Jean-Pierre-Marie Jazet (French, 1788–1871), *Portrait of Jacques-Louis David* (after a drawing by Odevaere), 1822. Engraving, 30 x 22 in. (76 x 56 cm). Bibliothèque nationale de France, Paris

François Rude (1784–1855)

Portrait of Jacques-Louis David

1826–31

Marble

22⅝ x 10¼ x 8¼ in. (57.5 x 26 x 21 cm)
overall; height of bust 15⅜ in. (39 cm)

Musée du Louvre, Paris. Département
des Sculptures (inv. RF419)

PROVENANCE
Probably given or bequeathed by the
sculptor to his pupil and nephew,
Jean-Baptiste-Paul Cabet (1815–1876);
1876, bequeathed to the museum by his
daughter Françoise Cabet, wife of René-
Louis Faber; 1881, acceptance of the
bequest by the museum at her death.

EXHIBITIONS
Paris, Salon of 1831 (uncatalogued);
Dijon 1955, p. 21, no. 12.

BIBLIOGRAPHY
Fourcaud 1904, pp. 449–50, 456;
Wilhelm 1964, pp 171–72; Wildenstein
1973, p. 239, no. 2044; J. Holderbaum in
Los Angeles 1980–81, p. 42; Gaborit 1998,
vol. 2, p. 575; M. Populaire in Ixelles
1985–86, p. 425; E. d'Agius-d'Yvoire in
Paris-Versailles 1989–90, pp. 634–36.

FIGURE 110 François Rude, *Portrait
Bust of Jacques-Louis David*, 1826.
Plaster, height 31¾ in. (80.5 cm).
Private collection

IN 1807 FRANÇOIS RUDE left his native Dijon
for Paris, where he studied with the sculptor
Pierre Cartellier; five years later he won the cov-
eted Prix de Rome for sculpture, although he did
not travel to Italy. His friend and protector Louis
Frémiet, also from Dijon, was a fervent Bonapartist
whom Rude followed to Brussels when he expatri-
ated in 1815 with his daughter Sophie—a girl to
whom the young sculptor was reportedly not
indifferent. In Belgium he managed to establish
his reputation, although he was at a disadvantage
compared to local artists. He shared with Frémiet,
who published articles in the press supporting
David (SEE CAT. 32), a deep admiration for their fel-
low exile, both the superior artist and the histori-
cal figure. Like Odevaere, he could avail himself of
his status as Prix de Rome to merit the encourage-
ments of the painter, who may have introduced
him to potential clients.[1] When Sophie Frémiet

became his wife in July 1821, she was an aspiring
history painter, collaborating closely with David.
A mysterious quarrel in 1822, however, led David
to break off all relations with the young couple.

In spite of this, Rude sustained his admiration
for David. In 1823 the couple named their first
child Louis, perhaps in homage to him; after
David's death on 29 December 1825, the sculptor
served as pallbearer during the burial ceremony—
which was finally organized in Brussels in October
1826, more than nine months after David's death,
only after it was clear the Bourbon government
would not give permission to take his body back
to France.[2] David's family commissioned Rude
to execute a bust probably around the time he
died, for the model was finished by May 1826.
The sculptor is known to have made a cast of the
painter's right hand, but no face mask is attested.
From molds of the lost clay he made a plaster
model, which served to cast a bronze and execute
this marble version. The 1826 plaster model repre-
sented the bust draped *à l'antique* (FIG. 110), while
in the bronze and the marble, the head is cropped
below the neck.[3]

The challenge for Rude, of course, was David's
face, the bulge of the exostosis that deformed the
left cheek. When Gros in a portrait of his wife in
1822 placed an imaginary bust of his master, with
which he seems to dialogue as he paints, he was
careful to show only the right side of his face
(FIG. 111). The discrepancy between moral character
and ungracious features was often discussed with
regard to Socrates, who according to Plato's *Sym-
posium* had Silenus-like features and resembled
the satyr Marsyas. Extant variations of the philoso-
pher's bust by Lysippos offered visual solutions to
this problem. In 1787 David himself had resolved
masterfully this physiognomic contradiction in
his *Death of Socrates* (Metropolitan Museum of

Art, New York), a composition Rude probably knew from engravings. That Lysippos was reputed for his attention to realistic detail in his portraits, especially in the treatment of the hair, was no doubt part of the lore in sculpture studios at the time, ultimately derived from Pliny the Elder's *Natural History.* In Rude's bust, along with the mouth, which has a natural dignity, David's proud locks are carved with virtuosity and give life to the portrait. Like the flame on the head of allegories of youthful genius, they are a metaphor for artistic inspiration. The motif evolved rapidly into a romantic cliché, as in the portraits of Alphonse de Lamartine by Pierre-Jean David d'Angers (1830) and François Gérard (1831). In their sculpted busts, however, both Rude and David d'Angers, who studied with his namesake, remained partisans of the antique and rejected eighteenth-century natu-

ralism, notably the practice of hollowing out the eyes to achieve expression.

NOTES

1. Fourcaud 1904, p. 100.
2. On David's death, see David 1880, pp. 605–18; on political reactions in Paris, see Kohle 1991.
3. The status of the various versions has yet to be fully established. The fully draped plaster (fig. 110), reportedly dated 1826, was at one time with Galerie d'Arenberg, Brussels (Ixelles 1985–86, pp. 425 [no. 422], 441). The Musée des Beaux-Arts, Dijon, recently acquired a plaster with the drapery cropped about halfway across the chest (repr. *GBA,* Mar. 2002, supplement), and has in its collection a bronze comparable to this marble finished by 1831. Another marble bust dated 1838, in contemporary dress and with more expressive features, commissioned in 1833 to decorate the Grande Galerie of the Louvre, is still in the collection (Gaborit 1998, vol. 2, p. 575, inv. LP1780).

FIGURE 111 Antoine-Jean Gros, *Portrait of Madame Gros,* 1822. Oil on canvas, 46½ x 35⅜ in. (118 x 90 cm). Musée des Augustins, Toulouse

ART AFTER POLITICS

1. This was to be no easy task, as the horrific details of the repression during the Terror (1793–94) were progressively made public; see the fundamental study, Baczko 1989.

2. Halliday 2000; Bordes in San Diego 2003–4.

3. See Bordes 1989.

4. For a fuller discussion of these portraits by David and Gérard, in light of recent debates, see Bordes in San Diego 2003–4, pp. 6–8. In his review of Halliday 2000, John Goodman well résumés the strategy adopted by the younger generation: "Like the elegant attire worn by Isabey in the portrait and its curious country-gentleman allure, in the post-Thermidorian context, the *exemplum amicitis* publicized by Gérard's portrait at the Salon would have fostered fantasy projections on to this emergent artistic elite, making commerce with its members seem more desirable" (2001, p. 166).

5. David has been linked to neo-Jacobin club meetings and petitions and to the civic religion of Theophilanthropy, but this question is in need of a close reexamination on account of problems of possible homonymy in the documents. Although the relation between such political activity and his art in the cultural context of the Directory is extremely problematic, the dismissal of such considerations in Lajer-Burcharth's recent narrative (1999), with the exception of a closely argued discussion of the series of medallion portraits David drew in prison, seems undue. Such repression of political activity, producing a figure of passivity, is concomitant with the author's fundamental dramatization of the presumed burden of the Terror on David's art. This critical concept is perhaps better suited to interpret the ambitions of younger artists, like Isabey and Guérin, rather than the more complex personality of David. To what effect the Robespierrist phase of the Revolution continued to haunt the latter after his release from prison remains very open to debate (for how David reacted to the revival of this past with the return of the Bourbons in 1814, see the essay "In the Service of Napoleon" in this volume).

6. See Bordes 1983, pp. 115–16, n. 273.

7. When David exhibited the *Horatii* to great acclaim in 1785, some criticism of this kind was already heard: "Cette uniformité affectée dans leur [the Horatii's] pose, n'est pas agréable et tient au bas-relief, ce qui est un défaut en peinture. Je crois que si ces guerriers étaient plus variés, qu'ils produiraient un meilleur effet, et n'ôteraient pas la simplicité noble, dont M. David affecte de faire abus dans tous ses ouvrages. . . . En vérité, je ne m'y reconnais plus! On appelle folie ce qui est génie et a du mouvement. . . . Et on appelle génie ce qui est froid et raide" (*Supplément* 1785, p. 3). At the Salon of 1795 some critics expressed fear that the "nouvelle méthode" based on the imitation of antique models would yield "des productions sèches et froides"; the following year, a Neoclassical composition by Taillasson was judged "d'un mérite glacial" (see R. Michel in Bordes and Michel 1988, pp. 65, 72). By 1804–5 criticism of David's influential manner had become more articulate and explicit. In a letter of 7 Oct. 1804 to Artaud de Montor in Rome, François Cacault from Paris implored that Wicar's *Concordat* would not be a "tableau à la David avec des ombres au noir de fumée"; he added on 12 Jan. 1805: "Il faut au lieu des raideurs de M. David, rendre la nature avec morbidezza: il faut dans le tableau de Wicar ce sentiment de nature; cette vie, ce caractère qui manquent à tout ce qu'on fait ici" (Archives communales de Mantes-la-Jolie, sous-série S3, collection Clerc de Landresse [on deposit from the Bibliothèque municipale], vol. 1, nos. 560–65).

8. David's reply to the "citoyens administrateurs," dated 27 Feb. 1796, quotes the flattering letter addressed to him, indicating that his name "fera époque dans l'histoire de l'art" (sale, Paris, Hôtel Drouot, autograph collection of Girod de l'Ain, 8 Dec. 1980, no. 49).

9. See the reference to Taunay by Joachim Lebreton in a letter dated 10 Nivôse Year IV (31 Dec. 1795): "sa personne est absolument irremplaçable dans le camp de la peinture de genre qui ne se trouveraient point représentée comme elle mérite de l'être. Son absence provoquerait des regrets et des blâmes" (cited in Jouve 2003, pp. 397–98).

10. The most detailed discussion of the *Sabines* project is provided by A. Schnapper in Paris-Versailles 1989–90, pp. 323–38. For elaborate interpretations of the painting's relation to Directory society, whose constitutive elements and internal dynamics might still merit greater focus, see Grigsby 1998, and Lajer-Burcharth 1999, pp. 130–35.

11. See Schnapper in Paris-Versailles 1989–90, p. 323. To the artists who treated this theme, including Guercino, with a painting for the gallery of La Vrillière and appropriated for the Revolutionary museum, can be added a recently rediscovered painting by Jean-Antoine Julien (Julien de Parme) dating from 1772, a disorderly mêlée in which the motif of the child raised in the air by his mother is prominent (see Rosenberg 1997, p. 18 n. 38; pp. 24–25 n. 72; repr. between pp. 48 and 49).

12. "Romulus suspend le javelot qu'il est prêt à lancer contre Tatius. Le général de cavalerie remet son épée dans son fourreau. Des soldats élèvent leurs casques en signe de paix. Les sentiments de l'amour conjugal, paternel et fraternel, se propagent de rang en rang dans les deux armées. Bientôt les Romains et les Sabins s'embrassent, et ne forment plus qu'un peuple." This is extracted from a pamphlet David published in the Year VIII (Sept. 1799–Sept. 1800), when he organized a paying exhibition of the *Sabines*, and gave to each visitor; for the complete text, see Wildenstein 1973, pp. 148–50, no. 1326.

13. Chaussard's text is often quoted, recently by Louise Govier who provides an innovative reading of the painting based on a rapprochement between the antique theme and the collective interventions by women during the 1790s on the political scene, a historical factor largely ignored by all other commentators (Govier 1998, pp. 119–33).

14. See the review of Lajer-Burcharth 1999 by Lebensztejn (1999). The best access to her book is the sympathetic review essay by Goodman 2001, pp. 170–76.

15. The crucial testimony, as noted by Schnapper (Paris-Versailles 1989–90, p. 328), is a passage of the *Notice* 1824, pp. 38–39: "Ce sujet [the *Sabines*], tout romain comme les Horaces, le ramenait souvent à ce dernier. C'est alors qu'il s'armait d'une noble sévérité contre lui-même. Peut-être, disait-il, ai-je trop montré l'art anatomique dans le tableau des Horaces? Dans celui-ci, en parlant de l'Enlèvement des Sabines [*sic*], je crois l'avoir caché avec plus d'adresse et de goût. Ce tableau sera plus grec." As Schnapper also notes, this fundamental biography was written at the painter's instigation (pp. 18–19).

16. See Bordes 1996, p. 60.

17. "Observez que ce sera le dernier ouvrage de cette importance qui sortira de ma main." David's manuscript is transcribed in Bordes 1983, pp. 177–78.

18. Lajer-Burcharth 1999, p. 208: "although it recreated the nucleus of power and privilege of the old academies, the Institut did not provide the artistic community with the collective imaginary corpus that would regulate its existence and give it a sense of belonging and self-recognition—that is, a subjective, and not just an institutional, support." This complaint would be instrumentalized by conservatives to call for a restoration of the Ancien Régime academy; see Boutard 1807.

19. For a gloss on the "psychosexual logic of male narcissism" operating in David's studio at this time, see Lajer-Burcharth 1999, pp. 218–21. That

analysis minimizes the social, cultural, and political diversity among the pupils, well attested by Delécluze, and although purporting to uncover some hidden dynamics within the studio, it interprets David's teaching practice in a manner that might also be applied to the other *chefs d'atelier.*

20. There has been much interest recently on this close association between master and pupils centered on the "narcissistic dynamic" of the nude male model (Lajer-Burcharth 1999, p. 222; see also Crow 1995, *passim*). David occasionally asked the young men to take up a pose for his own benefit or for the other pupils, a practice that undeniably gives a homoerotic potential to the pedagogic relationship. Whether this is an important key for understanding his art during the 1780s and 1790s is open to debate.

21. Carr 1807, pp. 147–48. John Carr was in Paris during the summer of 1802 and first published his *Tour* in 1803.

22. Lajer-Burcharth 1999, p. 217: "The low profile that David kept at the Institut was not just a symptom of his protective self-withdrawal but rather a function of his deliberate strategic effort to relocate cultural authority onto himself as a one-man Academy. It was part of an attempt to carve his own space of influence—not through the public institutions but through his studio practice" (p. 218).

23. "[La République] s'empressera de prouver aux autres nations, ce que peut un peuple libre; elle leur prouvera par la grandeur et la magnificence de ses édifices publics, combien elle est au-dessus de toutes les Républiques qui l'ont précédée." Bonnaire 1937–43, vol. 1, p. 59.

24. "Desséchés par sept années de stérilité, les arts du dessin ont besoin de travaux qui les tirent promptement de l'état de langueur dans lequel ils sont tombés." Bonnaire 1937–43, vol. 1, p. 64.

25. David 1880, pp. 331–34; Paris-Versailles 1989–90, pp. 593–94.

26. David 1880, p. 346 ("en considération du désintéressement de cet artiste"); Wildenstein 1973, pp. 146 (no. 1301), 147 (no. 1315); Schnapper in Paris-Versailles 1989–90, p. 328 (see also p. 595).

27. Wildenstein 1973, p. 153, no. 1352: "ornement intérieur," "dont le Salon avait besoin pour remplir l'objet proposé"; Schnapper in Paris-Versailles 1989–90, p. 332.

28. The fundamental study is Gonzalez-Palacios 1993, pp. 927–63, 998–1005, figs. 183–218. See also Pierre Arizzoli-Clementel, "Les arts du décor," in Bordes and Michel 1988, pp. 281–311.

29. Lajer-Burcharth 1999, pp. 157–61.

30. Delécluze 1855 [1983], p. 194: "Ce fait [that Madame de Bellegarde was posing for him] se répandit dans la ville, mais en passant d'abord par tous les ateliers de peinture du Louvre, ce qui lui fit prendre un coloris un peu plus cru, mais absolument faux."

31. For a recent discussion of these two portraits, with relevant references, see Bordes in San Diego 2003–4, pp. 9–11.

32. David's deposition during the trial is reproduced in Wildenstein 1973, p. 159, no. 1369.

33. "Cette production est plus d'un grand poète que d'un peintre." [Mende-Maurepas] 1789, p. 2.

34. For the aesthetic, moral, and social aspects of the polemic, see Schnapper in Paris-Versailles 1989–90, pp. 336–37; and Grigsby 1998.

35. Schnapper in Paris-Versailles 1989–90, p. 336. The nudity of the figures was largely covered in the bronze group, inspired by the painting, produced for a clock exhibited at the *Exposition des Arts de l'Industrie* in 1806; London 1991–92, pp. 87, no. 38, repr. Pl. XIX).

36. "Ce n'est point ici une spéculation vile, mais une tentative honorable pour l'art et les artistes." David 1880, p. 352. See the fundamental discussion of the debate concerning paying exhibitions by Schnapper in Paris-Versailles 1989–90, pp. 328–36.

37. The text of the brochure, from which the quotes in this and the following paragraph are taken, is reproduced by David 1880, pp. 352–58; and Wildenstein 1973, pp. 148–50, no. 1326.

38. Bordes 1992.

39. *Journal de Paris,* 10 Nivôse Year VIII (31 Dec. 1799), no. 100, pp. 453–54 ("*Peinture*"). A transcription is in the *Sabines* file of the Documentation Service of the Paintings Department of the Louvre. The passages cited: "Les artistes seuls ont commencé cette utile régénération, c'est au gouvernement à l'accomplir." The arts "influent puissamment sur toutes les branches de l'industrie, sur la morale publique, par conséquent sur la gloire et la prospérité nationale." "Le système des arts est changé, ou plutôt il n'y a plus de système dans les arts. Ramenés à leur véritable but, par l'imitation naïve de la nature, fécondés par l'étude des modèles antiques, rendus à leur destination morale et politique, en perpétuant les traits d'héroïsme et de vertu, ils ont pris un nouvel essor au milieu même des orages de la révolution, et tout annonce que l'état d'agrandissement vers lequel ils tendent de jour en jour, doit se fortifier, et recevoir du nouvel ordre des choses un éclat solide et permanent."

IN THE SERVICE OF NAPOLEON

1. David to Jean-Baptiste Wicar, 17 Thermidor Year XIII (5 August 1805); cited in Paris-Versailles 1989–90, p. 605: "c'est à Rome qu'il faut faire de ces sortes de tableaux."

2. "Les légitimités napoléoniennes se présentaient à la fois comme populaire (du fait du plébiscite), charismatique (du fait des victoires), dynastique et sacrale–ou si l'on préfère: pseudo-traditionnelle (du fait du sacre et de l'instauration de l'hérédité)." Stéphane Rials in Tulard 1999, vol. 1, p. 34. The absence of unity within Napoleonic culture is a leitmotif of Grigsby 1995.

3. Boyer 1969, p. 56: "qui manque à notre Muséum." See Jourdan 1998, pp. 66–73, 140–51.

4. Fontaine 1987, vol. 1, pp. 10–11: "Le Premier Consul qui, dit-on, n'est pas facile à contenter, en a paru satisfait."

5. Milan 2002, pp. 509–10, no. XIII.21, repr. p. 354; catalogued by F. Mazzocca, along with a pendant portrait of Josephine, 1796 (no. XIII.22, repr. p. 355).

6. *Mémoires du comte Miot de Melito . . . ,* Paris, 1858, vol. 1, p. 159. Cited by Jourdan 1998, pp. 144, 344 n. 14: "Une étiquette sévère déjà régnait autour de lui. Ses aides de camp et ses officiers n'étaient plus reçus à sa table. . . . Ce n'était déjà plus le général d'une république triomphante. C'était un conquérant pour son propre compte, imposant ses lois aux vaincus." "Mombello [where Bonaparte resided from late May to July 1797] però rappresenta anche, dal punto di vista dell'immagine, quasi una prova generale per la futura vita di corte a Parigi" (Giula Gorgone in Rome 1997, p. 91).

7. Marta Piveta in Rome 1997, pp. 93–94, no. 67.

8. Delestre 1867, p. 33: "dont la gloire et les détails qu'on me donnait de sa physionomie ne faisaient qu'irriter ce désir"; "d'une physionomie sévère, et fait comme j'entendais dire qu'était à peu près Bonaparte." Gros's letter is dated from Milan, 16 Frimaire Year V (6 Dec. 1796). The portrait he showed to Josephine may have been that of *Bruyère* (1796, Musée de Marseille, on deposit from the Louvre).

9. Quatremère de Quincy 1796 [1989], pp. 141–42. Delécluze evokes David's critical remarks when the spoils arrived in Paris (1855 [1983], pp. 208–9).

10. "On assure que Julien, un de ses aides de camp, fut chargé de faire au peintre la proposition de venir au camp du général, pour peindre les batailles, et se soustraire par ce moyen au danger des agitations politiques" (Delécluze 1855 [1983], p. 200). Delécluze's source is Rabbe 1827, p. 9.

11. "Je sens bien qu'avant d'être leur égal, je serai longtemps leur écolier. S'il était une manière plus expressive de leur faire connaître l'estime que j'ai pour eux, je m'en servirais. Les vraies conquêtes, les seules qui ne donnent aucun regret, sont celles que l'on fait sur l'ignorance. L'occupation la plus honorable, comme la plus utile pour les nations, c'est de contribuer à l'extension des idées humaines. La vraie puissance de la République française doit consister désormais à ne pas permettre qu'il existe une seule idée nouvelle, qu'elle ne lui appartienne." Letter dated 6 Nivôse Year VI, published in the *Réimpression de l'Ancien Moniteur* 29 (Paris, 1863), p. 110, 9 Nivôse (29 Dec. 1797). Cited in Italian in Moravia 1996, p. 39.

12. On the *Idéologues* (Destutt de Tracy, Cabanis, Volney, Daunou, Ginguené, and others), see Gusdorf 1978; Moravia 1974. David, whose preoccupations were more practical, does not appear to have sought out this group, although he was in contact with their ideas through Chaussard, the Salon reviewer for *La Décade philosophique,* a journal favorable to the *Idéologues.* In his reviews of the Salons of 1798 and 1799 Chaussard cites several comments made by David, suggesting a rapprochement and familiarity between the two men; in 1801, he indicates that David approves the urban proposals put forth in his *Monuments de l'héroïsme français,* an undated brochure first published in *La Décade philosophique* 28, no. 15 (30 Pluviôse Year IX [19 Feb. 1801]), pp. 361–67 (reference furnished by C. Lécosse). Lajer-Burcharth has seen an analogy between contemporary perception of David's *Sabines* and the gendered discourse of Cabanis on the relation between man's physical and moral nature (1999, pp. 174–80).

13. "Rien n'annonçait l'homme qui a renversé, soutenu ou créé plusieurs États et dont quatre rois et une foule de princes souverains ont imploré la protection; ni sa taille, ni ses traits, ni sa démarche, ni son ajustement ne pouvaient le faire remarquer; et cependant, entouré de l'éclat de son nom, il a frappé tous les regards." *La Décade philosophique* 16, no. 11 (20 Nivôse Year VI [9 Jan. 1798]), pp. 109–10. Cited by Jourdan 1998, p. 81.

14. Schnapper in Paris-Versailles 1989–90, p. 359.

15. Porterfield 1998; Grigsby 2002. Of course, David could not completely avoid confronting the Orient during the Napoleonic period: in Jan. 1799 he returned to Espercieux a "*manteau arabe*" he had borrowed (Wildenstein 1973, p. 145, no. 1299; Paris-Versailles 1989–90, p. 595) and when painting the *Coronation* and the *Eagles,* he included figures of exotically dressed dignitaries.

16. "Vous n'avez pas encore fait ce qu'on appelle un vrai tableau d'histoire." David to Gros, Brussels, 22 June 1820 (David 1880, p. 572; Wildenstein 1973, p. 219, no. 1877).

17. Delécluze 1855 [1983], pp. 230 ("Allons, dit David, j'avais toujours bien pensé que nous n'étions pas assez vertueux pour être républicains"), 478 n. 13 (the verse is from Lucan, *The Pharsalia,* book 1, 128).

18. "Bonaparte a prouvé qu'on pouvait allier la victoire à la modération et le patriotisme à l'humanité. On croit voir arriver avec lui la gloire, la paix et le bonheur." *Le Messager des relations extérieures* (24 Vendémiaire Year VIII [16 Oct. 1799]). Cited in Monnier 2001, pp. 295–96.

19. Hautecoeur 1954, p. 194; an article in the press in Jan. 1800 saw Bonaparte as the reincarnation of the Roman, noting that "le portrait de Junius Brutus était absolument le même que celui du Premier Consul" (Boyer 1941–44 [1947], p. 166 n. 1; Schnapper in Paris-Versailles 1989–90, p. 359). On the one hand, Bonaparte eliminated revolutionary emblems and figures after Brumaire; but on the other continued to exploit the republican imagery of the Armée d'Italie: the medal after Appiani, with the figure of the French People as Hercules clubbing a crowned hydra, was newly minted in Paris after 1799 (Zeitz 2003, pp. 36–37, no. 2).

20. Lilley 1985; Hubert 1986.

21. Fontaine 1987, vol. 1, p. 7 (La Malmaison "que Madame Bonaparte veut faire embellir"). See also vol. 1, pp. 9–10; vol. 2, pp. 1333–34.

22. "L'inspection et la surveillance de tout ce qui tient directement aux arts du dessin sont confiés à un conservateur qui prend le titre de conservateur des monuments nationaux, manufactures et arts. Le conservateur a la direction des écoles des arts, des établissements et des manufactures nationales qui ont pour base les arts du dessin, des édifices publics lorsqu'il sont soumis à des embellissements ou à des constructions nouvelles. Il présente au gouvernement les projets que les artistes proposent. Il est l'organe de la reconnaissance nationale envers eux et le dispensateur des récompenses que la République leur accorde. Il s'adjoint un conseil privé composé d'un architecte et d'un administrateur comptable. L'architecte fait au conservateur tous les rapports sur les travaux en activité, il vérifie, il règle les mémoires et les remet à l'administrateur. L'administrateur comptable révise les comptes après les vérifications et les règlements de l'architecte, il ordonnance les paiements sur les fonds mis à la disposition du conservateur." Fontaine 1987, vol. 1, p. 93. Fontaine in 1804 cites

the different projects submitted to the first consul since 1799 (1987, vol. 1, pp. 93–99) and dates the one by David to "nivôse an VIII, décembre 1799." A. Schnapper first called attention to this project (Paris-Versailles 1989–90, p. 360).

23. David 1880, pp. 365–66 ("un homme qui par ses lumières et ses préceptes, et par la beauté de ses ouvrages, a si bien contribuer à la [la prospérité publique] faire fleurir avec éclat").

24. David 1880, p. 336 ("qui ne paraissait devoir être profitable qu'à moi seul, et nullement à l'art et aux artistes, objets uniques de ma sollicitude"); Wildenstein 1973, p. 152, no. 1341 (the letter appeared in the press between 27 Feb. and 1 Mar. 1800). The episode of David's nomination and resignation is well résumé by Schnapper (Paris-Versailles 1989–90, pp. 360–61).

25. David's letter of refusal, dated 7 Frimaire Year IX (28 Nov. 1800), is reproduced in Wildenstein 1973, pp. 154–55 no. 1361. See Schnapper in Paris-Versailles 1989–90, p. 361. This Société Libre des Arts (Benoit 1897 [1975], p. 182; Halliday 2000, p. 154 n. 7) should not be confused with the Société Libre des Sciences, Lettres et Arts de Paris, a reunion mostly of artists excluded from the recently formed Institute that first met in August 1796, and at least until 1806 (see Gramaccini 1993, vol. 1, p. 171 n. 53). This latter group, which did not overlap with Boilly's fashionable *Reunion of Artists in Isabey's Studio* (Salon of 1798; Musée du Louvre, Paris), was too heterogeneous to have an influence, until Charles-Paul Landon emerged as its driving force, through the *Journal des arts* and his personal publications (*Annales du Musée, Nouvelles des arts*).

26. This may explain the unusually long rebuttal he wrote, with the architects Charles Percier (1764–1838) and Jacques-Guillaume Legrand (1753–1809), to the *Journal des arts* 157 (5 Vendémiaire Year X [27 Sept. 1801]), pp. 9–12 (from the contents, it is clear that David is the author of the text; David 1880, pp. 375–77) in reply to a letter by Athanase Détournelle (died 1807) published in no. 155 (29 Fructidor Year IX [16 Sept. 1801]), accusing them of partiality in the judgment of the projects for commemorative columns to be erected in each *départment.* (David 1880, pp. 374–75).

27. Hautecoeur 1954, p. 194; Wildenstein 1973, p. 147, nos. 1322, 1323. See cat. 3 in this volume.

28. The letter, dated 27 Messidor Year VIII (16 July 1800), is reproduced in Benoit 1897 [1975], p. 166 n. 2 ("de choisir les meilleurs peintres pour faire peindre les batailles suivantes"). A painting of

the Battle of Rivoli was already commissioned from Boguet; see cat. 2, note 3.

29. J. Lacambre in Paris 1974–75, p. 464. But by the time Gros was crowned by the jury and set to work painting (1802), Bonaparte was adopting a less open attitude: presumably upon official order, he abandoned the huge battlepiece and executed a series of portraits of the first consul (1802–3).

30. Fontaine 1987, vol. 1, pp. 13 ("Madame Bonaparte désire que ces tableaux représentent des traits de la vie du Général"), 26. The two paintings executed with Taunay's participation, sent to the Salon in 1801, have recently been located by Pierre Rosenberg in the Royal Palace in Milan and published in Jouve 2003, pp. 209–11, nos. P-422, P-423. The author cites the relevant Salon criticism and provides interesting comments on the iconography of the sleeping hero (with reference to Turenne, p. 61). See also Milan 2002–3, pp. 101–2, 163, nos. 15–16. The subject of the third painting is cited from the *Moniteur*, 14 Sept. 1801 (Jean-Pierre Cuzin in Paris 1974–75, p. 620; cf. Milan 2002–3, pp. 100, 162–63, no. 14).

31. He declared this concern to Daru on 19 June 1806, when presenting his project for the four coronation pictures: "Je me propose enfin de répondre à l'attente de l'Europe" (Paris-Versailles 1989–90, p. 366).

32. "Il est facile de remarquer, dans cette production, la satisfaction qu'a éprouvé l'auteur en y travaillant." Bruun Neergaard 1801, p. 100.

33. On the repetitions cited, see Paris-Versailles 1989–90, pp. 136–38 (no. 51), 162 (no. 67, "Oeuvres en rapport"), 534–39 (no. 233); David's letter to Denon concerning *Andromache* is reproduced in Wildenstein 1973, p. 163, no. 1409.

34. *Journal des bâtimens civils, des monuments et des arts* 182 (8 Prairial Year X [28 May 1802]), pp. 349–52; cited in Paris-Versailles 1989–90, p. 601 ("des prix fous").

35. Schnapper has presented the relationship between the painter and Napoleon under the auspices of "les pires difficultés": "En réalité les rapports de David avec Napoléon furent difficiles, marqués par plus d'échecs que de triomphes et le peintre eut quelque mérite à marquer autant de fidélité à l'Empereur" (Paris-Versailles 1989–90, pp. 359, 361). Johnson posits a "mutual esteem and suspicion" between the two men, but the artist's early "disillusionment" (1993a, pp. 174, 176); see n. 134 for the full quote.

36. He wrote that he had "ramené dans l'école française le bon goût qui la place aujourd'hui à l'égal de l'école d'Italie dans ses plus beaux jours." David to Lacépède, 7 Frimaire Year XII

(29 Nov. 1803), requesting admission to the Legion of Honor (cited by Foucart 1970, p. 714 n. 2).

37. Bordes 2004b, pp. 79–89, 397–400; with further bibliography.

38. Delécluze 1855 [1983], pp. 248–49 ("Il était beau à voir; cela m'a rappelé Jules II que Raphaël a peint dans l'Héliodore du Vatican"; "J'avoue que j'ai longtemps envié aux grands peintres qui m'ont précédé des occasions que je ne croyais jamais rencontrer. J'aurai peint un *empereur* et enfin un *pape!*")

39. Bordes in San Diego 2003–4.

40. The letter addressed on 13 Apr. 1801 by the Cisalpine government, signed among others by his future patron Sommariva (see cat. 32), is published in David 1880, pp. 393–94; it specifies that the painting was to measure 12 *pieds* by 15 (12 ft. 9 in. by 15 ft. 11 in., or just under 4 by 5 m). Further information is found in Zaghi 1958–60. A letter from Marescalchi, the Cisalpine representative in Paris, to Melzi, dated 19 August 1802 (vol. 2, p. 241), evokes a recent conversation with David, who claimed to have the first consul's approval of his "grande soggetto." Reacting to the price of 60,000 francs—half in down payment, the other half upon delivery, within two years—he concludes: "Veramente questa è una spesa forte, massime nelle circonstanze; ma siamo compromessi, tanto più che ho subordorato ch'esso sta terminando un ritratto di Bonaparte di ordine di Bonaparte stesso, di cui credo ch'esso voglia far regalo alla Repubblica." As this portends, the project for "le général Bonaparte donnant l'existence à l'Italie" (David's description of the subject in a letter to Marescalchi written three days earlier to remind him of the commission; vol. 2, p. 241) was supplanted by the gift of a version of *Bonaparte Crossing the Alps* (vol. 2, p. 328; vol. 3, p. 183; vol. 4, pp. 249, 279, 391; see cat. 4). The references to Melzi's *Carteggi*, edited by Zaghi, are given in Pillepich 2001, pp. 414–15, 419–21.

41. This résumé is based on Schnapper's convincing chronology for the early stages of work on *Leonidas* (Paris-Versailles 1989–90, pp. 490–91).

42. Wildenstein 1973, p. 159, no. 1373.

43. David appears prominently in representations of ceremonies involving artists, for example Boilly's *Napoleon Awarding the Legion of Honor to the Sculptor Cartellier*, composed in 1808–9 (Paris 1999–2000, pp. 366–67, nos. 375–76; see fig. 12), but not of grand court events, in which Denon is usually highlighted, as in Alexander Casanova's *Marriage Banquet of Napoleon and Marie-Louise in the Theater of the Tuileries*, exhibited at the Salon of 1812 (p. 282, no. 281). Official publications

concerning court etiquette focus on the organization of the household and do not mention the position of first painter. In Milan, Andrea Appiani was named first painter in June 1805, with an annual pension of 6,000 lire (Fernando Mazocca, "Vicende e fortuna grafica . . . " in Rome 1986, pp. 18, 25 n. 17.)

44. Denon to Daru, Intendant général de la Maison de l'Empereur, 29 Thermidor Year XIII (17 August 1805) (Denon 1999, vol. 1, p. 281, no. 727), listing painting and sculpture commissions then in progress (in response to the demand from Napoleon to Daru; see note 46). Schnapper cites two relevant texts by David evoking the inception of the commission (Paris-Versailles 1989–90, p. 362): a manuscript note (Wildenstein 1973, p. 180, no. 1547), undated but certainly after 1810, on account of a reference to the finished *Distribution of the Eagles;* and a letter of 1819 (Wildenstein 1973, no. 1843).

45. "La différence ici est bien grande, Rubens était le plus grand peintre que Marie était grande reine, mais ici l'empereur Napoléon est bien plus grand que le peintre!"; "Laissez faire au temps, c'est la dénomination qu'on lui donnera." Wildenstein 1973, p. 180, no. 1547; the conversation is precisely situated in 1804, at the time Napoleon commissioned the coronation pantings, and not 1808 as proposed. The notes on this sheet are not only undated but heterogeneous in date, as observed by Schnapper (Paris-Versailles 1989–90, pp. 361–62). David was more modest when presenting his project for the four coronation pictures to Daru on 19 June 1806: "Quel peintre, quel poète fut jamais mieux placé que moi: je me glisserai à la postérité à l'ombre de mon héros" (Paris-Versailles 1989–90, p. 366).

46. "Une grande portion de la dépense de la liste civile se compose d'ameublements, peintures, embellissements de palais, qui sont autant d'encouragements accordés aux arts. C'est sous ce point de vue que l'intelligence et les soins de l'intendant général doivent naturellement se porter sur tout ce qui peut alimenter l'industrie, encourager les arts et fournir une émulation aux artistes. David reçoit des sommes assez considérables pour les arts. Mon bibliothécaire m'a fait souscrire pour une grande quantité de gravures et d'ouvrages, et je ne me refuserai pas à accorder tout ce que vous jugerez nécessaire pour encourager les artistes; mais je ne veux pas que ce soit une obligation qui me soit imposée. La manufacture de la Savonnerie, celles des Gobelins, de Sèvres, doivent travailler sans qu'il en coûte rien à la liste civile, c'est-à-dire que je dois retrouver ce qu'elles me coûtent, en garde-

meuble. Toutes les fois qu'on fait un embellisse-ment dans un palais, il faut considérer de quel avantage il est pour les arts et les manufactures, chose qu'aujourd'hui on ne considère pas. Le Muséum est à mes frais; il me coûte considér-ablement; c'est encore là un encouragement pour les arts. Aucune de ces choses n'a été faite avec ensemble. Il faut vous emparer de tout cela, payer vous-même les individus, les voir, savoir quelles sont leurs fonctions. Je dois vous faire connaître que mon intention est de tourner spé-cialement les arts vers des sujets qui tendraient à perpétuer le souvenir de ce qui s'est fait depuis quinze ans. Il est étonnant, par exemple, que je n'aie pu obtenir que les Gobelins laissassent de côté l'histoire sainte, et occupassent enfin leurs artistes de cette foule d'actions de tout genre qui ont distingué l'armée et la nation, événements qui ont élevé le trône. Lorsque vous aurez le temps, vous me ferez une récapitulation des stat-ues, gravures, tableaux, etc., que j'ai ordonnés. J'imagine que M. de Ségur [Grand Master of Ceremonies], qui avait des fonds pour faire exé-cuter le livre du sacre, l'a fait commencer. C'est une affaire assez importante. Le travail dont s'oc-cupe M. Denon, qui parcourt les champs de bataille d'Italie pour lever des dessins et des plans qui feront le pendant de son atlas d'Égypte, of-frira encore une nouvelle carrière à l'émulation des peintres et des graveurs. M. de Fleurieu [the former intendant], par la circonstance de son âge, ne pouvait suivre tous ces objets, puisqu'à peine il pouvait se traîner et faire la besogne la plus pressante. Il faut, désormais, que M. Denon vous soit subordonné, comme il doit naturelle-ment l'être, en ménageant son amour-propre, et qu'il reste conservateur du Muséum, n'ordon-nant point de dépense, et mes ordres passant toujours par vous." *Correspondance de Napoléon I^er publiée par ordre de l'empereur Napoléon III,* vol. 6, Paris, 1862, pp. 78–80, no. 9050.

A direct consequence of these injunctions was Daru's letter to the director of the Gobelins, on 9 Aug. 1805: "Sa Majesté désire que vous vous oc-cupiez à reproduire les tableaux qui représentent des sujets pris dans l'histoire de France et particu-lièrement de la Révolution et, comme son règne en sera l'une des époques les plus glorieuses!! . . . " (cited by Benoit 1897 [1975], p. 169, wrongly dated 1815 and unreferenced).

47. Schnapper has underlined the crucial impor-tance of Denon's report to Napoleon, dated 19 Feb. 1806 (Paris-Versailles 1989–90, pp. 368–69). The report is reproduced in Denon 1999, vol. 2, pp. 1292–1302; reference to David on p. 1293.

48. Schnapper gives a lucid résumé of the price negotiations that last from 1806 to 1810 and a de-tailed history of David's financial dealings with the administration (Paris-Versailles 1989–90, pp. 361–64, 366–74; see also Schnapper 1993).

49. For Canova: Hubert 1964, p. 142; Morghen: Denon 1999, vol. 2, p. 1157. The *Livre du Sacre:* Fontaine 1987, vol. 1, p. 481.

50. Halliday 2000; Bordes in San Diego 2003–4.

51. Wrigley 1992, p. 102; Landon's article appeared in the *Journal des arts,* 25 Nivôse Year VIII (15 Jan. 1800), no. 35, p. 10: "une honnête aisance."

52. He wanted to moderate their "prétentions ex-agérées et de les ramener à la simplicité modeste des véritables artistes de tous les pays, dont la gloire a toujours consisté à produire beaucoup et à vivre honorablement mais sans faste des produits de leurs veilles et de leurs nombreux travaux." Denon 1999, vol. 2, p. 1293.

53. Denon's remarks are in the report cited in the previous note (see also, p. 1265, the same criti-cism of the sum paid to Guérin expressed in Oct. 1804, before David received the commission for the coronation pictures). For a press article on Guérin's dedication, see Wrigley, 1992, p. 98; for reactions to his stylish portrait by Lefèvre, exhib-ited successively at the Salon in 1801 and again in 1802, see Jean-Pierre Cuzin in Paris 1974–75, p. 523, no. 119.

54. David's reputation as an expensive painter was a commonplace. When in Paris during the sum-mer of 1801, the Spanish marquise de Santa-Cruz, who after the death of Christine Boyer longed to wed Lucien Bonaparte, wrote of a visit to the studio of Gérard "qui dit-on est le meilleur après David, et moins cher" (letters to Lucien, 15 June–19 Sept. 1801 [63 ff.], private archives [descendants of Lucien], Fano, Italy; photocopies graciously furnished by Jeannine Baticle; letter of 18–20 Aug. 1801, ff. 29–32). Not everyone around this time agreed that David was the new Raphael. For example, Luigi Mantovani writing in August 1803: "David in Francia passa pel Raffaello, in Italia gli si accorda il credito d'un Pamfilo [Carlo Francesco Nuovolone], del Sole [Giovanni Giuseppe dal Sole?]"—in other words with painters far less eminent (Mantovani 1987, pp. 179–80). Canova evokes praise of his *Napoleon* "in una lettera dell'immortal David," in his own letter to Quatremère de Quincy, dated 18 Aug. 1811 (Quatremère de Quincy 1834, p. 380; see also Boyer 1969, p. 140).

55. Schnapper (1993) has expertly documented David's financial resources and expenses. He declares that "Le couple David était habitué à mener assez grand train," but then qualifies his

remark by noting that servants were not "un grand luxe"; he also notes his four horses, "une voiture et deux cabriolets" (p. 923). All this points to a level of upper middle-class ease.

56. The cited remark (David to Wicar, 18 Feb. 1808, Custodia Foundation, Paris, inv. 5541; cited Paris-Versailles 1989–90, pp. 610–11) is ambigu-ous. Grammatically, "en" refers to the reports of the imperial administration: "le gouvernement qui entend les rapports que l'on fait de mon mérite ne fait rien pour lui, j'en ai quatre qui me ruinent et le gouvernement ne fait rien non plus pour moi, beaucoup de gloire à la vérité mais rien de profit, l'une vient de moi mais l'on ne fait rien pour l'autre." This passage in a stream of consciousness mode, understandable since David always lets loose more than usual with Wicar, is preceded by the avowal of his preoccu-pation with family matters: he regrets not being able to talk directly to Napoleon about the prob-lematic situation of his eldest son Jules in Rome (on 26 Feb. he would try to obtain for him the post of vice-consul at Civita-Vecchia; Wilden-stein 1973, p. 177, no. 1525). A close reading sug-gests that the reports are positive and not derogatory: the interjection "non plus" estab-lishes a distinction between the two interrelated preoccupations (obtaining payment for his pic-tures and financial security for his family). The endowment of the four children proceeded by stages; see the documents collected by Schnapper (Paris-Versailles 1989–90, p. 485, with reference to Wildenstein 1973, p. 242 n. 2049; Schnapper 1993, p. 923).

57. According to the fundamental study by Foucart (1970), Vien was the first artist to receive the Legion of Honor (2 Oct. 1803); David was distin-guished on 18 Dec. along with six other members of the Beaux-Arts section of the Institute (Houdon, Gondouin, Moitte, Pajou, Regnault, Vincent), the director of the French Academy in Rome (Suvée), an older sculptor (Masson), and two young painters (Gérard and Guérin). David's relative and former student, Jean-Baptiste Debret exhibited a painting of the Invalides ceremony at the Salon of 1812 (Versailles, inv. MV 1504), but it is difficult to ascertain whether he represented David (as affirmed in David 1880, p. 624). David is associated with the design of the first Legion of Honor medal on the basis of a dryly drawn sheet (Paris 1968, n.p., no. 228, illus.; sale, Fontaine-bleau, 1 Feb. 2004, p. 131, no. 635), whose attribu-tion is unconvincing. Jean-Baptiste Isabey is also given credit for the design (Basily-Callimaki 1909, p. 70), as is Denon (Laveissière in Paris 1999–2000, p. 475); neither affirmation is documented.

58. Schnapper proposes three reasons for the refusal of the portrait for Genoa: Denon found an occasion to bash David; it was the mediocre work of a pupil; the composition was unflattering to Napoleon (Paris-Versailles 1989–90, p. 435). Until this large painting reappears, perhaps never, no explanation is perfectly convincing. See also note 118, below.

59. David to Wicar, 18 Feb. 1808, Custodia Foundation, Paris, inv. 5541; cited Paris-Versailles 1989–90, pp. 610–11.

60. "J'en ai bien un cinquième en tête, même un sixième, mais je me réserve d'en causer avec vous quand ceux-ci seront finis." Schnapper reproduces the June 1806 report in Paris-Versailles 1989–90, pp. 364–66 (quote, p. 364). As early as 22 Dec. 1804, about a week after the last ceremony, the *Journal de Paris* had announced three projected paintings: "Le premier de ces tableaux représentera le couronnement à Notre-Dame; le second la distribution des aigles au Champ-de-Mars; le troisième la fête de l'Hôtel de Ville" (Schnapper in Paris-Versailles 1989–90, p. 405).

61. For a suggestive discussion of the *Coronation* and questions of religious policy and sensibility, see Johnson 1993a, pp. 190–98. To appreciate certain aspects of the ceremony, see Berthod 2000.

62. In his letter to Molinos, cited from Paris-Versailles 1989–90, p. 605 (correct date: 21 Prairial Year XIII [10 June 1805]), Degotti specifies that he is "chargé de la partie scénographique de tous ces tableaux [du Couronnement]" (Paris, Bibliothèque Thiers, Fonds Frédéric Masson, MS 170, fol. 94). For David's early contact with Degotti in April 1805, see Paris-Versailles 1989–90, p. 605.

63. The letter was in a sale, Paris, Hôtel Drouot, 17 May 1990, no. 235 (2); the catalogue cites only an extract, but it was possible to copy the full text prior to the sale. The cited passages: "de ne chercher simplement qu'à placer l'ensemble de la composition pour voir l'effet général"; "je replacerai les figures qui pourraient mal faire mais je ne puis le faire qu'en voyant le tout ensemble"; "qu'il prenne chez vous le panneau sur lequel je dois peindre l'esquisse et qu'il le porte demain à l'atelier de Cluny." Napoleon had approved the proposal to rent the church of Cluny for David on 30 Jan. 1805.

The identification of "Bourgeois" mentioned in David's letter to Degotti is not a simple matter. That he collaborated on the *Coronation* concurs with the undated attestation written by David in favor of a student named "Bourgeois," specifying that he had been in the studio for six years and that he "m'a déjà plusieurs fois aidé dans mes travaux et notamment en ce moment où je suis occupé à représenter les tableaux du couronnement de Sa Majesté l'Empereur" (Paris, Bibliothèque du Louvre, MS 353). According to Delécluze (1855 [1983], p. 414), three students with that name were at one time in the studio (one is qualified as "paysagiste," another as "dit Perroquet"). The first is certainly Florent-Fidèle-Constant Bourgeois (1767–1831), whose role as painter of panoramas is attested by the Institute's report referenced in note 76 (p. 260 n. 3) and by Gabet 1831, p. 91. For the *Coronation*, David would have needed instead the assistance of a figure painter. Benjamin-Eugène Bourgeois (1791–1818) also studied with David, but in 1805 he would have been too young and inexperienced to be recruited as a collaborator; furthermore, he worked especially as an engraver, exhibiting a print after Rouget's portrait of David at the Salon of 1814. The third and most likely candidate is Albert-Paul Bourgeois, who declared himself to be a painter and "élève de David," residing on rue Montmartre, when he registered for admission to the Galerie du Sénat Conservateur (Luxembourg) on 7 Ventôse Year XII (27 Feb. 1804) (Paris, Bibliothèque Thiers, Fonds Frédéric Masson, MS 172, fol. 9v). He was very likely the painter "Bourgeois" who participated in the preliminary contests for the Rome Prize in 1801 and each year from 1805 to 1808 (Grunchec 1989, vol. 2, pp. 24, 33, 35, 36, 38; misidentified as Constant Bourgeois, p. 269 n. 14). Albert-Paul Bourgeois exhibited at the Salon on three occasions: in 1810, *The Death of Marshal Lannes* (bought by the government and today at Versailles) along with a portrait, and in 1812, posthumously according to the *livret*, an Oriental scene of imperial clemency and, less expectedly, a subject with a soldier gone mad. In 1810, his address was "Passage des Panoramas," which might suggest a family connection with Constant. He may have been "Bourgeois" who produced the drawings after works by David (those after details of the *Sabines* probably at the request of Angélique Mongez in 1811, year of her contract with David [document dated 11 May 1811, Paris, L'Autographe, 1990, cat. 19, item 55]) listed in his death inventory (Wildenstein 1973, p. 237, no. 2041 [32, 33, 35]). To complete this homonymic gloss, it can be added that "Bourgeois" in Boilly's *Reunion of Artists in Isabey's Studio* (Salon of 1798; Paris, Musée du Louvre) is Charles Bourgeois (1759–1832), a miniaturist.

Mention of "Bourgeois" in 1805 raises some doubt that Georges Rouget (1783–1869), David's main assistant for the replica of the *Coronation* (1821–22), was much involved on the prime version. The sources collected by Schnapper (Paris-Versailles 1989–90, p. 414) and Pougetoux (1995, pp. 12–15) attesting to Rouget's role are all from a later date, as is Delécluze's categorical affirmation (1855 [1983], p. 247). It is certain that he was engaged by David to help with *Leonidas* around 1812 (Wildenstein 1973, p. 191, no. 1646; David's letter of 30 Dec. 1803, cited by Wildenstein 1973, p. 164, no. 1415, is addressed not to Rouget, as proposed, for he was not married at the time, but to Lenoir, and simply the same letter as the one to him under no. 1414). Rouget's emergence as David's main assistant may have coincided with the eclipse of Albert-Paul Bourgeois. In Apr. 1808 David wrote that he was giving 10,000 francs a year "à l'élève que j'emploie pour les choses de détail qui prendraient mon temps très inutilement" (Wildenstein 1973, p. 178, no. 1531). Rouget may have been recruited for such tasks once the *Coronation* was well advanced: the only proof of his collaboration on the first version is the list of possible spectators in the central tribune, with his name, jotted down by David (Prat and Rosenberg 2002, vol. 2, p. 1067, no. 1670v). His effective presence has been advanced, however, on the sole basis of the 1822 "key" to the second version: Massard's "key" of 1808 provides no identity for the "différents hommes célèbres" in the tribune. Rouget was only 25 in 1808, while the figure to David's right appears to be an older man, perhaps Degotti (who posed for the cross bearer, see note 78), or "Bourgeois."

64. Autobiographical memoir cited by Schnapper in Paris-Versailles 1989–90, p. 405.

65. "Ce grand mouvement rappelle aux spectateurs étonnés, cette vérité si généralement reconnue: que celui qui a su le conquérir saura bien aussi le défendre." Paris-Versailles 1989–90, p. 364.

66. "Il ne faut pas perdre de vue que Napoléon lui-même, tout empereur qu'il était, n'a jamais quitté un moment ses habitudes de général en chef, et que de près ou de loin il fallait toujours qu'il en fît le métier." Fain 1908 [2001], p. 84. These memoirs, written around 1829 by one of Napoleon's personal secretaries, concern the last five years of the Empire; during the first years, the emperor's military persona was probably even more affirmed.

67. "Tout est calculé dans un tableau, et le changement d'une figure peut en amener une suite incalculable, et désorganiser tout un côté du tableau, et souvent tout l'ouvrage." This is extracted from David's letter of 16 Sept. 1807 to Thiénon, a landscape painter in the service of Napoleon's brother Louis, King of Holland, after the latter's expression of dissatisfaction with his

portrait in the *Coronation.* The letter is reproduced by David 1880, pp. 435–36, and discussed by Schnapper in Paris-Versailles 1989–90, p. 412.

68. Schnapper in Paris-Versailles 1989–90, p. 413.

69. "L'action principale . . . est le couronnement de S. M. l'Impératrice par son auguste époux? L'empereur, la couronne sur a tête, en tient une autre des deux mains et descend le premier degré de l'autel. L'Impératrice, presque prosternée sur le a dernière marche, laisse voir sur ses traits cette involontaire émotion qu'imprime l'attente d'un événement aussi important." *Journal de Paris* 343 (9 Dec. 1807), p. 2453. The existence of two full-scale cartoons for the figure of the emperor, constituting a singular initiative with respect to David's preparatory procedures, may indicate a need to modify the figure of Napoleon in some haste. One cartoon, clearly executed by David, offers a rejected variant of the final pose (see cat. 5), which appears in the other cartoon, due to an assistant.

70. "Voulant autant qu'il était possible, représenter dans une seule action le couronnement de l'Empereur et celui de l'Impératrice, qui lors de la cérémonie, n'eurent lieu que successivement, l'artiste a choisi le moment où l'Empereur, après avoir lui-même posé sur son front, l'une après l'autre, deux couronnes, vient d'y reprendre la seconde, et où l'élevant dans ses deux mains, il s'apprête à la placer sur la tête de son auguste épouse." *Gazette nationale ou le Moniteur Universel* 16 (16 Jan. 1808), pp. 63–64 (quote, p. 63); *Description du tableau exposé au Musée Napoléon représentant le Couronnement de Leurs Majestés Impériales et Royales, peint par M. David, peintre de Leurs Majestés* (Paris, 1808), reprinted in Cabanis 1970, pp. 251–54 (quote, pp. 251–52). The same remark appears in the revised *Nouvelle description du tableau exposé au Musée Napoléon représentant le Sacre [sic] de Leurs Majestés Impériales et Royales* (1808), reprinted by Schnapper in Paris-Versailles 1989–90, pp. 416–18.

71. Schnapper has detailed the various ways early commentators account for the modification of the figure of Napoleon (Paris-Versailles 1989–90, p. 413). Credit is given notably to Gérard by Jal in a text of 1845. The source for this information is purported to be Rouget, who claimed to have been David's principal collaborator on the *Coronation* (but cf. note 63). A biographical article on Rouget, published during his lifetime in 1842, relates that Gérard proposed to assist David in painting the coronation series; the latter declined his offer, because, he is said to have confided to Rouget, if Gérard were to participate even slightly, he would go around claiming that he had exe-

cuted the whole picture himself (see Pougetoux 1995, p. 14). Gérard's proposal seems most improbable, however, since he was a confirmed artist and since 1806 commissioned to paint the Battle of Austerlitz. A remark made during his visit to David may however have sparked consideration of the change.

72. Durye 1970. Two novelties of the imperial nobility with respect to the Ancien Régime should be noted: all were titled and a minimum income–3,000 francs for a *chevalier*–was required for the nomination to be effective.

73. "Il demande cependant plus de richesse et de dorure, ce qui ne s'accorde guère avec nos moyens." Fontaine 1987, vol. 1, p. 214.

74. "Sa Majesté a vu avec intérêt la belle exécution de cet ouvrage et son aspect imposant, mais Elle pense que les formes en sont trop athlétiques et que vous vous êtes un peu mépris sur le caractère qui le distingue éminemment, c'est-à-dire le calme de ses mouvements." Cited by Boyer 1969, pp. 138–39 ("Canova, sculpteur de Napoléon," pp. 131–46); Johns 1998, pp. 100–101; Denon 1999, vol. 1, p. 713.

75. "Que cela est grand! quel relief ont tous les objets! Cela est bien beau! Quelle vérité! Ce n'est pas une peinture: on marche dans ce tableau." This reaction is attributed to Napoleon in the relation of the official visit to his studio on 4 Jan. 1808, inserted in the *Moniteur Universel* on 16 Jan., and in the *Description* and *Nouvelle Description* published that year (Cabanis 1970, p. 252; Schnapper in Paris-Versailles 1989–90, p. 418). For a discussion of the ambiguities of David's realism, see Germer 1990.

76. "En effet, le Panorama n'est autre chose que la manière d'exposer un vaste tableau en sorte que l'oeil du spectateur embrassant successivement tout son horizon, et ne rencontrant partout que ce tableau, éprouve l'illusion la plus complète." Bonnaire 1937–47, vol. 1, p. 256 (the report: pp. 255–62). The importance of the panorama for the conception of the *Coronation* is underlined by Germer 1990, pp. 96–99. David's use of figurines, detailed by Lenoir in 1817, also suggests a preoccupation with illusion: "M. David, pour peindre son tableau représentant le couronnement de Napoléon, avait fait faire en bois une espèce de temple dans l'intérieur duquel on voyait les marches du choeur et l'autel de l'église Notre-Dame où la cérémonie s'est passée. Là, il avait placé toutes les figures de son tableau tel qu'il l'avait composé. Il les avait fait modeler dans la proportion de six pouces et vêtir comme elles étaient à la cérémonie; son jour était disposé de haut et calculé comme il convenait pour la

lumière et les ombres, de manière qu'il n'a eu qu'à copier. Le petit temple, que j'ai vu, offrait le plus joli spectacle que l'on pût voir" (cited in Stendhal 1996, p. 569).

77. The adjunct of a mirror on multiple occasions is noted in Lebensztejn 2001, p. 156; with reference to Schnapper in Paris-Versailles 1989–90, pp. 335, 416 [n. 2], 521.

78. David to Degotti, 25 Mar. 1806, cited by Schnapper in Paris-Versailles 1989–90, p. 410.

79. *Account* 1822, p. 2; *Notice* 1824, p. 48. The second text appears to include a section corresponding to the original French text of the first; as Schnapper has proposed, David was closely involved in the writing, and very likely the author of the *Notice*—one can add he was most certainly of the French text of the *Account.*

80. "[David] songea ensuite que, pour tenir en harmonie une composition remplie d'un si grand nombre de portraits, il serait obligé d'adoucir un peu le style sévère qui avait assuré le succès de ses autres ouvrages, et qui fait la gloire de l'école moderne à laquelle il en a le premier donné l'exemple et le précepte." *Journal de l'Empire,* 24 Jan. 1808, p. 3.

81. "Il a signalé son entrée dans la carrière par des succès; il est grand coloriste, dessine avec fermeté, compose avec chaleur; son inspiration est capable de se ployer aux règles, et de recevoir le frein de la raison" ([Chaussard] 1806, pp. 171–72); "la transparence magique du coloris de Rubens, mêlée à la vivacité de celui du Tintoret, anime et fait vivre en quelque sorte la composition [Aboukir]" (p. 69). See also Lenoir 1811, p. xxxvi.

82. "L'émulation, pure de toute jalousie, qu'excitèrent en lui à cette époque les succès que son élève Gros venait d'obtenir en peignant des sujets contemporains, est un fait non moins remarquable; et pendant l'exécution du *Couronnement,* David parla plus d'une fois de l'auteur de la *Peste de Jaffa* comme d'un rival qui avait ranimé sa verve et étendu le cercle de ses idées." Delécluze 1855 [1983], p. 246.

83. "Bon goût": David's letter of 29 Nov. 1803, referenced n. 36; see also the speech attributed to Napoleon in 1808 by David, n. 89. "Le goût français": [Chaussard] 1806, p. 57. Luigi Lanzi, the foremost historian of Italian painting at the time, repeated a commonplace when in 1792 he designated the art of Natoire, Lemoyne, Coypel, and Boucher as the "cattiva epoca della scuola francese, non potendo essi istruire né in disegno, né in colorito" (Boyer 1969, p. 6). During the Empire, certain critics continued to employ "severe" as an unambiguous compliment: commenting on the sixty paintings celebrating the

exploits of the emperor at the Salon of 1810, Denon reported to Napoleon that they offered "la sévérité, la simplicité et la vérité de l'histoire" (11 Nov. 1810; Denon 1999, vol. 2, p. 1368).

84. Fontaine 1987, vol. 1, p. 185; cited by Schnapper in Paris-Versailles 1989–90, p. 413.

85. All these points concerning the repetitions of the *Coronation* are documented and discussed by Schnapper in Paris-Versailles 1989–90, pp. 534–35.

86. "David a repris l'attitude d'un jeune homme pour disputer la palme à ses élèves. Votre Majesté verra sûrement avec satisfaction qu'il est resté maître dans la lice, et qu'il est entièrement digne de l'honneur que vous lui avez conféré en lui accordant le titre de votre premier peintre." Denon to Napoleon, 13 Oct. 1808 (Denon 1999, vol. 2, p. 1345, no. AN75).

87. *Arlequin au Muséum,* cited by David 1880, p. 439. Lenoir 1811, p. xxix n. 1 (p. xxx).

88. David 1880, pp. 516–17; Foucart 1970; Durye 1970. David's painted coat of arms is reproduced in Wildenstein 1973, first frontispiece.

89. "M. David, je viens de récompenser ces habiles peintres, ce sont vos élèves, il est donc juste que j'en fasse autant à l'égard de leur maître. Je vous fais officier de la Légion d'honneur pour les services que vous avez rendus à l'art. C'est vous qui avez ramené le bon goût en France. Continuez à toujours bien servir votre pays." Napoleon's words are quoted by J. David (1880, p. 444), from what seems to be a brief manuscript recollection of the event by the painter, which begins in this manner: "Sa Majesté, que j'avais l'honneur d'accompagner en ma qualité de premier Peintre, s'adressant à moi, daigna me dire ces paroles." For the dating, see the following note.

90. "Mais ce qui mit le comble à mon triomphe: l'empereur consentit, d'après le voeu des artistes, que cette époque honorable pour les arts fût consacrée à la postérité par un tableau où Sa Majesté serait représentée me donnant la croix d'officier de la Légion d'honneur en présence de mes élèves, de la cour et de la foule qui y assistait. M. Gros fut chargé de ce tableau." David 1880, p. 444. The quoted text follows the one referenced in the previous note and is concluded by: "Il [Gros's painting] est ébauché, on attend qu'il le finisse." This suggests that David's text can be dated between 1809 and 1814.

91. Pougetoux refers to an article in the *Gazette de France* of 13 Nov. 1808, evoking the reunion of artists at David's home (Paris 1999–2000, p. 349 n. 51). Delestre (1867, p. 136) mentions the *souscription,* which could refer either to an engraving project or to a shareholding in view of a public exhibition. Delestre reproduces the preparatory drawing (opposite page 136, fig. 30) from his collection (p. 374).

92. Lenoir 1835, p. 10 n. 1. David's *épée de cérémonie* is in the Musée de l'Armée, Paris (Paris 1969, p. 80, no. 244).

93. "Sa Majesté l'Empereur, qui a suspendu le tableau commencé de l'Hôtel de Ville, me presse de me mettre de suite à celui qu'il préfère, la Distribution des Drapeaux impériaux au Champ-de-Mars"; "je ne m'occuperai point d'autres ouvrages . . . mon temps et mon talent étant entièrement consacrés à mon souverain." David to Daru, 25 Oct. 1808 (David 1880, pp. 480–81; Wildenstein 1973, p. 179 n. 1541). David had made a similar declaration to Napoleon on 24 Feb. 1808, in the wake of the latter's visit to his studio: "Depuis que Votre Majesté m'a fait l'honneur de me choisir pour peindre les cérémonies du Couronnement, j'ai eu l'intention de consacrer entièrement mon pinceau au service de Votre Majesté et de rendre ma famille heureuse par le produit de mon travail" (David 1880, p. 479; Wildenstein 1973, p. 177 n. 1523). The latter remark seems to refer to his ambition to endow his four children (see the text above and note 56). On the *Distribution of the Eagles,* see Schnapper in Paris-Versailles 1989–90, pp. 443–53; and Johnson 1993, pp. 206–16.

94. Schnapper in Paris-Versailles 1989–90, p. 447.

95. Schnapper in Paris-Versailles 1989–90, p. 446.

96. Reporting on the Salon of 1810, Denon assured Napoleon that his reign was illustrated by sixty paintings "sans allégorie, sans faste vain, ressource des arts pour peindre des princes sans caractère" (11 Nov. 1810; Denon 1999, vol. 2, p. 1368). One factor of discredit was the relative mediocrity of the allegorical paintings submitted to the 1802 competitions to commemorate the Peace of Amiens and the Concordat (Ledoux-Lebard 1978); however, throughout the Empire a number of artists, especially of second rank, continued to paint and engrave allegorical compositions in homage to Napoleon. For medals with comparable allegories of Victory, all contemporary with the coronation suite, see Zeitz 2003, pp. 126–27, no. 55–56; p. 147, no. 68.

97. Johnson has most astutely noticed an explicit reference to the Republic in the inscription on the flag held by a figure, in the lower right behind the steps, turned toward the barely distinct mass of soldiers below (1993a, p. 215, fig. 108). In my opinion, rather than contributing to her reading of the *Eagles* as a "subversive" critique of the Imperial regime (see below, note 103), it discreetly sets the ceremony in a historical perspective that Napoleon encouraged.

98. See the detailed entry by Raoul Brunon on "uniformes militaires" in Tulard 1999, vol. 2, pp. 886–902. On the radical evolution of attitudes toward the military since the eighteenth century, see Bordes 1986.

99. "Il semble que les artistes partagent l'enthousiasme des militaires qu'ils ont à peindre et veulent participer à leur gloire en retraçant leurs exploits." Denon to Napoleon, 11 Nov. 1810 (Denon 1999, vol. 2, p. 1368).

100. Landon 1810, p. 32.

101. The visual contrast "ajoute à l'effet moral du tableau." *Journal des arts* 45 (1810), p. 245. Cited by Jourdan 1998, p. 167, 349 n. 58. As Schnapper notes, the mixed reception of the *Eagles* produced a kind of critical stalemate (Paris-Versailles 1989–90, pp. 452–53).

102. The tone of the critique of the *Coronation* in the brochure, *Arlequin au Muséum* [attributed to Marant], is humorous, but the remarks are articulate and scathing (cited in David 1880, pp. 440–43); in 1810, Landon's critique of the *Eagles* invokes the reception of the *Coronation*: "On ne trouvait point assez de mouvement ni de variété dans le tableau du Couronnement. On trouve dans *le Serment* du fracas et du papillotage" (Landon 1810, p. 33). Denon managed to neutralize this criticism in his report to Napoleon: "au milieu du fracas d'une telle scène, la figure de Votre Majesté y est noble et grave" (11 Nov. 1810; Denon 1999, vol. 2, p. 1368). For speculation on possible symbolic and allegorical motivations behind David's appropriation of Giambologna's *Mercury,* unfounded except for a reference to a publication by Antoine Mongez, see Levin 1981, pp. 43–44, 63 n. 23.

103. "L'action . . . est équivoque; il ne tiendrait qu'à nous de la prendre pour un mouvement séditieux que le monarque et ses généraux s'efforceraient de calmer." *Journal de l'Empire,* 3 Dec. 1810, p. 2. Cited by Johnson 1993a, p. 299 n. 63. Although Johnson cites another passage of Boutard's review that aimed to neutralize the first observation ("Le mouvement et l'expression de toutes les figures, témoignent aussi qu'il s'agit d'un serment prêté avec allégresse et nullement de fureur séditieuse."), she arrives at a conclusion that is at odds with my own interpretation: "This passage indicates that several critics of the time had observed that the painting was, indeed, seditious and politically subversive. When examined closely the *Distribution [of the Eagles]* reveals the extent to which David had become disillusioned with the emperor and his court and the contempt in which he held the institution of the monarchy. The members of the court appear

fatuous and ineffectual in contrast to the energetic and vital colonels, the fighting men who are true, active participants in the Napoleonic battles" (p. 208). The importance David accorded to his status at court is discussed below; his fidelity to the emperor in 1814–15 and throughout the Restoration is patent. Nonetheless, it can still be debated how an artist, who held to his republican ideals but was flattered by aristocratic and princely patronage, viewed the imperial government around 1810, as the Ancien Régime aristocracy in ever greater numbers appeared at court after the emperor's marriage to a Hapsburg princess, grandniece to Marie-Antoinette.

104. Denon to Napoleon, 11 Nov. 1810 (Denon 1999, vol. 2, p. 1368); Guizot 1810 [1852], pp. 87–88. Guizot's critique of the domination of sculpture on contemporary painting is thoroughly discussed in Lichtenstein 2003, pp. 121–32.

105. "Ce bel ouvrage rappelle le tableau de Paul Véronèse, qu'on a admiré à la même place il y a quelques années; comme dans ce tableau, les spectateurs se confondent avec les figures peintes, tant elles sont naturelles et vraies." N. Ponce, "Tableau du couronnement par M. David," *Courrier de l'Europe et des spectacles,* 12 Feb. 1808, p. 3 (article brought to my attention by Joëlle Raineau).

106. Veronese's painting "où l'on voit tout, où l'on tourne autour de tout, où les figures se détachent de l'architecture, l'architecture du ciel, et où le ciel fuit et n'offre à l'oeil que l'espace." *Arlequin au Muséum* [attributed to Marant]; cited by David 1880, p. 443.

107. This claim, with reference to the *Marriage at Cana,* is made in the *Account* 1822, p. 2; the original French version of this text dictated by David inspired the anonymous *Notice* 1824, which makes the same claim, p. 48. See note 79 above.

108. Denon remarked on the opacity of the sky in Gérard's *Battle of Austerlitz,* in his report to the emperor on the Salon of 1810 (11 Nov. 1810; Denon 1999, vol. 2, pp. 1368–69). The association of transparency with the colorist tradition is proposed, for example, by the Salon critic of *La Décade* in 1802 (cited in Oppenheimer 1996b, p. 147); and by Chaussard in 1806 (quoted note 81). Unfortunately, the algous streaks of discolored varnish over the sky in the *Eagles* make it nearly impossible to evaluate David's execution.

109. See Denon 1999, vol. 1, pp. 508, 512–13, 598.

110. For an impressively thorough and dramatic study of the Concours Décennal, see Grigsby 1995; see also Jourdan 1998, pp. 270–76.

111. Schnapper in Paris-Versailles 1989–90, p. 451 (citing Fontaine 1987, vol. 1, pp. 294–95: "Les déférences que l'amour-propre et l'égoïsme de

cet artiste [David] ont exigées de nous dans l'exposition de cet ouvrage sont au-delà de tout ce que l'on pourrait concevoir").

112. See Sérullaz 1991, p. 327 (citing Wildenstein 1973, p. 181, no. 1556 [Amsterdam], p. 182, no. 1559 [Munich], p. 186, no. 1600 [Florence], pp. 189–90, nos. 1633, 1634, 1636 [Rome]). For the mixed feelings David had concerning his affiliation to foreign academies, see the important previously unknown letter he wrote to Wicar on 6 Mar. 1812, in Grigsby 1995, pp. 167–68 (Custodia Foundation, Paris, inv. 6402). He mentions that Metternich had recently notified him of his admission to the Vienna academy.

113. Lenoir 1810; Lenoir 1811 [and not 1810, cf. David 1880, p. 671], pp. xiii–xliii. In the Avant-propos of the latter volume, Lenoir inserts a revised and annotated version of his comments on the *Sabines,* the School of David, and the *Coronation,* published anonymously ("par un amateur des arts") as a brochure in Aug. 1810, in reaction to the Institute's Concours Décennal report in favor of Girodet's *Deluge.* Certain passages are also common to letters published by Lenoir in the *Journal de Paris* (265 [22 Sept. 1810], pp. 1871–72; 268 [25 Sept. 1810], p. 1891); other passages are later included in the text of a brochure on *Leonidas* and the *Sabines* he published in 1814.

114. Schnapper in Paris-Versailles 1989–90, pp. 372–73.

115. Denon to the minister of the interior, 22 June 1813 (Denon 1999, vol. 2, p. 984; quote: "présentera toujours de grandes difficultés").

116. Lenoir 1811, pp. xxxv–xxxvi; quote: "qu'il possède toutes les qualités qui constituent un peintre d'histoire."

117. "Sa Majesté l'Empereur m'ayant fait l'honneur de m'attacher à sa maison en qualité de son premier Peintre, je vous prie, Monsieur le Comte, de vouloir bien être mon appui auprès de Sa Majesté pour lui faire la demande de lui être présenté comme officier de sa maison, et de jouir, en cette qualité, des mêmes prérogatives que les autres personnes qui ont l'honneur d'en faire partie." David 1880, p. 483; Wildenstein 1973, p. 184, no. 1576. That Bergeron cites David among the Grands officiers civils de la Maison de l'Empereur in 1813 is misleading (1972, p. 90).

118. On this commission, see Bordes and Pougetoux 1983; and Schnapper in Paris-Versailles 1989–90, p. 433–36. Schnapper (p. 435) dates the revival of this commission to a letter written by David on 15 Dec. 1809 (Wildenstein 1973, p. 182, no. 1561; Paris-Versailles 1989–90, p. 614). Written on the day Napoleon's divorce was announced, the letter's mysterious reference to imperious circum-

stances which had put a stop to his "ouvrage," in my opinion, refers not to the Genoa portrait but to the *Eagles,* which David was authorized to pursue, with the obligation of scraping out the figure of Josephine. Schnapper antedates the revival on the basis of a panel in the Fogg Art Museum (see fig. 15), inscribed *1807* (a date that I presently accept as autograph; cf. Bordes and Pougetoux 1983, p. 99). The manifest connection between this composition and a large portrait of Napoleon painted in 1808 for Jérôme Bonaparte, king of Westphalia, exhibited at the Salon that year (presently lost), leads him to consider that this latter work was a copy of the second version of the one for Genoa. This is a play on words: David may have been thinking of Genoa (and the Napoleonic portraits of his rivals) when painting the *modello* in 1807, but Kassel was necessarily on his mind when he aggrandized it and exhibited it in 1808. With Alain Pougetoux, we still consider that he invested no energy and time in the 1811 proposal, which never materialized. Schnapper's somewhat ambiguous formulation (David "studied" a "new composition" in 1811 based on the 1807 panel; Paris-Versailles 1989–90, p. 436), has led to the misbelief that in 1811 David actually painted a (lost) portrait for Genoa (Donna Hunter, in Lyons 2003, p. 100, no. 22, on panel not canvas).

119. Schnapper in Paris-Versailles 1989–90, p. 436.

120. On these commissions, see Paris 1997–98, pp. 202–9. Prud'hon's ascendancy over David around the time of the emperor's second marriage was noted by Spencer-Longhurst (1976, p. 323 n. 11) .

121. Maze-Sencier 1893, pp. 344, 355.

122. Schnapper in Paris-Versailles 1989–90, p. 435; for other possible reasons for the failure to please, see note 58 above. Johns takes pretext of Napoleon's rejection of David's portrait in 1805 and his concurrent admiration for Canova to claim that he felt "a sense of Italy's artistic superiority" and "a lack of faith in French artistic opinion" (1998, p. 12), a position that seems biased and reductive. In 1807 Napoleon also complained of the mediocrity of the miniature portraits being provided for official gifts by Isabey and others (Maze-Sencier 1893, pp. 185–86).

Art historians are notorious and often lampooned for relishing contradictory interpretations and commentaries of works of art: a good example would be the available readings of the 1805 portrait. For two characterizations, at odds with that proposed here, see Johnson (1993a, p. 206: the portrait failed for being "anti-heroic and aniconic") and Spencer-Longhurst, who does

not dwell on the motive of Napoleon's refusal ("the first sign of the emperor's cooling towards David"), but esteems that the 1805 portrait "was composed according to the tradition established by Rigaud" (1976, p. 323 n. 10).

123. "Le peintre David qui était présent à cette visite n'a pas défendu et a même assez vivement blâmé les ouvrages que l'on attaquait, quoique j'eusse entrepris de lui faire croire qu'ils étaient faits par des élèves de son école. Ce n'est pas des élèves, a-t-il répondu, mais des maîtres que Sa Majesté doit employer pour orner ses palais." Fontaine 1987, vol. 1, p. 217, 22 Oct. 1808.

124. David 1880, pp. 484–86. Wildenstein 1973, p. 192, nos. 1658–59; Paris-Versailles 1989–90, pp. 618–19. Quotes: "de composer et de faire exécuter toutes les peintures qui doivent orner les palais impériaux"; "sous mes ordres par des artistes de mon choix, étant plus à même que personne de connaître le genre qui est propre à leur talent, puisqu'ils sont sortis de mon école."

125. Prat and Rosenberg (2002, vol. 1, pp. 260–67) provide a full discussion of the drawings and cite Français's letter (p. 260; quotes: "figures bizarres des rois, dames et valets"; "un dessin dont l'extrême élégance et la pureté rendent la contre-façon difficile et qui puisse en même temps par *la fidélité des costumes et l'exactitude des attributs,* répondre au but allégorique que paraît s'être proposé l'inventeur de ce jeu"). For the edited versions, see Keller 1981, vol. 1, pp. 193–94 (a set after David: FRA[NCE] 354, 355; after Gatteaux: FRA 359; see also p. 262 (after David: FRA sheet 210).

126. "Extrêmement simple dans toute sa personne, s'il aimait le luxe dans son entourage, c'était encore un calcul: une grande représentation lui semblait un moyen de supériorité et rendait l'action du gouvernement plus facile." Fain 1908 [2001], p. 219.

127. On this enterprise see Gersprach 1891, pp. 154–60 (quote, p. 158: "tous les dessins qui rentrent dans l'ameublement complet"); Ledoux-Lebard 1941–44 [1947], pp. 220–32; Paris 1969, pp. 98–105, no. 287, A–W; Gonzales-Palacios 1993, pp. 954–58.

128. Paris 1969, pp. 103–4, no. 287, T.

129. "Le premier aspect m'a fait plaisir, j'en ai loué les proportions et son élégance; ensuite après un plus mûr examen, j'ai fait quelques observations pour la délicatesse du style . . . comme par exemple, d'enlever au-dessus du chapeau des feuilles recourbées qui faisaient confusion." Maze-Sencier 1893, p. 269; Paris 1969, p. 105, no. 287, W.

130. "Je viens de voir peindre David. C'est un recueil de petitesse, et sur la manière de tracer son nom, et sur la différence d'un peintre d'histoire à un peintre en miniature à propos d'un costume de page qu'il a *envoyé* à l'empereur. Ces gens-là épuisent leurs âmes pour les petitesses, il n'est pas étonnant qu'il ne leur en reste plus pour ce qui est grand. Du reste, David n'a pas l'esprit de cacher cette petite vanité de tous les moments et de ne pas prouver sans cesse toute l'importance dont il est à ses propres yeux." Cited in Wildenstein 1961, p. 119.

131. "Vous avez tort de vous fatiguer à peindre des vaincus." *Notice* 1824, p. 57.

132. Baschet 1948, p. 295 (quote: "qu'on aimait pas vraiment les arts en France"). Exasperated by the Paris Royal Academy, during the late 1780s David thought of visiting London (Bordes 1992), and in Sept. 1815 he told an English visitor that "he has some thought of coming to England to found a school" (Pidgley 1972, p. 791 n. 6); on several occasions, as attested in his letters (Wildenstein 1973, pp. 28 [no. 207], 195 [no. 1689]), he also envisioned settling in Rome, and of course, political circumstances provoked his move to Brussels in 1816.

133. Johnson defends a different chronology and explanation, whereby David's republicanism and financial disputes provoked an early and circum-stantial "repugnance" for the imperial régime: "The completed paintings [the *Coronation* and the *Eagles*], in fact [*sic*], express the artist's pro-gressive disillusionment with the emperor" (1993a, p. 176).

134. Denon 1999, vol. 2, p. 879, no. 2522 (21 July 1812) (quote: "si M. David s'occupe de ces tableaux"); p. 914, no. 2632 (16 Nov. 1812); p. 937, no. 2703 (15 Jan. 1813). The commission allotted Prud'hon, for a painting measuring about thir-teen by twenty-one feet (4 by 6.5 m) and first mentioned in July 1812, was 20,000 francs, over three times the highest price usually accorded painters (6,000–8,000 francs). Denon's expectation that the painting would be shown at the Salon of 1814 was thwarted by Napoleon's abdica-tion in May of that year. In 1809 the same sum of 20,000 francs, fixed by David, had been approved for a copy of the *Coronation* by his students, to serve as a cartoon for the Gobelins; however, he was never paid, which is not sur-prising in light of Josephine's divorce, and in Dec. 1813 the project was formally annulled (Wildenstein 1973, p. 178, no. 1530, 1532; Schnap-per in Paris-Versailles 1989–90, p. 535; Denon 1999, vol. 2, p. 1031, no. 3009).

135. Paris-Versailles 1989–90, pp. 374, 618.

136. Bramsen 1947, p. 83: "David er en Mand maaske over 60 Aar hoy og velskabt, han har et Ansigt fuld af Aand og en Munterhed og *vivacité* som om han endnu var ungt Meneske paa 24 Aar, han holder meeget af at spoye og lee, naar han corigerer er han alvorlig, og taler med en Enthu-siasme om Natur og Kunst som er sjælden, han taler med Følelse og Varme om Kunsten." David, who hoped his Danish student might one day attain as a painter the fame of his compatriot Thorvaldsen as a sculptor (p. 92), paid a visit to his home studio on at least two occasions, in Apr. and June 1812 (pp. 29, 30, 91). My thanks to Bent Sørensen for help with this text.

137. Grunchec 1989, vol. 2, pp. 38–54. Girodet's letter to Fabre of 21 Sept. 1811, criticizing David "qui ne veut point souffir que d'autres élèves que les siens soient couronnés dans les concours," is cited in Grigsby 1995, p. 167. Suau, one of David's students, reported to his father on 28 July 1813 of the master's critique of the Prix de Rome judg-ment: "je vois, nous disait-il, la peinture aller tous les jours en décadence; il prétend que dans un autre genre on retombe dans le style de Van Loo; il avait raison relativement aux grands prix, quoique il y ait dans son dire un peu de préven-tion, car il en a toujours eu contre l'école de M. Vincent" (Mesplé 1969, p. 100).

138. Wildenstein 1973, p. 196, no. 1703.

139. "Les Russes en général, à l'exemple de votre Mag-ananime Alexandre, emportent tous les regrets. Votre grand empereur s'est fait adoré et mon bonheur aurait été complet s'il m'eut honoré de son Auguste présence ainsi que l'on daigné faire les autres souverains en visitant mon atelier." Wildenstein 1973, p. 195, no. 1689.

140. This is confirmed by the letter Madame David wrote to Odevaere, on 25 Aug. 1817: "Son Altesse royale le Prince d'Orange lui a fait l'honneur de venir chez lui voir son tableau de l'Amour et Psyché [see cat. 32]. Mon mari était au lit malade. Son Altesse a daigné s'approcher du lit de M' David, s'entretenir longtemps avec lui sur les arts. . . . Je me représentais François Ier au lit de Léonard de Vinci" (sale, Brussels, Devroe and Stubbe, 21–22 Nov. 2003, no. 588 [2]; kindly brought to my attention by Eric Bertin). The painting of this subject by Ménageot (Amboise, Hôtel de Ville), exhibited to great acclaim at the Salon of 1781, contributed decisively to the popu-larity of the story, relayed without explicit refer-ence to Vasari, for example Chaussard 1798, p. 12; and Lenoir 1810, "Introduction," pp. 29–30.

141. "Un exemple de modération comme celui qu'a fait voir de nos jours Alexandre de Russie qui éclipsera l'ancien dans les Annales du monde. . . . Alexandre a fait la conquête de tous les hommes de l'art et je ne doute pas que beaucoup se dis-posent à aller vivre dans ses États." Wildenstein 1973, p. 195, no. 1689.

142. "Ce dévouement de Léonidas et de ses compagnons produisit plus d'effet que la victoire la plus brillante: il apprit aux Grecs le secret de leurs forces, aux Perses celui de leur faiblesse." The text is cited in full by Schnapper in Paris-Versailles 1989–90, p. 486.

143. See the examples cited by Bordes 1988, pp. 83, 106; and Schnapper in Paris-Versailles 1989–90, p. 487.

144. "Artistes de la division du Muséum, vous vous élançâtes les premiers aux champs d'honneur! Il sera éternellement présent à ma mémoire ce jour où, semblables aux trois cents Spartiates qui se dévouèrent aux Thermopyles, vous vous avançâtes en ordre de bataille au sein de l'assemblée que j'avais l'honneur de présider, et qui reçut vos serments." Chaussard 1798, p. 19. Gaehtgens invokes a telling parallel, cited at the time, between Leonidas and the desperate heroism of General Rampon at Monte-Legino in 1796, commemorated through the Empire (1984, pp. 244–49).

145. "Tous les emblèmes, chiffres et armoiries qui ont caractérisé le Gouvernement de Bonaparte, seront supprimés et effacés partout où ils peuvent exister"; text reproduced in Day-Hickman 1999, p. 40.

146. Pidgley 1972, p. 791. Dawson Turner, author of the remark quoted, adds: "Of such the *Coronation*, in particular, is full."

147. Schnapper resumes the critical reception in 1814 of *Leonidas* in Paris-Versailles 1989–90, p. 497. Maze-Sencier mentions a *tabatière en carton vernis* with the inscription cited relative to Waterloo (1893, p. 304).

148. Paris-Versailles 1989–90, p. 620; the 1815 nomination is not mentioned in Foucart 1970.

149. See the informative entry on the *acte additionnel* by Stephane Rials in Tulard 1999, vol. 2, pp. 34–36.

PORTRAITS OF THE CONSULATE AND EMPIRE

1. Paris 1913, pp. 5–11 (introduction by Henri Lapauze).

2. The rapprochement with Manet was proposed by Charles Saunier in 1913 concerning *Claude-Marie Meunier* (see cat. 20), admittedly freer in handling than most portraits by David; "cet impressionnisme de David" was coined the same year by the duc de Trévise, commenting on the *Portrait of Jean-Baptiste Milhaud*, no longer attributed to David (Musée de la Révolution française, Vizille). For references, see Verbraeken 1973, pp. 19 n. 44, 162 n. 125. This was still the attitude of André Maurois in 1948: "David peintre de portraits, réaliste impeccable, de goût infaillible, semblait créé pour être, dans l'histoire de l'art français, le naturel chaînon de passage du dix-huitième au dix-neuvième siècle, l'ancêtre d'Ingres, Manet, Degas, et c'est bien en fait sous cet aspect et dans ce rôle qu'il reste si grand" (1948, n.p.). Maurois' publication in fact was an early attempt to rehabilitate his historical compositions, with stunning full-scale reproductions of details.

3. Regrettably, there exists no thorough study of the critical reception of portraiture during the Empire comparable to that of Halliday for the Directory and Consulate (2000).

4. "Je suis bien fâché qu'elle ait de moi un mauvais portrait, mais à Paris, nous verrons tout cela, et je serai moi, mon pinceau et mon peu de savoir, tout à vous et vos amis." Letter to Bièvre, 16 Feb. 1785 (Wildenstein 1973, p. 17, no. 136).

5. "Que les arts cessent donc de mendier l'appui du grand seigneur, que celui-ci les laisse tranquilles." Cited in Bordes 1983, p. 22, with a discussion of the determinant influence of David's milieu on his social and political attitudes.

6. "Il se délaissa souvent à faire des portraits et prouva plus d'une fois aux peintres de portraits que quand les peintres d'histoire se mêlent de faire des portraits, ils y mettent la vie que la présence de leur mannequin leur refuse toujours." Text reproduced in Bordes 1983, p. 175.

7. With the publication of Diderot's *Essais sur la peinture* in 1795 and again 1798, artists would discover a provocatively different view on the matter: "[Jean-Baptiste-Marie] Pierre disait un jour: Savez-vous pourquoi nous autres peintres d'histoire nous ne faisons pas le portrait. C'est que c'est trop difficile" (Diderot 1984, p. 65).

8. "Ce portrait est un de ses meilleurs jusqu'alors: il a eu toujours soin à la vérité de ne choisir que de belles têtes de femme, ne voulant pas prostituer son pinceau dans un genre qu'il ne faisait que pour s'amuser." Text reproduced in Bordes 1983, p. 175.

9. See Halliday 2000; and Bordes in San Diego 2003–4. The paragraphs on the Directory and Consulate resume ideas developed in the latter essay.

10. The impact of questions of social, political, and gender identity on art practice during the Directory has been suggestively discussed by Siegfried 1995, pp. 70–84 (p. 76, an illustration of *La Marche incroyable*); and Lajer-Burcharth 1999, pp. 181–204, and *passim*.

11. See the résumé of the contents of a recently rediscovered letter to Espercieux, 29 Fructidor Year III (15 Sept. 1795), by Bordes in San Diego 2003–4, p. 36 n. 9.

12. Vigée Le Brun [1869], vol. 2, pp. 170–72.

13. Millin 1806a, vol. 2, p. 58. The definition proposed is radically inclusive: "Sous ce rapport, on comprend parmi les Tableaux d'Histoire, non seulement ceux qui représentent des faits historiques, mais aussi ceux dont le sujet est pris de la mythologie, les tableaux allégoriques, les batailles, les tableaux de famille et de société, lors même qu'ils offrent des portraits; enfin, des personnages isolés, lorsqu'ils sont représentés en action, ou dans une situation déterminée, tels que les tableaux de la Madeleine repentante, de Bonaparte franchissant les Alpes, etc."

14. On David's reputed fees and the price for portraits during the Consulate, see Bordes in San Diego 2003–4, pp. 16–17, 37 (n. 37), 38 (n. 40).

15. A. Pougetoux has suggested that the double portrait of the nieces of Mollien, an important imperial dignitary, painted by Rouget in 1811 (Musée du Louvre, Paris), given the importance of the patron, may have been addressed initially to his master David (Pougetoux 1995, p. 39).

16. See notably the full-length portrait of Charles-Louis-François Letourneur in official costume, painted in 1796 by Jean-Baptiste François Desoria (Musée national du Château, Versailles), reproduced in Bordes and Chevalier 1996, p. 68. That Desoria produced a corresponding seated three-quarter-length in daily dress the same year (pp. 68–69; Musée de la Révolution française, Vizille) reveals the transitional culture of government during the Directory, between committee and court. David's concern for dignity in official portraiture is suggested by an anecdote reported (or invented) in *L'Ami des Lois* (no. 1633, 8 Ventôse Year VIII [27 Feb. 1800], p. 2): "On voit étalées sur les quais, sur les boulevards, partout, comme portraits coloriés des consuls, des ministres et des généraux, les caricatures les plus ridicules. Elles rappellent le fameux portrait de ce représentant du peuple exposé au dernier Salon [1799], que David traitait plaisamment *d'avilissement de la représentation nationale*. Si les méchants faiseurs d'images étaient aussi communs en Macédoine qu'en France, on trouve de quoi justifier Alexandre, qui défendit par un édit à tout autre peintre et sculpteur qu'Apelle et Lysippe de représenter ses traits."

17. "Et dans cette multitude de portraits, combien n'en pourrait-on pas citer qui, loin de relever la gloire de l'école actuelle, ou d'ajouter à l'ornement du Salon, semblent, au contraire, en déparer l'ensemble, et ne piquent la curiosité du public, ni par le caractère des personnages qu'ils représentent, ni par le mérite du travail; deux conditions dont l'une ou l'autre au moins devrait

mériter aux portraits les honneurs de l'exposition." Landon 1810, pp. 5–6. The requisites were already underlined by critics in 1806; see the texts cited by Fleckner (1995, p. 16). The vanity of exhibiting private portraits was condemned for example by Frédéric de Clarac in 1806 (Fleckner 1995, pp. 14–15) and François Guizot in 1810 (1852, pp. 91–92).

18. Frédéric de Clarac in 1806, cited by Fleckner (1995, p. 17). In June 1800, to persuade the husband of Henriette de Verninac not to send her portrait to the Salon, David explained: "il serait ridicule qu'un artiste comme moi exposât simplement un portrait, tel bon qu'il soit, quand il a tout à côté, un grand tableau qu'il fait voir pour de l'argent" (Wildenstein 1973, p. 152, no. 1350). Although the process may have been engaged at the time, the disqualification by David of the Salon as a possible destination for his private portraits was not yet a question of principle (cf. Verbraeken 1973, p. 42, who quotes only the first part of the phrase).

19. Mehdi Korchane, who is finishing a doctoral thesis on Guérin (Université Lyon 2), believes that this might explain why he painted so few portraits in his lifetime.

20. Delécluze 1855 [1983], p. 336. Schnapper in Paris-Versailles 1989–90, p. 21. A.-L. Millin's use of the expression "statue-portrait" to designate a public monument representing a historical figure suggests a parallel notion (1806a, vol. 3, pp. 353, 356; italicized in the second instance).

21. Grigsby 2002, p. 119.

22. "Je vous aurai une obligation spéciale de bien vouloir mettre mes observations sous les yeux du Premier Consul." Letter to Estève, 3 May 1803 (Wildenstein 1973, p. 162, no. 1400; Schnapper in Paris-Versailles 1989–90, p. 387).

23. See the suggestive remarks of Jean Cailleux, "Pourquoi l'Ovale," in Paris 1975, pp. 1–13.

24. On the two portraits of Estève, see the fundamental discussion by Schnapper in Paris-Versailles 1989–90, pp. 387–89. The second portrait, perhaps the victim of the treasurer's disgrace in Dec. 1811, was completely overpainted by an uninspired hand; Schnapper salvages the head (p. 387).

25. Diderot 1984, p. 68: "Un portrait peut avoir l'air triste, sombre, mélancolique, serein, parce que ces états sont permanents; mais un portrait qui rit est sans noblesse, sans caractère, souvent même sans vérité et par conséquent une sottise." This is extracted from his Essais sur la peinture, first published in 1795 and again in 1798. Millin denounced the "sourire" in portraiture as a "physionomie fausse" (1806a, vol. 3, p. 354).

26. Schnapper in Paris-Versailles 1989–90, p. 478 ("la contrepartie modeste, bourgeois et sympathique du grandiose portrait des Lavoisier").

27. Fleckner 1995, pp. 113–23; the expression portrait intime was coined by Charles Blanc in 1870 (Fleckner 1995, pp. 117–18). Riopelle in London 1999–2000, p. 254, concerning the Portrait of Jeanne-Suzanne-Catherine Gonin by Ingres (1821, The Taft Museum, Cincinnati).

28. See for example Lille 1984, pp. 41–44, for an album of drawings in the Musée des Beaux-Arts in Lille; others are in the Museo Napoleonico in Rome, the Accademia di Belle Arti in Perugia, and on the art market in Paris.

29. The portrait is reproduced in Paris 1913, opposite page 52. The proposed date (as well as for Madame Lecerf) is taken from Gérard 1888, vol. 2, p. 409.

30. When informing his wife of his return from a journey to Switzerland on 25 August 1815, David specified that he did not want to see him: "Quant à mon fils aîné ne lui en parle pas de mon arrivée, il ne m'a pas donné assez de preuves d'intérêt pour que je le voie avec plaisir. Entends-tu, ne me l'amène pas, il troublerait le plaisir que j'aurais de vous embrasser" (Agius d'Yvoire in Paris-Versailles 1989–90, p. 621; this phrase was censored by Jules David's nephew in his monograph [1880, p. 521]).

31. Pougetoux 1995, p. 41, no. 13.

32. Rouget's portrait of David is lost, but a copy in the National Gallery of Art in Washington is preserved: Pougetoux 1995, p. 44, no. 22; and Eitner 2000, pp. 329–33. The inception of Rouget's collaboration with David is antedated by the latter. Rouget's portrait is dated 1813 in the lithograph joined to the Flemish-language edition of the Vie de David in Th. 1826c. An engraving after the picture by Eugène Bourgeois was exhibited at the Salon of 1814. It was sanctioned by David for it illustrates the anonymous biographical Notice published with his collaboration in 1824.

33. These speculations are shared by L. Eitner (2000, p. 210), who adds, with reference to Delécluze (1855 [1983], p. 340–41) and the artist's grandson (David 1880, p. 509): "It was at this time that his pupils observed his quiet depression and his need to surround himself with his family."

34. A recent technical examination of Portrait of Antoine Mongez and Angélique Le Vol has revealed that it is not painted on canvas glued onto panel, as previously thought (Paris-Versailles 1989–90, p. 478), but directly on panel.

35. Watelet and Lévesque 1788–91, vol. 2, pp. 708–9.

36. Joseph Baillio in Fort Worth 1982, p. 95. Although the portrait in question exhibited at the Salon of 1791 was painted on canvas, it is characterized by what might be called a "panel" aesthetic, vigorous form and warm colors. Vigée Le Brun's adoption of panel supports after her trip to the Low Countries is mentioned p. 10.

37. For an exhaustive discussion of such considerations in the context of the aftermath of the Terror, see Lajer-Burcharth 1999.

38. "Il [Mengs] préférait de peindre sur panneau, quand il pouvait le faire, parce que la toile, quelque bien préparée qu'elle soit, ne présente jamais une surface aussi lisse, ni aussi unie que le bois; et chaque trou ou point raboteux, quelque petit qu'il puisse être, occasionne une fausse réflexion de lumière. D'ailleurs la toile a encore un autre défaut; c'est que pour peu qu'elle soit grande, elle cède sous le pinceau; de sorte que la main n'est ni ferme ni sûre." Oeuvres complètes d'Antoine-Raphaël Mengs, Paris 1786, vol. 1, p. 49. Watelet and Lévesque paraphrase this passage (1788–91, vol. 2, p. 709), as does Millin (1806a, vol. 3, pp. 37–38).

39. See, for example, the humorous critique by Charles-Nicolas Cochin first published in the Mercure de France, July 1756, pp. 187–202, and reprinted in his collected works in 1757 and again in 1771 (Michel 1993, p. 600). (Christian Michel called my attention to this text.) Millin developed a similar position: "Le visage seul doit fixer l'attention, et si le peintre est obligé d'admettre quelques ornements accidentels, il faut qu'il les place avec goût dans l'endroit où ils relèvent le caractère de l'ensemble" (1806a, vol. 3, p. 352).

40. See Bordes in San Diego 2003–4, pp. 32–34.

41. Paris 1974–75, p. 553, no. 136, repr. p. 213. In her entry, Isabelle Julia makes the connection with Henriette de Verninac.

42. The passage from chapter 5 of L'Émile ou De l'Education (1762) is justly famous: "Ajoutez à toutes ces réflexions que l'histoire montre bien plus les actions que les hommes, parce qu'elle ne saisit ceux-ci que dans certains moments choisis, dans leurs vêtements de parade; elle n'expose que l'homme public qui s'est arrangé pour être vu: elle ne le suit point dans sa maison, dans son cabinet, dans sa famille, au milieu de ses amis; elle ne le peint que quand il représente: c'est bien plus son habit que sa personne qu'elle peint."

43. Lenoir 1835, p. 5 n. 1: "David avait la fureur du violon: il se croyait un virtuose."

44. On an attempt in 1804 by the conservative critic Marie Boutard to rehabilitate the importance of accessories in portraiture, see Halliday 2000, p. 161; and further comments by Bordes in San Diego 2003–4, p. 26.

ANTIQUITY REVISITED

1. "En suivant sa marche [of his painting], depuis le *Bélisaire* jusqu'aux *Sabines,* on voit l'influence italienne diminuer et le goût pour le dessin antique se perfectionner, s'exagérer même jusqu'à l'excès." This is from Thiers's review of David's *Mars and Venus* (*Revue européenne,* 1824, pp. 335–39), reedited by Jacob 1873, p. 300.

2. "Au fracas, à l'appareil théâtral, à la manière académique, au papillotage, au faux tons, au faux goût ont succédé le calme de la composition, la sagesse de l'ordonnance, la sérénité du trait, la correction du dessin, une meilleure entente du coloris, enfin l'étude et l'imitation des beautés de l'antiquité." Chaussard, "Premier article sur l'exposition de 1798" in *La Décade philosophique,* 20 Thermidor Year VI (7 Aug. 1798), cited in Kitchin 1965, p. 234. By 1796 it was a commonplace to oppose the "*faire* maniéré de Boucher et des imitateurs" to the "touches mâles et sévères de David" (text cited by Becq 1994, p. 814 n. 129).

3. "L'âme se recueille davantage à l'aspect du malheur qu'à l'aspect du triomphe; et les affections particulières, les larmes d'une fille sont plus fortes pour nous que la massue d'Hercule. Tout ce qui est du ressort de l'humanité nous appartient, tout ce qui est au-dessus, nous semble étrange." An anonymous critic in 1799, opposing Guérin's *Marcus Sextus* and Hennequin's *Dix-Août,* cited by Gersmann and Kohle 1990, p. 17. See also Johnson 1990, p. 26: praise in 1801 of Girodet's *Sleep of Endymion* ("Voilà comme les artistes peintres ou poètes peuvent rajeunir les sujets usés de la mythologie"). On changing attitudes toward myth in the eighteenth century, see Johnson 1993a, pp. 242–44; and the nuanced review of the question by Stéphane Pujol, "Critique des fables," also based on distinctions proposed by Jean Starobinski, in Delon 1997, pp. 295–98.

4. Girodet to Jacques-Henri Bernardin de Saint-Pierre, undated letter, c. 1802–3 from internal evidence (Coupin 1829, vol. 2, p. 278). He comments here on his Ossianic painting for Malmaison and notes that David lauded its originality. However, in his journal Delécluze has the recollection of David's negative reaction (Baschet 1948, pp. 66–67).

5. Adolphe Lullin to Étienne-Jean Delécluze, 1 Vendémiaire Year IX (23 Sept. 1800); letter cited by Delécluze 1855 [1983], p. 105. Delécluze reproduces this document without noting that it faults his presentation of David's asthetic preoccupations. Hennequin's recollection of Vien's comment on the painting ("une production qui lui rappelait la belle école d'Italie") is cited by

Benoît 1986, p. 204. The *énergie* invoked by David and many others to characterize this picture is the quality commonly identified with Caravaggio, for example by Lenoir in 1816 (see his annotation in Stendhal 1996, p. 568).

6. Stéphane Guégan remarks on the "référence insistante" of Stendhal to this painting in 1811 ("Moderne," introduction to Stendhal 2002, pp. 22, 25).

7. "David à Lesueur (en sortant d'une représentation d'Ossian): Quand mon pinceau commencera à se refroidir, mon âme à se glacer, j'irai réchauffer l'un et l'autre aux sons brûlants et passionnés de votre lyre. Votre âme, dit-on, s'est élevée quelques fois à la vue des tableaux de mon école, la mienne brûle en entendant les vôtres. Signé David." Manuscript copy, annotated, "Extrait du journal *Le Citoyen français du 3 vendémiaire an 13* [25 Sept. 1804]," Arles, Bibliothèque municipale, Jacques Réattu Papers, MS 593, item 255. In the archives of the autograph dealer Charavay, Paris, is a note on the original letter, bearing the date "1er thermidor" [20 July 1804], ten days after the opera was premiered.

8. "[Q]u'est-ce qui constitue le chef-d'oeuvre? C'est, je pense, la réunion de la pensée avec la persévérance de l'artiste qui sans perdre le sentiment de sa 1ere idée, sait la mener à fin sans la refroidir, et c'est là positivement en quoi consiste le mérite de ces divins artistes, différents des nôtres qui font fort bien une esquisse et qui échouent dans le tableau." David to Paillot de Montabert, 24 Oct. 1820 (Paris, Bibliothèque nationale de France, Additional MS 29776, fol. 42; graciously brought to my attention by Mark Ledbury).

9. Becq 1986; Becq 1994, pp. 798–821.

10. On this point, see my remarks in San Diego 2003–4, pp. 24–26.

11. David to Gros, 13 Sept. 1817 (Wildenstein 1973, p. 208, no. 1807); Gros to David, Jan. 1817 (David 1880, p. 546). Hautecoeur is wrong to attribute to David's late historical works a "goût des surfaces lisses, émaillées," and a desire "d'atteindre l'éclat translucide des peintures sur porcelaine" (1954, p. 272).

12. See the review of *Mars and Venus* by A. Thiers (*Revue européenne,* 1824, pp. 335–39), reedited by Jacob 1873, p. 303. On his attitude toward David, see Chaudonneret 1998, pp. 101–2.

13. Cited from the *Oeuvres* of Falconet (Lausanne, 1781, V, p. 27), by Gaëtane Maës in her paper, "La réception de Rubens en France au XVIIIᵉ siècle: quelques jalons," for the conference *Le Rubénisme en Europe aux XVIIᵉ et XVIIIᵉ siècle* (Lille-Arras, Apr. 2004), forthcoming. My thanks

to her for a profitable discussion and allowing me to quote from her paper. On the cult of Rubens in Belgium around 1800, see Guédron 1998.

14. J. David mentions this, presumably on the basis of Delafontaine's recollections, and identifies the painting as a portrait of Rockox (1880, p. 363). The copy was inventoried after David's death and claimed by Delafontaine in 1826; Wildenstein 1973, pp. 239 (no. 2043 [no. 94]), 248 (no. 2072), 249 (no. 2077 [no. 15]).

15. "Suite des observations sur quelques grands Peintres, dans lesquelles on cherche à fixer les caractères distinctifs de leurs talent. Rubens," *Journal des arts,* no. 33, 15 Nivôse Year VIII [5 Jan. 1800], pp. 5–6. "Aucun peintre n'a porté l'expression a un plus haut degré que lui. . . . La nature a été créée dans ses tableaux Qu'ils sachent, ces esprits glacés, que le caractère des ouvrages de génie n'est point de marcher sans défauts, mais d'étonner par des beautés"(p. 6). The adoption of a Rubensian style was another matter: in 1802–3, Jean Naigeon, in charge of the Luxembourg Gallery, conceived of an homage to the Flemish painter for the end wall (and the following year a pendant honoring Lesueur) in a graceful style reminiscent of Canova (see the two drawings in an unpaginated and unbound *cahier* edited in 2004 by Galerie Eric Coatalem, Paris).

16. "Le 'sublime' Rubens leur a fait beaucoup de tort. Avant lui ils sentaient la peinture comme les Italiens du XVIᵉ siècle. J'admire tous les jours ces ouvrages antérieurs à cet homme de génie et je remarque que leurs anciens maîtres ajoutaient encore le coloris à leur beau dessin." David to Gros, 10 Nov. 1818 (Wildenstein 1973, p. 212, no. 1839). In his brochure on the *Horatii,* David's former pupil Péron insists on his admiration for Rubens (1839, p. 16 n. 2), but this may have been a way to render him more attractive to a later generation.

17. *Notice* 1824, p. 36; cited by A. Schnapper in Paris-Versailles 1989–90, p. 200. The provocative nature of the remark is underlined by the common criticism of Teniers's "formes ignobles" and "imitation triviale" (Droz 1815, p. 29). David's admiration of the Flemish painter was already attested by Chaussard in 1799: "Sous le seul rapport technique et d'exécution, demandez à David ce qu'il pense de Teniers" (*CD* XXI, no. 580, manuscript copy of a Salon review in *La Décade philosophique* [Fructidor–Brumaire Year VII], p. 449).

18. This must be appreciated in light of the relative status of the three schools of painting at the time: in the *Musée Napoléon,* the Northern school

occupied four bays of the Grande Galerie, like the Italian school, while the French school only occupied one (Bordes 2004b, p. 87).

19. On new notions of patriotism emerging around 1800, see Gersmann and Kohle 1990, p. 22 n. 70 (with reference to Pierre-Simon Ballanche). On Lethière's *Oath of the Ancestors,* see Grigsby 2002. On Steuben's *Oath of the Three Swiss,* see Landon (1824, p. 62, pl. 39), who comments on the picture with regard to David's *Horatii.* Stendhal judged that Steuben had failed miserably, and directs him toward the antique: "Je conçois qu'on s'égare dans notre siècle en voulant peindre des héros; mais enfin M. Steube[n] n'a donc jamais lu Plutarque?" (2002, p. 82).

20. This was a fundamental demonstration of Colin Bailey's *Amour des Dieux* exhibition (Paris 1991–92). *Paris and Helen* was one of nine paintings by David exhibited in the Luxembourg Museum between 1819 and 1825 (Chaudonneret 1999, p. 34). It inspired two compositions of *Hector Censuring Paris and Helen* by his pupils, Henri-François Mulard (1819; Musée de Clermont-Ferrand) and F. Heyndrickx (1820; Princeton University Art Museum). The latter picture (anonymous in Crow 1985, p. 247, fig. 119) is identified by a line engraving in Bast 1823, plate 25.

21. See the four prints from 1795 to 1799, including *Sappho Inspired by Cupid* after Anatole Devosge (1795), reproduced by Bordes 2001a, pp. 124–27, figs. 10–13.

22. The most thorough discussion is Vidal 2003. For an example of a critic who circumscribed iconography for women in 1804, see Bordes in San Diego 2003–4, p. 41 n. 89.

23. "Nous jouissons d'une tranquillité qui depuis longtemps nous était inconnue, toutes les tracasseries révolussionaires [*sic*] sont restées derrière nous et il ne nous est resté de leur souvenir que ce qui en est nécessaire pour nous faire apprécier le bonheur dont nous jouissons. Aussi Monsieur David s'est-il donné tout entier à sa chère peinture et depuis que nous sommes ici son génie ne s'est-il reposé que sur des compositions gracieuses et qui ont été admirées par tous les étrangers qui les ont vu et enlevé de suite." Marguerite-Charlotte David to Madame Huin, 12 Feb. 1822 (Peyre 1900, p. 111).

24. David to Gros, 22 June 1820 and 1 Apr. 1821 (Wildenstein 1973, pp. 219 [no. 1877], 221 [no. 1891]; the quote: "à l'abri des passions des hommes"). On Odevaere's huge painting, finished only in 1825 (Hôtel de Ville, Saint-Nicolas, near Liège), see M. Woussen and D. Coekelberghs in Ixelles 1985–86, pp. 169–71, repr. p. 171). David's earlier

praise of novel iconography is found in his letter to the president of the National Assembly, 5 Feb. 1792, cited by Bordes 1983, p. 165.

25. For the allusion to David's taste for *opera buffa,* see the quote in the entry for cats. 24–26, below, n. 12.

26. Guiffrey 1903; Carroll 1990. François-Joseph Talma asked Wolf, alias Bernard, the director of the Royal Theater in Brussels, to transmit his greetings to David, in a letter of 2 Feb. [1822] relative to his lead role in Jouy's tragedy of *Sylla,* as an incarnation of Napoleon that would be transparent to all (sale, Paris, Hôtel Drouot, 18 Apr. 1991, no. 164). In 1822–23 David may have had a hand in Sophie Frémiet's portrait of Wolf; see the essay "Portraits in Exile," n. 6.

27. "Je me suis avisé de peindre des Dieux, nouveau Titan, j'ai osé pénétrer dans leur demeure; puissé-je ne pas être foudroyé comme eux." David to Antoine Mongez and Angélique Levol, 12 May 1824 (E. Agius-d'Yvoire in Paris-Versailles 1989–90, p. 630; Johnson 1997, p. 93 n. 26).

28. "David est un composé singulier de réalisme et d'idéal." Cited by many, from R. Huyghe in London 1948, p. 4, to Lebensztejn 1993, p. 1018.

29. "[Q]uiconque ne fait pas chaque jour de nouveaux progrès, s'éclipse et tombe: c'est le résultat du mouvement et des révolutions dans les choses humaines." [Chaussard] 1806, p. 373, with reference to François-Guillaume Ménageot.

30. Goudail and Giraudon 2001, p. 200, 17 Apr. 1813 (an academy report, signed by a committee presided over by F.-G. Ménageot [cf. the previous note]). David was sensitive to this opinion: "Ovide a bien raison de dire qu'un vieux soldat et un vieil amoureux ne sont bon à rien; il aurait pu ajouter un vieux peintre. Il ne l'a point dit et j'en ai supposé la conséquence qu'il n'en était point ainsi de la peinture." This is extracted from the letter to Mongez and his wife, 12 May 1824, cited n. 27, but this quote is found only in Hautecoeur 1954, p. 271.

31. Stendhal 1996, pp. 311–53. See Stéphane Guégan's remarks on the *beau idéal moderne* in Stendhal 2002, p. 26.

32. Delécluze's review is cited in annex to Stendhal 1996, pp. 555–59; quote, p. 557: "Par quel singulier hasard M. de Stendhal n'a-t-il pas vu que le *beau* idéal moderne qu'il propose est précisément le type de ce gracieux effeminé, de ce *joli* qui domine dans tous les objets d'arts exécutés depuis 1721 jusqu'à 1780?" The first date may have been suggested by the year of Watteau's death, although he includes the latter in a list of artists who represent this period.

33. Baschet 1948, p. 292 (4 Jan. 1826).

34. The caricature is discussed by Bordes 1997, pp. 127–28, 134 (nn. 21–22); and in detail by Vasseur (1997, pp. 182, 184–85). She and others have attributed the print to Pierre-Nolasque Bergeret on the basis of an annotated copy in Berlin, but this appears untenable for reasons of style and artistic politics, since the anecdotal painter had much to gain from the Restoration. Its identification with *Romulus Calicot,* registered in the *Bibliographie de la France* on 11 Oct. 1817 (no. 852) (according to the repertory by George McKee, *Image of France:* http://www.lib.uchicago.edu/ efts/ARTFL/projects/mckee/) rests on the subject and the editor. Lajer-Burcharth relates the print to the pranks in David's studio (1999, pp. 221–22); she mentions Auguste de Forbin, who as the powerful director of the Royal Museum since June 1816, was probably targeted in the figure of the aristocratic fop. On the *calicot,* see Athanassoglou-Kallmyer 1991, pp. 140–41 n. 75; she reproduces a print in which a *calicot* has deliberately torn his trousers and untidies his hair, looking much like the Davidians in the lithograph, who in spite of the mockery appear to come out on top. On the vogue for dressing up and in military uniform during the early Restoration, see Mansel 1982, especially p. 122.

35. For the eighteenth century, see the persuasive demonstration of this paradox by Christian Michel (1996). That Delécluze was able in 1819 to damn Géricault for his "manière académique" in the *Raft of the Medusa* (Rubin 1985, p. 520) suggests the complexity of positions and expressions in art criticism during the early Restoration, yet to be thoroughly sorted out.

36. Vidal 2000, p. 718 n. 21.

37. Jal 1824, p. 11; cited by Kohle 1991, p. 142.

38. "J'ai pressenti de bonne heure ce qui vous arrive aujourd'hui. Vous avez eu le bon esprit de distinguer le genre d'étude qui vous convenait réellement. Vous l'avez constamment suivi et à présent vous vous en trouvez bien. Vous auriez pu faire comme bien d'autres ce qu'ils appellent l'antique et qui n'est antique que pour eux, ce qui fait que leurs ouvrages n'ont pas de caractère et n'ont point le cachet de l'ouvrage sorti de la main d'un vraiment habile homme. Le genre des Raphaël, des Léonard, etc., en vaut bien d'autres; en traitant nos sujets sacrés, [plutôt] qu'un genre en quelque sorte imaginaire puisque nous n'avons pas les mêmes moeurs et que nous avons une autre religion. Je dis plus, bouchez-vous les oreilles aux propos gigantesques des partisans de l'antique, dont je suis un associé, mon goût dans tous les temps m'y portait naturellement; vous, le vôtre n'est pas inférieur quand on sait le

traiter comme vous." Wildenstein 1973, p. 228, no. 1948: with a significant error ("Je *ne* dis plus . . ."; quoted correctly by B. Chenique in Flers 2000, p. 40).

39. On the painting see A. Schnapper in Paris-Versailles 1989–90, pp. 540–41, no. 234; and McPherson 1991.

40. On the various versions of Schnetz's painting, see Flers 2000, p. 103. Navez had treated the theme in 1821, a four-figure genre scene with Italian brigands, and exhibited his picture in Brussels the following year (Coekelberghs, Jacobs, and Loze 1999, p. 51, fig. 73; private collection). At the Salon of 1812 David's pupil Marie-Guillemine Benoist had exhibited a *Fortune Teller* (Musée des Beaux-Arts, Saintes) that mixes Italian folklore and classical landscape and centers on the love life of the shepherdess. A final variation, which debunks the noble aspirations of all the others, is Louis-Léopold Boilly's grimacing composition, lithographed in 1824.

LATE DRAWINGS: EXPERIMENTS IN EXPRESSION

1. Diderot 1984, p. 14 ("positions académiques"; extracted from his *Essais sur la peinture,* first published in 1795 and again in 1798). The expression by David ("le mauvais style de l'École française") is from an autobiographical text, written around 1808, in Wildenstein 1973, p. 156, no. 1368 (the different date proposed here rests on a reference in the text to Girodet's *Funeral of Atala,* exhibited at the Salon in 1808). Certain ideas developed in the opening section of this essay were initially articulated in Bordes 2004a.

2. For more on this practice and its genealogy, see Bordes 2004a, pp. 124, 128 n. 16.

3. "Le sentiment et le dessin voilà les vrais maîtres pour apprendre à remuer le pinceau. Qu'importe que l'on fasse des hachures à droite, à gauche, de haut en bas, de long en large; pourvu que les lumières soient à leur place, on peindra toujours bien." Letter dated 14 June 1789 (Wildenstein 1973, pp. 27–28, no. 207; facsimile in David 1880, between pp. 622 and 623).

4. "Les cuisses sont trop courtes ou bien il n'a pas de ventre. Le dessin, le dessin, mon ami mille fois le dessin!" Letter to Navez, dated 22 Mar. 1818 (Wildenstein 1973, p. 210, no. 1814). The picture analyzed by David is reproduced in Coekelberghs, Jacobs, and Loze 1999, p. 37.

5. "Nous massons avec du crayon notre figure au fur et à mesure, mais solidement; l'on ne se sert presque pas de tortillons. M. David aime que le dessin soit gras et moelleux, il n'aime pas les petits détails." "M. David n'aime pas que l'on fasse des dessins finis d'après l'antique sur de grandes feuilles, il veut que l'on se serve de livres de croquis; par ce moyen, dit-il, on étudie sans se fatiguer." David "ne veut pas entendre parler de dessins finis." Mesplé 1969, p. 95.

6. [Chaussard] 1806, p. 451 ("le dessin ne sera toujours que la partie froide et inanimée de la peinture"). This is the position Madame Campan attributes to David in 1800 in a letter to Hortense de Beauharnais, who hesitated between taking drawing lessons from Isabey or painting lessons from a pupil of David; she wrote, "celui-là vous dira: ne dessinez pas, cela vous refroidit" (Basily-Callimaki 1909, p. 42).

7. On these two drawings, and for further bibliography, see Prat and Rosenberg 2002, vol. 1, pp. 142–45, nos. 128–29.

8. On the medallion portraits, see Lajer-Burcharth 1999, pp. 89–91; Prat and Rosenberg 2002, vol. 1, pp. 164–73, nos. 147–55.

9. *Nouvelles des arts* 2 (Year XI, 1802–3), p. 103 ("l'extrême fini qu'elles aiment à mettre dans leurs ouvrages"). The author may be the editor, Charles Landon, reputed for his misogynous declarations.

10. For example, he chides the engraver Jean-Louis Potrelle in Apr. 1819 for having wanted to correct his *Cupid and Psyche* (see cat. 32, n. 20). David's relative disinterest for the reproduction of his work until his exile, and the minute attention he then gives to the terms of his contracts with engravers, also suggest a mistrust of the profession.

11. Paris-Versailles 1989–90, p. 548: "un ensemble numériquement assez important et dont l'évidente cohérence stylistique saute aux yeux." Her study (pp. 547–49) is fundamental.

12. Letter to Navez, dated 22 Mar. 1818 (Wildenstein 1973, p. 210, no. 1814).

13. Schnapper in Ixelles 1985–86, pp. 190–91; Prat and Rosenberg 2002, vol. 1, pp. 308–10, nos. 328–31.

14. *Conférences* 1996, p. 507 ("On craint quelquefois d'exprimer trop faiblement, et l'on s'emporte à l'exagération, sans penser que le trop déplaît ordinairement plus que le trop peu").

15. "On aime les coups de théâtre, et quand on ne peint pas des passions violentes, quand on ne pousse pas *l'expression* en peinture jusqu'à la *grimace,* on risque de n'être ni compris ni goûté." Delécluze 1855 [1983], p. 227.

16. See the suggestive remarks on Guérin and "L'esthétique du théâtre" by Régis Michel (1989, pp. 77–78).

17. Guizot 1810 [1852], pp. 24–28.

18. Ibid., pp. 29 ("l'air de véritables possédés"), 32 ("la manie de l'exagération"). In the Salon livret, Pajou's brief quote of Corneille put the focus on the face of Cleopatra: "voyez ses yeux / déjà tout égarés, troublés et furieux, / cette affreuse sueur qui court sur son visage, / cette gorge qui s'enfle, etc."

19. [Chaussard] 1806, pp. 118–20; p. 119: "tous les arts tendent à l'exagération et par conséquent à la corruption." Chaussard's text is quoted in Michel 1989, p. 93. On the popularity of the flaying scene, see Bordes 2004b, pp. 88, 400 n. 36. Chaussard links the demand for strong sensations to "la marche des temps" and "l'influence des images terribles qu'a présenté une grande révolution" (p. 119), like Guizot in 1810 (1852, pp. 38–39).

20. This has often been discussed, perhaps most eloquently by Michel 1989.

21. On Ducreux and Boilly, see Siegfried 1995, pp. 121–31. Although Boilly's compositions with expressive heads are ascribed to the early 1820s, they germinate from his work from around 1804: the "bouquet" of portraits after the *Reunion of Artists in Isabey's Studio,* and the busts in the background of the scenes in Houdon's studio (pp. 102–5). The group of spectators in Monsiau's *Comices de Lyon* (Salon of 1808; Musée national du Château, Versailles) develops the same vein. On Ducreux and the Royal Academy, see Lyon 1958, p. 67. The date of *Le Libéral* and *L'Ultra* engraved after Boilly is furnished by the mention of the first in the *Bibliographie de la France* (8 May 1819, no. 285; see the repertory by George McKee, *Image of France:* http://www.lib.uchicago.edu/efts/ARTFL/projects/mckee/). Even though the Ultra faction was weak at the time, the second image was presumably not submitted to avoid censorship.

22. On Girodet's interest in the theories of Lavater, see Levitine 1954. Etienne Bréton informs me that Boilly painted a portrait of Gall, who arrived in Paris in 1807 (private collection).

23. Johnson 1993a, p. 148. For references attesting to the sustained interest in Leonardo's head studies during the eighteenth century, from Mariette to Watelet and Lévesque, see Wilson 1981, pp. 144–47.

24. Kirchner 1991, pp. 190–229; reproduced are two drawings of *La douleur:* François-Louis Gounod's in 1785 (p. 213) is more dramatic than David's in 1773 (p. 211). Johnson 1993a, pp. 151–52; reproduced (p. 152) are drawings of *La Profonde vénération* by Alexandre-Charles Guillemot (1806) and of *Le Sommeil distrait par un songe agréable* by Charles-Jacques Lebel (1807), both pupils of David.

25. See Lina Propeck in Paris 1988, pp. 7, 22, 83–84, 119. The brochure, compiled by Bernard-Jacques Foubert bore the title: *Recueil de principes élémentaires de peinture sur l'expression des passions, suivi d'un abrégé sur la physionomie et d'un exposé du système nommé physiognomonie extrait des oeuvres de Ch. Le Brun, Winckelmann, Mengs, Watelet, etc., à l'usage des jeunes artistes et destiné à faciliter leurs études au Musée central des arts principalement dans la galerie des dessins.*

26. Lina Propeck, "La Chalcographie impériale: des estampes aux dessins," in Paris 1999–2000, p. 207.

27. On the *Collection de Têtes d'expression,* see *Nouvelles des arts* 2 (Year XI, 1802–3), pp. 102–3, 214–15. On Gault de Saint-Germain's *Des Passions et de leur expression générale et particulière sous le rapport des beaux-arts* (Paris 1804), see Johnson 1993a, pp. 148–50 (the prints after Tassaert [figs. 72, 74, 75] are not for this small volume but for the *Collection*).

28. Johnson 1993a, pp. 145–47. *Notice* 1824, p. 59: "Quelle expression céleste dans l'attitude et surtout dans la tête de Léonidas!"

29. Johnson ventriloquizes contemporary commentary in praising the "brilliance, subtlety, and ineffable quality of Leonidas' expression" (1993a, p. 147).

30. Prat and Rosenberg 2002, vol. 1, p. 201, no. 189.

31. Delécluze 1855 [1983], p. 225 ("Moi, je veux donner à cette scène quelque chose de plus grave, de plus réfléchi, de plus religieux"). The same text introduces two other religious metaphors to characterize Leonidas, but as mentioned, this was an interpretation forwarded by Delécluze, found neither in the *Explication* of 1814 (Paris-Versailles 1989–90, p. 486) nor in the *Notice* of 1824.

32. Kirchner 1991, pp. 124–25, 148 (quote: "Je lui fais lever les yeux vers le ciel, comme étant à la fois prêtre et victime"), 152–53, 155.

33. In a letter to a comrade written in Oct. 1821 from Rome, Navez reports that Victor Schnetz declared that Gérard's picture "était d'un français épouvantable, et que toute l'école à présent court après cela" (Coekelberghs, Jacobs, and Loze 1999, p. 52). David was most hostile toward his former pupil, who had become first painter to Louis XVIII: "il ne peut douter pour tant de petits tours perfides qu'il m'a joué depuis que l'ambition le tourmente, il ne peut pas douter, dis-je, qu'il est impossible à moins d'être un imbécile, que j'aie de l'estime pour lui" (Getty Research Institute, Los Angeles, 850444 [fol. 3], undated

letter to Odevaere, c. 1816–17; Gérard's identity is deduced on the basis of internal evidence). David would have discovered his *Henri IV* through the line-engraving in Landon's *Salon of 1817* or through the *petite copie* edited in 1818.

34. Bordes 2004a, pp. 123–24.

35. Prat and Rosenberg observe that sexual ambiguity is a characteristic of these drawings (2002, vol. 1, p. 327), but this may reflect our unfamiliarity with David's visual codes rather than artistic intention.

36. Guizot 1810 [1852], p. 29.

37. Girodet's illustration of the *Death of Phaedra* was for Pierre Didot's edition of Racine published from 1801 to 1804; the drawing in the Horvitz collection is discussed by Sylvain Bellenger in Cambridge 1998–2000, pp. 334–37, no. 109. See also the penetrating analysis of the composition by Michel (1989, pp. 93–95). Girodet's five drawings for Didot were exhibited at the Salon of 1804. Whereas his expiring Phaedra might appear to critically paraphrase David's *Marat,* from 1815 David repeatedly drew a figure that might seem to derive from Girodet's heroine (cat. 44; see also Prat and Rosenberg 2002, vol. 1, pp. 305 [no. 322], 327 [no. 353], 353 [no. 395]).

38. *Nouvelles des arts* 2 (Year XI, 1802–3), p. 157 ("Cet ouvrage fera faire des tableaux"). The article announces the publication of the *Odyssey* around Mar. 1803; the *Iliad* and the *Tragedies of Aeschylus* were forthcoming. The description makes an implicit reference to vase painting: "On retrouve dans ses compositions la naïveté du style étrusque, réunis aux formes grandes et simples du beau style grec."

39. Michel 1989, p. 127: "La Grèce n'y est qu'une forme vide. Un pur formalisme—on devrait dire: *fetichisme.*" He refers here to late Ingres and mid-nineteenth-century neo-hellenism (pp. 144–47), but its application to Davidian hellenism around 1820 seems pertinent. The notion of visual sign raises the question of David's familiarity with the ideas of David Pierre Humbert de Superville, head of the drawing academy in Leiden since 1814, who published his theory of expression only in 1827.

40. "Les choses du 14ᵉ et 15ᵉ siècle l'avaient entièrement captivé." "J'ai une estampe d'après Beato di Fiesole [Fra Angelico] sur laquelle il a écrit ces mots: je ne connais rien de plus sublime après les grecs que cette peinture, c'est le seul style à suivre aux peintres modernes." Coekelberghs, Jacobs, and Loze 1999, p. 9 n. 8.

41. Monica Preti Hamard in Paris 1999–2000, pp. 226–53. On Fra Angelico, see p. 234 n. 60.

42. Guizot 1810 [1852], p. 13. In 1802 the painter Joseph Farington wrote of the *Sabines:* "I never saw a Composition in which the art of arranging was less concealed" (see cat. 14). Michael Fried has noted this radicalization in the late drawings: "A nos yeux, les dessins de Bruxelles sacrifient toute cohérence et intelligibilité dramatiques—comme s'ils délaissaient ces notions perçues comme irrémédiablement théâtrales—dans une tentative de préserver, ne serait-ce que de manière ténue, l'expression et l'absorbement en tant que tels" (1993, p. 227 n. 42).

PORTRAITS IN EXILE

1. Luzzatto 1991.

2. On this portrait, whose location is unknown, see A. Schnapper in Paris-Versailles 1989–90, p. 376, fig. 95. For the contract with Delahaye, signed on 16 Jan. 1816, see Wildenstein 1973, p. 201, no. 1758.

3. "[J]e ne donne pas un coup de pinceau sans me pénétrer de l'idée que j'illustre ma patrie" (Getty Research Institute, Los Angeles, 870334, David to Auguste de Forbin, 25 Aug. 1824).

4. Wildenstein 1973, pp. 209 (no. 1812; to Odevaere), 212 (no. 1839), 215 (no. 1855), 219 (no. 1877; the last three to Gros).

5. David's two letters to Juliette Récamier, 20 Aug. and 14 Sept. 1818, are partially cited by E. Agius-d'Yvoire in Paris-Versailles 1989–90, p. 624 (quoted passages from the second letter: "un monument élevé à la mémoire de cette femme célèbre"; "un bon portrait de cette illustre dame pour en faire la principale figure du tableau"). The contents of the lost letter addressed initially by Juliette to David can be deduced from the one addressed by Augustus of Prussia to Gérard, 6 Apr. 1819 (Gérard 1888, vol. 2, pp. 202–3).

6. The most famous disattributed portrait is the so-called *Three Ladies of Ghent (Isabelle-Rose Morel de Tangry and Her Daughters)* (fig. 101); see A. Schnapper in Ixelles 1985–86, p. 422, no. 416. Probably dating from around 1817–20, it is a dry exercise, except for the faces and certain broad areas of the two hats, by another hand. Although close in spirit to the art of Navez (cf. *Madame Dupret,* 1816, Musée des Beaux-Arts, Charleroi; reproduced by Bordes 2001b, p. 52), it lacks his brilliant and easy manner. Another is the portrait of Wolf alias Bernard, the director of the theater in Brussels (Musée du Louvre); see Schnapper in Ixelles 1985–86, p. 421, no. 415. It is an unimaginative imitation of David's three-quarter length portraits from the 1790s, in very bad condition. When Bernard exhibited the portrait in his theater as an original by David in

1823, the latter did not protest, so he may have given it a few brush strokes. As his dealings with Schönborn reveal (see cat. 35), he was not averse to mixing his brush with that of pupils and assistants. In this case, a newspaper article in 1826 indicated that the author was Sophie Frémiet, who by then had married the sculptor François Rude. Among the other portraits at one time ascribed to David's Brussels production, the most intriguing are identified as *Mademoiselle Lucie de la Vault,* claimed to be signed and dated 1820 (Trévise Sale, Sotheby's, London, 9 July 1936, no. 100), perhaps the closest in spirit; *Madame Sauveur* (reproduced by Fierens 1926, p. 110), too stiffly posed and draped; *Madame Hermans, née Philippront,* a dressmaker's dream (reproduced in *Les Arts* 13 [Jan. 1913], p. 23); to these can be added an unidentified woman in the museum of Boulogne-sur-Mer, reportedly signed and dated 1825 (reproduced in *Musées de France* 9 [Nov. 1935], p. 153), which, judging from a photograph, is too tightly painted to be by David, and perhaps is by Charles-Pierre Verhulst (Rosenberg 1986, p. 923).

THE IMAGE OF THE ARTIST

1. "Que je voudrais pouvoir parler à fond ici de mon art, mais ceux qui vous ressemblent sont rares, j'en excepte cependant M. Odevaere, mon élève. C'est un homme très instruit, très initié dans la marche des anciens, ses ouvrages faits depuis mon arrivée en Belgique en font foi. Aussi n'y a-t-il que lui avec qui je puisse parler." David to Paillot de Montabert, 24 Oct. 1820 (Paris, Bibliothèque nationale de France, Additional MS 29776, fol. 42; brought to my attention by Mark Ledbury).

2. "Tu sauras que Odevaere a fait le portrait de Mr David dans son atelier et l'a fait graver par Jazet. Celui-ci trouva le dessin si mauvais qu'il demanda un prix excessif pour s'en débarrasser n'osant pas le refuser à cause du personnage qu'il représentait, cela n'arrêta pas Odevaere et la gravure fut faite. C'est tellement mauvais que tout le monde est en peine pour Mr David." Navez to Leopold Robert, 18 July 1822 (Neuchâtel, Bibliothèque de la Ville, MS 1408, fols. 11–12). Partially cited by E. Agius-d'Yvoire in Paris-Versailles 1989–90, p. 628. Jazet registered the print with the *Bibliographie de la France* on 1 June 1822 (no. 335) (according to the repertory by George McKee, *Image of France:* http://www. lib.uchicago.edu/efts/ARTFL/projects/mckee/).

3. The double rein without a nose piece identifies this version as no. 5, effectively in David's possession at the time (see cat. 4).

4. See the essay "In the Service of Napoleon," n. 38.

5. Prat and Rosenberg 2002, vol. 1, pp. 314–16 (nos. 336–38), 332 (no. 358).

6. On Jazet's two other prints, see the letter from Navez to Robert, cited n. 2; Bordes 1983, pp. 234–36 (for the *Oath of the Tennis Court*); Saunier 1919 (for the *Coronation*).

BIBLIOGRAPHY

ABBREVIATIONS

AB The Art Bulletin

BM The Burlington Magazine

BSHAF Bulletin de la Société de l'Histoire de l'Art français

CD Collection Deloynes (Paris, Bibliothèque nationale de France, Département des Estampes et de la Photographie)

GBA Gazette des Beaux-Arts

Journal des arts Journal des arts, de littérature et de commerce. no. 1 (c. 5 Thermidor Year VII)–no. 32 (Nivôse Year VIII); *Journal des arts, des sciences et de littérature.* from no. 33 (15 Nivôse Year VIII)

RA Revue de l'Art

RL La Revue du Louvre et des Musées de France

WORKS CITED

ACCOUNT 1822
Account of the Celebrated Picture of the Coronation of Napoleon, by M. David First Painter to the Emperor. London, 1822.

ADAMS 1977–78
Adams, Brooks. "Painter to Patron: David's Letters to Youssoupoff about the *Sappho, Phaon and Cupid.*" *Marsyas* 19 (1977–78): 29–36.

ALBI 1969
Musée Toulouse-Lautrec. *Chefs-d'oeuvre du Musée Jacquemart-André, XV^e au XVIII^e siècle.* Exh. cat. Albi, 1969.

ALBRIZZI 1822
Albrizzi, Isabella. *Opere di scultura e di plastica di Antonio Canova descritte da Isabella Albrizzi, nata Teotochi.* Pisa, 1822.

ALGIERS 1955
Musée National des Beaux-Arts. *Dessins de l'École française appartenant au Musée du Louvre.* Exh. cat. Algiers, 1955.

ALLEN 2001
Allen, Elizabeth. "David and Michelangelo." *Apollo* (June 2001): 18–19.

ANGRAND 1972
Angrand, Pierre. *Le Comte de Forbin et le Louvre en 1819.* Paris, 1972.

ATHANASSOGLOU-KALLMYER 1989
Athanassoglou-Kallmyer, Nina Maria. *French Images from the Greek War of Independence 1821–1830.* New Haven and London, 1989.

ATHANASSOGLOU-KALLMYER 1991
Athanassoglou-Kallmyer, Nina Maria. *Eugène Delacroix: Prints, Politics and Satire, 1814–1822.* New Haven and London, 1991.

ATHENS 1979
National Pinakothiki, Alexander Soutzos Museum. *Treasures from the Metropolitan Museum of Art, New York: Memories and Revivals of the Classical Spirit.* Exh. cat. Athens, 1979.

AULARD 1903–6
Aulard, Alphonse. *Paris sous le Consulat, recueil de documents pour l'histoire de l'esprit public à Paris.* 3 vols. Paris, 1903–6.

BACZKO 1989
Baczko, Bronislaw. *Comment sortir de la Terreur. Thermidor et la Revolution.* Paris, 1989. English ed., 1994.

BAILEY 1984
Bailey, Colin B. "Le Brun et le commerce d'art pendant le Blocus Continental." *RA* 63 (1984): 35–46.

BALTIMORE 1900
The Peabody Institute, Gallery of Art. *The Peabody Institute, Gallery of Art: List of Works on Exhibition.* Baltimore, 1900 (rev. ed., 1910).

BALTIMORE 1934–35
The Baltimore Museum of Art. *A Survey of French Painting.* Exh. cat. Baltimore, 1934–35.

BASCHET 1948
Baschet, Robert. *Journal de Delécluze 1824–1828.* Paris, 1948.

BASILY-CALLIMAKI 1909
Basily-Callimaki, [Madame de]. *Jean-Baptiste Isabey, sa vie, son temps, 1767–1855.* Paris, 1909.

BAST 1823
Bast, Liévin Armand Marie de. *Annales du Salon de Gand et de l'école moderne des Pays-Bas. Recueil de morceaux choisis.* Ghent, 1823.

BATICLE 1988
Baticle, Jeannine. "La Seconde mort de Lepeletier de Saint-Fargeau. Recherches sur le sort du tableau de David." *BSHAF* (1988): 131–45.

BEAN 1964
Bean, Jacob. "A Propos du *Léonidas aux Thermopyles* de David. I. Un dessin inédit au Metropolitan Museum." *RL* 6 (1964): 327–29.

BEAN AND TURČIĆ 1986
Bean, Jacob, and Lawrence Turčić. *15th–18th Century French Drawings in the Metropolitan Museum of Art.* New York, 1986.

BECQ 1986
Becq, Annie. "Esthétique et politique sous le Consulat et l'Empire." *Romantisme* 51 (1986): 23–37.

BECQ 1994
Becq, Annie. *Genèse de l'esthétique française moderne 1680–1914.* Paris, 1984. Reprint, 1994.

BENOIT 1897 [1975]
Benoit, François. *L'Art français sous la Révolution et l'Empire. Les doctrines, les idées, les genres.* Paris, 1897. Reprint, Geneva, 1975.

BENOÎT 1986
Benoît, Jérémie. "Un Chef-d'oeuvre oublié: *Les Remords d'Oreste* par Ph.-A. Hennequin." *RL* 3 (1986): 202–9.

BERESINA 1983
Beresina, V. *La Peinture française. Première moitié et milieu du XIX^e siècle. Musée de l'Ermitage. Catalogue raisonné.* Leningrad [St. Petersburg], 1983.

BERGERON 1972
Bergeron, Louis. *L'Episode Napoléonien. Aspects intérieurs, 1799–1815.* Paris, 1972.

BERLIN 1964
Schloss Charlottenburg. *Meisterwerke aus dem Museum in Lille.* Exh. cat. Berlin, 1964.

BERN 1948
Musée des Beaux-Arts. *Dessins français du Musée du Louvre.* Exh. cat. Bern, 1948.

BERTHOD 2000
Berthod, Bernard. "David n'était pas un enfant de choeur ou les incohérences liturgiques du Sacre de Napoléon I^er peint par David." *Revue de l'Institut Napoléon* 181 (2000): 9–20.

BERTIN 1893
Bertin, Georges. *1815–1832. Joseph Bonaparte en Amérique.* Paris, 1893.

BLANC 1845
Blanc, Charles. *Histoire des peintres français au dix-neuvième siècle.* Paris, 1845.

BLANC [1849–76]
Blanc, Charles. "École française. Louis David." *Histoire des peintres de toutes les écoles depuis la renaissance jusqu'à nos jours.* [Fascicle publication, 16 pp. with printed cover.] Paris, 1849–76.

BLANC 1857–58
Blanc, Charles. *Le Trésor de la curiosité, tiré des catalogues de vente.* 2 vols. Paris, 1857–58.

BLEYL 1982
Bleyl, Matthias. *Das klassizistische Porträt. Gestaltungsanalyse am Beispiel J.-L. Davids.* Frankfurt am Main and Bern, 1982.

BONNAIRE 1937–43
Bonnaire, Marcel, ed. *Procès-verbaux de l'Académie des beaux-arts (1795–1810)*. 3 vols. Paris, 1937–43.

BORDEAUX 1989
Le Leyzour, Philippe, ed. *Le Port des Lumières. La peinture à Bordeaux 1750–1800.* Exh. cat. Bordeaux: Musée des Beaux-Arts, 1989.

BORDES 1976 [1978]
Bordes, Philippe. "Documents inédits sur Topino-Lebrun." *BSHAF* (1976 [1978]): 289–300.

BORDES 1983
Bordes, Philippe. *Le Serment du Jeu de Paume de Jacques-Louis David. Le peintre, son milieu et son temps de 1789 à 1792.* Paris, 1983.

BORDES 1986
Bordes, Philippe. "*La Patrie en danger* par Lethière et l'esprit militaire." *RL* 4–5 (1986): 301–6.

BORDES 1988
Bordes, Philippe. *David.* Paris, 1988.

BORDES 1989
Bordes, Philippe. "David's Contemporaries: A Generation of Artists Against the Revolution?" In *Culture and Revolution*, ed. G. Levitine, 60–68. College Park (Maryland), 1989.

BORDES 1992
Bordes, Philippe. "Jacques-Louis David's Anglophilia on the Eve of the French Revolution." *BM* 134, no. 1073 (Aug. 1992): 482–90.

BORDES 1994
Bordes, Philippe. "*Jacques-Louis David: Art in Metamorphosis* by Dorothy Johnson." *BM* 136, no. 1095 (June 1994): 387–88.

BORDES 1996
Bordes, Philippe. "*La Mort de Brutus*" par Pierre-Narcisse Guérin. Vizille, 1996.

BORDES 1997
Bordes, Philippe. "*L'écurie dont je ne sortirai que cousu d'or*: Painters and Printmaking from David to Géricault." In *Théodore Géricault. The Alien Body: Tradition in Chaos*, ed. S. Guilbaut, M. Ryan, and S. Watson, 114–30. Exh. cat. Vancouver: Morris and Helen Belkin Art Gallery, The University of British Columbia, 1997.

BORDES 2000A
Bordes, Philippe. "Eine Werther-Illustration von Antoine-Jean Gros." In *Jenseits der Grenzen. Französische und deutsche Kunst vom Ancien Régime bis zur Gegenwart. Thomas Gaehtgens zum 60. Geburtstag*, ed. U. Fleckner, M. Schieder, and M. Zimmermann, 1:290–301. Cologne, 2000.

BORDES 2000B
Bordes, Philippe. "David's Portrait of Comte de Turenne at Williamstown." *BM* 142, no. 1166 (May 2000): 276–80.

BORDES 2001A
Bordes, Philippe. "Un Graveur disponible, Jacques-Louis Copia." In *Pierre-Paul Prud'hon*, ed. Sylvain Laveissière, 105–27. Paris, 2001.

BORDES 2001B
Bordes, Philippe. "Navez." *Apollo* 154, no. 477 (Nov. 2001): 52–53.

BORDES 2004A
Bordes, Philippe. "Le Catalogue des dessins de David, par P. Rosenberg et L.-A. Prat." *RA* 143, no. 1 (2004): 121–28.

BORDES 2004B
Bordes, Philippe. "Le Musée Napoléon." In *L'Empire des muses. Napoléon, les arts et les lettres*, ed. Jean-Claude Bonnet, 79–89, 397–400. Paris, 2004.

BORDES AND CHEVALIER 1996
Bordes, Philippe, and Alain Chevalier. *Catalogue des peintures, sculptures et dessins. Musée de la Révolution française.* Vizille, 1996.

BORDES AND MICHEL 1988
Bordes, Philippe, and Régis Michel, eds. *Aux Armes et aux arts! Les arts de la Révolution 1789–1799.* Paris, 1988.

BORDES AND POUGETOUX 1983
Bordes, Philippe, and Alain Pougetoux. "Les Portraits de Napoléon en Habits impériaux par Jacques-Louis David." *GBA* 102 (July–Aug. 1983): 21–34.

BOROWITZ 1980A
Borowitz, Helen O. "The Man Who Wrote to David." *Bulletin of the Cleveland Museum of Art* 67 (Oct. 1980): 256–74.

BOROWITZ 1980B
Borowitz, Helen O. "Critique and Canard: Henri de Latouche at the Salon of 1817." *GBA* 96 (Sept. 1980): 63–74.

BOTHMER 1964
Bothmer, Dietrich von. "A Propos du *Leonidas aux Thermopyles* de David. II. Les Sources classiques de l'oeuvre." *RL* 6 (1964): 327–32.

BOTT 1989
Bott, Katarina. "Franz Erwein Graf von Schönborn, Kunstsammler zwischen Klassizismus und Romantik." In *Die Grafen von Schönborn, Kirchenfürsten, Sammler, Mäzene*, 173–79, 535–36. Nuremberg, 1989.

BOTT 1993
Bott, Katharina. *Ein Deutscher Kunstsammler zu Beginn des 19. Jahrhunderts. Franz Erwein von Schönborn, 1776–1840.* Alfter, 1993.

BOTTINEAU 1986
Bottineau, Yves. *L'Art de cour dans l'Espagne des Lumières. 1746–1808.* Paris, 1986.

BOUTARD 1807
Boutard, Marie. "De l'ancienne académie de peinture et de sculpture." *Journal de l'Empire*, (23 Apr. 1807): 2–4, (25 Apr. 1807): 1–4. Manuscript copy, *CD* 54, no. 1650.

BOYER 1925
Boyer, Ferdinand. "Le Musée napoléonien du comte J. N. Primoli." *Revue des études napoléoniennes* (March–April 1925): 171–82.

BOYER 1941–44 [1947]
Boyer, Ferdinand. "L'Installation du Premier Consul aux Tuileries et la disgrâce de l'architecte Leconte [1800–1801]." *BSHAF* (1941–44 [1947]): 142–84.

BOYER 1969
Boyer, Ferdinand. *Le Monde des arts en Italie et la France de la Révolution et de l'Empire. Études et recherches.* Turin, 1969.

BRAMSEN 1947
Bramsen, Henrik, ed. *C. W. Eckersberg Dagbog og Breve. Paris 1810–1813.* Copenhagen, 1947.

BRAUN 1820
Braun, Georg Christian. "Gemälde im Besitz des Grafen von Schönborn zu Reichardtshausen am Rhein." *Kunst-Blatt* (supplement to the *Morgenblatt für gebildete Leser*) 49 (19 June 1820): 193–94.

BRIÈRE 1947
Brière, Gaston. "Sur un dessin de David." *Arts* 124 (18 July 1947): 1.

BRIÈRE 1948
Brière, Gaston. "Les Deux 'Couronnements' par Louis David." *Le Dessin* 13 (Mar. 1948): 110–23.

BROOKNER 1958
Brookner, Anita. "Aspects of Neo-classicism in French Painting." *Apollo* (Dec. 1958): 67–73.

BROOKNER 1980
Brookner, Anita. *Jacques-Louis David.* London, 1980.

BRUSSELS 1889
Musées royaux des Beaux-Arts. *Portraits du siècle, 1789–1889.* Exh. cat. Brussels, 1889.

BRUSSELS 1925–26
Musées royaux des Beaux-Arts. *David et son temps.* Exh. cat. Brussels, 1925–26.

BRUUN NEERGAARD 1801
Bruun Neergaard, Tønnes Christian. *Sur la Situation des beaux–arts en France ou lettres d'un danois à un ami*. Paris, Year IX–1801.

BUCHAREST 1931
Museul Toma Stelian. *Desenul Francez*. Exh. cat. Bucharest, 1931.

BURNEY 1975
The Journals and Letters of Fanny Burney (Madame d'Arblay), VI (France 1803–1812). Ed. Joyce Hemlow et al. Oxford, 1975.

BURTY 1859
Burty, Philippe. "Mouvement des arts et de la curiosité: Ventes." *GBA* (Feb 1859): 183–88.

CABANIS 1970
Cabanis, José. *Le Sacre de Napoléon*. Paris, 1970.

CAILLEUX 1963
Cailleux 1912–1962 (Jubilee Album of the Galerie Cailleux). Paris, 1963.

CALAIS 1975–76
Trésors des Musées du Nord de la France. II. Peinture française 1770–1830. Exh. cat. Calais: Musée des Beaux-Arts; Arras: Musée des Beaux-Arts; Douai: Musée de la Chartreuse; and Lille: Musée des Beaux-Arts, 1975–76.

CALVET-SÉRULLAZ 1969
Calvet-Sérullaz, Arlette. "Un Album de croquis inédits de Jacques-Louis David." *RA* 5 (1969): 65–68.

CAMBRIDGE 1998–2000
Clark, Alvin L., ed. *Mastery & Elegance: Two Centuries of French Drawings from the Collection of Jeffrey E. Horvitz*. Exh. cat. Cambridge: Harvard University Art Museums; Toronto: Art Gallery of Ontario; Paris: Musée Jacquemart-André; Edinburgh: National Gallery of Scotland; New York: National Academy Museum and School of Fine Arts; Los Angeles: Los Angeles County Museum of Art, 1998–2000.

CANBERRA 1992–93
Rembrandt to Renoir: 300 Years of European Masterpieces from the Fine Arts Museums of San Francisco. Exh. cat. Canberra: Australian National Gallery; Melbourne: National Gallery of Victoria; Auckland: City Art Gallery, 1992–93.

CANTALOUBE 1860
Cantaloube, A. "Les dessins de Louis David." *GBA* 6 (Sept. 1860): 284–303.

CANTAREL-BESSON AND CONSTANS 2001
Cantarel-Besson, Yveline, and Claire Constans. *Napoléon. Images et Histoire. Peintures du Château de Versailles (1789–1815)*. Paris, 2001.

CANTINELLI 1930
Cantinelli, Richard. *Jacques-Louis David, 1748–1825*. Paris and Brussels, 1930.

CAPON 1986
Capon, Laura. *Il Museo Napoleonico*. Rome, 1986.

CARR 1807
Carr, John. *The Stranger in France, or A Tour from Devonshire to Paris*. London, 1807. First ed., 1803.

CARROLL 1990
Carroll, S. "Reciprocal Representations: David and Theatre." *Art in America* 78, no. 5 (May 1990): 198–207, 259–61.

CASSOU 1951
Cassou, Jean. "David, Auteur Tragique." *La Revue des arts* 1 (1951): 37–43.

CAVICCHIOLI 2002
Cavicchioli, Sonia. *Le Metamorfosi di Psiche. L'iconografia della Favola di Apuleio*. Venice, 2002.

[CHAPERON] 1788
P. R. C. [Paul-Romain Chaperon]. *Traité de la peinture au pastel*. Paris, 1788.

CHARLEROI 1959
Palais des Beaux-Arts, *Fragonard, David, Navez*. Exh. cat. Charleroi, 1957.

CHAUDONNERET 1998
Chaudonneret, Marie-Claude. "Thiers, critique d'art." *Revue des Sciences morales et politiques* [special issue: "Thiers, collectionneur et amateur d'art"] (1998): 93–106.

CHAUDONNERET 1999
Chaudonneret, Marie-Claude. *L'État et les artistes. De la Restauration à la Monarchie de Juillet (1815–1833)*. Paris, 1999.

CHAUSSARD 1798
Chaussard, Pierre-Jean-Baptiste. *Essai philosophique sur la dignité des arts*. Paris, 1798.

[CHAUSSARD] 1806
[Chaussard, Pierre-Jean-Baptiste.] *Le Pausanias français: État des Arts du dessin en France, à l'ouverture du XIXᵉ siècle: Salon de 1806*. Paris, 1806.

CHESNEAU 1864
Chesneau, Ernest. *Les Chefs d'école*. Paris, 1864. First ed., 1862.

CHOMPRÉ 1778
Chompré, Pierre. *Dictionnaire abrégé de la fable, pour l'intelligence des poëtes, des tableaux & des statues, dont les sujets sont tirés de l'histoire poëtique*. 12th ed. Paris, 1778. Rev. ed., A.-L. Millin, Paris, 1801.

CLARK 1994
Clark, Timothy J. "*Gross David with Swoln Cheek*: An Essay on Self-Portaiture." In *Rediscovering History: Culture, Politics and Psyche*, ed. Michael S. Roth, 243–93. Stanford, 1994.

CLEVELAND 1964
Hawley, Henry, ed. *Neo-Classicism: Style and Motif*. Exh. cat. Cleveland: The Cleveland Museum of Art, 1964.

COEKELBERGHS 2000
Coekelberghs, Denis. "Jacques-Louis David à Bruxelles." In *Bruxelles, carrefour de cultures*, ed. Robert Hoozee, 45–52. Antwerp, 2000.

COEKELBERGHS AND LOZE 1993
Coekelberghs, Denis, and Pierre Loze. "David à Bruxelles et la peinture en Belgique." In *David contre David*, 2:1047–66. Paris, 1993.

COEKELBERGHS, JACOBS, AND LOZE 1999
Coekelberghs, Denis, Alain Jacobs, and Pierre Loze. *François-Joseph Navez (Charleroi 1787–Bruxelles 1869). La nostalgie de l'Italie*. Ghent, 1999.

COLOGNE 1987–88
Mai, Ekkehard, and Anke Repp-Eckert, eds. *Triumph und Tod des Helden. Europäische Hostorienmalerei von Rubens bis Manet*. Exh. cat. Cologne: Wallraf-Richartz Museum, and Zurich: Kunsthaus, 1987–88. (*See also* Lyons 1988)

CONFÉRENCES 1996
Mérot, Alain, ed. *Les Conférences de l'Académie Royale de Peinture et de Sculpture au XVIIᵉ siècle*. Paris, 1996.

CONNELLY 1968
Connelly, Owen. *The Gentle Bonaparte: A Biography of Joseph, Napoleon's Elder Brother*. New York, 1968.

CONSTANT 1830
Constant [Louis-Constant Wairy]. *Mémoires de Constant, Premier valet de chambre, sur la vie privée de Napoléon, sa famille et sa cour*. 6 vols. Paris, 1830.

COOPER 1948A
Cooper, Douglas. "Jacques-Louis David: A Bi-Centenary Exhibition." *BM* 90 (Oct. 1948): 277–80.

COOPER 1948B
Cooper, Douglas. "David and the Neo-Classic Style." *The Listener* 23 (Dec. 1948): 963–64.

COOPER 1949A
Cooper, Douglas. "The David Exhibition at the Tate Gallery." *BM* 91 (Jan. 1949): 20–22.

COOPER 1949B
Cooper, Douglas. "Letters: Jacques-Louis David." *BM* 91 (June 1949): 175–76.

COPENHAGEN 1914
Royal Museum. *Exposition d'art français du XIX^e
siècle*. Exh. cat. Copenhagen, 1914.

COPENHAGEN 1945
Ny Carlsberg Glyptotek. *Fransk Kunst, Malerei og
Skulptur fra det 19 og 20. århundrede*. Exh. cat. Copen-
hagen, 1945.

COPENHAGEN 1960
Ny Carlsberg Glyptotek. *Portraits français de
Largillière à Manet*. Exh. cat. Copenhagen, 1960.

CORNELISSEN 1818
Cornelissen, Egide Norbert. "Eucharis et Télé-
maque." *Annales belgiques des sciences, arts et littéra-
tures* 1 (1818): 383–93; 2:23–34. Offprint, 1818.

COUPIN 1827
Coupin, Pierre-Alexandre. *Essai sur J.-L. David, pein-
tre d'histoire, ancien membre de l'Institut, officier de la
Légion d'honneur*. Paris, 1827.

COUPIN 1829
Coupin, Pierre-Alexandre. *Oeuvres posthumes de
Girodet-Trioson, peintre d'histoire*. 2 vols. Paris, 1829.

CROW 1985
Crow, Thomas. *Painters and Public Life in Eighteenth-
Century Paris*. New Haven and London, 1985.

CROW 1995
Crow, Thomas. *Emulation: Making Artists for Revolu-
tionary France*. New Haven and London, 1995.

CROW 2001
Crow, Thomas. "Ingres and David." *Apollo* 154 (June
2001): 11–17.

CUZIN 1997
Cuzin, Jean-Pierre. "Le Centenaire de la Société des
Amis du Louvre et le don au musée d'un chef-d'oeu-
vre de David, le portrait de *Juliette de Villeneuve*." *RL*
2 (1997): 13–15.

DAVID 1867
David[-Chassagnolle], Louis-Jules. *Notice sur le
Marat de Louis David suivie de la liste de ses tableaux
dressée par lui-même*. Paris, 1867.

DAVID 1880
David[-Chassagnolle], Louis-Jules. *Le peintre Louis
David, 1748–1825, souvenirs et documents inédits*. Paris,
1880.

DAVID 1882
David[-Chassagnolle], Louis-Jules. *Le peintre Louis
David, 1748–1825, suite d'eaux-fortes d'après ses
oeuvres*. Paris, 1882.

DAVID CONTRE DAVID 1993
Michel, Régis, ed. *David contre David*. [Proceedings
of a conference at the Musée du Louvre, 1989.] 2 vols.
Paris, 1993.

DAVIDSON AND MUNHALL 1968
Davidson, Bernice, and Edgar Munhall. *The Frick
Collection: An Illustrated Catalogue*. Vol. 2, *Paintings:
French, Italian and Spanish*. New York, 1968.

DAY-HICKMAN 1999
Day-Hickman, Barbara Ann. *Napoleonic Art: Nation-
alism and the Spirit of Rebellion in France (1815–1848)*.
Newark (Delaware) and London, 1999.

DAYOT 1895
Dayot, Armand. *Napoléon raconté par l'image, d'après
les graveurs, les sculpteurs et les peintres*. Paris, 1895.

DAYOT [1896–97]
Dayot, Armand. *La Révolution française; Constituante,
Législative, Convention, Directoire, d'après des pein-
tures, sculptures, gravures, médailles objets du temps*.
Paris, n.d. [1896–97].

DELÉCLUZE 1855 [1983]
Delécluze, Étienne-Jean. *Louis David, son école et
son temps. Souvenirs*. 1855. Annotated reprint, ed.
Jean-Pierre Mouilleseaux. Paris, 1983.

DELESTRE 1867
Delestre, Jean-Baptiste. *Gros, sa vie et ses ouvrages*.
2nd rev. ed. Paris, 1867.

DELON 1997
Delon, Michel, ed. *Dictionnaire européen des
Lumières*. Paris, 1997.

DENON 1999
*Vivant Denon, Directeur des Musées sous le Consulat et
l'Empire. Correspondance (1802–1815)*. Ed. Marie-Anne
Dupuy, Isabelle Le Masne de Chermont, and Elaine
Williamson. 2 vols. Paris, 1999.

DENTON 1998
Denton, Margaret Field. "A Woman's Place: The
Gendering of Genres in Post-Revolutionary French
Painting." *Art History* 21, no. 2 (June 1998): 219–46.

DENVER 1978–79
Denver Art Museum. *Masterpieces of French Art: The
Fine Arts Museums of San Francisco*. Exh. cat. Denver:
Denver Art Museum; New York: Wildenstein & Co.;
and Minneapolis: The Minneapolis Institute of Arts,
1978–79.

DENVER 1982
Denver Art Museum. *French and Italian Master
Drawings from the Collection of Esmond Bradley
Martin Jr*. Exh. cat. Denver, 1982.

DIDBIN 1821
Didbin, Thomas F. *A Bibliographical, Antiquarian,
and Picturesque Tour in France and Germany*. 3 vols.
London, 1821.

DIDEROT 1984
Diderot, Denis. *Essais sur la peinture. Salons de 1759,
1761, 1763*. Ed. Gita May and Jacques Chouillet. Paris,
1984.

DIDOT 1855–66
Firmin Didot Fréres, ed. *Nouvelle Biographie générale*.
46 vols. 1855–66.

DIEU 1985
Dieu, Jean. *Le Séjour à Bruxelles de Jacques-Louis
David (1816–1825) et son influence sur l'école belge*.
Unpublished mémoire de licence, Université libre de
Bruxelles. Brussels, 1985. Photocopy in the J. Paul
Getty Museum files.

DIEU 1991
Dieu, Jean. "La Période belge de Jacques-Louis David
(1816–1825). Le grand genre en six tableaux." *Revue
belge d'archéologie et d'histoire de l'art* 60 (1991):
69–98.

DIJON 1955
Musée des Beaux-Arts. *François Rude 1784–1855*. Exh.
cat. Dijon, 1955.

DIJON 1982–83
Georgel, Pierre, and Lecoq, Anne-Marie, eds. *La
Peinture dans la peinture*. Exh. cat. Dijon: Musée des
Beaux-Arts, 1982–83.

DORBEC 1907
Dorbec, Prosper. "David Portraitiste." *GBA* 37 (Apr.
1907): 306–30.

DOWD 1948
Dowd, David L. *Pageant-Master of the Republic:
Jacques-Louis David and the French Revolution*.
Lincoln, Nebr., 1948.

DOWD 1955
Dowd, David L. "Louis David et le gouvernement des
Pays-Bas. Documents inédits sur le second 'Sacre de
Napoléon.'" *BSHAF* (1955 [1956]): 143–59.

DROZ 1815
Droz, Joseph-François-Xavier. *Études sur le beau dans
les arts*. Paris, 1815.

DUCOUREAU 1988
Ducoureau, Vincent. *Le Musée Bonnat à Bayonne*.
Paris, 1988.

DURYE 1970
Durye, Pierre. "Les Chevaliers dans la noblesse impériale." *Revue d'Histoire moderne et contemporaine* 17 (July–Sept. 1970): 671–79.

DUSSIEUX 1876
Dussieux, Louis-Étienne. *Les Artistes français à l'étranger.* 3rd rev. ed. Paris, 1876.

EDINBURGH 1985
Royal Scottish Museum. *French Connections: Scotland and the Art of France.* Exh. cat. Edinburgh, 1985.

EISLER 1977
Eisler, Colin. *Paintings from the Samuel H. Kress Collection.* Vol. 4, *European Schools, Excluding Italian.* London, 1977.

EITNER 2000
Eitner, Lorenz. *French Paintings of the Nineteenth Century*, Part I: *Before Impressionism (The Collections of the National Gallery of Art. Systematic Catalogue).* Washington, D.C., 2000.

ENGELHART 1996
Engelhart, Helmut. "The Early History of Jacques-Louis David's *The Farewell of Telemachus and Eucharis.*" *The J. Paul Getty Museum Journal* 24 (1996): 21–43.

ENGELHART 1998
Engelhart, Helmut. "'C'est l'Art divin Apelle.' Dokumente zur Erwerbungs- und frühen Wirkungsgeschichte zweier Gemälde von Jacques-Louis David und Antoine-Jean Gros in der Kunstsammlung des Franz Erwein Graf von Schönborn-Wiesentheid." In *Forschungen zur Reichs-, Papst-, und Landesgeschichte. Peter Herde zum 65. Geburtstag von Freunden, Schülern, und Kollegen dargebracht,* ed. Karl Bochardt and Enno Bünz, 2:899–935. Stuttgart, 1988.

ERNST 1924
Ernst, S. *Yusupovskaya Galerya – Frantsuskaya Skola.* Leningrad [St. Petersburg], 1924.

FAIN 1908 [2001]
Fain, A.-J.-F. *Mémoires.* Ed. Christophe Bourachot. Paris, 2001. First ed., 1908.

FARINGTON 1922–28
Farington, Joseph. *The Farington Diary.* Ed. James Grieg. 8 vols. London, 1922–28.

FARINGTON 1979
Garlick, Kenneth, and Angus Macintyre, eds. *The Diary of Joseph Farington. 5 (August 1801–March 1803).* New Haven and London, 1979.

FIERENS 1926
Fierens, Paul. "L'Exposition 'David et son Temps' au Musée de Bruxelles." *L'Amour de l'art* (Mar. 1926): 110–11.

FIERENS-GEVAERT 1926
Fierens-Gevaert, Hippolyte. "Exposition David et son temps à Bruxelles." *GBA* 13 (Mar. 1926): 163–74.

FILHOL AND BOURDON 1812
Filhol, Antoine-Michel, and Bourdon, ed. *Concours décennal, ou Collection gravée des ouvrages de peinture, sculpture, architecture et médailles, mentionnés dans le rapport de l'Institut.* Paris, 1812.

FISCHER 1996
Fischer, Hal, ed. *Timken Museum of Art: European Works of Art, American Paintings, and Russian Icons in the Putnam Foundation Collection.* San Diego, 1996.

FLECKNER 1995
Fleckner, Uwe. *Abbild und Abstraktion. Die Kunst des Porträts im Werk von J.-A.-D. Ingres.* Mainz, 1995.

FLECKNER 2000
Fleckner, Uwe. "La Rhétorique de la main cachée. De l'antiquité au *Napoléon, premier consul* de Jean-Auguste-Dominique Ingres." *RA* 123, no. 4 (2000): 27–35.

FLERS 2000
Chesneau-Dupin, Laurence, ed. *Jean-Victor Schnetz, 1787–1870. Couleurs d'Italie.* Exh. cat. Flers: Musée du Château, 2000.

FLORISOONE 1948
Florisoone, Michel. "Musée de l'Orangerie. Premières conclusions à l'exposition David." *Musées de France* (Nov. 1948): 253–61.

FONTAINE 1987
Fontaine, Pierre-François-Léonard. *Journal 1799–1853.* Ed. Marguerite David-Roy et al. 2 vols. Paris, 1987.

FORT WORTH 1982
Baillio, Joseph. *Élisabeth Louise Vigée Le Brun 1755–1842.* Exh. cat. Fort Worth: Kimbell Art Museum, 1982.

FOUCART 1970
Foucart, Bruno. "L'Artiste dans la société de l'Empire: sa participation aux honneurs et dignités." *Revue d'histoire moderne et contemporaine* 17 (July–Sept. 1970): 709–19.

FOUCART-WALTER 1984
Foucart-Walter, Elisabeth. "Paul Delaroche et le thème du Saint-Bernard par Bonaparte." *RL* 5–6 (1984): 367–84.

FOURCAUD 1904
Fourcaud, Louis de. *François Rude, sculpteur, ses oeuvres et son temps (1784–1855).* Paris, 1904.

FRANCIS 1963
Francis, Henry S. "Jacques-Louis David: *Cupid and Psyche.*" *The Bulletin of the Cleveland Museum of Art* 50 (Feb. 1963): 29–34.

FRANKREICH 1800 1990
Gersmann, Gudrun, and Hubertus Kohle, eds. *Frankreich 1800. Gesellschaft, Kultur, Mentalitäten.* Stuttgart, 1990.

FREDERICKSEN 1988
Fredericksen, Burton B., ed. *Masterpieces of Painting in the J. Paul Getty Museum.* Rev. ed. Malibu, 1988.

FRIED 1993
Fried, Michael. "David et l'antithéâtralité." In *David contre David,* 1:199–247. Paris, 1993.

FRIEDLAENDER 1952
Friedlaender, Walter. *David to Delacroix.* Cambridge, Mass., 1952.

GABET 1831
Gabet, Charles Henri Joseph. *Dictionnaire des artistes de l'école francaise au XIXᵉ siècle.* Paris, 1831.

GABILLOT 1906
Gabillot, C. *Les trois Drouais.* Paris, 1906.

GABORIT 1998
Gaborit, Jean-René, ed. *Musée du Louvre. Département des Sculptures. Sculpture française II. Du moyen âge, de la renaissance et des temps modernes.* 2 vols. Paris, 1998.

GAEHTGENS 1978–79
Gaehtgens, Thomas W. "*Bacchus et Ariane* de Antoine-Jean Gros." *Bulletin Annuel. Galerie Nationale du Canada* 2 (1978–79): 62–79.

GAEHTGENS 1984
Gaehtgens, Thomas W. "Jacques-Louis David: Leonidas bei Thermopylen." In *Ideal und Wirklichkeit der bildenden Kunst im späten 18. Jahrhundert,* ed. Herbert Beck, Peter Bol, and Eva Maek-Gérard. 211-51. Berlin, 1984.

GAEHTGENS AND LUGAND 1988
Gaehtgens, Thomas, and Jacques Lugand. *Joseph-Marie Vien, Peintre du Roi (1716–1809).* Paris, 1988.

GALLATIN 1916
Gallatin, James. *The Diary of James Gallatin, Ambassador from the United States to France (1813–27).* London, 1916. First ed., New York, 1914.

GALLO 2004
Gallo, Daniela. "Pouvoirs de l'antique." In *L'Empire des muses. Napoléon, les arts et les letters,* ed. Jean-Claude Bonnet, 317–29, 439–43. Paris, 2004.

GAUTIER, HOUSSAYE, DE SAINT-VICTOR 1864
Gautier, Théophile, Arsène Houssaye, and Paul de Saint-Victor. *Les Dieux et les demi-dieux de la peinture.* Paris, 1864.

GÉRARD 1888
Gérard, Henri, ed. *Lettres adressées au Baron François Gérard*. 3rd rev. ed. 2 vols. Paris, 1888.

GERMER 1990
Germer, Stefan. "On Marche dans ce tableau. Zur Konstituierung des 'Realistischen' in den napoleonischen Darstellungen von Jacques-Louis David." In *Frankreich 1800*, 81–103. Stuttgart, 1990.

GERSMAN AND KOHLE 1990
Gersman, Gudrun, and Hubertus Kohle. "Auf dem Weg ins 'Juste Milieu': Frankreich 1794–1799." In *Frankreich 1800*, 9–22. Stuttgart, 1990.

GERSPRACH 1891
Gersprach, E. "Le Meuble en Tapisserie de Napoléon Ier." *GBA* 5, no. 2 (1891): 154–60.

GÉTREAU 1995
Gétreau, Florence. "Les tableaux et les dessins français du XVIIIe siècle [du Musée Jacquemart-André]." *GBA* 137 (Feb. 1995): 176–90.

GIROD DE L'AIN 1970
Girod de l'Ain, Gabriel. *Joseph Bonaparte. Le roi malgré lui*. Paris, 1970.

GONSE 1900
Gonse, Louis. *Les Chefs-d'oeuvre des Musées de France. La peinture*. Paris, 1900.

GONZALES-PALACIOS 1967
Gonzales-Palacios, Alvar. *David e la pittura napoleonica*. Milan, 1967.

GONZALEZ-PALACIOS 1993
Gonzalez-Palacios, Alvar. "Jacques-Louis David: Le décor de l'antiquité." in *David contre David*, 2:927–63, 998–1005 (figs. 183–218). Paris, 1993.

GOODHEART 1998
Goodheart, Eric. "Competing Visions of the National Family in the Lepeletier Affair of Year VI." In *Symbols, Myths, and Images of the French Revolution: Essays in Honor of James A. Leith*, ed. I. Germani and R. Swales, 199–210. Regina [Canada], 1998.

GOODMAN 2001
Goodman, John. Review of Halliday 2000 and Lajer-Burcharth 1999. *Oxford Art Journal*. 24, no. 1 (2001): 162–76.

GOTTERIE 1992
Gotterie, Nicole. *Archives nationales. Secrétairerie d'État impériale. Rapports du ministre de la Guerre. An VIII–1814*. Paris, 1992.

GOUDAIL AND GIRAUDON 2001
Goudail, Agnès, and Catherine Giraudon. *Procès-Verbaux de l'Académie des Beaux-Arts (1811–1815)*. Paris, 2001.

GOVIER 1998
Govier, Louise. "Disabling the Fury: A Re-Examination of the *Sabines* as a Symbol of Revolutionary Peace." In *Symbols, Myths, and Images of the French Revolution: Essays in Honor of James A. Leith*, ed. I. Germani and R. Swales, 119–33. Regina [Canada], 1998.

GRAMACCINI 1993
Gramaccini, Gisela. *Jean-Guillaume Moitte. Leben und Werk*. 2 vols. Berlin, 1993.

GREATHEED 1953
Greatheed, Bertie. *An Englishman in Paris: 1803*. Ed. J. P. T. Bury and J. C. Barry. London, 1953.

GRIGSBY 1995
Grigsby, Darcy Grimaldo. "Classicism, Nationalism and History: The Prix Décennaux of 1810 and the Politics of Art under Post-Revolutionary Empire." Ph.D. dissertation, University of Michigan, 1995.

GRIGSBY 1998
Grigsby, Darcy Grimaldo. "Nudity *à la Grecque* in 1799." *AB* 80 (June 1998): 311–35.

GRIGSBY 2001
Grigsby, Darcy Grimaldo. "Revolutionary Sons, White Fathers, and Creole Difference: Guillaume Guillon-Lethière's *Oath of the Ancestors*." *Yale French Studies* 101 (spring 2001): 201–26.

GRIGSBY 2002
Grigsby, Darcy Grimaldo. *Extremities: Painting Empire in Post-Revolutionary France*. New Haven and London, 2002.

GRONKOWSKI 1913
Gronkowski, C. "*David et ses élèves* at the Petit Palais." *BM* 23 (May 1913): 77–78, 83.

GRUNCHEC 1989
Grunchec, Philippe. *Les Concours des prix de Rome. 1797–1863, II: Pièces d'archives et oeuvres documentées*. Paris, 1989.

GUÉDRON 1998
Guédron, Martial. "Mathieu-Ignace van Brée et la naissance du mythe romantique de Rubens à Anvers." *Jaarboek van het Koninklijk Museum voor Schone Kunsten Antwerpen* (1998): 401–17.

GUIFFREY 1903
Guiffrey, Jules. "David et le théâtre pendant son séjour à Bruxelles." *GBA* (Sept. 1903): 201–8.

GUIFFREY 1926
Guiffrey, Jules. "Une Esquisse pour le *Sacre* de David au Musée du Louvre." *Beaux-Arts* 1 (Mar. 1926): 69–70.

GUIFFREY AND MARCEL 1909
Guiffrey, Jules, and Pierre Marcel. *Inventaire général des Dessins du Musée du Louvre et du Musée de Versailles*. Vol. 4, École française. Paris, 1909.

GUIZOT 1810 [1852]
Guizot, François. "De l'État des beaux-arts en France, et du Salon de 1810." In *Études sur les beaux-arts en général*, 3–100. Paris, 1852. First ed., 1810.

GUSDORF 1978
Gusdorf, Georges. *La Conscience révolutionnaire: Les idéologues*. Paris, 1978.

HALLIDAY 2000
Halliday, Tony. *Facing the Public: Portraiture in the Aftermath of the French Revolution*. Manchester, 2000.

HASKELL 1972A
Haskell, Francis. *An Italian Patron of French Neo-Classic Art*. (The Zaharoff lecture for 1972). Oxford, 1972. Reprinted in *Past and Present in Art and Taste. Selected Essays*, 46–64. New Haven and London, 1987.

HASKELL 1972B
Haskell, Francis. "More about Sommariva." *BM* 114 (Oct. 1972): 691–95.

HASKELL 1975
Haskell, Francis. "Un Monument et ses mystères. L'Art français et l'opinion anglaise dans la première moitié du XIXe siècle." *RA* 30 (1975): 61–76.

HATTIS 1977
Hattis, Phyllis. *Four Centuries of French Drawings in the Fine Arts Museums of San Francisco*. San Francisco, 1977.

HAUTECOEUR 1954
Hautecoeur, Louis. *Louis David*. Paris, 1954.

HAVANA 1957
Museo Nacional de Cuba. *Obras clásicas de la pintura europea: siglos XV–XIX*. Exh. cat. Havana, 1957.

HÉNARD 1913
Hénard, Roger. "Louis David et ses élèves." *L'Art et les artistes* (Mar. 1913): 259–64.

HENRY 2002
Henry, Christophe. "Bonaparte franchissant les Alpes au Grand-Saint-Bernard. Matériaux et principes d'une icône politique." In *Le Cheval et la Guerre*, ed. Daniel Roche, 347-65. Paris, 2002.

HOCHMANN 1998
Hochmann, Michel. "Genre Scenes by Dosso and Giorgione." In *Dosso's Fate / Painting and Court Culture in Renaissance Italy*, ed. Luisa Ciammitti, Steven F. Ostrow, and Salvatore Settis, 63–82. Los Angeles, 1998.

HOFMANN 1958
Hofmann, Werner. "Un Dessin inconnu de la pre-
mière époque de J.-L. David." *GBA* 51 (Mar. 1958):
157–68.

HOLLANDER 1901
Hollander, O. "Nos drapeaux et étenards. Con-
tribution à l'histoire du drapeau sous le règne de
Napoléon Ier (1811–1814)." *Carnet de la Sabretache* 107
(30 Nov. 1901): 664–66.

HOLMA 1940
Holma, Klaus. *David, son évolution et son style.* Paris,
1940.

HONOUR 1972
Honour, Hugh. "Canova and David." *Apollo* 96 (Oct.
1972): 312–17.

HOUSTON 1952
Allied Arts Association. *Masterpieces of Painting
through Six Centuries.* Exh. cat. Houston, 1952.

HOUSTON 1986–87
Shackelford, George T. M., and Mary Taverner
Holmes, eds. *A Magic Mirror: The Portrait in France,
1700–1900.* Exh. cat. Houston: the Museum of Fine
Arts, 1986–87.

HOWARD 1975
Howard, Seymour. *A Classical Frieze by Jacques Louis
David.* Sacramento, 1975.

HUBERT 1964
Hubert, Gérard. *La Sculpture dans l'Italie napoléoni-
enne.* Paris 1964.

HUBERT 1979
Gérard Hubert. "Un portrait en mosaïque de
Napoléon par Belloni d'après Gérard. Contribution à
l'étude de l'école impériale de mosaïque de Paris et
des manufactures italiennes." In *Florence et la France.
Rapports sous la Révolution et l'Empire*, ed. Pierre
Rosenberg, Mina Gregori, and Marco Charini, 251–71.
Florence, 1979.

HUBERT 1980
Hubert, Gérard. *Malmaison.* Paris, 1980.

HUBERT 1986
Hubert, Nicole. "A Propos des portraits consulaires
de Napoleon Bonaparte. Remarques complémen-
taires." *GBA* 108 (July–Aug. 1986): 23–30.

HUBERT AND POUGETOUX 1989
Hubert, Nicole, and Alain Pougetoux. *Châteaux de
Malmaison et de Bois-Préau, Musées napoléoniens de
l'Ile d'Aix et de la maison Bonaparte à Ajaccio.* Paris,
1989.

HUCHARD 1976
Huchard, Vivianne. "Dessins de J.-L. David au Musée
d'Angers." *RL* 2 (1976): 82–83.

HUGO 1833
Hugo, A. "Souvenirs et némoires sur Joseph
Napoléon, sa cour, l'armée française et l'Espagne en
1811, 1812, et 1813." *Revue des deux mondes* 1 (1833): 315.

HUMBERT 1936
Humbert, Agnès. *Louis David, Peintre et Convention-
nel. Essai de Critique Marxiste.* Paris, 1936.

HUMBERT 1947
Humbert, Agnès. *Louis David, Peintre et Convention-
nel.* Paris, 1947.

HUNT 1992
Hunt, Lynn. *The Family Romance of the French
Revolution.* Berkeley and Los Angeles, 1992.

IXELLES 1985–86
Coekelberghs, Denis, and Pierre Loze, eds. *1770–1830.
Autour du néo-classicisme en Belgique.* Exh. cat.
Ixelles: Musée communal des Beaux-Arts, 1985–86.

JACOB 1873
Jacob, P. L. [Lacroix, Paul]. "David et son École jugés
par M. Thiers en 1824." *GBA* 7 (Apr. 1873): 295–304.

JAFFÉ 1963
Jaffé, Michael. "Cleveland Museum of Art: The
Figurative Arts of the West, ca. 1400–1800." *Apollo* 78
(Dec. 1963): 457–67.

JAL 1824
Jal, Auguste. *L'Artiste et le philosophe. Entretiens
critiques sur le salon de 1824.* Paris, 1824.

JANSON 1983
Janson, Anthony F. "The Sources of David's
'Anacreon' Paintings." *Source: Notes in the History of
Art* 3, no. 1 (autumn 1983): 19–22.

JOACHIM 1974
Joachim, Harold. *The Helen Regenstein Collection
of European Drawings: The Art Institute of Chicago.*
Chicago, 1974.

JOACHIM 1977
Joachim, Harold. *French Drawings and Sketchbooks of
the Eighteenth Century: The Art Institute of Chicago.*
Chicago, 1977.

JOHNS 1988
Johns, Christopher M. S. *Antonio Canova and the
Politics of Patronage in Revolutionary and Napoleonic
Europe.* Berkeley and Los Angeles, 1998.

JOHNSON 1982
Johnson, William. *The Nineteenth-Century Paintings
in the Walters Art Gallery.* Baltimore, 1982.

JOHNSON 1984
Johnson, Dorothy. "Some Works of Noble Note:
David's *La Colère d'Achille* Revisited." *GBA* 104 (Dec.
1984): 223–30.

JOHNSON 1986
Johnson, Dorothy. "Desire Demythologized: David's
L'Amour Quittant Psyché." *Art History* 9, no. 4 (Dec.
1986): 450–70.

JOHNSON 1990
Johnson, Dorothy. "Myth and Meaning: Mythological
Painting in France Circa 1800." In *Frankreich 1800*,
23-33. Stuttgart, 1990.

JOHNSON 1993A
Johnson, Dorothy. *Jacques-Louis David: Art in Meta-
morphosis.* Princeton, 1993.

JOHNSON 1993B
Johnson, Dorothy. "L'Expérience de l'exil: l'art de
David à Bruxelles." In *David contre David*. 2:1025–45.
Paris, 1993.

JOHNSON 1997
Johnson, Dorothy. *The Farewell of Telemachus and
Eucharis.* Los Angeles, 1997.

JONES AND GALITZ 2000
Jones, Sue, and Kathryn Calley Galitz. "Jacques-Louis
David's *Portrait of Comtesse Vilain XIIII and Her
Daughter.*" *BM* 142 (May 2000): 301–3.

JORDÁN DE URRIES Y DE LA COLLINA 1991
Jordán de Urries y de la Collina, J. "El retrato ecuestre
de *Bonaparte en el Gran San Bernardo* de David com-
prado por Carlos IV." *Archivio Español de Arte* 64,
no. 256 (1991): 503–12.

JOUBIN 1926
Joubin, André. *Catalogue des peintures et sculptures
exposées dans les galeries du Musée Fabre.* Paris, 1926.

JOURDAN 1998
Jourdan, Annie. *Napoléon. Héros, imperator, mécène.*
Paris, 1998.

JOUVE 2003
Jouve, Claudine Lebrun. *Nicholas-Antoine Taunay
(1755–1830).* Paris, 2003.

JUŘEN 1974
Juřen, Vladimir. "Fecit Faciebat." *RA* 25 (1974):
66–70.

KELLER 1981
Keller, William B. *A Catalogue of the Cary Collection
of Playing Cards in the Yale University Library.* 4 vols.
New Haven, 1981.

KEMP 1969
Kemp, Martin. "J.-L. David and the Prelude to a Moral Victory for Sparta." *AB* 51 (June 1969): 178–83.

KIRCHNER 1990
Kirchner, Thomas. "Physiognomie als Zeichen: Die Rezeption von Charles Le Bruns Mensch-Tier-Vergleichen um 1800." In *Frankreich 1800*, 34–48. Stuttgart, 1990.

KIRCHNER 1991
Kirchner, Thomas. *L'expression des Passions. Ausdruck als Darstellungsproblem in der französischen Kunst une Kunsttheorie des 17. und 18. Jahrhunderts.* Mainz, 1991.

KITCHIN 1965
Kitchin, Joanna. *Un Journal "philosophique," La Décade, 1794–1807.* Paris, 1965.

KOHLE 1991
Kohle, Hubertus. "Der Tod Jacques Louis Davids. Zum Verhältnis von Politik und Ästhetik in der französischen Restauration." *Idea. Jahrbuch der Hamburger Kunsthalle* 10 (1991): 127–53.

KOHLE 1993
Kohle, Hubertus. "La modernité du passé: David, la peinture d'histoire et la théorie néo–classique." In *David contre David*, 2:1093-1113. Paris, 1993.

KRASNOBAÏEVA AND KIRUCHINA 1999
Krasnobaïeva, Marina, and Ludmila Kiruchina. "Le Domaine-Palais d'Arkhangelkoïe." In *Hubert Robert et Saint-Petersbourg. Les commandes de la famille impériale et des princes russes entre 1773 et 1802*, ed. Hélène Moulin, 66–71. Exh. cat. Valence: Musée des Beaux-Arts, 1999.

LAFENESTRE 1914
Lafenestre, Georges. "La Peinture au Musée Jacquemart-André (troisième et dernier article)." *GBA* 11 (Feb. 1914): 101–16.

LAJER-BURCHARTH 1989
Lajer-Burcharth, Ewa. "Les oeuvres de David en prison: art engagé après Thermidor." *RL* 39, nos. 5–6 (1989): 310–21.

LAJER-BURCHARTH 1999
Lajer-Burcharth, Ewa. *Necklines: The Art of Jacques-Louis David after the Terror.* New Haven and London, 1999.

LANDON 1808
Landon, Charles-Paul. *Annales du Musée et de l'École moderne des beaux-arts. Salon de 1808.* Paris, 1808.

LANDON 1810
Landon, Charles-Paul. *Annales du Musée et de l'École moderne des beaux-arts. Salon de 1810.* Paris, 1810. References to reprint, 1829.

LANDON 1814
Landon, Charles-Paul. *Annales du Musée et de l'École moderne des beaux-arts. Salon de 1814.* Paris, 1814.

LANDON 1819
Landon, Charles-Paul. *Annales du Musée et de l'École moderne des beaux-arts. Salon de 1819.* 2 vols. Paris, 1819.

LANDON 1824
Landon, Charles-Paul. *Annales du Musée et de l'École moderne des beaux-arts. Salon de 1824.* Paris, 1824. [Only the first volume was published.]

LANZAC DE LABORIE 1913
Lanzac de Laborie, L. de. "Napoléon et le peintre David." *Revue des etudes napoléoniennes* 3 (1913): 21–37.

L'ARTISTE 1839
Anonymous. "De la Galerie de M. de Sommariva." *L'Artiste*, 2nd series, 2 (1839): 185–86.

LAVEISSIÈRE 1993
Laveissière, Sylvain. "Date obolum Picturae. Prud'hon, David du pauvre?" In *David contre David*, 2:898-906. Paris, 1993.

LEBENSZTEJN 1993
Lebensztejn, Jean-Claude. "Histoires Belges." In *David contre David*, 2:1011-23. Paris, 1993.

LEBENSZTEJN 2001
Lebensztejn, Jean-Claude. Review of Lajer-Burcharth 1999. *Les Cahiers du Musée national d'art moderne* 75 (spring 2001): 112–17. English translation in *AB* 83 (Mar. 2001): 153–57.

LECOINTE DE LAVEAU 1828–29
Lecointe de Laveau, G. *Bulletin du Nord.* 6 vols. Moscow, 1828–29.

LECOINTE DE LAVEAU 1835
Lecointe de Laveau, G. *Description de Moscou.* 2 vols. Moscow, 1835.

LEDOUX-LEBARD 1941–44 (1947)
Ledoux-Lebard, Guy, and Christian Ledoux-Lebard. "La Décoration et l'Ameublement du Grand Cabinet de Napoléon Ier aux Tuileries." *BSHAF* 1941–44 (1947): 220–32.

LEDOUX-LEBARD 1952
Ledoux-Lebard, R., Guy Ledoux-Lebard, and Christian Ledoux-Lebard. "L'inventaire des appartements de Napoléon Ier aux Tuileries." *BSHAF* (1952): 186–204.

LEDOUX-LEBARD 1978
Ledoux-Lebard, Guy, and Christian Ledoux-Lebard. "Les tableaux du concours institué par Bonaparte en 1802 pour célébrer le rétablissement du culte." *Archives de l'art français* 25 (1978): 251–61.

LEE 1999
Lee, Simon. *David.* London, 1999.

LEIGHTON 1987
Leighton, John. *Acquisition in Focus: Jacques-Louis David, "Portrait of Jacobus Blauw."* London, 1987.

LEIGHTON 1994
Leighton, John. "Jacques-Louis David, *Portrait of the Vicomtesse Vilain XIIII and Her Daughter.*" *The National Gallery Report* (Apr. 1993–Mar. 1994): 12–13.

LENOIR 1810
Lenoir, Alexandre. *Description historique et chronologique des monumen[t]s de sculpture réunis au Musée impérial des monumen[t]s français.* Paris, 1810.

[LENOIR] 1810
"Un amateur de arts" [Alexandre Lenoir]. *Examen du Tableau des Sabines et de l'École de M. David.* Paris, 1810.

LENOIR 1811
Lenoir, Alexandre. *Histoire des Arts en France prouvée par les monumen[t]s, suivie d'une description chronologique des statues en marbre et en bronze, bas-reliefs et tombeaux des hommes et des femmes célèbres, réunis au musée impérial des monumen[t]s français.* Paris, 1811.

LENOIR 1835
Lenoir, Alexandre. "David, souvenirs historiques." *Journal de l'Institut Historique* 3, no. 1 (1835). Offprint, 1838.

LESUR 1825
Lesur, C.-L. *Annuaire historique et universel pour 1819.* 2nd ed. Paris, 1825.

LE VACHER DE CHARNOIS 1786–89
Le Vacher de Charnois, Jean-Charles. *Costumes et annales des grands théâtres de Paris.* 4 parts. Paris, 1786–89.

LEVIN 1980
Levin, Miriam R. "David, de Staël, and Fontanes: *The Leonidas at Thermopylae* and Some Intellectual Controversies of the Napoleonic Era." *GBA* (January 1980): 5–12.

LEVIN 1981
Levin, Miriam R. "La définition du caractère républicain dans l'art français après la Révolution: Le *Léonidas aux Thermopyles* de David." *Revue de l'Institut Napoléon* 137 (1981): 40–67.

LEVITINE 1954
Levitine, George, "The Influence of Lavater and Girodet's *Expression des sentiments de l'âme.*" *AB* 36 (Mar. 1954): 33–45.

LEVITINE 1978
Levitine, George. *The Dawn of Bohemianism: The Barbu Rebellion and Primitivism in Neoclassical France.* University Park, Pa., and London, 1978.

LICHTENSTEIN 2003
Lichtenstein, Jacqueline. *La Tache aveugle. Essai sur les relations de la peinture et de la sculpture à l'âge moderne.* Paris, 2003.

LILLE 1983
Musée des Beaux-Arts. *Autour de David. Dessins néo-classiques du Musée des Beaux-Arts de Lille.* Exh. cat. Lille, 1983.

LILLE 1984
Oursel, Hervé, and Annie Scottez, eds. *Le Chevalier Wicar. Peintre, dessinateur et collectionneur lillois.* Exh. cat. Lille: Musée des Beaux-Arts, 1984.

LILLEY 1985
Lilley, Edward. "Consular Portraits of Napoleon Bonaparte." *GBA* 106 (Nov. 1985): 143–54.

LINDSAY 1960
Lindsay, Jack. *Death of a Hero: French Painting from David to Delacroix.* London, 1960.

LONDON 1932
Royal Academy of Arts. *French Art 1200–1500.* Exh. cat. London, 1932.

LONDON 1948
The Tate Gallery. *David. 1748–1825. Catalogue of Paintings and Drawings.* Exh. cat. London: The Tate Gallery; and Manchester: City Art Gallery, 1948.

LONDON 1959
The Tate Gallery. *The Romantic Movement: Fifth Exhibition to Celebrate the Tenth Anniversary of the Council of Europe.* Exh. cat. London, 1959.

LONDON 1972
Royal Academy of Arts. *The Age of Neoclassicism.* Exh. cat. London: Royal Academy of Arts and Victoria and Albert Museum, 1972.

LONDON 1975
Conisbee, Philip, ed. *French Drawings: Neo-Classicism.* Exh. cat. London: Heim Gallery, 1975.

LONDON 1979
Artemis Group. *The Classical Ideal: Athens to Picasso.* Exh. cat. London: David Carritt Gallery, 1979.

LONDON 1986
Penny, Nicholas, ed. *Reynolds.* Exh. cat. London: Royal Academy, 1986.

LONDON 1991–92
The Queen's Gallery. *Carlton House, The Past Glories of George IV's Palace.* Exh. cat. London, 1991–92.

LONDON 1999–2000
Tinterow, Gary, and Philip Conisbee, eds. *Portraits by Ingres: Images of an Epoch.* Exh. cat. London: The National Gallery; Washington, D.C.: National Gallery of Art; and New York: The Metropolitan Museum of Art, 1999–2000.

LOS ANGELES 1934
Los Angeles Museum. *Paintings from the Louvre: An Exhibition of Eleven Canvases.* Exh. cat. Los Angeles, 1934.

LOS ANGELES 1980–81
Fusco, Peter, and Horst W. Janson, eds. *The Romantics to Rodin: French Nineteenth-Century Sculpture from North American Collections.* Exh. cat. Los Angeles: Los Angeles County Museum of Art, 1980–81.

LUZZATTO 1991
Luzzatto, Sergio. *Mémoire de la Terreur. Vieux Montagnards et jeunes républicains au XIXᵉ Siècle.* Lyons, 1991. First ed.: *Il Terrore ricordato,* Genoa, 1988.

LYON 1958
Lyon, Georgette. *Joseph Ducreux (1735–1802), premier peintre de Marie-Antoinette. Sa vie, son oeuvre.* Paris, 1958.

LYONS 1988
Mai, Ekkehard, and Anke Repp-Eckert, eds. *Triomphe et mort du héros. La Peinture d'histoire en Europe de Rubens à Manet.* Exh. cat. Lyons: Musée des Beaux-Arts, 1988. (*see also* Cologne 1987–88)

LYONS 2003
Musée des Beaux-Arts. *La Collection Grenville L. Winthrop. Chefs-d'oeuvre du Fogg Art Museum, Université de Harvard.* Exh. cat. Lyons, 2003.

MADRID 2002–3
Museo Arqueológico Nacional. *1802. España entre dos siglos y la devolución di Menorca.* Exh. cat. Madrid, 2002–3.

MAHUL 1826
Mahul, A. *Annuaire nécrologique, ou complément annuel et continuation de toutes les biographies, ou dictionnaires historiques . . . , année 1825.* Paris, 1826.

MANSEL 1982
Mansel, Philip. "Monarchy, Uniform and the Rise of the *Frac* 1760–1830." *Past and Present* 96 (Aug. 1982): 103–32.

MANTION 1993
Mantion, Jean-Rémy. "David en toutes lettres." In *David contre David,* 2:805–25. Paris, 1993.

MANTOVANI 1987
Mantovani, Luigi. *Diario politico ecclesiastico 2: 1803–1805.* Ed. Paola Zanoli. Rome, 1987.

MANTZ 1865
Mantz, Paul. "La Galerie Pourtalès. IV. Les peintures espagnoles, allemandes, hollandaises, flamandes et françaises." *GBA* 18 (Feb. 1865): 97–117.

MARCEL 1919
Marcel, Henri. "Les enrichissements du Musée du Louvre." *Les Arts* 180 (1919): 8–12.

MARET 1943
Maret, Jacques. *David.* Monaco, 1943.

MARKHAM 1964
Markham, F. "Napoleon and His Painters." *Apollo* (Sept. 1964): 187–91.

MARMOTTAN 1925
Marmottan, Paul. "Le Paysagiste Nicolas-Didier Boguet." *GBA* 11 (Jan. 1925): 6–11.

MARTIGNY 2000
Fondation Pierre Gianadda. *Bicentenaire du passage des Alpes par Bonaparte, 1800–2000.* Exh. cat. Martigny, 2000.

MATHIEZ 1929
Mathiez, Albert. "Origines de l'expression: la 'Grande Nation.'" *Annales historiques de la Révolution française* (1929): 290.

MATHIS 1998
Mathis, Hans Peter, ed. *Napoleon I. im Spiegel der Karikatur (Sammlungskatalog des Napoleon-Museums Arenenberg).* Zurich, 1998.

MAUROIS 1948
Maurois, André. *J.-L. David.* Paris, 1948.

MAXON 1967
Maxon, John. "J.-L. David's Portrait of the Marquise de Pastoret." *Art News* 66, no. 7 (Nov. 1967): 45–46.

MAZE-SENCIER 1893
Maze-Sencier, Alphonse. *Les Fournisseurs de Napoleon Iᵉʳ et des deux impératrices.* Paris, 1893.

MAZZOCCA 1981
Mazzocca, Fernando. "G. B. Sommariva, o il borghese mecenate: il 'cabinet' neoclassico di Parigi, la Galleria romantica di Tremezzo." In *Itinerari: contribuiti alla storia dell'arte in memoria di Maria Luisa Ferrarri,* ed. Antonio Boschetto, 2:145–293. Florence, 1981.

MAZZOCCA 1983
Mazzocca, Fernando. *Villa Carlotta.* Florence, 1983.

MCCLELLAN 1994
McClellan, Andrew. *Inventing the Louvre: Art, Politics, and the Origins of the Modern Museum in Eighteenth-Century Paris.* Cambridge, 1994.

MCPHERSON 1991
McPherson, Heather. "The *Fortune Teller* of 1824 or the Elegant Dilemma of David's Late Style." *GBA* 118 (July–Aug. 1991): 27–36.

[MENDE-MAUREPAS] 1789
C.D.M.M. [Comte de Mende-Maurepas]. *Supplément aux Remarques sur les ouvrages exposés au Salon.* Paris, 1789.

MESPLÉ 1969
Mesplé, Paul. "David et ses élèves toulousains." *Archives de l'art français* 24 (1969): 91–102.

MEYER 1802
Meyer, F. J. L. *Briefe aus der Hauptstadt und dem Innern Frankreichs.* 2 vols. Tübingen, 1802.

MEYER 1995
Meyer, Arline. "Re-dressing Classical Statuary: The Eighteenth-Century 'Hand-in-Waistcoat' Portrait." *AB* 1977 (Mar. 1995): 45–63.

MICHEL 1989
Michel, Régis. *Le beau idéal ou l'art du concept.* Paris, 1989.

MICHEL 1993
Michel, Christian. *Charles-Nicolas Cochin et l'art des Lumières.* Rome, 1993.

MICHEL 1996
Michel, Christian. "La Querelle des anciens et des modernes et les arts en France au XVIIIᵉ siècle." In *Antiquités imaginaires. La Référence antique dans l'art moderne, de la renaissance à nos jours,* ed. Philippe Hoffmann and Paul-Louis Rinuy, 43–58. Paris, 1996.

MICHEL AND SAHUT 1988
Michel, Régis, and Marie-Catherine Sahut. *David, l'art et le politique.* Paris, 1988.

MIEL 1817–18
Miel, Edme-François. *Essai sur les beaux-arts et particulièrement sur le Salon de 1817.* Paris, 1817–18.

MIEL 1840
Miel, Edme-François. "David (Jacques–Louis)." *Le Plutarque français.* Vol. 7. Ed. E. Ménechet. Paris, 1840. Rev. from *Encyclopédie des gens du monde* 7 (1836): 578–82.

MIETTE DE VILLARS 1850
Miette de Villars. *Mémoires de David, peintre et député à la convention.* Paris, 1850.

MILAN 2002
Mazzocca, Fernando, ed. *Il Neoclassicismo in Italia. Da Tiepolo a Canova.* Exh. cat. Milan: Palazzo Reale, 2002.

MILAN 2002–3
Capra, Carlo, Franco Della Peruta, and Fernando Mazzocca, eds. *Napoleone e la Repubblica Italiana (1802–1805).* Exh. cat. Milan: Rotonda vi via Besana, 2002–3.

MILLIN 1806A
Millin, Aubin-Louis. *Dictionnaire des beaux-arts.* 3 vols. Paris, 1806.

MILLIN 1806B
Millin, Aubin-Louis. *Monumen[t]s antiques inédits ou nouvellement expliqués.* Vol. 2. Paris, 1806. (Vol. 1, 1802)

MILLIN 1808–10
Millin, Aubin-Louis. *Peintures de vases antiques, vulgairement appelées étrusques.* 2 vols. Paris, 1808–10.

MINNEAPOLIS 1965–66
Minneapolis Institute of Arts. *Fiftieth Anniversary Exhibition, 1915–1965.* Exh. cat. Minneapolis, 1965–66.

MINNEAPOLIS 1969
Minneapolis Institute of Arts. *The Past Rediscovered : French Painting 1800–1900.* Exh. cat. Minneapolis, 1969.

MÖLLER 1914
Möller, T. "L'Exposition de l'art français au XIXᵉ siècle à Copenhague." *GBA* 11 (Aug. 1914): 158–63.

MONGAN 1969
Mongan, Agnes, and Elizabeth Mongan. *European Paintings in the Timken Art Gallery.* San Diego, 1969.

MONGAN 1983
Mongan, Agnes, et al. *Timken Art Gallery: European and American Works of Art in the Putnam Foundation Collection.* San Diego, 1983.

MONGAN 1996
Mongan, Agnes. *David to Corot: French Drawings in the Fogg Art Museum.* Cambridge, Mass., and London, 1996.

MONNIER 2001
Monnier, Raymonde. "Brumaire, moment de rupture pour une référence républicaine? Le trajet de la notion de patrie." In *Du Directoire au Consulat 3,* ed. Jean-Pierre Jesenne, 289–302. Lille and Rouen, 2001.

MONTAIGLON 1879
Montaiglon, Anatole de. "Lettres du Comte Sommariva (1814–1825)." *Nouvelles archives de l'art français* 1, no. 2 (1879): 297–320.

MONTAUBAN 1967
Musée Ingres. *Ingres et son temps.* Exh. cat. Montauban, 1967.

MONTHOLON 1847
Montholon, Charles de. *Récits de la captivité de l'empereur Napoléon a Sainte-Héléne.* Paris, 1847.

MORAVIA 1974
Moravia, Sergio. *Il Pensiero degli idéologues.* Florence, 1974.

MORAVIA 1996
Moravia, Sergio. "La 'Raison' e il potere. Il Confronto tra tradizione illuminista regime napoleonico." In *Napoleone e gli intelletuali. Dotti e 'hommes de lettres' nell'Europa napoleonica,* ed. Daniela Gallingani, 37–47. Bologna, 1996.

MOSCOW AND ST. PETERSBURG 2001
Pushkin Museum of Fine Arts. *Sobiraniye Knyaza Nikolaia Borisovicha Yusupova: Uchenaia prikhet [The Collection of Prince Nikolai Borisovich Yusupov: A Learned Whim].* Exh. cat. 2 vols. Moscow: Pushkin Museum of Fine Arts; St. Petersburg: The State Hermitage Museum, 2001.

MUNICH 1952–53
Alte Pinakothek. *Meisterwerke der französischen Malerei von Poussin bis Ingres.* Exh. cat. Munich: Alte Pinakothek; Hamburg: Kunsthalle, 1952–53.

MUNICH 1964–65
Haus der Kunst. *Französische Malerei des 19. Jahrhunderts von David bis Cézanne.* Exh. cat. Munich, 1964–65.

NAEF 1977–80
Naef, Hans. *Die Bildniszeichnungen von J.-A.-D. Ingres.* 5 vols. Bern, 1977–80.

NANTES 1997–98
Coquery, Emmanuel. *Visages du grand siècle. Le Portrait français sous le règne de Louis XIV, 1660–1715.* Exh. cat. Nantes: Musée des Beaux-Arts; Toulouse: Musée des Augustins, 1997–98.

NANTEUIL 1985
Nanteuil, Luc de. *Jacques-Louis David.* New York, 1985.

NASH 1973
Nash, Steven A. "The Drawings of Jacques-Louis David: Selected Problems." Ph.D. dissertation, Stanford University, 1973.

NASH 1978
Nash, Steven A. "The Compositional Evolution of David's *Leonidas at Thermopylae.*" *Metropolitan Museum Journal* 13 (1978): 101–12.

NEWHOUSE 1982–83
Newhouse, Gloria Rexford. "A Newly Identified Drawing by Jacques-Louis David." *The Stanford Museum* 12–13 (1982–83): 13–19.

NEW YORK 1955–56
Wildenstein & Co. *Treasures of the Musée Jacquemart-André, Institut de France.* Exh. cat. New York, 1955–56.

NEW YORK 1963
Wildenstein & Co. *Master Drawings from the Art Institute of Chicago*. Exh. cat. New York, 1963.

NEW YORK 1982
Wildenstein & Co. *Consulat-Empire-Restauration: Art in Early XIX Century France*. Exh. cat. New York, 1982.

NEW YORK 1989
Wintermute, Alan, ed. *1789: French Art during the Revolution*. Exh. cat. New York: Colnaghi, 1989.

NEW YORK 1994A
Colnaghi. *Master Paintings*. Exh. cat. New York, 1994.

NEW YORK 1994B
Richard L. Feign & Co. *Neo-Classicism and Romanticism in French Painting 1774–1826*. Exh. cat. New York, 1994.

NEW YORK 1996
Colnaghi. *The French Portrait 1550–1850*. Exh. cat. New York, 1996.

NEW YORK 1999A
W. M. Brady & Co. *Old Master Drawings*. Exh. cat. New York, 1999.

NEW YORK 1999B
Wildenstein & Co. *Neo-classicism to Barbizon: French Drawings and Oil Sketches from the First Half of the 19th Century*. Exh. New York, 1999 [no cat.].

NEW YORK 2001
W. M. Brady & Co. *Master Drawings 1770–1900*. Exh. cat. New York, 2001.

NICE 1977
Rosenberg, Pierre, and Marie-Catherine Sahut, eds. *Carle Vanloo: Premier peintre du roi: (Nice, 1705–Paris, 1765)*. Exh. cat. Nice: Museé Jules-Cheret; Clermont-Ferrand: Musée Bargoin; Nancy: Musée des Beaux-Arts, 1977.

NOTICE 1824
Notice sur la vie et les ouvrages de M. J.-L. David. Paris, 1824.

NOTRE DAME 1993
Snite Museum of Art. *Drawings from the Reilly Collection*. Exh. cat. Notre Dame, Ind., 1993.

NUREMBERG 1989
Bott, Gerhard, ed. *Die Grafen von Schönborn: Kirchenfürsten, Sammler, Mäzene*. Nuremberg: Germanisches Nationalmuseum, 1989.

OPPENHEIMER 1996A
Oppenheimer, Margaret A. "Nisa Villers, née Lemoine (1774–1821)." *GBA* 127 (Apr. 1996): 165–80.

OPPENHEIMER 1996B
Oppenheimer, Margaret A. "Three Newly Identified Paintings by Marie Guillelmine Benoist." *Metropolitan Museum Journal* 31 (1996): 143–50.

OPPENHEIMER 1996C
Oppenheimer, Maragaret A. "Women Artists in Paris, 1791–1814." Ph.D. dissertation, Institute of Fine Arts, New York University, 1996.

ORDRUPGAARD 1957–58
Statens Museum for Kunst. *Fransk Kunst Udvalgt fra Ny Carlsberg Glyptotek*. Exh. cat. Ordrupgaard (Charlottenlund), Copenhagen, 1957–58.

OTTAWA 2003–4
Bailey, Colin B., Philip Conisbee, and Thomas W. Gaehtgens, eds. *The Age of Watteau, Chardin, and Fragonard: Masterpieces of French Genre Painting*. Exh. cat. Ottawa: National Gallery of Canada; Washington D.C.: National Gallery of Art; and Berlin: Gemäldegalerie, Staatliche Museen zu Berlin, 2003–4.

PADIYAR 2000
Padiyar, Satish. "Sade / David." *Art History* 23, no. 2 (Sept. 2000): 365–95.

PARIS 1830
Explication des ouvrages de peinture, sculpture, architecture, gravure, dessin et lithographie exposées dans la galerie de la chambre des pairs, au profit des blessés des 27, 28 et 29 juillet 1830. Paris, 1830.

PARIS 1846
Galerie des Beaux-Arts. *Exposition au profit de l'Association des artistes peintres et sculpteurs*. Exh. cat. Boulevard Bonne-Nouvelle. Paris, 1846.

PARIS 1878
Palais du Trocadéro. *Portraits Nationaux*. Exh. cat. Paris, 1878.

PARIS 1884
École des Beaux-Arts. *Dessins de l'école moderne exposés à l'école nationale des beaux-arts au profit de la caisse de secours de l'association des artistes peintres, sculpteurs, architectes, graveurs et dessinateurs*. Exh. cat. Paris, 1884.

PARIS 1885
École des Beaux-Arts. *Deuxième exposition de portraits du siècle au profit de la Société philanthropique*. Exh. cat. Paris, 1885.

PARIS 1889
Musée du Louvre. *Révolution française. Célébration historique du centenaire de 1789*. Exh. cat. Paris, 1889.

PARIS 1895
Galerie des Champs-Élysées. *Exposition historique et militaire de la révolution et de l'empire*. Exh. cat. Paris, 1895.

PARIS 1913
Palais des Beaux-Arts de la Ville de Paris. *David et ses élèves*. Exh. cat. Paris, 1913

PARIS 1936
Petit Palais. *Gros, ses amis, ses élèves*. Exh. cat. Paris, 1936.

PARIS 1939
Musée Carnavalet. *La Révolution française dans l'histoire, dans la littérature, dans l'art*. Exh. cat. Paris, 1939.

PARIS 1948
Florisoone, Michel, ed. *David*. Exh. cat. Paris: Orangerie des Tuileries, 1948.

PARIS 1949
Galerie Bernheim-Jeune. *Les Magiciens de la peinture*. Exh. cat. Paris, 1949.

PARIS 1950
Galerie Charpentier. *Cent portraits de femmes du XVᵉ siècle à nos jours*. Exh. cat. Paris, 1950.

PARIS 1952
Galerie Bernheim-Jeune. *Peintres de portraits*. Exh. cat. Paris, 1952.

PARIS 1953
Vaudoyer, Jean-Louis, ed. *Figures nues de l'école française, depuis les maîtres de Fontainebleau*. Exh. cat. Paris: Galerie Charpentier, 1953.

PARIS 1955
Orangerie des Tuileries. *De David à Toulouse-Lautrec. Chefs-d'oeuvre des collections américaines*. Exh. cat. Paris, 1955.

PARIS 1956
Office of the *Gazette des Beaux-Arts*. *De Watteau à Prud'hon*. Exh. cat. Paris, 1956.

PARIS 1965–66
Musée du Louvre. *Chefs-d'oeuvre de la Peinture française dans les Musées de Leningrad et de Moscou*. Exh. cat. Paris, 1965–66.

PARIS 1968
Musée national de la Légion d'honneur et des Ordres de Chevalerie. *Napoléon et la Légion d'honneur*. Exh. cat. Paris, 1968.

PARIS 1969
Grand Palais. *Napoléon*. Exh. cat. Paris, 1969.

PARIS 1972
Sérullaz, Arlette, ed. *Dessins français de 1750 à 1825 dans les collections du Musée du Louvre. Le néo-classicisme*. Exh. cat. Paris: Musée du Louvre, 1972.

PARIS 1973–74
Musée du Louvre. *Dessins français du Metropolitan Museum of Art, New York, de David à Picasso*. Exh. cat. Paris, 1973–74.

PARIS 1974–75
Grand Palais. *De David à Delacroix. La peinture française de 1774 à 1830.* (*French Painting, 1774–1830: The Age of Revolution.*) Exh. cat. Paris: Grand Palais; Detroit: The Detroit Institute of Art; and New York: The Metropolitan Museum of Art, 1974–75.

PARIS 1975
Galerie Cailleux. *Éloge de l'ovale. Peintures et pastels du XVIIIᵉ siècle français.* Exh. cat. Paris, 1975.

PARIS 1988
Sérullaz, Arlette, and Lina Propeck, eds. *L'An V. Dessins des grands maîtres.* Exh. cat. Paris: Musée du Louvre, Cabinet des Dessins, 1988.

PARIS 1989
Gaborit, Jean-René, ed. *La Révolution française et l'Europe, 1789–1799.* Exh. cat. Paris, Grand Palais, 3 vols., 1989.

PARIS 1991–92
Bailey, Colin B., ed. *Les Amours des dieux. La peinture mythologique de Watteau à David.* (*The Loves of the Gods. Mythological Painting from Watteau to David.*) Exh. cat. Paris: Grand Palais; Philadelphia: Philadelphia Museum of Art; and Fort Worth: Kimbell Art Museum, 1991–92.

PARIS 1995–96
Musée Marmottan. *De Le Brun à Vuillard: De l'Académie royale à l'Académie des beaux-arts. Trois siècles de peintures française.* Exh. cat. Paris, 1995–96.

PARIS 1997
Musée du Louvre. *Des Mécènes par Milliers: Un siècle de dons par les Amis du Louvre.* Exh. cat. Paris, 1997.

PARIS 1997–98
Laveissière, Sylvain, ed. *Prud'hon ou le rêve du bonheur.* Exh. cat. Paris: Grand Palais; New York, The Metropolitan Museum of Art, 1997–98.

PARIS 1999–2000
Dupuy, Marie-Anne, and Pierre Rosenberg, eds. *Dominique-Vivant Denon. L'œil de Napoléon.* Exh. cat. Paris: Musée du Louvre, 1999–2000.

PARIS 2000
Michel, Régis, ed. *Posséder et détruire. Stratégies sexuelles dans l'art d'Occident.* Exh. cat. Paris: Musée du Louvre, 2000.

PARIS 2000–2001
Cuzin, Jean-Pierre, Jean-René Gaborit, and Alain Pasquier, eds. *D'après l'antique.* Exh. cat. Paris: Musée du Louvre, 2000–2001.

PARIS-VERSAILLES 1989–90
Schnapper, Antoine, Arlette Sérullaz, and Elisabeth Agius-d'Yvoire, eds. *Jacques-Louis David 1748–1825.* Exh. cat. Paris: Musée du Louvre; and Versailles: Musée national du Château, 1989–90.

PAULI 1913
Pauli, Gustav. "David im Petit Palais." *Kunst und Künstler* 11 (1913): 540–50.

PÉRON 1839
Péron, Alexandre. *Examen du tableau du "Serment des Horaces" peint par David, suivi d'une notice historique du tableau, lus à la Société libre des Beaux-Arts.* Paris, 1839.

PERRIN DE BOUSSAC 1983
Perrin de Boussac, M. *Un Témoin de la Révolution et de l'Empire. Charles-Jean-Marie Alquier (1752–1826).* La Rochelle, 1983.

PEYRE 1900
Peyre, Roger. "Quelques lettres inédites de Louis David et de Madame David." *La Chronique des arts et de la curiosité* 11 (1900): 97–98; 12 (1900): 109–11.

PHILADELPHIA 1987
Garvan, Beatrice, ed. *Federal Philadelphia 1785–1825: The Athens of the Western World.* Exh. cat. Philadelphia: Philadelphia Museum of Art, 1987.

PIDGLEY 1972
Pidgley, Michael. "An Englishman in Paris: Dawson Turner's Visits to David and Prud'hon." *BM* (Nov. 1972): 791–92.

PILES 1990
Piles, Roger de. *Cours de peinture par principe (1708).* Ed. Thomas Puttfarken. Nîmes, 1990.

PILLEPICH 2001
Pillepich, Alain. *Milan capitale napoléonienne, 1800–1814.* Paris, 2001.

PILLSBURY 1982
Pillsbury, Edmund. "Recent Painting Acquisitions: The Kimbell Art Museum." *BM* 124 (Jan. 1982): supplement, vi.

PINELLI 2001
Pinelli, Antonio. "Prud'hon et Canova." In *Pierre-Paul Prud'hon,* ed. Sylvain Laveissière, 47–76. Paris, 2001.

POISSON 1963
Poisson, Georges. "A Propos de l'Exposition *Ile de France-Brabant.*" *RL* 13, no. 1 (1963): 33–42.

PORTERFIELD 1998
Porterfield, Todd. *The Allure of Empire: Art in the Service of French Imperialism, 1798–1836.* Princeton, 1998.

POTTS 1994
Potts, Alex. *Flesh and the Ideal: Winckelmann and the Origins of Art History.* New Haven and London, 1994.

POUGETOUX 1995
Pougetoux, Alain. *Georges Rouget (1783–1869), Élève de David.* Paris, 1995.

PRAKHOV 1907
Prakhov, A. V. *Khudojectvennie Sokrovitchtcha Rossii* [*Les Trésors de l'art en Russie*]. St. Petersburg, 1907.

PRAT AND ROSENBERG 2002
Prat, Louis-Antoine, and Pierre Rosenberg. *Jacques-Louis David 1748–1825. Catalogue raisonné des dessins.* 2 vols. Milan, 2002.

PRAZ 1994
Praz, Mario. *Histoire de la décoration intérieure. La philosophie de l'ameublement.* Paris, 1994.

PRENDERGAST 1997
Prendergast, Christopher. *Napoleon and History Painting: Antoine-Jean Gros's "La Bataille d'Eylau."* Oxford and New York, 1997.

QUATREMÈRE DE QUINCY 1796 [1989]
Quatremère de Quincy, Antoine-Chrysostome. *Lettres à Miranda sur le déplacement des Monuments de l'art de l'Italie.* 1796. Ed. Edouard Pommier. Paris, 1989.

QUATREMÈRE DE QUINCY 1834
Quatremère de Quincy, Antoine-Chrysostome. *Canova et ses ouvrages; ou, Mémoires historiques sur la vie et les travaux de ce célèbre artiste.* Paris, 1834.

RABBE 1827
Rabbe, Alphonse. "Notice sur Jacques-Louis David." In *Biographie universelle et portative des Contemporains.* Paris, 1827. Offprint.

RÉAU 1922
Réau, Louis. "Lettres de Greuze au Prince Nicolas Borisovitch Iousoupov." *BSHAF* (1922): 395–99.

RÉAU 1929
Réau, Louis. *Catalogue de l'art français dans les musées russes.* Paris, 1929.

REICHARDT 1804
Reichardt, Johann Friedrich. *Vertraute Briefe aus Paris geschrieben in den Jahren 1802 und 1803.* 3 vols. Hamburg, 1804.

REINHART-FELICE 2003
Reinhart-Felice, Mariantonia, ed. *Sammlung Oskar Reinhart "Am Römerholz" Winterthur: Gesamtkatalog.* Basel, 2003.

RÉVEIL AND DUCHESNE 1828–31
Réveil, E.-A, and J. Duchesne. *Musée de peinture et de sculpture; ou, Recueil des principaux tableaux, statues et bas-reliefs des collections publiques et particulières de l'Europe. Dessiné et gravé par Réveil, avec des notices . . . par Duchesne aîné.* 11 vols. London and Paris, 1828–31.

REY 1925
Rey, Robert. "Le moins Davidien des Davidiens." *L'Art vivant* 1, no. 24 (15 Dec. 1925): 9–12.

RIBEIRO 1995
Ribeiro. Aileen. *The Art of Dress: Fashion in England and France, 1750–1820.* New Haven and London, 1995.

ROBERTS 1989
Roberts, Warren. *Jacques-Louis David, Revolutionary Artist: Art, Politics and the French Revolution.* Chapel Hill and London, 1989.

ROME 1955
Palazzo delle Esposizioni. *Capolavori della pittura francese dell'Ottocento.* Exh. cat. Rome, 1955.

ROME 1962
Palazzo Venezia. *Il ritratto francese da Clouet a Degas.* Exh. cat. Rome: Palazzo Venezia; and Milan: Palazzo Reale, 1962.

ROME 1981–82
Académie de France à Rome. *David e Roma.* Exh. cat. Rome: Villa Medici, 1981–82.

ROME 1986
Museo Napoleonico. *Mito e Storia nei "Fasti di Napoleone" in Andrea Appiani.* Exh. cat. Rome, 1986.

ROME 1997
Gorgone, G., and M. E. Tittoni, eds. *Da Montenotte a Campoformio: La Rapida Marcia di Napoleone Bonaparte.* Exh. cat. Rome: Museo Napoleonico, 1997.

ROME 2004
Jean-Baptiste Wicar. Ritratti della famiglia Bonaparte. Exh. cat. Rome, Museo Napoleonico; and Naples: Museo Diego Aragona, Pignatelli Cortes, 2004.

ROSENAU 1949
Rosenau, Helen. "Letters: Jacques-Louis David." *BM* 91 (Apr. 1949): 113–14.

ROSENBERG 1974
Rosenberg, Pierre. "Un ensemble de dessins de David au Musée des Arts décoratifs de Lyon." *RL* 24, no. 6 (1974): 421–28.

ROSENBERG 1986
Rosenberg, Pierre. "Ixelles. Belgian Neo-Classicism." *BM* 128 (Dec. 1986): 922–24.

ROSENBERG 1987
Rosenberg, Pierre. "Correction." *BM* 129 (Feb. 1987): 152.

ROSENBERG 1997
Rosenberg, Pierre. *Julien de Parme 1736-1799.* Parma, 1997.

ROSENBERG AND PERRONET 2003
Rosenberg, Pierre, and Benjamin Perronet. "Un album inédit de David." *RA* 142, no. 4 (2003): 45–83.

ROSENBERG AND STEWART 1987
Rosenberg, Pierre, and Marion Stewart. *French Paintings, 1500–1825: The Fine Arts Museums of San Francisco.* San Francisco, 1987.

ROSENBLUM 1965
Rosenblum, Robert. "Neo-Classicism Surveyed." *BM* 107 (Jan. 1965): 32–33.

ROSENBLUM 1987
Rosenblum, Robert. "Jacques-Louis David *Telemachus and Eucharis*." In *Sotheby's Preview* 68 (Jan.–Feb. 1987): 4–5. Rev. ed. "David's *Telemachus and Eucharis*." In *Sotheby's Art at Auction 1986–87* (1987): 81–85.

ROSENBLUM 1990
Rosenblum, Robert. "Reconstructing David." *Art in America* 78 (May 1990): 188–97.

ROSENBLUM 2001
Rosenblum, Robert. "David and Monsiau: Bonaparte Tames Bucephalus." In *Mélanges en hommage à Pierre Rosenberg. Peintures et dessins en France et en Italie. XVIIᵉ–XVIIIᵉ siècles,* 400–402. Paris, 2001.

ROSENBLUM AND JANSON 1984
Rosenblum, R, and H. W. Janson. *Art of the Nineteenth Century: Painting and Sculpture.* London, 1984.

ROSENTHAL [1904]
Rosenthal, Léon. *Louis David.* Paris, n.d. [1904].

ROSENTHAL 1913
Rosenthal, Léon. "L'Exposition de David et ses élèves au Petit Palais." *Revue de l'art ancien et moderne* 33 (May 1913): 337–50.

ROUX 1969
Roux, Marcel. *Bibliothèque nationale. Département des Estampes. Collection de Vinck. Inventaire analytique. 4. Napoléon et son temps.* Paris, 1969. First ed., 1929.

RUBIN 1976
Rubin, James H. "Painting and Politics, II: J.-L. David's Patriotism, or the Conspiracy of Gracchus Babeuf and the Legacy of Topino-Lebrun." *AB* 58 (Dec. 1976): 547–68.

RUBIN 1985
James H. Rubin. "'Pygmalion and Galatea': Girodet and Rousseau." *BM* 127 (Aug. 1985): 517–20.

SAN DIEGO 2003–4
Bordes, Philippe, ed. *Portraiture in Paris around 1800: Cooper Penrose by Jacques-Louis David.* Exh. cat. San Diego: Timken Museum of Art, 2003–4.

SAN FRANCISCO 1934
Palace of the Legion of Honor. *French Painting from the Fifteenth Century to the Present Day.* Exh. cat. San Francisco, 1934.

SAUNIER 1902
Saunier, Charles. "Un dessin inconnu de la *Distribution des Aigles*." *GBA* 28 (Oct. 1902): 311–22.

SAUNIER [1903]
Saunier, Charles. *Louis David.* Paris, n.d. [1903].

SAUNIER 1913
Saunier, Charles. "David et son école au Palais des beaux-arts de la ville de Paris." *GBA* 9 (May 1913): 271–90.

SAUNIER 1919
Saunier, Charles. "La gravure du Sacre de Napoléon, estampe séditieuse." *Revue des études napoléoniennes* 15, no. 1 (1919): 46–57.

SAUNIER 1925
Saunier, Charles. "Les dessins de David." *L'Art vivant* 1, no. 24 (15 Dec. 1925): 13–18.

SAUNIER 1929
Saunier, Charles. "Le dessin de Louis David." *Le Dessin* 5 (Sept. 1929): 409–20.

SAVINSKAÏA 1999
Savinskaïa, Lioubov. "La Collection de Peintures de Nikolaï Borrissovitch Youssoupov." In *Hubert Robert et Saint-Petersbourg. Les Commandes de la Famille Impériale et des Princes Russes Entre 1773 et 1802,* exh. cat., ed. Hélène Moulin, 72–87. Valence, 1999.

SCEAUX 1962
Musée de l'Ile de France. *Ile de France-Brabant.* Exh. cat. Sceaux: Musée de l'Ile de France and Brussels: Palais des Beaux-Arts, 1962.

SCHLENOFF 1972
Schlenoff, Norman. "L'Âge du néoclassicisme." [Review of London 1972.] *L'Oeil,* nos. 212–13 (Aug. 1972): 5–9, 70.

SCHNAPPER 1980
Schnapper, Antoine. *David, témoin de son temps.* Paris, 1980. English ed., 1982.

SCHNAPPER 1991
Schnapper, Antoine. "Après l'exposition David. La *Psyché* retrouvée." *RA* 91 (1991): 60–67.

SCHNAPPER 1993
Schnapper, Antoine. "David et l'argent." In *David contre David,* 2:919–29. Paris, 1993.

SCHNITZLER 1834
Schnitzler, J. H. *Moscou. Tableau statistique, géographique, topographique et historique de la ville et du gouvernement de ce nom.* St. Petersburg and Paris, 1834.

SCHOCH 1975
Schoch, Rainer. *Das Herrscherbild in der Malerei des 19. Jahrhunderts.* Munich, 1975.

SEIGNEUR 1863–64
Seigneur, Jean du. "Appendice à la Notice de P. Chaussard sur Louis David." *Revue universelle des arts* 18 (1863–64): 359–69.

SÉRULLAZ 1939
Sérullaz, Maurice. *Musée du Louvre. Collection de reproductions de dessins de J.-L. David, 1748–1825. Quatorze dessins.* Paris, 1939.

SÉRULLAZ 1972 [1975]
Sérullaz, Arlette. "A Propos de quleques dessins de Jacques-Louis David pour *Mars Désarmé par Vénus et les Grâces.*" *Bulletin des Musées royaux des beaux-arts de Belgique* 21, nos. 1–4 (1972 [1975]): 107–15.

SÉRULLAZ 1974
Sérullaz, Arlette. "Quelques dessins néo-classiques conservés à la Bibliothèque Thiers." *RL* 24, no. 6 (1974): 417–20.

SÉRULLAZ 1980A
Sérullaz, Arlette. "Dessins de Jacques-Louis David." *La Donation Suzanne et Henri Baderou au Musée de Rouen. Peintures et Dessins de l'École française, Études de la Revue du Louvre et des Musées de France* 1 (1980): 100–105.

SÉRULLAZ 1980B
Sérullaz, Arlette. "Un Carnet de croquis de Jacques-Louis David." *RL* 30, no. 2 (1980): 102–8.

SÉRULLAZ 1991
Sérullaz, Arlette. *Musée du Louvre, Cabinet des dessins. Inventaire général des dessins. École française. Dessins de Jacques-Louis David 1748–1825.* Paris, 1991.

SHERIFF 1996
Sheriff, Mary D. *The Exceptional Woman: Elisabeth-Vigée-Lebrun and the Cultural Politics of Art.* Chicago, 1996.

SHILLONY 1982
Shillony, Helena. "En marge du *Chef-d'oeuvre inconnu*: Frenhofer, Apelle et David." *L'Année Balzacienne,* new series, no. 3 (1982): 288–91.

SIEGFRIED 1957–59
Siegfried, J. "The Romantic Artist as a Portrait Painter." *Marsyas* 8 (1957–59): 30–42.

SIEGFRIED 1993
Siegfried, Susan L. "Naked History: The Rhetoric of Military Painting in Post-Revolutionary France." *AB* 75 (June 1993): 235–58.

SIEGFRIED 1995
Siegfried, Susan L. *The Art of Louis-Leopold Boilly: Modern Life in Napoleonic France.* New Haven and London, 1995.

SPENCER-LONGHURST 1976
Spencer-Longhurst, Paul. "Premier Peintre de l'Empereur: The Rôle of J.-L. David under the Empire." *The Connoisseur* 193, no. 778 (1976): 317–23.

SPENCER-LONGHURST 1992
Spencer-Longhurst, Paul. "*Apelles Painting Campaspe* by Jacques-Louis David: Art, Politics, and Honour." *Apollo* 135, no. 361 (Mar. 1992): 157–62.

STEIN 1907
Stein, Henri. "Girodet-Trioson, peintre officiel de Napoléon." *Annales de la Société historique et archéologique du Gâtinais* 25 (1907): 358–59.

STENDHAL 1936
Stendhal [Henri Beyle]. *Mélanges intimes et marginalia.* Ed. Henri Martineau. 2 vols. Paris, 1936.

STENDHAL 1996
Stendhal [Henri Beyle]. *Histoire de la peinture en Italie.* Ed. Vittorio del Litto. Paris, 1996. First ed., 1817.

STENDHAL 2002
Stendhal [Henri Beyle]. *Salons.* Ed. S. Guégan and M. Reid. Paris, 2002

STERLING 1957
Sterling, Charles. *Le Musée de l'Ermitage. La Peinture française de Poussin à nos Jours.* Paris, 1957.

STRYIENSKI 1905
Stryienski, Casimir. *Soirées du Stendhal Club.* Paris, 1905.

SUIDA AND SHAPLEY 1956
Suida, W. E, and F. R. Shapley. *Paintings and Sculpture from the Kress Collection Acquired by the Samuel H. Kress Foundation, 1951–1956.* Washington, 1956.

SUPPLÉMENT 1785
Supplément au peintre anglais au Salon. Paris, 1785. CD, 14, no. 328.

SUTTON 1965
Sutton, Denys. "Editorial: The Magnificent 'Met.'" *Apollo* (Sept. 1965): 158–68.

SWANE 1930
Swane, Leo. *Fransk Malerkunst fra David til Courbet.* Copenhagen, 1930.

SYRACUSE 1952
Syracuse Museum of Fine Arts. *Old Masters. 100 Years of Painting: French, English and American Paintings Dating from the Mid-18th Century.* Exh. cat. Syracuse, 1952.

TAIT 1983
Tait, A. "The Duke of Hamilton's Palace." *BM* 125 (July 1983): 394–402.

TERNOIS 1965
Ternois, Daniel. *Montauban, Musée Ingres. Peintures: Ingres et son temps (artistes nés entre 1740 et 1830).* Paris, 1965.

TH. 1826A
Th., A. *Vie de David, premier peintre de Napoléon.* Brussels, 1826.

TH. 1826B
Th., A. *Vie de David.* Paris, 1826.

TH. 1826C
Th., A. *Leven van den Schilder David.* Brussels, 1826.

TIHON 1986
Tihon, Marie Claire. "Le Roman de Mademoiselle Nation chatelaine de Verneuil." *Revue d'information municipale de Verneuil* (1986): 4–8.

TOKYO 1987–88
Fuji Museum of Art. *La Révolution française et le Romantisme.* Exh. cat. Tokyo, Hiroshima, Fukuoka, and Shizuoka, 1987–88 [in Japanese and French].

TOKYO 1992
Metropolitan Art Museum. *European Masterworks from The Fine Arts Museums of San Francisco.* Exh. cat. Tokyo: Metropolitan Art Museum; Fukuoka: Art Museum; Osaka: Municipal Museum of Art; and Yokohama: Sogo Museum of Art, 1992.

TOULOUSE 1955
Musée Ingres. *Ingres et ses maîtres de Roques à David.* Exh. cat. Toulouse: Musée des Augustins, 1955.

TRIPIER LE FRANC 1880
Tripier le Franc, J. *Histoire de la vie et de la mort du Baron Gros.* Paris, 1880.

TULARD 1994
Tulard, Jean. "Les épurations en 1814 et 1815." *Revue du souvenir napoléonien* 396 (July–Aug. 1994): 4–21.

TULARD 1999
Tulard, Jean, ed. *Dictionnaire Napoléon.* 2nd rev. ed. 2 vols. Paris, 1999.

VALENCE 1999
Moulin, Hélène, ed. *Hubert Robert et Saint-Petersbourg. Les commandes de la famille impériale et des princes russes entre 1773 et 1802.* Exh. cat. Valence: Musée des Beaux-Arts, 1999.

VALENTINER 1929
Valentiner, Wilhelm Reinhold. "David and the French Revolution." *Art in America* 17 (Apr. 1929): 115–42; (June 1929): 153–75.

VALLERY-RADOT 1959
Vallery-Radot, Jean. "Autour du Portrait de Lepeletier de Saint-Fargeau sur son lit de mort, par David (d'après des documents inédits)." *Archives de l'art français,* new period, 22 (1959): 354–63.

VAN DER KEMP 1963
Van der Kemp, Gérald. "Nouvelles acquisitions du Musée national de Versailles et des Trianons." *RL* 13, no. 1 (1963): 43–48.

VASSEUR 1997
Vasseur, Dominique H. "Three Lithographs by Pierre-Nolasque Bergeret." *Print Quarterly* 14, no. 2 (June 1997): 179–85.

VERBRAEKEN 1973
Verbraeken, René. *Jacques-Louis David jugé par ses contemporains et par la postérité.* Paris, 1973.

VIARDOT 1855
Viardot, Louis. *Les Musées d'Angleterre, de Belgique, de Hollande et de Russie.* 2nd rev. ed. Paris, 1855.

VIDAL 1999
Vidal, Mary. "'With a Pretty Whisper': Deception and Transformation in David's *Cupid and Psyche* and Apuleius's *Metamorphoses.*" *Art History* 22, no. 2 (June 1999): 214–43.

VIDAL 2000
Vidal, Mary. "David's *Telemachus and Eucharis*: Reflections on Love, Learning and History." *AB* 82 (Dec. 2000): 702–19.

VIDAL 2003
Vidal, Mary. "The 'Other Atelier': Jacques-Louis David's Female Students." In *Women, Art and the Politics of Identity in Eighteenth-Century Europe,* ed. Jennifer Flam and Melissa Hyde, 237–62. Aldershot, 2003.

VIENNA 1950
Albertina. *Meisterwerke aus Frankreichs Museen.* Exh. cat. Vienna, 1950.

VIGÉE LE BRUN [1869]
Vigée Le Brun, Élisabeth. *Souvenirs de Madame Vigée Le Brun.* 2 vols. Paris, n.d. [1869].

VITRY 1926
Vitry, Paul. "La Fondation Ny Carlsberg." In *Beaux-Arts,* 1–15 Oct. 1926.

WAAGEN 1854
Waagen, Gustav Friedrich. *Treasures of Art in Great Britain.* 3 vols. London, 1854.

WALKER, EMERSON, SEYMOUR 1961
Walker, J., G. Emerson, and Charles Seymour, Jr., eds. *Art Treasures for America: An Anthology of Paintings and Sculptures in the Samuel H. Kress Collection.* London, 1961.

WASHINGTON 2003–4
Conisbee, Philip, Kaspar Monrad, and Lene Bøgh Rønberg, eds. *Christoffer Wilhelm Eckersberg 1783–1853.* Exh. cat. Washington, D.C.: National Gallery of Art, 2003–4.

WATELET AND LÉVESQUE 1788–91
Watelet, Claude-Henri, and Pierre-Charles Lévesque. *Encyclopédie méthodique: Beaux-Arts.* 2 vols. Paris, 1788–91. Reissued as *Dictionnaire des arts de peinture, sculpture et gravure.* 5 vols. Paris, 1792. Reprint, Geneva, 1972.

WILDENSTEIN 1950A
Wildenstein, Georges. "À la Malmaison. Un chef-d'oeuvre de David retrouvé." *Arts* (29 Sept. 1950): 1.

WILDENSTEIN 1950B
Wildenstein, Georges. "Du nouveau sur le Bonaparte au Saint-Bernard." *Arts* (10 Nov. 1950): 1.

WILDENSTEIN 1959
Wildenstein, Georges. "Les Davidiens à Paris sous la Restauration." *GBA* 53 (Apr. 1959): 237–46.

WILDENSTEIN 1961
Wildenstein, Georges. "David, la comtesse Daru et Stendhal." *GBA* 57 (Feb. 1961): 117–22.

WILDENSTEIN 1973
Wildenstein, Daniel, and Guy Wildenstein. *Documents complémentaires au catalogue de l'oeuvre de Louis David.* Paris, 1973.

WILHELM 1964
Wilhelm, Jacques. "David et ses portraits." *Art de France* 4 (1964): 158–73.

WILSON 1981
Wilson, John Montgomery. "The Painting of the Passions in Theory, Practice, and Criticism in Later Eighteenth-Century France." Ph.D. dissertation, University of Iowa. New York and London: Garland, 1981.

WISNER 1991
Wisner, David A. "L'Iconographie révolutionnaire dans l'oeuvre post-thermidorienne de Jacques-Louis David 1794–1802." In *Révolution française 1988–1989* [Papers of the Congrès national des Sociétés savantes, Strasbourg, 1988, Paris, 1989], 275–90. Paris, 1991.

YORKE 1906
Yorke, Henry Redhead. *France in Eighteen Hundred and Two Described in a Series of Contemporary Letters.* Ed. J.A.C. Sykes. London, 1906.

ZAGHI 1958–60
Zaghi, C. *I Carteggi di Francesco Melzi. La Vice-Presidenza della Repubblica Italiana.* 4 vols. Milan, 1958–60. [Additional vols. published after 1960.]

ZEITZ 2003
Zeitz, Lisa, and Joachim Zeitz. *Napoleons Medaillen.* Petersburg, 2003.

ZURICH 1937
Kunsthaus. *Zeichnungen französischer Meister von David zu Millet.* Exh. cat. Zurich, 1937.

ZURICH 1994
Lang, Paul, ed. *Ein Blick auf Amor und Psyche um 1800. / Regards sur Amour et Psyché à l'âge néo-classique.* Exh. cat. Zurich: Kunsthaus; and Carouge: Musée de Carouge, 1994.

PHOTOGRAPHY CREDITS

Permission to reproduce illustrations is provided by courtesy of the owners as listed in the captions. Additional photography credits are as follows:

Administration Générale du Mobilier National, Paris (FIGS. 17, 18)

Michael Agee (FIGS. 11, 25, 39, 46, 53, 65, 78, 87)

© The Art Institute of Chicago (FIG. 33; CATS. 11A, 11B)

The Baltimore Museum of Art (CAT. 34)

Courtesy of Bayerische Staats Gemäldesammlungen, Munich (FIG. 63)

© Bildarchiv Preussischer Kulturbesitz / Art Resource, New York: photo Jörg P. Anders (FIG. 66)

© 2004 Board of Trustees, National Gallery of Art, Washington, D.C. (FIG. 47; CATS. 12, 23)

Courtesy of W. M. Brady & Co., New York (FIG. 89; CATS. 37, 42)

Jenni Carter, Art Gallery of NSW (CATS. 52, 53)

Courtesy of Ms. Marie-Claude Chaudonneret (FIG. 12)

Charles Choffet, Besançon (FIG. 35)

© 2004 The Cleveland Museum of Art (CATS. 30, 32, 43)

Prudence Cuming Associates Ltd., London (CATS. 33, 45)

Courtesy of the Denver Art Museum, Reed Photo (CAT. 46)

Documentation du Louvre, Paris (FIGS. 50, 86, 93)

Walter Drayer Fotograf, Zurich (FIG. 45)

Courtesy of Comte Estève (FIG. 41)

Courtesy of Richard L. Feigen & Co. (CAT. 51)

© Fine Arts Museums of San Francisco (FIG. 67; CATS. 22, 39)

© Fondation Napoléon (FIG. 27)

Foto Studio 3 di Michele Rubicondo (FIG. 4)

© The Frick Collection, New York (CAT. 18)

© Horvitz Collection, Boston: photo Michael Gould (CAT. 44)

Courtesy of Ellen Josefowitz (CAT. 19)

Courtesy of Ms. Claudine Jouve-Lebrun (FIG. 5)

© The J. Paul Getty Museum, Los Angeles (CATS. 15, 35, 54)

© 2004 Kimbell Art Museum, Fort Worth, Texas (CAT. 36)

Erich Lessing / Art Resource, New York (FIG. 94)

© The Metropolitan Museum of Art, New York (CATS. 25, 50)

© Musée de l'Armée, Paris (FIG. 9)

Musée des Augustins, Toulouse (FIG. 111)

Musée des Beaux-Arts d'Arras (FIG. 68)

© Musée Fabre, Montpellier: photo Frédéric Jaulmes (CATS. 6, 24)

© Musées de la Ville de Rouen: photo Catherine Lancien and Carole Loisel (FIG. 92)

Suzanne Nagy, Malakoff, France (FIGS. 13, 84)

© 2004 National Gallery of Canada, Ottawa (FIG. 42)

© National Gallery Picture Library, London (CAT. 47)

Courtesy of Mr. Benjamin Perronet, c/o Mr. Pierre Rosenberg (FIGS. 22, 23, 38, 79, 98, 104; CAT. 13)

© Philadelphia Museum of Art: photo Joseph Mikuliak (FIG. 49)

Photo d'Art / Kunstfoto Speltdoorn (FIG. 110)

Photothèque of the Museums, Ville de Paris (FIGS. 56, 57, 95)

H. Preisig, Sion, Switzerland (FIG. 24)

© 2004 President and Fellows of Harvard College: photo Allan Macintyre (FIGS. 28, 83); photo David Mathews (FIG. 97); Photographic Services (FIGS. 15, 100)

Antonia Reeve Photography (FIG. 2)

© Réunion des Musées Nationaux / Art Resource, New York (FIGS. 6, 14, 26, 34, 37, 55, 58, 59, 70, 81, 91, 99, 101; CATS. 2, 3, 17, 28, 57): photo Daniel Arnaudet (FIGS. 19, 82, 96; CAT. 4); photo Michèle Bellot (FIGS. 32, 69; CAT. 26); photo J. G. Berizzi (CAT. 56); photo P. Bernard (FIGS. 10, 40; CAT. 31); photo Gérard Blot (FIGS. 3, 43, 44, 48, 51, 60, 61, 62, 77; CATS. 1, 5, 8, 9, 10, 29); photo G. Blot and C. Jean (FIG. 76); photo Gérard Blot and Jean Schormans (FIG. 103); photo C. Jean (FIGS. 73, 75); photo Lagiewski (FIGS. 7, 30); photo Herve Lewandowski (FIG. 106); photo R. G. Ojeda (FIGS. 1, 21, 80, 85); photo Popovitch (FIG. 74); photo Jean Schormans (FIG. 54); photo Peter Willi (FIG. 31)

Roumagnac Photographe (FIG. 90)

© Royal Museum of Fine Arts, Brussels, Belgium: photo Cussac (FIG. 64); photo Speltdoorn (FIG. 52)

Courtesy of Mr. Guy Stair Sainty (FIG. 88)

Scala Archives / Art Resource, New York (CAT. 21): © 2004 State Hermitage Museum, St. Petersburg (CAT. 27)

Courtesy of Nicolas Schwed, Christie's, Paris (CAT. 38)

© Ph. Sebert (CAT. 40)

Stanley R. Smith (CAT. 16)

Staatliche Museen, Kassel, Germany (FIG. 29)

© 2005 Sterling and Francine Clark Art Institute, Williamstown, Massachusetts. All rights reserved (CAT. 48)

Courtesy of Wildenstein & Co. (CATS. 20, 41)